THE HARVEST OF WAR

ALSO BY STEPHEN P. KERSHAW

A Brief History of Atlantis
A Brief History of the Roman Empire
A Brief Guide to Classical Civilization
A Brief Guide to the Greek Myths
Barbarians

THE
HARVEST
OF WAR

MARATHON, THERMOPYLAE, AND SALAMIS:
THE EPIC BATTLES THAT SAVED DEMOCRACY

STEPHEN P. KERSHAW

PEGASUS BOOKS
NEW YORK LONDON

THE HARVEST OF WAR

Pegasus Books, Ltd.
148 West 37th Street, 13th Floor
New York, NY 10018

Copyright © 2022 by Stephen P. Kershaw

First Pegasus Books cloth edition October 2022

ISBN: 978-1-63936-234-9

10 9 8 7 6 5 4 3 2 1

Printed in the United States of America
Distributed by Simon & Schuster
www.pegasusbooks.com

For Lal & Hero

Contents

Acknowledgements ix

A Note on Names, Spellings and Dates xi

Maps xiii

1 Athens: The World's First Democracy 1

2 Persia: The World's Most Powerful Empire 36

3 Darius the Great 65

4 This is Sparta! 88

5 The Ionian Revolt 120

6 The First Interwar Interlude 146

7 Marathon: Democracy Saved 161

8 The Second Interwar Interlude 186

9 The Persians are Coming! 219

10 Xerxes Ascendant: Artemisium and the 300 Spartans 245

11 Democracy Resurgent: Greek Victory at Salamis 277

12 Greece in the Ascendancy: Plataea 312

13 Democracy on the Offensive 352

14 Modern Afterlife 364

Notes 393

Bibliography 441

Index 449

Acknowledgements

I am extremely grateful to a great many individuals, groups and institutions without whose help and inspiration this book could not have been written. I would like express my deepest thanks to many of my fellow students, and the brilliant teachers, from Salterhebble County Primary School, Heath Grammar School and Bristol University, without whose enthusiasm, dedication and expertise I would never have been able to engage with the ancient Greeks and Persians, their languages and culture; the fine people at Swan Hellenic and Vikings Navita, whose itineraries allowed me to explore the physical world of the Greeks and Persians in so much style; my colleagues and students (both 'real' and 'virtual') at Oxford University Department for Continuing Education, the Victoria and Albert Museum and the Arts Society, who in their various ways have sustained my interest and facilitated my professional development via our explorations of the ancient world together; Duncan Proudfoot, Zoe Bohm, Zoë Carroll, Ben McConnell, Howard Watson, David Andrassy, Kim Bishop, David Atkinson and Kate Hibbert for their professional excellence in the publishing world; my late parents

Philip and Dorothy Kershaw for their unconditional, rock-solid support throughout my career; Hero for her unwavering canine companionship; and my wife Lal Jones, whose constant love and understanding make all this possible.

A Note on Names, Spellings and Dates

The question of Greek and Persian names transliterated into English presents an insoluble problem. The Persian sources are often written in multiple languages, so the ruler commonly known as Darius was *Dārayavauš*, sometimes shortened to *Dārayauš* in Old Persian, *Da-ri-(y)a-ma-u-iš* or *Da-ri-ya-(h) u-(ú-)iš* in Elamite, *Da-(a-)ri-ia-(a-)muš* or *Da-(a)ri-muš* in Babylonian, *tr(w)š*, *trjwš*, *intr(w)š* or *intrjwš* in Egyptian, and *Dareios* in Greek. Greek names are commonly Latinised into slightly more familiar-looking English equivalents, so that *Alexandros* (the direct transliteration from the Greek) becomes Alexander, *Themistokles* becomes Themistocles, *Peististratos* becomes Peisistratus or Pisistratus, etc. Our Greek sources are also written in different dialects, so the Spartan *Leotychidas* (*Leotykhidas*) also appears as *Leotychides*, *Latychidas* and *Leutychides*, and sometimes there is just confusion over what the correct form of the name should be, as with the Persian *Artaphernes/Artaphrenes*. There are frequently multiple names for the same place: the island of Keos can appear as Ceus, Ceos, Cea, Kea, Zea and Tzia. With this in mind, I have, for the most part, followed the convention of Latinising the

Greek names, and using the Greek renderings of Persian names, but there will inevitably be inconsistencies.

All the dates in the text are BCE unless it is obvious or otherwise specified. To avoid causing religious offence, the neutral expressions BCE and CE, 'Before the Common Era' and 'Common Era', are used instead of BC and AD respectively.

Translations

All the translations and paraphrases are my own, unless otherwise indicated and acknowledged.

Maps

1. Greece and the Aegean
2. The Persian Empire
3. The Persian Invasions of Greece
4. The Crucial Battlefields

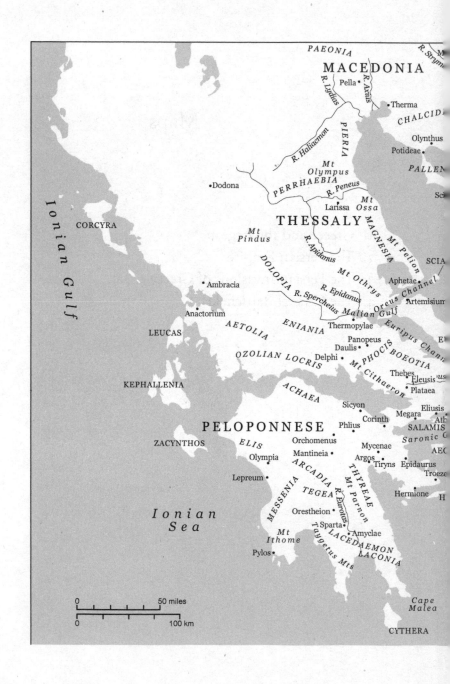

PAEONIA
MACEDONIA
R. Strymon
R. Lydias
Pella • •Axius
R. Axius
•Therma
CHALCIDI
PIERIA
Olynthus
Potideae •
PALLEN
Mt
Olympus
R. Haliacmon
PERRHAEBIA
R. Peneus
•Dodona
Larissa
Mt
Ossa
Sci
CORCYRA
THESSALY
MAGNESIA
Mt
Pindus
R. Apidanus
Mt Pelion
SCIA
DOLOPIA
Mt Othrys
Aphetae •
SCIA
•Ambracia
R. Epidanus
R. Spercheius
Malian
Gulf
Artemisium
Oreus Channel
Anactorium
ENIANIA
Thermopylae
Euripus Chann
LEUCAS
AETOLIA
Panopeus
Daulis •
E
OZOLIAN LOCRIS
Delphi •
PHOCIS
BOEOTIA
Ionian Gulf
KEPHALLENIA
Mt Cithaeron
Thebes
Eleusis us
Plataea
ACHAEA
Sicyon •
Eliusis
Megara
Ath
ZACYNTHOS
PELOPONNESE
Phlius •
Corinth
SALAMIS
Saronic G
ELIS
Orchomenus
AEC
Olympia
Mantineia •
Mycenae •
Argos Tiryns
Epidaurus
Troeze
Lepreum •
ARCADIA
TEGEA
Mt Parnon
Hermione
MESSENIA
Orestheion •
R. Eurotas
THYREAE
H
Ionian
Sea
Mt
Ithome
Sparta • •Amyclae
Taygetus Mts
LACEDAEMON
LACONIA
Pylos •

0 50 miles

0 100 km

Cape
Malea

CYTHERA

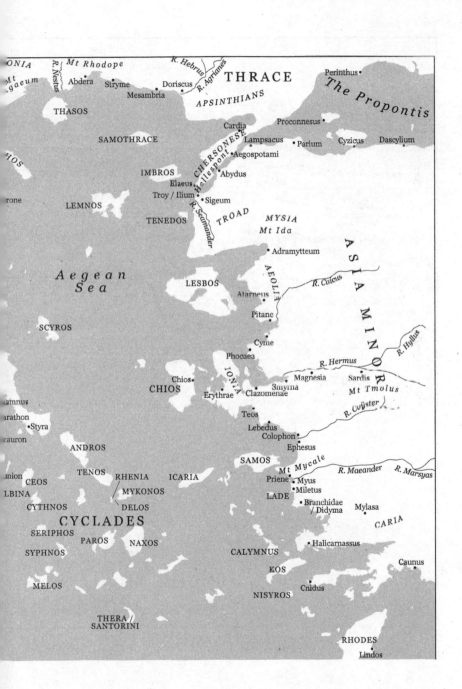

ONIA
Mt *Rhodope*
R. *Nestus*
Mt
gaeum

Abdera
Stryme
Doriscus
R. *Hebrus*
R. *Agrianes*
THRACE
Perinthus •

The Propontis

Mesambria
APSINTHIANS

THASOS
Cardia
Proconnesus •

SAMOTHRACE
CHERSONESE
Lampsacus
Parium
Cyzicus
Dascylium

HOS
IMBROS
Aegospotami

Elaeus
Abydus

rone
Troy / Ilium
Sigeum

LEMNOS
R. *Scamander*
TROAD
MYSIA
Mt Ida

TENEDOS

• Adramytteum

*Aegean
Sea*
LESBOS
AEOLIS
R. *Caïcus*

ASIA MINOR

Atarneus

SCYROS
Pitane

R. *Hyllus*

Cyme

Phocaea
R. *Hermus*
Sardis
Chios •
Magnesia
Mt *Tmolus*
CHIOS
IONIA
Smyrna
Erythrae
Clazomenae
R. *Caÿster*

amnus
arathon
• Styra
Teos

rauron
Lebedus
Colophon •
Ephesus

ANDROS
SAMOS
Mt *Mycale*
R. *Maeander*
R. *Marsyas*

TENOS
RHENIA
ICARIA
Priene
Myus

union
CEOS
MYKONOS
LADE
Miletus

LBINA
CYTHNOS
DELOS
Branchidae
/ Didyma
Mylasa

CYCLADES
CARIA

SERIPHOS
PAROS
NAXOS

SYPHNOS
CALYMNUS
Halicarnassus •

MELOS
KOS
Caunus

Cnidus

NISYROS

THERA /
SANTORINI

RHODES
Lindos

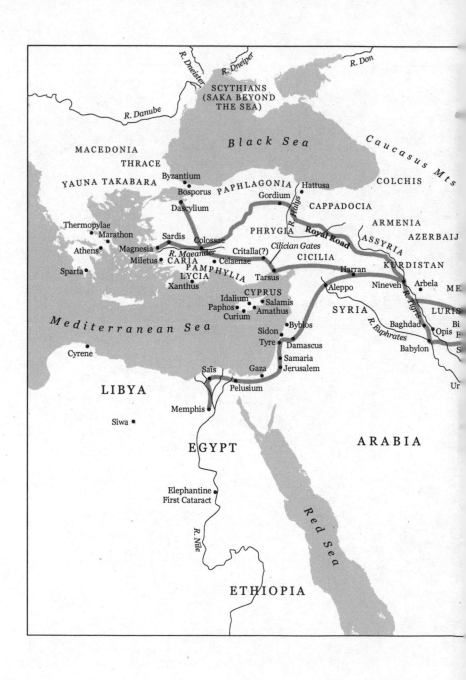

SCYTHIANS
(SAKA BEYOND
THE SEA)

R. Dniester

R. Dnieper

R. Don

R. Danube

Black Sea

Caucasus Mts

MACEDONIA

THRACE

YAUNA TAKABARA

COLCHIS

Byzantium

Bosporus

PAPHLAGONIA

Hattusa

Gordium

CAPPADOCIA

Dascylium

R. Halys

ARMENIA

AZERBAIJ

Thermopylae

Marathon

Sardis

Colossae

PHRYGIA

Royal Road

ASSYRIA

Athens

Magnesia

R. Maeander

Critalla(?)

Cilician Gates

CICILIA

KURDISTAN

Miletus

CARIA

Celaenae

ME

Sparta

PAMPHYLIA

Tarsus

Harran

Nineveh

Arbela

LYCIA

Xanthus

CYPRUS

Idalium

Salamis

Paphos

Amathus

Curium

SYRIA

LURIS

Mediterranean Sea

Aleppo

R. Tigris

Baghdad

Bi

Byblos

Opis

E

Sidon

Damascus

Babylon

S

Tyre

Samaria

R. Euphrates

Cyrene

Saïs

Gaza

Jerusalem

Ur

Pelusium

LIBYA

Memphis

Siwa

EGYPT

ARABIA

Elephantine

First Cataract

Red Sea

R. Nile

ETHIOPIA

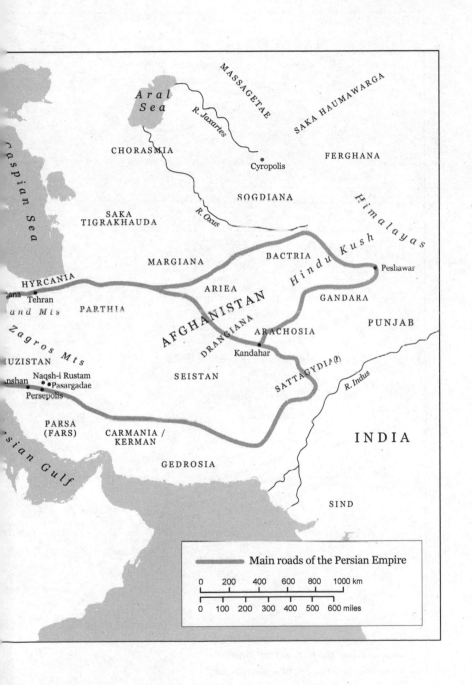

Main roads of the Persian Empire

| 0 | 200 | 400 | 600 | 800 | 1000 km |

| 0 | 100 | 200 | 300 | 400 | 500 | 600 miles |

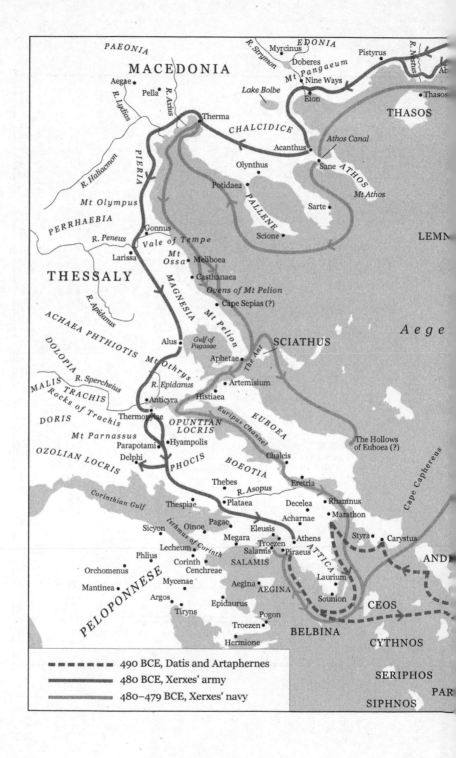

PAEONIA

MACEDONIA

Aegae • Pella •
R. Lydias
R. Arcius

R. Haliacmon

PIERIA

Mt Olympus

PERRHAEBIA

R. Peneus

Gonnus

Vale of Tempe

Larissa •

THESSALY

R. Apidanus

ACHAEA PHTHIOTIS

DOLOPIA R. Spercheius

MALIS
TRACHIS
Rocks of Trachis

DORIS

Alus •

Mt Othrys

R. Epidanus
Anticyra •
Thermopylae •

Mt Parnassus
Parapotami •
Delphi •

OZOLIAN LOCRIS

Corinthian Gulf

Mt
Ossa • Meliboea

• Casthanaea

Ovens of Mt Pelion
• Cape Sepias (?)

Gulf of
Pagasae
Aphetae •

MAGNESIA

Mt Pelion

SCIATHUS

The Ant

• Artemisium

Histiaea •

Euripus Channel

OPUNTIAN
LOCRIS
• Hyampolis

PHOCIS

R. Strymon

Myrcinus •

EDONIA

Doberes •

Mt Pangaeum

Lake Bolbe

Therma •

CHALCIDICE

Olynthus •

Potidaea •

Nine Ways
• Eion

Acanthus •

Athos Canal

Sane • ATHOS

Mt Athos

Sarte •

PALLENE

Scione •

EUBOEA

The Hollows
of Euboea (?)

BOEOTIA

Thebes •
R. Asopus

Thespiae •
• Plataea

Sicyon •

Oinoe
Pagae •

Isthmus of Corinth

Lecheum •

Phlius •

Orchomenus •

Mantinea •

Mycenae •

Argos •

Tiryns •

PELOPONNESE

Chalcis •

Eretria •

Decelea •

Acharnae •

Eleusis •
Megara •
Salamis •

SALAMIS

Corinth •
Cenchreae •

Aegina •

AEGINA

Epidaurus •

Pogon •

Troezen •

Hermione •

Pistyrus •

R. Nestus

Ab

• Thasos

THASOS

LEMN

Aege

Cape Caphereus

• Rhamnus
• Marathon

Troezen •
Piraeus •

ATTICA

Athens •

Styra •
• Carystus

Laurium •

Sounion •

BELBINA

AND

CEOS

CYTHNOS

SERIPHOS

PAR

SIPHNOS

– – – – 490 BCE, Datis and Artaphernes
———— 480 BCE, Xerxes' army
———— 480–479 BCE, Xerxes' navy

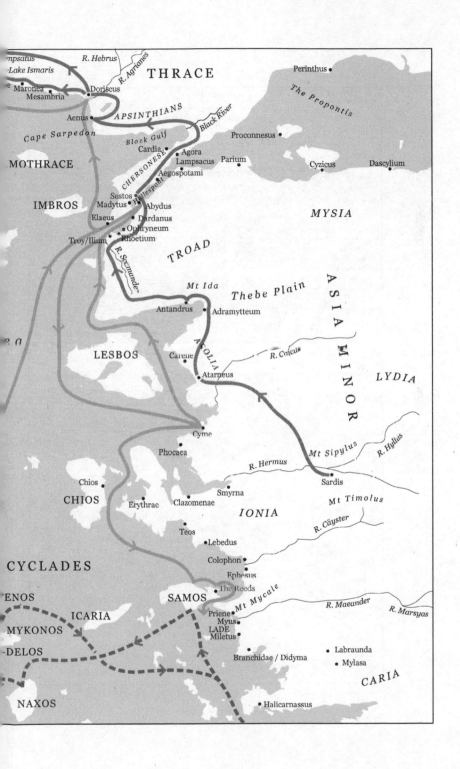

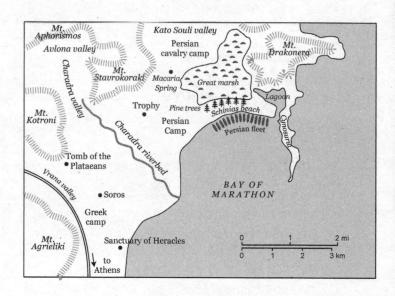

Mt. Aphorismos
Avlona valley
Kato Souli valley
Mt. Drakonera
Persian cavalry camp
Mt. Stavrokoraki
Macaria Spring
Great marsh
Charadra valley
Trophy
Pine trees
Lagoon
Mt. Kotroni
Charadra riverbed
Schinias beach
Cynosura
Persian Camp
Persian fleet
Tomb of the Plataeans
Vrana valley
Soros
BAY OF MARATHON
Greek camp
Mt. Agrieliki
Sanctuary of Heracles
to Athens

0 1 2 mi
0 1 2 3 km

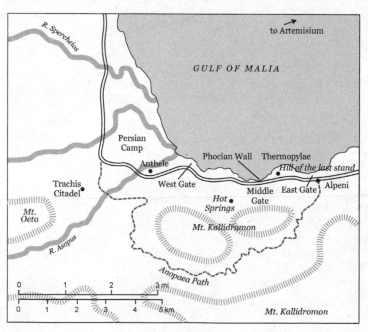

R. Spercheios
to Artemisium
GULF OF MALIA
Persian Camp
Anthele
Phocian Wall
Thermopylae
Hill of the last stand
Trachis Citadel
West Gate
Middle Gate
East Gate
Alpeni
Hot Springs
Mt. Oeta
Mt. Kallidromon
R. Asopus
Anopaea Path
Mt. Kallidromon

0 1 2 3 mi
0 1 2 3 4 5 km

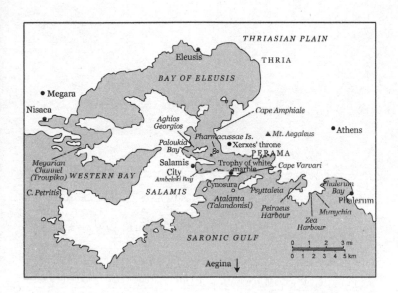

THRIASIAN PLAIN

THRIA

Eleusis

BAY OF ELEUSIS

• Megara

Nisaca

• Cape Amphiale

Aghios Georgios

▲ Mt. Aegaleus

• Athens

Paloukia Bay

Pharmacussae Is.

• Xerxes' throne

PERAMA

Salamis City

Trophy of white marble

Cape Varvari

Megarian Channel (Troupika)

WESTERN BAY

Ambelaki Bay

Cynosura

Phalerum Bay

C. Petritis

Psyttaleia

Phalerum

SALAMIS

Atalanta (Talandonisi)

Peiraeus Harbour

Munychia

Zea Harbour

SARONIC GULF

0 1 2 3 mi
0 1 2 3 4 5 km

Aegina ↓

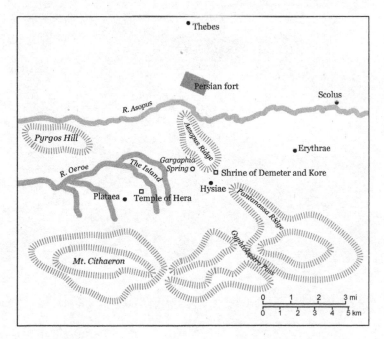

• Thebes

Persian fort

R. Asopus

Scolus

Pyrgos Hill

Asopus Ridge

• Erythrae

R. Oeroe

The Island

Gargaphia Spring ○

□ Shrine of Demeter and Kore

Plataea • □ Temple of Hera

Hysiae •

Pantanassa Ridge

Gyphtokastro Pass

Mt. Cithaeron

0 1 2 3 mi
0 1 2 3 4 5 km

CHAPTER I

Athens: The World's First Democracy

Athenians are here, whose city is thought to have developed civilisation, learning, religion, crops, justice, and laws, and disseminated them across the entire world.

Cicero[1]

Astonishing Elections

As winter was turning into spring in the year they called 'The Archonship of Hybrillides' (490 BCE), the free, native-born, adult, male Athenians did something utterly extraordinary. They went to the polls to elect their annual military officers and civilian magistrates for the next year. Hardly anyone else anywhere in the ancient world had a democratic political process like this, and the outcome of the election is sometimes felt to have determined the entire history of the Western world.

Hybrillides and his fellow citizens certainly knew it was important. Athens was under threat from the might of the Persian Empire of King Darius I. Persian forces had already made one attempt at invading Greece, which had come to grief in the rough seas off the Mt Athos peninsula about eighteen

months before, and Darius had demanded 'earth and water' as tokens of submission from the Athenians, which they had unceremoniously refused to provide. They knew what was coming.

Standing for election was a charismatic and controversial figure, Miltiades ('Son of the Red Earth'/'Redearthson') son of Cimon. He was an Athenian aristocrat with many domestic enemies; he had operated as a tyrant, admittedly on Athens's behalf, in the Thracian Chersonese (Gallipoli peninsula); he had close and possibly ambiguous relations with the Persians; and he had narrowly escaped death on two recent occasions, first when he evaded the Persian invasion force by the skin of his teeth as it was heading for Greece, and second when he had arrived in Athens, only to be put on trial for his tyranny in the Chersonese. He had been acquitted then, and he was elected now, as one of the ten *strategoi* (generals) who would command their respective tribal contingents in the inevitable war. It was one of the most politically and militarily significant decisions ever made. An equally important choice was the appointment alongside Miltiades of Callimachus ('Beautiful-Fighter') of Aphidnae as the *polemarkhos* ('polemarch' or 'war leader'). The two men would take up office in the summer of 490 BCE.

Mythical Athens

Ancient Athens has become synonymous with democracy, and the exploits of the Greeks at the three epic battles of Marathon, Thermopylae and Salamis are lauded for saving the world from tyranny. Yet Athens had not always had a democratic system of government. In the mythical tradition the city was ruled by kings, who had a zero-tolerance policy when it came to

democracy. In Homer's *Iliad*, Odysseus is said to put any 'man of the people' firmly in his place: 'sit still,' he says, 'listen to men who are better than you; you are unwarlike; you are impotent; you are an irrelevance in combat and in counsel; we can't all be kings; the rule of many is a bad thing; there should just be one king and commander who takes the decisions on behalf of his people.'[2] No ordinary person should ever challenge the authority of a mythical king, and when a common soldier, who is incredibly ugly, bandy-legged, lame in one foot, round-shouldered, pointy-headed and never shuts up, criticises the supreme commander Agamemnon, Odysseus thrashes the unfortunate man with his golden staff, making him cringe and cower, burst into tears, and break out into livid bruises. The army think it is the best thing that Odysseus has ever done.[3]

A defining element in the self-image of the Athenians, which undoubtedly played a key role in stiffening their resistance to the Persians, was the idea that they were autochthonous, i.e. the aboriginal inhabitants of their land (Greek: *khthon* = 'earth'). This defined them as definitively different from the Spartans, whose traditions expressed their nature as incomers equally strongly.[4] The second-century CE travel writer Pausanias informs us that Actaeus was the first king of Attica (the region of which Athens was the main city).[5] However, an inscription known as the *Parian Chronicle*,[6] which records a selection of key dates in Greek history/mythology, calculated from a baseline date of 264/263 BCE when it was inscribed, takes its starting point as the reign of Cecrops I, who it describes as 'the first King of Athens': 'From when Cecrops became king of Athens, and the land previously called Actica after the earth-born Actaeus was called Cecropia: 1318 years [i.e. 1581/1580 BCE[7]].'[8] The date can doubtless be taken with a pinch of salt, but the

fact that Actaeus was born of the very soil of his land was crucial.

Some of Athens's mythical kings rank among the weirdest characters in the whole of Greek mythology, and Cecrops was no exception. He too was truly autochthonous, having been born literally from the earth with no recorded parents. He had a human body with a serpent's tail, and was a civilising figure whose reign witnessed a widespread modernising of social customs and one of the most important incidents in Athenian mythology – a divine dispute between Poseidon and Athena for possession of Attica.[9] To stake his claim Poseidon smashed his trident into the Acropolis and a saltwater spring came into being,[10] but Athena trumped this with the infinitely superior gift of an olive tree.[11] She took possession of Attica, and called the city Athens after herself.

A succession of usually earth-born and sometimes semi-serpentine kings ruled the city, including Cranaus, who was also said to have been on the throne when the Great Flood (*kataklysmos*) associated with Deucalion (the 'Greek Noah') occurred, dated by the *Parian Chronicle* to 1528/1527,[12] Erikhthonius, who was born from the sordid aftermath of Hephaestus's attempt to rape Athena, and Erekhtheus, in whose reign the *Parian Chronicle* records that the fertility goddess Demeter first came to Attica (1409/1408), the first corn was sown by Triptolemus (1408/1407), and the Eleusinian Mysteries were first celebrated (date unclear).[13]

Further down the Athenian mythical king-list, their great monarch Theseus took the throne after his various impressive monster-slaying feats, Minotaur included. Plutarch says that Theseus was a big admirer of Heracles and performed these deeds in emulation of his Labours,[14] and the Athenians may well have

constructed the story to provide themselves with an 'Attic Heracles', probably as late as the last quarter of the sixth century, when Athens was making its final steps towards democracy. In the historical period, Athens's number-one hero certainly needed to be given democratic credentials: although he was a monarch, he was made into a political reformer with democratic leanings. His greatest achievement was said to be the *synoecism* of Attica: 'From when Thes[eus . . . became king] of Athens and amalgamated [*synoikisen*] the 12 communities [*poleis*] and grant[ed] the constitution [*politeian*] and the democracy [*demokratian*] . . . of Athens [. . .] 995 years [i.e. 1258/1257].'[15]

This *synoecism* was the amalgamation of all the small independent communities of the region into one state, with Athens as its capital – one people, one city, one town hall and council chamber, and one common set of interests. As Plutarch wrote: 'Theseus promised both a kingless constitution and a democracy to the powerful, with himself as the only commander in war and guardian of the laws, while in other respects everyone would have equal shares.'[16] This is historically false, but mythologically interesting: even mythical Athenians came to be seen as democrats.

Theseus was also credited with establishing the Panathenaia Festival to Athena, fighting off a major assault on Athens by the Amazons,[17] and then laying aside his royal power. In Homer's Catalogue of Ships in the *Iliad*, the Athenians take fifty 'black ships' from their 'well-built citadel' to Troy,[18] but it is notable that they are the only contingent who are described as a 'people' (*demos*).[19] The *Iliad* was edited at Athens in the sixth century, and this pointed reference to their democratic credentials might also reflect contemporary preoccupations. That is certainly the case in Euripides' tragedy *Suppliant Women*, first performed in

about 423, where Theseus has a spat with a herald from Thebes. When the Theban asks, 'Who is the ruler (*tyrannos*) of the land?' Theseus gives him a lecture on Athenian politics: don't ask for a *tyrannos* here; the city is free, not subject to one-man rule; the people (*demos*) are sovereign; political office is held on an annual basis; rich and poor are equally honoured. The herald is unimpressed: his city is ruled by one man, he says, not by a mob (*okhlos*); no one can trick the city with weasel words and manipulate it to his own advantage; the common people (*demos*) are incapable of making a proper speech, so they can't possibly know how to govern a city effectively; time, not speed, gives superior understanding; a farmer might not be stupid, but his workload doesn't allow him to look at the common good; and anyway, the better people think it's a sad state of affairs when a low-born nonentity becomes well known by seducing the common people with his slick tongue. Theseus rises to the bait: this doesn't seem to have much to do with your errand, he says; you started this argument; listen to me; there's nothing more hostile to a city than a tyrant; to have one man controlling all the laws is unjust; written laws allow both the weak and the rich equal access to justice; the little guy can get the better of the bigwig, if he has right on his side; freedom is the right to be able to put proposals to the city and have them debated; if you want to be famous, you can be, and if you don't, you can keep quiet; what is fairer for a city than that? The herald never gets the chance to respond because Theseus makes him deliver his message, although he starts by saying, 'OK. I'll speak. But as far as our argument goes, you can have your views and I'll think the opposite.'[20]

Theseus's mythical democracy was not quite the classless society of its onstage incarnation, however: Plutarch tells us

that rather than allowing 'his democracy [*demokratia*] to become disorderly or diverse because of a random multitude pouring into it',[21] he segregated the Athenians into three privilege groups: the nobles (*Eupatridai*), who excelled in dignity; the landowners, who excelled in usefulness; and the artisans, who excelled in numbers.

Theseus is also said to have made a clear-cut ethnic and geographical division between the Ionian Athenians and the Dorian Peloponnesians, who derived the name of their land from the mythical King Pelops: Peloponnese = 'Island of Pelops'. Theseus erected a pillar at the Isthmus of Corinth with a two-line verse inscription: the one facing east said, 'Here is not the Peloponnese, but Ionia'; the west-facing one read, 'Here is the Peloponnese, not Ionia.'[22] Their Ionian ethnicity was very important to the Athenians, and the fact that Theseus reputedly established various rituals including the 'Crane Dance' at the Ionian cult-centre of Delos on his way back from slaying the Minotaur was exploited by them as they asserted their leadership of the Ionian world.[23]

Not all of Theseus's personal dealings, however, were consensual. Prior to the events that triggered the Trojan War[24] he kidnapped Helen of Sparta – he was already fifty years old and she was still a child.[25] Outrage at this caused political chaos, which gave his domestic opponents, led by Menestheus, their chance.[26] Menestheus was said to be the first person to 'set himself up as a demagogue, and ingratiate himself with the multitude',[27] and he played on the ill feelings generated by Theseus's reforms: the nobles thought that he had robbed them of their local royal powers (whatever they might have been), and had treated them as subjects and slaves; the *hoi polloi* felt they had been robbed of their native homes and religions, and

that the various 'good kings who were their own kinsmen', i.e. the nobles, had been supplanted by 'one master who was an immigrant and a foreigner'.[28] The power of local loyalties in Attica was strong, and would in due course be a major factor in the Athenian success in repulsing the Persian invasions, but on this occasion it led to factional infighting and political chaos in which Theseus lost control. He fled to the island of Scyros, where, so he thought, the people were friendly to him. But he had misjudged the situation badly, and King Lycomedes pushed him off a cliff. So Athens went back to being a monarchy, and the Athenians, 'masters of noise of battle',[29] duly fought at Troy under their new King Menestheus, 'son of Peteos, driver of horses'.

Proto-historic Athens

There is a sense in which, for the Greeks, the Trojan War marks the transition between myth/prehistory and what we might call proto-history. The *Parian Chronicle* tells us that Menestheus set off for the war in the thirteenth year of his reign in 1218/1217, and that Troy fell in 1208/1207.[30] After that there is a space of between three and five letters, indicating a new section: it is rather like the modern BC/AD (or BCE/CE) distinctions.

The Greek tradition places the Trojan War towards the end of what we call the Mycenaean Period (*c.* 1600–1200 BCE). The archives of clay tablets, written in a script called Linear B, enable us to reconstruct details of the Mycenaean social and political hierarchy. Athens was an important Mycenaean centre, and A-TA-NA (Athena) appears to have been a significant Mycenaean deity. Although, despite one clever 'April Fool' joke played in 2017,[31] there have been no finds of tablets from

Athens itself, we can extrapolate the information from other sites to reconstruct Athens's Bronze Age political structures. In the *Iliad* there is a moment where Menestheus fails to respond to Agamemnon's instructions quickly enough, much to his annoyance:

> Son of King [Greek: *basileus*] Peteus [. . .] why are you stand-
> ing back, cowering, and waiting for the others? You ought to
> be properly taking your stand in the front line, confronting
> the blazing battle! You are the first to hear when I call people
> to my banquets [. . .] You're happy enough to wolf down the
> roast meat and quaff goblets of honey-sweet wine for as long
> as you like! But now you'd gladly just watch, even if ten
> contingents of the Greeks were to fight ahead of you with
> pitiless bronze.[32]

However, the real-life Mycenaean situation seems rather more organised. We are not looking at high-maintenance, temperamental, honour-obsessed, quarrelling warlords, but at a bureaucratic system in which officials and administrators are possibly at least as powerful as the aristocrats (although there may have been some overlap between the groups). We know the names of some ordinary people – KA-RA-U-KO = Glaukos; A-RE-KA-SA-DA-RA = Alexandra (female); A-RE-KU-TU-RU-WO E-TE-WO-KE-RE-WE-I-JO = Alektryon, son of (the -I-JO ending) Eteokles; E-KE-A = 'Mr Spears'; MO-RO-QO-RO = Molobros (literally 'devourer of excrement', a word used as an insult against Odysseus); and also of some cattle, such as KE-RA-NO = Kelainos ('black'), PO-DA-KO = Podargos ('white-' or 'swift-footed'), and WO-NO-QO-SO = Woinokws ('Wine-Dark')[33] – but the kings and other leaders are completely anonymous.[34]

At the top of the hierarchy was the WA-NA-KA (*wanax/anax*), who was the ruler of the kingdom and occasionally oversaw religious rituals. Next in status and power was the RA-WA-KE-TA (*lawagetas*), the 'Leader of the Warriors', possibly the military commander-in-chief, rather than the *anax*. In classical Greek, the word *basileus* means 'king', including later the Great King of Persia, but in Linear B the QA-SI-RE-U (*basileus*) is a local chieftain of lesser status, controlling a group of people rather than a whole kingdom. So Mycenaean Athens was not an egalitarian society of the type attributed to Theseus. There was a DA-MO (*damos/demos*), a word that is used of both the common people and the land they held, rather like the English 'village', which seems to have had its own organisation, spokesmen and the right to own land, but no democracy. And, whether their city was democratic or not, the Athenians also owned slaves who could be bought and sold. The words they used are DO-E-RO (male) and DO-E-RA (female), giving us the classical Greek *doulos/doule* = 'slave'.[35]

Historical Athens

At some point shortly after the supposed date of the supposed Trojan War the Mycenaean world transitioned into what is conventionally called the Dark Age.[36] Events between the twelfth and eighth centuries are difficult to trace, but what emerges towards the end of that era is a people who are divided into a large number of independent communities which they called *poleis* (singular: *polis*). There was no such thing as Greece in the sense of the twenty-first-century nation state. The primary identity was centred on the *polis*: they were Athenians, Spartans, Corinthians, Thebans, Samians, Milesians, and so

on, before they were Hellenes/Greeks – indeed 'Greece' is a Roman designation.[37]

Polis is practically impossible to translate into English. 'City state' is the most common solution, but there is a sense in which it is both and neither of those things. A *polis* is not just a place or a community of people. It is a civic and religious centre, a town or city, its surrounding villages and countryside, the people who live there, and their moral, cultural, political, economic and religious way of life. The *poleis* were small by modern standards. In his *Republic*, Plato said the ideal size was 5,000 citizens,[38] and Aristotle felt it was about right if all the citizens knew each other's personal characteristics.[39] Only three of them – Athens and the Sicilian cities of Acragas and Syracuse – had more than 20,000 citizens, and the rest could be numbered in the low thousands, or even hundreds.

The geography of Greece was crucial to the lifestyle of its people and would be a vital factor in their attempts to defend that lifestyle from the Persian menace. The environment is ruggedly mountainous, which makes land-based communication awkward. The mountains often acted as cultural as well as physical barriers between the communities, who were not necessarily inclined to unite or cooperate with one another. On the contrary, they developed separately and lived separately, cherished their isolation, and put a high value on their independence, autonomy, freedom, civic pride and self-sufficiency. This segregation was both a blessing and a curse: if the mountains provided awesome natural fortifications against alien invaders, they also fostered disunity, jealousy and hostility between the communities who would need to man those defences in the early years of the fifth century.

The Mycenaean system of a king, warrior elite and highly developed bureaucracy controlling the wider population, along with the slaves or serfs, was well suited to make the transition from the mythical monarchies to the aristocracies that are in place when we start to get our first historical records. The aristocrats were hereditary groups, and the Athenian ones called themselves *Eupatridai* ('Sons of Good Fathers'). They justified their supremacy on the prestige of their families, which conferred the status of being the *aristoi*, the 'best' men, and as such they dominated all the political, legal, military, social and religious aspects of the *polis*.

Some of the *poleis* of this period flourished under these rulers, but the aristocrats' success was often their undoing, unleashing unforeseen forces that they could not control. Greece only had limited amounts of arable land, and much of that was of poor quality, and a combination of population increase and subsequent food shortages led to quests for new lands. An extensive colonising movement got under way in the eighth and seventh centuries, in which the Greeks established settlements as far afield as Italy, Sicily, the Black Sea, North Africa and Spain. However, this expansion gave new wealth-creation opportunities to enterprising non-nobles, who started to resent the fact that the aristocratic system did not allow them to cash in their wealth for political influence. There was also often a good deal of rivalry within the aristocratic groups themselves, and some Eupatrid families exploited popular discontent to try to subvert the dominance of their rivals. Disaffected nobles or wealthy non-nobles emerged (or posed) as 'champions' of the masses, and manipulated the situation to seize personal control.

The word used for someone who took over like this was a non-Greek term which might be of Lydian origin: *tyrannos*,

'tyrant'/'dictator'.⁴⁰ *Tyrannos* did not initially carry the over-tones that 'tyrant' now does, although it came to do so later thanks to Plato and Aristotle, who regarded tyranny as the worst form government, and the behaviour of the likes of Periander of Corinth who indulged in sex with his dead wife and had all the women of Corinth stripped naked to appease her ghost, and Phalaris of Acragas (modern Agrigento) in Sicily, who roasted his enemies alive in a bronze bull.⁴¹ At the time of the Persian Wars, however, *tyrannos* simply distinguished a usurper (or his successors) from a hereditary king.

The prospect of tyranny at Athens materialised just after 640 when a man called Kylon tried to effect a coup d'état with Megarian troops and Athenian collaborators. He seized the Acropolis but the involvement of foreign troops alienated most Athenians, who rallied against him. Kylon himself escaped, but his followers took refuge in a temple, only to be summarily executed by the magistrate Megacles of the aristocratic Alcmaeonid family. This sacrilegious act brought religious pollution on the entire *polis*, and the Alcmaeonids were condemned before a court of 300 fellow (and rival) aristocrats, cursed and exiled for eternity (although they would be back within a generation), while their dead ancestors were exhumed and cast beyond the frontiers of Attica.⁴² In April 2016, archaeologists working at Phalerum discovered a mass grave containing the skeletons of eighty bodies, thirty-six of whom had been restrained by iron shackles at the wrists. The fact that pottery fragments found near them date from between *c.* 650 and 625, and many of them show signs of being killed by violent blows to the head, has led to suggestions that the victims may have been followers of Kylon.⁴³

The Kylon affair illustrates the hostility of the wider Athenian population to any semblance of foreign dominance. But there

was clearly social unease, and the *Eupatridai* were aware of it. Around a decade later they appointed Drako as *Thesmothetes* ('Law-Recorder') in an attempt to defuse some of the discontent. A *tyrannos* was the last thing they wanted, and they were prepared to compromise. The laws which Drako put in place were literally and figuratively 'draconian': although Drako thought they were harsh but fair, Demades quipped that they were written not in ink, but in blood.[44] Death was the penalty for everything from sacrilege and murder to idleness and stealing salad or fruit, and the provisions for debt were particularly oppressive: creditors were entitled to seize debtors and their families as slaves.[45] It gradually became obvious that if the aristocrats wanted to maintain their grip on power, they would have to do more to rectify Athens's internal dissentions.

The Eupatrids' risk assessment came down to a simple cost/benefit analysis: the new non-noble rich want a say in politics, and will support a tyrant to get it; so will the poor, who are demanding release from the oppression of debt and slavery; so how much power are we prepared to give away in order not to lose it all? Ultimately, in *c.* 594/593, it was decided that Solon, son of Exekestides, should be appointed as 'mediator and *archon*'[46] to ease the tensions. He was from a noble background; 'he had no involvement in the injustices committed by the rich, and no part in the deprivations suffered by the poor';[47] and his integrity and moderation were public knowledge.[48]

One of the first problems Solon had to address was that Athens had two types of landowner: the *orgeones* (members of guilds), whose property was alienable; and members of the *gene* ('clans'), men of pure Athenian descent, whose estates were not. This meant that the clansmen were not able to use land as the security for a loan. However, they could use its produce,

and if they became bankrupt they were forced to pay one-sixth of this to the creditor, and became known as *hektemoroi* ('sixth-parters'). The *orgeones* were able to mortgage their property, as well as themselves and their wives and children if necessary, although in that case bankruptcy could result in slavery. Solon's package of measures to solve these inequalities became known as the *seisakhtheia* ('shaking off of burdens'). It became illegal to secure a loan of someone's personal freedom, the status of *hektemoroi* was abolished, all debts were cancelled, and anyone who had been enslaved for debt was freed. In Solon's own words,

The black Earth, greatest mother of the Olympian Gods,
Who was once enslaved, is now free.
I brought back many who had been sold,
This one unjustly, that one justly,
To Athens, their divinely created fatherland,
And some who had fled out of terrible necessity,
Who had wandered far and wide
And no longer spoke their Athenian language,
And others, who suffered shameful slavery right here,
Shuddering before the whims of their masters.
I liberated them.[49]

Athenians would never again be kept as slaves at Athens.

Political measures were then introduced which smashed the aristocratic monopoly on holding office. The Athenians were now divided into four census classes based on the number of *medimnoi* (approximately 52-litre measures) of corn or oil that their land produced. This was a seismic shift. Athens moved from an aristocracy, where political power was based on birth,

to a timocracy where it was based on property and/or wealth. The highest offices in the state were open to the *Pentakosiomedimnoi* (whose estates produced over 500 *medimnoi* per annum) and the *Hippeis* or Knights (wealthy enough to equip themselves as cavalry and generating 300 *medimnoi*); minor offices were available to the *Zeugitai* (200 *medimnoi*, wealthy enough to equip themselves as hoplite soldiers); and everyone else, who were the vast majority, were known collectively as the *Thetes* (sing. *Thes*) or 'labourers', and had what Aristotle dubbed 'the barest minimum of power': 'that of electing the magistrates and calling them to account (because if the people were not to have total power over this, they would be the same as slaves and enemies)'.[50] Solon was planting the fragile roots of Athens's democratic system, albeit probably unwittingly. But a century or so later it would be the lower two economic classes, the *Zeugitai* fighting in the close-knit hoplite phalanx, and the *Thetes* providing the muscle power to propel Athens's warships, whose commitment to the fully grown democracy would save Athens, Greece, and indeed democracy itself, from Persian domination.

Prior to Solon's reforms, Athens's highest magistrates were the nine archons (*arkhontes*), made up of the *arkhon eponymos* (the 'eponymous archon' who gave his name to the year), the *arkhon basileus* ('magistrate-king') and the *polemarkhos* ('war leader'), plus six *thesmothetai* ('law recorders'/'statute setters'). Solon removed the nobles' exclusive right to this office by opening it to the top two wealthy classes, and therefore to nonnobles too. The author of *The Constitution of the Athenians* tells us that '[Solon] made the selection of state officials happen by a process of a lottery out of a shortlist elected by each of the [four] tribes.[51] For the nine archons, each tribe first elected ten

candidates, and lots were drawn out of those.'[52] There is enormous scholarly dispute about whether the lottery element of this is accurate,[53] but ex-archons became life members of the Council of the Areopagus after their year of office expired. This august body had been a very powerful and exclusive vehicle for aristocratic rule, but under Solon, although it remained prestigious, its pre-eminent constitutional place was taken by a Council of 400 (Greek: *Boule*) chosen by lot from members of the four Athenian tribes, although the *Thetes* were excluded.[54] This now handled the discussion and presentation of business for the Assembly of the People (*Ekklesia*) to vote on – legislation, matters of war and peace, key questions of public policy, and the selection of magistrates – and became the fulcrum of the entire constitution. These were only incremental steps towards the democracy of the future, but the lowest class was acquiring a stake in the system.

Solon left Athens to avoid endless awkward questions on points of detail.[55] But his 'end-of-term report' was favourable:

> Some people think that Solon was a good lawgiver, because he terminated an oligarchy that was too unqualified, stopped the people being enslaved, and set up our traditional democracy in a neatly mixed constitution: the Areopagus Council was oligarchic, the elected magistracies aristocratic, and the law-courts democratic.[56]

Solon's own assessment was that these laws were only the best that the Athenians would accept.[57]

However, the reforms also had unintended consequences. New forms of political unrest occurred, in which the old aristocratic inter-family tussles became mixed up with class

struggles that were played out in a localised way. The turmoil led the Athenians to split into three factions: the Plain, led by Lycurgus, comprising oligarchic-leaning Eupatrids; the Coast, led by Megacles of the Alcmaeonids, formed from the *orgeones*, who sought a 'middle form' of constitution; and the Hill, led by Peisistratus and dominated by *Thetes*, which seemed to aim at democracy.[58]

None of the groups was prepared to compromise. In 561/560[59] Peisistratus pre-packed the Assembly with his supporters, claimed to have been wounded by a political opponent, and arranged to be voted a bodyguard. He used this to take the Acropolis and control of Athens with it.[60] However, this simply united Lycurgus and Megacles, who drove him out almost immediately.[61] But in 557/556 or 556/555 Megacles joined his erstwhile rival to play what Herodotus described as 'the silliest trick I've ever come across'.[62] They dressed up a tall, strikingly beautiful woman as Athena and drove her into Athens in Peisistratus's chariot, saying that the goddess was bringing him home. The supposedly intelligent Athenians fell for it.[63] Unfortunately, although Peisistratus had married Megacles's daughter as part of their deal, he didn't want to add to his sons from a previous union, so he 'had sex with her in a way that wasn't normal'.[64] Herodotus leaves his readers to imagine what this involved, but the girl told her mother, who told Megacles, who immediately reunited with Lycurgus and expelled the man who had violated his beloved child.[65]

Peisistratus spent about a decade planning another coup d'état, and in *c.* 546/545, backed by foreign money and mercenaries, he struck. It was third time lucky: he landed close to Marathon and crushed his enemies' forces near the sanctuary of Athena at Pallene in a surprise attack, catching them

unawares when they were snoozing or playing dice after their lunch.[66] Interestingly, a brand new subject appears on Attic pottery at around this time, first painted by the brilliant Exekias and featured on over 150 vases in the next fifty years or so:[67] Achilles and Ajax, both fully armed, are playing dice, in some versions blissfully unaware of the fighting going on around them, and with Athena in agitated attention. No literary version of this scene survives, and it has been suggested that it is a parable to comfort the losers: even the mightiest heroes of the Trojan War can be taken off their guard.[68]

Peisistratus's opponents were murdered, exiled or kept as hostages, and the appointment of the archons was tightly controlled,[69] notably by removing the lottery element in their selection, allowing him to choose the candidates, who duly administered his policies and entered the Areopagus. Much of Solon's legislation was consigned to the dustbin of history through not being used,[70] but Peisistratus observed enough of the Athenian civil and constitutional legal protocols to allow the nascent democracy to hibernate rather than die under his regime,[71] and Athens flourished economically. His period of rule was dubbed 'The Age of Cronus' (a mythical Golden Age).[72]

When Peisistratus died in 527, his sons Hippias and Hipparchus took over.[73] A vibrant cultural and building programme flourished, with first-rate artists and architects invited to Athens, and new silver coins known as 'Athenian Owls' enhancing Athenian trade and prestige throughout the Hellenic world and beyond. But in 514/513, things unravelled. Hipparchus developed a same-sex passion for an exquisitely beautiful young man called Harmodius.[74] The ancient Greeks had developed homosexual relationships in a uniquely

elaborate way,[75] and Herodotus tells us that they taught having sex with boys to the Persians.[76] Yet they did not categorise anyone as 'a homosexual' despite giving us the 'homo-' part of the word: Greek *homos* = 'one and the same'; the '-sexual' part is Latin, from *sexus* = sex (as in male/female, be this in humans or animals). The Greek vocabulary focused on the *erastes* ('lover'), who was generally a mature man, and the *eromenos* ('beloved'), who was usually someone between their late teens and early twenties – Harmodius in this case. This was seen as typically Greek: the Persian King Cyrus the Great allegedly joked that getting yourself a beautiful young boyfriend was 'the Greek way',[77] although making sexual advances towards underage boys was both morally unacceptable and illegal. The 'Greek way' of sex between males was not usually bending over, but face-to-face and non-penetrative, particularly *diamerion* ('between the thighs': Greek, *dia* = through; *meros* = thigh). You can have *diamerion* sex with a man or a woman, but any male who enjoyed receiving anal sex was mocked as being *euryproktos* ('having a wide arsehole') or *katapygon* ('a down-into-the-arse man'), which was also the word used for the middle finger used in obscene gestures.

Unfortunately for whatever Hipparchus would have liked to have done with Harmodius, the youth was not available – he was already in a relationship with an *erastes* called Aristogeiton. Having been rejected twice, Hipparchus insulted Harmodius by denying his sister the honour of being a basket-bearer at the Great Panathenaia of 514/513. Aristogeiton feared that Harmodius might be taken from him by force, so the two of them plotted to exploit the chaos of the festival and get their retaliation in first. But things went wrong for everyone. Hipparchus ignored an ill-omened dream, and the lovers

botched their attack. They did succeed in killing the unwelcome suitor, but his brother Hippias got away, Harmodius was killed, and Aristogeiton was tortured to death.

In later times statues would be erected of the 'Tyrannicides' as symbols of liberty, showing the bearded Aristogeiton and the young beardless Harmodius advancing into action, and, in a patriotic distortion of the facts, drinking songs proclaimed that they 'killed the tyrant, a man called Hipparchus [and] made Athens a land of equality under the law'.[78] However, Herodotus and Thucydides saw the historical reality: the motive was not political, but 'erotic grief';[79] 'assassinating Hipparchus simply angered the surviving Peisistratids';[80] 'the tyranny became harsher';[81] and 'in the fourth year [the tyranny] was terminated by the Spartans and exiled Alcmaeonids'.[82]

The Alcmaeonids had been exiled during Hippias's post-assassination purges. In exile they secured the contract for the construction of the Temple of Apollo at Delphi,[83] and deployed their great wealth to upgrade the specifications of the facade from tufa to Parian marble. This gave them sufficient leverage to bribe the oracle to pressurise the Spartans into 'liberating Athens'. The Spartans put religion above their guest-friendship with the Peisistratids, and sent a seaborne task force led by Anchimolius (Close-at-Hand), son of Aster (Star Man). When he failed, the Spartans upped the ante and despatched King Cleomenes by land with a much greater army, which forced the tyrant's family to take refuge on the Acropolis. Some of the Peisistratids' children were captured as they were being smuggled away, and Hippias came to terms in order to get them back. Despite the drinking songs, Thucydides says that the Athenians really knew it was the Spartans, not they and Harmodius, who had ended the tyranny,[84] and in Aristophanes'

comedy *Lysistrata*, Lysistrata robustly told her Athenian audience that the Spartan involvement was crucial:

> Don't you remember how, when you were wearing slaves' sheepskin jackets, the Spartans arrived with their spears and annihilated many [. . .] of Hippias' comrades and allies? How on that day they were the only ones that helped you to expel him? And how they set you free, and [. . .] clothed you in democratic cloaks again?[85]

Hippias left the country. He made his way to Sigeum in the Troad, from where he maintained communications with his friends in Athens and Sparta, as well as cultivating a relationship with the Persians that would contribute to their hostility and conflict with Greece.

Democratic Athens

The expulsion of Hippias from Athens led eventually to democracy. Ironically the Peisistratid tyranny had probably created a situation in which democracy could flourish, principally by replacing the aristocratic infighting and class struggle with thirty-six years of stable government. Herodotus's verdict is that Athens, which had been great once upon a time, now became even greater.[86] Elsewhere in Greece, the normal post-tyranny backlash was for aristocratic regimes to reassert themselves, and this was initially the case at Athens. The Eupatrids took control for a couple of years, but then quickly descended into factional feuding again. This came to a head when Cleisthenes, the leader of the Alcmaeonids, was frustrated by Isagoras, another aristocrat (of unknown family[87]) who had ties

of hospitality with King Cleomenes of Sparta, and also connec-
tions with Hippias. Cleomenes was also rumoured to have
'connections' with Isagoras's wife.

There was a bitter clash in the first half of 508 over who
should become archon for the coming Athenian year 508/507.
Isagoras stood, but because Cleisthenes had already held the
office in 525/524 he could not do so again. He put up his
nephew Alcmaeon instead, but amid vicious hostility it was
Isagoras who was elected. The outcome of this setback was that
'the people put their trust in Cleisthenes', and that he 'went
into partnership with the people'.[88] He proposed radical, demo-
cratically orientated reforms to the constitution, even though
such populist proposals went against his own aristocratic vested
interests. Isagoras feared that his rival was trying to re-establish
the tyranny, and so invoked his guest-friendship with Cleomenes
and asked him to intervene.[89] This he did, and he successfully
engineered a bloodless coup by invoking the 'Curse of the
Alcmaeonids' from the time of Megacles[90] to banish Cleisthenes
and 700 households of his supporters. He also tried to replace
the Council of 400 (*Boule*) with a junta of 300 of Isagoras's
supporters. However, Cleomenes underestimated the opposi-
tion and came with insufficient resources: his and Isagoras's
supporters occupied the Acropolis in the face of resistance from
the *Boule* and the *demos*; the priestess of Athena Polias officially
opposed the occupation; and a brief siege ended with the
Spartans being allowed to leave, taking Isagoras with them,
although his supporters were put to death two years later.

Cleisthenes returned with the 700 families. The Alcmaeonids
cast themselves as patriotic liberators of Athens from the
oppression of tyrants (Hippias), oligarchs (Isagoras) and
foreigners (Sparta), and the whole episode became something

that later Athenians could laugh about, as when the Chorus of
Old Men in Aristophanes' *Lysistrata* sang:

> Cleomenes, who was the first to occupy the Acropolis,
> Went away without me grabbing him by the balls.
> Oh no! He might have farted like a true Spartan,
> But he went away after he'd surrendered his weapons to me,
> Wearing only his little threadbare Spartan cloak,
> Hungry, filthy, unshaven,
> And he hadn't washed for six years![91]

Whether Cleisthenes was cynically furthering his own
power-seeking ends or truly committed to widening participa-
tion in the running of the state, he gave Athens the world's first
truly democratic system of government, built on the three
pillars of *isonomia* (= 'equality under the law'), *isegoria* (= 'equal-
ity of speech') and *isokratia* (= 'equality of power'), which
together added up to *demokratia* (= 'rule of the people').[92]
Admittedly the system excluded women, resident foreigners
and slaves, but the average Athenian adult male now possessed
greater political power than any citizen of a modern
democracy.

Cleisthenes achieved *demokratia* by replacing Athens's four
old Ionian tribes with ten new ones, created specifically for
political purposes, and making small localities called 'demes'
(pl. *demoi*, sing. *demos*) the basic unit of local government.
Each deme had its own *Boule*, *Demarkhos* ('Demarch', Chief
Magistrate), Treasurers and Assembly of nominally equal
demesmen, mimicking in miniature, and linking with, the
hands-on, face-to-face, participatory central organisation of
Athens.[93] The demesmen were hereditary groups and comprised

a social unit with virtually a family feeling.[94] People were now officially identified by three names: given name, patronymic and deme-surname – Themistocles ('Glory of the Law') son of Neocles, from Phrearrhioi; Miltiades ('Son of the Red Earth') son of Cimon, from Lakiadai; and so on.

There were 139 demes, based either on the urban neighbourhoods of central Athens or on groups of villages in the countryside of Attica, and varying considerably in size and population from small hamlets to large towns.[95] The mountainous nature of Attica meant that many of the demes were quite isolated from one another, especially in the rural areas, which fostered an exceptionally strong and cohesive deme-identity:[96] the demesmen lived close by one another, cooperated in local government, celebrated communal religious rituals, and helped one another out at demanding times of the agricultural cycle. They controlled their own membership;[97] their interactions were face to face; they were neighbours, friends, relatives, sometimes lovers,[98] and they all knew each other; and they saw themselves as truly autochthonous, because they and their ancestors had always lived in the land where they originated. They were proud of their demes, and in around twenty years' time, when the Persians invaded their land, they would be prepared to fight, kill and die for them.

Democratic Warriors

Along with the coveted rights of Athenian citizenship came duties, one of which, for men of the *Zeugitai* class or higher, was to serve as a hoplite soldier in the Athenian phalanx. Enfranchisement equalled military recruitment and call-up when necessary,[99] and when they went to war, they did so as a

community. An average-sized deme, such as Prasiai or Steiria in the coastal area, would probably have sent 56 hoplites to fight at Marathon in 490, and although the large urban deme of Kydathenaion would have sent around 276, the small rural deme of Konthyle would only have contributed 18.[100]

These small, unified groups of demesmen-warriors would have constituted what in modern military parlance is a 'primary group', a band of fighters 'characterized by intimate face-to-face association and cooperation'.[101] On the battlefield this is crucial: 'acting in congruence with group norms not only maintains or enhances the soldier's status, but also ensures continued access to physical and psychological support. Conversely, deviance reduces the deviant's status and leads to reduced access to support.'[102] Reputation in the public arena was everything to these men. They operated as a socially, politically, religiously, physically, emotionally and tactically unified group; they scrutinised each other's attitudes and performance; they jealously guarded their own *andreia* ('manly reputation'), which only had value if it was seen by their peers; they were acutely aware of manifestations of weakness or cowardice; and they were sensitively attuned to the power of village gossip, be this good or bad.[103] They were amateur warriors full of their own native spirit, not professional soldiers like the Spartans, whose 'artificial manliness' they disparaged,[104] and as such their capacity 'to endure sustained and savage close-quarter combat was, in every way, exceptional'.[105] It could be said that the Athenian success in the Persian Wars was achieved not with a superhuman effort of Greek national unity, but by the everyday local interactions of life in Cleisthenes' demes.

The demes needed to be linked to the ten new tribes, and Cleisthenes did this by dividing each of the three areas of Attica

(i.e. the Coast, Inland and City) into ten, taking groups of between one and ten (usually) neighbouring demes from each area, and amalgamating them to form a *trittys* (pl. *trittyes* = 'third'). Three (probably non-adjacent[106]) 'thirds' were then artificially united to form a tribe. This complex arrangement meant that each tribe contained demesmen from across the coastal, inland and urban areas, giving it, in theory, a cross-section of the community, with the intention of eradicating the party strife based on local differences which had dogged Athens for so long.[107]

The ten tribes were named after Athenian mythical heroes and they came to have an official order: 1: Erekhtheis (named after Erekhtheus); 2: Aigeis (after Aigeus); 3: Pandionis (after Pandion); 4: Leontis (after Orpheus's son Leos); 5: Acamantis (after Acamas); 6: Oineis (after Oineus); 7: Cecropis (after Cecrops); 8: Hippothontis (or Hippothoontis, after Hippothoon); 9: Aiantis (after Ajax); and 10: Antiochis (after Heracles' son Antiochus).[108]

Much of Athens's military and political organisation now came to centre on these ten tribes. Their hoplite phalanx, which usually went into combat several thousand men strong, would have been far too unwieldy without more flexible sub-units, so the Athenians organised it on a tribal basis into ten units known as *taxeis* (sing. *taxis*), each commanded by a *taxiarkhos*.[109] Even then, with the *taxeis* each comprising as many as around 900 men, they were still too big for effective tactical operations, so they were further subdivided into *lokhoi* (sing. *lokhos*, literally 'the men who form an ambush', and hence simply 'a band of armed men'), commanded by a *lokhagos* (= '*lokhos*-leader').[110] The number of *lokhoi* per *taxis* varied, and the *lokhoi* possibly had a loose relationship with the demes.[111] The overall command

of this non-professional army seems to have been entrusted to the equally non-professional polemarch at this point, although in due course it was transferred on an ad hoc basis to the *strategoi* ('Generals', sing. *strategos*).[112] However, in 501/500 *isonomia* began to infiltrate the armed forces when the Athenians started democratically electing the generals on a one per tribe basis, even though the entire army remained under the polemarch's authority.[113]

The *taxis* 'was not a regiment [. . .] It was [. . .] little more than an administrative and tactical convenience. Therefore, when the Athenian hoplite met his enemy [. . .] he did so without the benefit of military unit cohesion.'[114] The *taxeis* were disbanded as soon as the war was over, but their tribes remained central to the commemoration of the war dead:

> The bones of the deceased lie in state for three days in a specially erected tent, and everyone brings whatever offerings they want to their own dead. When the day of the funeral arrives, cypress-wood coffins are borne on wagons, one per tribe, and each person's bones are in their tribe's coffin. One empty funerary couch, covered with a pall, is carried in the procession for the 'unknown soldiers' [. . .] Anybody who wants [. . .] can take part, and the female relatives of the deceased are present and make lamentation at the burial. The coffins are placed in the public tomb, which is located in the city's most beautiful suburb,[115] where they always bury those killed in combat, apart from the ones who fell at Marathon.[116]

When they had been laid to rest, a state-appointed orator delivered a eulogy, and the people departed.

The fellow tribesmen of the fifty-two members of the Aiantis tribe who fell at Plataea regularly honoured them with state-funded sacrifices,[117] and on the official funeral memorials the deceased were identified by their tribe and name, not by their patronymic and deme:

> These Athenians died:
> Epiteles, general
> Of Erekhthcis: Pythodorus, Aristodicus, Telephus,
> Pythodorus
> Of Aigeis: Epichares, Mnesiphilus, Pheidimides, Laches,
> Nicophilus
> Of Pandionis: Lysicles
> Of Leontis: Khaires
> Of Oineis: Rhodocles, Eurybotus, Polites, Herokleides
> Of Cecropis: Aristarchus, Carystonicus, Theomnestus,
> Aristarchus, Eucrates, Nicomachus
> Of Hippothontis: Sotelides, Poseidippus
> Of Aiantis: Diphilus
> Of Antiochis: Craton, Anticrates, Eudoxus.
>
> These [. . .] lost their shining youth
> Fighting together, bringing glory to their fatherland,
> So that the enemy groaned, bringing in the harvest of war,
> And they erected an immortal memorial of their virtue.[118]

In the political reorganisations of Cleisthenes, membership of the *Boule* was increased to 500, with 50 councillors per tribe selected by election, then lottery. So, for instance, the Pandionis tribe's 50 councillors were made up of 12 from the deme of Kydathenaion, which was so large that it also comprised all of

the City *trittys*; the Coastal *trittys* contributed 2 councillors from the deme of Angele, 6 from Myrrhinous, 3 from Prasiai, 5 from Probalinthus and 3 from Steiria; and the Inland *trittys* sent 1 from Konthyle, 2 from Cytherus, 4 from Oa, 1 from Upper Paiania and 11 from Lower Paiania. These councillors had to be thirty years old, but all classes were eligible. The *Boule* effectively became the supreme administrative authority of the Athenian state, preparing the agenda for the Assembly, ensuring its decisions were carried out, scrutinising new magistrates before they took up office, handling its own internal discipline, practically controlling all the state finances, and conducting relations with foreign officials and envoys. The impracticality of keeping the entire *Boule* together 24/7 led to the establishment of a system in which a smaller sub-committee was authorised to act for the whole group in certain circumstances. Its members were called *Prytaneis* (sing. *Prytanis*) and each tribe took it in turn to act 'in prytany' for one of the ten months of the Athenian year.

Cleisthenes is also credited with the remarkable innovation of ostracism. This was an optional, annual 'unpopularity contest', at which all Athenian citizens could write the name of one person on a piece of broken pottery known as an *ostrakon*. Subject to a rule of 6,000 votes, the person who polled the highest had to leave the state for ten years. The intention behind ostracism was to prevent tyranny, but the process eventually became a somewhat cynical tool of party politics. Hipparchus son of Charmus was the first man to be ostracised, but not until 488/487, in the aftermath of the Athenian victory at Marathon.[119]

Athens, Sparta, Thebes, Aegina, Persia, Earth and Water

Although the majority of Athens's citizens clearly enjoyed their newfound equalities, there was still some resistance to Cleisthenes and his ideologies, both at home and abroad. Cleomenes still bore a grudge for his ignominious expulsion from the Acropolis, and his attempts to avenge his humiliation and to restore Isagoras had ramifications that affected the relationships of Sparta, Athens and Persia.

The Athenians knew that war with Sparta was a strong possibility. They needed powerful allies, so they looked beyond the Hellenic world to King Darius's paternal half-brother Artaphernes son of Hystaspes, the powerful Persian satrap of Sparda/Lydia, based at Sardis (modern Sart, Turkey), and sought an alliance with Persia. Herodotus calls him Artaphrenes, probably seeing the Greek *phren* (= 'spirit', 'soul') in his name, but he should properly be Artaphernes, corresponding to the Old Persian *Artafarnah-* (= 'Endowed with the Glory of the Right').[120] While the envoys were delivering their message, possibly through interpreters, Artaphernes interrupted them and asked who they were, where they were from, and why they wanted to be Persia's allies. This was disingenuous: he knew full well who they were, and their ex-tyrant Hippias was probably already at his court. But he put the Persian case in a nutshell, and made a crucial demand: 'If the Athenians give both earth and water to King Darius, he will conclude an alliance with them; but if they do not, he commands them to leave.'[121] The poetic words 'both earth and water' form the end of a line of hexameter verse in Greek, but earth and water were also tokens of submission to the Persian king.[122] However, the Athenian envoys were keen to close the deal, so they acted on their own

initiative and said that they would do this. Herodotus dryly observes that they 'got into a lot of trouble' when they arrived home,[123] but this drastically underplays the significance of what they had done. They had promised Athenian submission to Persia, and their offer had been accepted. The greatest betrayal of the Greek cause during the future Persian invasions was 'Medism', submission or collaboration with 'the Mede', as the Greek frequently called the Persians. Athens had Medised.[124] The Athenians had technically become subjects of the Great King, and they did nothing to reverse their envoys' actions.

Back in Sparta, in *c.* 505,[125] Cleomenes was stoking his resentment and mobilising an army from every part of the Peloponnese.[126] His forces got as far as Eleusis,[127] and in a simultaneous attack from the north, the Boeotians seized two outlying Attic villages and a frontier fort,[128] while the Chalcidians broke in from the island of Euboea in the east. The Athenian response was confidently casual: they decided just to confront the Spartans, and to worry about the Boeotians and Chalcidians later. But just before the forces engaged, Sparta's Corinthian allies withdrew. Herodotus ascribes this to a feeling that they were in the wrong, although it could be that news of Athens's recent Medism deterred them from attacking an ally of Persia.[129]

The Corinthian withdrawal was immediately followed by that of Cleomenes' fellow king and joint commander, Demaratus the son of Ariston.[130] The two had never quarrelled before, but the shockwaves of their split, and the hatred it instilled, would resonate throughout the Greek and Persian world for a generation. Crucially, the Spartans passed a law that from now on only one of their kings should go on campaign with the army. This increased the potential for further friction

between the kings and would have a significant bearing on how Spartan operations were carried out during Xerxes' invasion, as did the decision taken a year or two later to allow collective decision-making within the Peloponnesian League, effectively allowing Sparta's allies a veto over matters of foreign policy.[131]

When Sparta's other allies joined the 'ignominious dispersal'[132] of the invasion force, the Athenians looked to gain their revenge. They marched against the Chalcidians, defeating the Boeotians and taking 700 prisoners on the way, and hammered them in battle. The lands of the aristocratic Chalcidian *Hippobotai* ('Horse-feeders') were appropriated and allocated to 4,000 Athenian settlers, the prisoners were ransomed, and their fetters were displayed on the Athenian Acropolis.[133]

Fighting tribally as democratic demesmen, and exercising their freedom and equality of speech, the Athenians had triumphed. Herodotus felt that this was no accident:

> The Athenians went from strength to strength. It is obvious [. . .] that freedom of speech (*isegoria*) is an excellent thing. Here is the proof: when they were under tyrannical rule they were no better in the military sphere than any of their neighbours, but once they had freed themselves from their tyrants they became far and away the best.[134]

Interestingly, a fragmentary dedication found at Thebes spins these events somewhat differently: 'Capturing Oinoe and Phylai [. . .] and Eleusis [. . .] Chalcis [. . .] ransoming [. . .] dedicated.'[135] This is history written by losers putting a positive gloss on a failure that was costly in both lives and cash, but the Thebans did not fully accept defeat and asked their friends on the island of Aegina to help them.[136] The Aeginetans'

friendship with Thebes was matched by their longstanding hostility to Athens: the two enemies were visible to one another across the waters of the Saronic Gulf; the Aeginetans were capable and assertive seafaring traders; their island was an important mercantile hub; and aggression, counter-aggression and mutual blame-games had been a feature of their relations with Athens ever since 'once-upon-a-time'.[137]

Atheno-Aeginetan relations had led to Athenian women adopting an Ionian/Carian style of dress, and in due course would be a major factor in the outcome of the Persian Wars, but in *c*. 504 the Thebans, carrying images of Aeginetan heroes, invaded Attica.[138] When they received a savage mauling they asked to swap the statues for real men, whereupon the Aeginetans initiated the 'Unheralded War' and launched their warships against Phalerum and other Attic maritime communities. The Athenians took to the field, but their preparations were immediately stymied by another anti-democratic intervention by the Spartans, who had now found out that the Alcmaeonids had been manipulating the Delphic oracle. They resented being duped into driving their Peisistratid guest-friends out of Athens, thought that freedom would allow the Athenians to challenge Spartan supremacy but oppression under tyranny would not, and regretted delivering Athens to a 'thankless mob'.[139] So they sent for Hippias from Sigeum.

Now, though, the Corinthians put a stop to Spartan intentions for a second time. Their spokesman gave the Spartans a detailed and impassioned lesson in Corinthian history, explaining why they had zero tolerance for tyranny, and persuaded the Peloponnesian League Congress that Hippias the tyrant should be sent back to Sigeum.[140] Hippias's journey back had important repercussions on future relations between Athens and

Persia. En route he received favourable offers from the Macedonian King Amyntas and from the Thessalians, both of which he turned down.[141] However Hippias, the Macedonian kings and the Thessalians would all have Medising futures. Hippias spent over a decade cultivating friendly relations with Persia and bad-mouthing the Athenians to Artaphernes. Hippias did everything he could to engineer the subjection of Athens to himself, and Artaphernes was insistent that the Athenians should take him back. Given that they had recently promised earth and water to Darius, their refusal was regarded as an act of war.[142] The processes that would drive Greece and Persia to their momentous conflict were now under way. There could be no stopping them.

CHAPTER 2

Persia: The World's Most Powerful Empire

If you should now wonder, 'How many are the lands that Darius the King held?', behold the sculpted figures who bear the throne, then you shall learn, then it shall become known to you that the spear of the Persian man has gone forth a long way, then shall it become known to you that the Persian man has given battle far afield from Persia.

Darius I of Persia[1]

Medes and Persians on the Rise

The Persian Empire which was threatening Greece was ruled by Darius I (Old Persian: *Dārayavauš*, sometimes shortened to *Dārayauš*;[2] Greek: *Dareios*), whose name means 'He Who Holds Fast to the Good', not, as Herodotus thought, 'Doer of Deeds'.[3] His vast multicultural realm covered no less than 5.2 million km² between the rivers Indus in the east and Danube in the west, and from the Himalayas in the north to the Sahara Desert in the south. Strictly speaking, 'Persian' describes the ethnicity of the empire's ruling elite, but the Greeks were somewhat imprecise and tended to conflate the Persians with the

Medes, both of whom they usually regarded as generic Eastern Barbarians. But their impact on the Greeks was still such that they referred to the ruler of Persia simply as 'King' without the definite article: there was no need to specify what he was 'King' of.

The Persians may have begun to migrate into what is now south-western Iran in the middle of the second millennium, but archaeologically they are practically invisible, and the dates and itinerary of their movements are obscure. Their first appearance in our written records is in the reign of the bellicose Assyrian King Shalameser III (r. 858–824 BCE),[4] who raided their homelands of Parsua or Parsu(m)aš in the central-western Zagros Mountains, and started to exact tribute from twenty-seven kinglets in his province of Parsua. The Medes are also somewhat elusive: they do not provide us with any documentary material about themselves, and Herodotus's entertaining account of their history seems to contain as much myth as fact.[5] They first crop up in Assyrian records for 836 BCE, and around 700–675 they seem to have come together into a united kingdom under the powerful and energetic Deioces (Iranian: *Dahyu-ka*), who built both a reputation for justice and a stunning royal palace at Ecbatana (Old Persian: *Hagmatāna*; modern Hamadan in Iran).[6] It had mighty walls constructed in seven concentric circles of coloured stone, the inner two being overlaid with silver and gold, which ascended in height towards to centre, where the palace itself was located.[7]

Fact and fantasy are hard to disentangle here: most of the city now lies under modern Hamadan, and we could be dealing with a stereotyped Greek image of Barbaric excess. Herodotus certainly makes Deioces act like a Greek tyrant on steroids — aloof, suspicious and luxurious.[8] But after a reign of over fifty

years,[9] perhaps 727–675, Deioces was succeeded by his son Phraortes (Iranian: *Fravartiš*), who confirmed the unification of the Median tribes, subjugated the Persians and conquered other Asian communities before dying in battle against the Assyrians in either 653 or 625.[10] His son Cyaxares (Old Iranian: *Uvaxštra*)[11] took the Medes to the zenith of their power, which lasted for a century or so between *c.* 650 and 550[12] at a time when the Assyrian King Ashurbanipal (r. 669–*c.* 630) brought the Persians and their ruler Cyrus I under his subjection. As Ashurbanipal boasted:

Cyrus, the King of Parsumash [Akkadian for Persia], heard about my victory. He became aware of the might that I wielded with the aid of Ashur, Bel, and Nabu, the great gods my lords [. . .] He sent Arukku, his eldest son, with his tribute to Nineveh, the city of my lordship, to pay homage to me. He implored my lordship.[13]

After Ashurbanipal's reign his successors' hold over their dominions began to loosen. The Babylonians started to break free, and an important source called the Babylonian Chronicle shows that the Medes were an essential element in Assyria's demise. In 614 the Mede Cyaxares made an alliance with the Babylonian Nabopolassar which, tradition has it, was sealed by the marriage of Nebuchadnezzar/Nebuchadrezzar II to a Median princess called Amyntis, for whom he built the Hanging Gardens of Babylon:

Within his palace he erected lofty stone terraces, in which he closely reproduced mountain scenery, completing the resemblance by planting them with all manner of trees and

constructing the so-called Hanging Garden; because his wife, having been brought up in Media, had a passion for mountain surroundings.[14]

Herodotus's visit to Babylon was one of the highlights of his travels. He was impressed by its size and splendour, and particularly its walls, which were named in our first list of the Seven Wonders of the World before being supplanted by the Lighthouse at Alexandria:

> I have set eyes on the wall of lofty Babylon on which is a
> road
> for chariots, and the statue of Zeus by the Alpheus, and the
> hanging gardens, and the colossus of the Sun, and the huge
> labour of the high pyramids, and the vast tomb of
> Mausolus;
> but when I saw the house of Artemis that mounted to the
> clouds, those other marvels lost their brilliancy.[15]

Cyaxares and Nabopolassar went on to sack the great Assyrian capital of Nineveh, smashed the army of the last Assyrian king, Ashuruballit II, and terminated the Assyrian Empire. For their part, the Persians, albeit under the suzerainty of the Medes, took over what had been the kingdom of Elam at the head of the Persian Gulf, with its capital at Susa, the 'City of Lilies'.

Persians and Lydians: 'You Will Destroy a Mighty Empire'

Cyaxares was still ruling as a venerable old man when his Medes fought the so-called 'Battle of the Solar Eclipse' in 585 against

the Lydians, who occupied the western end of Anatolia. The Lydians are an important element in the web of people involved in the Persian Wars, and Herodotus devotes considerable attention to their story. He tells us that a courtier called Gyges overthrew the Lydian king Candaules.[16] Gyges (r. *c.* 680–645) appears as King Gugu of Lydia in one of Ashurbanipal's inscriptions, where not a single person at the Assyrian court could understand a word his ambassador said, but Gyges started to attack the Greek cities of the Asia Minor coast. Although unsuccessful against Miletus and Smyrna, he did take Colophon and was, apparently, the first foreigner to send gifts to Delphi since the mythical Phrygian king Midas – he of the 'Golden Touch'.[17] One of the Lydians' key resources was the gold that was washed into their territory by the River Pactolus (modern Sart Çayı, Turkey), bringing staggering wealth to their rulers. Herodotus also credits them with being the first known people to use both gold and silver currency, and to sell by retail.[18]

Herodotus skips over the reigns of Ardys and Sadyattes to that of Alyattes[19] (r. *c.* 618–561), who brought most of the Greek cities of Asia Minor under his control, with the notable exception of Miletus, under its enigmatic tyrant Thrasybulus.[20] On his eastern borders Alyattes also came into conflict with Cyaxares in bizarre circumstances when some Scythian guests at Cyaxares' court slaughtered a Median boy, served him to the unsuspecting king for his dinner, and immediately fled to Alyattes.[21] When the Mede refused to hand them over, Cyaxares declared war, which culminated in the aforementioned 'Battle of the Solar Eclipse' in Cappadocia.[22] The eclipse had been predicted by Thales of Miletus, but when day was turned to night it was felt to be such an extraordinarily bad omen that both sides concluded a peace and fixed the River Halys (modern

Kızılırmak, Turkey) as the boundary between their two realms. Lydia thrived under Alyattes' rule, and when he died in *c.* 560 he was laid to rest in an immense tumulus on the plain to the north of Sardis, which was excavated in the nineteenth century:

> It was constructed by the men who visit the market, the artisans and the sex-workers [. . .] and measurements showed that the latter did most of the work. All the daughters of the ordinary Lydians work as prostitutes to collect dowries for themselves, until they can find husbands; and they give themselves away in marriage.[23]

Alyattes was succeeded by his son Croesus (r. *c.* 560–546). He captured the Greek city of Ephesus, although he treated its temple of Artemis with great respect, and had his name inscribed in Greek and Lydian on its columns. He eventually compelled all the Greek cities of Asia Minor apart from Miletus to pay tribute,[24] although he did allow the Greeks a certain degree of economic freedom and donated generously to Greek sanctuaries such as Didyma, and consulted the Delphic oracle.

Lydia was at its peak, and Croesus was probably the wealthiest man alive and felt that he was the happiest.[25] However Solon, travelling after his reforms, told him otherwise, and warned him that 'the gods are envious and disorderly'.[26] Croesus was dismissive of Solon's wisdom, but his hubris would be his undoing. His nemesis was Cyrus II 'the Great' of Persia (Old Persian: *Kuruš* = 'Young/Child/Adolescent' or 'Humiliator of the Enemy in Verbal Contest'; Greek: *Kyros*, r. 559–529).[27] The first reference we have to him comes from the Nabonidus Cylinder from Sippar, now in the Pergamon Museum in Berlin. The Babylonian King Nabonidus (r. 556–539) had dreamed

that the Medes were a threat, but the god Marduk had reassured him:

> The *umman-manda* [literally 'Troops of Manda': a very disparaging term in Akkadian for military entities and/or foreign people = the Medes here] who you speak of [. . .] are no longer a threat' [said the god]. At the beginning of the third year [553], the gods roused Kurash [Cyrus], king of the country Anshan, his second in rank, against the *umman-manda*. With his small army he decisively defeated the vast hordes of *umman-manda*. Cyrus seized Ishtumegu [Astyages son of Cyaxares], the king of *umman-manda*, and brought him in chains to his land.[28]

The Babylonian Nabonidus Chronicle in the British Museum dates Cyrus's victory to 550, and relates how Astyages the Mede attacked Cyrus, only for his army to defect, handing victory to Cyrus.[29] But whatever the precise date, the Persian King Cyrus had conquered the Medes.

Cyrus was born in 600 and lived seventy years. On the Cyrus Cylinder, a fragmentary clay cylinder with an Akkadian inscription of forty-five lines composed by priests of Marduk and containing an account of Cyrus's conquest of Babylon,[30] he claimed that he was 'the son of Cambyses, the Great King, King of Anshan, grandson of Cyrus, the Great King, King of Anshan [. . .] from a family [that] always [exercised] kingship'.[31] An inscription from the Babylonian city of Ur is even less lacking in self-effacement: 'Cyrus, King of all the World, King of the land of Anshan, son of Cambyses, King of the land of Anshan'.[32] According to Herodotus and Xenophon his mother was Mandane, a daughter of the Median king Astyages,

who had weird dreams about her: she urinated so much that she flooded the whole of Asia, and a vine that grew from her genitals overshadowed the entire Asian continent, signifying that Cyrus would take his place as king.[33] So Astyages ordered that Cyrus should be killed the moment he was born. A Mede called Harpagus was given the unwelcome job, but gave the baby to one of Astyages' shepherds, who decided to raise the child as his own. Astyages eventually discovered the truth and sent Cyrus back to his birth parents in Persia, where he married the Achaemenid princess Cassandane, who gave birth to Cambyses II, Bardiya (Smerdis in Greek), Atossa, Artystone and probably Roxane.[34]

Ten years after his accession in 559, Cyrus's Persians probably occupied Parthia, Hyrcania and Armenia, which had all been parts of the Median kingdom.[35] But in 547 or thereabouts Croesus found a *casus belli* and decided to attack him.[36] The precise dating hinges on one of the Babylonian Chronicles, which is unfortunately cracked in the crucial place,[37] but the campaign became the subject of a famous oracular story.[38] Croesus asked both the Delphic oracle and the oracle of Amphiaraus at Thebes, 'whether he should march against the Persians and whether he should make an alliance with any other military force'.[39] Both oracles were in agreement: 'If he marched against the Persians, he would destroy a great empire, and they advised him to ascertain who were the most powerful of the Greeks and make an alliance with them.'[40] Croesus wrongly took this to mean that he would be victorious, and of course the oracles came true. His Lydian troops invaded the Median province of Cappadocia and enslaved its people; Cyrus hit back swiftly, enjoying a numerical advantage from the newly conquered Medes; and a savage but inconclusive battle took

place by the River Halys.[41] Croesus did not expect Cyrus to carry on campaigning in the winter, and made the mistake of pulling back and disbanding his mercenary troops. But Cyrus pursued him to Sardis, where he comprehensively defeated the Lydian forces. Two weeks later, probably in mid-December, his troops captured Sardis and Croesus with it.[42] Croesus had indeed destroyed a great empire – his own.[43]

Croesus's fate made a big impression on the Greeks. But for Cyrus this was just the beginning. A Lydian called Pactyes was given the massive task of collecting Croesus's gold,[44] but he used it to fund an anti-Persian rebellion. Captive Croesus advised Cyrus to focus his wrath on Pactyes personally, not the Lydians in general, and suggested an innovative solution:

> Pardon them [. . .] but do not allow them to possess weapons of war. Order them to wear unisex tunics under their cloaks, put high boots on their feet, and teach their sons to twang away on stringed instruments, and to become small-scale retailers. Then, your Majesty, you'll quickly see them become women instead of men. That way they won't be frightening to you, and they won't rebel.[45]

Cyrus loved the idea, and, duly emasculated by singing, dancing and shopping, the Lydians ceased to be a threat.[46]

Pactyes was brought to heel; Sardis was retaken; the Greek *poleis* of Priene and Magnesia were reduced to slavery; Cyrus's general Harpagus brought further Ionian Greek cities under Persian control; the people of Phocaea and Teos took to their ships and escaped; the islands of the Ionian coast surrendered too; but Miletus made a treaty with Cyrus and escaped destruction for the time being. Harpagus added the Carians and

Lycians to the Persian realms; the people of Cnidus capitulated; the Pedasians were also overcome; and the inhabitants of Xanthus and Caunus died to the last man, woman and child in frenzied, futile resistance.[47] Heavy tribute was now imposed on the Greek cities, and they were expected to contribute forces to Persia's army and came to be governed by pro-Persian tyrants.

Greeks in the Persian World

The western fringes of the area that came under Persian control in the mid-sixth century had been populated by Hellenic people for centuries. This territory is now in Turkey, but the parameters of modern nation states are largely irrelevant to the ancient world: in antiquity you find Greece wherever you find Greeks. In the Bronze Age one of the most strategically important settlements was a city whose mythical past was stoking the historical hatred that was used as justification for the forthcoming Greek versus Persian conflicts in the early fifth century. Its remains now stand at Hisarlık, 6 km east of the Aegean coast and 4.5 km south of the Hellespont in modern Turkey. The Greeks called it Troia, (W)Ilios or (W)Ilion; its inhabitants were called Troes (Trojans); their territory was known as the Troia or Tro(i)as ('the Troad'); and we call it Troy.

Whether in some sense the Trojan War – which provided the raw material for Homer's epic poem the *Iliad*, in which the mighty Greek coalition assembled by Agamemnon 'Lord of Men', the king of Mycenae 'Rich in Gold', was pitted against 'Well-built' Troy ruled by 'Godlike' Priam – was a historical event has long been a matter of controversy.[48] But for many Greeks it was, and some writers went as far as providing dates:[49] 1334/1333 BCE (Douris of Samos[50]); 1291 (Eretes[51]); 'about

800 years before my time', so roughly 1250 (Herodotus[52]); 5 June 1208 for the city's destruction (the *Parian Chronicle*[53]); 1193 (Timaeus[54]); 1184/1183 (Eratosthenes, for whom the Fall of Troy marks the beginning of computable time[55]); 6 or 7 May 1135 (Ephorus[56]); and 966 (Pherecydes the Athenian[57]), to name but a few. Clearly there are major discrepancies here, which is unsurprising given that these are effectively based on 'creative calculations' that show that the Greeks had no secure definitive knowledge about when the fall of Troy might have taken place.

Troy had trading relations with the Aegean region from the very first phase of its settlement in the archaeological level known as Troy I (*c.* 3000–2500 BCE).[58] During roughly the same era that the Minoan culture based on Crete flourished and then merged into that of the Mycenaeans, we really see the zenith of Trojan culture with the rise of Troy VI (*c.* 1700–1250),[59] with the city possibly governed by rulers of Luwian[60] ethnic origin using it as the capital of the kingdom known to the Hittites as Wilusa. The people of Troy VI forged trade and cultural relations with the Mycenaean cities of mainland Greece, the Aegean islands, Crete, Cyprus and the Hittites of central Anatolia, until their city was severely damaged by a hotly disputed possible combination of earthquake and/or human internal or external agency. The subsequent Troy VII settlement (*c.* 1250–1000)[61] looks like a city still occupied by the same people, but with considerably less prosperity. If the contemporary written records from the Hittite archives discovered at Hattusa are a reliable guide,[62] they lived in a deeply unsettled environment. Whether the Hittite activities of this period can be made to support the seductive idea of an historical Trojan War in the Homeric sense remains doubtful, however, with the scholarly consensus

leaning heavily against it. We do hear of Hittite hostilities with the aggressively annoying *Ahhiya*, or *Ahhiyawa*, which could be located in Greece or Anatolia and which sounds similar to Homer's *Akhaioi* (Achaeans), who come from the land of *Akhaiis* (Achaea) to attack Troy;[63] the Hittite references to Wilusa and Taruisa suggest they are talking about the Greek 'Wilios' and 'Troia';[64] the Hittite High King Muwattalli II (r. c. 1295–1272) interacts with Alaksandu of Wilusa (likely to be the same name as Alexandros, which is the proper name Paris, the Prince of Troy), and a pest called Piyamaradu (possibly the same name as Priamos/Priam);[65] and a tiny fragment of a sixteenth-century song, written in Luwian, that has the line, 'when they came from steep Wilusa',[66] has led to suggestions that this might be a fragment of a pre-Homeric *Wilusiad* epic. All of this, however, is tantalisingly inconclusive.

Following the violent destruction of Troy VII in *c.* 1000 there was a hiatus with Troy only sparsely – if at all – populated, until Aeolian Greeks occupied Troy VIII in the late eighth century, roughly when Homer's epics were being committed to writing. The poems are less interested in recording historical fact than in presenting a version of the past that legitimises the present, and the Trojan War serves to define Greekness in a positive, warlike way and to justify Greek military encroachment into Asia Minor – rescuing Helen makes it a 'Just War', and therefore a crucial tale for Greek colonists moving into the region. Troy is a real city in an unsettled, interconnected and violent world, which has become the setting for the incredibly old Indo-European 'myth of the abduction of the beautiful wife' (Helen by Paris), and 'the twins who must rescue their sister/wife' (Agamemnon and Menelaus, and Helen).[67] The story of the Trojan War is not as historical as it might seem.

Whether the Trojan War was historical in a Homeric sense or not, there is certainly evidence of destruction throughout the eastern Mediterranean, and as the Greek world moved into the Iron Age we start to see Hellenic people migrating eastwards across the Aegean Sea. As the *Parian Chronicle* puts it: 'From the time Neileus founded Miletus [. . .] Ephesus, Erythrae, Clazomenae, Priene, Lebedus, Teos, Colophon, Myus, Phocaea, Samos, Chios, and the Panionia came into being, 813 years [= 1077/1076], when Medon was king of Athens.'[68] Aeolian Greeks settled in the area north of Smyrna (modern İzmir, Turkey), including at Troy; importantly, if bogusly, Athens claimed to be the mother-city of the Ionians, who settled to the south of the Aeolians as far as the River Maeander (also spelled Meander; Greek *Maiandros*; Turkish Büyük Menderes); and Doric dialect speakers established themselves south of the Maeander and in the islands of Rhodes and Kos. All the cities founded in this migration were on or near the coast, and although there was inevitably plenty of ethnic intermingling with the local populations, they all regarded themselves as quintessentially Greek, united by their institutions, language, literature and religion, and living in a highly beneficial natural environment:

The communities who live in the cold regions and those of Europe are full of energy, but rather lacking in intelligence and skill, so they maintain a degree of freedom, but are politically disorganised and do not have the ability to rule their neighbours. However, the Asians have souls that are intelligent and skilful, but they are indolent, which is why they always live under conditions of subjection and slavery. But the Greek race has a 50/50 share in both these

characteristics, just like it occupies the geographical mid-
point: it is both energetic and intelligent, so it maintains its
freedom, has the best political institutions, and has the abil-
ity to rule all of humanity.[69]

Giving specifics about this, Herodotus says that the Ionians
founded their cities in the world's finest climatic environment:
nowhere to the north, south, east or west had a better balance
between cold and wet, or heat and drought. The Aeolians'
climate was not quite so good, but their land was better,[70] and
certainly the history of the eastern Greeks is one of quite excep-
tional cultural brilliance. The number-one figure was Homer,
who the Ionians claimed as their own, but in the sixth century
their prosperous and dynamic cities, along with those of the
adjacent islands, were the homes of some of the world's most
important early thinkers.

The epicentre of this intellectual flowering was Miletus. In
one mythical tradition Cretans led by either Sarpedon or
Miletus (grandson of King Minos) founded the city, although
in Homer the people of Miletus were Carians who fought
against the Greeks in the Trojan War.[71] Herodotus endorses the
Ionian version in which settlers under Neileus, son of King
Codrus of Athens, seized Miletus from the Carians, killed the
adult population and married the Carian girls.[72] Miletus would
certainly have been a culturally diverse environment, and by
the seventh century it was as impressive as any other city in the
Greek world. The Milesians founded numerous colonies in the
Black Sea region, had close contacts with Sybaris in Italy, and
pioneered the Greek presence of Ionian 'bronze men from the
sea' in Egypt.[73] Their tyrant, Thrasybulus, who seized power in
c. 610, was notable for recommending a ruthless application of

'tall poppy syndrome' against one's political opponents;[74] Milesian wool, furniture and sex toys became world famous;[75] and the city became a hothouse of science and philosophy.

Diogenes Laertius began his *Lives of Eminent Philosophers* in polemical style:

> Some people say that the study of philosophy began among the barbarians. They say that there have been the Magi among the Persians, the Chaldaeans among the Babylonians or Assyrians, and the Naked Wise Men among the Indians; and among the Celts and Gauls are those who are called Druids or Holy Ones [. . .] The Egyptians assert that Hephaestus was the sovereign of the Nile, and that philosophy started with him [. . .] However [the authors who give this information] forget that they are assigning successful accomplishments to the barbarians that actually belong to the Greeks, who are responsible not just for the birth of philosophy, but the human race itself [. . .] It was from the Greeks that philosophy originated: you can't translate 'philosophy' into any barbarian language.[76]

Whether or not there is any truth in Diogenes' nationalistic assertions, we start to encounter in Ionia a great range of thinkers who were sceptical of traditional mythology and who started to engage in vibrant debates about mythology versus science as they developed radical astronomical, allegorical, historical and mathematical theories about the origins of the gods and the Universe.[77]

The first of the ancient Greece cosmological theories that we know of was put forward in around 585 by Thales of Miletus, one of the Seven Sages of Greece who between them became

associated with numerous important sayings of Spartan-style brevity, variously attributed, such as 'painted wood [i.e. the law] is the best protector of the city', 'nothing in excess' and 'know thyself'.[78] Where others saw divine action, Thales saw natural processes, although his statements 'all things are full of gods' and 'god is the mind of the Universe' show that he did not reject the gods entirely.[79] But his startling assertion that water is the *arkhe*, the 'beginning' or 'first principle' of all things, was a radical departure from any previous speculation about the nature of the world. In Plato's *Theaetetus* there is an anecdote that casts Thales as a stereotypical 'mad professor', so focused on the sky that he didn't notice a well beneath his feet and fell into it.[80] But his skygazing was outstanding, especially when he predicted the solar eclipse that took place on 28 May 585.[81] The Babylonians had established that eclipses tend to repeat themselves on the so-called Saros cycle of just over eighteen years; Thales had that information; he knew of an eclipse in Egypt in 603; so he put two and two together, made 585, and risked the prediction. His luck was in, since an eclipse that year was visible in the Greek world, but more important than the accuracy of his prediction was his mental attitude. About a century earlier, the poet Archilochus had reacted very differently to a solar eclipse: 'Nothing is unexpected, or impossible, or amazing any more, now that Zeus has replaced midday with night, and hidden the light of the sun.'[82] Moving away from superstition in an attempt to understand things in terms of natural cycles was an epoch-making change of outlook.

Thales' rough contemporary Anaximander of Miletus (611–546) was said to have been the first person to dare to make a map of the inhabited world. Anaximander also believed in infinity. Rejecting Thales' primacy of water, he argued that *to*

apeiron, 'The Boundless'/'The Unlimited', which was ageless, deathless, eternal and, unlike the anthropomorphic gods, ungenerated, was the key principle:

> It is neither water nor any other of the so-called elements, but some other boundless nature, from which all the heavens and the world orders in them originate. Everything that exists is both created and destroyed out of this according to necessity.[83]

Anaximander's world was created out of a 'cosmic vortex' operating within The Boundless, which resulted in four major 'opposite' powers: Hot, Cold, Wet and Dry. These interacted like hostile forces trying to conquer one another: the sun's heat dries up water; water extinguishes fire; and on a world level, Cold and Wet gain a temporary ascendancy in winter before the balance swings back in favour of Hot and Dry in summer. The whole process is self-regulating, since no single opposite can ever gain total ascendancy as this would destroy the balance of the Universe. As he expressed it in what is perhaps the earliest surviving sentence of European prose: 'Things give recompense and pay reparations to each other for their injustice, according to the ordering of time.'[84]

Anaximander regarded the earth as rather like the drum of a column three times as broad as it is deep, which sat in the exact centre of the Universe. For him, this solved the age-old problem, 'What does the earth rest on?' If it sits on water, as Thales said, what did the water rest on? 'It rests on nothing,' said Anaximander, 'stays there because it maintains an equal distance from everything',[85] and has no reason for falling in one direction rather than another. He also wrote the first Greek prose

treatise, *On the Nature of Things*, in which he stated his belief that animals first arose from primeval moisture in a kind of embryo form inside fishes (or animals quite like them), before moving on to dry land, where they changed shape: 'When these animals split open, men and women emerged who were capable of looking after themselves.'[86] The divine forces that we find in the myths were not necessary in Anaximander's universe. Natural philosophy was here to stay.

The great triumvirate of Milesian thinkers was completed by Anaximenes (traditional *floruit* 546–525). He was a student of Anaximander but rejected his idea of The Boundless. Anaximander's primary element was *aer*, 'Cosmic Air', which supported the world from below. His other elements were formed and modified by rarefaction and condensation: fire is highly rarefied air; air becomes wind when it moves; water is condensed air; water congeals into ice when it is cooled (i.e. condensed); and if you condense it further it becomes earth and rocks. He also argued that different densities of air caused the qualities of hot and cold, as he showed empirically by breathing out with his mouth open (the rarefied air feels warm on the hand), and then blowing out through compressed lips (the compressed air feels cold). Attempting to explain differences of quality by differences of quantity was a major innovation in scientific thought.

A few years after Cyrus the Great defeated Croesus of Lydia, the Ionian world witnessed the birth of the famously grumpy, aristocratically born Heraclitus of Ephesus (*c.* 540–480). He became known as 'The Riddler' because he regarded riddles as good vehicles for expressing the paradoxical nature of the truth of things. Heraclitus felt that Homer 'deserves to be ejected from the contests and beaten with a stick' because his

understanding of cosmology was so weak, and had a similarly dim view of Hesiod: 'Hesiod is the teacher of the masses. They are certain that he had the greatest knowledge – he who failed to understand day and night! For they are one.'[87] Heraclitus's point is that night does not 'produce' day, because the only difference between them is the presence or absence of sunlight. He was similarly astonished that people worshipped the gods, noting that people believed themselves to be purified with the blood from sacrifice 'as if someone who had trodden in mud should bathe in mud to wash himself',[88] and effectively saying that praying to a statue was like having a conversation with your house. However, he did recognise a divine presence in the cosmos, and his central philosophical insight was to reject the validity of binary distinctions: 'God is day [and] night, winter [and] summer, war [and] peace, satiety [and] famine, and changes in the way that olive oil, when it is blended with spices, is named according to the aroma of each of them.'[89] Heraclitus's opposites cannot exist without the other: each pair is basically one, not two, and each term is only meaningful in the light of the other: '[Harmony] is backward-turning like the structure of a bow or a lyre.'[90] The stability and functionality of the bow and lyre depend on mutually opposed tensions between the strings and frame: if a string breaks, all the hidden forces spring loose. And at world level, order is similarly produced by hidden tensions. Heraclitus's most succinct statement of this is simply, 'from all things one and one from all'.[91]

Like Anaximander, Heraclitus believed in infinity: his world had no beginning and would have no end: 'No god or man has made this world order, which is the same for all. It always has existed, does exist, and will exist, an ever-living fire, being kindled in measures and being extinguished in measures.'[92] For

Heraclitus, everything has to change continually, just like 'beer stands still by moving, rather than separating if it isn't stirred.'[93] Plato credits him with stating, 'all things move and nothing stays still',[94] and saying that reality is like a river: 'You can't step into the same river twice.'[95] The river is 'the same' because it is a more-or-less permanent element in the landscape, but when we step into it, different water flows past us all the time – that is what makes a river a river, and that is what makes Heraclitus's Universe.

Babylon's Burning

Once Cyrus had brought these dynamic Greek cities firmly within his orbit he shifted his focus eastwards, and 'subdued the entire continent'.[96] This finally put him a position where he could eye the great prize of Babylon. Herodotus visited the city in the course of his *Researches*, and was mightily impressed:

> It lies in a vast plain and is square in shape, with each side measuring 24 km, making the entire circuit of the city 96 km. That is the size of the city of Babylon, but it was laid out like no other city we know of. First of all, a deep, wide moat full of water runs around it and then a wall about 25 m thick and 100 m high.[97]

His description is manifestly absurd and exaggerated – 96,000 x 25 x 100 m = 24 million m³ of material in the walls[98] – which underlines the difficulties in taking our ancient evidence literally. But in the summer of 539 King Nabonidus and the Babylonians knew Cyrus was coming. While they were removing the cult statues from various cities and stockpiling food,[99]

the Persian king took time out to punish the River Gyndes (modern Diyala) for carrying away one of his sacred white horses in a hubristic engineering project of the type that would become a cliché in Greek perceptions of Persian monarchs: he dispersed the river into 360 channels to reduce its strength.[100] Cyrus was also able to control the narrative of the fall of Babylon: the Nabonidus Chronicle, the Cyrus Cylinder and the fragmentary Akkadian text known as the Verse Account of Nabonidus, all give an unequivocally pro-Cyrus picture: the Persians defeated the 'black-headed people', as they called the Babylonians,[101] and on 12 October 539 they took the city: 'Without battle or fighting he let him enter his city Babylon. He saved Babylon from its oppression. Nabonidus, the king who did not honour him, he handed over to him.'[102] Cyrus entered the city in triumph on 29 October,[103] and the Cyrus Cylinder implies that everyone was delighted: 'All the inhabitants of Babylon, the whole of the land of Sumer and Akkad, princes and governors knelt before him, kissed his feet, rejoiced at his kingship; their faces shone.'[104]

There were certainly happy faces in the Jewish tradition, since Cyrus allowed the Jews, who had been deported to Babylonia after Nebuchadnezzar's sack of Jerusalem some fifty years before, to return, and he was also credited with reconstructing the temple of Yahweh, which had been razed during Nebuchadnezzar's sack.[105] Cyrus was the messiah:

I am the LORD [. . .] that saith of Cyrus, He is my shepherd, and shall perform all my pleasure: even saying to Jerusalem, Thou shalt be built; and to the temple, Thy foundation shall be laid. Thus saith the LORD to his anointed, to Cyrus, whose right hand I have holden, to subdue nations before him.[106]

Whether Cyrus was motivated by expediency or altruism, or both, he promoted a policy of religious and cultural toleration and later Greek thinkers came to see him as an ideal ruler.[107] The Athenian in Plato's *Laws* eulogises the way the Persians under his rule maintained an appropriate balance between slavery and freedom, which allowed them first to free themselves and then to dominate others.[108] The Cyrus Cylinder talks of how the conquest of Babylon led to the automatic surrender of

> all the kings, who sit on thrones [e.g. the Phoenicians], from all parts of the world, from the Upper Sea [the Mediterranean] to the Lower Sea [the Persian Gulf], who dwell [in distant regions], all the kings of Ammaru ['the west', i.e. Syria–Palestine], who dwell in tents [Arabs]. [They] brought their heavy tribute to me and kissed my feet in Babylon.[109]

By 535 all the territory up to the Egyptian border had acknowledged Cyrus's authority. Well might he describe himself as 'Cyrus, King of the Universe, Mighty King, King of Babylon, King of Sumer and Akkad, King of the Four Quarters [of the World]'.[110] Yet even the King of the Universe could not live for ever. The Babylonian evidence suggests that he died in the second half of 530, fighting against the Scythian Massagetae, a people who lived beyond the River Araxes/Jaxartes (modern Syr Darya in Kazakhstan), who were adeptly led by Queen Tomyris.[111] The Persian army was annihilated in what Herodotus thought was 'the fiercest battle that was ever fought between barbarians',[112] and Cyrus was among the dead. Although more mundane accounts circulated, Herodotus thought the most trustworthy one was that in which Tomyris filled a wineskin with human blood, sought out Cyrus's corpse,

and jammed his head into it. That, she said, would quench his thirst for blood.[113]

Cyrus the Great was buried in a small but elegant and richly furnished tomb at Pasargadae (modern Mašhad-e Morḡāb)[114] that had an inscription in Persian: 'Mortal! I am Cyrus, the son of Cambyses, who established the Persian Empire and was king over Asia. So do not begrudge me this memorial.'[115] No one did. Herodotus commented that no Persian would even think of comparing himself with Cyrus.[116]

The Madness of King Cambyses

Cyrus was succeeded by his elder son Cambyses II,[117] who married his own full sisters Atossa and Roxane, as well as Phaidyme, daughter of the Persian noble Otanes.[118] His reign left later Greeks scratching their heads about what went wrong after Cyrus: 'How come the Persians were ruined under Cambyses?' asked the Athenian in Plato's *Laws*, and then answered his own question. 'Cyrus probably spent his entire life soldiering, and gave his children to the women to bring up [. . .] his sons were educated by women and eunuchs'.[119] The main event in Cambyses' reign was his massive invasion of Egypt, and Herodotus records stories concerning women, which allegedly lie behind Cambyses' action. In the 'Persian version' Pharaoh Ahmose II (aka Amasis II, r. 570–526) sends the 'big and beautiful'[120] Nitetis, daughter of the previous Pharaoh,[121] to Cambyses as a wife/concubine, disguised as his own daughter. The discovery of the deception gives Cambyses his reason for war. The 'Egyptian version' claims that Cambyses was the daughter of Nitetis and Cyrus. Herodotus also records a tale that Cambyses invaded Egypt to fulfil a promise that he

had made as a ten-year-old to avenge the honour of his real
mother Cassandane, who had been sidelined by the new, exotic,
alluring Egyptian princess Nitetis.[122] In reality Cambyses'
motives were naked imperialism, and Greeks would be involved
in the campaigns.

Ahmose II had cultivated amicable relations with the power-
ful Greek tyrant of Samos, Polycrates 'the fortunate in every-
thing',[123] but during Cambyses' reign their relationship broke
down, and now Polycrates offered ships to the Persian king for
his assault on Egypt. Ionian and Aeolian Greeks also formed
part of Cambyses' invasion force, conscripted as 'slaves which
he had inherited from his father'.[124] As the Persian preparations
were under way Ahmose II died in 526, leaving his son
Psammetichus III (aka Psamtik, Psammenitus, r. 526–525) to
wage the impending war. In 525 Cambyses fought a successful
battle against the Egyptian army, which also included Greek
and Carian mercenaries, at Pelusium in the Nile Delta.[125]
Herodotus later visited the battlefield, where he made an
extraordinary discovery:

> The skulls of the Persians are so brittle that you only have
> to throw a pebble and it will make a hole in them, but the
> Egyptian skulls are so strong that you can hardly break
> them by smashing them with a rock. They told me [. . .]
> that this is because the Egyptians shave their heads from
> childhood, and the bone grows thick from exposure to the
> sun [. . .] and it is also the reason why the Persian skulls are
> weak: they keep their heads in the shade from their earliest
> childhood by wearing felt hats called *tiaras*.[126] That's how it
> really is.[127]

The weak-skulled Persians pursued the Egyptians to Memphis, which they captured along with Psammetichus.

By summer 525 Cambyses was Pharaoh – 'The Horus, Uniter of the Two Lands, King of Upper and Lower Egypt, Mesutire, son of Re, Cambyses – may he live for ever!'[128] – but now he started to behave like a stereotypically bad one as hubris and madness took hold of him. To the west, the Libyans and the Greek cities of Cyrene and Barca voluntarily submitted to him,[129] but possession of the biggest empire in the world was not enough, and various unsuccessful acts of imperialist aggression combined with sacrilege to bring, at least in the Greek tradition, insanity in their wake.[130] He became paranoid that his brother Bardiya/Smerdis might usurp his throne, and had him murdered, and when his sister/wife mourned him he killed her outright or induced a fatal miscarriage by jumping on her in a rage.[131] No criticism was tolerated: he asked his trusted henchman Prexaspes what the Persians thought about him, but when Prexaspes made the mistake of telling the truth, that they regarded him as a crazed alcoholic, Cambyses shot Prexaspes' son through the heart with an arrow to demonstrate both his sanity and his steady hand.[132] Herodotus attributes this unhinged behaviour to 'the Sacred Disease' (epilepsy), but in the eyes of many Greeks Cambyses was just a typical tyrant, whose behaviour prefigured that of Darius and Xerxes.

Cambyses was travelling back to Persia in 522 when he died childless. He was succeeded by his brother Bardiya, who managed six months on the throne before he was replaced by Darius I. Our sources present a confused, confusing and contradictory picture of the transition of power, which is not helped by the fact that our major primary source is deliberately

misleading and written by the victor, Darius himself. His version of events is inscribed on a trilingual inscription (sometimes known as the 'Rosetta Stone of cuneiform') in Old Persian, Elamite and Babylonian augmented by relief sculptures, on the rock face at Bisitun at the foot of the Zagros Mountains in the Kermanshah region of Iran. Copies of the text still survive in Babylon and Elephantine in Egypt, and it was still being transcribed on to papyrus a hundred years later.[133] It claims that Cambyses secretly murdered Bardiya *before* the Egyptian expedition, and that while he was there, the people became morally evil and disloyal, and 'the Lie' (*dranga*) started to grow.[134] 'The Lie' is essentially the forces of chaos, which can be religious, cosmological and/or real-world political, and Darius and the god Ahura Mazda, who the Greeks equated with Zeus and whose name appears for the first time in our written sources during Darius's reign, fight implacably against it.

In March 522, a Mede or Magus called Gaumata falsely said that he was Bardiya and claimed the kingship on 1 July. After that (we are not told precisely when) Cambyses 'died his own death',[135] and Darius stepped in: 'No one dared say anything about Gaumata the Magus, until I came. Then I invoked Ahura Mazda; Ahura Mazda brought me help. On 29 September 522, I, with a few men, killed that Gaumata the Magus, and his foremost followers.'[136] The text is accompanied by an image of Darius triumphantly trampling Gaumata, who pleads in vain for mercy. Darius names his 'few' accomplices as Vindafarna (Intapherncs or Intaphrenes in Greek), Hatuna (Otanes), Gaubaruva (Gobryas), Vidarna (Hydarnes), Bagabukhsha (Megabyzus, aka Megabyxus) and Ardumanish.[137] A catalogue of Gaumata's transgressions follows, along with a list of the

measures that Darius took to restore order in the world, and outlining his family's right to rule. Darius had clearly had to face serious opposition, but now he was victorious and ruthless:

> Darius the King proclaims: A man called Cicantakhama from Sagartia[138] revolted against me [. . .] By the favour of Ahura Mazda, my army defeated the rebel army [on 12 October 522] captured Cicantakhama and brought him to me. After that I cut off his nose, ears [and tongue], and ripped out one eye. He was confined in fetters at the entrance to my palace. All the people saw him. Then I impaled him at Arbela.[139]

Darius's family connections to Cyrus were tenuous at best, so military dominance became the basis of his right to rule.[140]

Herodotus's account also featured a body-double motif centred on Smerdis/Bardiya. In this, two Magi brothers rebelled against Cambyses. One of these was coincidentally called Smerdis ('fake-Smerdis') and also looked a lot like Cambyses' brother. They knew that the murder of real-Smerdis, son of Cyrus, was still secret, so they installed fake-Smerdis as king. Cambyses was making his way back to Persia from Egypt when he got wind of what was going on. Realising that false-Smerdis was impersonating his dead brother, real-Smerdis/Bardiya, he jumped on to his horse to ride to Susa, but accidentally stabbed himself in the thigh as he did so and subsequently died of gangrene.[141] Fake-Smerdis enjoyed seven months as a popular king until his cover was blown. The Magi bribed Prexaspes to make a public statement that fake-Smerdis was indeed Smerdis son of Cyrus, but with the entire population of Susa assembled

below, Prexaspes climbed to the top of a tower, broadcast the truth of the whole situation, and jumped headfirst to his death.[142]

This triggered a conspiracy, which had already been in the making, led by Otanes (Hatuna), whose daughter Phaedymia had been married first to Cambyses and then to fake-Smerdis. She had discovered her new husband's true identity when they had sex: real-Smerdis had ears, fake-Smerdis had had his chopped off by Cyrus.[143] Feeling for his ears while making love was not a normal thing to do: one Graeco-Persian engraved seal now in Malibu shows a Persian male, fully clothed in his long undergarment, a knee-length long-sleeved tunic with loose-fitting leggings, and still wearing his ear-covering floppy hat tied under his chin, penetrating an ample-breasted naked woman from behind, while she looks back at him with interest and holds a mirror which gives him a full frontal view of her.[144] But somehow Phaedymia got the information, and Otanes confided in Aspathines (who replaces Ardumanish from the Bisitun inscription) and Gobryas. The three of them each added one extra person to the conspiratorial group – Intaphernes, Megabyzus and Hydarnes – and Darius, son of Hystaspes (Vishtaspa), brought to total up to seven.[145]

Darius became the dominant force in the 'Magnificent Seven', who struck quickly. They fought their way into the main hall of the palace, where the two Magi fought back, one ineffectually with his bow, the other with a spear. Darius and Gobryas pursued the bowman into a bedroom. Darius dithered while the other two grappled in the dark. 'Why aren't you helping?' shouted Gobryas. 'Because I'm scared I'll stab you,' said Darius. 'Use your dagger anyway!' Gobryas replied.

Darius struck, and was fortunate only to hit the Magus. The conspirators severed both the Magi's heads and displayed them to the crowd that was still shell-shocked from Prexaspes' death-dive.[146]

CHAPTER 3

Darius the Great

I am the kind who is a friend of what is right. I am no friend
of what is wrong.

Darius I[1]

It was not a foregone conclusion who would become king of
Persia in 522 BCE. At an alleged meeting between three of the
seven conspirators, Otanes argued that monarchy had passed
its sell-by date and led to unacceptable abuses of power, and
advocated giving power to the Persian people on the Athenian
democratic model. Megabyzus wanted oligarchy. For him,
democratic 'mob rule' was ineffective, stupid, and just as brutal
as tyranny, so they should entrust power to a few 'best men'
(obviously including themselves), because the best men make
the best decisions. Darius was not convinced. He agreed about
the evils of corrupt democracy, but felt that oligarchy led to
violent factionalism, bloodshed and ultimately to monarchy,
which just proved that monarchy was the best system, espe-
cially if the best man in the world was the monarch. Four of the
seven agreed with Darius. Persia would retain its ancestral
system. Otanes did not want either to rule or to be ruled, so he

renounced his claim on the kingdom on condition that he should never be ruled by any of the others. They agreed.[2]

The seven conspirators granted special privileges to one another, including the right to enter the royal palace unannounced, unless the king was sleeping with a woman, and agreed that the king should not marry outside the conspiratorial group. They then decided that the new ruler would be selected by whoever's horse neighed first at a prearranged place the following morning.[3] Herodotus was told two versions of how this played out. In one, Darius's groom knew that his stallion had a favourite mare, so that night he let him mount her. When the six contestants arrived at dawn the next day, Darius's horse immediately started whinnying. In the other, the groom wiped the mare's genitals with his hand, kept his hand concealed in his trousers all night, and put it under the nostrils of Darius's stallion to create the desired snorting and neighing when the candidates arrived.[4]

To legitimise his status, Darius made his ideology explicit, and nowhere more so than on the Bisitun monument:

I am Darius, the Great King, King of Kings, King in Persia, King of *dahyāva*,[5] son of Vishtaspa [Hystaspes], grandson of Arshama [Arsames], an Achaemenid.
[. . .]
Darius the King proclaims: [. . .] We are called Achaemenids. From long ago we are noble; from long ago we are royal.[6]

Darius needed to tie himself into Cyrus's Achaemenid family as closely as he could, and so he provided the dynasty with an eponymous founder called Hakhaimanish/Achaemenes, who is never mentioned by Cyrus. When Darius completed the

construction of Cyrus's unfinished capital at Pasargadae some-
time in the 510s BCE, he also installed two inscriptions, which
were copied numerous times on to the columns of Palace S and
Palace P:

> I am Cyrus the King, an Achaemenid.
> Cyrus the Great King, an Achaemenid.[7]

Darius is blatantly appropriating Cyrus the Great as one of his
ancestors so as to assert his own (flimsy) Achaemenid creden-
tials, and hence his legitimacy. His ethnicity was also crucial,
and inscriptions at Susa and on his tomb at Naqsh-i Rustam
made great play of him being Iranian (from Old Persian *Ariya*).[8]
Identity politics were a key factor in the Persian kingship.

Also essential to Darius's legitimacy was his partnership with
Ahura Mazda: 'A great god [is] Ahura Mazda [. . .] who
bestowed wisdom and energy upon Darius the King.'[9] They
form a powerful team, with Darius as Ahura Mazda's enforcer
of order and balance: 'Darius the King proclaims: By the favour
of Ahura Mazda, I am the kind who is a friend of what is right.
I am no friend to what is wrong.'[10]

Darius presents himself as self-controlled, loyal to his friends
but harmful to his enemies, reluctantly prepared to punish
transgressors, generous towards faithful subjects, supremely
intelligent, and a mighty warrior:[11]

> This (is) my ability, that my body is strong. As a fighter I am
> a good fighter [. . .] I regard myself as superior to panic.
> I am furious in the strength of my revenge with both hands
> and feet. As a horseman I am a good horseman. As a bowman
> I am a good bowman, both on foot and on horseback. As a

spearman I am a good spearman, both on foot and on horseback.[12]

This fighting prowess with bow and spear was publicised on the gold coins known as Darics, and on the Darius Seal in the British Museum.[13] This features a carved hunting scene showing a bearded Darius, decked out in a crown and full-length formal robe, standing in a two-horse chariot shooting arrows into the eye and front fore-paw of a rampant lion, while the horses trample a dead lion cub. The 'good bowman' self-identifies on the trilingual inscription: 'I [am] Darius the [Great] King'. Ahura Mazda hovers above, giving divine support to the king's power.[14] Together the Great King and the 'Wise Lord' Ahura Mazda fight for truth, justice and order, but, as the Greeks would shortly discover, they would meet any perceived threat to their ascendancy with overwhelming force.

The king's majesty was further reinforced by pomp, circumstance and carefully stage-managed imagery:

> The King's attire was particularly remarkable for its luxuriousness: a purple-edged tunic with white woven into its centre; golden hawks that looked like they were attacking one another with their beaks adorned his gold-embroidered cloak; and a gold belt, which he wore in female fashion, supported his *akinakes* [dagger], whose scabbard was adorned with gems. The Persians called the King's head-dress the *kidaris*; this was encircled by a blue ribbon flecked with white.[15]

He also sported a long elaborate false beard, and frequently held a sceptre and a lotus flower. Reliefs at Persepolis give a

good idea of the intricacy of his robe's detailing: it had animal
and floral motifs and lion borders; white-woven elements on
his tunic were a unique indicator of status; his shoes had straps
without buttons (non-royal ones did have buttons); and his
tiara, aka *kurbasia* or *kidaris*,[16] was bigger than anybody else's,
and left his ears and neck exposed. The *kidaris* was probably
elaborately inlaid with metal and/or precious stones, and was
worn upright to distinguish the king from other elite Persians
who did not wear it in this way.[17] This gave rise to scurrilous
double entendres in Aristophanes' comedy *The Birds*:

> EUELPIDES: Ah! So that's why even now the Cock struts
> about like the Great King, and he's the only one of the birds
> who has his *kurbasia* erect on his head![18]

The *akinakes*, which was suspended from his belt, was not
unique to the king but was a symbol of royal favour. Its sheath
was elaborately decorated: an example on the Treasury Relief at
Persepolis is adorned with rampant goats, griffins and lotus
flowers, while a surviving ivory example from Takht-I Sangin
in Tajikistan shows a lion with a male deer in its claws, and
another, part of the Oxus Treasure now in the British Museum,
is of embossed gold with images of a royal lion hunt.[19]

Royal Women, Loyal Eunuchs

On his accession Darius was already married to a daughter of
Gobryas, and he proceeded to add Otanes' daughter Phaedymia
to his harem. He also violated the 'no external wives' rule by
marrying the Achaemenid Atossa (daughter of Cyrus and
ex-wife of Cambyses and fake-Smerdis), Artystone (daughter

of Cyrus, previously unmarried), Parmys (daughter of real-Smerdis son of Cyrus), as well as Phratagune, daughter of his brother Artanes. Atossa was the principal wife – in effect the queen – and these royal women were immensely powerful. The Persepolis Fortification Tablets dating from Darius's reign allow us to observe their bureaucratic, economic and social status. Artystone, for instance, received very generous wine-rations:

> Parnaka spoke thus:
> Issue 200 *marriš* [*c.* 2,000 litres] of wine to princess Irtashduna [Artystone]. It was ordered by the King.
> Month 1, year 9 [March/April 503 BCE].[20]

Parnaka (Greek: *Pharnakes*) son of Arsham (Old Persian: *Arshama*; Greek: *Arsames*) was Darius's uncle. He oversaw a vast bureaucracy, and received lavish rewards for doing so. His daily rations amounted to two sheep, nine *marriš* (*c.* 90 litres) of wine and eighteen BAR (*c.* 167.5 litres) of flour.[21] Obviously he was not going to consume his entire bodyweight in meat, bread and wine on a daily basis, and Artystone was not going to get through 2,000 litres of wine on her own, but the quantities are an indication of their exalted status: when Artystone and Abbaukish (= Irdabama, Darius's mother or oldest wife) travelled towards Susa, they had seventy-one valets between them,[22] and Irdabama herself controlled a workforce of 480 men, women, boys and girls at Shiraz.[23]

Plutarch informs us that the wives of the Persian kings sat beside them at dinner, but that they would be sent away when their husbands wanted to party and get drunk. Music-girls and concubines would then be summoned, and Plutarch feels this is morally justifiable because the king did not involve his wives

in lewd behaviour.[24] Darius's retinue of concubines was commonly numbered at 300 or more, and their astonishing beauty was frequently commented on.[25] The Bible's Book of Esther, set in the reign of Darius's son Ahasuerus (Xerxes), describes how each girl underwent a year-long preparation period of beauty treatments with oil, myrrh, perfumes and cosmetics for a single night with the king (unless he 'delighted in her'),[26] and Heraclides of Cumae added the type of salacious detail that Greek readers loved: the 300 women who stood guard over the king would sleep in the daytime, so that they could stay up all night singing and playing harps, and that the king 'made use of them frequently'.[27] Merely crossing the route of a waggon carrying royal concubines could result in the death penalty.[28] Deinon tells us that the queen had no choice but to put up with the situation: 'Among the Persians the Queen tolerates the vast number of concubines because the King rules his wife just like a master rules his slaves, and also because the Queen [. . .] is literally worshipped by the concubines: for instance, they bow down before her.'[29]

Engraved gems made by Greek artists working at the Achaemenid court afford us some invaluable insights into the domestic aspects of the lives of these elite Persian women, interacting with their menfolk, children and pets.[30] On one chalcedony scaraboid gem we see a woman in Persian dress, with a long veil draped behind her, sitting on a chair playing a triangular harp in front of her pet Maltese dog, which seems to have been very much the canine companion of choice. On the reverse side she is sitting in the company of a small figure – child or slave – with her pet songbird.[31] Another lady brings her male partner a flask of wine or ointment, a cup and a dipper as he sits on a cloth-covered stool with his feet on a footrest.[32]

Another seated Persian woman holds a flower and offers a rattle to her child.[33] On a gem now in Baltimore a woman offers a cup to an armed man in Persian dress, who is about to depart for war. He leans on a spear, and between them is a large, tame waterbird, symbolising her constancy in his absence.[34] All these women are exquisitely attired.[35]

The Achaemenid robe comprises a large, voluminous tunic made from pleated linen, which is cinched at the waist and then pulled out to create large, elegant sleeves. The skirt is folded so that the pleats create a central 'waterfall' of cloth at the front. The garment features a small train at the back, and the skirt is hitched up at the front to afford a glimpse of a pair of soft slippers or boots. The on-trend Persian hairstyle is a single plait or braid that hangs right down to the small of the back and is often ornamented with tassels or pom-poms.[36]

Physically all the Persian women depicted on these gems are 'plus-size', with full breasts and large buttocks that are deliberately emphasised by their outfits.[37] Their ampleness indicated fertility and was considered exquisite and desirable. Nitetis was big and beautiful, and therefore a threat to other women in the harem,[38] and Xenophon was acutely aware of their curvy, sexy allure: 'I'm really worried that if we once learn to live in leisure and luxury, and to mingle with these big and beautiful Median and Persian women and girls, we might forget our way home, like the Lotus Eaters.'[39] One gem now in Boston illustrates the pleasures to be enjoyed by Darius with Atossa and his other partners.[40] A young couple, naked apart from the girl's slippers, make love face to face on a large comfortable bed. She is big-breasted, wears her hair in a long Persian pigtail, and is supporting her weight on her arms while she reclines on a pile of cushions. She has her feet over his shoulders, while he

holds her behind her knees as he enters her. For the Greeks, her legs-in-the-air position was an indicator of her enthusiasm, and her Persian slippers would come to be seen as an exotically luxurious kinky accessory. When Aristophanes' Lysistrata is coordinating a pan-Hellenic sex strike in the comedy that bears her name, she makes the women of Greece swear: 'I will not stretch my Persian slippers towards the ceiling.'[41] When *Lysistrata* was produced in 411 the Persians had become a byword for barbarity for the Athenians, but a little Persian-style role-play could still spice up their marriages.

The Greeks also came to regard the Persians as rampantly effeminate, with the royal palace filled with 'herds' of eunuchs who were all 'accustomed to play the woman's role in sex'.[42] For the most part this is just crass stereotyping: we hear of young, good-looking, sexually submissive types; sinister schemers whose ambitions lead to their execution; and untrustworthy servants who end up with their eyes torn out, flayed alive, impaled and left as carrion for the birds.[43] A much more measured account is given in Xenophon's *Cyropaedia*, where Cyrus is said to have used trusted eunuchs because their prime loyalty was to him, rather than to children, wives or girlfriends, since he could offer them riches, status and protection against bullies. He also rejected the idea that eunuchs are weak: gelded horses do not bite or prance, but they are still effective in war; castrated bulls become less aggressive but are still strong enough to work; and when you castrate a dog, he stops running away, but still makes a good guard dog or hunter. The same applied to men.[44]

Eunuchs occupied positions from tutors in the royal household, to attendants of princesses and concubines, to low-status domestic positions, and we even hear of Persians playing dice for them.[45] Castration could be used or threatened as a

punishment for prisoners of war,[46] and there was vibrant trade in eunuchs, with a notorious Greek from Chios called Panionius making the 'most unholy' of livings from acquiring beautiful boys, castrating them, and selling them in Sardis and Ephesus to serve as eunuch priests.[47] They fetched very high prices because the survival rate from the 'operation' was low – it was done either by crushing the genitals, or by fully or partially removing them – and again because 'among the barbarians they were regarded as being totally trustworthy, unlike whole men'.[48] Darius, being a conspirator himself, was well aware of the possibility of assassination if he alienated the wrong people. Shortly after his accession Intaphernes had asserted his right to enter the palace unannounced, only to end up being arrested and executed.[49] Similarly when Oroetes,[50] whom Cyrus had installed as satrap at Sardis, murdered one of Darius's couriers for delivering a message that he disliked, he too was done away with in a ruthless demonstration of the hold that the king had over the officials and the military throughout his dominions, and of his zero-tolerance policy towards anything other than the total loyalty that eunuchs could provide.[51]

Administration and Communication

Darius's reign would effectively combine consolidation, reorganisation and expansion. He stood at the heart of a complex network of bureaucratic and personal relationships, and Herodotus credits him with dividing the Persian Empire into twenty administrative units called satrapies (Greek: *satrapeia*), each governed by a satrap (Old Persian: *xšaçapāvan* = 'Protector of the Realm') with a palace, a bodyguard and immense civil and military authority.[52] The power dynamics were reciprocal:

the king needed competent, loyal and experienced satraps to run his empire; the satraps owed their position directly to the king.

The Persian royal inscriptions give varying lists of the *dahyāva* (peoples/countries) ruled by the king. All of the Great King's subjects were *bandakā* (slaves/subjects/servants),[53] and as far as Greece was concerned these included Ionians (*Yauna*, i.e. Greeks) of the Plain, *Yauna* by the Sea, *Yauna* Beyond/Across the Sea, Lands Beyond the Sea, Thrace, and *Yauna* who wear the *Petasos* (i.e. Macedonians).[54] Some of the Ionian/*Yauna* cities were ruled by Persian-backed tyrants, and the satrapies that they belonged to paid between 360 and 500 talents per annum in tithes and taxes to the king.[55] These were considerable amounts, adding up to 11.3 per cent of the total tribute paid to Darius, and it was the responsibility of the satraps in Sardis and Dascylium to collect and deliver them. Because Darius imposed a formalised system of tribute, rather than of 'gifts', the Persians gave him the nickname 'The Retail-Dealer'.[56]

The threat posed by potentially ambitious and disloyal satraps meant that the king kept them under constant scrutiny. Pseudo-Aristotle envisages the king holed up 'invisible to all' in a wondrous palace gleaming with gold, electrum and ivory, surrounded by bodyguards and servants who included 'door-watchers and listeners-out-for-danger', so that the king might 'see all things and hear all things'.[57] Various Greek sources (but no Persian ones) refer to an official called 'the King's Eye', or a network of informants known as 'the King's Eyes' and 'the King's Ears', whose job it was to keep him informed of absolutely anything that might be of interest, and keep his satraps and *bandakā* in a constant state of fear.[58]

Swift and clear communication was essential to the system, and messages could be quickly transmitted from the outer limits of the empire to Susa and Ecbatana via a system of signal beacons, which allowed 'the King to know every new development in Asia on the same day'.[59] There was also an extensive road network, including one that Herodotus called the Royal Road. This passed entirely through safe territory, and was well supplied with 111 waystations, one of which, in the form of a six-columned, roofed lodge, has been excavated at Deh-Bozan between Ecbatana and Bisitun.[60] From Sardis it traversed Lydia and Phrygia to the River Halys, ran on through Cappadocia and Cilicia,[61] crossed the River Euphrates into Armenia, then went into Matiene where four rivers including the Tigris and the Gyndes had to be crossed by ferry, entered the land of Cissia, and finally arrived at the River Choaspes (modern Karkeh), on whose banks Susa was located.[62] By Herodotus's arithmetic the road was 13,500 *stadia*, or 450 *parasangs* in length (approximately 2600 km), and a traveller in no particular hurry could travel it in exactly ninety days.[63] Official messages, delivered using a system of relays, rations and fresh horses at each waystation, could move much faster, and neither snow, rain, heat nor night-time impeded their rapid progress.[64] The Persepolis Fortification Tablets give us a vivid picture of the messengers, both male and female, and their elite guides, fortified by flour, wine and beer, carrying sealed documents to and from every corner of the empire:

1 QA [930 ml] wine provided by Karkashsha [an Iranian wine supplier].
1 woman travelled from Susa [to] Kandahar. She carried a sealed document of the King, and she received [it].

Zishandush [is] her elite guide.

Year 22, month II [April/May 500 BCE].[65]

Persia Moves into Europe: Darius's Scythian Expedition

Once Darius was confident that his personal situation was secure, he felt able to expand his empire's borders and advertise his success in trilingual texts inscribed on gold and silver tablets at Persepolis and Ecbatana: 'Darius the King proclaims: This is the kingdom that I hold: from the Saka [Scythians] who are beyond Sogdiana all the way as far as Kush [Nubia/the Sudan], from Hidush [the Indus Valley] all the way as far as Sardis.'[66] In Egypt he also completed the construction of a canal, wide enough to take two triremes abreast, linking the Nile to the Red Sea.[67] This type of project was frequently regarded by the Greeks as an indication of Persian hubris, and the king was not shy about telling his *bandakā* about it: the trilingual pink granite Chalouf Stela reads:

> King Darius proclaims: I am a Persian; from Persia. I took control of Egypt. I ordered this canal to be dug, from a river called the Nile, which flows in Egypt, to the sea which goes to Persia. Therefore this canal was dug as I had ordered, and ships sailed from Egypt through this canal to Persia, as was my wish.[68]

The Egyptian canal probably made good commercial sense to 'The Retail-Dealer', but when it came to Darius's expedition into Thrace and against the Scythians in *c.* 513, the motives are harder to ascertain.[69] Herodotus gives us a sexy vignette of Queen Atossa manipulating him into adding to his empire

because that is what 'real men' do, and of Darius rejecting the advice of his brother Artabanus, who argued against the expedition.[70] Herodotus suggests that Darius was avenging Scythian attacks on the Medes from about 100 years earlier, and that his overall goal was the conquest of all Europe, but neither motive is likely:[71] the old invaders comprised the Saka Haumawarga ('Haoma-Drinking Scythians'), so-called from their use of the *haoma* plant, an intoxicant used in Zoroastrian ritual practices that was known for facilitating healing, physical strengthening, intellectual stimulation and sexual arousal, and the Saka Tigrakhauda ('Pointed-Hat Scythians'), whose King Skhunda appears comprehensively subdued on Darius's Bisitun monument.[72] The Scythians whom Darius attacked now were known as the Saka Beyond the Sea, and inhabited the Pontic steppe to the north of the Black Sea. Furthermore, the whole of Herodotus's narrative should come with a spoiler alert in the context of Xerxes' invasion of Greece in 480/479, which will feature a set of matching motifs and events ranging from the disastrous rejection of good advice to the mobilisation of every nation of the Persian Empire, to bridge-building, to failure and defeat.[73]

The astonishing construction of a pontoon bridge of 200 ships, well over 1,000 m long, across the difficult waters of the Bosporus indicated the long-term seriousness of Darius's intent.[74] He rewarded its architect, Mandrocles of Samos, with every kind of gift; Mandrocles commissioned a painting of it which he dedicated at Olympia; and Darius erected two bilingual marble pillars listing all the peoples under his sway, every one of which had contributed a contingent – a grand total of 700,000, plus what seems to be a standard figure of 600 ships, and, if we believe Dicaearchus, 360 concubines.[75] Some of the

fighting forces were Greeks: the Ionians, Aeolians and Hellespontines, who between them had overall command of Darius's navy, sailed into the Black Sea, headed north, entered the delta of the River Ister (Danube), sailed upriver for two days, built a bridge, and waited for the king there. For his part, Darius marched overland through Thrace subduing, enslaving, conscripting, gaining control of trade routes and erecting monuments as he went, before making the rendezvous.[76]

Across the Danube were the largely nomadic Scythians Beyond the Sea.[77] Known to Homer and Hesiod as the Hippemolgoi ('Mare-milkers') and Galaktophagoi ('Milk-eaters'),[78] this agglomeration of illiterate tribes stretched across the Siberian steppes to the borders of modern China. They have left vivid material traces, most famously now displayed in the Siberian Collection of Peter the Great in the State Hermitage Museum in St Petersburg, along with well-preserved *kurgans* (burial mounds) in the permafrost of the Altai mountains near the borders of modern Russia, Kazakhstan, China and Mongolia.

Herodotus also travelled intrepidly up the River Borysthenes (Dneiper) where he acquired his own invaluable knowledge about the Scythians.[79] The combined evidence presents the Scythians to us as fearsome, tattooed, horse-riding, hard-drinking, drug-crazed, gender-fluid, bling-flaunting, Barbarian warriors. Their mummified remains show that both sexes deco-rated their wrists, thumbs, arms, legs, shoulders and upper torsos with soot-based tattoos, with a preference for animal, bird and fish designs, or just simple dots.[80] The author of the Pseudo-Hippocratic *On Airs, Waters and Places* also said that their bodies were physically flabby – the girls 'wondrously' so – and that they cauterised their arms, wrists, chests, thighs and

loins for medical reasons.[81] They used four- or six-wheeled ox-drawn wagons as their houses, which were wonderfully insulated from the elements, and were the territory of the women. The men rode alone on horseback, followed by their sheep, cattle and other horses.[82]

This alien, itinerant lifestyle made them terrifying to the Greeks:

> They have discovered a way in which no one who attacks them can get away, and no one can catch them if they do not want to be found. You see, they don't have permanent cities or fortifications, but instead they all live in mobile homes and shoot their arrows from horseback. They don't live by cultivating the land, but by cattle-rearing and transporting their houses on wagons. So how could they not be invincible and elusive?[83]

Their horses were their prime asset, and they took their equestrian skills to the highest level. The finds from the *kurgans* show that the horses' tack was hardwearing, light and fit for purpose, as well as beautifully decorated, and that the animals themselves were well looked after in life and buried with elaborate costumes after death.[84] Their riders' weaponry was also formidable. They used short composite bows, typically around 80 cm in length, constructed from wood and animal sinew glued together and strung with sinew. The tensile strength of these weapons made them immensely powerful: Anaxagoras son of Dimagoras was said to have shot an arrow over 500 m,[85] and an adept archer could unleash around ten missiles per minute drawn from a quiver mounted on the saddle. A favoured tactic was to lure their enemy into pursuit, and shoot back over their

shoulders – the so-called 'Parthian shot', which the Scythians themselves may well have developed. The arrows generally had shafts made from reeds or birch wood and had heads made from bone, bronze or iron, often with a hooked barb at the base. On occasion they were smeared with a poison made from human blood and snake venom.[86]

Any fighting on foot was carried out with swords, daggers, maces, *akinakes*-type weapons, whips, and/or battle-axes with narrow cutting-blades mounted at right angles to a long shaft. The latter were gruesomely effective: the warrior interred in the Pazyryk *kurgan* 2 in Siberia had suffered two blows to the head from one, prior to being scalped. Defensive armour comprised leather and wood shields, scale armour, leather waist girdles faced with iron or bronze plates, short-sleeved shirts covered in overlapping metal scales, greaves, and helmets made from cast bronze with cheek pieces and neck protection.

Combat, however, was not an exclusively male pursuit. Herodotus tells us of a tribe called the Sauromatae:

> The women of these people ride, practise archery, hurl javelins from horseback, and fight with their enemies – at least while they are still virgins. They do lose not their virginity until they have killed three enemies [. . .] They do not have a right breast, because when they are still babies their mothers heat up a purpose-made bronze implement until it is red-hot, apply it to the right breast, and cauterise it, so that it stops growing, and all its strength and size go into the right shoulder and right arm.[87]

In Herodotus' colourful account, some Scythians became Sauromatae through marriage with the Amazons (*a-mazos* in

THE HARVEST OF WAR

Greek means 'without a breast').[88] The Scythians called the
Amazons 'Man-slayers'[89] and after initially thinking that they
were male and fighting with them, started to respect them,
have sex with them, settle down into stable relationships, and
set up homes in Sauromatia.[90] Since then, says Herodotus, the
Sauromatian women ride and hunt with or without their men,
go to war, and wear the same clothes as them.[91] There are tanta-
lising hints of a potential historical basis for these gender-fluid
fighters in the archaeology. At least four of the fifty warrior
graves at Chertomlÿk have anatomically female occupants,
perhaps endorsing Herodotus's comments that if a virgin fails
to kill an enemy man, she remains unmarried until she dies,
presumably still in her male gender role.

Scythian male sexuality was equally non-binary: Pseudo-
Hippocrates says that because of their constant horse-riding,
the cold, damp climate, and the fact that wearing trousers
makes them forget to masturbate, some male Scythians have a
very low libido and think that they have lost their manhood.
They dress and behave like women, and work alongside them:[92]
'Very many of the Scythians become eunuchs, do women's
work, and live and talk like them. They call these people
"Not-men".'[93]

The Greeks also regarded the Scythians as barbarous drunk-
ards.[94] Extensive archaeological finds of amphorae and drink-
ing equipment testify to the large-scale consumption of wine,
and their preference seems to have been to drink it neat, not
diluted with water like the abstemious Greeks. The poet
Anacreon was all for moderation:

Come now, let's not drink
In Scythian style any more,

With crashing and shouting over our wine,
But do it in a mellow mood,
To the sound of beautiful hymns.[95]

In Athenian comedy the Scythian archers whom Athens used as a police force in the fifth century are mocked as weird, ineffectual, incoherent idiots, and when the Magistrate in Aristophanes' *Lysistrata* has to tell one of them to stop staring at the wine shop, the audience would have enjoyed the joke.[96] But the Scythian warriors drank to create sacred bonds, sharing a mixture of wine and their own blood, into which they had dipped their offensive weapons.[97]

One of the indigenous plants in Scythia was cannabis (Greek: *kannabis*). They made clothes from it, and used it for cleansing themselves both physically and ritually in a kind of 'spliff-sauna':

> They prop up three wooden poles leaning against each other,
> and stretch felted woollen blankets over them, making them
> as airtight as they can. Then they put a bowl in the middle,
> underneath the poles and blankets, and throw red-hot stones
> into it.[98]

Archaeological remains of sets of this equipment, including small bronze brazier-like vessels containing burnt stones and charred cannabis seeds, have been found throughout Scythian territory,[99] and Herodotus describes how the cannabis was used:

> The Scythians take the cannabis seed, crawl under the blan-
> kets, and throw it on to the glowing stones. The effect of this
> is that the cannabis seed smoulders like incense, and emits so

much vapour that a Greek steam-bath could not possibly outdo it. The vapour makes the Scythians howl with joy.[100]

The great lengths the Scythians went to in their personal appearance can be seen from a gold-plated silver bowl from Gaymanova Mogila in Ukraine, and on a magnificent gold beaker from Kul'-Oba in the Crimea,[101] where the men, with full beards and shoulder-length hair, wear long-sleeved, thigh-length felt- or fur-lined leather tunics, longer at the back than the front and belted at the waist, over close-fitting elaborately embroidered trousers. Calf-length boots tied at the ankle, felt stockings with leather and gold appliqué designs, and a tall, pointed hat complete the look. Women's clothing was fabulously colourful: tight-sleeved caftans with squirrel or otter fur for warmth, yellow silk shirts, red-and-white striped wool skirts, thigh-length white felt leggings, red and brown leather boots ornamented with metal and crystals, and tall wood and felt headdresses. The gold ornamentation that they used for themselves and their horses was produced for them by Greek craftsmen from the Black Sea coast, working to commission on pieces whose motifs reflected the mythology, history, lifestyle and values of a people who were now faced by the vast forces of Darius's Persian Empire.

The Great King led his men across the pontoon bridge over the Danube, ordered the Ionians to dismantle it, and then changed his mind and told them to leave it in place for sixty days and guard it with their lives.[102] The Scythians looked to support from other tribes of the region.[103] The Gelonians, who had a vast fortified settlement at Bel'sk in the Dnieper valley,[104] the lice-eating Bundinians and the Sauromatae came on board, but the Agathyrsians, whose women were always available to

any man to have sex with, the Neurians, who were said to become werewolves once a year, the Man-eaters, the Black Cloaks (the clue is in the names) and the Taurians all accused the Scythians of starting the war by invading Persia a century ago, and told them, 'it's not our problem'.[105]

There is no mention anywhere in the Persian official records of the campaign that followed, and Herodotus got all his information from the Scythian side. They told him that the Scythians retreated, devastating the land as they withdrew, and divided their forces. One group kept roughly a day's march ahead of the pursuing Persians, and by the time Darius finally called off the advance he had crossed the River Tanais (Don) and had found himself in completely uninhabited territory with not a Scythian in sight.[106] When he turned back the other Scythian detachments lured him into the lands of the Black Cloaks, Man-eaters, Neurians and Agathyrsians in an attempt to provoke them into resisting him. This failed: the first three groups fled, and the Agathyrsians said they would resist the Scythians.

Frustrated, Darius contacted the Scythian King Idanthyrsus. 'This is weird!' said Darius's messenger. 'Why are you always running away? Fight us if you think you're going to win, or send earth and water to Darius and surrender if you don't.'[107] Idanthyrsus responded that he had no leverage over the other Scythians: 'This is what we always do. We're nomads. We behave like this in peacetime too. We don't have any towns to defend, and we've got no intention of fighting on your terms. And you won't be getting earth and water from us!'[108] In a new move, the Scythians then sent one detachment to the Danube to hold discussions with the Ionians guarding the bridge, while the rest of them started to attack the Persians when they were foraging for food.[109] This put so much stress on the Persians'

logistics that the Scythians felt it was worth risking a set-piece battle. Both sides deployed, but when a hare ran across the intervening space the Scythians' hunting instinct kicked in and they all gave chase. The Persians decided to head for home.[110]

The Scythians now united their forces and made for the Danube, which they reached before the Persians got there. They reminded the Ionians that their sixty days were now up and suggested that they should dismantle the bridge. That, they said, would result in eternal Scythian gratitude, the destruction of their former master Darius, and the liberation of Ionia.[111]

A debate that had immense political ramifications now took place among the Greek leaders. The Athenian Miltiades son of Cimon, the future hero of Marathon, now appears in Herodotus's narrative for the first time,[112] arguing in favour of destroying the bridge. In all likelihood this is a bogus story: at this moment, which pre-dates Cleisthenes' democratic reforms, Miltiades was ruling as tyrant of the Hellespontine Chersonese, and his subsequent treatment by Darius, who kept him in his post, tells against any anti-Persian actions here. Also present at the meeting were eleven other tyrant-generals from Abydus, Lampsacus, Parium, Proconnesus, Cyzicus, Byzantium, Chios, Samos, Phocaea, Cymae and Histiaeus of Miletus. Histiaeus opposed Miltiades' supposed plan:

Each one of us owes our position as tyrant [. . .] to Darius. But if Darius's power is destroyed by force, I will no longer be able to rule the Milesians, and none of you will be able to rule anyone else. Every one of our cities will choose to be ruled democratically rather than by a tyrant.[113]

Self-interest and anti-democratic politics trumped any feelings of Greek unity, and the tyrants voted with Histiaeus.

The Greek tyrants tricked the Scythians into heading off in search of Darius by dismantling the northern half of the bridge, but their quest was fruitless. Darius duly arrived back at the Danube after a round trip of well over 3,000 km, and although he had not suffered any major defeat, Herodotus regarded the campaign as an abject failure, and it is conspicuous by its absence from Persian official documentation. Histiaeus organised the restoration of the missing part of the bridge and the ferrying across of other troops, leaving the Scythians singularly unimpressed by the Greeks' behaviour:

> They regard the Ionians as the worst and most unmanly free people in the whole world, but if they were to be thought of as slaves, they would say that they were the most master-loving and submissive. That is how the Scythians have insulted the Ionians.[114]

With the onset of winter the king withdrew, never again to set foot in Europe. However, he left 80,000 fighters on the continent under the command of his general Megabazus, who proceeded to subdue any settlements in the Thracian/Hellespontine region who were not collaborating with the Persians. Darius's plans for Europe were by no means finished.

CHAPTER 4

This is Sparta!

Lacedaemon was always free of tyrants.

Thucydides[1]

Mycenaean and Mythical Sparta

Ancient Sparta still has a terrifying reputation for xenophobic, totalitarian violence, as the state pulverised both its enemies and its own citizens and subjects. Writing after the Persian Wars, the Athenian historian and general Thucydides rather prophetically compared his city with Sparta, which, in his lifetime, had become mortal enemies:

> If the city of the Spartans were to become deserted, and nothing but its temples and the foundations of other buildings should be left, I think future generations would [. . .] struggle to believe that its power was as great as its famous reputation [. . .] Because Sparta does not have a regular city plan, has not equipped itself with temples and other expensive structures, and is inhabited in village-style in the old-fashioned Greek way, its appearance would

appear disappointing. On the other hand, I think that if the Athenians were to suffer the same fate, the appearance of their city's ruins would make you think it had been twice as mighty as it really is.[2]

The Peloponnesian War between Sparta and Athens, in which Thucydides fought and Herodotus wrote, ended in 404 BCE with victory for the Spartans,[3] but the cliché that 'history is written by the winners' simply does not apply to them. For much of the sixth and fifth centuries they were far too preoccupied with winning, or preparing to win, to waste valuable time and energy recording it, and so although they often won, they seldom wrote. This means that our picture of them comes primarily from non-Spartans – Herodotus (whose research took him to Sparta), Thucydides (who was frustrated by what he felt to be 'Spartan secrecy'[4]), Xenophon (an unashamed admirer of Sparta who later fought against the Persians alongside his friend the Spartan King Agesilaus), Aristotle (highly critical of Sparta), Pausanias (another visitor), Plutarch (another admirer, who compiled a fascinating collection of *Sayings of Spartans* and *Sayings of Spartan Women*), and others – who, regardless of whether they found them appealing or appalling, were mesmerised by the enigmatic weirdness of their politics, lifestyle and militarism. Plutarch tells us that 'a form of expression which mixed spiciness with grace, and condensed close examination into just a few words'[5] was a crucial element in any Spartan's education, and their own literally and figuratively 'Laconic'[6] statements often provide a memorably terse commentary on the events of the Persian Wars.

Sparta was located in the fertile Eurotas valley in Laconia in the south-east Peloponnese.[7] But actually what we usually refer

to as Sparta was known to the non-Spartan Greeks as Lacedaemon (Greek: *Lakedaimon*), inhabited by Lacedaemonians (Greek: *Lakedaimonioi*). The term 'Lacedaemonian' is as old as *ra-ke-da-mi-ni-jo* or *ra-ke-da-mo-ni-jo*, which appears on the Bronze Age Linear B tablets from Thebes.[8] Homer referred to it as 'Sparta of the Beautiful Women' (Helen of Troy was Spartan), 'spacious Lacedaemon', 'hollow', and by a word that can be translated either 'full of ravines' or 'teeming with sea monsters'.[9] The Spartans themselves called their territory 'the Laconian Land'. So Lacedaemon became the name of the country and Sparta (or *Spartê*, as its inhabitants pronounced it) of its capital. 'Spartans' are really a specific sub-group, although in normal usage Lacedaemon/Lacedaemonians, Laconia/Laconians and Sparta/Spartans are interchangeable.

Sparta/Lacedaemon/Laconia had not always been the taciturn military powerhouse that the ancient writers loved or loathed. Despite its prominence in Homer as the home of Menelaus and Helen, and hence as the place where Paris's transgressions triggered the Trojan War, the reality was that its power took a long time to grow. Archaeological finds from the Mycenaean period (*c.* 1600–1100 BCE) at Sparta itself have been relatively sparse, although Mycenaean settlements have been discovered in and around the Sparta plain. Recent excavations at Ayios Vasilios revealed the ruins of a strategically well-located palace complex, probably built around the seventeenth or sixteenth centuries BCE, that seems to have had a well-established bureaucracy, but this was destroyed by a fire which broke out at the end of the fourteenth or the beginning of thirteenth centuries, and the buildings were not rebuilt at the same location.[10]

At the end of the period known to archaeologists as Late

Helladic IIIB2, conventionally dated to roughly 1200 BC, Mycenaean cultural ascendancy came to a pretty sudden end with the destruction of the palaces and their associated social systems. Up until the late twentieth century the demise of the Mycenaean palaces was often associated with a possible 'Dorian Invasion' by Doric-dialect-speaking Greeks from somewhere north of the Peloponnese. An alternative viewpoint is that these Dorians invaded at some later, unspecified time during the Dark Age. The Greek tradition regarded the Dorians as alien newcomers, and the relevant mythology saw this as unfolding via the legendary 'Return of the Children of Heracles'/'Heraclidae'/ 'Heraclids' to the Peloponnese, which Thucydides dated to the eightieth year after the capture of Troy.[11]

But it is by no means certain that such an invasion actually happened or, if it did, when it happened: the ancient chronologies, based on genealogies with multiple variants, which are traced back to a vaguely dated Trojan War, are sketchy in the extreme; the ancient sources give no impression of any single large-scale migration, and the whole idea of the 'return' of the Heraclids implies that they were not alien intruders; archaeological evidence to support the legends is practically impossible to unearth and hard to plug into them, in part because an invasion on the scale required to overwhelm the Mycenaeans would have left clear-cut remains from a very specific date and with a geographically traceable itinerary; so the whole concept of a 'Dorian Invasion' is now widely regarded as untenable in serious academic circles. However, the idea that the Spartans were essentially incomers distinguished them clearly from the autochthonous Athenians.

The Growth of Sparta: From Villages to Regional Superpower

After the demise of Mycenaean Lacedaemon at the end of Late Helladic IIIB2, *c.* 1200 BCE, there was a hiatus in which the 'village style' settlement of Doric dialect to which Thucydides refers[12] was established in the valley of the River Eurotas. Doric was a very distinct mode of speech, instantly recognisable to other Greeks. A splendid example of this comes from a poem by Theocritus[13] entitled *The Syracusan Women*. This presents a conversation between two ladies of Sicilian origin, who, like all Greeks from the island, have strong Dorian accents. They are having a nice day out at a festival of Adonis, but their running commentary on the artworks they see annoys a fellow festival-goer:

STRANGER: Oi! You horrible women! Stop that never-ending twittering! You're like turtle-doves! [*Grumbling indignantly to himself*] They'll wear you out with all those broad vowels.[14]

PRAXINOA: Ooh, err! Where's this guy from? What's it got to do with you if we twitter? Don't give orders to people who aren't your slaves![15] You're ordering Syracusans. And let me tell you this – we're descended from Corinthians.[16] Just like Bellerophon.[17] We speak Peloponnesian. Dorians are allowed to speak Doric, you know![18]

These villages of Doric speakers were scattered around a low hill that served as an acropolis, in land that is suitable for the exploitation of pastoral, agricultural and possibly human

resources. Sparta's name, 'the Sown Land',[19] could reflect the fertility of its environment, which is surrounded by the beautifully rugged mountainous areas of Taygetus (west), Skiritis (north) and Parnon (east), and has access to useable harbours on the coast, about 50 km to the south. These mighty natural fortifications negated the need for man-made ones.

The settlement that was to become classical Sparta appears to have been established sometime after 1000, when there was a *synoecism* of four villages or 'obes' (Greek: *obai* = 'villages'/'civic subdivisions'), adjacent to the acropolis, which were augmented in the eighth century by the conquest of 'Achaean Amyclae', a few kilometres to the south.[20] A rather less heroic tradition gave rise to the saying, 'Amyclae perished by keeping quiet.' The Amyclaeans had supposedly become completely paranoid because of constant fake news that they were being attacked, so they forbade anyone to talk about it. So when the Spartans did attack, nobody said a thing.[21] 'Amyclaean silence' became proverbial.

From *c.* 750 onwards, Sparta expanded aggressively to become the ruler of the whole of Laconia, reducing the non-Doric-speaking population to the status of Helots (Greek: *helotai* = 'serfs'),[22] and making the other communities of Perioikoi ('dwellers round about') politically subservient. Then, while most Greek states were sending out colonists, Sparta focused on a softer target of lands closer to home. Their warriors went west across the Taygetus Mountains, descended upon 'spacious Messenia, good to plough and good to plant',[23] and enslaved the Messenians as Helots.

By the middle of the seventh century Lacedaemon was flourishing, as was its culture: ceramics, sculpture, architecture, music and poetry were of high quality, and there was

widespread trade with the east. But in *c.* 650 the Messenians revolted, and Sparta found herself embroiled in a conflict lasting nineteen years.[24] The Spartan fighters were inspired by the gritty verses of their great elegiac war-poet Tyrtaeus:

> Young men! Fight standing firmly at each other's side.
> Don't initiate shameful flight or fear,
> But make the spirit in your hearts mighty and brave.
> Don't love your own lives when you are battling against
> other men.
> Don't run away and abandon the elders,
> Those dignified men whose knees no longer move freely.
> [. . .]
> But come! Let everyone stand fast, with legs planted apart
> for fighting
> And both feet fixed firmly on the ground, biting his lip
> with his teeth.[25]

The victorious Spartans re-Helotised the Messenians, and divided their lands into allotments, *klaroi*, which were granted to the Spartiates (Greek: *Spartiatai*, i.e. the 'true Spartans', as opposed to the Perioikoi and Helots), who were always a small and elite minority of the overall population.

Lycurgus

Tyrtaeus did not just sing of arms and men. Politics interested him too, particularly as he lived in what Robert F. Kennedy called 'interesting times [. . .] They are times of danger and uncertainty; but they are also the most creative'.[26] Herodotus says that once upon a time the Spartans were the 'most badly

governed of nearly all the Greeks',[27] which contrasts directly with the period after the Persian invasions, when their *eunomia* ('good government' and/or 'whole way of life') was widely admired.[28]

The change was seen to be as a result of the reforms made by their semi-mythical lawgiver Lycurgus (Lykourgos), a mysterious figure who ancient sources and modern scholars variously date as living at any time between *c.* 1100 and *c.* 600, if at all.[29] Plutarch puts it perfectly in the opening of his *Life of Lycurgus:*

> Generally speaking, there is nothing undisputed to say about Lycurgus the lawgiver: there are differing stories about his ancestry, travels, and death, and most of all about his treatment of the laws and the constitution. There is least agreement of all concerning the times in which the man lived.[30]

The Delphic oracle played a key role in the story, which perhaps indicates a series of constitutional crises, compromises and resolutions, played out between the kings, the aristocracy and the wider population. Tyrtaeus tells of how the Spartans brought home oracles from Delphi:

> The divinely honoured kings, who care for the desirable city of Sparta, and the ancient elders, shall be the first in debate [or 'the leaders of the Council'], but then the men of the common people, answering them back with forthright ordinances,[31] shall both speak what is good and do everything that is just, and shall not counsel anything for the city that is [crooked]. Victory [*nike*] and might [*kratos*] shall accompany the mass of the people [*demos*].[32]

The laws were couched in terse and somewhat opaque state-
ments, which seemed to suit the Spartans: Lycurgus's nephew
Charilaus famously said, 'Those who don't use many words
don't need many laws',[33] and the resulting system was admired
in antiquity for the *eunomia* that it brought to Sparta, combin-
ing monarchy (the two kings), oligarchy (the Council of Elders)
and democracy (the mass of the people) into a harmonious
system with an effective system of internal checks and balances.[34]

After Lycurgus's death, the Spartans established a sacred
precinct, where they revered him greatly.[35] And well they might
have done, because before he died he was also credited with
dramatically changing the entire Spartan way of life, banishing
'the needless and superfluous arts'.[36] The result was a new
austerity, iron discipline, intense devotion to duty, diminishing
foreign imports, and clear signs of artistic decay. The Spartans
embraced the idea that courageous warriors have more allies
and fewer casualties: it seemed to make sound military sense,
and led the Spartans to feel that their cultural sacrifice was
counterbalanced by the battlefield successes which they went
on to achieve.

Sparta's Constitution

The main elements of Sparta's constitution formed a curious
hybrid of monarchy, oligarchy and democracy. There were the
two kings, the Council of Elders, the popular Assembly (*Apella/
Ekklesia*) and five officials known as ephors. Why there were
two kings and two dynasties at Sparta is hard to ascertain. For
what it is worth, Herodotus relates a classic story of a mother
tricking slower-witted males in order to secure the kingship for
her sons, in which Argeia, the wife of King Aristodemus, gave

birth to identical twins just moments before her husband died.[37] The Spartans wanted to make the elder child king, but they had no idea which was which. Argeia did, of course, but pretended she didn't. She hoped that somehow both might end up on the throne. The Delphic oracle's response to the Spartans' conundrum was to instruct them to treat both boys as kings, but to give the elder one the greater honour. This left the Spartans none the wiser, but the puzzle was solved by a Messenian called Panites, who suggested that they should watch the mother closely, and see which she bathed and fed first. If she varied the order, she obviously knew no more than they did, but if she always maintained the same routine, that would tell them everything they needed to know. Apparently, despite the logical problems raised by the story (how did the observers know which child was which?), Panites' scheme worked. However, the subsequent bad relationship between the two boys, Eurysthenes and Procles, who stood at the head of the Agiad and Eurypontid dynasties respectively, was said to be the reason for the antagonism between the two Spartan royal houses, which surfaced especially on the eve of the Persian invasions.[38] The kings were Sparta's supreme military commanders and, although Aristotle said the office could be described as 'simply a perpetual hereditary generalship, so to speak',[39] it could be a lot more than that. In a militaristic society such as Sparta's, the advice and expertise of a successful warrior could carry considerable political weight.

A king would ordinarily be succeeded by his eldest son born after his accession ('porphyrogeniture'). The nearest male relative became the regent for a child, or became king himself if there were no male children. Sparta's history can be told as a series of reigns of influential kings,[40] but many ancient writers

also represent the *Gerousia* (Council of Elders) as being pretty much the governing body:

> Among the many innovations that Lycurgus made, the first and most important was the establishment of the elders [i.e. the *Gerousia*], which as Plato says, by being mixed with the inflamed extravagance of the kings, and by having equal voting rights in the most important matters, brought safety and a sense of moderation.[41]

The *Gerousia* consisted of twenty-eight life members, who had to be sixty years old or over, plus the two kings. The system of election was by a method that Aristotle twice described as 'childish':[42] an Assembly of the citizens was convened; judges were confined nearby in a place in which they could neither see nor be seen; the candidates came forward in an order determined by lot; the people shouted; the judges recorded the volume of the shouting on wax tablets; and whoever got the most noise was elected.[43] The *Gerousia* was the Lacedaemonian criminal court, and functioned as the guiding committee of the Assembly of Citizens, which it summoned at fixed periods. It put motions (*rhetrai*) before the Assembly of Citizens, which comprised all male Spartiatai from the age of thirty, but to what extent they enjoyed the right of free debate in the era of the Persian Wars is doubtful: Aristotle implies that the Assembly could simply vote yes or no on motions that were presented to it.[44]

The final pieces in Sparta's constitutional mosaic were the five ephors (Greek: *ephoroi*), representatives of the people, who came to wield formidable powers, even if they were always subject to restrictions in that their term of office was only one

year, after which they became private citizens and could be called to account for their actions. All Spartiates over the age of thirty were eligible to become ephors, but nobody could serve twice. They were elected by acclamation, assumed office on the full moon after the autumnal equinox, and apparently made a proclamation to all citizens: 'trim your moustache [or "don't overgrow it"] and obey the laws!'[45] They issued this moustache order simply because they could. It was not a Spartan law as such, but the ephors had the right to make things up as they went along: the training and discipline of the young were under their supervision, and the point of this was to get the young Spartans used to obeying even the most irrelevant instructions instantly and unquestioningly. In fact, the ephors exercised disciplinary powers over all the citizens: they presided in the *Gerousia* and the Assembly, and could introduce *rhetrai* into those bodies; the decision as to which age classes should go to war was theirs; orders mobilising the army were issued by them; they could give instructions to the military commanders, and recall them if they failed; every year they declared war on the Helots (who could therefore be killed without incurring any religious pollution) and could execute them without trial; and they controlled the *Krypteia*, a notorious and rather enigmatic body that operated as a secret police that gave the government a useful, if cynically violent, way of neutralising and terrorising potentially subversive elements. Specially selected eighteen-to-twenty-year-old men were periodically sent out into the countryside, armed just with daggers and basic rations. They would conceal themselves by day, and emerge at night to kill every Helot they came across.[46] The ephors also exercised powers in relation to the kings, in whose presence they remained seated when everyone else stood. They would exchange a monthly

oath: 'For each king that he would rule in accordance with the established laws of the city, and for the city that as long as he was true to his oath, they would maintain his kingdom unshaken.'[47] The ephors could also fine a king, as they did when Archidamus II (r. c. 469–427) married a little woman. 'She will not bear us kings,' they said, 'but mini-kings!'[48]

How to Build a True Spartan

In a rather Orwellian sense, the 'true' Spartans called themselves 'the Equals' (Greek: *Homoioi*). Their equality applied to one another, but they were certainly more equal than everybody else in the Lacedaemonian state. Yet their elitism was not financial, since they rejected economic activity almost completely. Xenophon says that at Sparta

> There is no need to make money even for the sake of cloaks, because they adorn themselves with the excellent condition of their bodies, not with very expensive clothing [. . .] In the first place [Lycurgus] established a currency system that if you brought even a tiny amount of money[49] into the house, neither the master nor a servant could possibly be unaware of it: in fact, it would need a lot of space, and a wagon to transport it.[50]

This was because their currency was in the form of iron bars or 'cakes', weighing around 600 g each, not gold or silver coins, which the Equals were not allowed to have.[51] So the Spartiates depended instead on the Perioikoi and the Helots for their economic needs, devoting the time created by not having to concentrate on money-making to intensive military training,

as well as the more 'gentlemanly', but equally militaristic, pursuits of hunting and athletics. At Athens and elsewhere only a small section of the citizens fought as hoplites, whereas every single Spartiate was a hoplite, and as a hereditary group of professional warriors their primary goal in life was to turn themselves into Greece's finest fighters. By the time of the Persian invasions, that is exactly what they had done.[52]

The qualifications for true Spartan 'Equal-status' were strict: you had to be the son of a Spartan father and mother; to have gone through the Spartan education system; and to have been unanimously elected to one of many fifteen-strong 'mess-companies' that were called *sysskania* or *pheiditia*. Your un-wavering dedication to Sparta was reciprocated by the life-long grant of one of the *klaroi* in Laconia or Messenia, which was cultivated on your behalf by the body-shattering labours of the Helots. By the time a Spartiate was accepted into his mess-company he had already undergone the *agoge* ('education system'), whose learning outcomes were designed to produce courage, unquestioning obedience to authority, and the ability to endure hardship and pain. It was quite literally the survival of the fittest. The father would take his newborn to a special location where the elders sat. They would examine the child:

If it was well built and robust, they ordered the father to bring it up, and assigned it one of the 9,000 *klaroi*. But if it was badly born and deformed, they sent it away to the so-called 'Apothetae' ('Places of Rejection'), a pit-like spot near Mt Taygetus, on the premise that the life of anyone who was not beautifully well built and robust from day one was of no use either to itself or the state. For the same reason, the women bathed their babies in wine, not water, making a

kind of test of their strength, because it is said that unmixed wine makes epileptic and disease-prone children have convulsions and lose consciousness. On the other hand, the healthy ones are hardened like iron, and brought into a permanent condition of strength.[53]

The first six years of a boy's life were spent at home with his mother and a nurse. They trained him not to be fussy about his food, not to be scared of the dark or of being left on his own, and not to cry or throw temper tantrums. Then at the age of seven he would leave home, join one of the age groups known as 'herds',[54] and probably live in a barracks with other boys (*paides*) of the same age. From this moment to the point where they finished their education, these young people were under the control of a *paidonomos* (= 'public guardian of education'), who was assisted by a group of whip-wielding young adults, who helped him punish any miscreants. In fact, though, the boys were under supervision 24/7, because every Spartan had the right to discipline them.

At around the age of twelve, the *paides* were made to go barefoot all the time; they received just one garment, a cloak which non-Spartans described as *phaulos* – 'short'/'paltry'/'ordinary'/ 'low quality'/'slight'/'insufficient' – which had to last them for an entire year; literacy was confined to the barest minimum; they cropped their hair; and they exercised naked: 'their bodies were rough, and their knowledge of baths or oiling was minimal: they only took part in such pleasures on a few specific days in the year.'[55] They also did their own housekeeping, plucked reeds by hand to make their beds, and were only given basic amounts of food. The rationale behind this was to make them taller, more beautiful and resistant to hunger when on active

service, although stealing to supplement their diet was accept-
able – providing they were not caught.⁵⁶ Thieving was bad; bad
thieving was unforgivable. This attitude is graphically illus-
trated by the famous story of the boy who had stolen a fox cub:
to escape detection he hid it inside his cloak and was prepared
to have his insides torn to shreds by the animal. The roughness
of their bodies was an indicator of their hyper-masculinity; in
Greek thought it was the exact opposite of effeminacy.⁵⁷

Plutarch also informs us that at around the age of twelve the
boys started to receive erotic advances from *erastai* (older lovers)
from among the best of the adults, as they were educated in
how to become true Spartans,⁵⁸ and Xenophon also passes
comment about men's 'eroticism with boys', which has gener-
ated a huge amount of debate:

> If a person of the right character admired a boy's soul and
> tried to make him a friend without incurring blame on
> himself, and to associate with him, [Lycurgus] approved,
> and considered this the most beautiful training. But on the
> other hand, if it was obvious that someone was yearning
> after a boy's body, he regarded this as absolutely disgusting,
> and decreed that in Lacedaemon *erastai* should keep their
> hands off boys no less than parents should keep off their
> children, and brothers keep away from brothers, as far as sex
> is concerned.⁵⁹

The nuances of his meaning are hard to unravel – the word
translated 'associate with' is a common euphemism for 'have
sex with'; 'yearning after' could be 'reach out to'/'grasp at' in a
physical sense; and Xenophon actually says that he would not
be surprised if no one believed this, because it was so weird in

Greek culture,⁶⁰ but his responses are not unique. Aelian (161/77–230/8 CE) talks of Spartan boys behaving in the exact opposite way to those in other states, and asking their lovers to 'inspire' (Greek: *eispnein*) them, which he tells us is the Spartan term for 'love', and that Spartan love has nothing shameful whatsoever about it.⁶¹ Theocritus also refers to a technical term for a Spartan *erastes*, which was *eispnelas* ('inspirer') in the Spartan dialect,⁶² and might have been a double entendre.

The Greek rhetorician Maximus of Tyre said that Spartiate *erastai* are only in love with their *eromenoi* like people are with statues: any abusive pleasures are not mutual, but they do share a mutual 'eros of the eyes'.⁶³ This raises the question of whether it was all about the eyes. Did Spartan men and boys not have sex with one another? Or if they did, how did they do it? How often? The Roman writer Cicero gives an intriguing possibility:

> Even the Spartans, who have an 'anything goes' attitude to love relationships with young men, except in the matter of penetration, use a very thin barrier to prohibit this one exception: they allow them to embrace and to sleep together provided that there is a cloak in between.⁶⁴

A fragment of a Red Figure *kylix* (cup) in Boston might illustrate how this took place. It shows a winged deity having non-penetrative, face-to-face, *diamerion* intercourse with a youth while in flight. The deity is naked and has a visible erection, which is thrusting at his beloved at groin level; the *eromenos* is wearing a (possibly) Spartan-style cloak that is depicted as see-through, which forms a Ciceronian 'thin barrier' between them.⁶⁵ The identity of the figures is disputed: they may be Eros and a generic *eromenos*, or possibly Zephyrus

(the West Wind) and Hyacinthus, the beautiful son of King Amyclas, the founder of Amyclae, and the grandson of the hero Lacedaemon,[66] which would give the scene an extra Spartan flavour, and perhaps endorse Cicero's comments about cloaked sex.[67]

Similar vase paintings, however, depict naked male couples having cloakless, 'unprotected' sex. The Metropolitan Museum in New York has a bobbin by the Penthesilea Painter showing Nike, the personification of Victory, on one side offering a victor's ribbon to a youth, naked apart from a diadem and an ankle bracelet, whose body is wrapped in, but not concealed by, a red cloak, and Hyacinthus and Zephyrus on the other.[68] The youthful nude Zephyrus grabs the long-tressed Hyacinthus by the right arm, making him hold his red cloak behind himself and display his body for the viewer's delight. An inscription above Hyacinthus's head says, 'the boy is beautiful', making it clear what is Zephyrus's desired outcome of the scenario. This again raises the question of whether, if this is a Spartanesque scene, we could be looking at someone not only yearning after, but physically grasping at, a boy's body. Would Lycurgus, if not the viewer, be morally outraged by this? And could it be that the customs instituted by Lycurgus, allowing the *eisplenas/erastes* to be in love with the soul of his *eromenos* but not to be physically intimate with him, actually create a cognitive dissonance between the ideal and the reality?

No-sex-Sparta was certainly not an idea that other Greeks instinctively bought into, and neither was Spartans only having between-the-thighs intercourse. Hesychius of Alexandria's lexicon of weird and wonderful Greek words includes *lakonizein* (= to 'Laconise'), which can mean to be politically pro-Spartan and adopt Spartan dress fashions, but which here is defined as

'to use [male] darlings',[69] presumably because that was seen as a Spartan thing to do. Also, the entry for 'In the Laconian way' says this means 'ejaculate; and be a lover of boys; offer themselves [feminine plural] to strangers. Because the Laconians guard their women the least.'[70] Laconising with your *kysos* (= anus or vulva) makes you a *kysolakon*[71] ('Spartanus' perhaps), although the term is used of both homosexual and heterosexual intercourse: in myth, Theseus, having abducted Helen of Sparta when she was a child, is said to have 'used' her in this way.[72] But it was seen as a typically Spartan male thing to do. At the end of Aristophanes' comedy *Lysistrata*, in which the Athenians and Spartans are forced to make peace by a female sex strike, when an Athenian says, 'Why don't we call Lysistrata [feminine], who is the only one who can reconcile us?' the Spartan comes back with, 'Yes, and summon Lysistratos [masculine] as well if you want!'[73] The joke that Athenians like women and Spartans prefer men continues when they then map out which areas of Greece they would like to control, using the naked female body of personified Reconciliation. The Spartan negotiator says he wants her 'fortification' (i.e. her buttocks), and that he 'longs for/gropes at' Pylos, which gives a double entendre on *pyle*, 'gateway', i.e. 'anus'.[74] The Athenian, preferring her front, asks obliquely for her vulva and legs, and when the deal is done they trade agricultural metaphors for sex: 'Now I want to get naked and work the land!' says the Athenian. 'And I want to have first go and shovel some manure!' says the anally fixated Lacedaemonian.[75]

If this type of behaviour might have outraged the semi-mythical Lycurgus, we have archaeological evidence of real-life negative responses from the historical era in the form of a series of inscriptions from the island of Thera/Santorini, close to the

Temple of the quintessentially Spartan Carneian Apollo.[76] Dating to the seventh century BC and earlier, these contain unequivocal references to pederastic couples[77] in which the authors identify themselves and sometimes give physical details: 'Krimon sodomised his "brother", the brother of Bathykles here'; 'Krimon [the same one? We don't know] sodomised Amotion'; 'Pheidippidas sodomised, Timagoras and Empheres and I sodomised . . .'[78] The context of these boasts/slanders is much discussed,[79] but whether they were indications of highly sanctified religious activity or simply scurrilous filth, they attracted the opprobrium of one later visitor to the site whose graffiti declares, with Laconian succinctness, 'faggot!'[80]

Apparently there was no rivalry in these 'inspired' relationships; instead, if two *eisplenai* found themselves yearning after, or grasping at, the same youth, they made this the basis for mutual friendship and did everything in their power to make their loved one's character as noble as possible.[81] Then from eighteen to nineteen years the boys graduated to the class of youths (*paidiskoi*) and could be called up for military service. Xenophon says that at this life stage, young adults become very self-willed, cocky and subject to violent cravings for pleasure, which is why Lycurgus felt they should be kept as busy as possible,[82] and be made to observe strict rules relating to their public behaviour.

At the age of twenty the Spartiates officially became young men (*hebiskoi*). Now they were permitted to marry, although they still lived in the barracks and only visited their wives in secret. This resulted, we are told, in some husbands having children even before they saw their own wives in daylight. The sources again stress the moralistic side of this:

Assignations like this were not only an exercise in self-restraint and moderation, but brought the partners together for sex when their bodies were physically fertile and their desires were new and fresh, not when they were exhausted and losing their power because of unrestricted sexual activity.[83]

As a result, they remained very much in love, both carnally and spiritually.

The Spartan male became a front-line combatant at the age of twenty-four, and at thirty he became a full citizen with the right to participate in the Assembly. From this point on he lived at home with his wife and family, although he was still obliged to dine in the mess every night. The citizens were now also allowed to let their hair grow: 'in times of danger they took a great deal of care over it, making it look glossy and well-combed. They remembered one of Lycurgus's sayings about long hair, that it makes handsome men even better-looking, and ugly ones more terrifying.'[84] Their haircare regime before the Battle of Thermopylae would astonish their Persian adversaries,[85] but such high-maintenance coiffure was a sign of high social status: Aristotle pointed out that a male with long hair cannot easily do manual labour;[86] these men were elite warriors.

The education of girls was aimed at producing feisty minds and healthy bodies, and their exercise regime was intensive. They were made to run, wrestle and throw the discus and javelin, and one particularly strenuous workout was called *bibasis*, where they had to jump up and down, repeatedly touching their buttocks with their heels.[87] Spartan women also had strong responses to the physical attractions of one another. We

can see this in the *Partheniai* (Songs for Choruses of Virgins) composed for performance at festivals, one of whose finest composers was Alcman:

> [. . .] and with limb-relaxing longing, and she looks [at
> me?]
> More melting in the mouth than sleep or death,
> And not without reason is she sweet.
> But Astymeloisa ['Darling of the City'] does not respond to
> me;
> Instead, holding her garland,
> Like a star flying away
> Through the shining heavens
> Or a golden shoot, or soft feathers [. . .]
> She passed through with long-legged steps; [. . .]
> Cinyras's[88] moist charm gives beauty to her tresses,
> And sits on the girl's hair.
> In truth, Astymeloisa moves through the crowd
> The sweetheart of the people
> [. . .]
> If only I were to see whether she might love me.
> If only she would come near and take my soft hand,
> I would instantly become her suppliant.[89]

In another fragment a chorus of ten maidens sing both about themselves and about several individuals. They namecheck a number of 'radiant', 'desirable', 'lovely', 'nymph-like' girls with 'big dark eyes' and 'beautiful hair', who shine 'like the sun', but lament that Aenesimbrota, who can cast love spells, is of no help:

Hagesichora distresses me.
Because lovely ankled Hagesichora
Is not present here.[90]

The language of the poem is erotic: hot Hagesichora 'distresses' her admirers because they have sexual yearnings for her. The nature of the festival performance also demands that all these gorgeous girls must sound and look magnificent. Young men also attended events like this,[91] but what is remarkable is not only that the girls were getting lavish praise from other women, but that this was highly sexualised,[92] to the point where it has been argued that this fitted into Spartan society in the form of 'an overt counter-culture' in which women and girls received from their own sex what segregation and monogamy denied them from men.[93]

The girls participated in these choral performances wearing basic short slit-sided tunics. This divided opinion: to some it indicated healthy-minded purity, to others the exact opposite. Lycurgus was supposed to have done away with prudishness, 'safe spaces', and 'girliness', and a fragment from the second-century historian Heraclides Lembus tells us that Spartan females were not allowed any cosmetics, or to grow their hair long, or wear gold.[94] In addition to dancing and singing at festivals with the young men looking on, Lycurgus also made young girls take part in processions in the nude.[95] Plato was cynical about this, regarding it as using sexual attraction to make the young men think about marriage, and suggesting that in persuading or driving the majority of the common people to do anything 'eroticism is probably more effective than geometry'.[96] Yet others saw it differently. Plutarch insists that there was no hint of immorality about the girls' nakedness,

and that it encouraged simple habits and enthusiasm for well-conditioned bodies, and imparted a touch of noble pride.[97] Typical of this noble pride is the attitude of King Leonidas's wife Gorgo, who, when a foreign woman commented, 'You Laconian women are the only ones who rule their men,' replied, 'That's because we're the only ones that give birth to men.'[98]

Spartan women were famous for their intense patriotism, epitomised by the woman who handed her son his shield as he went off to battle, with the famous instruction to come back 'with it or on it'.[99] Throwing away your shield and fleeing from combat was the ultimate act of cowardice, and there was a class of individuals at Sparta called the *Hypomeiones* (= 'the Inferiors'), which included the Tremblers (Greek: *Tresantes*), who were Equals demoted for timidity. But Spartan mothers could be even more hardline: one unnamed woman killed her pusillanimous offspring with the words 'not my son', and Damatria did the same for similar reasons.[100] The death of a son in battle was a 'Good Thing': Spartan women bore sons to die for Sparta, so they were happy when they did. Other Greeks, though, were often critical of Spartan women: Aristotle complained that they lived 'dissolutely in respect of every kind of dissolute behaviour, and luxuriously too',[101] and in Euripides' *Andromache* King Peleus rants against their lack of morals: 'A Spartan girl couldn't grow up chaste even if she wanted to! They leave the house with young men, and naked thighs, and loose tunics, and they wrestle and run races together with them. I can't stand it!'[102] His clinching example of Spartan female moral depravity is Helen.

Helots and Perioikoi

Essentially the Spartans were taught a way of life. It was an upbringing that certainly produced very courageous and loyal citizens, but it didn't encourage adaptability, and one of the main restricting factors was the Helots. Helotage was a different form of bondage from chattel slavery on the more 'normal' Athenian model. No one bought Helots at a slave market: they were a homogeneous, self-reproducing, native Greek people who all spoke Doric, and who had become dependants through conquest. Tyrtaeus gives us a very vivid picture of their economic conditions:

> Like donkeys worn out with enormous burdens
> Bearing half of all the fruit that the land brings forth
> To their masters, compelled by baneful constraint.[103]

Those fruits of the earth enabled the Spartiates to live their warrior lifestyle, but this also created a catch-22 situation: Sparta also needed the Helots for military purposes, and they were regularly enrolled in the army, but arming large numbers of oppressed serfs was a high-risk strategy. The Spartans never trusted the Helots 100 per cent. The systemic problems were evident in a discussion in Plato's *Laws* about Spartan-style Helotage: 'The slave is an awkward possession. Real-life experience has shown so many times, in the frequent and habitual revolts in Messenia [. . .] just how many evils result from the system.'[104] The reality, or simply just the threat, of Helot revolts was a constant influence on Sparta's domestic and foreign policy.

Not all the inhabitants of Lacedaemon were brutally oppressed, though, and the people who most closely approximated to the

citizens of 'normal' Greek states were the Perioikoi. They lived in communities with some degree of local autonomy, and although they were liable for military service, they were not bound by the warrior code of the Spartiates. This meant that they could conduct all the everyday economic activities of the state by cultivating the land, manufacturing and trading. Overall, they enjoyed a fairly secure position, and they seldom showed any real signs of disaffection. They were a key factor in Lacedaemon's stability, and it is no accident that the official designation of what we call Sparta was not 'the Spartiatai', in the way that, say, 'the Athenians' equalled 'the Athenian state', but 'the Lacedaemonians', which expressly included the Perioikoi.

Sparta's Immediate Pre-Persian War History

At roughly the same time as Athens was falling under the control of the tyrant Peisistratus, and the Ionian Greeks were being swallowed up into the newly dominant Persian Empire of Cyrus II the Great,[105] Tegea and Argos both fell prey to Sparta's new taste for arrogant expansionism, with the Tegeans being incorporated into the Lacedaemonian state, albeit as Perioikoi rather than Helots, and the Argives suffering a shattering defeat at the 'Battle of the Champions': 300 fighters were chosen from each side, and the combat was so ferocious that there were only three survivors, two Argives, and the Lacedaemonian Othryades. The Argives assumed that they had won and went home; Othryades plundered the Argive dead, and stayed where he was. At dawn the following day, both sides claimed victory, their entire contingents engaged, and in a highly attritional battle the Lacedaemonians prevailed, leaving the Argives psychologically scarred for generations: their men

THE HARVEST OF WAR

stopped wearing their hair long, and their women were forbidden from wearing gold jewellery. For their part, the Spartans started to wear their hair long, and Othryades took his own life in shame for having outlived his fallen comrades.[106] The Battle of the Champions left Sparta at the head of a loose confederacy of all the Peloponnesian states, with the exceptions of Achaea and Argos. The confederacy is known to modern scholars as the Peloponnesian League, but in antiquity as 'The Lacedaemonians and their Allies'. Sparta's allies were obliged to follow them wherever they might lead.[107]

These events started to build up Sparta's reputation across and outside the Greek world. King Croesus of Lydia sought their help in his struggle against Cyrus II of Persia, help which they promised but failed to deliver, losing an enormous bronze mixing bowl which was supposed to be a gift for the king in the process;[108] Pharaoh Ahmose II sent them a stupendous linen breastplate, decorated with woven figures and embroidered with gold and cotton, but they never reciprocated with any direct practical help;[109] and the Ionians and Aeolians also appealed to them for aid against the Persian menace, but their over-wordy embassy was rebuffed. The Spartans did send a solitary ship to conduct reconnaissance, but when the expedition leader went to Sardis to tell Cyrus to keep his hands off Greece or risk having to deal with the Spartans, the bemused Persian king simply asked, 'Who are the Spartans?'[110]

Lacedaemonian interest in the eastern Aegean continued into the reign of Cambyses II. This involved supporting an aristocratic faction who had been expelled from Samos by their tyrant Polycrates. Typically for eastern Greeks, the Samian ambassadors initially spoke at far too great a length for the

114

tight-lipped Spartans with their short attention spans, so they tried a different tactic. They just brought in a sack and said, 'This sack needs barley-meal.' The Spartans replied that there was no need to say 'this sack', but gave them the help they desired.[111] They owed the Samians a debt of gratitude for helping them in one of their wars against the Messenians, but also wanted to avenge the loss of the mixing bowl which they had been taking to Croesus, and the theft of Amasis's breastplate, both of which were attributed to pro-Polycrates Samians.[112] They were joined by the Corinthians, who also had a grudge against the Samians for giving refuge to 300 noble-born Corcyraean boys who were being sent to King Alyattes of Lydia by the Corinthian tyrant Periander, to be made into eunuchs in retaliation for the murder of his son.[113] The Spartans landed on the island and laid siege to Samos city, but their attempts to storm the walls failed and after forty days they went home. Herodotus notes that this was the first time that any Dorians had launched an expedition against Asia, even though Samos is technically not in Asia.[114]

In c. 520, about five years after the Spartan intervention on Samos, one of Sparta's most influential kings ascended to the Agiad throne. He was Cleomenes I son of Anaxandridas II. Anaxandridas's first wife was his own sister's daughter, and although he loved her dearly, she was childless.[115] This was a worry to the ephors, who told him to divorce her and marry someone else. The king dug his heels in: he liked her too much; she was completely blameless; and he would not do it. The issue escalated. The Council of Elders was convened and a compromise was proposed: Anaxandridas could keep his wife, but he had to marry a second one and have children with her. Our sources do not record how the first wife felt about this, or

indeed what her name was, but her husband agreed and 'inhabited two separate hearths',[116] despite the fact that this was un-Spartiate and illegal. The new wife, also not named, soon bore Cleomenes, who became the heir apparent. Anaxandridas's first wife then gave birth to three sons: Doreius, who died leading an expedition in Sicily; Leonidas, who would later lead the 300 Spartans at Thermopylae; and Cleombrotus, who ruled as regent after Leonidas's death.[117]

As king, Cleomenes acquired a very negative reputation. Herodotus records that 'Cleomenes, it is said, was not of sound mind, but the exact opposite: he was on the verge of being a lunatic.'[118] Yet he was a regular recipient of appeals for help from foreign powers. In 519,[119] as he was conducting military operations in central Greece, the people of Plataea on the northern slopes of Mt Cithaeron in Boeotia sought his help in their conflict with Thebes, offering total subservience to Sparta if this was forthcoming. Cleomenes' reply was a classic example of Spartan wily disingenuousness:

> We live too far away, and any help we could offer would only
> be cold comfort to you. In fact, you might have been enslaved
> multiple times before any of us heard about it! We suggest
> that you entrust yourselves to the Athenians. They are your
> neighbours, and they are not bad at giving help.[120]

Cleomenes' advice was not given out of goodwill towards the Plataeans, but to make trouble for the Athenians and their tyrant Hippias, by getting them embroiled in hostilities with Thebes. The Plataeans took his advice, and a generation later the state of Spartan–Athenian–Theban–Plataean relations would be crucial to the Greek resistance to Persia.

Samos also reappeared on Sparta's radar around 515, in the aftermath of the grisly death of its tyrant Polycrates in 522. The Persian satrap Oroetes had played on Polycrates' avarice, lured him to the city of Magnesia, had him killed in an 'unspeakable' way, and impaled his lifeless body.[121] Civil disorder broke out on Samos, and when the Persians intervened to instal Polycrates' brother Syloson as tyrant a prominent Samian refugee called Maeandrius made his way to Sparta, taking a considerable number of gold and silver drinking vessels with him with which he tried to bribe Cleomenes. But reinstating Maeandrius would embroil Sparta in conflict with Darius's Persia, and that was not a scenario that Cleomenes was prepared to countenance.

Cleomenes also (again allegedly[122]) received an embassy from some Scythians a couple of years after Darius's invasion of their territory. The Scythians proposed a massive, combined counter-attack, and although Cleomenes rejected the proposal he spent rather too much time with the envoys, who plied him with unmixed wine. Spartans were noted for their moderate consumption of wine, and indeed they used to force Helots to get paralytically drunk and make them perform degrading songs and dances for the young Spartans to inspire their disgust of both Helots and alcohol.[123] Drinking undiluted wine was a sure sign of barbarism, and we are told that this transgressive behaviour caused irreparable damage to Cleomenes' mental health.[124]

A third attempt to drag the Spartan king into hostilities with Persia came in the winter of 499/498 when Aristagoras son of Molpagoras arrived from Miletus seeking aid for a rebellion against Darius. He showed Cleomenes a wondrous bronze tablet with a detailed map of the world engraved on it, and

made a flattering, emotional, though not overly deferential, appeal to the Spartans to liberate the Ionians from Persian slavery. This would be easy, he said:

> the barbarians are spineless, you are pre-eminent in war; they fight with bows (how unmanly!) and short spears; and they go into combat wearing weird and theatrical trousers (how effeminate!) and tall pointy caps! They live in a land of precious metals, fine clothing, rich livestock, and copious slaves, which are all there for the taking. Check out this map! Why fight insignificant local wars when you can have all of this?

Cleomenes' deadpan reply was, 'I'll give you my answer on the third day.'[125]

When the day came, Cleomenes asked how far it was from the sea to Darius's residence. Aristagoras made the mistake of telling the truth: it would take three months. Cleomenes immediately terminated the interview, and told Aristagoras to leave Sparta before sunset. The Milesian, however, was persistent. He adopted the role of a suppliant, and followed Cleomenes home. The king's eight- or nine-year-old daughter Gorgo listened in on the conversation, in which Aristagoras offered her father ever-increasing bribes, until she couldn't contain herself any longer: 'Daddy, the stranger will corrupt you if you don't keep away from him and leave!'[126] Cleomenes took Gorgo's advice.

Aristagoras departed and tried his luck at Athens. There he rehashed the arguments he had deployed at Sparta. Herodotus comments that 'it seems that it is easier to fool a lot of people than one individual',[127] and where Aristagoras had failed face to

face with one man (plus his daughter), he succeeded with 30,000 Athenian democrats. They voted to send twenty ships to help his cause. In Homer's *Iliad* the ships with which Paris had abducted Spartan Helen were described as 'the starters of troubles',[128] and so it was again with the Athenian vessels: 'These ships were the start of troubles for Greeks and barbarians.'[129]

CHAPTER 5

The Ionian Revolt

Master, remember the Athenians!

Slave of Darius[1]

Trouble-starting Ships and the Eastern Greeks

Trouble-starting ships have a long backstory in ancient Greece. Piracy has been a fact of Mediterranean life for as long as we can trace, and the English word 'pirate' is derived from the Greek *peirates* (= 'a person who makes attacks by sea').[2] And it is with a number of acts of piracy that Herodotus, the 'Father of History',[3] begins his *Researches* into the Persian Wars. He tells us that Persian scholars thought that the Phoenicians started it all. They sailed on a trading mission to Argos, from where they abducted Io, the daughter of Inachus, and sailed away to Egypt.[4] The Phoenicians saw it differently: in their version Io had sex with the ship's captain, got pregnant, and sailed away of her own accord because she couldn't face her parents. But if Io's abduction was the 'original sin', it was compounded by certain unspecified Greeks who landed in Phoenicia and abducted Europa, daughter of King Agenor of

Sidon. With the balance of transgression equal, the Greeks now perpetrated a second wrong by sailing into the Black Sea and carrying off King Aietes of Colchis's daughter Medea. His demands for justice were met with the assertion that since the Greeks had been denied reparations for the abduction of Io, they would not return Medea.[5] Two generations later the Trojan Paris heard about this and decided to pillage a wife for himself from Greece. So he went to Sparta, abducted Helen, and met the Greek requests for her return with whataboutism and accusations of hypocrisy.[6]

Up until this point, Herodotus says, it had been 'only rape' on both sides.[7] But the Greek attack on Troy was regarded by the Persians as an unjustified escalation of the aggression:

> We think that raping women is the action of unjust men. However, we also think that the desire to avenge the rape-victims is stupid. Wise men have no concern for raped women. Obviously, they wouldn't have been raped if they didn't want to be. We Persians say that the people of Asia do not think the rape of women is a big deal, but, merely for the sake of a Lacedaemonian woman, the Greeks assembled a huge expeditionary force, came into Asia, and smashed the power of Priam.[8]

Bronze Age/mythical Troy had practically nothing to do with the Persians of Herodotus's time. The traditional date of the Trojan War[9] long pre-dates the Persians' domination of that part of the world, but in the fifth century they regarded all of Asia, Troy included, as their territory, and so for them the destruction of the city generated their righteous feud with the Greeks. Herodotus remains agnostic about the truth of the

different tales, although he also speaks of a person that he knows did 'unprovoked wrong to the Greeks'.[10] This was King Croesus of Lydia, who had brought the Greeks of the Asia Minor coast under Lydian control prior to his defeat by Cyrus the Great in 546, after which they came under Persian domination. That was the context in which Aristagoras had made his journey to Sparta with his map, and then to Athens, unleashing the 'trouble-making ships'.

Underlying and Immediate Causes

In around 500 BCE an economic crisis threatened Ionia. Her pottery was being replaced by Corinthian ware in Egypt and by Athenian ware in the Black Sea areas. Her not-inconsiderable trade with the west had been severely curtailed by military defeats in south Italy and the activities of Carthage and the Etruscans. All this came to be blamed on Persia, and it led to a revolt against rulers who were totally unprepared.

Herodotus also implies that internal disputes among the leading Greek political figures in a number of cities served to focus the discontent on the nature of their government. Persian control was the most obvious aspect of that administration, and the tribute and taxes that they paid were not put back into local circulation. The cities were, for the most part, ruled by Persian-backed tyrants, and the idea of subjection to a Barbarian monarch was deeply unfashionable. Aristagoras certainly could not have stirred up a rebellion of disunited Greek communities if they had not been unhappy with their situation.

However, whatever the underlying causes for the Ionian Revolt might have been, Herodotus sees it as an impulsive fling led by a couple of adventurers. While the Persian forces were

still withdrawing back across the Hellespont from their oper-
ations in Scythia, Histiaeus of Miletus was busy fortifying
Myrcinus by the River Strymon (modern Strymonas, Greece),
which Darius had given him as his reward for guarding the
bridge. This made Megabazus, Darius's commander in Europe,
uneasy. Once he was back in Sardis he asked Darius what on
earth he thought he was doing, allowing a dangerous and highly
intelligent Greek to build a city in an area where there were
forests to supply shipbuilding materials, rich silver mines and
an easily manipulated local population. He suggested that the
Great King should take Histiaeus to Sardis, and make sure he
never went back to Greece. Darius agreed and sent Histiaeus a
message telling him that because he had shown himself to be
such a reliable friend, he should come to Sardis, because the
king had great plans for him. Proud and pleased, Histiaeus did
as he was asked, and amid extravagant flattery Darius made
him an offer he couldn't refuse: 'Forget Miletus and your newly
founded city in Thrace, and follow me to Susa, where all that is
mine will be yours, and you will be my dining companion and
advisor.'[11] This was a high honour in the Achaemenid world,[12]
and it was exactly what Histiaeus wanted, even if he should
have been careful what he wished for.

With the decision made, Darius appointed his paternal half-
brother Artaphernes as governor of Sardis and headed for Susa
with Histiaeus. We have some knowledge of Artaphernes'
routine administrative duties from two Persepolis Fortification
Tablets that record official journeys from Sardis. These detail
the travel rations that formed part of Persia's sophisticated
system of transport and communication, which involved elite
guides, caravan leaders, messengers, fast messengers and passen-
gers. These travellers were moving to and from India, Kandahar,

Bactria, Arachosia, Areia, Kerman, Egypt, Babylon and Sardis, which was at the westernmost end of the Royal Road.[13] The tablets were written at the supply station and sent to Persepolis, where the items were credited to the supplier's account and debited from the account of the official who had provided the travellers with a *halmi* (sealed document). The authorising official could be some distance from Persepolis, as was the case with Artaphernes:

> 65 BAR (of) flour Dauma received.
> 23 men (received) each 1½ QA.
> 12 boys received each 1 QA.
> He carried a sealed document of Artaphernes.
> They went forth from Sardis.
> They went to Persepolis.
> Ninth month, 27th year [of Darius's reign, i.e. late 495].
> [At the stopping place of] Hidali.[14]

> 1.7 [BAR of] flour Dadumanya received, and 8 gentlemen received each 1½ QA, 5 boys received each 1 QA.
> He carried a sealed document of Artaphernes. They went to the king.
> Ninth month.[15]

Even the mighty Persian satraps were not exempt from the demands of routine bureaucracy.

Before Darius left, he also made Otanes[16] 'General of the Coastal Men', possibly as a counterweight to Artaphernes, although the precariousness of Otanes' own situation was made abundantly clear. Otanes' father had been one of King Cambyses II's royal judges, but had had his throat cut for taking bribes

and giving an unjust decision. He was flayed, and then his skin was cut up into human-leather strips and used to 'string' the throne from which he had given his judgements. Otanes now occupied that seat. Mutilation and disfigurement were common penalties for Persian officials who abused their office, and doubtless with that in mind Otanes took over from Megabazus, and swiftly captured a range of cities in the Hellespontine area, from Byzantium to Lemnos (modern Limnos in Greece).[17]

At this point, Herodotus tells us, trouble started to afflict the Ionians. This came out of Naxos, the wealthiest island in the Aegean region, and Miletus, 'the ornament of Ionia'.[18] Civil strife at Naxos led to some 'fat cats'[19] being driven out by the ordinary people. They went to Miletus, where the governor, acting as deputy for his father-in-law and uncle Histiaeus, was Aristagoras son of Molpagoras. The Naxians had been guest-friends of Histiaeus, who was now at Susa, and they asked Aristagoras to give them some military assistance to enable them to return. He saw this as an opportunity to take over Naxos for himself, so he made them a proposal:

> I don't have the capability to do this personally, because your opponents on Naxos are too powerful. But I do have a plan. Darius's brother Artaphernes is a friend of mine. He is the overlord of all the maritime peoples of Asia, and he commands a powerful army and a strong navy. I'll get him to do it.[20]

The Naxians liked the idea, and offered to meet the costs of whatever bribes and military resources might be necessary. The possibility of the other Cycladic islands becoming part of this project also seems to have been in the air.

Aristagoras went to Sardis and told Artaphernes that Naxos was an island 'of no great size' (it is in fact the largest of the Cyclades), that it was 'beautiful and good', that it was close to Ionia (it isn't really) and had an abundance of wealth and slaves. He urged the satrap to send in the military and restore the exiles, adding that he had the money to finance the operations, plus a bit extra for Artaphernes, of course. Naxos, and the rest of the Cyclades would fall under Persian control, and after that they could move on to the island of Euboea, which he described as being 'large, prosperous, no smaller than Cyprus [it is only about one-third of the size[21]], and really easy to take',[22] adding that 100 ships should be enough for the job. Artaphernes liked the plan, although he said they would need twice as many ships and Darius's consent. Herodotus says that Aristagoras was 'over-delighted' by the outcome;[23] Artaphernes duly contacted Darius at Susa; Darius gave his assent; 200 triremes were kitted out, supported by a large contingent of Persian and allied troops; Megabates, a cousin of both Artaphernes and Darius, was put in command; and the expeditionary force was dispatched to Aristagoras.

Megabates' Persians joined forces with Aristagoras's Ionians and the Naxians in around 501 BCE. However, when they anchored off Chios, intending to sail due south to Naxos, things went badly wrong. Megabates was checking the ships' sentries, and discovered that one of the Myndian[24] vessels had nobody on watch. The Persian commander regarded this as a serious security breach, so he ordered his guards to seize the captain, Skylax ('Sea-dog'), and bind him in such a way that his head was sticking out of one of the ship's oar holes. Aristagoras was outraged: Skylax was his guest-friend, and he would not tolerate such degrading — and to Greek sensibilities typically

Persian – treatment. But when his appeals to Megabates fell on deaf ears, he released Skylax himself. Unsurprisingly Megabates resented this undermining of his authority, and Aristagoras's cocky words to him did not help his mood: 'What has any of this got to do with you? Didn't Artaphernes send you to obey me? To sail wherever I order you? Why are you interfering?'[25] Megabates completely lost his temper, to the point that he betrayed the expedition by sending a boat on a secret night-time journey to Naxos to inform the islanders about the impending attack, of which they had been completely unaware. Forewarned, the people of Naxos forearmed themselves, and successfully withstood the ensuing siege for four months. The Persians ran out of money, and so did Aristagoras. So, the invaders constructed a fortress for the Naxian fat cats and headed back to Persian territory. The whole expedition had been an abject failure.

Aristagoras began to fear for his own position. He was in deep financial difficulties, and was in danger of being 'robbed' of what he regarded as his 'kingship' of Miletus,[26] even though he was merely Histiaeus's 'deputy governor'. So, with that in mind, he planned to increase the stakes and revolt against Darius. The trigger for this was the famous 'Man with the Tattooed Head', who now arrived in Miletus.[27]

Herodotus's readers all seem to have known the story, but it was too entertaining for him not tell anyway.[28] The man had been sent by Histiaeus, who by now was sick of staying at Susa, but thought that if there was an insurrection on the coast, he would be the man sent to deal with it. So, in order to get the message past the guards on the road, he had taken his most trusted slave, shaved his head, tattooed a message on his scalp, waited for his hair to grow back, and sent him to Aristagoras at

Miletus with instructions to say just one thing: 'Shave my hair and examine my scalp.' The bizarre text message on his head simply said, 'Revolt'. Aristagoras decided to go for it.

The initial plan was that one of the rebels would sail to Myous, about 15 km north-east of Miletus, where the expeditionary force had stopped after it had left Naxos, and try to arrest its commanders, who were still on the ships. The job was given to a man called Iatragoras, who successfully tricked and seized the commanders, at which point Aristagoras came into the open about his revolt, focusing completely on damaging Darius. His first move was to pretend to give up his own tyranny and to proclaim *isonomia* in Miletus and throughout Ionia. He forced some of the Persian-backed tyrants into exile and handed the ones who had sailed against Naxos with him back to their cities of origin in order to win those cities' support. The Lesbians stoned their ruler Koes to death, but others let theirs go. With the various tyrannies now being toppled across the region, Aristagoras urged the cities to instal military commanders, before embarking for mainland Greece to garner support. His mission to King Cleomenes at Sparta was an abject failure, but Athens and Eretria agreed to send those notorious ships that 'were the start of troubles for Greeks and barbarians'.[29]

The Troubles Start

Mission semi-accomplished in Greece, Aristagoras sailed back to Miletus. Once the Athenians arrived with their twenty ships of unspecified type, but probably not all triremes, along with the five Eretrian ships, which definitely were triremes, he planned an attack on Sardis. He himself stayed at Miletus, but appointed two Milesians, his own brother Charopinus, along

with Hermophantus, to lead the assault. The Ionian battle group moved to Ephesus, and then marched inland, using Ephesian guides. They followed the River Caÿster,[30] possibly casting themselves in the role of Homer's Greeks invading Asia in a kind of Trojan War II, remembering verses they would have learned as children:

And like the many tribes of winged birds,
Of geese or cranes or long-necked swans
In the Asian water-meadow by the Caÿstrian streams
Wheel hither and thither, exulting in the glory of their
 wings,
And settle with clanging cries, and the meadow echoes,
So their many tribes issued from their ships and huts
[. . .] and the earth
Resounded fearfully beneath the feet of men and horses.
And they stood in the flowery meadow [. . .],
In their thousands, like leaves and flowers appear in their
 season.[31]

Morale was doubtless high as they as they crossed the Tmolus mountain ridge to their north (modern Boz Dağ), descended on Sardis.

The Greeks easily took the entire lower city, but not the acropolis, which was robustly defended by Artaphernes. Most of the houses in Sardis were made of reeds, and the Greeks accidently set one of them alight. The fire became an inferno that spread right across the city, trapping the Lydians and Persians on the acropolis, and possibly leaving a layer of carbonised material that is still visible in the archaeological remains.[32] But the Greeks shied away from a serious fight, left the city,

and retraced their steps back to their ships. The Persians doubt-
less regarded the burning of Sardis as an outrageous act of
unprovoked aggression, but the situation was made immeasur-
ably worse by the fact that a major religious site was destroyed
in the fire.[33] This was the temple of the ancient Anatolian
goddess Cybebe (aka Cubaba) who was often seen as the equiv-
alent of the Phrygian Cybele or the Great Mother. When Xerxes
subsequently torched the temples on the Athenian Acropolis in
480, he would be 'burning them in return',[34] but for now the
Persians mustered their local forces, followed the retreating
Greeks to Ephesus, and inflicted a very heavy defeat on them.
The survivors made their way back to their home cities, and
nothing that Aristagoras said could persuade the Athenians to
rejoin the Ionian cause.

Darius's reaction to the events at Sardis was one of confi-
dence that the Ionians could be brought to heel, and mock
bemusement as to the identity of the Athenians. In a neat echo
of Cyrus's 'Who are the Spartans?'[35] he pretended never to have
heard of them. Of course, he knew exactly who the Athenians
were, but once he had been given the information anyway he
asked for his bow, shot an arrow skywards, and prayed:

> 'O Zeus [Ahura Mazda], may it be allowed for me to exact
> vengeance on the Athenians,' and once he had made his
> request he instructed one of his servants to say three times,
> whenever his dinner was being put in front of him, 'Master,
> remember the Athenians.'[36]

After what became famous as 'the things involving the
bow',[37] the king also wanted words with Histiaeus. He effec-
tively told him,

I've found out that Aristagoras, who *you* put in charge of Miletus, has been conducting a rebellion against me. He's persuaded men from the other continent to come over and join the Ionians – I'm going to punish them severely, by the way! – and he's deprived me of Sardis. Do you think that's a good thing? And how could it have happened if you weren't involved in it somehow? You need to be really careful right now, in case you get the blame for it![38]

Histiaeus acted all innocent. He asked how Darius could say such a thing. He would never plot against the Great King, he protested: he had no motive; he had everything he could ever want; if Aristagoras was behaving like that, he was doing it on his own initiative; the story sounded like fake news, but if it was true, it just went to show how valuable Histiaeus was to the Ionian coastal region; if only he'd been there all along, none of this would have happened; so Darius should send him back as soon as possible to put things right and capture Aristagoras. Histiaeus ended his speech with a bizarre promise not to take off the tunic that he would wear in Ionia until he had made Sardinia, which he said was the biggest island in the world, pay tribute to Darius. The king was completely taken in by Histiaeus's deceit and let him go, telling him to come back to Susa once he had fulfilled his promises.

Meanwhile the revolt was spreading exponentially: the Ionians sailed into the Hellespont and as far as Byzantium, which they subjugated along with numerous other cities of that region;[39] coming back out of the Hellespont they moved southwards into Caria, most of which joined them;[40] and the rebellion also infected Persian-controlled Cyprus, where Gorgus, the king of the Salamis in eastern Cyprus (not to be confused

with the island close to Athens where the decisive naval battle would be fought almost a decade later), had a younger brother called Onesilus, who had been nagging him to revolt for some time. However, Gorgus remained unmoved, so Onesilus waited for his brother to leave the city, and then shut the gates against him. Gorgus did what the losers in domestic civil strife in the region often did, and 'fled to the Medes',[41] while Onesilus, now king of Salamis, persuaded all the Cypriots, apart from King Rhoecus of Amathus (about 10 km east of modern Limassol), to join him in revolt.

Onesilus besieged Amathus;[42] the Ionians sent an army to help the Cypriot rebels; and the Persians despatched their own land forces and a Phoenician fleet to the island. Darius's response could well have resembled the order he had issued early in his reign as recorded on an inscription of Bisitun: 'Go! This rebellious army, which does not call itself mine, smite it!'[43] The Persians, commanded by Artybius (= 'Eagle'),[44] crossed from their bases in Cilicia and bore down on Salamis, while the Phoenicians approached round the north-east tip of the island. The Cypriot leaders, still 'tyrants' despite their desire to throw off the Persian yoke, offered the Ionians a choice: fight the Persians on land, while we confront the Phoenicians at sea; or vice versa. The Ionians chose the seaborne option.

The land forces deployed for battle on the plain of Salamis. The Cypriots were equipped like standard Greek hoplites,[45] but with distinctive headgear – turbans for the kings, felt caps for the rank-and-file – whereas the Persians deployed their formid-able archers and cavalry. In fact,[46] Artybius had a specially trained steed that would rear up against a hoplite opponent, and then kick and bite him to death. However, Onesilus had heard about this, so he asked his squire for some advice. The

man felt it was appropriate for the two generals to fight hand-to-hand, and when it came to the horse, he had a plan. Artybius charged towards Onesilus; Onesilus struck out at Artybius; the horse brought its hooves down on Onesilus's shield; and his squire chopped its feet off with his scimitar.[47] That was the end of Artybius and his horse.

Elsewhere on the field, the tyrant of Curium (near modern Episkopi) turned traitor along with his contingent; the Salaminian war-chariots did likewise; the Persians gained the upper hand; carnage ensued; and Onesilus was among the numerous Cypriot dead. The people of Amathus cut off his head and took it back to their city, where they displayed it over their gates for his arrogance in daring to besiege them.[48] In the fighting at sea the Ionians got the better of the Phoenicians, but when news came of the outcome of the land battle, and that all the cities of Cyprus were under siege apart from Salamis, which had been restored to Onesilus's brother Gorgus by its inhabitants, they sailed away to Ionia.

There are not many literary references to the sieges on Cyprus, although at Idalion (Dali, near Nicosia), where the 'Medes and Citians' forced King Stasicyprus to surrender on terms, a bronze tablet was found, promising substantial rewards to a family of doctors who were brought in to treat the wounded 'without payment'.[49] However, the violent details of the siege at Paphos have been vividly brought to light by archaeology. Here, the Persians were confronted with a deep V-shaped ditch cut into the rock, behind which was a stone-faced, mud-brick wall with towers and a gateway. Siege artillery in the form of either torsion or non-torsion catapults would not be developed for at least another century, so the Persians attacked the area in front of the walls, between the gate and the nearest tower, using

a vast siege mound. Tactics such as this had been borrowed by the Persians from the Assyrians: they can be seen on the Assyrian palace reliefs of Sennacherib, depicting the siege of Lachish in Palestine in 701,[50] and by now they were standard procedure. The mound was inexorably pushed into and across the ditch, and up to the wall, and the progress of the fighting can be seen from the finds of 229 three-bladed bronze arrowheads, mainly in the corner between the wall and the gate. These are of a standardised pattern that would also be used at Thermopylae, so they were probably the missiles of professional archers, providing covering fire throughout the operation.[51] Hurled against the attackers were at least 253 crudely made four-sided javelin points, aimed by more amateurish defenders from the wall. A bronze Corinthian-type hoplite helmet was found, along with some 464 roughly shaped limestone projectiles, varying between 2.7 and 21.8 kg, which were scattered at the base of the wall, thrown down to crush the attackers.

The ramp-builders used a large number of limestone statues and architectural ornaments, which they pillaged from a nearby sanctuary and pushed into the ditch. The ramp grew to a height of at least 7.5 m, almost level with the battlements, and the attackers were able to bring forward their wooden siege towers, which had battering rams in the lower storey and archery platforms on top. The Cypriots, some of whom may have been expert miners, given the abundant copper resources that were extracted from the island, responded by digging three tunnels underneath the city wall to arrest the Persians' progress.[52] The tunnels were supported with timber and mud-brick piers, and at the end of each sap was a massive bronze cauldron, filled with flammable material. When these were ignited the intense heat turned many cubic metres of the mound to lime dust and

blackened stone. The archaeology cannot tell us whether the countermines destroyed the siege towers, but it does show that the Persian fighters made it across to the gateway, where they forced open and burnt the wooden doors.[53] So Paphos fell.[54]

Persian Backlash; Persian Victory

The Cypriots had enjoyed 'freedom' lasting one year; now they were 'enslaved' again.[55] On the mainland, Darius's sons-in-law Daurises, Hymaees and Otanes-of-the-human-skin-throne[56] each led an army in a counteroffensive, probably starting in 497. They began by pursuing the Ionians who had marched on Sardis, drove them to their ships, divided the cities among themselves, and sacked them. But then they received intelligence that the Carians had joined the revolt. This was a very serious development, so Daurises immediately diverted his forces to confront that threat. When the Carians got advance warning that Daurises was on his way they assembled at the 'White Pillars' by a tributary of the River Maeander called the Marsyas.[57] They decided to make the Persians cross the Maeander, hoping they could be slaughtered in the water once they had been defeated. But the Carian confidence was misplaced: the Persians incurred 2,000 casualties, but the Carians suffered five times as many.[58] The fugitives took refuge in the remote sacred grove of plane trees in the precinct of Zeus of Armies at Labraunda in the mountains north of Mylasa and were weighing up their options when the Milesians and their allies arrived. With even greater misplaced confidence they renewed the fighting, and suffered an even greater second defeat.[59] Even so, the Carians renewed the struggle for a third time. They laid an ambush in awkward terrain on a mountain

road in Milesian territory;[60] the Persians walked into the trap at night and were annihilated, with the loss of their commanders, Amorges, Sisimaces and Daurises included.[61]

The chaos that he had unleashed had now become more than the spineless Aristagoras could take. Despite the Carians' success, the prospect of defeating Darius seemed remote. Aristagoras discussed his options with his henchmen, entrusted Miletus to a well-regarded citizen called Pythagoras, sailed to Thrace with any volunteers that would follow him, and took over the fortified stronghold of Myrcinus, which Darius had gifted to Histiaeus.[62] But he and his army were wiped out by the local Thracians.[63] It was a pointless death, suffered as he was laying siege to a local town, despite the fact that the Thracians had been perfectly happy to leave it under a truce.

While Aristagoras was breathing his last in Thrace, Histiaeus was arriving in Sardis following his release by Darius.[64] There Artaphernes asked him why he thought the Ionians had rebelled. 'I don't know,' was Histiaeus's response, 'I'm really surprised. And actually, I don't know anything about it anyway.' But Artaphernes was not as gullible as Darius. He told Histiaeus exactly what he thought: 'You stitched this sandal; Aristagoras just put it on.'[65] Histiaeus was terrified. He knew this was a reference to the cause of revolt, so he fled over to Chios. From there he then sent a man called Hermippus with letters to some Persians at Sardis with whom he had already held discussions about revolt,[66] but unfortunately for him the messenger gave the letters directly to Artaphernes instead. The satrap's response was appropriately devious: he told Hermippus to deliver the letters to their intended recipients, and give him the return letters that were intended for Histiaeus. Favourable replies to Histiaeus meant death for their Persian authors.

Thwarted at Sardis, Histiaeus asked the Chians to take him to Miletus. But the Milesians had got rid on one tyrant, Aristagoras, already, and had no desire to be ruled by another. Histiaeus tried to enter the city by force at night, but ended up wounded in the thigh. He went back to Chios, but when the Chians refused to provide him with ships he crossed over to Mytilene, where he had better luck with the Lesbians. They manned eight triremes, sailed north with him to Byzantium, established a base, and started to perpetrate acts of piracy against the shipping sailing out of the Black Sea.

Back in Miletus there was worry that the Persians would send a massive fleet and army against them. And so there should have been, as we can see from the Persepolis Fortification Tablets:

> 7 *marriš* (of) beer Datiya received as rations.
> He carried a sealed document of the King.
> He went forth from Sardis [via] express [service], went to
> the King [at] Persepolis.
> Eleventh month, 27th year [i.e. between 17 January and 15
> February 494].
> [At the stopping place of] Hidali.[67]

Datiya is Datis,[68] who would later command the Persian troops at Marathon. His ration of about 70 litres of beer indicates his status rather than his personal drinking habits, and we can see that he has been travelling with official documentation on the road from Sardis to Persepolis, where he has almost arrived, courtesy of the 'express service'. The date of the journey in early 494 indicates that Datiya was involved in the final preparations for the Persian offensive that the Milesians feared.

The Persian attack was sharply focused. Their land generals joined forces and concentrated primarily on Miletus, while their fleet, comprising the Phoenicians, who were always a crucial part of the Persian navy and were very much up for the fight, plus the Cilicians, Egyptians and recently subdued Cypriots, approached from the south. The Cypriots would have been equipped in the Greek style, but with tunics and their distinctive felt caps;[69] the Egyptians wore 'plaited' helmets, possibly of woven leather, and body armour, and carried convex shields with broad rims, spears for sea warfare, battle-axes and long swords; the Cilicians wore woollen tunics and 'the helmets of their country', which Herodotus does not describe, and armed themselves with shields of raw ox hide, two javelins and a scimitar-style sword like the one with which Onesilus's squire had maimed Artybius's horse;[70] the Phoenicians wore linen body armour and used helmets in the Greek style, and fought with rimless shields and javelins.[71]

It is possible that the naval contingents were delayed at Lindos on Rhodes as they approached.[72] Evidence for this comes from the Lindian Chronicle, an inscription erected by the Lindians in 99 BCE, cataloguing divine epiphanies, and the dedications made in the Temple of Athena, including one which occurred in the Persian Wars:[73]

Epiphanies
When King Darius of Persia sent a mighty force to enslave Greece, his naval expedition approached Rhodes, because this was the first island on the itinerary. The inhabitants were terrified by the arrival of the Persians, and sought refuge together in fortified locations, with most of them gathering at Lindos. The barbarians laid siege to them there, until the

Lindians were on the point of dying of thirst and were think-
ing about surrendering the city to the enemy. At that point
the goddess appeared to one of the magistrates in a dream,
and told him to stay confident, because she would ask her
father [Zeus the Rain-god] to provide water for them. The
magistrate related his vision [. . .] to the citizens. They calcu-
lated that they only had five days' supply, and asked the
barbarians for a truce, saying that Athena was going to send
her father to their aid, but if help should not arrive within
the specified time, they would surrender the city to them.
Darius's admiral Datis burst out laughing when he heard
this, but on the very next day an enormous cloud appeared
over the acropolis and poured with rain in such a way that,
remarkably, the besieged had plenty of water, but the Persian
army did not get any. The barbarian was terrified by this
divine epiphany, and took off his clothes and sent his cloak,
chain-mail shirt, bracelets, *tiara*, *akinakes*, and even his char-
iot, as an offering [. . .] Datis abandoned the operation,
established friendly relations with the besieged, and declared
that the goddess had looked after these people.[74]

The list of offerings on the inscription also mentions some
quintessentially Persian dedications – presumably the same
ones as in the epiphany story – by a 'General of the Persian
King', whose name is illegible, but who must be Datis: 'Earrings;
chain-mail shirt; *tiara*; bracelets; *akinakes*; trousers.'[75]

With the jewellery-laden Persian generals bearing down on
Miletus, the Ionians went into a conclave in their communal
meeting place at the Panionium on Mt Mycale. They decided
not to challenge the Persians with land forces, but to leave the
Milesians to defend their walls, and commit everything to a

battle at sea. Every last ship would be manned, and the armada would muster at the small island of Lade, just off Miletus, from where they could cover the seaward approaches to the city and keep its supply lines open.[76]

The Ionian/Aeolian battle line-up was impressive: Miletus, on the eastern wing with 80 ships; next to them 12 vessels from Priene, and 3 from Myus; then Teos (17); Chios (100); next in line was Erythrae with 8, Phocaea with 3, and beside them Lesbos with 70; the ships of Samos held the western wing with 60. Grand total: 353 triremes. At roughly 200 crew members per vessel, the rebels were committing around 70,000 men to the fight.[77]

Without elaborating further, Herodotus say that 'the number of barbarian ships was 600'.[78] We should be suspicious about this, even if 'ships' does not mean exclusively triremes: it is a generic number that appears regularly in Persian contexts.[79] In any case, they tried political machinations first. This was not unusual: the Persians always thought it was far better to trick or terrify their enemies into submission without fighting if they could. They gathered the Ionian tyrants who had been expelled by Aristagoras, and told them that now was the time to show their loyalty: try to detach your fellow countrymen from the rebel alliance, they urged; promise them that their shrines and personal property will not be burnt; they will be treated no more repressively than they were before; but if they resist . . . 'Once they have been defeated in battle they will be enslaved. We will castrate their sons as eunuchs, drag their virgin daughters off into captivity in Bactria, and give their land to others.'[80] The tyrants delivered their messages, but Herodotus says the Ionian commanders were 'stupidly stubborn, and so did not succumb to this treachery'.[81]

The Ionian stubbornness was articulated by the Phocaean commander Dionysius, who addressed one of their assemblies at Lade. He opened his speech with words that quoted Nestor in Homer's *Iliad* to emphasise the epic nature of the confrontation:

Ionians! Our situation is balanced on a razor's edge[82] – either to be free or slaves, and runaway slaves at that. So now, if you are prepared to submit to hardships, you will have gruelling work in the short term, but you will be able to overcome your enemies and be free; but if you are soft and disorganised, like you usually are, I hold out no hope of you not being punished by the King for this revolt.[83]

The Ionians were suitably inspired, and they put themselves under Dionysius's command, despite that fact that he only had three ships with him. He immediately instituted a rigorous training regime.

The preferred naval tactic of a modern, well-trained, fifth-century Greek navy was a complicated manoeuvre called *diekplous* – 'through-and-out-sailing' – which was highly effective against ships sailing line-abreast. A well-crewed trireme was fast and agile, and *diekplous* exploited its superior handling to break through the gap between two vessels in the enemy's line, and then turn sharply to ram one of them amidships or in its stern quarter, with the object of crippling it by holing its hull or shearing off its oars. If the ships employing *diekplous* were operating in line-astern, the disabled enemy vessel would become a sitting duck for the following ship, and once the line break had been made, the enemy was vulnerable to attack from the rear as well. If the enemy countered *diekplous* by reducing the space

between their vessels, they then became vulnerable to outflanking manoeuvres, for which the technical term was *periplous* (= 'around-sailing').

Dionysius drilled the navy in these tactics for a week, but his demands just became too much for the soft and disorganised Ionians. They stopped obeying his orders, put up tents, stayed out of the sun, and refused even to get back on board the ships, never mind do military exercises. The Samian generals were influenced by the Ionian ill-discipline and started to reconsider the Persian invitation to desert that had been relayed to them by Aeaces son of Syloson, who had been deposed as tyrant of Samos by Aristagoras.[84]

Dionysius's training was not entirely wasted, since when the Phoenicians did decide to attack, his fleet engaged in line-astern, ready to employ his *diekplous* tactics. But then everything went horrendously wrong: all but eleven of the Samian ships betrayed the cause by hoisting their sails – normally only oars were used in naval encounters, so using sails made their intentions obvious[85] – and heading for home. The Lesbians followed their lead, as did the majority of the other contingents. The Samians who stayed to fight acquitted themselves honourably, and the Chians also fought heroically, breaking the Persian line and giving as good as they got, although they still suffered the worst casualties on the rebel side. They abandoned their damaged ships on the beach of the Mycale peninsula, and fled overland into Ephesian territory. Tragically, during the night, they came across a group of women celebrating the women-only Thesmophoria festival. The Ephesians took the Chians for bandits, and responded with overwhelming military force.[86]

The rout of the Ionian fleet allowed the Persians to lay siege to Miletus. The Delphic oracle knew what would happen:

And on that day, Miletus, crafty deviser of evil deeds,
You shall serve a banquet and gleaming gifts to many people,
And your wives will wash the feet of many long-haired men;
Others will take care of our temple at Didyma.[87]

The city was taken, and the oracle had come true: although long hair was not a common ethnic signifier of the Persians, and the oracle of Apollo at Didyma was looted and burnt rather than 'cared for', and fell silent for around 160 years,[88] the women and children of Miletus were enslaved. The Milesian POWs were deported to the Persian Gulf; Caria was quickly brought back into submission; and the propertied class on Samos sailed away to Sicily with some Milesian survivors, where they ultimately established themselves at the beautiful city of Zankle (modern Messina).

When the news of the events at Miletus reached Athens, the reaction was one of intense shock and grief. The poet Phrynichus later produced a tragedy called *The Fall of Miletus* which had a shattering effect on its audience: the entire theatre dissolved into floods of tears; and Phrynichus was fined a whopping 1,000 drachmas for reminding them about a disaster that was so close to their hearts. The human cost had been appalling, but on top of that to see the reinstallation of Barbarian-supported tyranny among their Ionian kinsmen was just too much for the Athenian democrats to bear, and the play was banned from ever being staged again.

Endgame

As the revolt which he had helped trigger for his own self-interest was collapsing in Ionia, Histiaeus was still attacking

shipping around Byzantium.[89] On hearing the news he sailed to Chios with his Lesbians. There he destroyed the Chian warships and subdued the shellshocked islanders. The gods had warned of this, Herodotus tells us: the Chians had sent two choruses of fifty boys each to compete in the Pythian Games at Delphi, but they had been smitten by disease, and only two had returned; then, shortly before the sea fight, the roof of a school had fallen in and killed all of the 120 boys inside.[90]

Histiaeus then marshalled a significant force of Ionians and Aeolians to attack Thasos in the northern Aegean, but there he received news that the Phoenicians had put out from Miletus to attack the rest of Ionia. This was not a direct threat to him, but he raised the siege, hurried to Lesbos and crossed over to the mainland opposite, where unfortunately he ran into the Persian general Harpagus. A hard-fought battle ensued, which was decided by a Persian cavalry charge. As he fled, Histiaeus was overtaken by a Persian cavalryman: 'Histiaeus, confident that King Darius would not put him to death for his recent transgression, grabbed at his life because he still loved it [. . .] he cried out in the Persian language and made it known that he was Histiaeus of Miletus.'[91] His linguistic abilities saved him temporarily, and had he made it safely to Darius at Susa he might have survived for longer, but he only got as far as Sardis. Artaphernes and Harpagus clearly regarded him as too dangerous, so they impaled him then and there, before sending his embalmed head to the king. Darius, who is not always depicted as a barbaric monster, made his displeasure with this known, and decreed that Histiaeus's head should be washed and buried with all the proper religious observances. He had, said Darius, done a great deal of good for Persia and its king.

The Ionian Revolt was over, and Aristagoras and Histiaeus were dead. Yet the whole series of events, which made such a deep impression on the Greek psyche, seems to have been ignored in the official Persian propaganda. There are no monuments commemorating the victories 'by the favour of Ahura Mazda', perhaps because the Ionian Revolt was thought of as insignificant or just as a temporary embarrassment. But Darius was still being reminded three times a day to remember the Athenians, and the troubles that the twenty Athenian ships had started in 499 were now about to move out of Asia and into Europe.

CHAPTER 6

The First Interwar Interlude

I want you to invade Greece! I've heard all about the amaz-
ing women there, and I want some Spartan, Argive, Athenian
and Corinthian slave-girls to wait on me.

Queen Atossa, in bed with King Darius I[1]

Miltiades son of Cimon

With the once glittering city of Miletus now a shattered,
smouldering, depopulated wreck, and Ionia falling into
impoverishment and decline, many Ionians, including some
of their leading intellectual lights, abandoned their homelands
for Greece, Italy, Corcyra (modern Corfu), Thrace and else-
where, with Athens in particular benefitting from this inward
migration. The Persians began to mop up any vestigial resist-
ance with ruthless efficiency. In 493 BCE the inhabitants of
Chios, Lesbos and Tenedos were rounded up by 'netting': 'The
men link hands with one another and spread out from the
northern waters to the southern ones, and then move across
the whole of the island hunting people down.'[2] Mainland
cities were also taken, and the Persians delivered on their

threats to burn the towns and their temples, make the best-looking boys into eunuchs, and deport the most beautiful virgins to the Persian heartlands.[3] The cities on the southern side of the Hellespont were subdued by Darius's land forces, while his Phoenician war fleet brought the northern towns back under Persian control. But one city escaped destruction: Cardia. And one man escaped from Cardia: an Athenian called Miltiades son of Cimon.

Miltiades ('Son of the Red Earth') had been tyrant of the Hellespontine Chersonese. He was a member of the powerful Athenian aristocratic Philiad family, who were inextricably tied to tyranny, both at Athens and beyond. Around the mid-550s[4] his relative, also called Miltiades, son of Cypselus,[5] had become the tyrant of the Chersonese at the invitation of the Dolonci, one of the local tribes, and presumably with Athenian approval. In due course the tyranny devolved on to Stesagoras son of Cimon, who was killed by an axe-wielding fake-deserter, and then on to his brother Miltiades. He sailed out on the first recorded Athenian trireme, and assumed control by practising some stereotypical tyrannical duplicity.[6] He feigned mourning for his dead brother, and when the local leaders came to pay their respects, he imprisoned them and took control of the whole region. He then underpinned his power by recruiting 500 bodyguards and marrying Hegesipyle, the daughter of the Thracian King Olorus.[7]

Miltiades must have sailed from Athens shortly before Darius's Scythian expedition of c. 513, by which time he had become a vassal of the Great King. During the expedition Miltiades had allegedly spoken in favour of the Scythian plan to isolate Darius's army by destroying the Danube bridge,[8] but afterwards he was himself expelled from the Chersonese by a

Scythian invasion.[9] He seems to have joined his fellow Greeks during the Ionian Revolt, in which he gained control of the island of Lemnos. Athenian troops, some from the deme of Rhamnus on the north-east coast of Attica, appear to have fought with him in this action. An inscription on a typical Corinthian-style hoplite helmet of the period, captured and dedicated as a prize of war, has been found at the cult centre of Nemesis: 'The men of Rhamnus on Lemnos dedicated [this] to Nemesis.'[10] A similar inscription on the neck flap of another plundered helmet dedicated on the Acropolis tells us that other Athenians were fighting alongside them: '[The Athenians dedicated this] from the [spoils] from Lemnos.'[11] Furthermore, a very fragmentary casualty list from the island could well record the names of the Athenians of the Hippothontis tribe who died in action and were buried on the battlefield: Anpycides (*sic*), Dorcon, Callicrates and Callinomus, plus Euthymachus from the Cecropis tribe.[12] Lemnos is strategically located on the corn route between Athens and the Black Sea, and, despite the loss of life, such an acquisition would have done Miltiades' standing within his home *polis* no harm whatsoever.

During the course of the Ionian Revolt, around 495, Miltiades' friends the Dolonci facilitated his return. Twelve surviving silver staters (roughly 16.5 g coins) depict a fine roaring lion on the obverse ('heads'). On the reverse ('tails') is an incuse square (stamped impression) showing the head of Athena wearing a crested Attic helmet and an earring, together with the ethnic inscription XEP (= 'CHER').[13] It has been proposed that Miltiades struck these coins in the Chersonese during his tyranny, and that the lion symbolises Miletus's leadership of the Ionian Revolt, with the reverse referencing Miltiades' Athenian heritage.[14]

As the roaring of Miletus's lion turned to whimpering with the suppression of the revolt, Miltiades felt that the Phoenician fleet under their admiral Hydarnes was too close for comfort, and in 493 he loaded his possessions on to five triremes and made a run for it. He was intercepted by the Phoenicians but still made it to the island of Imbros (modern Gökçeada, Turkey) with four of his vessels, but the fifth was chased down and captured[15] along with his son Metiochus ('Cunning-Intelligence-Man'). The Phoenicians felt he would be a valuable prize. They took him to Darius, but rather than exacting retribution, the Great King did quite the opposite: Metiochus was given property, possessions and a Persian wife, who bore him several children. So far as we know, he lived happily ever after. Miltiades managed to get safely away from Imbros, and arrived in Athens, probably in 493/492.[16]

Democratic Athens wasn't necessarily a welcoming environment for a man who had spent the greater part of his adult life ruling as a tyrant. He had a Barbarian wife, connections with Darius, various other dodgy foreign friends, and numerous enemies and opponents within the Athenian aristocracy. 'He arrived in his home country, and when he seemed already to have made it to safety, his enemies "welcomed" him by dragging him into court and prosecuted him on a charge of "Tyranny in the Chersonese".'[17] The trial placed him in mortal danger: the Athenians still very much approved of tyrant-slaying. However, in political cases such as this, personal popularity tended to outweigh legal niceties, and his capture of Lemnos played heavily in his favour. So, in what might have been the most important legal judgement the Athenians had ever made, Miltiades was acquitted.[18]

Themistocles

One person who might have been present at the proceedings against Miltiades was the equally controversial Eponymous Archon of 493/492, Themistocles son of Neocles from the deme of Phrearrhioi.[19] He was of mixed-race heritage, born around 524 to a father from the lower-tier aristocratic Lycomid family and a mother who was believed to be non-Greek – possibly a Thracian called Abrotonon, or a Carian called Euterpe.[20] As a youth he was stroppy, rebellious and awkward, although as he later said himself, 'the wildest colts become the best horses'.[21] However, he also had a strong drive to become a celebrity. According to Plutarch in his *Life of Themistocles*, 'from the outset he was overcome with the desire to be Number One in the state, so he unhesitatingly confronted the hostility of the people who already had power and were pre-eminent'.[22]

Themistocles' politics were radically democratic, and although he was an aristocrat he stood outside Athens's conventional family factionalism, regarding the people as his party.[23] This did not always endear him to the ancient historical writers, many of whose sources were small 'c' conservatives who mistrusted the radical democracy that Themistocles helped to promote and preserve. However, Plutarch, who is also largely negative in his assessment, at least acknowledges that he was held in affection by the people, had the remarkable ability to know every single citizen by name, and was a fair judge of private lawsuits,[24] and Thucydides wrote glowingly about his abilities as a strategist in both the political and military arenas:

Themistocles was a man who exhibited an incredibly strong natural talent, and in this respect, he was utterly extraordinary.

He deserves our admiration above everyone else. Just by using this native intelligence, and without studying a subject beforehand or analysing it after the event, he was a long way ahead of everybody: he could accurately assess the immediate situation with only the slightest consideration and weigh up what was likely to happen in the distant future more perceptively than others [. . .] He was especially good at looking forward and picking up the hidden possibilities, for better or worse. In a nutshell, because of his innate brilliance, and the short time for preparation that he needed, he was the best of anyone at doing exactly the right thing at exactly the right time.[25]

To attain the archonship of 493/492 from outside the traditional power structures was a considerable achievement, and Themistocles used his appointment to start a project to turn Athens into a naval power. The unprotected beaches of Phalerum had already proved inadequate in the defence of Athens,[26] so he focused on the enclosed bays of Piraeus, some 5 kilometres from the city, which provided much more effective harbours, and started to fortify them. Plutarch comments that Themistocles wanted to 'join the entire *polis* to the sea',[27] and without the military, political and economic impact of the Piraeus as its naval base and commercial harbour, Athens would probably never have grown into the cultural and imperial powerhouse that history acknowledges it to have been.

Persia on the Move

Themistocles' and Miltiades' intelligence, tenacity, and political and military acumen would be essential to the survival of Athens and its newborn democracy. While the two leaders were

cementing their positions the Persians were moving through a process of reprisals, reorganisation and reconciliation. In 493 Artaphernes forced the Ionians to make non-aggression treaties between each other, and reorganised their administration and taxation levels in a way that seemed to be acceptable.[28] In the spring of the following year, a young commander called Mardonius[29] ('The Soft Man'), who had recently married his uncle Darius's daughter,[30] led a sizeable army and fleet into Ionia, where: 'Mardonius terminated all the Ionian tyrants, and then began to establish democracies in their cities.'[31] Given that he was about to unleash his mighty forces against the leading democracy in Greece, this is an extraordinary policy. Presumably the Persians felt that the Ionian tyrants had passed their sell-by date, and did not object to democracies on ideological grounds, providing they remained passive. Athens, on the other hand, would not readily submit to Persian domination, but had a viable would-be puppet-tyrant-in-waiting in the person of Hippias.

The Persian military machine marched into Europe, heading specifically towards Eretria and Athens, although Herodotus felt that Darius's revenge on these Greek states was simply a pretext for wider imperialist expansion.[32] The Persian kings valued conquest; they needed to be on the front foot all the time; the divided and vulnerable European Greeks probably looked like a soft target; and the rewards of victory would be high. Herodotus also adds an engaging personal story that Darius's invasion was undertaken to appease his wife Atossa. The two of them are in bed when she strikes up a conversation: 'You're young! You should be doing something dynamic to prove to the Persians that they've got a real man ruling them! I want you to invade Greece! I've heard all about the amazing

women there, and I want some Spartan, Argive, Athenian and Corinthian slave-girls to wait on me.' 'OK,' says Darius, 'I'll start the war.'[33] Quite how Herodotus gained knowledge of intimate Persian royal pillow talk is unclear, but it is interesting that the 'Atossa in bed' scene predates the Ionian Revolt and Athens's involvement in it. She wants conquest, not revenge.

An early victim of the march towards Greece was the rich gold-mining island of Thasos, after which the Macedonians under King Amyntas were added to the 'slaves' that Persia already had. This was a cause for Persian celebration, as the inscription on Darius's tomb at Naqsh-i Rustam would later show:

> King Darius says. By the favour of Ahura Mazda these are the countries outside Persia which I seized; I ruled over them; they bore me tribute; they did as they were told by me; they held firmly my law: [a list of twenty-four peoples, then] *Yauna takabara* [= 'Greeks wearing shield-hats'].[34]

The 'shield-hat' is the *petasos*, a round sunhat characteristically worn by the Macedonians.

As Mardonius pressed on, his fleet attempted to round Mt Athos, 'a big and famous mountain that reaches down to the sea, with settlements scattered across it'.[35] But disaster struck. A violent northerly gale blew up and 300 of his ships were destroyed, with the loss of some 20,000 men: some were dashed on to the rocks, others drowned because Persians could not swim, others succumbed to hyperthermia, and considerable numbers were carried off by the big 'sea-monsters'.[36] The catastrophe was compounded when Mardonius's land forces suffered a night attack by a Thracian tribe of the Bryges/Brygi. They took severe casualties, and although they eventually got the

upper hand and 'enslaved' the Thracians, Mardonius pulled his forces out and returned to Asia. Herodotus dryly comments that the entire episode was a disgrace.[37]

It was standard Persian procedure to try to secure bloodless conquests if at all possible – far better to menace their enemies into submission than actually to fight them – and Greece was clearly in Darius's sights regardless of the recent setbacks. In 492/491 he commanded his Ionian subjects to construct warships and horse transports, and despatched heralds to Greece to demand earth and water. This allowed him to discover that the Greek resistance to Persia would never be unified or universal: the Ionians built the ships; many mainland cities and every single island state that was asked for earth and water provided it. But two states did not. The Athenians had in the past,[38] but in a dramatic U-turn, which violated all diplomatic and religious protocols, they threw Darius's ambassadors into a pit reserved for condemned criminals. Plutarch also includes a story that Themistocles had the interpreter put to death for daring to use the Greek language to transmit the commands of a Barbarian.[39] The Spartans took things to another level and pushed them into a well, telling them with typical Laconian terseness, 'Fetch earth and water for the King from there!'[40]

Aegina and the Spartan Kings

The islands of the Aegean generally submitted because they were vulnerable to naval attack, but one of them might also have done so on the principle that 'my enemy's enemy is my friend'. This was Aegina: powerful on the sea, a member of the Peloponnesian League, and implacably hostile to its mainland rival Athens. A potential Persian base within view of Attica

would have been catastrophic for Athens. So, firing off accusations that the Aeginetans were traitors to Greece, the Athenians sent envoys to ask Sparta to make the island toe the line. The Athenian appeal opened a festering can of worms at Sparta in the form of a feud between Cleomenes and his co-king and rival Demaratus. Amid hostage-taking, love triangles, wife-swapping, corrupt interventions by the Delphic oracle and political manipulation, Demaratus was deposed and replaced by Leutychides, and promptly defected to Persia. Darius received Demaratus warmly and gave him land and cities, possibly including Teuthrania and Halisarna in the area around Troy.[41] There he would nurse his grudges: his involvement with Greece was not over.

As for Leutychides, Demaratus's mother had cursed him, hoping that his wife would bear illegitimate children to donkey-keepers, and after the Persian Wars he came to a sordid and dishonourable end, banished from Sparta amid allegations of bribery and treachery.[42] However, in the first year of his reign he accompanied Cleomenes to Aegina, where the islanders provided ten elite hostages as security for their loyalty. The Spartans handed them over to the Athenians.

Then King Cleomenes went rogue. He started to have some increasingly serious mental health issues.[43] He would smash any Spartan that he met in the face with his sceptre, and when his relatives had him 'shackled in wood', he asked his Helot guard for a dagger and started a bizarre process of self-mutilation:

Cleomenes grabbed the iron blade and started to mutilate himself, starting with his shins. He worked upwards to his thighs, slashing his flesh into strips, and proceeded from

there to his hips and then his flank. When he reached his belly, he cut that into slices, and that is how he died.[44]

Various theories were put forward to explain his behaviour, one of which was the effects of drinking unmixed wine, which he had picked up from the Scythians some twenty years before. 'Going Scythian' became the Spartan phrase for wanting stronger alcohol.[45] Another suggestion was the effects of sacrilege, perpetrated when he had invaded Argive territory, probably in 494. The two armies had encamped close to one another at Sepeia near Tiryns, and Cleomenes noticed that the Argives always followed the same routine, which was dictated by the calls of the Spartan herald. They were doing this out of fear of the first half of the 'shared oracle' that had also been given to the Milesians:[46]

> But when the female shall conquer the male,
> And drive him from the battlefield, and win glory among
> the Argives,
> Many Argive women will tear both their cheeks in grief.
> And so it will come to be said by later generations of men:
> 'The terrible thrice-coiled serpent was slain by the spear.'[47]

So Cleomenes changed his plans. This time, when his herald gave the signal for breakfast and the Argives started to make their meal, the Spartans armed themselves and attacked. It was carnage: the female Sparta (a word of feminine grammatical gender) had conquered the male Argos (masculine in Greek) and won glory in Argive territory; the Argive women were in mourning; and serpentine Sepeia (*seps* in Greek is a poisonous viper[48]) had been slain by the spear. The Argive survivors took

refuge in a sacred grove. Cleomenes invited about fifty of them to come out, telling them that their ransom had been paid, and then put every single one of them to death. Then he instructed his Helots to torch the grove. Some 6,000 Argive warriors were said to have died in the massacre,[49] which meant one of mainland Greece's most important states was effectively removed from the impending conflict with Persia, whichever side they might have joined.

Cleomenes had been supportive of Athens in its spat with Aegina, and his death was well received on the island. But Atheno-Aeginetan relations deteriorated, with further hostilities taking place probably prior to the Battle of Marathon, although Herodotus is not explicit in his chronology: there was more hostage-taking; appeals to the Delphic oracle; high-level discussions at Sparta; claims to be working on behalf of the common good of Greece; attacks on religious festivals; tit-for-tat reprisals; attempts to betray the island; fighting at sea; and unofficial help for Aegina from Argos. Eventually Aegina got the upper hand, but still faced internal dissension: various ex-patriot Aeginetans were allowed to leave and live in Sounion in Attica, from where they continued to conduct pirate-style raids on Aegina, while on the island itself internal strife between the *demos* and the 'fat cats' resulted in 700 people being rounded up and executed. One of them managed to get away as far as the vestibule of the Temple of Demeter the Upholder of Right, where he grabbed hold of the doorhandles. When his enemies could not loosen his grip, they chopped off his hands, leaving them still clinging to the handles. It was in many ways a fitting image of the state of Greece at the end of the 490s BCE: violently disunited in a complex web of hostilities, both between and within the different states.[50] It suited Darius perfectly: 'The

thing that united Athens and Aegina was mutual hostility. Meanwhile the King of Persia was making his own plans.'[51]

Darius on the Offensive

With Darius's servant repeating the 'remember the Athenians' mantra, and the Peisistratids-in-exile continually bad-mouthing their fellow-countrymen, it would only be a matter of time before Persian soldiers would be back in Greece. The Athenians knew it. Hence, probably, their decision to elect Miltiades and Callimachus in 490. For his part, Darius under-stood that Greece was never going to act as a unified whole, and neither was Athens. To an ex-tyrant such as Hippias and his aristocratic supporters, collaboration with Persia was infi-nitely preferable to living under their 'social inferiors' in the infant Athenian democracy: their 'people' were their family, relatives and friends, and class and social status trumped feel-ings of nationalism at all times. The Athenian and Spartan response to the request for earth and water also provided Darius with a perfect pretext, as did the burning of Sardis. So, having fired Mardonius for performing so 'abysmally' in 492,[52] the king appointed the Mede Datis – he of the large beer rations of 494[53] – and his own nephew Artaphernes, the son of the satrap Artaphernes. Their brief was straightforward: enslave Athens and Eretria, and take the slaves to Darius.[54] And if mission creep set in and wider conquests ensued, so much the better.

The Persian battle group mustered in Cilicia (near modern Adana, Turkey). It was large, well equipped and supported by a formidable navy that included horse transports, which Darius had compelled his Ionian subjects to supply. They sailed to Ionia with the obligatory 600 triremes,[55] heading north up the

coast as far as Samos, turning to port and striking out across the Aegean Sea, island-hopping to avoid Mt Athos. Naxos was a key stepping stone: the Persians had unfinished business there from the time of Megabates' failure to take it in 499,[56] and now they enslaved whoever they could catch, and burnt the temples and the city. Next, they moved over to Paros. The Parians sent one trireme to join the Persian fleet and, in an act of hubris that would backfire on them later, the Persians took a large block of Parian marble, intending to carve it into a victory monument once their objectives had been fulfilled. However, after their defeat at Marathon it was turned into a statue of Nemesis, the goddess who punishes violence and hubris, and installed in her sanctuary at Rhamnus, close to the battle site.[57] From Paros, Datis's fleet sailed to the holy island of Delos at the centre of the Cyclades islands.[58] The Delians fled but Datis spared the island, burning 7.5 tonnes of frankincense on the altar to Apollo and Artemis.[59] The pillars of smoke rising from the two islands would have broadcast vivid messages into the Aegean sky about the effects of compliance or resistance.

Datis's armada now sailed for Euboea, most likely via Mykonos, Tenos and Andros, enlisting and/or pressganging further Greeks as they went. The people of Carystus on the southern tip of the island 'saw the Persian point of view'[60] and surrendered. Eretria was next on the list. The Eretrians defended heroically for a week,[61] until internal treachery achieved what external violence could not: Euphorbus son of Alcimachus (Well-Fed Strong-Fighterson) and Philagrus son of Cineas (Hunt-lover Hunting-with-Houndsson) betrayed the city and were rewarded handsomely with lands in Persian territory;[62] the city was plundered; the temples were torched in revenge for what the Eretrians had done at Sardis; 789 citizens were

rounded up, perhaps by 'netting', and shipped off to await deportation into Persian slavery.[63] Philostratus tells us that 400 captives survived the journey, before they were settled at Ardericca (modern Kīr-āb, Iran), some 65 km from Susa, close to a well that was famous for the extraction of bitumen, salt and oil.[64] A touching poem attributed to Plato provides a funerary epigram for them:

> Leaving the loud-roaring swell of the Aegean
> We lie in the very heart of the plains of Ecbatana.
> Farewell, Eretria, once our famous fatherland!
> Farewell, Athens, Euboea's neighbour! Farewell, beloved
> Sea![65]

Datis and Artaphernes could be well satisfied. Their mission was 50 per cent accomplished: now they could focus exclusively on Athens.

CHAPTER 7

Marathon: Democracy Saved

The Battle of Marathon, even as an event in English history, is more important than the Battle of Hastings. If the issue of that day had been different, the Britons and Saxons might still have been wandering in the woods.

<div align="right">

John Stuart Mill[1]

</div>

The Persians Arrive at Marathon

In the Museo Archeologico Nazionale in Naples there is an impressive Apulian red-figure volute crater, which is the 'name vase' of the Darius Painter.[2] It stands some 1.15 m high, and the main body of the vase is decorated in three bands, which between them foreshadow Darius's invasion of Greece, hint at exactly what was at stake, and allude to its outcome. The highest tier depicts various divine onlookers and influencers: Artemis and Apollo, representing Greek order and reason; Aphrodite and Eros, representing Greek love; Athena leading personified Hellas towards Zeus; and Apate, the personification of Deception, who is trying to move personified Asia away from an altar where she is seeking protection. Enthroned in the

centre of the middle tier is Darius, 'a truly Persian peacock',[3] decked out in a full-length, long-sleeved robe, with a high *tiara* on his bearded head. He holds a sceptre and a sheathed sword, and is interacting with a similarly bearded man who is standing on a low, circular, two-tiered platform with the word PERSAI ('Persians') written on it. Whether this person is a messenger delivering news or a personification of the Persian people giving advice is unclear.[4] The king is protected by a sword-wielding bodyguard, and members of his court, possibly including his son Xerxes, are also in attendance. On the lowest tier we see a Persian tax-gatherer counting tribute payments from conquered peoples using white pebbles on a special table. There are signs for numbers, and they are large – 100, 1000, 10,000 – as well as signs for Greek currency, and the treasurer brandishes a wax tablet with the considerable sum of 100 talents etched on it. The scene illustrates what would be the likely fate of the Greeks should Darius's goals be realised, although their suffering would be more than just financial.

The Persians spent a few days on Euboea, sending menacing messages:

> [Datis] sent a horror-story to our city [Athens] of how not one single Eretrian had got away from him: his soldiers had linked hands and trawled the whole of Eretria as though catching fish in a net. Whether it was true, and wherever it came from, the tale terrified the Greeks in general, and the Athenians in particular.[5]

Terrified though they were, the Athenians did not cave in, and as each side traded spurious mythological manipulations to support

their claims that they should rule the other, Datis prepared for battle.[6] Hippias experienced a Freudian dream in which he slept with his own mother. But rather than interpret this as foreboding a calamity of Oedipal proportions, he decided it indicated that he would return to Athens (his 'mother' country), recover his power and die ('sleep') there as an old man.[7] On his advice, Datis's forces now sailed over to Attica and landed at Marathon, some 40 km north-east of Athens.

It certainly provided a convenient place to make an unopposed landing and beach the ships, excellent terrain for the formidable Persian cavalry, and proximity to a pro-Peisistratid area of Attica from which Peisistratus himself had marched on Athens in the past.[8] But the topography also held advantages for the defenders, if it could be harnessed effectively. The Bay of Marathon has a flat, sandy, 8-km-long beach, inland from which is the plain, roughly 8.5 km long by 2.5 wide, which is hemmed in by the mountains of Agrieliki, Aphorismos, Kotroni, Stavrokoraki and Drakonera. The valleys of Vrana, Avlona, Charadra and Kato Souli run between those mountains respectively. The torrential Charadra River issued more or less into the middle of the plain, although in the summer of 490 its dry bed would not have created a significant obstacle. Extensive geological study has been made of the coastline, which seems to have been broadly similar to how it is today, but with the sea level between 1 and 3.5 metres lower, making the plain slightly wider in antiquity.

The ancient sources comment on the area's fecundity: Marathon itself means 'The Place of Fennel'; Pindar called it 'fertile'; Nonnus said it was deeply wooded, olive-clad and olive-planted; Aristophanes wrote of the plentiful grazing land and the flocks of birds that nested there; and the mythical hero

Marathon or Marathos was an 'agricultural hero'.[9] The people of Marathon claimed to be the first Greeks to acknowledge Heracles as a god, and there was a religious sanctuary dedicated to him between Mt Agrieliki and the sea.[10] Another key feature was a large area of marshland at the north-eastern end of the plain. It was uneven, muddy, full of lakes, unsuited to riding, and was infested with 'Tricorythian gnats'.[11] There was a spring called Macaria at Tricorythus,[12] and a river ran from the lakes, providing good water for cattle.[13] Modern geological research has suggested that these 'lakes' could have been a lagoon, providing a natural harbour with access to the sea. There were pine-clad sand-dunes between the north-eastern marsh and the sea (modern Schinias beach), and the northern horn of the bay was formed by a 2.2-km-long peninsula known as Cynosura ('The Dog's Tail'). The deme of Marathon covered the plain, with those of Tricorythus to the north-west, Probalinthus to the south-west, and Oinoe to the west.[14]

Although Herodotus tells us why the Persians went to Marathon, he leaves the precise location of their arrival vague, as does the tragic poet Aeschylus in his self-written funerary epigram, which proclaimed that the witnesses of his manhood were 'the grove at Marathon, and the Persians who had landed there'.[15] The most likely place would be the beach at Schinias near its corner with the Cynosura peninsula.[16] The vessels were drawn stern-first on to the sand, with some of them perhaps moored close to the beach, or installed in the lagoon. In all, they would have formed an impressive and intimidating sight,[17] and Herodotus presents Hippias as overseeing this 'barbarian' landing, and organising the troops once they had disembarked, essentially leading a non-Greek enemy against his motherland.

The Persians most likely bivouacked in the Tricorythus area, with some soldiers on the plain itself between the Charadra riverbed and the marsh. Local tradition certainly placed the cavalry in the former location: 'Beyond the lake are the stone mangers of Artaphernes' horses, and the marks of a tent on the rocks.'[18] While Hippias was dealing with this, he had a coughing fit, which made one of his teeth fall out into the sand, and he was unable to find it. As a Freudian dream symbol this indicates a fear of castration or a punishment for masturbation,[19] but Hippias interpreted it differently, if equally pessimistically: 'This land is not ours; we will not be able to conquer it. My tooth has the share of it that belonged to me!'[20] Datis and Artaphernes doubtless read the situation more favourably. They must have thought that in the unlikely event of the Athenians confronting them at Marathon, they would simply overwhelm them, or that once they marched on the city they would take it by storm or secure its betrayal by fifth columnists. It looked like a win–win–win situation.

The Athenians Mobilise

The Athenians were under no illusion as to what they were facing, and their army had already assembled in Athens. The so-called 'Decree of Miltiades' had instructed them to 'collect provisions and march out',[21] and once the Athenians had voted on how many hoplites were needed, and who would command them, the conscription process would have kicked in.[22] There was a wealth qualification for hoplite service – the fighters had to provide their own equipment, and were drawn primarily from the *Zeugitae* – and each deme would have helped to compile the *katalogos* (list/register/catalogue) that gave each of

the ten tribes the information it needed.[23] Every Demarch could consult deme-registers (*lexiarchika grammateia*)[24] to confirm who was liable to call-up in their area, but also, because they presided over close-knit local communities, they would have known who was officially exempt, for instance on the grounds of disability, and their personal knowledge of friends, relatives and neighbours allowed them to assess who were the most effective fighters. The average deme contributed around fifty-six hoplites, and so as far as was possible only the highest quality warriors would march to war, hopefully minimising any unnecessary loss of life.[25] The weak, cowardly and inept were a dangerous liability: everyone's survival depended on everyone else.

The Demarchs provided the information to their respective tribes; each tribe compiled its own *katalogos* of whose services were required; and the generals collated this information. The final muster could take place in the Agora, the Lyceum or on the Pnyx hill, and any conscript who failed to appear could be prosecuted for draft-dodging. However, it is hard to ascertain precisely how many soldiers now assembled. Herodotus says that that there were only 'a few',[26] but he never gives actual figures. He implies that all ten tribes were present, and if the army was at full strength, comparison with other Athenian military activities would give a ballpark figure of around 9,000 to 10,000 hoplites. Nepos gives a figure of 9,000, and also says that the Athenians were outnumbered ten-to-one by 100,000 Persians; Plutarch, Pausanias and the Byzantine Suda lexicon, all possibly going back to one of the Atthidographers (fourth-century BCE local historians of Athens who wrote *Atthides*[27]) give us 9,000; and Justin comes in with 10,000.[28] Pausanias adds that there was also something unique about

Athens's army: 'Not more than 9,000 Athenians marched to Marathon, even including those who were technically too old for active service and slaves.'[29] This is extraordinary if it is true. Not only were slaves fighting alongside their masters, but they would be buried separately, and on the battlefield, which was a major honour: 'On the plain [of Marathon] there is another grave [. . .] for this was the first battle in which slaves ever fought.'[30] How many there were, how they were equipped, whether they were freed first and how they were integrated into the Athenian battle-line, however, can only be guesswork.[31]

The Persians thought the Athenians were crazy to attack them just with hoplites who had no cavalry or archer support.[32] But the use of light-armed troops, *psiloi*, in the shape of archers or javelin throwers, was not the norm in the Athenian military in 490: the Marathon generation liked to fight hand-to-hand. In Aeschylus's tragedy *The Persians*, set ten years after Marathon, the Chorus tells Queen Atossa about 'a special army that has already done the Medes considerable harm' at Marathon. 'Why?' she asks. 'Are they adept at wielding bows and arrows?' 'Not in the least,' the Chorus replies. 'They use spears for offence, and shield for defence.' 'But how can they resist a hostile invader?' she wonders. The Chorus tells her, 'Well enough to have annihilated Darius's large and splendid army.'[33] The Chorus Leader in Aristophanes' comedy *Wasps* also reminisces about how

> We immediately charged forward 'with spear, with shield' and fought with [the Persians], dripping with bitter spirits,[34] standing man next to man, each of us biting our lips with fury.[35] We couldn't see the sky because of all the arrows!

But even so, with the help of the gods, we drove them back towards evening.[36]

There was something fundamental about this: it wasn't just that *psiloi* were inferior troops; they were inferior *men*.[37] One Spartan famously quipped that the spindle, by which he meant the arrow, would be worth a great deal if it could discriminate between brave men and cowards.[38] The spindle is used by women, not by men. A similar prejudice applied to the cavalry despite their socially elite status. Without stirrups it was impossible to fight effectively hand-to-hand and shield-to-shield, so skirmishing with javelins was the best they could do. It was a soft option: only the hoplite fought eyeball-to-eyeball; only the hoplite was a real man.[39]

These Athenian real men equipped themselves with a bronze 'Corinthian'-style helmet (Greek: *kranos*, *kuneē* or *korus*).[40] This somewhat dehumanising item provided maximal protection to the wearer's head, with just almond-shaped eyeholes and a vertical slit for the mouth, a prominent nose protector and a large, curved projection protecting the nape of the neck. It was usually fashioned from one piece of bronze, lined with leather or linen, and weighed around 3 kg. It made peripheral vision and hearing difficult but was ideally suited to close-order fighting. The hoplite's upper body was covered by a bronze corselet (*thorax* or, to the Spartans, *aigis*[41]) consisting of two bronze pieces fastened together at the shoulders, modelled on, and decorated to replicate, a muscularly sculpted torso. The *thorax* flared out slightly just above the hips, which aided mobility and gave extra protection to the abdominal area. It was heavy and hot, but highly effective. A linen tunic (*khitoniskos*) served as underwear, and the body armour was completed by flexible

bronze greaves (*knemides*), which were shaped to fit the muscu-lature of the wearer's calf and to provide protection for the shins.

Perhaps the hoplite's most valuable defensive asset was his convex circular shield (*aspis*) with a flat offset rim (*itys*), made from wood or hardened leather, faced with bronze, and some-times emblazoned with family or mythological insignia (*episema*).[42] It was typically about 80 cm in diameter, and was held by putting your left arm through a central leather fasten-ing (*porpax*) at the centre, and grasping a strap or cord (*antil-abe*) at the edge. It could weigh anything between 8 kg and 15 kg, and was formidable in close-order group combat, but too awkward for more improvised, individual encounters.[43] The way it was held made the *aspis* project to each man's left, which forced everyone to rely on his right-hand comrade's shield to protect his own right side and created a well-known tendency for the formation to drift to the right when it advanced.[44]

Contrary to popular belief, the hoplite was not named after his shield:[45] the Greek word *hoplon* means a tool/implement, and a *hoplites* is simply 'someone who is equipped' (not 'tooled up' in a military sense). The misunderstanding goes back to Diodorus Siculus, who rather bizarrely argued that because the lightly armed 'peltast' was named after his shield, the *pelta*, the hoplite was named after his – the *aspis*.[46] In fact, 'hoplite' itself does not appear until 467,[47] and in 490 the words were prob-ably *aikhmetes* ('spearman') as in Homer, or *panoplos* ('totally equipped man') as in Tyrtaeus. The hoplite went on the attack using a 2.5–3 m-long thrusting spear (*dory*), which was wielded one-handed. It had an ash wood shaft, an iron point and an iron spike on the butt called a *sauroter* ('lizard-slayer'), which allowed it to be rammed into the ground or a trampled enemy

'lizard', or used as a viable weapon in its own right should the spear-shaft be broken.[48] An iron sword, generally not more than 60 cm long, completed the soldier's kit. This was either a straight *xiphos*, or a curved *makhaira* or *kopis*, and doubtless hoplites also carried a dagger, just in case . . .

These totally equipped men deployed in what is usually described as a phalanx (Greek: *phalagx*).[49] They fought shoulder-to-shoulder and one behind the other, usually in files eight men deep, which were as far as possible constituted of fellow demesmen. 'Good order' (*eutaxia* in Greek) was crucial here; disorder (*ataxia*) was fatal. As Aristotle put it, 'without orderly formation hoplite soldiers are useless'.[50] An unbroken wall of shields and spearpoints was terrifyingly effective when it was powering forward in good order. As soon as they were within striking distance, the front ranks would begin a frenzied stabbing with their spears, usually wielded overarm. The finest fighters were not only stationed in the front rank as the most honoured cutting edge, but also at the rear, as enforcers providing a backstop and ensuring there was no combat avoidance.[51]

The spear-thrusting was augmented by *othismos* ('shoving'), with the rear ranks shoving against the backs of the ones in front, somewhat like a hyper-violent rugby scrum or rolling maul, but with no referee and no laws of the game.[52] The file system created a process of automatic replacement of casualties by forcing new fighters into the front rank, and was acknowledged as being the key feature of hoplite fighting.[53] Yet somewhat surprisingly, these Athenian spearmen did hardly any training, and the same went for almost all the other Greeks except the Spartans.[54] This was partly a class-based attitude: the elevated social status of the *Zeugitai* who fought as hoplites

meant that any form of training would be deeply resented. For them extensive training = forced labour = slavery.

To the Rescue at Marathon

When news of the Persian landing arrived, the Athenians had some tough decisions to make. They made their belligerent intentions clear by vowing to sacrifice a goat for every enemy they killed, but where should they make their stand? In the city, behind the safety of their walls, but at risk of betrayal from within? On the field at Marathon, with all the risks associated with confronting a much larger, more mobile enemy on disadvantageous terrain? Our sources mention the 'Miltiades Decree' which suggests that General Miltiades persuaded the authorities to take the Marathon option.[55] It was an enormous gamble, but the Athenians went all in.

The Athenians also looked for help from other sources. They sent a plea to Plataea in Boeotia and despatched the first of their two famous 'Marathon' runners. This was Philippides (sometimes called Phidippides/Pheidippides),[56] an incredibly fit specialist 'day-runner', who set off for Sparta and experienced a 'sonic epiphany' of the god Pan, or so he said, before arriving at Sparta on the day after he left Athens.[57] He made an emotional appeal for the Spartans not to allow 'the most ancient city in Greece to be brought into bondage by Barbarians'.[58] They were happy to help, but not immediately, because they were celebrating the important festival of the Carneia in honour of Apollo, which culminated at the full moon, and Dorians did not engage in warfare during that time. Sparta's obligations to Apollo trumped those to Athens, so Philippides ran back to deliver the news while the Spartans waited for the full moon.

Meanwhile, the Athenian soldiers had left the city to 'go to the rescue at Marathon'.[59] They were led by the Polemarch Callimachus, and their tribal *strategoi* 'of whom Miltiades was the tenth'.[60] They needed to be at Marathon before the Persians could get out of the plain, and they had a choice of routes: an easier but longer one up the coast, which was vulnerable to attack from the sea; or a shorter and considerably safer inland one, through much more demanding mountainous terrain. We do not know which option they took, or if they split their forces and chose both, but when 'rosy-fingered Dawn' shed her light on to the mountains of Marathon the following morning, the Persians would have been astonished to see Athenian forces covering the southerly exits from the plain. Miltiades had seized the initiative.

Herodotus says the Athenians encamped 'in the Sanctuary of Heracles', which we know from an inscription was north of modern Brexiza.[61] This covered the southern routes out from the plain via the Vrana valley and the coastal road, and had the advantage of being well supplied with water and backed by the wooded south-eastern slopes of Mt Agrieliki, which also provided a useful vantage point for observation. They felled trees to provide further defensive material and impede the Persian cavalry, and the narrowness of the space between the hills and the sea also played to their advantage.[62] The Athenian forces were further boosted by the timely arrival of the Plataeans 'with all the resources they had'[63] – anything between 600 and 1,000 hoplites.[64]

A stand-off then ensued for several days. Each side would have deployed their troops but not engaged, and there was no immediate rush to do so. The Persians wanted to fight on the plain, where their assets could be utilised to maximum effect,

and there was always the possibility that Athens might be betrayed if they delayed, whereas the Greeks could afford to stay observing the Persian routines and covering the roads to Athens, knowing that the Spartans would be with them before too long. Nevertheless, the Greek high command was split. The ten generals decided strategy by majority vote and held the presidency of the group in daily rotation. Five of them urged caution; the other five, including Miltiades, favoured immediate engagement. To break the deadlock, they decided to consult the Polemarch Callimachus. His status is hard to ascertain: Herodotus says he held the office 'by lot' (literally, 'by the bean'), although that was not the method of selection in 490 BCE as he had been elected, and that the polemarch had a casting vote; Aristotle says he was the 'leader/commander-in-chief', but whether his status was real or just a title is disputed.[65] Nevertheless, he was Miltiades' go-to man. He said,

Callimachus, you've got a choice. You can enslave Athens, or liberate her. You can be even more famous than Harmodius and Aristogeiton. If the Athenians submit to the Medes their fate is sealed: it will be back to the days of Hippias. But if the city is saved, it will become the greatest in Greece. And it's all down to you! Look, the generals are split 50/50, but if we hold back, the chances are that we'll become even more divided, and eventually make friends with the Persians. We need to fight and win before that happens. If you support me in the debate, you will liberate Athens and make it the greatest state in Greece; if you don't, the opposite will happen.[66]

Faced with this emotive appeal to fame and freedom, Callimachus cast his vote for Miltiades.

The Battle of Marathon

The Athenians waited for Miltiades' designated day of leadership to come round,[67] and doubtless for the Spartans to arrive. Coincidentally, on that day, on or around 12 September 490 BCE,[68] a good opportunity to attack presented itself. Polemarch Callimachus of the Aiantis tribe, which also included the local demes of Marathon, Tricorythus and Oinoe, had the place of honour on the right wing. Next to him came the other tribes, probably in their standard numerical order,[69] with the Plataeans led by Arimnestus on the left. Miltiades' Oineis tribe was certainly fairly centrally positioned, which was crucial. At eight men deep the Greek line would stretch around 1250 m, but it needed to be extended by another 300 m or so to match the length of the Persian formation. So, the Greeks thinned the centre, while keeping the wings at full depth. Plutarch says that the tribes of Leontis and Antiochis performed brilliantly in the centre, with their respective tribesmen and future democratic superstars Themistocles and Aristides 'the Just' fighting side by side, but this is unlikely: Leontis and Antiochis would not be adjacent, although the proximity of the two future Athenian heroes makes an attractive tale.

Because none of the ancient sources tells us, the starting positions of the two armies have been the subject of considerable speculation. The Athenians and Plataeans would logically want to fight on the narrowest front possible, and the plain presents a number of options for this: between Mt Stavrokoraki and the sea, close to the Great Marsh, with the Persians deployed with their backs to it; further into the plain, with the protagonists on either side of the Charadra riverbed; the Greeks parallel with the coast in the foothills of Mt Kotroni and the sea

behind the Persians; at the entrance to the Vrana valley, between Mt Kotroni and Mt Agrieliki; the Greeks on the north-east slopes of Mt Agrieliki, and the Persians with the Charadra river behind them; or at the entrance to the plain, between Mt Agrieliki and the sea. There are nuanced versions of all these theories, and valid arguments can all be made for and against them.[70] All that we can confidently assert is that the events unfolded on the plain of Marathon.

Sacrifice was made, and the omens were good. An owl, Athena's bird, was also said to have flown over the battlefield.[71] Miltiades gave the order to charge.[72] They made for the Persians 'at a run/at a jog/at the double/in quick step'.[73] The Persians' tactics of choice were to use their cavalry to shower enemy infantry formations with missiles, wheel about, regroup and repeat. The infantry would deploy a combination of shield-bearers and archers that they called *sparabara* (from *spara* = 'shield'), creating a palisade of wicker shields on the ground in front of the first rank, and unleashing endless volleys of arrows from behind it until the enemy's formations disintegrated. Only against a beaten and disorganised army would Persian forces choose to engage hand-to-hand. So, the Greeks had to move quickly: Herodotus puts the distance between the two battle-lines at about 1425 m,[74] and for the final 175 m or so they would have to run through salvo after salvo of arrow fire. The Persians were not expecting such an un-Persian-style onslaught, and thought it was 'lethal insanity' to do this, particularly in the absence of supporting archers and horsemen.[75] But the Greeks may have spotted that the Persians themselves were also without cavalry and seized that opportunity to attack.

The Byzantine Suda lexicon has an entry under 'The cavalry are away!':

They say that after Datis had withdrawn/*gone away*, the
Ionians came inland to a wooded area/*climbed into the trees*
and signalled to/*told* the Athenians that the cavalry were
away/*apart*, and that when Miltiades learned of their
absence/*realised what they were doing*, he charged, and so
emerged victorious.[76]

These may be Ionian 'alternative facts' to soften the fact that
Ionians were fighting against their fellow Hellenes, but
Herodotus makes no mention of Persian cavalry in his descrip-
tion of the battle. Some scholars simply reject the idea;[77] others
wonder whether the horses were being watered at the Macaria
spring and pastured by the Great Marsh and returned too late
on this occasion;[78] others again suggest that the Persians were
re-embarking their cavalry in order to sail around the Greek
army and land to their rear, or to attack Athens.[79]

Herodotus's description of the main action takes fewer than
150 words in Greek:

> The Athenians engaged all together with the Barbarians and
> fought in a way that is worthy of the highest praise. Firstly,
> they were the first Greeks that we know of who used running
> at the enemy as a tactic, and secondly, they were the first to
> endure the sight of Median clothing and the men who wore
> it. Prior to that the Greeks were terrified simply to hear the
> name of the Medes.
>
> They fought for a long time at Marathon. The Barbarians
> were dominant in the centre – that is where the Persians
> themselves and the Sacae were deployed. There the Barbarians
> got the upper hand, smashed through the Greek line, and
> began to pursue them inland. However, the Athenians and

Plataeans were triumphant on both wings, and once they had broken through, they allowed the routed Barbarians to flee, and brought the wings together to engage those who had smashed the centre of their line. And the Athenians were victorious. They followed the fleeing Persians, smiting them as they went, until they got to the sea, where they called for fire and began to seize the ships.[80]

The Athenians captured seven Persian ships,[81] and Herodotus's account references the crucial moments in Homer's *Iliad* where Trojans break into the Greek camp. 'Smiting' is a recognisably epic activity, and Herodotus uses the same unusual word as Homer for 'carved stern-posts': among the high-profile Greek casualties was Aeschylus's brother Cynegirus, who died when his hand was 'smitten off' with an axe as he grabbed a ship's carved stern-post.[82] Justin adds that even after his right hand was cut off, he grabbed the ship with his left, and when that was cut off he sank his teeth into the timbers of the vessel, and continued to fight like a wild beast.[83]

Thirty years after the battle, the veterans of Marathon would have been able to view a large commemorative painting in the Painted Stoa in Athens. Pliny the Elder was impressed by its portraits of Miltiades, Callimachus, Cynegirus, Datis and Artaphernes,[84] and Pausanias also saw it:

At the far end of the painting are the men who fought at Marathon. The Plataeans from Boeotia and the contingent from Attica are engaging hand-to-hand with the Barbarians: neither side has the upper hand in this area. But in the heart of the battle the Barbarians are fleeing, shoving each other into the marsh. The painting ends with the Phoenician ships,

and with Greeks slaughtering Barbarians as they scramble aboard them [. . .] The most conspicuous fighters in the picture are Callimachus, who was chosen as polemarch by the Athenians, and Miltiades, one of the generals.[85]

A second-century CE sarcophagus, now in the Museo di Santa Giulia in Brescia, is also thought to depict the fighting here: we see heroically nude Athenians pursuing barbarically clothed Persians back to their ships and massacring them on the beach. Phoenician triremes are pulled on to the shore in the background, while on the left a shieldless Athenian grabs a Persian cavalryman by the head to unhorse him. Various acts of brutality are being perpetrated, notably a Persian biting the lower leg of a Greek warrior in the bottom-left corner, and a bearded Persian (or Phoenician) wielding what might be an axe to sever the hand of a Greek, possibly Cynegirus,[86] who is clinging tenaciously to the stern of a ship.

Numerous high-profile Athenians were killed in action by the ships, notably Callimachus. His memorial was erected on the Acropolis, in the form of an inscribed Ionic column of Parian marble surmounted by a figure of Nike (Victory). It was later damaged by the Persians, and although less than half of the text now survives, its fragmentary inscription can be seen restored in the Acropolis Museum in Athens:

[Callimachus] of the deme of Aphidnae dedicated [me] to Athena
The messenger of the immortal gods [i.e. Nike] who dwell [in their Olympian homes]
[Callimachus] Polemarch of the Athenians who fought the battle

Of Marathon [for] the Greeks
To the sons of the Athenians, a memorial [letters
 missing].[87]

Herodotus says Callimachus achieved glory by his illustrious
death; Plutarch describes how he was transfixed by so many spears
that he remained standing upright, even though he was dead.[88]

Our big picture of the Battle of Marathon is clear enough, but
there are endless questions about the detail. Nevertheless, some
of the local traditions and monuments recorded by Pausanias
can help to piece things together. He tells that 'the grave on the
plain is that of the Athenians. On it there are *stelai*, which have
the names of the dead listed according to their tribes.'[89] One of
these *stelai* is now in the Archaeological Museum of Astros.[90]
Under the tribal heading 'Erekhtheis' it gives a moving list of
twenty-two real Athenians who gave their lives for their *polis*:

Fame, which always reaches the ends of the bright earth
Will speak of the valour of these men and how they died
Fighting against the Medes and bringing a crown of glory
 to Athens.
Few as they were, facing many in battle.
Dracontides; Antiphon; Apsephes; Xenon; Glaukiades;
 Timoxenus; Theognis; Diodorus; Euxias; Euphroniades;
 Euktemon; Callias; Araithides; Antias; Tolmis;
 Thucydides; Dios; Amynomachus; Leptines; Aeschraeus;
 Peron; Phaedrias.[91]

The 'grave' to which Pausanias refers is the mound called the
Soros, originally 12 m high and 50 m in diameter, which was,
and still is, the most prominent monument on the plain. It is

generally accepted to be the burial site of the Athenians, and some scholars argue that this is where the thick of the fighting took place. Pausanias also tells us that there was another grave (or graves) for the Plataeans, Boeotians and slaves, and this information has been used to try to locate the place where the Plataeans lined up on the battlefield.[92]

As Pausanias walked north-westwards along the plain, he was also shown a private memorial to Miltiades, erected many years after the battle. Its location remains lost, but Pausanias has a spooky tale to tell about it: 'Here, every night you can hear the sound of horses whinnying and men fighting. No good has ever come of it for anyone who has deliberately stayed there to observe this vision closely, but if it happens by accident the anger of the spirits will not pursue him.'[93] This may just be a local ghost story told by a guide to a gullible tourist, but it has also been brought into discussions about the presence or absence of the Persian cavalry in the battle.

One other monument which Pausanias saw, of which a few fragments still survive, was 'a trophy made of white marble'.[94] This seems to have stood close to the church of Panagia Mesoporitissa, near to the Great Marsh. The few surviving fragments, now in the Marathon Museum, suggest it was an unfluted Ionic column, about 10 m high, possibly surmounted by a figure of Nike (Victory). The English word 'trophy' derives from the Greek *tropaion*, and trophy monuments (*tropaia*), decked out with captured weaponry, were usually erected at the point where the battle 'turned' (Greek: *trope* = 'turn'). The Athenians were especially proud of the Marathon trophy,[95] and in all the speculation about how and where the battle was fought, it is an important indicator that a crucial moment of the battle happened at that spot.

The supernatural appears quite regularly in relation to Marathon. A spectral manifestation of Theseus appeared in the battle, fully armed and rushing ahead against the Barbarians;[96] the picture in the Painted Stoa showed Theseus rising out of the earth, along with Athena and Heracles;[97] and Pausanias also relates that

> the people of Marathon worship those who died in the battle as divine heroes, as well as Marathon from whom the deme gets its name [. . .] They say that there happened to be a man in the battle with a rustic appearance and some agricultural equipment. He killed a lot of Barbarians with a ploughshare and disappeared when the engagement was over. When the Athenians asked about him, the god said nothing, apart from ordering them to honour Echetlaus ['Ploughshare-handle Man'] as a hero.[98]

One particular otherworldly battlefield experience has prompted considerable recent interest. Plutarch says that 'When [the Athenian army] had engaged the enemy, Polyzelus saw a supernatural vision, lost his sight, and went blind.'[99] Herodotus gives him a different name, Epizelus son of Cuphagoras, and more details. While he was fighting hero-ically, he went blind, even though he had not incurred any physical injury. He never recovered his eyesight but said that he thought it happened after a huge hoplite figure confronted him. The unworldly hoplite's beard cast a shadow all over his shield, and the phantom killed the man next to him. Or so Herodotus said Epizelus said.[100] In the years after the First World War, it was suggested that this might be the first account of 'shell shock', aka 'post traumatic stress disorder'.[101] However,

severing ancient episodes like this from their social context and trying to assess them retrospectively based on twenty-first-century diagnostic criteria can create misunderstandings.[102] The symptoms of PTSD include sleeplessness, anxiety, re-experiencing (flashbacks, nightmares, repetitive and distressing images or sensations, physical sensations like pain, sweating, feeling sick or trembling), avoidance and emotional numbing, hyperarousal (feeling 'on edge', irritability, angry outbursts, difficulty concentrating), other mental health problems (depression, anxiety, phobias), self-harming or destructive behaviour, and other physical symptoms, such as headaches, dizziness, chest pains and stomach aches.[103] Herodotus is writing his *Researches*, not patient notes. This is not what Epizelus suffers, and it seems inappropriate to demythologise his experience.[104]

Pausanias was informed that the Barbarians incurred the most casualties in the Great Marsh, because they did not know the paths through it. However, there were no mounds or grave markers there, and his assumption, doubtless correct, was that the Persians' bodies were hurled into a pit near where they fell. Herodotus says there were 6,400 of them against 192 dead on the Athenian side.[105] The Athenian number is probably reliable; the Plataeans seem to be edited out of the accounts almost as soon as the battle was over; and although the Persian figure looks high, a massacre in the marsh is not out of the question, and it did take Athens many years to sacrifice the promised number of goats.[106]

After the Battle: Running and Sailing to Athens

Victory on the Marathon plain did not end Athens's jeopardy. The Persians were able to push their intact ships off from the shore, pick up the Eretrian slaves, and make a dash for the undefended city. What time of day it was is now hard to tell: Herodotus just says that the battle 'lasted for a long time', but does not say when the battle commenced – estimates vary from dawn to late afternoon[107] – and although the Chorus of Aristophanes' *Wasps* boasts that the Greeks pushed the Persians back 'before evening', that might not be a reliable historical statement.[108] But whatever time it started, a race for the future of democracy now began. The Persians took the sea route and sailed south down the Euripus channel and round Cape Sounion. A story did the rounds of a shield being held up as a signal to them, but where and by whom this was done is not specified. Allegations of treachery by the Alcmaeonids started to circulate, but Herodotus was keen to dismiss them as fake news: the Alcmaeonids were, after all, renowned tyrant-haters.[109]

Meanwhile the Athenian spearmen returned from the field of battle as fast as they possibly could, and one of them immortalised himself as the second of the great Marathon runners: 'Most historians say that it was Eucles, who, still hot from the battle, ran in full kit, burst through the Archons' doors, and could only say, "Rejoice! We won!" He then immediately breathed his last.'[110] In the meantime, the main Athenian force marched from one sanctuary of Heracles at Marathon to another, at Cynosarges, south-east of Athens. They arrived before the Persians, who would have needed around thirty to forty-five hours depending on wind and sea conditions.

Stymied in their intentions, the invaders rode at anchor off Phalerum until their commanders called off the mission and set sail for Asia.

As the blood was drying on the plain at Marathon, 2,000 Spartans arrived. They had left after the full moon as promised, but only reached Attica the day after the battle.[111] They still wanted to see the Medes, so they went to the battle site, where they might have acquired some crucial military knowledge for the future, before marching home again after lavishing praise on the Athenians. Miltiades, the one-time tyrant and Persian collaborator, was hailed as the saviour of democracy. He, the Marathonomakhoi ('Marathon-fighters') and Athens revelled in the glory: a hoplite helmet inscribed 'Miltiades dedicated this to Zeus' was dedicated at Olympia, which has traditionally been seen as a dedication for the Marathon victory;[112] at Delphi the Athenians advertised their victory by constructing a beautiful treasury out of Parian marble, decorated with sculptures showing scenes from the mythologies of Theseus and Heracles, and bearing the inscription, 'The Athenians dedicate this to Apollo as first-fruits from the Medes at the Battle of Marathon';[113] in Athens we hear of a colossal bronze statue of Athena Promachus ('Who Fights for Us') by Phidias on the Acropolis, which was visible from Cape Sounion,[114] and it has been suggested that the equestrian figures and grooms on Phidias's Parthenon frieze, who can be made to number 192, represent the heroised dead of the battle.[115]

The Marathonomakhoi became role models for the young and a byword for the virtues of the 'Good Old Days' at Athens,[116] and Aeschylus's self-composed epitaph shows that, despite his stellar career as a playwright, he regarded fighting at Marathon as his finest achievement:

This tomb in grain-bearing Gela covers Aeschylus son of
 Euphorion,
An Athenian who died here.
The famous grove of Marathon could tell of his prowess,
And the Mede with his thick long hair knew it all too
 well.[117]

Athenian orators never tired of singing the praises of the
heroes who saved Greece from the Barbarian menace:

They alone faced incredible dangers in defending the whole
of Greece against many tens of thousands of Barbarians. For
the King of Asia, who wasn't satisfied with the wealth that he
already had, and hoping to enslave Europe as well, sent out
an army of 500,000 [. . .] But our ancestors had no fear of
the vast numbers of their adversaries. Far from it! They had
belief in their own courage. They felt shame that the
Barbarians were in their country [. . .] They didn't want to
have to thank others for their salvation. No! They wanted
the other Greeks to have to thank them [. . .] They proved
that they were real men, and when courage was needed, they
were as careless of their limbs as they were of their lives [. . .]
And so, in their own land, they erected a trophy on behalf of
Greece for victory over the Barbarians.[118]

Darius, meanwhile, yearned for revenge.

CHAPTER 8

The Second Interwar Interlude

After this, constant threats-and-promises and stories of
massive preparations kept arriving from the Great King.
But as time went on news came through that Darius had
died, and that his violent young son had succeeded to the
throne, and that there was no way he was going to call off
the expedition.

The Athenian Stranger[1]

The Death of Miltiades and a Spate of Ostracisms

From Darius's perspective the 'trauma'[2] at Marathon was only a
temporary setback. On the positive side the mission against
Eretria had been accomplished, but if the Great King wanted
to complete the job at Athens he would have to learn from his
mistakes and return with a larger force that was fitter for
purpose. For the Athenians Marathon had been a huge moral
victory as well as a military one. Democracy had triumphed
over tyranny and barbarism, and the Athenians' prestige had
shot through the roof. They had stopped the seemingly invin-
cible Persian war machine in its tracks, and they and their

fellow Greeks were confident, perhaps overconfident, that they could do it again.

Miltiades used his newfound celebrity to go on the offensive. In the autumn of the archonship of Phaenippus (490/489), he asked the Athenians to give him seventy ships, which was practically their entire navy,[3] plus an army and funding for an expedition. He did not disclose where he was going to lead these 14,000 men beyond saying that it was rich in gold. Athens's democratic bodies gave him the go-ahead.[4] His prime target was in fact the island of Paros, which is richer in marble than gold,[5] and his pretext was that the Parians had sent a trireme to assist Datis and Artaphernes.[6] His real reason was said to be a personal grudge against a man of Parian descent called Lysagoras, who had soured his relationship with the eminent Persian Hydarnes son of Hydarnes.[7] Miltiades' forces laid siege to the Parians, demanded 100 talents, and threatened to storm the city if this was not forthcoming. The Parians had no intention of paying and strengthened their fortifications. Their version of events was that a Parian slave woman called Timo advised Miltiades to go to the precinct of Demeter Thesmophoros ('Bringer of Treasure'), although the Delphic oracle later said that it was actually a phantasmal image of Timo that lured Miltiades into his transgressions. He climbed over the fence, entered the shrine, probably saw some sacred things that no male should ever see, and was overcome with uncanny horror. As he made his way back out, he jumped off the wall and badly twisted his thigh or damaged his knee.

The siege had been going on for twenty-six days when the Parians decided to negotiate, but when a wildfire broke out they mistook it for a Persian fire signal and called off the talks.[8] 'Breaking treaties like the Parians' became a proverbial

expression, and having failed to capture the town, the injured Miltiades abandoned the devastated island and returned to Athens. Everyone was talking about him when he got back, and Xanthippus son of Ariphron from the deme of Cholargus immediately had him impeached, demanding the death penalty.[9] By now Miltiades' festering injury had made him too sick to speak in his own defence, so, in a scene that could have been taken straight out of an Athenian tragic drama, he was brought into court on a bed.[10] His friends and relatives reminded the jurors of his great achievements at Marathon and about his conquest of Lemnos,[11] but he was still found guilty. Although he escaped being hurled into the pit, as Darius's emissaries had once been, he was fined the hefty sum of fifty talents.[12] He never paid the fine, because gangrene set in and Miltiades died of his wound.[13]

The Roman writer Cornelius Nepos concluded his biography of Miltiades with an epitaph:

> He had huge authority throughout all the Greek states, a noble name, and the greatest renown in military matters. The Athenian people looked at these qualities, and preferred that, even though he was thought innocent, he should suffer, rather than that they should continually live in fear.[14]

Their worry, as they looked at their precious and thriving democracy, was that he might still choose to make himself a tyrant, and ultimately that fear, and inter-factional politics, outweighed any gratitude for spectacularly saving the democracy that they now guarded so jealously.

The Athenian *demos* took a zero-tolerance approach to any hint of collaboration with the Persians or the Peisistratids that

might lead to a tyrannical takeover, and two years after Marathon they started to use ostracism to purge the perceived enemies of democracy. In 488/487 the first victim was Hipparchus son of Charmus from the deme of Collytus, who was probably married to a daughter of the ex-tyrant Hippias. The next year's victim was the leading Alcmaeonid Megacles son of Hippocrates from the deme of Alopece, nephew of the democratic reformer Cleisthenes. Even the family who gave the Athenians their democracy could be seen as a tyrannical threat. Various unnamed 'friends of the tyrants' were ostracised over the next three years, followed in 485/484 by Miltiades' prosecutor Xanthippus. Although he was 'unconnected with the tyranny',[15] one surviving *ostrakon* claims that 'Xanthippus son of Arriphron [*sic*] does the most wrong of all the sacred leaders'.[16] These were politically nervous times.[17]

Further significant tweaks were also made to Athens's democratic system, reputedly in 487/486 by the 'champion of democracy [. . .] clever in political matters and outstanding in his integrity',[18] Aristides son of Lysimachus from the deme of Alopece ('Fox-deme'). He was a fox by nature as well as by deme, and he saw that the majority of Athenians wanted a more popular form of government, so he pushed through a new system for selecting the archons: 500 candidates, 50 per tribe, were pre-elected, from whom the nine archons were selected by lot.[19] This inevitably made the archonship far less attractive to ambitious politicians: no matter how popular anyone was, he only had a 2 per cent chance of winning the office even if he won through the first election. The effects of this were to make the elected office of general the key political position for ambitious men, weaken the hold on the government by the old aristocracy, and increase the direct power of

the *demos*. Marathon had not just saved democracy, it was now gradually making it more radical.

Persia: A New King and New Plans

While Athens was exploring the potential and challenges of democratic rule, King Darius was licking his wounds and nursing his grievances:

> When the report about the battle at Marathon reached Darius [...] who was already beside himself with anger because of the Athenian attack on Sardis, he became even more enraged, and even more determined to launch an assault on Greece. He lost no time in sending messengers to the cities that he controlled, with orders to mobilise a much larger army than they had done previously, along with warships, horses, food supplies and transport vessels. The King's command was communicated, and the whole of Asia descended into turmoil for three years, with the finest fighters being enrolled in the army and prepared for the invasion of Greece.[20]

However, his 'just grievances' and Queen Atossa's desire for Greek slave girls had to be put on hold: in 486 BCE Egypt revolted from Persia, and bringing this important satrapy back under control was far more important than any expansionist projects in Europe.

Darius also had dynastic issues to resolve. He had had three sons by his first wife, the daughter of his co-conspirator Gobryas, of whom Artobazanes was the eldest, and four by Atossa, all born after Darius became king: Masistes, Hystaspes,

Achaemenes and the eldest Xerxes (Old Persian: *Xšayaršā* = 'He Who Rules Over Heroes', not, as Herodotus thought, 'Man of War'[21]). Artobazanes claimed precedence on the basis of primogeniture, Xerxes on porphyrogeniture, and the conflict was resolved by Demaratus the ex-king of Sparta, now in voluntary exile at Susa:[22] at Sparta the eldest child born after the accession of the king became the heir, and Darius gave Xerxes the nod on that basis.[23] Xerxes, though, attributed his primacy to the god Ahura Mazda:

> A great god is Ahura Mazda [. . .] who made Xerxes King, one King of many, one Lord of many.
>
> Xerxes the King proclaims: Darius also had other sons, but thus was the wish of Ahura Mazda: my father Darius made me the greatest after himself [I.e. his successor]. When Darius, my father, died, I became King in my father's place by the favour of Ahura Mazda.[24]

In the midst of his preparations for Greece, and with the Egyptian revolt still raging, Darius died from unknown causes in 486 after a thirty-six-year reign.[25] Xerxes ascended to the throne:

> I am Xerxes, the Great King, King of Kings, King of Countries Containing Many People, King of this Great Earth Far and Wide, son of Darius, the King, the Achaemenid.[26]

The Athenian in Plato's *Laws* was unimpressed by the Great King:

After Darius came Xerxes, who again was raised with a regal and luxurious upbringing: 'O Darius' – I think that's the best way of addressing him – 'you really haven't learned from Cyrus's mistake have you? You've educated Xerxes to have exactly the same morals as the ones that Cyrus instilled in Cambyses!' And because Xerxes was the product of the same type of education, he ended up with a life that repeated almost the identical misfortunes as Cambyses's. Ever since then hardly any Persian king has been truly 'great', except in having the title 'the Great'.[27]

Herodotus, on the other hand, said that Xerxes was a tall, good-looking man who was eminently worthy of holding royal power,[28] and Xerxes himself proclaimed his royal qualities with supreme self-confidence – his inscription found 2 km north of Persepolis uses the exact same wording as that on Darius's tomb at Naqsh-i Rustam, except with his own name.[29] He married Amestris, daughter of Onophas or one of two people called Otanes, with whom he had three sons, Darius (aka Dariaeus), Hystaspes and Artaxerxes, and two daughters, Amytis and Rhodogyne.[30]

As King of Countries Containing Many People, Xerxes needed quickly to quash the revolt in Egypt, which he did in 485, making it 'much more enslaved than it had been under Darius'.[31] Rather closer to home were one or possibly two revolts which broke out in Babylonia in 484.[32] Babylonian documents mention two kings, Bel-shimanni and Shamash-eriba, who had brief reigns, and Ctesias says that Zopyrus, the governor of Babylon, was murdered before order was restored by Xerxes' son-in-law Megabyzus, to whom the grateful king gave a golden millstone weighing around 180 kg.[33]

With the empire firmly under control, Xerxes had to decide what to do about his parents' plans for Greece. He was ambivalent about the project at first, but his nephew and son-in-law Mardonius son of Gobryas, whose ships had been wrecked off Mt Athos in the expedition of 492,[34] was gung-ho: the Athenians had to be punished, he said; it would bring fame to Xerxes; victory would deter others from attacking Persia; Europe was a truly beautiful and excellent land, full of exquisite trees; only Xerxes was worthy of ruling it; and although he did not say as much, Mardonius wanted adventures and to be the satrap of the newly conquered territory.[35] He 'misleadingly seduced'[36] Xerxes to his way of thinking, although other considerations played on the king's mind: the Aleuadae, who were the ruling family of Thessaly, invited him into Greece; Peisistratus, still at Susa, did the same, promising extra rewards; and a dodgy Athenian oracle-monger called Onomacritus recited suitably edited favourable prophecies.[37] Xerxes also felt impelled to complete his father's unfinished business: Sardis must be avenged; Athens must be destroyed; Marathon must be overturned; the Hellespont must be bridged; and, in a significant piece of mission creep beyond crushing Athens, Persian power must be extended to the ends of the earth:

> If we conquer these people, and the ones who live near them in the land of Pelops of Phrygia [i.e. the Spartans in the Peloponnese], we shall make the limits of Persian territory coterminous with the sky, the domain of Ahura Mazda.[38] The sun will not look down on a single land that does not lie within our borders [. . .] It is not just those who have wronged us who will bear the yoke of slavery; it is also the innocent![39]

Xerxes asked his advisors whether they agreed. Mardonius was completely in favour: he loved the idea of subduing and enslaving people who had done the Persians no wrong, so they should be especially ruthless with these '*Yauna* Beyond the Sea' who had attacked them without provocation; there was no reason to fear people who stupidly fought among themselves all the time; and 'when they see the combined forces of Asia arrayed against them they will crumble immediately, but if they fight they will inevitably lose; we are the greatest warriors on earth; let's go for it!' he said.[40]

After a brief deafening silence, Xerxes' uncle Artabanus the son of Hystaspes urged caution, as he had with Darius and the Scythian expedition. That had ended badly, he argued, and could have been much worse, and the people Xerxes was now intending to attack were much better fighters on both land and sea; if Histiaeus hadn't talked the other Greek tyrants out of it, Darius would have ended up stranded on the wrong side of the Danube;[41] it would be much worse for Xerxes to become isolated across the Hellespont; the god smites great people with his thunderbolts more often than ordinary ones; huge armies are defeated by smaller ones; the only person in whom the god tolerates pride is himself; haste is the father of failure. He felt it was wrong for Mardonius to disrespect or underestimate the Greeks, so he offered him a deal. Mardonius could take the army while Xerxes stayed in Persia, but Mardonius and Artabanus should put their own and their children's lives on the line. If Mardonius returned victorious, Artabanus and his sons should die; defeat would mean death for Mardonius and his sons.

Xerxes did not like what he heard. He accused his uncle of cowardice, and decreed that he should stay behind with the

women – the ultimate disgrace. Compromise with the Greek states was unthinkable:

> There is no middle ground in our mutual hatred. It is entirely right that we should exact vengeance for what was done to us first. That way I shall find out what this 'terrible disaster' is that is supposed to happen to me when I march against these men – men that even Pelops the Phrygian, who was a slave of my forefathers, so completely dominated that even today the people and their country are called by the name of their conqueror.[42]

In myth 'Pelops the Phrygian', the eponym of the Peloponnese, originally ruled the area around Mt Sipylus in Lydia,[43] which was near enough to Phrygia in Xerxes' rather bizarre reappraisal of the Greek tradition, and allowed Xerxes to credit this 'slave of my forefathers' with subduing Greece: the Persian king himself could surely outdo mere Persian subjects, he thought.

At this crucial moment Herodotus presented his readers with a dream sequence. Xerxes' anger subsided and, as he slept on the decision, he decided that Artabanus had been right after all. But a ghostly apparition in his sleep instructed him to stick to the invasion plans. The king chose to ignore the vision, and he told the Persians that Artabanus was right, and the expedition was off. However, the phantom appeared again the next night, with the same belligerent message. Xerxes summoned Artabanus and told him that although he still preferred his wise advice, he did not dare to go against the gods, and to make sure it was a genuine divine vision, Artabanus should dress up in Xerxes' clothes, sit on his throne, and then sleep in his bed to see if the apparition visited him as well. Artabanus was

sceptical, but Xerxes was insistent, and when the menacing vision duly appeared again the wise advisor yielded to the will of the gods:

> Since your enthusiasm is of supernatural origin, and since the destruction on its way to the Greeks seems to be of divine origin, I myself back down and reverse my opinion. You must now communicate the god-given message to the Persians and instruct them to implement your original command about making preparations.[44]

So the expedition was on again, and Xerxes had yet another vision, in which he was crowned with an olive bough, whose shoots spread over the entire world before it disappeared into thin air. The Magi interpreted this as meaning that he would enslave the whole of humanity.

It took from 484 to 481 to prepare and equip the army, and Herodotus says that when it set out on campaign in 480 there had never been one that came anywhere near to it in size.[45] The invasion would be a combined land-and-sea operation, and every nation of the Persian Empire would provide ships, infantry, cavalry, food and logistical support. They would follow the same route that Mardonius had used in 492: the army would march through Thrace and Macedonia into northern Greece, supported by an enormous fleet, and the advance preparations would involve some extraordinary feats of engineering.

In northern Greece Xerxes' multi-ethnic workforce, supplemented by local labour, worked in relays under the lash for about three years, digging a canal through base of the Mt Athos peninsula to avoid the treacherous waters that had previously destroyed Mardonius's ships. The mountain's landward end has

a low, narrow isthmus about 2.5 km wide, and there Xerxes'
workers divided the terrain up by nationality:

> They marked out a straight line near the town of Sane, and
> then, when the trench had been excavated to a reasonable
> depth, some workers stood at the bottom and carried on
> digging, while others took the soil that was continually being
> removed and passed it on to other labourers who were stand-
> ing on higher platforms. They then took it and handed it on
> to others, until they got to the people at the top, who took it
> away and disposed of it. Everyone apart from the Phoenicians
> found that the steep sides of the canal kept falling in, thereby
> doubling their workload. They were making the width at the
> top the same as that at the bottom, so something like that
> was bound to happen. But the Phoenicians [. . .] took the
> section that had been assigned to them and started by
> digging the top part of the trench twice as wide as the actual
> canal was going to be, and gradually narrowed it as they
> went along, until by the time they got to the bottom, their
> work was the same width as everyone else's.[46]

The finished canal was about 30 m wide at the top, and 15 m
at water level, wide enough to take two triremes abreast, and
moles were constructed at the canal's entrances to stop them
silting up.[47]

For Herodotus the entire project was all about Xerxes' over-
inflated ego. He says it would have been a simple task to drag
the ships across the isthmus (in fact, it would not have been),
and Xerxes just wanted to display his power and leave a perma-
nent memorial (he did – archaeological traces of it still
remain[48]), but it would be a useful project for the future, once

there was regular traffic between Persia and the new satrapy of Greece.

Herodotus says that the same workforce also constructed a bridge across the River Strymon at Nine Ways,[49] along with at least one other, presumably near the mouth of the river, to avoid traffic congestion among Xerxes' mighty army. The same skills were applied to creating bridges from Asia to Europe across the Hellespont. These spanned a distance of around 1,500 m[50] and stretched from just west of Abydus on the Asian side to somewhere between Sestos and Madytus on the European.[51] The Greeks were particularly impressed by the cables that formed the basis of the construction:[52] the Egyptians wove theirs out of papyrus, whereas the Phoenicians used heavier 'white linen' (esparto grass), which Herodotus says weighed one Samian talent per cubit (about 49 kg per metre), and so about 75 tonnes in total.[53] But as soon as the structures bridging the straits had been completed, a storm 'chopped them up'[54] and smashed them to pieces. Xerxes' response of 'yoking the Hellespont with devices in order to create a passage'[55] and binding its 'boisterous neck in fetters of flax'[56] became a classic example of Barbarian hubris, although it might also have been a case of Herodotus misreading a Persian religious ritual:[57]

He was livid, and ordered that the Hellespont should be flogged with 300 strokes of the lash, and that a pair of shackles should be sunk in the sea. I have even heard that he sent tattooists to brand the Hellespont as well. Whatever, he instructed them to speak these barbaric and wicked words, while they were doing the whipping: 'Bitter water! Our master is inflicting this punishment on you for doing wrong to him when he had done nothing wrong against you. Xerxes

the King will cross you, whether you want him to or not. No one sacrifices to you, and rightly so – you are a troubled and salty river![58]

In Aeschylus's tragedy *The Persians*, the ghost of Darius also lamented Xerxes' transgressions:

He hoped to stem the flow of the divine Hellespont, the Bosporus, a god's river, by putting shackles on it like a slave, and tried to change the rhythm of its course, hurling hammer-wrought fetters into it, and creating a great pathway for a great army. He stupidly thought that he, a mortal, could rule over all the gods, and over Poseidon. How can my son not have been mentally ill?[59]

Once the seaway had been duly punished, the project managers of the bridge were beheaded. Lessons were learned, and a new batch of workers completed the construction under the supervision of a Greek astronomer/mathematician called Harpalus,[60] who developed a kind of pontoon-cum-suspension-bridge. Each bridge now had four papyrus and two esparto-grass cables, which were started on land, and then twisted on wooden 'donkeys' (windlasses) on shore until they reached the other side. Herodotus does not tell us how, or precisely where, the ends of the cables were secured,[61] but the upstream bridge, nearer the Black Sea, was made from 360 penteconters and triremes positioned at right angles to the centre line of the bridge, and the downstream one from 314 ships, more loosely aligned to present their bows to the strong and variable current, and so reduce the strain on the cables. The vessels were anchored on the upstream and downstream

sides to secure them both against the current and the winds blowing in opposite directions from the Aegean and Black Seas. This was no mean feat, given that the channel is over 100 m deep at some points.

The vessels, which had effectively become pontoons supporting the cables, causeway and traffic, were anchored quite close to one another. A trireme had a beam of about 6 m and a penteconter of 4 m, so over 300 of them would have stretched almost across the whole waterway, although gaps were left at some points to allow the passage of light craft if needs be. The ships were positioned to take the weight and strain of the cables, which themselves formed the basis of the causeway. Tree trunks were sawn to match the width of the pontoons and were neatly arranged in rows on top of the cables, which in their turn held the roadway together. The tree trunks were covered in brushwood and then soil, which was packed down to form a normal road surface, probably about 4 m wide, and fences were erected on either side to prevent the horses getting spooked by the sight of the water.[62] The construction of the bridge project is a brilliant example of the engineering skills deployed by the Persian Empire, but for Herodotus it simply underlined the out-of-control arrogance of its ruler.

The final element in Xerxes' forward preparations was the establishment of supply depots along the planned route into Greece. Strategically selected sites from Thrace to Macedon were used for warehousing the enormous quantities of provisions that were shipped in from all across Asia.[63] Nothing was being left to chance.

As his subjects were carrying out his wishes, the King of this Great Earth Far and Wide was on the move himself.[64] The army had been mustered at Critalla (possibly modern Tiralla, Turkey[65])

in Cappadocia, and Xerxes travelled with it along the Royal Road. They crossed the River Halys into Phrygia, which may have been another symbolically transgressive action in Greek eyes,[66] and arrived at Celaenae (Dinar, Turkey), whose main tourist attraction was the flayed skin of the mythical Marsyas, whose hubris had led to his own indescribably painful punishment by Apollo.[67] Here Herodotus begins a story about a Lydian called Pythius, the richest man in the world after Xerxes, which has strong parallels in *Arabian Nights* and echoes of the tragic tale of King Midas of Phrygia.[68] Again hubris comes to the fore. Pythius entertained Xerxes and his army in fine style and offered the king all his money as funding for the war. He could afford it because he could still live in luxury from the proceeds of his farms. Xerxes was impressed but declined the offer. Instead, he rounded up Pythius's wealth to the nearest million gold *staters*, and told him to keep everything,[69] at which point Herodotus left the story to be continued . . .

Xerxes then moved on through Anaua (aka Sanaos, modern Sarıkavak), past a salt lake (modern Acı Göl, which still exists), and on to the city of Colossae (near modern Honaz), where the River Lycus (Çürüksu Su) temporarily goes underground on its way to join the Maeander. From there he moved into Lydia at the town of Cydrara (precise location unclear), where there was an inscribed pillar erected by Croesus, another transgressive boundary crosser. The road later forked in two, and the king's army turned west towards Sardis, crossing the River Maeander, and passing Callatebus (location unknown), which was famous for its honey, before reaching a plane tree that was so beautiful that Xerxes decorated it with gold and detailed one of his Immortals to guard it. Golden plane trees appear in the Zoroastrian holy text the *Avesta*, and one of Xerxes' cylinder

seals, now in Brussels, shows the king ('I Xerxes') offering a crown to a tree,[70] but again the Greeks would have been more inclined to read Xerxes' nature-loving religiosity as stereotypical Barbarian luxury. The next day the army reached Sardis at the end of the Royal Road. There they went into winter quarters as they waited for the bridges and canal to be completed.

The first thing on Xerxes' 'to do list' at Sardis was to send heralds to the Greek states demanding the obligatory earth and water, and commanding them to prepare meals for the king when he arrived. Some states did Medise – Herodotus lists the Thessalians, Dolopians, Enienians, Perrhaebians, Locrians, Magnesians, Malians, Achaeans of Phthiotis, Thebans, and all of the Boeotians apart from the Thespians and Plataeans[71] – while others remained neutral or dithered. Posterity would never forgive Thebes for its Medism, although it was ruled by a narrow oligarchy who may have gone over to the Persians against the wishes of the majority of the population.[72] All this gave Xerxes a good indication of how divided Greece might be, but he did not repeat Darius's request for earth and water from Athens or Sparta. Even though they had pointedly refused on that occasion, he was sure that fear would make them surrender this time.[73] There was no need to ask twice.

Silver and Ships

While the Persians had been undergoing the transition of power from Darius to Xerxes, Athens's focus had been on internal factional struggles, and external animosities with their old enemies on Aegina.[74] There would have been no mistaking the immediate implications when Xerxes' engineers started to build the Athos canal, but while that project was under way, in the

archonship of Nicodemus (483/482), Athens's own excavators discovered an unusually rich vein of silver at Maronea in the state-owned mining district of Laurion on the Sounion penin-sula: 'they have a fountain of silver, the treasure-house of the land', said the Chorus in Aeschylus's *Persians*.[75] The usual policy in these circumstances was to distribute the windfall to the citizens, but on this occasion Themistocles, who had had his sights set on Athenian naval power for a decade,[76] persuaded them to spend it differently. In one account, he was secretive about what the money would buy, just proposing that the *demos* should lend Athens's 100 richest citizens one talent each, and that if they were not ultimately satisfied with the outlay of the funds, they could recoup the money. The Assembly agreed, and each man built a trireme. In Herodotus's tradition, Themistocles was more transparent. He persuaded the *demos* to build 200 triremes for the hostilities against Aegina.[77] Herodotus comments on the irony that this was what saved Greece from the Persians, because it had forced the Athenians to become seamen.[78] However, the Persian menace may also have been an unspoken factor in Themistocles' thinking, even though Plutarch suggests that 'there was no need to use the Persians as a threat, because they were far away and caused very little fear that they might come'.[79]

Themistocles' trireme-building programme was one of the most significant decisions the Assembly ever made, but the transition from the land-fighting era of Marathon to what would ultimately become Athens's sea-based imperialist domi-nance of the Aegean world did not happen without a fight. The opposition came from Aristides 'the Just', son of Lysimachus, and the prosperous, landowning hoplite class, who were worried that the lower classes might experience a

'levelling up' in their status if they provided rowers in a fleet, and that the wealthier citizens would be responsible for maintaining the warships.[80] The impasse was resolved by ostracism. Archaeological finds of well over 1500 *ostraka* with Themistocles' name on them show how controversial he was. These include 190 pieces that are so similar in material (mostly the broken bases of drinking cups), spelling (Themisthokles is common) and handwriting (they were written by just fourteen people) that they must have been pre-prepared to hand out before the vote.[81] But Themistocles could always mobilise more supporters than his opponents, and by astute propaganda he secured the ostracism of Aristides at 'around this time'[82] (483/482). In later times a story did the rounds about Aristides' integrity:

> While the voters were writing their *ostraka*, an illiterate man, who was an absolute peasant and thought Aristides was one of the ordinary citizens, handed him his *ostrakon* and asked him to write 'Aristides' on it. Aristides was taken aback, and he asked the man what harm Aristides had ever done to him. 'Absolutely nothing,' he said, 'I don't know the man. But I'm fed up to the back teeth of people calling him "the Just".' When he heard this, Aristides didn't say anything, but he wrote his own name on the *ostrakon* and gave it back.[83]

Aristides went to Aegina;[84] the shipbuilders got to work.

Triremes

The construction of a large fleet of state-of-the-art warships in a matter of months, and the ability to crew and maintain them, were a testament to Athens's wealth and political dynamism.

'Trireme' is an Anglicisation of the Latin word *triremis*, but that is a literary landlubber's word: Greek and Roman sailors called the vessel *trieres*. Our ancient written sources tell us next to nothing about how a trireme was actually built and how it functioned – there was no need to because everyone knew – although the extensive inscribed records from the Athenian naval yards give us insights into the everyday processes of keeping the fleet at sea.[85] *Trieres* enigmatically means 'three-fitted', but because the evidence for what it was like could only be inferred from scattered pieces of evidence in sculpture, vase paintings, coins, inscriptions, literary references and archaeological discoveries, there was considerable argument about the 'Trireme Question' going back as far as the fifth century CE. But in the 1980s a brilliant multinational, interdisciplinary experimental archaeology project used the best available evidence to reconstruct a fully operative, full-scale trireme called *Olympias*, which was tested in sea trials to provide illuminating answers.[86]

When the Athenian shipbuilders laid the keel for a trireme, they were intending to build a light, manoeuvrable and streamlined vessel, but one that was robust and durable. She would have a displacement of around 45 tonnes when fully laden, and be about 37 m long and 6 m wide in order to fit into the ship sheds at the Piraeus. She had a beam of approximately 3.7 m at the waterline, measured 4 m keel to deck, and had a draught of roughly 1.2 m when fully crewed and loaded. The shallow draught was an asset when it came to beaching and launching, which could be done quickly and efficiently, but it meant that triremes were unsuited to the open sea and effectively restricted to sheltered and coastal or inshore waters. Even a 1 m swell could pose a danger of water coming in through the lower oar

ports, or of excessive longitudinal stresses on the hull springing the mortice-and-tenon joints of the ship's sides. With that in mind, sturdy reinforcing hawsers called *hypozomata* ('under-belts') were passed from stem to stern under the gunwales. The typical working life of these craft was around twenty years.

The trireme's prime offensive asset was its ram (*embolon*), which projected from the prow at the waterline. It was made from a mighty piece of timber that was clad in bronze, and which ended in a blunt, square-ish face with three transverse fins. It was designed to deliver a shattering blow that smashed the planking of the enemy's hull so that it started to take water on board. Timing was everything here: if the ramming vessel was too slow, the target could take evasive action; if the attacking trireme was too fast it risked getting stuck in the target's broken hull and becoming vulnerable to attack itself; but if it delivered the perfect blow, it could cripple the enemy vessel and then swiftly backwater and seek a new target. Well-trained fleets could coordinate their manoeuvres to execute the *diekplous* and *periplous* tactics that were attempted at the Battle of Lade,[87] although individual 'dogfights' were common enough in the chaos of battle.

In order to deliver the killer blow, the trireme needed top-quality seamen. The muscle power was supplied by 170 oarsmen who were generally recruited from the *Thetes*, who could not afford to serve as hoplites. The rowing techniques were relatively easily learned, and all they had to supply was upper-body strength, stamina and a sheepskin pad to sit on. Any clothing, weaponry, and food and drink taken aboard was at their own discretion but was severely limited by the space available. The rowers sat in the tiers of three that gave the *trieres* its name. They were positioned one above the other, with each of

them pulling a single oar, but working in twenty-seven units of three, plus two oarsmen rowing singly fore and aft on each side. The oars were of uniform length – about 4.25 m, with slightly shorter ones issued to the rowers at the bow and stern, where the curve of the hull restricted their space a little – which made standardising the logistics simpler. Two hundred oars were issued to each vessel: one per man, plus thirty spares. The rowers in the upper tier were called *thranitai* (from *threnys* = 'a stool'). They sat on an outrigger (*parexeresia*) which projected about 60 cm out from the gunwale and ran, following the curve of the hull, from slightly abaft of the ram to just before the two steering oars at the stern. These rowers enjoyed the best of the fresh air, but were more vulnerable to missile attack, and needed greater strength to manipulate their oars because they were sitting relatively high above the water, which they had to strike at quite a steep angle. Below, inboard and slightly aft of the *thranitai*, just below the gunwale, sat the 'thwart-men', the *zygioi*, so-called because they sat by the thwarts (*zyga*). The rowers sitting in the bowels of the ship, below, inboard and slightly aft of the *zygioi*, were the *thalamioi*, named after the oar ports (*thalamiai*) which they used. The *thalamioi* sat between the hull beams and only about 50 cm above the waterline, and to prevent the vessel taking on water through the openings each rower had a leather bag (*askoma*) that fitted neatly around the oar and its oar port.

The rowers had only about 1 m between them and the man in front, with the buttocks of those on the higher levels practically in their face, so the enclosed space occupied by the *thalamioi* was a foul-smelling, claustrophobic area with hardly any peripheral vision, and must have been a very disorienting environment during combat. The trireme also had no latrines, and

once the oarsmen were seated there was little freedom of movement. In the tightly packed, confined area, there would have been people sweating profusely with the exertions of rowing, vomiting with seasickness, and urinating and defecating, voluntarily or involuntarily, through lengthy confinement and/or fear. In their lighter moments the Athenians could see the funny side of this, however, and Aristophanes' comedy *Frogs* generates great hilarity by making the god Dionysus suffer intense discomfort while rowing:

DIONYSUS: I've got blood-blisters! My arsehole's been
 sweating for ages, and any moment now it'll peep out
 and say . . .
FROGS: [interrupting with impeccable comic timing]
 Brekekekex koax koax![88]

The Frogs' farting sounds are echoed later in the play when Aeschylus is telling Dionysus about the 'good old days':

AESCHYLUS: In the olden days, when I was alive, the
 only thing the sailors knew how to do was shout for
 their barley cakes and cry 'rhupapai'![89]
DIONYSUS: Fuck, yeah! And fart in the *thalamios*'s face,
 shit all over their messmates, and nick other people's
 clothes when they're on shore![90]

The rowers' energies were channelled into effective actions by a crew of 16 sailors, plus 10 hoplite marines and 4 archers, giving a full complement of 200. The official commander was the trierarch (*tierarkhos*), the wealthy civilian/political figure who had paid for the vessel, but in reality the helmsman

(*kybernetes*) ran the ship. He was assisted by a *keleustes* (time-beater), who had responsibility for training and morale, the *pentekontarchos* (literally 'Captain of Fifty', from the days when the penteconter was the standard ship), who was the purser and recruitment officer, the *naupegos* (ship's carpenter), and the *proreus*, who was the bowman or lookout. A *trieraules* (trireme-flautist) provided rhythmic accompaniment to the rowers, and various matelots took care of the ship's tackle. The hoplites and archers provided the trireme's secondary offensive asset, tasked with strafing the enemy's decks as the ships closed for ramming, taking over a stricken vessel or repelling boarders if necessary.

Thucydides tells us that the Athenian triremes of this generation 'were not constructed with full decks'.[91] They had decking (*katastroma*) over the bow and the stern, roughly 1 m above the *thranitai*, with gangways running lengthways over the gunwales and a companionway down the centre. Ships of this sort were called *aphraktos* (unfenced/unfortified/not decked[92]), and although they only carried a few deck-fighting troops, they were fast, agile and highly suitable for ramming tactics. The boat was steered with two rudders at the stern and could execute a 360-degree turn in a circle of 3.4 ship-lengths in diameter with both sides rowing, and in under 2 ship-lengths if one side took their oars out of the water, while a sharp 90-degree turn was possible in less than 1 length, even at maximum speed. Fully decked (*kataphraktos*) triremes also existed, which had planking all the way from the bow to the stern, protecting the rowers and providing a fighting platform which could accommodate an extra twenty to thirty crewmen. These were slower and less manoeuvrable, but better suited to deciding the issue through boarding, grappling and hand-to-hand combat. Both types of trireme needed to be careful about the weight

distribution on deck. If the marines literally rocked the boat, it would make rowing extremely awkward.

Ancient accounts indicate that a trireme could maintain a cruising speed of 6–7 knots (roughly 11–13 km/h) for several hours at a time, and the sea trials of *Olympias* showed that at around 45 strokes per minute she could accelerate to about 10 knots (18.5 km/h) in the quick bursts that were necessary in combat. A large square linen mainsail (*histion*) was raised amidships, but it was either stowed or left onshore for battle – the extra weight was a needless impediment and a ship under sail was not sufficiently manoeuvrable – but in pacific conditions the ship could sail just as fast as she could be rowed, although she was dependent on following breezes and did not have the ability to tack. Hoisting the sail during a sea-battle was a sure sign that a trireme was running away and in seamen's slang 'hoisting sail' meant precisely that.

True to universal nautical traditions the triremes were all given names, and because the Greek word *trieres* is feminine in gender, most vessels were 'she', as in English. The Athenian naval lists record some 300 names for the ships: *Amphitrite* and *Thetis* (names of sea-deities); *Aphrodisia* ('Ship of Aphrodite'); *Polias* (a cult title of Athena 'Defender of the City'); *Tauropole* (a cult title of Artemis 'Huntress of Bulls'); names that indicated desirable qualities, like *Hebe* ('Youth'), *Sozousa* ('Saving') and *Eukleia* ('Fame'); names of real or mythical animals such as *Lykaina* ('She-Wolf') and *Hippokampe* ('Mythical Seahorse'); names with warlike associations, such as *Akhilleia* (a female Achilles), *Aikhme* ('Spear') and *Aristonike* ('Best Victory'); and names that referenced districts of Athens, like *Sounias*, or crucial aspects of democratic life, as in *Komodia* ('Comedy'), *Eunomia* ('Good Government'), *Eleutheria* ('Freedom') and

indeed *Demokratia* ('Democracy') herself.[93] The new trireme
fleet brought crucial realignment of the political balance at
Athens, since the *Thetes* now acquired an importance in the
military which they had never had before, and with military
service came political leverage. Naval power and democracy
were inextricably linked from here on.

The fleet and its operation also generated a new kind of
industrial language, whose potential for scurrility was seized
upon by the comic poets. Oars and boat poles provided obvi-
ous Freudian double entendres, as did the oar strap (*tropoter*)
that attached the oar to the tholc pins and allowed the oar to be
pulled back and forth.[94] 'Managing two boats with one oar' was
a threesome,[95] and the stern of the vessel provided cheap homo-
sexual innuendo: 'Who is this gay sailor, right next to your arse,
leaning up against your stern?'[96] The ram could stand for a
phallus swollen by lust and wine, as in Aristophanes' *Birds*
when Peisetaerus describes his comically enormous erection as
a 'triple-rammed hard-on'.[97]

Features of the maritime landscape such as gulfs, channels
and promontories, and activities such as sailing into port,
could serve the same purposes, and whereas the land-based
Athenians tended to 'ride' their sexual partners, the seafaring
community 'sailed' theirs.[98] The fifth-century comedian (not
the philosopher) Plato even has deities 'sailing' one another:
'Aphrodite's being sailed by secret oar-strokes; Dionysus is
doing the sailing.'[99] On the mortal level, one woman in
Aristophanes' *The Women in the Assembly* says the reason she
did not answer the door in the early hours was not because she
was asleep: 'Darling, my husband, the man that I fuck with, is
from Salamis. He was sailing me all night long under the
sheets!'[100] The island of Salamis, where Themistocles' navy

would eventually emerge triumphant, seems to have been a highly sexed place. We get references to the island in relation to women straddling their partners, which was generally seen as characteristic of lascivious housewives and professional sex-workers. In *Lysistrata*, when the eponymous heroine complains that no women from the coast or from Salamis have turned up to her meeting, her friend Calonice exploits the double meaning of the word *keles*, which can either mean 'phallus' or 'fast yacht with a single bank of oars',[101] to explain the situation: 'I know that these women came at daybreak, sitting astride their fast yachts.'[102] 'Sea-fighting' was also used for having vigorous sex: Callias son of Hung-Like-a-Horse was doing it dressed in a lionskin in *Frogs*; Nausimakhe ('Sea-Fight-Girl') was the name of a prostitute who was better at it than the admiral Charminus; and when Dionysus said he was 'serving as a marine' with the famous passive homosexual Cleisthenes, Heracles asked him, 'And did you do any sea-fighting?'[103] In an all-female exchange in *Knights*, three personified triremes, including a young virgin one, talk about being requisitioned for an expedition, and worry that they will soon be 'boarded' by a particularly unpleasant politician.[104] In later times, however, Philip of Thessalonica imagines a vessel called 'The Good Ship Sex-Worker' who had fewer scruples: 'I am everybody's friend. Board me with confidence. I don't demand an expensive fare. I take everybody. I carry locals and foreigners alike. Row me on land or at sea!'[105]

In the end Athenian shipwrights built more vessels than they could initially man themselves. Another 100 or 200 ships in addition to the 70 or so that they already had would demand a force of between 34,000 and 54,000 personnel, even before they recruited any hoplites for land fighting.[106] However,

Herodotus was in no doubt that the Athenians' decision to resist Xerxes, and to do so with ships, not only saved their own city, but the whole of Greece:

> If the Athenians had been terrified by the impending danger, and abandoned their homeland, or indeed if they had stayed where they were but had surrendered to Xerxes, then nobody would have attempted to resist the King at sea. [Land-based resistance alone would have been futile] But as it is, anyone who says that the Athenians were the saviours of Greece is 100 per cent correct. The scales were bound to tip in favour of whichever side they joined, and by deciding that Greece should remain free it was them, and no one else, who motivated all the other Greeks (apart from the ones who had Medised), and, with the gods at their side, drove the King back.[107]

Greek Leadership

Athens's sea power was crucial, but Greece needed effective fighters on land as well as at sea. The victory at Marathon had been impressive, but when the rest of Greece looked for military leadership, they instinctively turned to Sparta. With their crushing victory over Argos at Sepeia still fresh in the memory,[108] their well-established hegemony over the Peloponnesian League, a tradition of uncompromising opposition to Persia and their all-round reputation for military excellence, the Spartans were the go-to warriors. They were also one of Xerxes' primary targets and had only failed to play an active role against Darius's invasion because of their religious commitments. Herodotus gives an insight into their steely attitudes in a tale

about two Spartiates who volunteered to go to Xerxes and let him execute them to expiate divine displeasure for the death of the Persian heralds.[109] En route they were entertained by Hydarnes, who asked them why they spurned Xerxes' friendship. If they would surrender to him, they would probably be granted large areas of Greece to rule over. But the Spartans were unimpressed:

> Hydarnes, your advice to us is unbalanced. It's partly based on knowledge, but also on ignorance. You know what it's like to be a slave, but you have never experienced freedom. You don't know whether it tastes sweet or not. If you did know what it was like, you would not just advise us to fight for it with spears, but with axes![110]

Once they had been admitted into Xerxes' presence, they bluntly refused to prostrate themselves before him. Spartans only prostrated themselves before the gods, they said, and in any case, that was not why they had come. They had come to die. Xerxes took the moral high ground and refused to lower himself to the Spartans' level by murdering heralds. They would have to live with their guilt, and the religious pollution it brought with it.

The influence of the divine was not to be underestimated. No Greek state would undertake a major military campaign without consulting the oracles. Contrary to popular belief, Greek oracles were not the product of frenzied, intoxicated, incoherent, substance-abusing women whose obscure, equivocal gibbering invariably left the enquirer completely bamboozled. The verifiably authentic responses that survive are usually direct answers to direct questions, although the stories

surrounding the consultations prior to Xerxes' invasion are gloriously colourful, and possibly invented after the event.[111] In Herodotus's account, Apollo's oracle at Delphi was deeply pessimistic. The Pythia (priestess) told the Spartans that either Lacedaemon would be destroyed by foreigners, or that its king would die:

> This is your fate, you who dwell in Sparta of the spreading
> roads:
> Either your great and glorious city must fall,
> Sacked by descendants of Perseus [i.e. Persians], or that will
> not happen,
> And the borders of Lacedaemon will mourn
> The death of a king descended from the stock of
> Heracles.[112]

The citizens of Argos also consulted the oracle, and got their response:

> Detested by those who dwell around you, but dear to the
> immortal gods,
> Keep your spear at rest indoors, crouch in a defensive
> position,
> Protect the head, and the head will keep the body alive.[113]

The Argives said that this prompted them to enter into negotiations with Sparta about signing a Thirty Years Truce in return for command of half the allied forces, but the talks went so badly that they ended up saying that they would rather be ruled by the Barbarians than give in to the Lacedaemonians. Other Greeks said Xerxes contacted the Argives directly, making great

play of their supposed common ancestry through the mythical Perseus, and that this resulted in Argos maintaining a position of neutrality. There was even a conspiracy theory that it was the Argives who invited Xerxes into Greece in the first place – alternative facts which Herodotus had no time for.[114] Argos's neutrality was crucial: had they proactively Medised they would effectively have taken their traditional Spartan enemies out of the conflict.

The Athenians' response to their own visit to Delphi in September 481 was pivotal to the entire resistance. The Pythia Aristonike ('Best Victory', an ultimately well-omened name) gave them a terrifying, doom-laden vision of shattered fortresses, burning houses and shrines of the gods sweating in fear and dripping with blood. She advised them to abandon their homes and flee to the ends of the earth.[115] The Athenian *theopropoi* ('oracle-seekers') were shell-shocked, but an eminent Delphian, Timon son of Androbulus, advised them to go and ask again. This they did, telling Apollo that they wanted a better answer, and that if they did not get one, they would just stay in his temple until they died. So, the Pythia gave them a new oracle:

Everything that the borders of Cecrops' land contain,
And the ravines of holy Cithaeron, shall fall to the enemy.
But far-seeing Zeus gives a wooden wall to Tritonian
 Athena,
This alone shall stand unravaged and help you and your
 children.
You must not stay and wait for the great host of horsemen
 and foot soldiers
Bearing down on you from the mainland. Withdraw!

Turn your backs! You will confront them in battle in due
 course.
Divine Salamis, you will destroy women's sons
When the seed is scattered, or when it is gathered in.[116]

The oracle ignited a vigorous debate. Once upon a time the
Acropolis had been defended by a wooden fence, and many old
men felt this was the 'wooden wall'.[117] Others saw it as an
oblique reference to Athens's ships, but were perplexed by the
apparently ominous reference to death at Salamis. Ultimately
Themistocles unlocked the riddle: 'divine' Salamis, as opposed
to, say, 'cruel' Salamis, would bring victory, not defeat; the
women whose sons would be destroyed there would be Persian;
they should fight at Salamis.

The Athenians decided to put their trust in the gods and
resist 'the Barbarian' with the full might of their fleet, ships and
men, alongside any other Greeks who would join them. The
Spartans were already committed, Argos at least would not
Medise, and messengers were sent out across the rest of the
Greek world. Gelon, the powerful tyrant of Syracuse in Sicily,
offered to contribute a large fleet and military force, but wanted
overall command of the war in return. This was rejected, as was
his compromise solution of command on either land or sea. So,
he sat on the sidelines. Corcyra (modern Corfu) despatched
sixty ships, but these delayed on purpose and only sailed as far
as Pylos, where they sat and waited for the outcome of the
fighting. The cities of Crete also consulted the Delphic oracle,
and opted to stay neutral, which in itself sheds interesting light
on Delphi's attitude: Apollo's earthly representatives were not
confident of a Greek victory, and saw neutrality as a viable
option.[118]

Finally, the Greeks tried espionage. Three spies were sent to conduct surveillance on the king's army at Sardis, but their cover was blown and they were condemned to death. However, Xerxes commuted the sentence, and showed them everything that they wanted to see, before sending them home unharmed. His thinking was that they would report back about his invincible power, which would make the Greeks surrender their 'weird freedom'[119] even before he set out. The first element in Xerxes' strategy was always to try to force bloodless capitulation by deploying overwhelming force, in the hope that it would never be needed. But his expectations were confounded. The Greek resistance by no means enjoyed universal support, but it did provide a framework of unity. The states who had refused to Medise held a conference at Hellenion in Laconia in which they exchanged ideas and pledges. Their prime concern was to bury their differences and cease the numerous wars between one another, especially that between Athens and Aegina.[120] The Persians were coming; the Greeks were as ready as they would ever be.

CHAPTER 9

The Persians are Coming!

Woven into the pattern [of the tapestries of gold at Babylon] you can see Datis wrenching Naxos up out of the sea, and Artaphernes laying siege to Eretria, and the battles that Xerxes said he won. Obviously, there is the occupation of Athens, and Thermopylae, and other scenes that are even more suited to the Median taste, like rivers being removed from the land, the bridge yoking the sea, and Mt Athos being cut in two.

Philostratus[1]

Xerxes on the Move

In the spring of 480 BCE Xerxes left Sardis to join the fleet at Abydus. Herodotus tells us that as they were on the move there was an eclipse of the sun. In fact, no such event was visible there at this time – the nearest ones were seen at Susa in 481 and at Sardis in 478 – but Xerxes was said to have consulted the Magi, who told him that this portended the destruction of Greece. However, Pythius the Lydian[2] felt it signified something far less positive. Confident in his good standing with the king, he asked for a favour, which Xerxes granted before he

knew what it was. Pythius wanted the eldest of his five sons to be allowed to stay at home to take care of him in his old age. Xerxes' reaction was of unmitigated fury: he was marching against Greece with his own sons, brothers, kinsfolk and friends, so how could Pythius, as a mere 'slave', talk about his eldest son? His past generosity would save Pythius and his four younger ones, but the eldest was chopped in half, and his dismembered body parts were placed on either side of the road down which the Persian army marched.[3] Xerxes' hubris was starting to get the better of him.

The army that marched between the severed cadaver was impressive. The baggage train led the way, followed by the ethnically diverse assemblage of fighters, who were not drawn up in any regular order. Just after halfway down the column they left a space for the king. He was preceded by 1,000 Persian cavalrymen, 1,000 handpicked spearmen whose weapons were tipped with golden pomegranates, and who marched with their spears reversed, 10 magnificent Nesaean horses – a breed from Media, now extinct, but much admired for their strength and speed – and the Sacred Chariot of Ahura Mazda, pulled by 8 white horses led by a charioteer on foot. No mortal was allowed to sit in the seat of this holy chariot, but it was followed by that of Xerxes, pulled by Nesaean horses under the control of his Persian charioteer. Occasionally, though, Xerxes would travel in a covered wagon. Behind him were another 1,000 noble-blooded Persian spearmen, whose weapons were tipped with golden apples and were held the right way round, another 1,000 elite Persian horsemen, and the 10,000 handpicked infantrymen known as the Immortals, so-called because any casualties were always immediately replaced to keep their numbers exactly the same; 1,000 of these had golden

pomegranates on their spear tips, and they surrounded the other 9,000, who had silver pomegranates. Following them were another 10,000 Persian horsemen, then a gap, and finally the rest of the army in a somewhat amorphous mass.[4]

Their journey took them to the River Caicus (modern Bakırçay, Turkey) and into Mysia, through Atarneus to the town of Carene, across the plain of Thebe, past the coastal towns of Adramytteum and Antandrus, and into the land of Ilium.[5] As they stopped for the night in the foothills of Mt Ida, from where Zeus had watched the Trojan War, they experienced a violent electrical storm in which a number of Persians were killed – another indicator that hubris was being perpetrated and punished. In myth, Achilles had fought with the River Scamander, the main river of Troy, but now it was the first of many rivers that the Persians drank dry.[6] Xerxes made the first recorded 'tourist visit' to Troy, where he sacrificed 1,000 head of cattle to Athena and the Magi poured libations to the Trojan heroes. But the army was seized with an irrational panic attack during the night, adding to the sense of foreboding, and raising echoes of the great Greece-versus-Asia conflict over Troy which Xerxes was seeking to avenge.[7]

From Troy it was a short journey north to Abydus via Rhoetium, Ophryneum and Dardanus. The bridges over the Hellespont were ready, and Xerxes now wanted to survey his army. The people of Abydus erected a white marble throne on a hill (modern Mal Tepe, probably) that had a perfect vantage point, from where he enjoyed watching a ship race that was won by the Phoenicians of Sidon: 'he was pleased with both the contest and the army'.[8] However, as the Great King contemplated the Hellespont, whose waters were entirely hidden from view by his ships, and the shores and plains, which were full of

his men, his smiles turned to tears. When Artabanus, who had already advised him not to invade Greece,[9] asked him what the matter was, Xerxes revealed his sensitive side: he was crying because not one of the people he was looking at would be alive in a hundred years' time. Artabanus pessimistically responded that most human beings have such awful lives that they frequently wish they were dead rather than alive anyway. Xerxes asked Artabanus whether he would still have advised against the expedition had it not been for the vision. His uncle confessed that he was still deeply worried, because Xerxes' worst enemies were the two greatest things in the world: the sea, because there was no harbour that could shelter the huge fleet; and the land, because the supply lines would be far too long. Events control men, he said, not vice versa, and the size of the invasion force meant that it would be self-defeating. Nevertheless, Xerxes rediscovered his mojo, acknowledging but rejecting Artabanus's points: great things are not achieved without great risks, he said. They would return as the conquerors of the whole of Europe.[10]

Artabanus offered one last piece of advice: under no circumstances should Xerxes lead the Ionian Greeks against their Athenian kinsmen, because the possibility of treachery was an unnecessary risk. Xerxes thought this was a ridiculous idea. The Ionians had remained loyal during Darius's Scythian expedition, and their wives and children at home were effectively hostages. Once again the Great King had rejected sound advice, and he ended the conversation by entrusting Artabanus with his symbols of authority, telling him to keep his household and tyranny safe, and sending him back to Susa.[11]

The self-styled King of Countries Containing Many People now gave an inspirational speech to the Persian commanders,

poured a libation into the Hellespont from a golden dish, and prayed for the success of the mission, whose goal was now to subjugate Europe in its entirety. As either an offering to the Sun, or an act of atonement for having the Hellespont flogged, he hurled the dish into the waters, along with a golden bowl and an *akinakes*,[12] and with the rituals carried out,

> the city-sacking royal army [. . .] crossed the strait of Helle on a raft bound with cables of flax, placing a much-bolted roadway upon the neck of the sea like a yoke [. . .] trusting in thinly made cables and people-carrying devices [. . .] like a swarm of bees [. . .] crossing the sea-washed headland that yokes both sides of the two continents together.[13]

The fighting forces crossed via the upstream bridge, and the baggage train used the one closer to the Aegean. The Immortals led the way, decked out in garlands, followed by the other Persian contingents, with the multinational forces in their train.[14] The ships also made the short transit before sailing south-east and taking up their first station at Elaeus ('Olive City', near modern Seddülbahir in Turkey) on the tip of the Gallipoli peninsula, and once Xerxes himself was in Europe 'he watched his army crossing under the lash'.[15]

It took a rather symbolic seven days and seven nights to flagellate everybody across in Herodotus's narrative,[16] and again the supernatural background was unsettling. When a mare gave birth to a hare, Herodotus said the meaning was obvious: the mare was Xerxes marching into Greece full of swagger and pride, while the hare was him running for his life. Again, Xerxes took no notice of this, as previously he had ignored an uncanny portent at Sardis, where a mule had given birth to another mule

that had both male and female genitalia. Mules are generally infertile, so when a mule gives birth to a hermaphroditic foal it is like 'when Hell freezes over', and Xerxes' refusal to acknowledge this further foreshadows his imminent defeat.[17]

Xerxes Counts His Troops

Xerxes' navy sailed out of the Hellespont, turned to starboard, and followed the coast north-westwards to Cape Sarpedon, named after a hubristic local Thracian tyrant who had been killed by Heracles in another prefiguration of Xerxes' demise.[18] From there they navigated to the fort of Doriscus at the mouth of the River Hebrus (modern Evros, Greece) in Thrace. Initially the army headed north-east, before swinging back westwards along a purpose-built road which later came to be called the King's Road,[19] drinking the Black River (modern Kavaksuyu, Turkey) dry, and making their rendezvous with the fleet. Xerxes thought this was now a good place and time to count his troops. He started with all 1,700,000 of the foot soldiers,[20] a number that is doubtless wildly exaggerated to illustrate the king's megalomaniac hubris: Herodotus says it was calculated by gathering 10,000 men together, drawing a circle round them, sending them away, building a waist-high wall on the circle, corralling as many men as they could into the walled space, and then emptying and filling it as many times as was necessary.[21] The cavalry was numbered at 80,000, not including 20,000 camels and charioteers,[22] and there were 1,207 triremes, adding another 241,400 crewmen and 36,210 marines to the total.[23] Three hundred penteconters with 80 sailors each contributed another 240,000, bringing the grand total to 2,317,610 fighting men.[24] Once Herodotus had added in the ships and soldiers

who Xerxes would recruit on his march into Greece, the head count had risen to 2,641,610, but that did not include servants, crews of supply vessels or camp followers, so he doubled it, making 5,283,220.[25] On top of that there were the female cooks and concubines, eunuchs, beasts of burden and Indian hunting dogs, by which time Herodotus had lost count, although he estimated they were consuming almost 4,500 tonnes of wheat per day.[26] The catalogue bears strong similarities to Xerxes' list of his subjects on the Daiva inscription from Persepolis,[27] but modern scholars are understandably sceptical about the numbers: estimates come in at anything between around 80,000 and 250,000 personnel.

Catalogues of armies were a crucial fixture in the Greek epic poetic tradition,[28] and Herodotus provided one to show that this was going to be a truly epic tale. First on the list were the Persians, commanded by Xerxes' father-in-law Otanes, wearing their characteristic *tiaras*, multicoloured long-sleeved tunics with fish-scale armour, trousers, button-strap shoes, and equipped with wicker shields, shorts spears, long bows, quivers full of reed arrows and daggers. The elite group of these were the 10,000 Immortals, commanded by Darius's co-conspirator Hydarnes. The Persians were regarded as the best soldiers in the army, and the polychrome glazed brick reliefs, of which there are fine examples in the Louvre, the British Museum and the Pergamon Museum in Berlin, show the richness of their clothing, the ornateness of their equipment, blingy bracelets and earrings, and their elaborate beards. They were accompanied by carriages carrying their copious number of concubines and servants, and their food was transported on camels and beasts of burden separately from all the other contingents. The Medes were next, equipped in the same way as the Persians, because,

as Herodotus notes, the Persians now wore Median dress.[29] Their commander was Xerxes' cousin Tigranes/Tritantaechmes, son of the Artabanus whose risk assessments had been ignored.

The nations of the east were listed next – Hyrcanians from south-east of the Caspian Sea, attired like the Persians; the Cissians of central Persia, with the same gear, but wearing the *mitra*, which enveloped their heads and necks, rather than the *tiara*. Then came the club-wielding, bronze-helmeted Assyrians; Bactrians with their Median-style headgear, reed bows and short spears; the Sacae, comprising the Pointed-Hat Scythians and Haoma-Drinking Scythians; Indians in their 'garments made out of wood'[30] (i.e. cotton); Arians from near modern Herat, armed with Median-style bows; Parthians, Chorasmians, Sogdians, Gandarians and Dadicae, all from central Asia, and kitted out like the Bactrians; Caspians who carried an *akinakes*, Sarangians with brightly dyed clothing and knee boots, and Pactyes, from the eastern end of the Iranian plateau; and Utians, Mycians and Paricanians, all with cloaks and local bows and daggers.[31]

From the south of the empire were the Arabs, wearing belted robes and using exceptionally powerful 'bent-back bows'; Ethiopians (i.e. Nubians), who painted half their bodies white with gypsum and the other half red with vermilion, wearing leopard or lion skins, and brandishing spears tipped with gazelle horn, studded clubs and 2-metre-long palmwood bows that fired stone-tipped arrows; and Libyans, by which Herodotus means Africans in general, with leather clothing and fire-hardened wooden spears.[32]

Asia Minor provided the Paphlagonians with their plaited helmets, calf-length boots, small shields, short spears, javelins and daggers, and the similarly equipped Ligyans, Matieni,

Mariandyni, Syrians, Phrygians and Armenians; the Lydians, armed to all intents and purposes like Greek hoplites, and the Mysians, with local-style helmets, small spears and fire-hardened javelins, all under the command of Artaphernes, the son of Darius's brother Artaphernes who had led the Marathon expedition. The Thracians, whose territory Xerxes had just been transiting, were distinguished by their fox-skin caps, coats of many colours, deerskin boots, javelins, small shields and daggers; a lacuna in Herodotus's text obscures the next people on the list, although it is likely that they were the Pisidians of central Anatolia, carrying oxhide shields, a pair of wolf hunter's spears,[33] and decked out with bronze helmets ornamented with bronze ox ears and ox horns. Wooden helmets, oxhide shields, short spears and swords were the signature weaponry of the Cabalians, Milyans, Tibareni, Macrones, Mossynocci and Colchians, whereas the Mares from the eastern end of the Black Sea used local-style woven helmets.[34]

The peoples from the islands of the Persian Gulf, equipped like the Medes, completed the roll call, under their commander Mardontes, probably the Mardunda of the Persepolis Fortification Tablets who had been deputy satrap at Susa and would later command the Persian forces at the Battle of Mycale in 479.[35]

The forces were organised in decimal contingents: brigades of 10,000, battalions of 1,000, companies of 100 and sections of 10. The overall high command was shared between Mardonius, Xerxes' cousins Tritantaechmes and Smerdomenes, Masistes son of Darius and Atossa, Gergis son of Ariazus and Megabyzus son of Zopyrus.[36] Five of Darius's sons were among the generals, and the fact that the Great King himself accompanied the expedition in person is a clear indication of how

important it was for him to defeat the Greeks and also prove that he was the equal of Cyrus, Cambyses and Darius.

The Persian cavalry contingent was equipped like the infantry, although some of them wore hammered bronze or iron helmets; the 8,000 Persian-speaking nomadic Sagartian cavalry used leather lassos to ensnare and kill their enemies;[37] and the Median, Cissian, Bactrian, Caspian, Paricanian, Libyan, Arab and Indian riders were all equipped like their foot soldiers. The Indians rode particularly fast horses and used both horse- and wild-donkey-drawn chariots, the Libyans also drove horse chariots, and the Arabs used fast camels, which meant that they had to be stationed at the rear, because the horses were frightened of the sight of the camels.[38]

The 1,207 triremes of the war fleet came from the Phoenicians and Syrians of Palestine (300), Egypt (200) and Cyprus (150), all equipped in the same style as those who had fought during the Ionian Revolt.[39] These contingents sailed alongside the Cilicians (100), with their raw oxhide shields, woollen tunics, twin javelins and Egyptian-style knives, the Pamphylians (30), who used Greek arms and armour, and the heavily armoured Lycians (50), who wore goatskins over their shoulders and feather-trimmed felt hats.[40] The Asiatic Dorians (30) also used Greek weaponry, as did the Carians (70), except that the latter also carried sickles and daggers. The Greeks fighting on the Persian side included the Ionians (100), the islanders (17), the Aeolians (60) and the Hellespontines (100).[41] All of these vessels carried Persians, Medes and Sacae as marines, and it was unanimously acknowledged that the Phoenician ships, and particularly the Sidonian ones, were the best. These differed from the Greek triremes in several significant ways. They were constructed from cedar wood, rather more flamboyantly

decorated, equipped with longer, pointed rams, and had a slightly broader beam. The upper tier of rowers sat fully inboard, rather than on outriggers, and the decks were surrounded by gunwales or by rails with shields draped over them. This gave them more deck space and greater troop-carrying capacity. Their poop decks were built higher to afford the commander and helmsman better visibility, and overall, at least on paper, they were better built and more seaworthy than the Greek triremes.

Herodotus tries to obscure the fact that Greeks were sailing against their own people by refusing to name the individual commanders, because they were all effectively 'slaves' of the Persian high command – the Ionians and Carians sailed under Darius's son Ariabignes. However, there was one commander who Herodotus did single out. This was Queen Artemisia, the daughter of Lygdamis, tyrant of Halicarnassus, and a Cretan mother. She was the ruler of Halicarnassus, Cos, Nisyrus and Calymnus, albeit under Persian orders, and her five-ship squadron, made up of Dorian Greeks, was the second best in the Persian navy. She came to play an important role as both a wise advisor to Xerxes, and as a 'sea-fighter' in both the military and sexual senses.[42]

Xerxes conducted a final review of his immense army, riding along the land forces in his chariot, and sailing along the ships under a golden canopy in a Sidonian vessel, questioning the commanders and having his scribes take notes as he did so. He then summoned Demaratus, who was accompanying the expedition, and quizzed him about what he should expect from the Greeks. 'Will they fight me?' he wondered. 'Surely they don't stand a chance?' Demaratus asked him whether he wanted a comfortable answer or a truthful one. 'The truth,' said Xerxes.

'Very well,' said the Spartan, 'I'll speak about my own people, not all the Greeks. They are poor, but brave, and they will never submit to anything that remotely resembles slavery. And it makes no difference how few of them there are, or how many of you – they will definitely fight.' 'I just don't believe you!' was Xerxes' response. 'How could even 50,000 of them stand up to my army, particularly when they all have the same degree of freedom and no one in overall command? My men are motivated by fear of me, and fight under the lash. And in any case, my best fighters are just as good as any of the Spartans. You're talking rubbish!' 'There's no love lost between me and the Spartans,' said Demaratus, 'but I do know their fighting qualities. They are indeed free, but they still have a master – the law. They always obey it. Whatever the odds against them, they will always fight and never retreat.[43] For them it is victory or death.' The King of Kings laughed.[44] Once again he had ignored important information and underestimated the power of freedom. It was an attitude that would cost him dear.

The Journey to Greece

Xerxes moved his troops out of Doriscus just before the Athenians entered their new year, the archonship of Calliades (480/479).[45] The invaders were yet to enter hostile territory, and they continued to move through areas that had either Medised or been subdued, conscripting more fighters as they progressed. The land forces marched in three columns: one kept close to the sea coast under Mardonius and Masistes; another, commanded by Tritantaechmes and Gergis, travelled further inland; and Xerxes himself accompanied the third which marched between the other two, with Smerdomenes and

Megabyzus as its generals.[46] In Thrace they passed Mesambria, drank the River Lisus (modern Lissos, Greece) dry, kept the Greek maritime settlements of Stryme, Maronea, Dicaea and Abdera on their left-hand side, crossed the River Nestus (modern Nestos), and watched the beasts of burden drink down a saltwater lake near Pistyrus. The inland Thracian tribes all joined Xerxes' army, apart from the ferocious mountain-dwelling Satrae, who Herodotus says have never been subject to any man.[47] The army marched onwards into Macedonia, keeping the gold-rich Mt Pangaeum to their right, until they reached the River Strymon and the city of Eion, where the Magi sacrificed some white horses to appease the river deity. They crossed the Strymon at a place called Nine Ways, about 5 km upstream from Eion, where their engineers had already constructed a bridge, the remains of which have been excavated by the Athens Archaeological Society.[48] Having discovered the name of Nine Ways, the Persians are said to have made a matching sacrifice by burying the same number of local children alive. Herodotus drily observes that 'burying people alive is a Persian thing', although no non-Greek source corroborates this.[49]

On arrival at Acanthus at the base of the Mt Athos peninsula Xerxes rewarded the locals for their work on the canal by making them his guest-friend and presenting them with a Median garment, both of which were very high marks of honour.[50] However, like all the states on Xerxes's route, the Acanthians were eaten out of house and home. Advance notice of Xerxes' arrival had been served, and the Greeks had stockpiled corn, fattened their herds, tended their poultry, and produced gold and silver tableware simply to entertain him. He installed himself in a temporary pavilion, while the troops,

who were fed much more basically, slept in the open air. In the morning they would move on, leaving nothing behind. The cost was horrendous: Antipatrus son of Orgeus ran up a bill of 400 silver talents for one dinner, and Megacreon of Abdera told his fellow inhabitants to thank their lucky stars that Xerxes only ate one meal a day.[51]

From Acanthus the army and navy had to separate to allow the fleet to transit the canal and sail around the fingers of Chalcidice (Mygdonia) to the appointed rendezvous at Therma (near modern Thessaloniki), pressganging the people and ships of two dozen Greek cities as it did so. They stationed themselves on the beaches between Therma and the River Axius, where Xerxes' land forces duly rejoined them, having suffered attacks from the local lions, who took an especial liking to his camels. The army's camp stretched an astonishing 30 km or so from Therma to the River Haliacmon (modern Aliakmonas), whose waters, unlike those of the Echeidorus (modern Gallikos), were able to cope with the demands of the thirsty Persians.[52]

From Therma, Xerxes could see Mt Olympus (2,918 m), the home of the Greek gods, and the peak of Mt Ossa (1,978 m). He heard that the River Peneus (modern Peneios) flowed through a narrow pass between them – the so-called Vale of Tempe (modern Tembi) – and that this provided the most direct route into Thessaly. Before this he had been planning to use a more mountainous, but safer, inland route, but now he wanted to see Tempe for himself. He took the entire navy with him and was awestruck by the rugged beauty of the valley, and indulged in some enormous engineering fantasies about diverting and damming the Peneus to inundate the entire Thessalian plain. This time, however, his hubris failed to get the better of him. He reverted to Plan A. One-third of his monstrous war machine deforested

parts of what Herodotus vaguely called 'the Macedonian Mountain' and started building a road past the city of Gonnus (near modern Gonnoi) and into the country of Perrhaebia in the western shadow of Mt Olympus.[53] While Xerxes waited, his heralds returned with news of which Greek states had complied with his demands for earth and water.[54] He would encounter precious little resistance from the northern Greeks.

Resistance from the Southern Greeks

Further to the south the states which 'had the best attitude towards Greece'[55] had assembled at a congress at the Isthmus of Corinth, where they confronted the monumental decisions about how and where they should organise their resistance. This was a seminal moment in the history of Greece: it was the first time they referred to themselves collectively as 'The Greeks' (or 'the Hellenes').[56] Later, following the Battle of Plataea in 479, thirty-one communities would add their names to the 'Three-headed Serpent', aka the Serpent Column, a victory monument in the form a gold or gilded tripod cauldron on top of three bronze intertwining snakes, which was dedicated at Delphi and is now in the Hippodrome in Istanbul.[57] The coils of the snakes carried the names of the states who resisted the Persians, and Thucydides records that 'on his own authority' the Spartan leader Pausanias had a verse couplet composed by the great contemporary poet Simonides of Ceos inscribed on it:

When as leader of the Greeks he had destroyed the army of
 the Medes,
Pausanias erected this memorial to the god Phoebus
 Apollo.[58]

However, because this was a highly transgressive thing to do, the Spartans immediately had it chiselled off and replaced with the names of all the states who had united in defeating the Persians. Thirty-one names are still on the column:

Those who fought the [Persian] war:
Laced[aemonians], Athenians, Corinthians
Tegeans, Sicyonians, Aeginetans
Megarians, Epidaurians, Orchomenians
Phleiasians, Troezenians, Hermionians
Tirynthians, Plateans, Thespians
Mycenaeans, Ceans, Melians, Tenians
Naxians, Eretrians, Chalcidians
Styrians, Elians, Potidaeans
Leucadians, Anactorians, Cythnians, Siphnians
Ambraciots, Lepreians.[59]

A 4.5-m-high bronze statue of Zeus by Anaxagoras of Aegina, which had an inscribed base listing the states in a slightly different order, and omitting Thespiae, Eretria, Leucas and Siphnos, was also erected at Olympia.[60] Overall there are some illuminating anomalies, suggesting that some states may have been added as an afterthought, even though their patriotic claims were questionable: Mycenae (possibly), Elis, Lepreum, Cythnos and Siphnos are either located in the wrong geographical grouping on the Serpent Column and/or appear as deliberate later additions;[61] the Naxians were perpetually prone to changing sides, although their trierarch Democritus brought four triremes over to the Greek side;[62] and the inclusion of Tenos was because 'a Tenian trireme commanded by Panaetius son of Sosimenes

deserted from the Persians [bringing important naval intelligence]'.[63] Corinth's colony of Potidaea also originally contributed to Xerxes' forces, but then came over to the Greek side and supplied 300 hoplites at the Battle of Plataea.[64] The warriors of Elis, who did not fight at Thermopylae and for unexpected reasons were too late to fight at Plataea, were nevertheless included, whereas the Mantineians, who similarly missed the engagement at Plataea, but did contribute 500 hoplites at Thermopylae, were omitted.[65] The Greek victors were scrupulous in their rewriting of history, and it was a matter of the highest honour to be included among the 'The Thirty-One'.

The Spartans' place at the head of the list shows that their leadership was never seriously contested;[66] the Athenians were second on the list and second-in-command, having swallowed their pride and waived any claim to leadership at sea 'because their number-one priority was the survival of Greece',[67] and because the other Greek states had insisted that if a Spartan did not have the overall command, there would be no alliance to lead. Corinth took the third place because, as a highly influential member of the Peloponnesian League, the city was able to bring a number of her important colonies into the conflict. It was a fragile and sometimes fractious alliance, but never before and never again would the disparate Greek *poleis* display even such limited unity. As Herodotus poetically said, 'infighting among one's own race compares as badly to a war fought with a unity of purpose as war compares to peace.'[68] The Greek unity of purpose was cemented by an oath to dedicate all the possessions of the Greeks who voluntarily surrendered to the Barbarians, should the resistance emerge victorious.[69]

The interstate cooperation needed to be reinforced at a local level within the *poleis* themselves. The Athenians knew the dangers of factional and familial infighting well enough, and that exiles and victims of ostracism would have no scruples about collaborating with the enemies of their cities in order to be restored to power, so they allowed them to be recalled. Xanthippus and Aristides both returned to play important roles, and possibly Megacles too, although Hipparchus did not. The *Constitution of the Athenians* dates this to the archonship of Hypsechides (481/480), but Plutarch locates it in September of the following archon year (480/479).[70] The Decree of Themistocles, aka the Troezen Decree, which survives on an inscribed stele found at Troezen in 1959, does not date it at all: 'To ensure that in a spirit of unity all Athenians will fight off the Barbarian, those banished for the [ten-]year span [i.e. ostracised] shall leave for Salamis and they are to remain [there until the people] make a decision about them.'[71] The Athenians went into 'fight or flight' mode, and the Themistocles Decree indicates that they opted for both:

The *polis* shall be entrusted to Athena [i.e. evacuated], Athens's Protectress, and to the other gods, all of them, for protection and defence against the Barbarian on the country's behalf. All the Athenians and the foreigners who live in Athens shall place their children and women in Troezen [. . .][72] The elderly and movable property shall be deposited in Salamis for safety. The treasurers and the priestesses are to remain on the Acropolis guarding the possessions of the gods, and all the other Athenians and those foreigners who have reached military age must embark on the 200 ships that have been prepared, and they shall repulse the Barbarian for

the sake of both their own freedom and that of the other Greeks, alongside the Spartans, Corinthians, Aeginetans and the others who wish to share in the danger.[73]

Scholars are divided about the authenticity of this decree, the date of the events it refers to, and how comprehensive the evacuation was: a later date makes the story much more dramatic; an earlier one makes Themistocles look much more prescient. Herodotus, Diodorus Siculus and Plutarch all place the decree and evacuation in September 480 BCE, between the battles at Thermopylae/Artemisium and Salamis, but this seems to give the Athenians unfeasibly short notice to organise such a massive undertaking;[74] the decree also specifies that 100 ships should 'bring assistance to the Artemisium in Euboea', implying that the decree was made while Xerxes was still moving through northern Greece; and some aspects of the lettering and phrasing on the stele imply that it comes from at least around 150 years after Xerxes' invasion,[75] raising the question of whether it is a copy or a fake. If it is original, the balance of probability lies with it being made around June 480:[76] it was time for the civilians to move out and the military to do battle.

It was a deeply emotional experience. The city was filled with fear, pity, tears and farewell embraces, not just by the humans, but by their pets too, which ran alongside their owners, howling in distress. The dog owned by Xanthippus could not bear to be parted from his human, so he jumped into the sea and doggy-paddled alongside his trireme all the way to Salamis, where, tragically, he died of exhaustion. His tomb, the 'Dog's Mound', was still being pointed out 500 years later.[77]

Despite the emotional stress, the Athenian resistance comes across as highly organised and intensely motivated. Just as the

hoplites drew their *esprit de corps* from their demes, the rowers looked to their triremes as their primary groups for psychological and military cohesion:

> Appointment will also be made of 200 trierarchs, one per ship, by the generals, beginning tomorrow [. . .] They shall not be more than fifty years old and each man's ship shall be allocated by lot. The generals shall also enlist ten marines for each ship, [. . .] and four archers. They shall also appoint the specialist officers for each ship by lot [. . .] A list of the rowers shall be drawn up by the generals, on notice boards, on a ship-by-ship basis, with the Athenians to be selected from the deme-registers, and the aliens from the list of names registered with the polemarch [. . .] When they have completed the manning of the ships, 100 of them shall bring assistance to the Artemisium in Euboea, while the other 100 shall lie at anchor all around Salamis and the rest of Attica, and guard the country.[78]

A few temple attendants stayed on in Athens to protect the sacred property, along with some citizens whose poverty prevented them getting to Salamis, plus a number of people who refused to believe the experts and chose to interpret the 'Wooden Wall' oracle as meaning they should defend the Acropolis.[79] However, the vast majority were confident that the 'Wooden Wall' was the triremes, and when the great snake that lived on the Acropolis refused to consume its monthly offering of a honey cake they agreed with the priestess that the goddess Athena had herself left the Acropolis and followed her lead.

Battle Stations

The Greeks knew that engaging the Persians in a fair fight on open ground would be suicidal. Somehow, they had to make the sheer size of Xerxes' forces count against him, and make Artabanus's reservations about the logistical difficulties of the invasion come true.[80] They needed to harness the very landscape of Greece itself by exploiting mountain passes and narrow waterways, where the enemy's strength in numbers could not just be minimised, but be turned into a real weakness. One of the pinch points in the geography of Greece is the 6-km-wide Isthmus of Corinth, and understandably, if self-interestedly, the Peloponnesian states were in favour of making that the line of defence. However, that option would have been catastrophic, no matter how many fortified walls they could build across it, especially if Athens's sea power was removed from the equation. Sparta's allies might have been picked off one by one by the Persian navy, and Sparta itself might have either Medised when she saw that happening or chosen to go down in a heroic blaze of glory. Either way, Greece would have been subdued. The Peloponnesians never entirely lost their desire to defend the Isthmus, but ultimately it was decided that there were better strategic options much further to the north. The Medising Aleuadae of Thessaly were out of synch with the majority of their people who 'disliked their machinations',[81] and these anti-Aleuadae made an eloquent appeal to the Greeks at the Isthmus to move to defend the Vale of Tempe in force. They were ready to fight, they said, but if the Greeks abandoned them, they would Medise.

The Greek alliance embarked their land army on to ships, which sailed north to Alus (near modern Almyros) on the west

side of the Gulf of Pagasae in Achaea Phthiotis, from where
they marched with a force of around 10,000 men to the pass of
Tempe to rendezvous with the Thessalians. Themistocles led
the Athenian contingent, and Euaenetus son of Carenus was
the general (not a king) of the Lacedaemonians. But no sooner
had they encamped than messengers arrived from the inscrut-
able King Alexander I of Macedon, telling them to leave. The
Persian forces were overwhelming, they said, and there were
other easily accessible routes into Thessaly. The Vale of Tempe
was the wrong place to make a stand, so the Greeks packed up
and returned to the Isthmus, and the Thessalians Medised
without a second thought.[82]

Back at the Isthmus the Greeks discussed Plan B. There was
a pass at Thermopylae, which was narrower and nearer to home
than Tempe, and as far as the Greeks were aware, there were no
viable alternative routes around it:

> The entrance into Greece through Trachis is about 15 metres
> wide at its narrowest point. However, the narrowest coastal
> area is not at this point but in front of Thermopylae ['the
> Hot Gates'] and behind it: at Alpeni, which is behind it, it is
> just a wagon track; and it is also just a wagon track in front
> at the River Phoenix, near the town of Anthele. [. . .] In the
> pass there are Hot Springs for bathing.[83]

The Greeks hoped the terrain would negate the Persian
numbers and effectively take their cavalry out of the equa-
tion. It seemed perfect, and if their fleet took up a station at
Artemisium, a beach (not a cape or promontory, as is
frequently asserted) in the territory of Histiaea on the north
of Euboea, it could maintain close contact with the land

forces and prevent the Persian fleet from outflanking their position. A temple of Artemis Prosoea ('to the East') on the beach gave Artemisium its name,[84] and now it is known as Pevki Beach. It conveniently faces north towards the Pelion peninsula, allowing the Greek navy to interdict the Persians from landing on either side of Euboea, and giving them control of the Orcus channel between the island and Mt Othrys on the mainland opposite. They could also restrict access to the Malian Gulf and the Euripus channel beyond. By the time they had decided to make their stand in this combined position the Persians had already got as far as Pieria, so the Hellenes needed to get to their various stations as fast as they could. The Delphic oracle told them to pray to the winds,[85] which was sound advice, since it was now the season of the annually recurring Etesian winds, known to Greek sailors as the Meltemi, which blow steadily from the north and north-west, bringing capricious sailing conditions.[86]

Xerxes' army continued to make its way inexorably southwards. Ten of his fastest ships sailed on ahead to the island of Sciathus, which effectively closed off the eastern end of the Oreus channel. Three triremes from Troezen, Aegina and Athens, which were operating as an advance guard, saw them coming and made a run for it. The Troezenian vessel was overtaken, and its captors sacrificed its finest fighting man, Leon ('Lion'), by slitting his throat on the ship's prow; the Aeginetan ship was also taken, despite the efforts of Pytheas son of Ischenous, who fought until he was so badly wounded that the Persians bandaged him up and displayed him to their own side as an honoured POW; the Athenian trireme ran aground at the mouth of the River Peneus, a long way to the north, from where the crew managed to get back to Athens.[87] Although

three of the Barbarian ships were wrecked on a reef known as 'the Ant' (the modern Lefteri or Lefkari reef) between Sciathus and Magnesia, the incident demoralised the Greeks, who relocated down the Euripus to Chalcis, leaving lookouts on the heights of Euboea. The main body of the Persian fleet departed from Therma eleven days after the land army, with Pammon of Scyros acting as their pilot. Herodotus says it just took them a day to sail down to the beach between Casthanaea (close to modern Sklithro and Keramidi) and Cape Sepias (probably Cape Pouri/Pori) in Magnesia.

The following morning the Greek prayers to the winds were answered, and the landscape began to exert an influence. As 'rosy-fingered' Dawn 'was rising from the streams of Oceanus in her saffron robe, to bring light to immortals and mortals',[88] a storm blew in from the east. Four hundred Persian ships that could not be hauled ashore because of the narrowness of the beach were destroyed along with their crews on the rocks known as the Ovens of Mt Pelion (large sea-caves close to modern Veneto), on the beach, on Cape Sepias, and near the towns of Meliboea (Sitki or Kastro Velika) or at Casthanaea. The storm blew itself out after four days, and the grateful Athenians later built a temple of the North Wind Boreas – he was, after all, the son-in-law of their mythical King Erekhtheus.[89]

The Greek observers on Euboea relayed the news to the fleet at Chalcis. With a renewed sense of optimism, they sailed back to Artemisium, while the Barbarians resumed their voyage along the coast, turning to starboard to round the headland of Magnesia, and into more sheltered waters where the transports headed into the Gulf of Pagasae, leaving the warships to anchor on the southern coast of Mt Pelion at Aphetae (probably

modern Platania Bay[90]), about 16 km to the north-east across the water from Artemisium. Fifteen Persian ships were left in the wake of the main flotilla, and unwittingly sailed into the Greek fleet and were duly captured. Their commanders, two Greek, one Carian, were interrogated, and once they had divulged useful intelligence about Xerxes' army, they were shipped back to the Isthmus in chains.[91]

Three days later the Persian land forces arrived in Malis, having transited Thessaly, where Xerxes' men drank the River Onochonus dry and he greatly enjoyed seeing his horsemen win races against the Thessalians. In Herodotus's itinerary the River Epidanus in Achaea was reduced to a tiny trickle, before the invaders followed the coastline of the Malian Gulf, traversing low-lying land that was hemmed in by impassable mountains known as the 'Rocks of Trachis', passing the town of Anticyra (at modern Kostalexis), close to where the River Spercheius flows into the Malian Gulf, the River Dyras some 4 km down the road, the Black River 4 km beyond that, before arriving at Trachis (near modern Ano Vadates and Delfino), situated 1 km further along on a plain at the head of the Gulf. Beyond Trachis there was a gorge through which the River Asopus flowed. The Asopus was fed by the smaller River Phoenix, which marked the narrowest point between the mountains and the sea. The Asopus disgorged into the sea near the village of Anthele (near modern Loutra), where the ground opened out slightly, and beyond Anthele, 3 km from the Phoenix, running east–west (although north–south in Herodotus's description), was Thermopylae, the 'Hot Gates', known to the locals as simply 'the Gates'.[92]

Xerxes most likely encamped between Trachis and Athele, controlling everything to the north and maintaining

communications with his fleet, while the Greeks took up their position in the pass of Thermopylae, likewise in close contact with their ships at Artemisium, defending the lands of freedom and democracy to the south.

Xerxes Ascendant: Artemisium and the 300 Spartans

Wow, Mardonius! What kind of men have you brought us to fight against? They do not hold contests for cash prizes, but for glorious achievement!

Tritantaechmes son of Artabanus[1]

The Naval Battle at Artemisium

Like Homer in the *Iliad*, Herodotus began his account of the epic drama that was about to unfold with a Catalogue of Ships. There were 127 Athenian triremes, crewed by both Athenians and Plataeans. The latter were extremely low on naval expertise and so probably served as marines. Corinth contributed 40 ships, Megara 20, Chalcis provided crews for 20 Athenian-built triremes, Aegina 18 ships – a surprisingly low number for such a prominent naval power – Sicyon 12, Sparta 10, Epidaurus 8, Eretria 7, Troezen 5, Styria and Ceos 2 each, plus 2 Cean pente-conters and another 7 penteconters from the ex-Medisers in Opuntian Locris, which were more useful as transport vessels than warships. Overall, at a grand total of 271 triremes and 9

penteconters, this was a rather uneven turnout. The Spartan Eurybiades son of Eurycleides, who did not belong to either of the royal families and was described as somewhat spineless in times of danger, assumed control: only one Spartan king could go out on campaign, and Leonidas son of Anaxandridas, the descendant of Heracles who never thought he would be king, was leading the allied troops at Thermopylae.[2]

The Greeks at Artemisium had a terrifying shock when they discovered that the entire region was swarming with Barbarian soldiers and there were far more enemy ships at Aphetae than they had expected. Once again they debated fight or flight, with the majority leaning towards heading homewards. The more resilient and duplicitous Euboeans asked Eurybiades to give them time to evacuate their families, but when he refused they allegedly gave Themistocles a massive bribe of thirty talents to ensure that the fleet stayed and fought.[3] Themistocles' trickiness and willingness to cut deals behind the backs of the other Greeks becomes a strong theme in the narrative,[4] and now, pretending that it was his own money, he passed on five talents of the Euboean bribe to the venal Eurybiades. The Spartan was then able to influence all the other admirals apart from the Corinthian Adeimantus. Accordingly, Themistocles offered Adeimantus what he thought was a greater gift than Xerxes would give him if he deserted the Greek cause, and when three talents of silver duly turned up on the Corinthian's ship, he was happy to remain loyal. Having bought the future freedom of Hellas for the bargain price of eight talents, Themistocles kept the change.[5]

The Persian response to seeing their adversaries' ships was a mirror image of the Greek one. They arrived at Aphetae in the early afternoon and were delighted that the Greek navy was as

small as they had been led to believe. However, it was too late in the day to attack immediately, and if night fell while they did, the Greeks would get away. In Persian parlance, 'they did not want even a fire-bearer to escape and survive'[6] – only the total annihilation of the Greeks would be acceptable. So, they detached 200 ships to undertake a 325-km clandestine voyage, sailing behind Sciathus, and then turning southwards to circumnavigate Euboea with the island on the starboard side, before cruising up the Euripus to trap the Greeks in a pincer movement. In reality, Sciathus is easily visible from Artemisium, and the Greeks would have been able to observe the flotilla's movements from the heights of Euboea, but Herodotus was confident that was the plan, despite some modern scholarly scepticism.[7] Meanwhile the main force had a count-up at Aphetae: since the muster at Doriscus they had lost 418 ships and gained 120.[8] While the Persians were preoccupied, a renowned diver called Scyllies from Scione allegedly took the opportunity to leap into the sea at Aphetae and swim 16 km underwater without coming up for air until he reached Artemisium, where he informed Eurybiades of the shipwrecks off Magnesia and the encircling manoeuvre. Herodotus is circumspect about this extraordinary feat: he thinks Scyllies went by boat. But Scyllies still had a statue erected in his honour at Delphi and was later credited with inventing submarine warfare by diving down to cut the cables of the anchors of Xerxes' ships.[9]

It was a busy day. The Greeks decided that they would remain with the ships beached at Artemisium, and then embark in the middle of the night to attack the 200 Persian encircling ships. But then they changed their minds and opted for a more imme-diately aggressive move. They put to sea to test out the Persian

capabilities in the *diekplous* manoeuvres. Just as at Marathon, the Persians thought the precipitous Greek assault was crazy. There were so few Greek vessels, and their own were far more numerous, with better-trained and more experienced crews. With their hubris rising they encircled their attackers. It is not clear whether the fleets initially met facing north–south or east–west, or where in the channel they engaged, but there was no need for a Persian *diekplous*. Their superior numbers meant they could envelop the Greeks with the *periplous*. The Greeks countered by forming a circle or crescent, with their sterns together and rams pointing outwards. The Ionians on the Persian side were conflicted in their response: the ones who had joined the Barbarians reluctantly, who Artabanus had warned Xerxes against bringing, were distressed at the prospect that no Greek would make it home; but the rest were delighted and competed with one another to win the king's favour by being the first to capture an Athenian ship. Even though the Greeks were tightly hemmed in, they exploded outwards at a given signal and attacked the Persians prow-to-prow, with some indecisive success: they captured thirty ships; the brother of the Cypriot king Gorgus[10] was among the prisoners; and the Athenian Lycomedes son of Aeschraeus was voted MVP for being the first to capture a Barbarian vessel.[11] The Greeks rowed back to Artemisium, having narrowly won on points, while the Persians returned to Aphetae with a sense of disappointment.[12]

Many attempts have been made to ascertain a definitive chronology of the concurrent events at Artemisium and Thermopylae, and Herodotus's account is more concerned with literary than historical or temporal coherence. Nevertheless, the overall sequence of events is clear, and the big picture is doubtless accurate enough. Darkness now falls and the Greek

night-sailing is cancelled. A fierce rain- and thunderstorm blows up from Mt Pelion, flash floods pour down the mountain, and the corpses and wreckage of the day's fighting are driven ashore at Aphetae, to the great distress of the Persians: first the storm off Magnesia, then the sea fight, and now this. The uncanny meteorological events, occurring unseasonably in midsummer, were suggesting that the gods were creating a level playing field,[13] and the Greeks had been right to pray to the winds: in the night the Persian ships rounding Euboea were caught in open waters, driven on to the jagged rocks of the Hollows of Euboea somewhere on the east coast, and smashed to driftwood with horrendous loss of life.[14]

Dawn brought blessed relief to the Persians at Aphetae, who had lost their motivation and were just content not to do anything. Reinforcements came to the Greeks in the shape of fifty-three Athenian vessels (where they had been prior to this we are not told) bearing news of the disasters suffered by the Persian ships in the night. Some skirmishing took place that afternoon, in which the Greeks managed to destroy a number of Cilician ships that could have been limping home from the storm or making an attempt to break through the Oreus channel.[15] It had been a satisfactory day for the defenders of democracy, although unbeknown to them the Persian land forces would be making decisive moves in the mountains above Thermopylae while they slept.[16]

At daybreak the next day, the Persian admirals were overcome with shame at suffering so much damage from so few enemy ships, and fear of Xerxes' wrath. The Great King himself constantly stressed his powers of self-control: 'I am not hot-tempered,' he said, on a stone tablet that is practically an exact copy of a text written by his father, whose inscriptions also

emphasised his powers of anger management.[17] But the Greek tradition saw him as an overemotional, irrational, irascible tyrant, and that stereotype is what his commanders feared now. Rather than waiting for the Greeks to take the initiative with skirmishing in the early afternoon, they went all-in at around noon. If they could smash through the Greek sea defenders, they could access the Euripus channel and turn the position at Thermopylae. The initial engagement replicated the first day's tactics, with the Persians advancing in a concave crescent in an attempt to envelop the Greeks. But the size of the Persian battle fleet worked against itself. This time the Greeks rowed straight at them, throwing them into confusion, and causing them to run foul of one another and get their oars entangled in the narrow seaway. The end result was an attritional, but indecisive engagement. The Egyptians fought most effectively on the Persian side, while the Athenian Clinias son of Alcibiades, commanding his own privately funded trireme, won the Greek plaudits. The Greeks secured possession of the wrecks and the dead, which was a sign of victory, although half of the Athenian triremes were damaged. All the same, a draw was a good result for the Greeks: they had gained invaluable experience, faced down the danger, and discovered that 'neither vast numbers of ships, nor brilliantly decorated figureheads, nor arrogant shouts, nor barbarous battle-hymns, hold any fear for men who understand how to close to hand-to-hand combat and dare to do battle.'[18]

They themselves became the heroes of song in later ages. Simonides penned an elegiac poem called 'The Sea-battle at Artemisium',[19] and the Temple of Artemis Prosoea later also boasted an elegiac epigram:

The sons of the Athenians set up these tokens to the Virgin
 Artemis
When on this stretch of the sea, they had defeated in a
 sea-battle
Men from the lands of Asia, men of races of every kind,
When the army of the Medes was destroyed.[20]

For the great poet Pindar, Artemisium was 'Where the sons of
the Athenians laid the shining foundation-stone of freedom.'[21]

For now, however, the praise-singing would have to wait.
The Greek naval high command again decided that retreat was
the best option but, as usual, Themistocles still had some tricks
up his sleeve. If he could detach the Ionian and/or Carian
contingents from Xerxes's army, there might be a possibility of
levelling the odds. But before he divulged his scheme to the
admirals, he told the Greeks to slaughter all the Euboeans'
sheep – far better for the Greeks to eat them than let the Persians
have them – and to light their campfires. This they did. The
Euboeans were not happy, but they had ignored an oracle from
the seer Bacis:

Think about this! When a barbarian-speaking man throws a
 papyrus yoke onto the salt-sea,
Let the much-bleating goats keep away from Euboea.[22]

Having missed the reference to barbarically bleating Xerxes
and the papyrus cables of the Hellespont bridges, and kept
their flocks on the island, they had no reason to complain that
they were slaughtered in the patriotic cause now.

While the Greeks were doubtless enjoying some fine Euboean
roast lamb, they received some shocking news. They had a

two-way communication system with the forces at Thermopylae some 60 km away, and now the lookout from Trachis, an Athenian by the name of Abronichus son of Lysicles, came in a thirty-oared triaconter with a message that prompted the fleet to leave instantly. King Leonidas of Sparta and the defenders of Thermopylae had been annihilated.

Thermopylae: The Hot Gates

The Hellenic forces had arrived at Thermopylae far enough ahead of the Persians to establish their base, reconnoitre the position, assess its strengths and weaknesses, and consolidate it as best they could.[23] The pass runs west (Persians) to east (Greeks), between the ridge of the 'impassable and precipitous'[24] Mt Kallidromon that rises 1399 m to the south and the Malian Gulf to the north.[25] Since the fifth century continuous tectonic activity, combined with the silting up of the Malian Gulf, has pushed the shoreline back by several kilometres, and covered the sites of the Persian encampment and the combat zone with some 20 m of sediment. Although the thermal springs that gave the pass its name, which the locals called 'The Pots', are still a feature, the modern landscape makes visualising the tightness of the space practically impossible. The pass was squeezed in between the mountains and 'nothing except for the sea and marshes',[26] with three significant 'Gates' or pinch points. The two outer ones were about 5.5 km apart: the West Gate was near the town of Anthele, and the East Gate was at Alpeni, from where the Greeks would provision their army. Both were formed by quite gently sloping spurs of Mt Kallidromon, but although they were only wide enough to take a single-lane cart track, the spurs themselves could be traversed

relatively easily. This weakness probably led the Greeks to focus their defence on the Middle Gate. This was a mere 15 m wide, and the mountainside to the south was steep enough to make it virtually impassable to formations of armed troops.[27] Three hundred Spartan hoplites arrayed eight deep would fill it comfortably, with their right flank protected by the sea, to which there was possibly a sheer drop into the waters of the gulf, and with their shield side facing the mountain:

> These were the places that the Hellenes thought were the most suitable. They had reconnoitred the whole area and calculated that the Barbarians would not be able to exploit their superior numbers or their cavalry in the pass, so this is where they decided to confront the invaders of Greece.[28]

There were also some existing fortifications that could be utilised. In times past the Phocians had built a gated wall across the pass. It was in ruins, but now the Hellenes decided to rebuild it 'to keep the Barbarian out of Greece'.[29] Archaeological excavations in the mid-twentieth century by Greece's archaeological superstar-to-be Spyridon Marinatos unearthed foundations of a wall built in a style characteristic of the pre-invasion era, which ran in zigzags for approximately 200 m, but running parallel with the coast and not across the pass. Most current thinking regards this as built later than 480 BCE for a different war, recycling parts of the original structure. No remains of a gated structure blocking the pass from prior to the battle have been found, and in any case the wall was destroyed during the fighting. However, this old wall must have been at the heart of the Hellenes' attempted fortifications, and in the few days that they had available they created a barrier high enough to prevent

Persian observers seeing over it, and making their own position even narrower and more defensible.[30]

Xerxes could have used alternative routes into the southern parts of Greece, including one via the Dhema Pass out of the south-western corner of the Malian plain between Mt Oeta and Mt Kallidromon that would take him on an inland route into Boeotia via Phocis and Doris. However, the Thermopylae option was more direct, and would enable him to keep his army and fleet in close contact. At this point it was strategically more attractive to try to smash his way through, even if that meant he would have to deal with some very constricted terrain.[31]

The 300

Our sources provide differing numbers for the Greeks.[32] Herodotus's list begins with the Peloponnesians: 300 Spartans, 500 fighters from each of Tegea and Mantinea, 120 from Orchomenus in Arcadia, 1,000 from the rest of Arcadia, 400 from Corinth, 200 from Phlius and 80 Mycenaeans. Boeotia contributes 700 Thespians, and 400 Thebans under their general Leontiades, who Herodotus says Leonidas brought along forcibly because he suspected their loyalty and wanted to put it to the test.[33] The Opuntian Locrians turned up 'with their entire army', and 1,000 Phocians complete the muster.[34] In all there were 5,200 – 3,100 warriors from the Peloponnese, 2,100 from central Greece, plus however many the entire army of Opuntian Locris might be. Pausanias replicates Herodotus's numbers exactly, but calculates that the Locrians' fighting force 'could not have numbered more than 6,000',[35] giving the army a maximum strength of 11,200. The battle took place in their

territory, so the Locrians had good reason to commit heavily, and Diodorus counts them at 1,000, adding that they now revoked their Medism. However, he leaves out the Thespians – a major omission since (spoiler alert) in his own account they are wiped out fighting alongside the 300 Spartans and become heroes in their own right[36] – and simply enumerates the 'other Greeks' at 3,000, in addition to 1,000 Phocians, 1,000 Malians, 400 patriotic Thebans, plus '1,000 Lacedaemonians, and with them [i.e. including] 300 Spartiates'.[37] So, a total of 7,400.

Diodorus's 1,000 Lacedaemonians plus 3,000 other (presumably Peloponnesian) Greeks fits neatly with an inscription which Herodotus saw at the battle site:

Here is the place where three million men once fought
Against four thousand from the Peloponnese.[38]

The mid-fourth-century Athenian orator Isocrates also spoke in round thousands when he reminded his audience of the glories of the past, although his massaging of the figures to amplify the Athenian achievement does not inspire confidence in their accuracy:

We shared the danger against a King who had become incredibly arrogant [. . .] The Lacedaemonians marched out to confront the land forces at Thermopylae with 1,000 specially chosen soldiers of their own [. . .] in order to prevent the Persians in the narrow pass from progressing any further; at the same time our ancestors sailed to Artemisium with 60 triremes that they had manned to take on the entire enemy navy.[39]

In his *Archidamus* Isocrates also pits the seemingly traditional 'One Thousand' who chose death over defeat against 700,000 Barbarians.[40]

We are also continually faced with the problem of what our sources mean by 'Lacedaemonians'.[41] The 700 making up Diodorus's 1,000 along with the 300 Spartiates could be Perioikoi, or possibly even armed Helots, but again it is hard to reconcile the numbers. Herodotus implies that each Spartan was accompanied by 'his Helot', but the disparaging Greek attitudes towards the Helots would not necessarily mean they were included in the figures, either as fighters or on the memorials, even though they certainly fought and died for a freedom in which they had no share.[42] Yet even if the 700 were Perioikoi there is still no trace of them in the memorials either. It was the 300 Spartiates who became the stuff of legend: Herodotus tells us explicitly that he had learned the names of every single one of them, even though he does not pass that information on to his readers, and six centuries later Pausanias was shown an inscription at Sparta with all the names on it, although he does not record them either.[43]

Three hundred 'true' Spartans still remains a fraction of their total fighting capability. Cornelius Nepos describes them as 'picked' men,[44] but suggestions that they were Leonidas's personal bodyguard[45] are not supported by the ancient sources: 'When [the Spartans] go into battle, the kings go out first and come back last. On campaign they have 100 [not 300] chosen men to guard them.'[46] Herodotus also says that Leonidas went to Thermopylae after specifically choosing 'the customary 300 men', who had living sons.[47] He does not explain why that choice was made. It certainly adds an extra emotional level, but as fathers the 300 would all have been mature, experienced

fighters. Their presence was a statement of Sparta's commitment to the cause, and 300 was the normal strength for a unit of Spartan 'special forces'.[48] The Spartan army had an elite group of *hippeis*, 'Knights', chosen by 'the three best men in the prime of their life', themselves chosen by the ephors. These three commanders then each selected 100 elite warriors for their unit, and these are in all likelihood the legendary 300.

The Spartans in Combat

On the battlefield it would have been obvious who the Spartans were, even though they were kitted out in standard hoplite panoplies.[49] Each man's standard-issue cloak, known as a *phoinikis* after purple-red dye extracted from thousands of *Bolinus brandaris* shellfish (Greek: *phoinix*) that thrived off the Laconian coast, made him instantly recognisable. His *phoinikis* was the colour of elitism, manliness and magic; it helped to disguise bloodstains and to focus his adversaries' attention on his and his comrades' intimidating unity; and it would be his funeral shroud.

One modern misapprehension is that Leonidas's Spartans were identifiable by the Greek letter labda or lambda, Λ (transliterated as 'L'), standing for Laconia or Lacedaemon, emblazoned on their shields. They certainly used blazons (Greek: *episema/semeion*), but these took the form of mythical or heraldic devices such as Gorgons, scorpions, Heracles' club or, in the case of one Spartan, a life-size fly, which he carried because it would be seen full size when it was shoved in his enemy's face.[50] But no contemporary source mentions the lambda device, which has never been found in an archaeological context and is not illustrated on any of the vase paintings that depict hoplite

weaponry. The idea seems to stem from a ninth-century CE Byzantine dictionary by Photius, who includes an entry under the letter lambda: 'The Lacedaemonians wrote lambda on their shields, like the Messenians wrote mu [M] on theirs.'[51] Photius may have known Pausanias's story of a Messenian ruse in a war against Elis in the third century BCE: '1,000 hand-picked Messenian troops reached Elis ahead of the others, displaying Laconian signs on their shields. When the pro-Spartan faction at Elis saw the shields, they hoped that an allied force had arrived, and let the men into the fortifications.'[52] However, there is no indication that the fake-Spartan shields were displaying a lambda, any more than the Eleans were expecting to see a mu. Photius has just jumped to that conclusion, and his dictionary entry continues with a quotation: 'Eupolis: "He was scared when he saw the glistening lambdas." So also Theopompus.'[53] Theopompus was a fourth-century BCE historian who Photius had obviously read, and he appears to be quoting the fifth-century BCE Athenian comic poet Eupolis.[54] But Eupolis's scary 'glistening lambdas' might well have nothing to do with Spartan shields – he does not mention Spartans – but everything to do with comic scurrility involving the letter lambda. Performing fellatio, for which the usual verbs are *laikazein*, *lesbiazein* and *lesbizein*, was comically said to have been invented by the Lesbians (inhabitants of Lesbos).[55] As Theopompus put it, 'I won't mention that clever old trick, passed down by word of mouth, so to speak, that they say the sons of the Lesbians invented.'[56] *Lesbiazein* and *lesbizein* could cover a multitude of sexual acts,[57] but the verb and its initial letter (the 'L-word', rather like our 'C-word') were especially associated with oral sex. In Aristophanes' *Women in the Assembly* one woman insults another one, doubtless pronouncing the

labial sounds with lots of tongue for comically onomatopoeic effect, 'I reckon you also want to "do the Labda" like the Lesbians!'[58] So Eupolis's 'glistening lambdas' might well not reference Spartan shields that say 'Lacedaemon', but ones that tell their opponents to *lesbizein*.

Leonidas's Spartans certainly stood out from their fellow Greeks for professionalism, though. Their mission in peace was to prepare for war, and they were experts in battlefield manoeuvres that were beyond other hoplite formations. The chain of command was clear, their tactical subdivisions flexible, and their procedures well drilled. At the time of Xerxes' invasion, they fought in five units called *lokhoi*, each of which was commanded by a *lokhagos* and was divided into smaller units known as *enomotiai* ('Bands of Sworn Soldiers'), led by an *enomotarkhos* ('Commander of the Sworn Soldiers'). Orders were transmitted from the king to senior officers called *polemarkhoi*, on to the *lokhagoi*, and finally down to the *enomotarkhoi*, who gave them to the rank-and-file sworn soldiers.[59]

The command structure enabled them to convert from a column of march into a line of battle with the utmost efficiency; they could quickly turn to face an enemy that was threatening them from the rear; they could perform complicated countermarching manoeuvres known as the 'Laconian *exeligmos*' to move the commander from the left wing to the right and the rear guard from the right to the left; and Xenophon compares their tactical agility to that of a well-handled trireme.[60] They were nimble on their own feet too. As well as practising endless military drills they cultivated a strong sense of rhythm using marching songs and warlike dances. Whereas the Athenians had advanced at pace against the incredulous Persians at Marathon,[61] the Spartan way was slow and rhythmic:

The Spartans advanced slowly and to the rhythm of the many flute players deployed in their midst. This was [. . .] to maintain a steady rhythm as they advanced, and to avoid their good order being broken, which often occurs when large formations go on the offensive.[62]

Other states also used flute players, as the famous Chigi vase[63] shows, where a musician is embedded in a Corinthian hoplite phalanx, but as with so much else in the military sphere, the Spartans took this to another level.[64] And when push came to shove, as it literally did in the *othismos*, their prowess was incomparable.[65]

However effectively the Spartans 'brandished their murderous ashen spears',[66] their numbers were still small. Diodorus tells us that when Leonidas announced his plan to take 1,000 Lacedaemonians to Thermopylae, the ephors simply told him that he should take more. But the king told them, 'They are indeed a small number to prevent the Barbarians transiting the passes, but they are plenty for the task they are now setting out to accomplish.'[67] This is enigmatic but illuminating, as is his laconically terse statement that the manpower of the whole of Greece would not be sufficient if he were just relying on numbers, but since he was relying on courage, he had all that he needed.[68] This raises questions about what was Leonidas and his troops' 'task they are now setting out to accomplish'. Some 400 years later Diodorus praised the Spartans for being the only people he knew of who chose to preserve the laws of their state rather than their own lives,[69] and dramatised an exchange between Leonidas and the ephors where he told them in secret: 'On the face of it I am leading them to guard the passes, but in reality to die for the freedom of everyone.'[70]

He added that however many Spartans he took, every single one would die in battle, because no one would turn and run. Around 150 years later Plutarch repeated the story: Leonidas was quizzed by the ephors, who were wondering whether he had decided to do anything apart from block the pass, to which he responded, 'No. Not in theory. But actually, my real mission is to die for Greece.'[71] Plutarch also records an exchange between Leonidas and his wife Gorgo as he left Sparta. She asked him whether he had any instructions and was told to marry good men and bear good children.[72] Statements like these, allied to the fact that Leonidas only took Spartans who had living sons,[73] who were therefore expendable, and Plutarch's statement that the Spartans held their own funeral games in front of their parents before they went off to war, have generated the idea that this was a suicide mission.[74] But although the expedition was high-risk and the attrition rates would doubtless be high, Leonidas and the 300 were neither expecting nor seeking to die to a man for no perceptible strategic gain. They were prepared to give their lives for the cause, but that was not their objective. It was their retrospective glamorisation which gave rise to that tradition.

The depleted numbers of troops from the Dorian states were also due to the same religious considerations that had prevented the Spartans from participating in the Battle of Marathon. Now, as then, it was the festival of the Carneia, and the intention was to march out with their full army once it was over. Furthermore, it was also the year of the quadrennial pan-Hellenic festival of Zeus at Olympia, which hindered other states from immediate full-scale mobilisation. Many of the contingents were simply advance guards, and the expectation was that the fighting would last for longer than it did.[75] The

overall Greek objective was relatively simple: to stop the massed ranks of the Persians smashing through the pass and 'keep the Barbarians out of Greece',[76] and do so in combination with the fleet at Artemisium. Furthermore, the focus on the low numbers of fighters at Thermopylae ignores the huge commitment of manpower to the Greek fleet: 271 triremes and 9 penteconters represented a deployment of approximately 55,600 men. This was not a token force, nor was it the moment for heroic but futile gestures, and they were not countenancing defeat:

> They had announced via messengers that they had come to Thermopylae in advance of all the other states, that these remaining allies were expected any day now, and that the sea was being watched and guarded [. . .] by the naval contingents. So there was nothing to fear (they said): 'The invader of Greece is not a god, he's a man, and there is not, and never will be, any person who, from the moment he is born, is not given some mixture of misfortune. The bigger the man, the bigger the misfortunes!'[77]

The timing of the Carneian and Olympic festivals is crucial in attempting to establish the precise dating of the battle, but unfortunately the evidence we have is thin, vague and open to multiple (mis)interpretations. These depend, among other considerations, upon the rising of Sirius the Dog Star, precisely what Herodotus means by 'summer', the relative timing of the battles at Thermopylae and Salamis, and exactly what the Greek text of some of the crucial pieces of evidence should be. Both festivals culminated at a full moon, but whether this was in August or September remains the subject of considerable dispute. The most popular options make Xerxes' initial attack

happen on 27 or 29 August, or 12, 13 or 17 September 480 BCE.[78] Yet there was almost a point at which the battle did not happen at all, with Xerxes' policy of forcing submission by a demonstration of overwhelming force nearly achieving its goal. Greek morale took a huge hit as the Persians got near the entrance to the pass. Again, they debated whether to stay or go, but this time it was the Phocians and Locrians who won the argument. Leonidas issued orders to remain, regardless of the odds.[79]

Come and Take Them!

In the ancient accounts, Xerxes now sends a scout to reconnoitre the Greek position, but the Phocian Wall prevents him seeing anything in detail, apart from an astonishing sight in front of it: the Spartans are exercising and combing their long hair.[80] Xerxes thinks this is both weird and hilarious, so he asks Demaratus to explain. 'I've told you about these people once already,' he says, 'but you didn't take me seriously. But it's true. I'll tell you again. The Spartans have come to fight, and that's what they're getting ready to do. It's their tradition to take care of their hair whenever they are about to put their lives on the line.'[81] Demaratus is clear that if the Spartans are going to die, they are going to do so in the most beautiful way they can, both figuratively and literally. He adds that the Spartans are the bravest nation in Greece, and only they are capable of withstanding Xerxes. The king remains incredulous: 'How can so few fight against so many?' he wonders. 'Just wait and see,' says Demaratus.[82] 'You have already experienced Greek courage at first hand. You use Greek forces to subdue Barbarians. They fight better than Persians. So how much more bravely do you

think people who risk their lives to maintain your sovereignty will fight to preserve their own freedom?'[83] Again Xerxes laughs.

Our sources speak of an exchange of letters between the two kings. Xerxes offers Leonidas the lordship of all Greece if he comes over to the Persian side. The Spartan writes back saying that if Xerxes truly understood the beautiful things in life, he would not covet other people's possessions: Leonidas would rather die for Greece's freedom than be sole ruler of his own race;[84] his Spartans will not surrender their weapons; and the Greeks are not in the habit of gaining lands by cowardice, but by courage.[85] Most famously, when Leonidas receives Xerxes' three-word letter ordering him to 'Surrender your weapons', he responds in two: '*Molon labe*' (= 'Come. Take!').[86]

Leonidas's words are in what grammarians call the aorist tense, which describes a single, complete event (literally 'having come, take'/'once you have come, take'), not an ongoing process, but Xerxes decided to take his time. He waited for four days, expecting the Greek resistance to crumble. When it did not, his anger got the better of him. He ordered his troops into action on the fifth, telling them to take the Greeks alive. When a man from Trachis allegedly told the Spartan Dieneces that the enemy forces were so numerous that their arrows would obscure the sun, far from being intimidated, he made a laconic joke of it: 'Our Trachinian friend brings totally excellent information! If the Medes hide the sun, our battle against them will take place in the shade, not the sunshine!'[87]

The Medes, bolstered by Cissians, Sacae, and the brothers and sons of the men who had died at Marathon, in the hope that they would exact savage vengeance on the Greeks, led the first onslaught.[88] They had to negotiate the bottleneck of the West Gate, while the defenders packed the narrow area around

the Middle Gate, where they could utilise the wall to provide cover from the arrows hiding the sun. The Persians' *sparabara* tactics[89] could be awesomely effective in the right terrain, but here, once the initial salvoes had failed to cause the desired chaos in the Greek ranks, and the *othismos* of eyeball-to-eyeball combat had begun, the risk of casualties from friendly fire neutralised their effectiveness altogether. The invaders were under-equipped to go toe-to-toe against heavy-armed hoplites, and although the fighting was ferocious and lasted a long time, the Medes could make no impression. By the time the retreat was sounded they had suffered severe casualties, and Xerxes, watching anxiously from his throne overlooking the action, was starting to realise that although he had a massive number of human beings, he had very few 'real men'.[90]

The Great King now turned to his elite troops. Hydarnes was ordered to lead the Immortals into action. But the same constrictions brought the same results: the space was too narrow; the fighters pushing from the rear made life difficult for those at the front; the more the troops at the back pushed forward 'under the whip' of their commanders, the worse the situation became; they could not outflank the Greeks; their arrows were useless; their spears were not long enough; their body armour was inadequate; their wicker shields were ineffectual; their numbers were a hindrance; and the Spartans were just too good. It was professionals against amateurs:

> Sometimes the Spartans would turn their backs and pretend to flee, and then, when the Barbarians saw them retreating and were pursuing them with shouts and screams, and were just about to catch up with them, they would wheel to face them and slaughter countless numbers of Persians.[91]

The Immortals could make no impression. The Spartans incurred some casualties, but nothing on the scale of the Persians. Xerxes called the attack off for the night, and while he slept the ships which might have brought a solution to his tactical problems were wrecked on the rocky shores of Euboea.[92]

Day two was an action replay of day one. Xerxes sent his finest warriors into the pass, promising them immense rewards for victory and threatening death for failure, and they hurled themselves on the Greeks in massed fury. Leonidas's Spartans closed ranks again, and the other Greeks took it in turns to fight and regroup. The narrow front allowed them to withdraw out of arrow range to await their turn to join the action, and fresh troops could be brought up to the combat zone whenever there was a pause in the fighting or another Persian battle group was repelled. Our sources do not tell us how this was organised, but it enabled continuous combat throughout the heat of the day, and although Leonidas's Spartans emerged with the undying *kleos* (glory), it is clear that all the Greek contingents were heroes. The Persians were again hampered by their numbers, since every time one of their attacks was repulsed the troops stationed in reserve blocked their retreat and forced them to return to the fray in an exhausted and demoralised state.[93] When the Persians finally pulled back for the day, the Greeks could congratulate themselves on the effectiveness of their weaponry, courage and unity. Their comrades at Artemisium were still holding the Barbarian navy at bay, and they were confident that the pass remained secure.

The Malian Nightmare

The King of this Great Earth Far and Wide was at a loss. The landscape, sea conditions and weather were all against him, his resilient adversaries were proving that Demaratus's words were not so funny after all, and his vaunted massed ranks were becoming their own worst enemy. The fact that they could drink rivers dry was a major problem: the average daily temperature in August is between 32 and 23 °C, and 28 and 20 °C in September, and each fighter would need 10 litres of water per day to stay properly hydrated, while their animals were consuming about 40 litres. They needed millions of litres of potable water, which was not readily accessible. Every beast also ate around 9 kg of fodder, adding up to a total consumption of well over 500 tonnes, or 750 hectares of pasture, every single day, so the Persians had to forage further and further afield to feed the animals and themselves. Their sailors would require some 3,600 calories plus 80 g of protein per diem to sustain their performance, but their rations of one *khoinix* of unmilled grain were giving them less than half of that. And what goes in must come out. The amount of human and animal faeces being produced was staggering – in excess of 500 tonnes of manure and nearly 300,000 litres of urine even before any humans had relieved themselves. This, allied to the heat, thirst, hunger, swarms of flies and cramped conditions, brought the threat of disease, and without clean drinking and washing water the survival rates of non-fatal casualties would have been minimal.[94] All these problems would have been far less serious for the Greeks, who had much easier access to local food and water,[95] fewer mouths to feed, hardly any horses, and better sanitary and waste-disposal facilities.[96]

In Aeschylus's *Persians*, the ghost of Darius described how the Persians can prosper in the future:

> By not marching into Greek territory
> even if the army of the Medes is greater than theirs.
> The land itself becomes their ally.[97]

However, at this point Xerxes acquired an ally who could help him exploit the Greek land to his own advantage. A Malian from the region of Trachis, by the name of 'Nightmare', Ephialtes (or Epialtes) son of Eurydemus, arrived with some local knowledge and a proposition that he thought the king would reward him for.[98] There was a path that led over the mountain. It was narrow and precipitous, but it came out behind the Greek position, and Ephialtes was happy to act as a guide. Xerxes was even happier. He despatched Hydarnes and his Immortals straight away, at what Herodotus says was around lamp-lighting time, roughly 8 p.m. or a little earlier.

This path was known to the Greeks, and they had already deployed lookouts on the heights and stationed 1,000 Phocian troops behind Mt Kallidromon at its eastern end, from where they could maintain contact with their comrades in the pass.[99] The Phocians seemed like a good choice: they were familiar with the terrain, a Persian victory would put their wives, children, parents and property at risk before anyone else's, and they had volunteered for the task. It was a significant commitment of manpower, which shows how seriously Leonidas was taking the threat.

Herodotus gives a vague description of the path, as does Pausanias: it starts where the River Asopus flows through a sheer-sided ravine about 5.5 km west of the entrance to the

pass, crosses the ridge of the mountain (which, like the path itself, is called Anopaea, 'Unseen'), and ends at the town of Alpeni near 'Black Buttock Rock'.[100] The intervening route is discussed with an intensity that is directly proportional to its uncertainty: establishing the precise route of the path, or paths, and particularly the line of the first ascent, is deeply problematical, in terms of the terrain, the length of time it would take on a stealth mission through oak woods on a still moonlit night, and the ease with which a force of up to 10,000 fully equipped men could traverse it.[101] In Herodotus's narrative Hydarnes sets off, crosses the River Asopus, and follows the track throughout the night, keeping the mountains of Oeta on his right and those of Trachis on his left, until he reaches the highest point of the path at around 6 a.m., and takes the Phocian defenders totally by surprise. He should not have done: the Phocians had only one job, and this was it. The lookouts had failed abysmally in their duty.

The thing that gave the Persians away was the rustling of leaves underfoot, and each side was as stunned as the other when they met. The time it took for the Phocians to grab their weapons denied them any element of surprise, while Hydarnes was apprehensive that he had run into a force of Spartans until Ephialtes put his mind at rest. The swords of 1,000 men should still have been sufficient to block the Persians' progress, but when the Immortals' arrows started to fly the Phocians mistakenly thought that they were the prime focus of the attack and retreated to the top of the mountain, fully expecting to die there. But they had overestimated their own importance. They were just a temporary annoyance. The Immortals had no need to kill them, and once they were out of the way Hydarnes just kept marching, leaving the Phocians isolated, ineffectual and

incapable of getting a message to Leonidas. They vanish from the narrative just as they probably vanished into the woods. Ephialtes led Hydarnes and the Immortals down the path as fast as he could.

The Last Stand

It appears that Leonidas had at least some advance warning about the Persians on the Anopaea path. The Acarnanian seer Megistias told him that the dawn would bring death; deserters arrived during the night with intelligence about the night march; and as the sun rose the mountain lookouts confirmed the sightings.[102] Yet again the Greeks debated whether to remain or leave, and this time their actions followed their opinions: the leavers scattered to their home cities, while the remainers prepared to stand alongside Leonidas and the Spartans. However, he sent them away: he wanted to ensure their survival, but it would also be unthinkable for the Spartan king not to stand and fight; leaving would tarnish his and Sparta's reputation for eternity; remaining would bring 'mega-*kleos*', the everlasting public honour that every mythical hero aspired to:[103] just like Achilles had said, 'my return home is gone, but my *kleos* will be imperishable'.[104] True Spartiate that he was, Leonidas knew the right thing to do. Nevertheless, a few stayed with him: Megistias sent his only son home, but disobeyed orders and chose to remain himself; the 700 Thespian volunteers under their general Demophilus son of Diadromes opted not to abandon Leonidas; and the Thebans were forced to stay, practically as hostages.[105]

At this point, Diodorus Siculus introduces a bizarre incident and a memorable soundbite. As the Persians led by 'the

Trachinian' (he cannot bear to call Ephialtes by name) were emerging from the mountain to surround Leonidas, his men asked him to lead a night attack. He was delighted to: 'He ordered them to have their breakfast quickly, because they would be having their dinner in Hades.'[106] They attacked the Persian camp, targeting Xerxes' tent, and ran amok in a night-time killing spree, slaughtering Persians, inflicting blue-on-blue casualties among themselves in the darkness and chaos, and narrowly missing the king. But when the sun came up the Persians realised how few Greek warriors there were and shot them down to a man with their bows and javelins.[107] Herodotus makes no mention of this version of Leonidas's death. It is highly problematical in terms of the topography, archaeology, timing and strategy, and appears to be a later addition to the tradition.[108] Much to be preferred is Herodotus's account, where Xerxes is the aggressor.

The Great King offered libations to Ahura Mazda at sunrise. At Ephialtes' suggestion, he waited until 'the time in the morning when the market-place is at its fullest',[109] around 10 to 11 a.m., and his schedule was perfect since it allowed the encircling troops time to get down from the mountain and position themselves behind the remaining defenders. The Barbarians advanced; Leonidas and his men left the safety of the Middle Gate and moved towards them into the wider part of the pass; the Persian commanders drove their contingents forward with their whips; the Greeks wanted to make the most of their offensive assets and inflict maximum damage before the Immortals reached the combat zone; the oncoming Persians were again funnelled into a highly constricted space, and suffered losses by being driven into the sea and drowned, or trampled underfoot by their own side; and the Greeks fought in frenzied violence,

hacking down their assailants with their swords when their ashen spears were smashed into splinters.[110]

Xerxes' brothers Abrocomes and Hyperanthes went down in the fighting, but when the Thebans sensed that the battle was turning in the Persians' favour, they broke away and threw themselves on the Barbarians' mercy. They had been Medisers from the start, they pleaded; they had given earth and water; they had been compelled to come to Thermopylae by Leonidas; they were innocent! Some were slain in the confusion, but most were spared and later tattooed with Xerxes' royal insignia. This was not a badge of honour: to the Greeks tattooing was a sure sign of slavery, even though judging the Thebans as unworthy of freedom was a harsh if enduring verdict.[111]

Theban infamy would later be sharply contrasted with Leonidas's imperishable *kleos*. He died in this phase of the combat – we are not told how – along with many others of the 300. A ferocious contest for possession of his body then ensued. The Greeks took possession of it and repulsed four Persian attacks before the Immortals appeared. Leaderless though they now were, the Spartans and Thespians maintained enough tactical awareness to withdraw to the wall at the narrowest pinch point of the pass. They made their last stand on a knoll at the opening of the pass, Kolonos Hill, which is still visible today and where a stone lion stood in honour of Leonidas in the fifth century BCE. There they defended themselves with increasingly dwindling resources – daggers if they still had them, then their fists, and finally their teeth. But their elevated position simply made them target practice for the Persian bowmen: 'The Barbarians buried them beneath a hail of missiles, some of them attacking them head on and throwing down the defensive wall, and

others surrounding them on all sides.'[112] In the late 1930s some bronze and iron Persian-, Egyptian- and Assyrian-style arrowheads of fifth-century BCE date were unearthed on Kolonos Hill, plus a *sauroter* and a single spearhead, finds which Marinatos felt supported Herodotus's description of the Greek defenders' last moments.[113] On this occasion, perhaps, the archaeology and the historian speak very much with one voice.

In Memoriam: Stranger, Tell the Spartans . . .

Xerxes was shown Leonidas's corpse. He had the head severed and the body crucified.[114] Diodorus describes his triumph as a 'Cadmean victory', as battles that were won at such a cost that they were not worthwhile were called before Pyrrhus of Epirus won his 'Pyrrhic victories' in the third century BCE.[115] He had destroyed relatively few of the enemy and lost enormous numbers of his own troops – 20,000 in Herodotus's estimate – but staged a bizarre and unconvincing PR exercise by inviting the sailors in the fleet to come and view the scene of his triumph. All but about 1,000 of his own dead were buried in trenches covered with leaves, and the sightseers were allowed to inspect what they thought were the Spartans and Thespians, although they were actually seeing Helots as well. No one was fooled, and Herodotus describes the stunt as laughable.

Herodotus numbered the great pile of Greek corpses at 4,000, having strongly implied that only 700 Thespians and the 300 Spartans made the last stand.[116] Even allowing one Helot per Spartan warrior, and factoring in any casualties among the surrendering Thebans, these numbers look strange, although it

could be that he was influenced by the memorial that was erected where they fell, which spoke of 4,000 from the Peloponnese who fought (not died) resisting 3,000,000.[117] The Spartans also had a pillar specific to themselves erected by the Amphictyons, which carried an elegiac couplet written by Simonides:

> Stranger, tell the Spartans that here
> We lie, obeying their words.[118]

Their exploits rapidly entered the historical and literary traditions, and Simonides also produced a work which may have been sung at the shrine of the fallen in Sparta:

> On Those who Died at Thermopylae
>
> Famous is their fortune; fair their fate;
> Their tomb is an altar; remembrance not wailing;
> Their dirge is praise.
> This shroud is such that neither dank decay
> Nor all-subduing Time shall fade.
> This sepulchre of excellent men
> has taken the good name of Greece
> as its servant. Leonidas the king of Sparta
> bears witness: he has bequeathed an ornament
> of the highest virtue and undying glory [kleos].[119]

Simonides also wrote the epitaph of Megistias, celebrating his decision to die alongside Sparta's king. Others who were honoured were Dieneces, fighting in the shade to the last, two Lacedaemonian sons of Orsiphantus called Alpheus and Maron, and the Thespian Dithyrambus son of Harmatides.

Ephialtes the traitorous nightmare fled. A price was put on his head, and he lived as a fugitive until he returned to Anticyra, where he was slain by a Trachinian called Athenades, for reasons that Herodotus promises, but forgets, to tell us.[120]

The 300 did not quite die to a man. Eurytus and Aristodemus both had serious eye-infections and were left behind at Alpeni. When Eurytus heard of Hydarnes' encircling manoeuvre he got his Helot to lead him into the battle. Once there, the Helot ran for it, but Eurytus plunged into the melee and was killed. Aristodemus was not so brave. In one version he stayed behind, and eventually made it back to Sparta. In another he was acting as a messenger, but deliberately took longer than he should and missed the fighting, unlike his fellow messenger, who got back in time to die. Aristodemus was formally disgraced and dishonoured, and came to be called Aristodemus the Trembler, although he would later partially redeem himself at the Battle of Plataea. A similar tale was told about Panites, who missed the battle because he was delivering a message to Thessaly. When he was similarly dishonoured on his return to Sparta, he hanged himself.[121]

Overall, though, the glorious defeat was said to outshine the glory of any magnificent victory. The defenders of the pass had unflinchingly faced overwhelming odds, put the laws and values of their state before their own lives, and although they had died in a losing battle, they were responsible for Greece's ultimate triumph:

You would rightly think that these men were more responsible for the common freedom [eleutheria] of the Greeks than the ones who emerged victorious in the later battles against Xerxes, because the Barbarians fell into despair when they

thought about the achievements of these men, and the Greeks were inspired to show the same levels of courage.[122]

It was one of the supreme ironies of history that the oligarchic Spartans under their celebrated monarch should, in defeat, facilitate the victory of democracy.

CHAPTER 11

Democracy Resurgent:
Greek Victory at Salamis

No! No! No! A vast sea of evils has broken on the Persians
and the entire Barbarian race!

Queen Atossa[1]

Greek Retreat; Persian Advance

While Xerxes' navy were doing their macabre sightseeing at
Thermopylae, the Greek ships were heading south. The
Corinthians led the way down the Euripus channel and the
Athenians brought up the rear, which possibly suggests that there
was tension between the two contingents.[2] However, Themistocles
is said to have taken advantage of being the last in line to wage
some propaganda warfare. He put in at places where their pursu-
ers would stop for anchorage and drinking water, and inscribed
messages on the natural rocks or on specially made stelae, aimed
at the Ionians on the Persian side.[3] Herodotus quotes one of them:

Men of Ionia, you are acting unjustly by fighting against the
land of your ancestors and enslaving Greece. The best option

is for you to come over to our side. But if you cannot do that, please adopt a neutral position [. . .] and personally ask the Carians to do the same. If neither of these is possible [. . .] we ask you to fight in a cowardly way when we engage in combat. Remember that you are descended from us, and that our hostility with the Barbarian originated with you.[4]

Herodotus suggests that Themistocles hoped either that Xerxes could not read Greek and so the Ionians would change sides, or, if the messages were relayed to him, he would lose confidence in the Ionians' loyalty and withdraw them from the conflict. No such inscriptions have been found, and Herodotus's transcription does not conform to the conventions of Greek epigraphy, and the final passive-aggressive point about the Ionian Revolt seems unlikely to have been persuasive. In all likelihood the existence of these inscriptions is bogus.

Once the Persians had verified news of the Greek departure their entire armada crossed over to Artemisium, and by noon they had taken possession of Histiaea. From there they overran all the coastal villages on the north of Euboea, but they were in no immediate hurry to pursue the allied fleet. In fact, the Persians found their opponents completely mystifying. When some Greek deserters from Arcadia arrived in Xerxes' camp seeking employment as mercenaries, the Persians asked them what the Greeks were doing. 'Holding the Olympic Games,' they said, 'watching sport and horse racing.' The Persians asked what the prize was. 'A crown of wild olive,' they replied. Tritantaechmes was impressed. 'Wow, Mardonius!' he said, 'What kind of men have you brought us to fight against? They do not hold contests for cash prizes, but for glorious

achievement!'[5] Xerxes in his hubris thought Tritantaechmes was just being cowardly, but yet again he had missed a clear warning sign.

The Great King of this Great Earth Far and Wide was continually failing to heed good advice about how to deal with these incomprehensible Hellenes. He was utterly perplexed by what had happened at Thermopylae, and questioned Demaratus again: 'Is every Spartan warrior as good as these? How many of them are there?' 'A lot of them,' the ex-king told him, 'and a lot of cities. Sparta itself holds around 8000 men exactly like the ones you have just fought. The rest of the Lacedaemonians are not at their level, but they are still brave men.' 'What can we do about it?' asked Xerxes. 'You should know. You've been their king.' Demaratus's advice was to open a second front against the Spartans by sending 300 ships to the island of Cythera, just off the Laconian coast. 'The Spartans have a saying that it would be better if Cythera were under the sea, not above it,' he said, 'and occupying the island will immediately stop the Spartans fighting further north. That will make it relatively easy to enslave the rest of Greece.'[6] Xerxes' brother Achaemenes, the admiral of the fleet, was suspicious of this advice. He felt that the king was listening to a man who might be traitorous to his cause, and he had a stereotyped view of the Greeks as jealous of other people's success. 'We have already lost 400 ships,' he argued, 'and if you divide the fleet by sending 300 more vessels to the Peloponnese, the remaining force will be susceptible to attack. But if you keep it united, it will be invincible. Fight on your own terms, not your enemy's. We will defeat the Spartans next time.' Xerxes preferred Achaemenes' strategy, but forbade him from bad-mouthing Demaratus, who was his honoured guest-friend.[7]

Xerxes' victory at the Hot Gates had opened the road into southern Greece. Yet oddly the Persians do not seem to have made use of it. Instead, Herodotus says they used an inland route which avoided the pass altogether, although some scholars think it seems unlikely that at least part of his army and its logistical support would not have gone that way: the road beyond the pass was a good one; they could maintain contact with the fleet; it would restrict the opportunity for Greek attacks on the rear of the main force; and ultimately the two columns could reunite further south in Boeotia.[8]

After inflicting the trauma at Thermopylae, the Persian army once again exploited some longstanding Greek-on-Greek hostilities, this time between the Phocians and the Thessalians. The Medising Thessalians demanded fifty talents of 'protection money' to divert the Persians away from Phocis's territory, but the Phocians said that they would never be traitors to Greece. Had the Thessalians been the loyalists, Herodotus suggests, the Phocians would have been the Medisers, on the principle that 'my enemy's enemy is my friend', but as things turned out the Thessalians became Xerxes' guides.[9] They probably led the Persian army through the Dhema Pass, and then followed the Cephisus River into the lands of their Phocian enemies. 'War is cruelty, and you cannot refine it',[10] and the consequences of not submitting to Persia, or of submitting and reverting to loyalism, were now made brutally clear in an orgy of destruction, and sacrilege, and sexual violence.[11]

From Trachis Xerxes' army moved into Doris, which had Medised so it came to no harm. As the invaders descended upon Phocis its inhabitants scattered: some took refuge on the heights of Mt Parnassus at a peak called Tithorea ('Breast Mountain'), near the town of Neon (modern Tithorea); others

made their way to Amphissa in the territory of Ozolian Locris ('Smelly Locris'), near Delphi.[12] The Persians devastated Phocis, torching towns and temples as they went: Drymus, Charadra, Erochus, Tethronium, Amphicaea, Neon, Pediea, Tritea, Elatea, Hyampolis and Parapotami were all destroyed,[13] and the rich temple and treasury of Apollo Abae (modern Kalapodi) were pillaged, although the oracle continued to function in later times and Herodotus himself saw statues that were dedicated there as a monument to Persian impiety.[14] The atrocities escalated further when Xerxes' men gang-raped some of the Phocian women so viciously that they died as a result of the multiple violations.[15]

At this point Xerxes divided his army. The main force marched with him to Athens, while a smaller contingent veered off to attack Delphi. Xerxes' own march was relatively routine. Boeotia Medised in its entirety, and the mercurial King Alexander I of Macedon maintained his canny stance of being, or pretending to be, a friend of both sides by sending agents who made sure Xerxes knew the Boeotians and Macedonians were fully committed to his cause. However, the Thebans ensured that the territory of Thespiae and the town of Plataea were laid waste even though their occupants had already escaped to the Peloponnese.[16] From there Xerxes moved into Attica, ravaging the countryside as he went. The other battle group set off for Delphi, devastating more Phocian towns – Panopeus, Daulis and Aeolis – on the way. Their mission was to plunder the Temple of Apollo and take its famous treasures to Xerxes.[17]

Delphi was the premier shrine of Apollo, god of prophecy. Apollo's priestess, the Pythia, was an ordinary local peasant over the age of fifty, chosen by unknown criteria, who served

for life but had no special training. The oracle's prime function was not so much to predict the future as to give 'unfailing advice',[18] but up until this point the advice had been somewhat conflicting. On the one hand it had implied that the Persians would win, but it had also given more optimistic responses to both the Athenians (the 'Wooden Wall'), and the Spartans ('if the king dies, the state survives').[19] Essentially Delphi was hedging its bets, which opened it up to charges of Medism, and numerous scholars think that when Herodotus later interviewed the oracle's administrators they fed him fake news that was designed to rehabilitate its image and to smear that of Xerxes.

The story makes the Delphians ask their own oracle whether they should bury their sacred treasure or take it somewhere else. Apollo said that he was perfectly capable of looking after his own property, so the Delphians sent their women and children across the Gulf of Corinth into Achaea, and either took refuge in the sacred Corycian Cave above Delphi on Mt Parnassus[20] or escaped to Amphissa in Locris, leaving behind just sixty men and Aceratus ('Pure'), the priest who transcribed the Pythia's responses. The Persians were within sight of the Temple of Apollo when Aceratus saw some holy weapons, which must have come from inside the temple of their own accord, lying in front of it. A second miracle then happened when the Persians approached the sanctuary of Athena Pronaea, about 1,500 m away from the main precinct: they were struck by thunderbolts, two enormous rocks broke off from the cliffs above the site and came crashing down, killing many of them, and supernatural war cries were heard coming from Athena's temple. The Barbarians turned and ran, pursued by the Delphians. The Persian survivors claimed that they been chased

by two superhuman-sized hoplites who the Delphians identified as the local heroes Phylacus ('Guardian') and Autonous ('Freedom of Thought').[21] A huge boulder lies in the sanctuary today, and although that one fell in 1905, it illustrates the very real natural hazards at Delphi, which suffers regular earthquakes. The Delphians erected a trophy in the Athena Pronaea precinct:

> The Delphians set me up as a memorial to War, the
> Defender of Men,
> And as a witness of victory,
> Giving thanks to Zeus and Apollo, who pushed back the
> city-sacking ranks of the Medes
> And saved the bronze-crowned sanctuary.[22]

Athens in Flames

The outcome of the raid on Delphi made little difference to the king as he bore down on Athens overland and his fleet ravaged the coasts of Euboea and Attica.[23] There was further disappointment among the Athenians when they discovered that the Peloponnesians had decided not to resist the Barbarians in full force in Boeotia, and were constructing fortifications across the Isthmus of Corinth: the defence of the Peloponnese was their top priority; the rest of Greece was expendable; Leonidas's brother Cleombrotus, now ruling as regent of Sparta for his underage nephew Pleistarchus, was in command; and they had destroyed the vertiginous Scironian Road that led through Eleusis and Megara to the Isthmus, where tens of thousands of men were now shifting stones, bricks, logs and crates full of sand 24/7. The roll call of shame included men from Lacedaemon,

Arcadia, Elea, Corinth, Sicyon, Epidaurus, Phliasia, Troezen and Hermione.[24]

The Athenians felt betrayed, angry, dejected, isolated and devastated at having to abandon the shrines of their gods and the tombs of their ancestors.[25] They insisted that the Greek fleet returning from Artemisium should put in at Salamis, but from there they could only look on in helpless horror as the Persians torched their city. The few remaining religious officials, poor Athenians and oracle-deniers took refuge on the Acropolis, behind wooden walls of their own; the Persians occupied the Areopagus Hill, from where they unleashed fire-arrows; the pro-Persian Peisistratids offered to broker terms of surrender; but the defenders rolled large, disc-shaped stones down on to the attackers when they assaulted the gates. Some of Xerxes' men eventually found a way to scale an unguarded sheer cliff near to the shrine of Cecrops I's daughter Aglaurus (aka Agraulus) on the east side of the hill. The story went that she had gone mad and hurled herself to her death from the Acropolis,[26] and now mythology repeated itself when some of the defenders did the same. Others took refuge in the inner chamber of one of the temples, where the Persians slaughtered them before setting fire to the whole Acropolis complex.[27] Parts of the old Mycenaean Wall, the Old Temple of Athena Polias and the Older Parthenon were badly damaged – the heat effects on the stonework of the latter are still visible – plus the Temple of Nike, the Great Altar of Athena and numerous dedications, including Callimachus's victory monument from the Battle of Marathon.[28] In an act that symbolised the political destruction facing Athens, the statues of Harmodius and Aristogeiton were also pillaged and sent back to Susa: a real-life Barbarian tyrant had supplanted the democratic tyrant-slayers.

Xerxes had accomplished his mission. He sent a rider back to Artabanus at Susa to announce that his father's vengeance project was complete. He also sent the Athenian exiles who were with him up on to the Acropolis and told them to perform Greek-style sacrifices. For the most part, the Achaemenid kings prided themselves on their religious tolerance: Xerxes had come to destroy the temples of the people who had violated his and would not submit to him, but not to stamp out their religion. The Greeks did as they were told, with miraculous results. Athena's sacred olive tree in the sanctuary of the Earthborn Erekhtheus had been burnt, but twenty-four hours later it had put out 50 cm of new growth, which the Athenians interpreted as a sign of the regeneration of the city:

> There is a plant which I have heard does not grow in Asia
> [. . .]
> It is not planted by human hand; it is self-renewing;
> It is a thing of terror to the spears of the enemy;
> And it flourishes in our land:
> The grey-leaved olive that nourishes our children.[29]

However, Xerxes might well have regarded the miracle as divine acceptance of his sacrifice, signifying that Athens would rise from the ashes under his rule. Only time would tell who was right.

Divine Salamis: Fight or Flight?

Across the waters from Athens, the Greek ships that had retreated to Salamis were joined by the rest of the allied navy, which had previously mustered at Troezen's port of Pogon

('Beard Harbour'). They now had a total of 378 triremes, still under the command of Eurybiades, 54 up from the 324 that had gone to Artemisium, with the addition of nine further states, minus the loss of Opuntian Locris.[30] Herodotus treated his readers to another epic Catalogue of Ships, as the tension began to build. From the Peloponnese came 16 Lacedaemonian triremes, 40 Corinthian ones like at Artemisium, 15 from Sicyon, 10 from Epidaurus, 5 from Troezen and 3 from Hermione. Mainland Greece furnished 180 Athenian triremes, which, despite the damage incurred at Artemisium, were still the navy's most seaworthy ships, although now no longer co-crewed by the Plataeans, who were preoccupied with evacuating their city;[31] Megara matched its commitment at Artemisium with 20; the Ambraciots sent 7 and Leucas 3. From the islands came 30 high-quality vessels from Aegina, although they kept other ships back as a home guard; 20 from Chalcis; the same 7 from Eretria that had fought at Artemisium; 7 from Ceos; 4 from Naxos, which had defied the Medism of their fellow Naxians to join the Greek cause under their leader Democritus;[32] Styria brought 2; Cythnia 1 trireme and a penteconter; and the islands of Seriphos, Siphnos and Melos, which had never offered earth and water to Xerxes, sailed with 4 penteconters between them. From south Italy came the men of Croton in a single trireme captained by Phaullus, a celebrity athlete who had twice won the pentathlon at the Pythian Games.[33]

This was an extremely impressive roster of troops – in excess of 75,000 fighting men – but establishing unity of purpose was not easy. Again, they argued about whether they should fight and, if so, where. The clearly visible smoke rising from the Athenian Acropolis was a savage blow to their morale, and

some Greek ships 'hoisted their sails' even before any decision was made. When Eurybiades canvassed the admirals' opinion about where their preferred place to engage might be, Attica was not even on the agenda: defeat at Salamis would leave them isolated on an island, whereas if they fought at the Isthmus, they would have easy escape routes, along with some fortified defences and supporting troops at the wall taking shape between Lechaeum and Cenchreae.[34] It was a foregone conclusion. The navy prepared to leave. However, this was not an acceptable outcome for Themistocles. His old teacher Mnesiphilus told him that leaving Salamis would effectively mean abandoning Athens for ever, and that the allied fleet would probably fragment during the retreat. Even if the allies made it to the Isthmus, they would simply be overwhelmed in the open waters there, and Themistocles could not let that happen. He needed to lure Xerxes into the confined waters around Salamis that the Athenians knew so well, and to ensure that the rest of the Hellenes fought there with him.[35]

Our sources give broadly similar overall accounts of what happened next, but with slightly different sequences of events and interactions between the key personalities. In Herodotus's version Themistocles told Eurybiades that they needed to talk. He had assimilated Mnesiphilus's ideas and added a few of his own, and he persuaded Eurybiades to reconvene the admirals. The debate was bad-tempered, as the characters 'hurled words at each other like missiles'.[36] At one point, Eurybiades raised his Spartan staff to smite Themistocles, who told him, 'Smite, but listen!'[37] An Eretrian who tried to argue with Themistocles was given similarly short shrift: 'Yes! What can you say about war? You're like a calamari – all sword and no heart!'[38] But the main argument came with the Corinthian admiral Adeimantus.

'At the games, Themistocles, those who make a false start are whipped,' he said. 'True,' came the reply, 'but those who are left standing don't win crowns!'³⁹ Themistocles went on to outline the strategic options: (1) fighting in open waters at the Isthmus with fewer, less manoeuvrable ships,⁴⁰ necessarily losing Salamis, Megara and Aegina in the process, and inevitably leading the Persian land army into the Peloponnese; or (2) engaging in the narrows where the enemy numbers would not count,⁴¹ saving the aforementioned islands and their women and children in the process, and keeping the enemy away from the Isthmus. There was no option (3), although the Greeks did have the Salamis oracle.

Adeimantus's response was scathing: a homeless man had no right to speak, he argued; Eurybiades should operate a 'no city no vote' policy; Themistocles had no city to lose, but all the allies did. Themistocles' reply was robust: 200 triremes were a greater city than Corinth, he argued, and Athens could use them to conquer any Greek state they wanted, and make a new home there.⁴² He then took Eurybiades aside and told him again that remaining was the right and courageous thing to do, and that leaving for the Isthmus would lead to the destruction of Greece. This time he added a threat: unless you stay, we will immediately leave en masse and sail to Siris (an Ionian city in Italy) and colonise it; without us, you are all doomed.⁴³ Eurybiades now saw Themistocles' point of view. He would fight at Salamis.

At sunrise the following day there was an earthquake. This was a propitious sign for the Greeks, indicating success on both land and sea, and they prayed to the gods and the local heroes Ajax and Telamon, who were already on Salamis (presumably in the form of statues), and sent a ship to fetch their father

Aeacus and his other descendants from Aegina. The Persians had a different divine manifestation. An Athenian exile called Dicaeus was with Demaratus on the Thriasian Plain around Eleusis in Attica when the Persians were ravaging the land. They saw a dust cloud raised by the feet of 30,000 men and heard the cry of 'Iacchus!' that the initiates of the Eleusinian Mysteries sang. Dicaeus was convinced that this portended disaster for Xerxes – by land if the cloud floated towards the Peloponnese, by sea if it drifted to Salamis. Demaratus warned him not to tell Xerxes this – it was dangerous to speak unwelcome truths to a ruler who disliked democratic equality of speech – and as the two exiles watched, the cloud made its way towards Salamis.[44] Plutarch also mentions a story that an owl, Athena's bird, flew through the Greek fleet from the good-omened right-hand side and perched in the rigging of Themistocles' ship.[45] Athena might have abandoned the Acropolis, but the gods had not abandoned Greece.

Various attempts have been made to rationalise the dust-cloud story.[46] The Persian land army had been marching towards the Peloponnese during the night,[47] and our sources speak of Xerxes' engineers attempting to construct a causeway from a stretch of shoreline called the Heracleum or the quarries of Cape Amphiale across to Salamis, either in the form of a pontoon bridge or a mole. This would have been a construction project on a par with bridging the Hellespont, possibly linking the shoreline to the Pharmacussae ('Enchantress') Islands, Agios Georgios and then Salamis, and the Persians would have needed unhindered access of the channel in order to build it. Herodotus and Plutarch place the attempted construction on the day after the battle, which would have been impossible and pointless, but Ctesias and Strabo both say

it was started before the fleets engaged, possibly providing a more mundane explanation for the supernatural dust.[48]

Xerxes Decides to Engage at Salamis

After their grisly tourist trip to Thermopylae, the Persian navy had waited for three days before taking another three to sail down the Euripus channel, round Cape Sounion, and beach at Phalerum. Phalerum itself could not have easily accommodated the whole fleet, but we are left in the dark as to where else any other vessels might have been placed. Herodotus felt that Xerxes' losses of over 600 ships and 20,000 soldiers in storms and battle would have been completely offset by Medising recruits from Malis, Doris, Locris, Boeotia, Carystus, Andros, Tenos and various other islands, although this seems unlikely. Nevertheless, the armada was impressive, and Xerxes now sat enthroned in all his finery to plan its next move.[49] If the 'audience-scene' reliefs from Persepolis are an accurate guide, his throne would have had a straight back, a footstool, and been covered with an embroidered canopy, and his *Arshtibara* (Spear-bearer) and *Vaçabara* (Bow-bearer) would have been in attendance. He summoned the tyrants and the commanding officers, sat them down in strict hierarchical status order – Tetramnestus of Sidon first, Matten of Tyre second,[50] and so on down the ranks – and sent Mardonius to pose the highly loaded question: 'Should we fight?'

No one dared say no apart from Queen Artemisia. As 'a woman making war on Greece',[51] Herodotus found her an intriguing character, and she is another of the 'wise advisor' figures whose expertise Xerxes fatally rejects, and is continually associated with gender reversals.[52] She talked up her own

effectiveness in the fighting off Euboea, and appealed directly to Xerxes' common sense: 'On sea the Greek forces are stronger than yours in the same way as men are stronger than women,' she said. 'Why fight now? You have already done what you set out to do. Athens is captured, and so is the rest of Greece. Everyone who resisted you has got their just deserts.' Her specific advice was simple: stay at Phalerum; time is on your side; you can scatter the Greek fleet sooner or later; they are short of food; a land attack on the Peloponnese will split the Greek resistance; and fighting now, at sea, is needlessly hazardous. She finished with a withering assessment of the fighting capabilities of the Persian navy:

> And another thing, my King [. . .] Good men tend to have bad slaves just like bad men have good ones. You are the best of all men and you have awful slaves who are counted as your allies – Egyptians, Cypriots, Cilicians and Pamphylians. They are totally useless![53]

Artemisia would probably have used the Persian *bandakā*, 'subjects', rather than Herodotus's *douloi*, 'slaves', but to a freedom-loving Greek subjection to the king and slavery were one and the same. Her friends and enemies all thought she had just signed her own death warrant. But Xerxes had always had a high opinion of her. He knew she was motivated by speaking *Arta* (truth/justice), and her status went up even more now, even though he decided to go with the majority opinion. He felt that Artemisium had gone so badly because he had not been there. This time he would watch the battle himself.

Orders were issued to set sail. However, by the time the Persian fleet was in battle order it was too late in the day to do

any fighting. The naval engagement would have to wait until tomorrow but, as night fell, the Persian land forces began marching towards the Peloponnese. They might ultimately have advanced as far as the Isthmus. The Persians regarded the temples of their enemies as the haunts of false demons, which needed to be purified with fire, and the archaeology shows evidence that the Temple of Poseidon was burnt at around this time, possibly close to the partial solar eclipse of 2 October.[54]

Meanwhile on Salamis, Greek morale and unity were imploding. The Peloponnesians were far from home, about to fight for someone else's territory while their own lands were unguarded, and on an island where they might end up trapped. They wanted to withdraw immediately. The army on land felt a similar sense of terror, and all across the Greek forces a sense of mutiny was setting in.[55] People started to trash-talk Eurybiades behind his back, but then it all came out into the open and another assembly had to be held. They rehashed the same old issues, dividing on the same lines as before, and it looked like the Peloponnesians would get their way until Themistocles 'devised and implemented the famous Sicinnus Affair'.[56] This was later dramatised by Aeschylus.

> Your Majesty [reports a messenger to Queen Atossa], an
> avenging spirit
> Or evil demon appeared out of nowhere to begin all our
> disasters.
> A Greek man came from the Athenian forces
> And said this to your son Xerxes,
> That when the dimness of black night fell,
> The Greeks would not stay, but would jump onto the
> rowing benches

Of their ships, and every one of them would try to save his
 own life
By fleeing in all directions under the cover of darkness.[57]

The 'evil demon' is named as Sicinnus by Herodotus and
Plutarch, who make him Median or Persian not Greek, and
agree that he was Themistocles' *paidagogos*, the household slave
who was responsible for his children's education.[58] He claimed
to have been sent by Themistocles, who was secretly on Xerxes'
side, to tell them that the Greeks were on the point of fleeing,
disunity was raging in their camp, the army and fleet had
become separated, and that if he wanted an easy victory he
should attack right now. It was a message Xerxes wanted to
hear, and he swallowed the bait:

The moment the King heard this, not understanding the
 trickery
Of the Greek mortal or the jealousy of the gods,
He broadcast the following order to all his naval commanders.
'When the sun stops burning the earth
With its rays, and darkness takes hold of the sky,
You will deploy the close array of our ships in three lines
And guard the escape routes and the surging straits,
And also position other vessels in a circle all around Ajax's
 island.[59]
If the Hellenes avoid their gruesome fate
By stealthily finding some means of escape with their ships,
All of you will be beheaded!'
That is what he said. He was in an extremely good mood,
Because he failed to understand what the gods were about
 to do.[60]

Diodorus includes a story, modelled on that of Scyllies at Artemisium,[61] that an unnamed Samian swam over to the Greek forces to deliver intelligence about the king's strategic plans, and to say that the Ionians were planning to desert during the battle,[62] to the immense satisfaction of Themistocles: his plan had worked.

Persian Night Moves

Xerxes' commanders put his orders into effect. Night was falling – a departure time of around 8 p.m. seems reasonable – and the Persian rowers put out to sea having had hardly any rest and having already given the Greeks a foretaste of what their tactics might be.[63] From this point onwards, the events immediately preceding the battle, the locations of the key topographic features, the dispositions of the respective navies and their contingents, and the actual course of the fighting, can only be the object of intelligent guesswork. We know what the outcome was and have brilliant narratives of exciting individual incidents, but 'Herodotus' report of the battle of Salamis is in essence a ragbag of stories',[64] which are linked to places where his sources – one of which, Aeschylus, was possibly an eyewitness[65] – thought they took place. But beyond this, historians struggle to create any definitive strategic, tactical and geographical appraisal of the epic battle in which democracy was saved. No reconstruction is universally accepted.

Plutarch makes Xerxes order his sea-captains to mobilise the main body of the fleet at leisure, but also immediately send 200 vessels to surround the strait on all sides and encircle the islands; Diodorus has him dispatch the Egyptian squadron to block the waters between the western end of Salamis and Megara, while

the armada is ordered to head for Salamis and decide the issue there; while in Herodotus's words they landed a Persian force on 'the islet of Psyttaleia that lies between Salamis and the mainland'[66] and was in the way of the impending sea-battle. These were elite troops, perhaps 400 strong,[67] 'at the peak of their strength, the bravest in spirit, outstanding in their noble birth, and among those who the King trusted most',[68] and their mission was to save their own men and slay the Greeks, because Psyttaleia was where the men and wreckage would end up. It could also serve as a base from which to land on Salamis and massacre the civilian population in due course.

The location of Psyttaleia greatly affects how and where the battle might be reconstructed. Aeschylus describes the island and locates it 1 kilometre from Salamis, but does not name it; Plutarch places it at the epicentre of the fight; and Pausanias says it is famous because Persians died there.[69] There are two main modern schools of thought: one favours Agios Georgios ('St George'), which lies in Paloukia Bay inside the narrowest part of the strait between Salamis and Mt Aegaleus on the mainland (a minority view), while the other prefers the island now again called Psyttaleia after having its name corrupted to Leipsokoutali in the medieval period, which lies outside the strait, about 1 km offshore between Cape Varvari and Piraeus.[70]

Wherever the island of Psyttaleia was situated, Xerxes wanted to exact the maximum punishment for what had happened at Artemisium by annihilating the Hellenes, so at midnight his flotilla advanced its western wing, probably held by the Phoenicians, towards Salamis[71] in an encircling manoeuvre. Vessels stationed off Ceos and Cynosura were also deployed, and their ships 'occupied all the passage as far as Munychia'.[72] This raises further problems. Where were Ceos and Cynosura?

The options for Ceos include Talandonisi Island just south of Cape Varvari; the Zea harbour on the Piraeus Peninsula; the Attic headland of Keramos east of modern Psyttaleia; Poros Megaron between the north-west side of Salamis and the mainland to the west; and the island of Ceos/Kea just to the southeast of Cape Sounion. Cynosura ('Dog's Tail') was the name of the promontory near where Darius's Persians landed at Marathon, although that would leave the Persian fleet spread out over a considerable expanse of water, extending round Cape Sounion, past Cycladic Ceos and Phalerum, and on to Munychia. However, this Cynosura is more likely to be the long thin peninsula on the east side of Salamis, now Cape Varvari (= 'Cape Barbarians', which is probably not accidental), which juts out towards Piraeus. Such a deployment would effectively prevent almost all the traffic to and from the Greek forces on Salamis, and isolate them from any potential reinforcements from Aegina to the south.

Despite the enormity of the Persian fleet, it was also on a stealth mission: '[The Persians] did these things in silence, so that their enemies would not notice.'[73] To do this under cover of darkness is impressive, even if it is highly unlikely that the Greeks were unaware that something was happening. There would have been sounds from the vessels, easily audible across the waters in a world without noise pollution. Visual contact with the fleet might have been difficult against the sea and the mountains behind on what Aeschylus described as a 'black night', although the goddess Artemis Munychia was later credited with playing a valuable role in the battle by shining over the waters with a full moon.[74] The stench of hundreds of triremes and their oarsmen could also have aroused the local canine population, if not the humans. Nevertheless, Herodotus

felt that the Persians did initially escape notice while the Greek were still involved in a vigorous '*othismos* of words'.[75]

A crucial intervention now took place. The recalled ostracism victim Aristides the Just managed to elude the blockading Barbarians and sail over from Aegina. He asked to speak with his old adversary Themistocles. Now he wanted their rivalry to be about who could do the best for Athens, and it was time for them to bury the hatchet, preferably in Persian heads. The fact that the Peloponnesians still wanted to retreat had become irrelevant, Aristides said, because he knew that the Greeks were hemmed in. Themistocles was delighted. This suited his master plan, but the Corinthians, Eurybiades and the others would never believe the news if he told it to them, so he suggested that Aristides should break it. And even if they refused to believe him, the truth was that there was now no possibility of escape. So, Aristides briefed the commanders. But no one wanted to hear what they thought was fake news. So he left, and they descended into bickering again. However, a second trireme, crewed by Tenian deserters and captained by Panaetius son of Sosimenes, then arrived telling the same story.[76] It was a message that would earn Tenos a place on the Serpent Column at Delphi and the Bronze Zeus at Olympia,[77] and with courage born from necessity the Hellenes prepared to fight.

The Battle of Salamis

'When Day with her white horses spread her bright-shining light over all the earth',[78] Xerxes, One King of Many, One Lord of Many, was seated on his golden throne on a vantage point on Mt Aegaleus overlooking his armada, surrounded by scribes tasked with recording everything that happened in the battle.[79]

Across the waters Themistocles was sacrificing. When three beautiful-looking POWs, nephews of Xerxes, were brought to him, and uncanny flames shot forth from the sacrificial animals accompanied by a well-omened sneeze from the right-hand side, the seer Euphrantides urged him to sacrifice the men to carnivorous Dionysus. Themistocles was not prepared to commit such an act of sacrilege, but superstitious mob rule took over. The prisoners were dragged to the altar and slaughtered, or so the story went.[80] In case the Greeks were not sufficiently fired up by this, Themistocles proceeded to deliver a brilliantly inspirational speech to the marines on the theme of the contrast between the positive and negative aspects of human nature and society.[81]

As the Greeks were embarking, the trireme that had been sent to Aegina to fetch the descendants of Aeacus sailed back into port. In the hours that followed the Aeacidae would be said to have been seen in the form of apparitions of armed men, stretching out their hands to protect the Hellenic triremes.[82] The religious aspect of the fight was crucial, and the Greeks proceeded to raise their Holy Paean. The loud and joyful sound of their singing, accompanied by trumpet blasts, rose into the air and reverberated from the cliffs of the island as their ships set out to battle in a blaze of cheerful confidence.[83] 'When the command was given, they immediately struck the deep seawater with the simultaneous thrust of their rushing oars.'[84] Aeschylus's 'simultaneous thrust' is a well-chosen word: it encompasses the oar stroke, charging, ramming and sexual penetration. There was no doubting what the Greeks intended to do to those 'effeminate Barbarians'.

From the Persian perspective, the sight and sound of the Greek navy making an uncanny and terrifying noise were a

total shock. The Persian night-time stealth mission should have caught the Greeks unawares, but instead Themistocles' Hellenes had seized the initiative and were lining up in good order to fight on their own terms. The Persians had spent much of the previous day and all the night rowing back and forth on unfamiliar waters, whereas their opponents were as well rested as possible and had deployed the land, sea and air of Greece as their most important allies. All Herodotus tells us about the dispositions of the fleets is that the Phoenicians were drawn up facing the Athenians on the western (Greek left) flank, which was nearest to Eleusis, that the Persian contingents in the centre were arrayed in such a way as to minimise the linguistic barriers between them, and that the Ionians fighting for Xerxes faced the Lacedaemonians, who occupied the place of honour on the eastern (Greek right) wing, nearest to Piraeus.[85] Diodorus Siculus muddies the waters for us by placing the Athenians and the Lacedaemonians on the Greek left opposite the Phoenicians and, by implication, the Cypriots, who were followed in line by the Cilicians, Pamphylians and Lycians. He places the Aeginetans and Megarians on the honoured right, stationed there partly because of their maritime prowess, and partly because they had everything to lose in case of defeat. Everyone else was in the centre.[86]

The Greek headquarters are likely to have been at the commercial and military harbour of the classical deme of Salamis. Recent underwater archaeological research, also using aerial drone photography, photogrammetry, and topographical and architectural documentation, has shown that this was located at the inner (western) part of the present-day Bay of Ambelaki, formed by the peninsulas of Pounta (ancient Kolouris) and Cynosura.[87] However, the space available here

would not comfortably accommodate the entire Greek fleet, which would probably have had to extend into Paloukia Bay to the north, and even beyond.[88] Quite how and where we should visualise their position in the battle is problematical, however: Diodorus makes them occupy 'the strait between Salamis and the shrine of Heracles',[89] on the mainland right underneath Xerxes' throne 'where only a narrow passage separates the island from Attica',[90] but although this would have closed the strait, it would have left their HQ undefended and exposed their left flank to Persian archery; modern suggestions tend to favour each side fighting with its sterns facing friendly shores, with the Greeks taking the space between Cynosura and Agios Georgios, Pounta and the Pharmacussae Islands opposite Agios Georgios, or various combinations thereof.[91]

The Persian locations pose similar difficulties. Aeschylus's Xerxes orders them to sail into the channel in three lines, but how far into it they were able to move is impossible to ascertain – anywhere up to Cape Amphiale is suggested – and Herodotus positions them extended in an arc circling towards Salamis (whether this is the town or island is argued over) on the west, and stationed around the elusive locations of Ceos and Cynosura on the east.[92] Likewise, assessing the numbers of vessels going into action is fraught with difficulty: 397 triremes plus 7 penteconters on the Greek side, versus 1,227 Persian ships, not counting the 200 Egyptian vessels sailing around the island, are the maximum figures given, although some modern scholars find this grossly exaggerated.[93]

Similarly the physical space occupied by the opposing squadrons is hard to compute. A trireme using its oars is approximately 11 m wide;[94] in order to perform a *diekplous* attack there must be enough room to sail into the gap between the oar tips

of the opposing vessels; but closing the gaps to less than a ship's width creates further navigational challenges since triremes drift to leeward even in light winds;[95] so, any attempts to calculate the number of ships deployed abreast across any space are fraught with difficulty. And finally, the relative sea levels in the area have changed since the battle was fought.[96]

Any attempt to produce neat maps showing the dispositions of the rival navies and their movements can only be (often highly) intelligent guesswork. Herodotus, at least, is honest about how little he knows: 'I am unable to say precisely how individual Barbarians and Greeks fought.'[97]

Things now happened very quickly. The Greeks put to sea with all their ships, and the Persians immediately fell upon them. In later times, the Athenians made the accusation that at that exact moment the Corinthian admiral Adeimantus 'hoisted his sails' and was followed by the rest of his flotilla. They got as far as the Temple of Athena Sciras (location unknown[98]) but were intercepted by a divinely sent boat whose crew accused Adeimantus of betraying the Greeks, who were by now winning the battle. This shamed the Corinthians into returning, but they arrived too late to take part in the victory.[99] Many Greeks regarded this as evil Athenian propaganda, and so do most modern scholars.[100] If the Corinthians had indeed sailed away, it could have been a ruse to lure the Persians further into the straits, or they might have been heading off on an interdiction mission against the Egyptian ships that were encircling the island.

In due course bronze statues of women were erected in the temple of Aphrodite on the Acrocorinth, with an inscription by Simonides:

These women have been set up because they prayed to
 miraculous Cypriot Aphrodite
On behalf of the Greeks and their hard-fighting citizens.
Heavenly Aphrodite was not minded to surrender her
 Acropolis
To the arrow-bearing Medes.[101]

This draws a pointed contrast between the surrender of Athens's
Acropolis and the survival of Corinth's, makes a wordplay in
Greek on 'minded' and 'Medes', and also carries a pertinent
double entendre. The word translated as 'hard-fighting' can be
used of fighting 'fairly and openly', and as such it references
Themistocles, who did not always do so with either the Persians
or Adeimantus, but it can also mean 'fight with a hard-on', and
we also hear that Corinth's sacred prostitutes of Aphrodite
prayed that their men would 'ram themselves into the
Barbarians with a passionate love for battle', with all the sexual
connotations that brought with it.[102] Plutarch also pointed out
the existence of a memorial to the Corinthian dead that was
erected on Salamis, their inclusion next to the Athenians on the
Serpent Column, and Adeimantus's epitaph, which proclaimed
that 'thanks to him all Greece wore the crown of Freedom'.[103]

 Freedom was the keyword, and the cry went up from the
Greeks, articulating all the values of their culture:

Sons of the Greeks, come on!
Freedom for your fatherland! Freedom for your
Children, your wives, the temples of your fathers' gods,
And the graves of your ancestors! Now the contest is for
 everything![104]

As the fleets closed to within striking distance some of the Greeks began to backwater, which may have been a deliberate tactic to exploit the diurnal wind variations that would have been well known to the Greeks:

> Themistocles took care that his triremes did not engage prow-to-prow with the barbaric ones until it was the time of day when a fresh breeze always blew off the sea and churned up the waves in the narrows. This wind did no damage to the Greek ships because they were light and sat relatively low in the water, but the Barbarian ships had towering sterns, high decks and took time to get under way. It made them pitch and roll, and as it struck them it spun them broadside on to the Greeks.[105]

Recent climatological analysis of the wind patterns in the Salamis straits show that the north-west wind which prevails during the night and early morning would have converged with a southerly sea breeze after around 10 a.m. to form a 'pincer' that not only assisted the Greeks when the fleets came together in the morning, but also caused chaos in the Persian fleet and badly hindered their escape in the early afternoon.[106]

The Athenians boasted that they were the first to take advantage of these 'ship-destroying breezes'[107] and attack. Aeschylus dramatises the start of the ramming with a Greek ship shearing off the entire stern of a Phoenician one.[108] In other accounts, Ameinias from the deme of Pallene (or Decelea), who might have been Aeschylus's brother (although Aeschylus was from Eleusis), led the charge and rammed a Persian vessel head on.[109] Diodorus says that the ship he attacked was the Persian flagship, commanded by Xerxes' brother Ariamenes. It

had been pounding the Greeks with arrows and javelins 'as though from a city wall', and as the vessels became entangled in each other's rams Ariamenes tried to board the Greek trireme, only to be struck down and hurled into the sea by Ameinias and Socles of Paeania.[110] With the two vessels unable to extricate themselves, the other Greeks waded into the conflict, and the battle commenced in earnest. Plutarch relates that the first person physically to capture an enemy ship was an Athenian called Lycomedes, who cut off its figurehead and later dedicated it to Apollo the Laurel-bearer.[111] The Aeginetans told a different tale, in which their ship, which had brought the Aeacidae, was the first to strike, responding to a vision of an unearthly woman who indignantly shouted at them to stop backing water.[112]

The combination of the narrowness of the passage, the wind, the swell and the fatigue of having been rowing for hours on end started to play havoc with the Persian sailors. As they were compelled to adjust their formation, catastrophic *ataxia* ('disorder') took over: the loss of their admiral disrupted their communications; too many commanders gave too many conflicting commands; they tried to withdraw to find more room to manoeuvre, but only backed into the oncoming vessels behind them; and the Greeks seized the opportunity either to ram them head on or to use *diekplous* tactics where there was space, shearing off their oars and leaving them at the mercy of vessels following in their wake.[113] There was no doubting the commitment of the invading forces, and any expectations that the Ionians might desert or fight badly were disappointed: Theomestor of Samos was rewarded by being made tyrant of his home city, and Phylacus of Samos became one of Xerxes' *orosangae*[114] ('benefactors') and was given great tracts of land.[115]

This was a contest between cohesion and chaos, not between courage and cowardice:

> At first the flood of our Persian force held out.
> But when our mass of ships was crammed into the narrows,
> No one could go to anyone else's assistance.
> They were impacted by our own side's bronze-pointed
> rams,
> All their banks of oars were smashed,
> And the Greek ships, in a carefully coordinated way,
> Totally surrounded them, and kept on ramming them.[116]

Most of the damage was inflicted by the Athenians and Aeginetans.

One extraordinary participant in the fighting was the 'woman making war on Greece', Artemisia. In the midst of the mayhem, she found herself being pursued by Ameinias's trireme, now free of the stricken Persian flagship, but her escape route was blocked by friendly ships. So, she went blue-on-blue and rammed and sank the ship commanded by King Damasithymus of Calyndus. This fooled Ameinias. Had he known it was her ship he would never have let her go – there was a massive 10,000 *drakhma* reward for her capture – but her marines would have looked like Greek fighters, and he was unsure whether her ship was Greek or deserting to the Greek side. Accordingly, he set off to hunt down other Persian craft. Xerxes saw the incident from his throne, and one of his attendants remarked on how well she was fighting. 'Is that really her?' he asked. 'Yes, it is,' they said. 'You can tell by the emblem on her ship.' This could have been a figurehead, flag or painted device that was not known to Ameinias, and they assumed she had sunk a Greek vessel whose

identifying marks were not discernible. Luckily for her there were no survivors from Damasithymus's ship to tell what really happened. Xerxes himself famously expressed how impressed and appalled he was by this: 'My men have turned into women, and my women into men.'[117] This gender reversal was the highest praise for Artemisia, and utterly damning for the rest of the Persians: 'Among the Persians the biggest insult is to be called worse than a woman.'[118]

It rapidly became hard to tell who was fighting on which side. The Phoenicians slandered the Ionians by claiming it was the Ionians' fault that their ships had been destroyed. They told Xerxes that the Ionians were traitors, but at that very instant a ship from Samothrace (not technically Ionian, but certainly *Yauna* to the king) sank an Athenian trireme, only to be sunk itself by an Aeginetan one. But as the Samothracian ship was going down, its javelin-throwers boarded the Aeginetan vessel and captured it. Xerxes turned his anger on the Phoenicians: cowards should not accuse braver men, he said, and had the Phoenicians beheaded.[119]

Xerxes' scribes recorded the name, patronymic and city of seamen whose excellent deeds caught the king's attention, but for the most part there was only a catalogue of deaths. Xerxes' brother Ariabignes was killed in action, alongside many renowned Persians, Medes and allies. In the words of the Messenger in the *Persians*, their aristocracy was annihilated:

All those Persians who were in the prime of their life
With the best personal qualities, distinguished for their
 high birth,
Who were always the foremost in loyalty to their Lord
Have died most shamefully by the most inglorious fate.[120]

The Greek losses were much fewer, partly, we are told, because most of them could swim, whereas the Barbarians, according to the Greek stereotype, could not.[121] Their weakness in swimming (Greek: *nein* = 'to swim') was linked to their mental weakness (*noein* = 'to think'),[122] whereas the Greeks used all their strength and cunning intelligence to slaughter those who were still floundering amidst the wreckage:

> They kept on clubbing them, they kept on hacking through
> their spines,
> Using broken bits of oars and shattered shards of wreckage,
> As though they were tuna or some other haul of fish.[123]

The surface of the water was barely visible beneath the wreckage, corpses and body parts:[124] 'The troughs of the emerald-haired sea were turned red by blood dripping from the ships, and everywhere there were shouts mixed in with screams.'[125]

The carnage and chaos hit their peak when the leading Persian ships finally turned to flee – first the Phoenicians and Cypriots, then the Cilicians, Pamphylians and Lycians, and finally the Barbarians' left wing[126] – because the ships at the rear were still pressing forward, creating further confusion and congestion in their desire to show their own prowess to their ruler. 'Never before has such an enormous number of men died on one day,'[127] said the Messenger to Atossa, before informing her that there was even worse news. The fighting had left the troops on Psyttaleia cut off. So Aristides took a contingent of Athenians across from Salamis.[128] They equipped themselves with 'finely fashioned bronze armour', leaped ashore at numerous points on the island, showered the Persians with stones, shot them down with arrows, and finished them off with a

coordinated charge that left no survivors.[129] It was a combined democratic victory for Athens's light-armed *Thetes* and hoplite *Zeugitai*, and one which Aeschylus's Persian Messenger rated twice as bad as the naval defeat.[130] Xerxes screamed with anguish, tore his robes, issued orders to his land forces to retreat and, mirroring the actions of his fleet below, left his observation point 'in chaotic flight'.[131]

Daylight was fading by the time the routed Persians were trying to make it back to Phalerum. The Athenians and Aeginetans cooperated, with the Athenians pushing the invaders out of the strait and the Aeginetans lying in wait for them, probably off the Cynosura promontory, and mopping them up at will. In this melee Themistocles was chasing down an enemy vessel when he came close to an Aeginetan trireme under Polycritus son of Crius ('Ram'). Polycritus had just rammed the self-same Sidonian ship that had captured the Aeginetan patrol ship off Sciathus, and which had been carrying the heroic prisoner Pytheas son of Ischenous.[132] Polycritus had recognised Themistocles' ship by its insignia, and with the Sidonians captured and Pytheas safely liberated, he shouted across: 'How dare you accuse us Aeginetans of Medising!'[133]

'The black eye of night'[134] brought the fighting to an end. Diodorus is the only source to quote casualty figures: 40 Greek ships against over 200 Persian ones, not including those that were captured.[135] In terms of human lives, this computes at anything between 6,000 (at 30 marines per Persian vessel) and 40,000 (at 200 crewmen per trireme). Xerxes still maintained a numerical advantage, but the morale of the navy was shattered. The Greeks towed as many of the wrecks as they could back to Salamis, and the tragic poet Timotheus described the 'star-sprinkled sea, swarming with corpses', and the shores laden

with bodies, while Aeschylus's Messenger spoke of the shores of Salamis teeming with ill-starred rotting cadavers, and of the dead, disfigured by their time in the water, drifting in all directions.[136] Some of the floating hulks were caught by the West Wind and driven ashore in Attica, neatly fulfilling an oracle with which Herodotus end-stopped his narrative: 'The women of Colias shall roast their barley with oars.'[137]

Honours and Memorials

The Athenians, at least in their own opinion, had once again successfully led the resistance to a hostile invasion from the Barbarian world. The confrontation between their democratic citizens sailing in newly built triremes against the naval excellence of the monarchically ruled Phoenicians was especially significant: it had been the 'GOAT' versus the Kid, and the Kid had overturned the old world order. However, there was still disunity as the Greeks distributed the honours and memorialised their heroes. Three Phoenician triremes were dedicated as first-fruits offerings to the gods, one in the Temple of Poseidon at the Isthmus, another at Sounion, and the third to the hero Ajax at Salamis. Further spoils were used to create a 6-metre-high male statue holding a ship's figurehead at Delphi.

Aegina was decreed to have won the greatest renown, with Athens second, but Apollo was not happy with the Aeginetan response: he said their initial dedication was not sufficient, so they made an additional one of three gold stars set into a bronze mast, which was installed in the god's temple.[138] The Corinthians also took a slice of the *kleos*, eloquently expressed by the epigram erected over the grave of their dead at Salamis:

Stranger! We once lived in the well-watered city of Corinth
But now Salamis, the Isle of Ajax, holds us.
Here we captured Phoenician ships, Persians
And Medes. We rescued Holy Hellas.[139]

The lines which they had inscribed in the sanctuary of Poseidon
at the Isthmus were similarly expressive:

The fate of all of Greece was balanced on the razor's edge.
We lie here now: we rescued her with our souls.[140]

Monuments later erected on the Cynosura peninsula
included a trophy at the tip of Cape Varvari, which Sophocles
allegedly used to dance around, and possibly a tumulus contain-
ing Greek casualties in the middle of the northern shore, where
a modern sculpture currently memorialises the battle.[141]

Individuals also received special mention. Herodotus's top three
were the non-Medising Polycritus of Aegina, plus the Athenians
Ameinias and Eumenes of Anagyrus ('Stinking Bean').[142]
Democritus of Naxos earned the poetic praise of Simonides for
capturing more enemy vessels than the ships he brought with him:

Democritus was the third to go into battle
When Greeks and Persians clashed at sea by Salamis.
He captured five ships that he had smashed to pieces and
 rescued a sixth,
a Dorian vessel, which had been captured by Barbarian
 hands.[143]

Others were not shy of self-publicity. Plutarch relates how
the Hellene commanders were motivated by selfishness and

envy. When they held a ballot for who should receive the first prize for valour, everyone voted for himself. However, the universal second choice was Themistocles. The Spartans later gave him the prize for wisdom and cleverness, a crown of olive, the best chariot they had, and the unique honour of an escort of 300 picked youths. This inspired the raging jealousy of Timodemus of Aphidnae, a complete nonentity who taunted Themistocles by endlessly repeating that the honours were not for him, but for Athens. Quick-witted as ever, Themistocles told him what the reality was: 'If I had come from [the tiny, insignificant island of] Belbina [off Sounion] I would not have been honoured like this by the Spartans. But neither would you, even though you are an Athenian!'[144] With those words Themistocles departs from Herodotus's narrative, but at the next Olympic Games the crowds lauded and applauded him all day,[145] and his achievements were readily acknowledged by Simonides, who described the 'beautiful and famous victory' that was 'the most brilliant achievement ever performed by Greeks or Barbarians on the sea', accomplished 'by the communal courage and enthusiasm of those who fought the sea battle, and also by the intelligence and awesomeness of Themistocles.'[146]

CHAPTER 12

Greece in the Ascendancy: Plataea

Soft lands usually breed soft men; it is not in the nature of the same land to produce marvellous fruits of the earth and warriors who are magnificent in battle.

Cyrus the Great[1]

Should I Stay or Should I Go?

Xerxes' relay riders took the news of his defeat back to Susa. A previous despatch sent after the burning of Athens had prompted feasting and celebration, but now those emotions turned to tears, recriminations against Mardonius, and fear for Xerxes' safety. The ancient accounts, however beautifully dramatised, only give us sporadic insights into the true human experience of the conflict. We lack hard evidence for people's private responses; we know hardly anything about what the ordinary soldiers said, how they felt or how they reacted; and there is very little focus on the emotions and mental health of the non-combatants – no interviews, no diaries, no letters (if these existed) to or from their wives, no voices from the children, precious little on the psychological injuries, and next to

nothing on the collective trauma suffered by those who fought, or those who waited for news at home.

The nearest we get to this, perhaps, although still a dramatisation, is Aeschylus's *The Persians*. The Chorus of Persian Elders sing of the Demon of Toil and Trouble that has trampled the entire Persian race with both its feet; of how Zeus the King devastated the vast army of the mega-arrogant Persians, and covered Susa and Ecbatana in mists of gloomy grief; of women rending their veils with their tender hands and drenching their breasts with tears; and how 'prettily lamenting' brides longed for their newlywed husbands, their 'prettily cushioned' marriage beds, and the pleasures of voluptuous youth.[2] The women luxuriate in their grief and become all the more exquisite for it, while the old men focus on youth and all its beauty, power and sexuality. 'Xerxes led,' they shout, 'Xerxes destroyed, Xerxes idiotically mishandled the sea-battle!'[3] The invasion was a catastrophic own goal: 'the ships led,' they shout, 'the ships destroyed', Xerxes had yearned for naval power, and although the ships had 'rams of total destruction',[4] they had destroyed their own people.

In Greece, Xerxes had some crucial decisions to make. His immediate fear was that the Greeks would sail to the Hellespont, destroy the bridges, and leave him cut off in Europe. Mardonius was worried that he might become the scapegoat for persuading Xerxes to make the expedition, so he decided to go double-or-quits and try to get the king to let him conquer Greece. Better to die heroically doing that than be ignominiously executed now. He argued that the naval defeat was an irrelevance; the land forces were what mattered; the Greeks were powerless; the defeat was the fault of the Phoenicians, Egyptians, Cyprians and Cilicians, not the Persians; and there were two

options: (a) Xerxes should attack and enslave the Peloponnese, or (b) if Xerxes still wanted to go home, Mardonius should stay and conduct the operations with a handpicked force of 300,000.[5] Xerxes' mood improved. He sent for Artemisia, who favoured option (b): Xerxes' personal safety was paramount, she insisted; if Mardonius succeeded, Xerxes could take the credit; Mardonius was merely a slave of the king, and it would have nothing to do with Xerxes if he failed; and in any case, the king had already achieved his objectives by burning Athens. This was the advice Xerxes wanted to hear, and Artemisia knew it. He gave her the task of taking some of his bastard sons by various concubines back to Ephesus,[6] and told Mardonius to choose his 300,000 men and to deliver on his promises.

Greek Dilemmas

The Persian navy sailed away from Phalerum during the night. The Greeks set off in pursuit, but by the time they got to the island of Andros they had failed to make any visual contact. It was decision time again. Themistocles favoured chasing the Persians to the Hellespont and destroying the bridges, but Eurybiades felt that if they cut off Xerxes' retreat it would simply provoke him into ravaging Greek lands to keep his army from starving. He argued that it would be much safer to let him go back to his own empire, and to do any fighting on Persian soil.[7] Unsurprisingly the Peloponnesian admirals agreed with him.

Themistocles adjusted his position. The Athenians were still angry and up for the fight, but he advised them that they could sail to the Hellespont and Ionia the following spring. It is not entirely clear whether Themistocles was playing an astute

diplomatic game or acting out of cynical self-interest, or both, but our sources tell us he secretly sent a messenger (Sicinnus in Herodotus, a royal eunuch called Arnaces who was a POW in Plutarch, or his *paidagogos* in Diodorus) to Xerxes once again. Sicinnus's message was that Themistocles had talked the Greeks out of a plan to destroy the Hellespont bridges, so Xerxes could now make an unopposed retreat; Arnaces said that the Greeks were going to attack the bridges, but Themistocles was going to make it awkward for them; and the *paidagogos* just told the king that he ought to move quickly because the Greeks were intending to attack the bridges.[8] The story raises many questions, principally about why Xerxes would believe a tale spun by Themistocles, given what had happened after his previous message before the Battle of Salamis,[9] but the king decided to leave Athens.

Another slightly dubious tale, which fits the 'scheming avaricious' Themistocles narrative, concerns the island of Andros, which had fought for Xerxes at Salamis, and was now refusing Themistocles' demand that they should contribute money to the Greek cause. When Themistocles boasted that he had two mighty goddesses on his side – Peitho and Anankaia (Persuasion and Necessity) – they retorted by invoking their similar-sounding local deities Penia and Amekhania (Poverty and Lack of Resources). Paradoxically, Athens's power could never overcome their weakness, they said, and Poverty and Lack of Resources did indeed keep them safe. However, Themistocles' agents went elsewhere to extort money with menaces. Medising Carystus was destroyed, and neutral Paros was forced to give in. Rumours circulated that Themistocles' personal wealth increased dramatically at this time, but bringing the Cycladic islands back under Greek control made sound strategic sense.[10]

Xerxes Heads for Home

Xerxes waited for several days after the Battle of Salamis before commencing his own retreat. His army retraced the steps of their original invasion back to Boeotia, where, in the picture painted by the Messenger in *The Persians*, many men died of thirst even when they were close to a spring. From there they traversed the other Medising territories of Phocis and Doris, crossed the River Spercheius near the Malian Gulf, moved through Achaea Phthiotis, and arrived, thirsty and hungry, in Thessaly,[11] where food and pasture were finally available for the army and its animals. This was where Mardonius planned to spend the winter. It was also here that he chose his 300,000: he picked more Persians than any other ethnic group, starting with the 10,000 Immortals, although their commander Hydarnes chose to stay with his king; then he selected the Persian heavy infantry and one of the elite groups of 1,000 cavalry, followed by the entire foot and horse contingents of the Medes, Sacae (commanded by Xerxes' brother Hystaspes), Bactrians and Indians, a selection of the best warriors from the rest of the allies who were distinguished by their physical appearance or proven prowess, and a group of knife-wielding Egyptians who had previously been serving as marines.[12] In the spring they would descend into Greece once again.

Xerxes parted company with Mardonius in Thessaly and set off on what turned out to be a nightmarish journey. It took him forty-five days to reach the Hellespont, and again the army became the victim of its own numbers. They transited Magnesia and Macedonia, turned eastwards at the River Axius, entered the marshes around Lake Bolbe (modern Volvi in Greece), and came within sight of Mt Pangaeum in Edonia. Nowhere could

support their needs for food, and they were reduced to eating grass, leaves and the bark of trees; plague and dysentery broke out, killing some Persians and forcing Xerxes to abandon many others in friendly cities in Thessaly, Paeonia and Macedonia, along with his Sacred Chariot of Ahura Mazda.[13] When the Persians arrived at the River Strymon, the weather turned unseasonably cold and the river froze. It seemed like a god-given miracle, and the army started to cross into Thrace, but as the sun reached its zenith the ice melted and cracked, and like at Salamis the Persians found themselves crowding into the water, tumbling on top of each other, and sinking into oblivion.[14] The survivors made it through Thrace to Abydus, only to discover that the Hellespont bridges had been put out of action by a storm. Food and water were now readily available, but as they waited for the navy, which had returned to Asia, to ferry them across, a combination of overindulgence and a change in the water quality brought even more deaths.[15]

Alternative facts were always being put forward, and one version of Xerxes' retreat suggested that when he got to Eion he embarked on a Phoenician ship and sailed for Asia. During the passage the strong north-north-easterly Strymonian Wind caused a storm which put the overloaded vessel in considerable danger. Stereotypical tyrant that he was, Xerxes put the loyalty of the Persians who were with him to the test: he ordered them to jump overboard, and they obeyed. This stabilised the ship, which made it safely to Asia, where Xerxes rewarded the helmsman with a golden crown for saving his life, and then decapitated him for causing the death of so many Persians. Herodotus does not believe a word of this, mainly because there was firm evidence that Xerxes had travelled through Abdera, where he made a pact of friendship with its citizens, gave them a gold

akinakes and a gold-spangled *tiara*, and allegedly had his first change of clothes since leaving Athens. The fact that he would have had to go past Eion to reach Abdera makes the storm episode impossible, despite it being a tale worth telling.[16]

Once Xerxes had reached Sardis he became the object of another tale of sex and violence that further underlined the way the Greeks saw the Persians as impious transgressors of the boundaries of politics, religion and domestic normality. The king developed an erotic passion for his brother Masistes' wife. But this was not reciprocated. The woman, whose anonymity is an indicator of her honour, refused to be seduced. Out of respect for his brother the king did not go so far as raping her but, instead, he arranged for Crown Prince Darius, his eldest son by Amestris, to be married to his beloved's daughter, whose name was Artaÿnte. He felt this would give him the best chance of 'making' the object of his lust.[17] Then he left for Susa, with a story to be continued . . .

In Aeschylus's *Persians* Xerxes, possibly played by Aeschylus himself, cuts a pathetic figure as he finally makes it back to Susa. He sings a lament with the Chorus of Persian Elders.[18] In Athenian culture the ritual lament is traditionally a female performance, so for Persian males to do this is to invert gender roles – Barbarian culture is again presented as overemotional and feminised. Xerxes has crammed the Underworld with myriads of Persian youths, exchanging their lives for his failed attempt at eternal imperialist glory; his hubris is a harvest of death; he admits that he is an evil to his fatherland; and he accepts personal responsibility for the disaster at Salamis.[19] In a remorseless catalogue of death the Elders ask about the Persian nobility who have been left behind unburied and unlamented in Greece. 'I abandoned their corpses battered against the rocks

off the headlands of Salamis,' he says, adding that the ultimate indignity was that the last thing they saw was 'primaeval, detested Athens'. The Chorus persists in its questioning. 'Stop!' he says, but the Elders carry on, and 'all the leaders of my army have gone', is all that he can admit.[20] The king's garments have been torn to shreds, and his golden quiver is almost empty, like a treasure chest whose money has all been spent in the same way that he has expended vast human and material resources on his vanity project. 'Do you see the remnants of my outfit?' he asks, using a word which can mean both 'robe' and 'armament/equipment'.[21] 'Sing a song of grief and match it to mine!' he commands. 'Beat your breasts! Tear your hair, tear your beards, tear your clothes! Express your pity for the army!'[22] They comply, making rowing gestures as they go, which suggest the voyage of the ferry of the dead across the River Styx into Hades in honour of the unburied Persian fighters, but also mirror the deadly Greek oar strokes which robbed them of their lives.[23] As Xerxes howls with grief, the Elders have to finish his incoherent penultimate sentence for him, before escorting him off stage:

XERXES: Aaah-aaah, aaah-aaah! The triple-banked . . .
CHORUS: Aaah-aaah, aaah-aaah! Ships destroyed them![24]

Even in defeat, however, Xerxes still remained the King of this Great Earth Far and Wide, and he still had erotic intrigue on his mind. He took his son Darius's bride Artaÿnte into his own house in the style of a wife, and promptly lost his amorous interest in her mother. He made advances to Artaÿnte, which she did not turn down, but inevitably his wife Amestris found out about the relationship. She was not a woman to be trifled

with. *Amāstrī-* means 'Strong Woman' in Old Persian, and later in life she had fourteen noble Persian children buried alive as an offering to the god who is said to dwell beneath the earth.[25] Now she wove a gorgeous, multicoloured cloak and gave it to her husband. Xerxes loved it but so, unfortunately, did Artaÿnte. He was also so delighted with their sex life that he promised her anything that she asked for. She wanted the cloak. This would give Amestris clear evidence of what was going on, and no matter how much Xerxes tried to talk her out of it, Artaÿnte was adamant, and he had no choice but to give the cloak to her, and she went around showing it off to everyone. Amestris was now 100 per cent sure about the situation, but she directed her anger against the girl's unnamed mother instead. She waited until it was Xerxes' birthday, when it was customary for him to host a banquet known as the *tacht* (Greek: *tutka*) and give presents to the Persians. The gift Amestris asked for was Masistes' wife. Xerxes knew why, and that the woman was entirely innocent, but he felt forced to give his irrevocable nod of assent.

Xerxes immediately took Masistes aside and told him that he must divorce his wife and marry Xerxes' daughter instead. Masistes could not believe what he heard: he really loved his wife, and even though it was an amazing honour, he would not do it. Xerxes had been forced to give what he did not want to give, and now he could not give what he did want to give. He descended into impotent fury: 'You will take what you are given, Masistes,' he said, 'and you will neither keep your wife nor have my daughter!' Meanwhile, Amestris had got Xerxes' bodyguards to mutilate Masistes' wife by cutting off her nose, ears, lips, tongue and breasts, which she threw to the dogs. Mutilation was a common enough punishment in Persia,[26] but

such a personal and gender-specific act of vengeance against an innocent woman was completely beyond the pale. Masistes tried to raise a revolt against Xerxes but was assassinated before he could put his plans into action.[27] Herodotus undoubtedly told this story to infer that the Persians were always subject to the will of over-powerful rulers and to a system that was tyrannical, cruel, violent, vengeful, decadent, weak and feminised. However inaccurate that picture might have been, it was the one that many Greeks accepted.

The Persians in Northern Greece

Aeschylus's *Persians* presents the Battle of Salamis as bringing the downfall of the Persian Empire, but Salamis had not even won the war. Xerxes would rule for another fifteen years, until his assassination in 465, and his generals were still continuing the Greek conquest project. Artabazus (Elamite: *Ir-du-masda*), the cousin of Darius I and possibly the son of the Parnaka (Pharnakes) who was the treasury official at Persepolis,[28] had escorted his king as far as the Hellespont with 60,000 of Mardonius's troops, and on his way back to rejoin the army in Thessaly and Macedonia, he discovered that the previously friendly city of Potidaea had declared its independence, along with the people of the Pallene peninsula. He laid siege to Potidaea, and also the neighbouring city of Olynthus. He captured Olynthus and massacred its menfolk, and Timoxenus, a general from Scione, offered to betray Potidaea. However, the plot went wrong when, during an exchange of secret letters tied to arrows, Artabazus shot a Potidaean by mistake, thereby revealing the traitor and the treachery. A three-month siege ensued, which ended when Artabazus's besiegers noticed that

the sea had retreated an unusually long way, and tried to exploit this to attack from a new direction. But they were caught when the sea came rushing back in with devastating consequences. This is a classic description of a tsunami, which has been corroborated by seismic research by scientists from RWTH Aachen University.[29] Artabazus called off the siege and marched away to join Mardonius. The Potidaeans sent 300 men to fight for the Greek cause.

When the spring of 479 made military campaigning viable once again the opposing fleets reassembled, although there was a reluctance to engage. Xerxes' ships, 300 in total[30] carrying primarily Persians and Medes, but Ionians and Phoenicians too, mustered at Samos under the command of Mardontes, Artaÿntes (Old Persian: *Artavanta* = 'Pursuing Justice') and probably Artaÿntes' nephew Ithamitres.[31] Their morale was still shattered after Salamis, so their focus was on peacekeeping in Ionia. For their part, the Hellenes deployed just 110 vessels under the authority of the Eurypontid Spartan king Leutychides,[32] who reluctantly sailed as far as Delos before his Spartan fear of the naval unknown set in. Samos is not visible from Delos, and it might as well have been in the Atlantic Ocean for all that he knew.[33]

On land the Athenians were occupying their refugee camps on Salamis, the smoking remains of their city and the ravaged farmland of Attica. Remarkably the Athenian general was now Xanthippus, not Themistocles, who must have failed to be re-elected: so far as we know, he never commanded the Athenian navy again.[34] Being honoured at Sparta was politically damaging for any Athenian, no matter how brilliant. In keeping with the Persian desire to win bloodless victories wherever possible, Mardonius now contacted the Athenians, using King

Alexander I of Macedon as his go-between. Alexander was adept at playing for both sides: his sister Gygaea was married to the Persian general Boubares, and the growth of his kingdom might well have benefitted from Persian support. On the other hand, he was the Diplomatic Representative and Benefactor of Athens,[35] traced his ancestry back to Zeus, and had a great love of Greek culture. Archaeological excavations show that fine Greek pottery and sculpture had been arriving in Macedonia by around 500 BCE, and the gold-rich burial of the 'Lady of Aegae' – possibly his father's queen – gives good evidence that the Macedonian court had access to highly talented craftsmen, working in a Greek style.[36] Alexander's kingdom occupied the liminal space between the Greek and Barbarian worlds, and the Hellenes continually struggled to make up their minds whether his people, with their strange speech and ambivalent mythological ethnicity, were Barbarians or not,[37] but it certainly mattered to Alexander that he should not be thought of as one of the Barbarians, even if he was skilful at playing the Greeks off against them for his own advantage.

Alexander's mission was to make the Athenians Medise. On Mardonius's and Xerxes' behalf he offered them a deal or destruction. It was crazy to resist Xerxes' army, he said, and all they needed to do was enter into a military alliance without any treachery or deceit. Then they could be free. Alexander recommended accepting the offer: Xerxes' power was superhuman, he said, and he feared for Athens if they did not accept his forgiveness and friendship. However, the Spartans had heard about Alexander's embassy and had sent representatives of their own. They urged the Athenians not to do a deal: 'No one can trust a Barbarian,' they added. 'Barbarians never tell the truth. Do not trust Mardonius!'[38]

The Athenians told Alexander that their freedom was non-negotiable, and gave him a message for Mardonius: 'we trust in the gods and heroes whose shrines he has violated, and we swear by the unchanging course of the Sun that we will never make peace with Xerxes'.[39] Alexander was told by the Athenians never to relay such a proposal to them again: he might be their official friend, but they could not guarantee his safety if he did. The Athenians also had a message for Sparta and the wider world:

> We understand you are worried that we might collaborate with the Barbarians, but your fears are misplaced. No amount of gold or land could persuade us to join the Persians and enslave Greece. We want vengeance for the destruction of our temples, not a deal with their destroyer. We are all Greeks: we share the same blood, the same language, the same religion, and the same way of life! As long as one single Athenian survives, there will never be peace with Xerxes.[40]

But they also needed the Spartan army to take the field. It was obvious that once Alexander had told Mardonius about these discussions the Persians would descend into Greece, and it was essential to confront them before they arrived in Attica. So, the Athenians said they were going to move north into Boeotia, while Sparta's envoys returned to inform their compatriots of the situation.[41]

Summer 479 BCE: The Archonship of Xanthippus[42]

The Athenian response to Mardonius could not have been unexpected, and Mardonius moved south immediately,

recruiting forces from the territories he passed through on the way, with the Aleuadae of Thessaly, and notably Thorax ('Breastplate') of Larissa, singled out for particular anti-Greek treachery. When Mardonius arrived in Boeotia the ever-enthusiastically Medising Thebans suggested that some well-targeted bribes would divide the Greek cities against themselves and make them an easy prey.[43] Diodorus implies that Mardonius tried this and failed, while Herodotus says he rejected the idea because he had an irrational lust to take Athens again, and a vain desire to watch beacon fires relaying the news back to Xerxes, in the same way as the Greeks had once announced the fall of Troy.[44] So he swept into the city of the Athenians before they could intercept him in Boeotia, and around nine months after Xerxes had sacked it, at the beginning of the archonship of Xanthippus (479/478), Mardonius did the same again, ravaging the countryside, burning what was left of the city, and inflicting further damage on the temples that were still standing.[45] Yet if Mardonius thought that having their lands taken at spearpoint and watching the smoke rising over their sacred Acropolis would induce the Athenians to soften their resistance, he was mistaken. He sent a Greek collaborator called Murychides over to Salamis to restate the deal that Alexander had offered. An Athenian called Lycides[46] suggested they should at least discuss it, but the other Athenians were in no mood to compromise: they dismissed Murychides unharmed, but the men stoned Lycides to death, and the women did the same to his wife and children.[47]

The Athenians knew that Spartan help was essential, so they sent a delegation led by their generals Xanthippus, Myronides, possibly Aristides and Cimon son of Miltiades, backed up by representatives from Megara and Plataea, with a two-part

message.[48] Firstly, they were unhappy that the Spartans had ignored the invasion of Attica and had not accompanied the Athenians on their planned attack on the Barbarians in Boeotia; secondly, they said that Mardonius's terms for Athens changing sides were very attractive. Typically, when the envoys arrived, the Spartans were on holiday. This time it was the summer festival of the Hyacinthia in honour of Apollo that prevented them from acting immediately, although the Spartans were also aware that the Isthmus fortifications were practically complete (these always seemed to be nearly, but not quite fully, finished whenever it suited them).[49] The envoys told the ephors that they would not betray Hellas unless they were forced to, reminded them how alarmed Sparta had been at the prospect of Athens abandoning the Greek cause before Salamis, reasserted their determination to resist the Persians, accused the Spartans of cowering behind the wall and breaking their promises to move into Boeotia, and expressed their anger at their sluggish indifference. Now was the time to send an army, they said, and Aristides was in the process of canvassing the Delphic oracle's opinion on the best battle site.[50] But still the Spartans dithered. For ten days the ephors kept on putting off their decision until tomorrow, while frenzied building activity at the Isthmus wall continued.

In the end, Chileus from Tegea was credited with breaking the impasse on the day before the Athenians were due to have their last audience, reminding the ephors about the uselessness of the wall if the Athenian navy defected to Xerxes.[51] Yet, when the ephors did finally make their decision, they did not tell the envoys about it. With stereotypical Spartan secrecy they mobilised 5,000 Spartiates accompanied by 35,000 Helots, gave the command to the twenty-something Pausanias son of Cleombrotus

(the regent for his underage cousin Pleistarchus son of King Leonidas), who co-opted Euryanax son of the late king Dorieus as his colleague, and sent the army out before dawn. The poet Simonides portrayed the departure in rather more glorious terms:

[They set out], leaving the Eurotas and the city of Sparta behind them, with the Tyndarid heroes, those horse-taming sons of Zeus, and mighty Menelaus [. . .] leaders of the city of their fathers, those that the son of brilliant Cleombrotus led out, the best man [. . .] Pausanias.[52]

In the morning the bitterly disillusioned envoys returned to the ephors for their final interview. 'You carry on partying at your Hyacinthia,' they said. 'The Athenians have decided to go over to the Persians. You will have to live with the consequences!' The ephors were laconically relaxed. They laughed. They called Aristides a sleepy-headed idiot. And they told him their army was already at Orestheion to the north-west of Sparta, marching against the 'strangers', as they called Barbarians. Aristides failed to see the funny side. He thought it was disrespectful to deceive your friends instead of your enemies, and the Spartans should not regard all strangers as the same – Barbarian strangers were different to Greek ones. But the ambassadors still set out to follow the army in the company of an elite force of 5,000 Perioikoi.[53] In fact, the secrecy of the operation was well advised, and the slightly circuitous route that the army chose was not only better suited to wheeled traffic, but also took it away from the treacherous Argives, who immediately sent a 'day-runner' to Mardonius at Athens to inform him of the developments.[54]

The day-runner's information prompted Mardonius to move out of Athens. The terrain of Attica was not well suited to his cavalry forces, so he headed for Thebes, where he could fight near a friendly city on favourable ground. His withdrawal was a leisurely one, and while he was on the road he received intelligence that 1,000 Lacedaemonians had arrived at Megara, so he wheeled the army around, sent the cavalry on ahead and overran the outskirts of the city. Whether the news about the Lacedaemonians was simply wrong or an attempt to lure the Persians into engaging in an unfavourable environment, the Megarians said that when these troops were returning to Thebes, the goddess Artemis caused them to wander into the mountains during the night. They fired random arrows to see if any enemy were nearby, which caused the rocks to make sounds like wounded humans, so they shot off more and more until they completely ran out. At daybreak the Megarians attacked in full hoplite kit and massacred the men, who were barely able to defend themselves. Close to Pagae (modern Kato Alepochori), second-century CE tourists were still being shown a rock with the Persian arrow marks on it.[55]

Pagae was probably the furthest south-westerly point that any of the Persian soldiers reached. As Mardonius resumed his journey he passed through Decelea in Attica and along the River Asopus valley into Theban territory, where he immediately started to prepare the landscape to suit his battle plans by clearing all the trees.[56] The army spread itself out along the north banks of the River Asopus, covering the ground from a point 'beginning from Erythrae past Hysiae'[57] (whose locations are on the south side of the river, but otherwise unclear, since the place names have either been lost or have been changed) and reaching westwards into the land of Plataea.

The vagueness of our sources again makes precise details elusive, but the Persians probably occupied a frontage of some 8 km and were well positioned to control the various access points into Boeotia. They also constructed a 2-km-square camp with a ditch and wooden palisade, whose 400 hectares could have accommodated some 60,000 to 70,000 men including 10,000 cavalry.[58]

Herodotus received an eyewitness account from Thersander of Orchomenus of a dinner party for fifty Persians, including Mardonius, and fifty Thebans, hosted by a Theban called Attaginus. Thersander's Greek-speaking Persian neighbour became more emotional as he had more to drink and ended up weeping into his wine because he realised that before long very few Persians would still be left alive. When Thersander asked the Persian why he did not tell this to the other guests, he said that they all already knew, but were resigned to their fate, and it was a terrible burden to have maximum knowledge and minimum power.[59]

For his part, Mardonius's knowledge/power worries concerned the loyalty of the 1,000-strong Phocian contingent in his army. They were not instinctive Medisers[60] and had only come into the Persian fold relatively recently and under compulsion. Mardonius ordered them to form up in battle array away from the rest of the army and then sent his cavalry to surround them. Their general Harmocydes suspected that their pro-Persian Thessalian enemies were behind this, and that they were about to be shot down with javelins. He inspired his men in patriotic terms: 'We will teach them that they are mere Barbarians weaving schemes of death against men of Greece!'[61] The menacing cavalry may have released some missiles, but the Phocians faced them down. Mardonius was pleased at the

outcome, either because he acknowledged their courage, or because he felt they had been suitably intimidated.

In the meantime, the forces marching from Sparta collected other contingents of patriotic Peloponnesians from the Isthmus fortifications, and advanced into Megara and on to Eleusis, where the Athenians from Salamis completed the muster.[62] It was probably here that the Greeks swore the 'Oath of Plataea' (if they swore anything at all, and if any such thing existed), which is known from three sources: Diodorus, whose work is based on the fourth-century BCE historian Ephorus, neither of whom has a particularly high reputation for reliability;[63] Lycurgus's speech *Against Leocrates*, made in 330; and an inscription from Acharnae in Attica dating to *c.* 336–307.[64] The three texts have broad similarities, but significant differences, and a composite version might read like this, with Diodorus in plain text, Lycurgus in *italics*, and the inscription underlined:

I shall fight as long as I live, and I shall not consider being alive more important than freedom [or more than being free], nor shall I abandon the leaders [or the Taxiarch or the Enomotarch[65]], whether they are [or he be] alive or dead, [and I shall not abandon my post unless the commanders should lead me away, and I shall do whatever the generals order], but I shall bury all of the allies who are killed in the battle [or I shall bury in the same place those of my comrades who are killed, and I shall leave no one unburied]; and if I prevail over [or while fighting] the Barbarians in the war, I shall not destroy any of the cities that joined in the struggle [or *fought on behalf of Greece*]; [*but I shall tithe*[66] *all of those that chose the side of the Barbarians*, or I shall tithe the city of

Thebes, and I shall not destroy Athens, or Sparta, or Plataea, or any of the cities that joined in the fight, and I shall not permit them to be pressed by famine nor shall I bar either my friends or my enemies from running water]; and I shall [*absolutely*] not rebuild any of the sanctuaries that were burned and demolished [by the Barbarians], but I shall let them be and leave them [or *allow them to remain*] as a memorial to the impiety of the Barbarians for future generations.[67]

Diodorus tells us that the Greeks also vowed to celebrate an Eleutheria ('Festival of Freedom'), with games at Plataea, if they were victorious, and the inscription ends with solemn curses against violating the oath: may my city be plague-ridden; may my city be sacked; may my land be barren; may my women bear monsters; may my cattle bear monsters.[68] Whether this represents a genuine oath that was sworn at Eleusis, a later reconstruction of a genuine but semi-remembered oath or a blatant forgery[69] remains the subject of considerable scholarly debate, although the mainstream view is that 'the oath in its entirety was invented long after the battle', and that 'the weight of argument firmly tips the balance in the direction of literal, verbal inauthenticity'.[70] However, what matters most is that it became part of the retrospectively triumphalist Athenian narrative.

The Opening Skirmishes

The Hellenic allies marched into Boeotia over Mt Cithaeron, possibly passing the border fort at Oinoe, and descended as far as the foothills near Erythrae. They pitched their bivouacs in the knowledge that although their phalanx was devastatingly

effective on ground of its own choosing, it was extremely vulnerable to the mobility of Mardonius's powerful cavalry, who were waiting for them on the flat, open terrain beneath their position, across the River Asopus. A standoff ensued. Each side waited for the other to make the first move.

Mardonius blinked first. After a few days he sent in the cavalry. Diodorus says it was a night attack, which was initially met by the Athenians, but all our sources focus on the 3,000 Megarians who were posted in a more vulnerable position. The Persian commander Masistius, a tall, good-looking man resplendent in his purple tunic and golden-scaled breastplate, seated astride his high-spirited Nesaean horse with its golden bit and glittering adornments, led the cavalry up to the Greek formations. They attacked in squadrons, riding up to within missile range, unleashing their arrows and javelins, and inflicting serious casualties before wheeling away and taunting the Greeks for being women.[71] The Megarians sent messengers saying they would have to abandon their position if they did not receive aid quickly, and Aristides sent an elite force of 300, possibly his personal bodyguard, plus some archers, to the rescue. The Persian squadrons kept coming, but Masistius's horse was hit by an arrow, reared up and threw him, and as he lay immobilised by the weight of his armour the Athenians hacked away at him until one of them speared him through the eyehole of his helmet. Both sides strove for possession of his body, but in the end the Greek weight of numbers prevailed and the leaderless Persians were forced to withdraw. The loss of Masistius was a severe blow to Persian morale, and while the Greeks admired his magnificent corpse the Barbarians shaved their heads in tribute, cut off the manes of their horses and mules, and filled the plain with the wails of mourning.[72]

At this point the Greeks probably received the reply from the Delphic oracle to Aristides' question about the best place to fight.[73] The Pythia said that the Athenians would overcome their adversaries, but only if they prayed to Zeus, Hera of Cithaeron, the founding heroes of Plataea and the Nymphs of Sphagis on Mt Cithaeron, and they 'risked a battle on their own territory in the plain of Eleusinian Demeter and Kore'.[74] Aristides was baffled: the local references were clear enough, but was Apollo telling them to return to the plain of Eleusis? He consulted the Plataean commander Arimnestus, who had a dream in which Zeus told him that they were missing the point of the reference. There was a shrine to the Eleusinian goddesses Demeter and Kore near Hysiae, occupying an excellent strategic location on the slopes of Cithaeron, and just to make the conditions of the oracle's prediction explicit, the Plataeans moved the boundary stones along their border with Attica, and so allowed the Athenians to fight for Greece 'on their own territory'.[75]

Prompted by the psychological boost of Masistius's death and the need to make tactical adjustments, Pausanias now decided to move aggressively forward and down along the lower slopes of Mt Cithaeron, past Hysiae and into the territory of Plataea. This gave the Hellenes access to a better water supply from the Gargaphia spring near the precinct of the local hero Androcrates. The location of the landmarks is now not known, although neither was particularly close to a river.[76] The new deployment put the Greeks on rising ground that stretched about 7 km from one of the north-eastern spurs of what is now called the Asopus Ridge to the north of Hysiae, to the western end of Pyrgos Hill. This gave them good views over the Persian positions, favourable ground against both infantry and cavalry

attack, and the ability to intercept any possible Persian thrusts to the south. On the other hand, this put them in a more isolated position, lengthened and exposed their lines of supply, and caused ructions among the different contingents about who should now occupy the places of honour. The Spartans assumed their traditional location on the right wing and the smaller contingents were placed in the centre, but when it came to the left wing there was a serious spat between the Athenians, who had been stationed there by Pausanias, and the Tegeans, who as Sparta's oldest allies felt that they should hold that honoured place. Another 'great *othismos* of words'[77] ensued, with both sides quoting achievements from their mythical and ancient pasts, down to Athens's 'single combat' with 'forty-six nations'[78] at the Battle of Marathon. The army shouted that the Athenians were more worthy, although Tegean pride was accommodated by allowing them to fight next to the Spartans.[79]

Again, Herodotus provided an epic Catalogue of Forces. On the Greek side, from right to left, were 10,000 Lacedaemonians, of whom 5,000 were Spartiates, each accompanied by seven light-armed Helots; 1,500 Tegean hoplites; 5,000 Corinthians with 300 fighters from their colony of Potidaea alongside them; 600 Arcadians from Orchomenus; 3,000 from Sicyon; 1,000 Troezenians; 200 from Lepreum; 400 from Mycenae and Tiryns; 1,000 from Phlius; 300 men of Hermione; 600 Eretrians and Styrians; 400 from Chalcis; 500 from Ambracia; 800 from Leucas and Anactorium; 200 from Pale on Kephallenia; 500 Aeginetans; 3,000 Megarians; 600 Plataeans; and 8,000 Athenians under the command of Aristides, making a grand total of 38,700 hoplites, plus the 35,000 Helots, and another 34,500 light-armed troops calculated by Herodotus at one per non-Spartan hoplite. This gives 800 light-armed men too many

(it should be 33,700), but these are most likely the Athenian archers, rather than an error in Herodotus's arithmetic. One thousand eight hundred Thespian survivors from Thermopylae brought the final tally to 110,000.[80]

The figures for the Greek fighters seem broadly credible. The numbers are roughly proportionate to the size and probable populations of each individual *polis*. On the Persian side, however, the numbers are wildly exaggerated, both for Mardonius's 300,000, and the 50,000 Medisers that joined them.[81] Mardonius would not have been able to provision a force of anywhere near that size, but it was critical to Greek self-esteem that their forces of civilisation and freedom should overcome a vast oppressive Barbarian horde. Herodotus arrays the foot soldiers against the Greeks as follows: Persians against Lacedaemon and Tegea, who they greatly outnumbered, and, on treacherous Theban advice, with more Persians up against the Lacedaemonians; Medes versus Corinth, Potidaea, Orchomenus and Sicyon; Bactrians facing Epidaurus, Troezen, Lepreum, Tiryns, Mycenae and Phlius; Indians against Hermione, Eretria, Styra and Chalcis; Sacae confronting the Ambraciots, Anactorians, Leucadians, Paleans and Aeginetans; the Medising hoplites of Boeotia, Locris, Malis and Thessaly, plus 1,000 disloyal Phocians, were arrayed against the Megarians, Plataeans and Athenians; and the Athenians also had to confront the Macedonians, Perrhaebians, Enianians, Dolopians, Magnetes and Achaeans of Phthiotis. Also in the Persian mix were the ethnically diverse warriors of Phrygia, Thrace, Mysia, Paeonia and Ethiopia, alongside the Hermotybian and Calasirian ex-marines from Egypt.[82] Herodotus does not indicate where the cavalry was stationed, beyond saying that it was 'drawn up somewhere else'.[83]

Omens and Oracles

Strategically neither side wanted to make the first move, and their experts in divination endorsed this approach. Modern scholars often see cynical political or military manipulation of the omens, but the ultimate decision on whether to act in accordance with the signs always lay with the commander: in Plato's words, 'the general rules the seer; the seer does not rule the general'.[84] Pausanias's diviner was Tisamenus ('the Avenger') of Elea, who the Delphic oracle said was destined to win the 'five greatest contests', meaning not, as he first thought, the Pentathlon at the Olympic Games of 484 BCE, but battles, of which this would be the first. He read the omens as indicating a good outcome for the Greeks if they stayed on the defensive and did not cross the river, and the opposite if they attacked.[85] Mardonius used a highly paid, wooden-footed Greek, Hegesistratus ('Leader of the Army') of Elis, who had once escaped from his bonds in a Spartan prison by slicing off the bottom of one of his feet. His advice was the same: a defensive approach would bring success, an offensive one disaster. The Medising Greeks also had their own diviner, Hippomachus ('Horse-fighter') of Leucas, who read the omens in the same way.[86]

The omens stayed the same for six days, during which reinforcements streamed into the Greek army, and Mardonius started to have concerns about supplies. However, the Athenians had to deal with an internal crisis of their own. A number of wealthy aristocrats now met in secret to plot the overthrow of the democracy, or if that failed, the betrayal of Athens to the Barbarians. The conspiracy gained momentum, but Aristides eventually got to hear of it. He could not afford to become

implicated in it himself, or for it to become too well known, but he had no idea how many people were involved. So, he arrested eight ringleaders. But when two of them escaped, he let the others off with a warning, which allowed any further conspirators, who did not know whether or not they had been detected, to keep their heads down and reassess their loyalty to the Athenian cause.[87]

After the two armies had stood and watched each other for a week, some perfidious Thebans prompted Mardonius to make the next move. Timagenides son of Herpys advised him to close off the pass over Cithaeron known to the Boeotians as 'Three Heads' and the Athenians as 'Oak Heads' (the modern Gyphtokastro Pass). This seemed sensible to Mardonius, so he sent a cavalry force there after dark. They encountered a wagon train of 500 pack animals and their drivers carrying provisions from the Peloponnese, hunted down the men and beasts alike, rounded up the remnants, and drove them back to the Persian camp.[88] Then, for the next couple of days, the Persians came down to the Asopus to harass the Greeks, but neither side crossed over. The Theban collaborators were again instrumental in guiding the Medes and Persians to the flashpoints but were too cowardly to do any fighting themselves once they got there.[89]

By the time the armies had been staring at one another for ten days, Mardonius was running out of patience, and possibly provisions. He called in Artabazus, who spoke freely: they should strike camp right now, he said, and lead the entire army inside the walls of Thebes, which was only 10 km away;[90] there was food and fodder there; they could relax with no one to hassle them, and end the war without fighting; and they had enormous amounts of gold, silver and drinking vessels that

they could send to the leading citizens of all the cities in Greece, who would soon surrender their freedom. The Thebans endorsed this opinion, but Mardonius did not. Yet again, a Persian ignored good advice with disastrous outcomes, and his response was utterly uncompromising. Our army is far stronger than the Greek one, he asserted; we should give battle now before any more reinforcements reach the Greeks; and it is time to stop taking notice of Hegesistratus and his Greek-style sacrifices, and to engage according to the customs of the Persians.[91] No one dared contradict him.

Mardonius still wanted to know the will of the gods, though. He asked whether anyone knew of any oracles that prophesied the destruction of the Persians. Some did not. Others did, but thought it was too dangerous to say so. Mardonius suspected as much. 'Well, I will tell you, then,' he said. 'I know an oracle which says that Persians are destined to come to Greece and pillage the temple at Delphi, and after the pillage, they will all die. So we will not go to the temple, and we will not try to plunder it. Rejoice! We will conquer Greece!'[92] Yet the oracle makes no reference to a Persian victory, and Mardonius conspicuously ignores the attempted raid on Delphi by Xerxes' troops the previous year,[93] misses the point that the prophecy was actually about the Illyrians and the Encheleans,[94] and overlooks the existence of a prophecy by the Boeotian prophet Bacis:

By the River Thermodon[95] and the grassy banks of Asopus
The Greeks muster to fight, and Barbarian cries for help
 ring out.
There shall fall in battle, when his fate has exceeded its
 allotted share and portion,

Many an arrow-shooting Mede, overcome by his day of
 destruction.[96]

Nevertheless, Mardonius issued orders to prepare for battle at
dawn the next day.

Treachery and Disobedience

In the middle of the night a lone horseman rode into the Greek
camp. It was King Alexander I of Macedon, and it is very diffi-
cult to ascertain what he was up to. He claimed to be acting in
good faith and without Mardonius's knowledge, and he had a
secret message for Aristides and Pausanias. He asserted his royal
Macedonian Greek heritage,[97] said that he could not bear to see
Hellas exchange freedom for slavery, and informed them that
Mardonius was going to attack at first light. Alexander's advice
was not to retreat, since Mardonius was having desperate logis-
tical problems and would run out of food in a few days. With
that, he told them that he expected to be rewarded appropri-
ately, disclosed his identity and rode off.[98]

 The message caused chaos in the Greek ranks. Then Pausanias
made the decision to switch his Spartans with Aristides'
Athenians, on the grounds that their experience at Marathon
would make them more effective at fighting the Medes, whereas
the Spartans were very used to dealing with Boeotians and
Thessalians. The Athenians said they were surprised he had not
thought of this before, but the massed troop movement was
clearly visible from across the river, and Mardonius mirrored
the swap with his forces. Once Pausanias saw the countermove
he returned his men to their original places, as did Mardonius.[99]
The tactical reasoning behind this bizarre choreographed 10–15

km round trip is inscrutable, if indeed it is not a fake story, but it gave Mardonius the opportunity to taunt the Spartans. He sent a herald to express his disappointment: 'We thought you Spartans were supposed to stand your ground, not run away,' he said. 'It's a myth that you either slay your enemies or are slain yourselves. We've just seen you trying to make the Athenians fight against us while you take on our slaves! We thought better of you! We were expecting a straight Spartans v. Persians showdown, not this grovelling cowardice. Why don't we fight it out to the end in another Battle of the Champions?'[100] The Spartans responded with heroic, contemptuous silence;[101] Mardonius unleashed his cavalry.

The Persian horsemen showered the Greek hoplites with javelins and arrows, and crucially forced the Spartans, who could not engage them hand-to-hand, to withdraw from the Gargaphia spring. Mardonius's men fouled the spring and blocked it off, depriving the Hellenes of their prime water supply, since it was impossible to draw water from the Asopus, which was within easy range of the Persian bowmen. In addition, Mardonius's cavalry had managed to close off the routes from the Peloponnese, so the Greeks were desperately short of food.[102] So Pausanias's high command decided to relocate to a place about 2 km to the south-west in front of the ravaged town of Plataea. There was an 'Island', whose location cannot now be identified, that was formed by two diverging streams of a tributary of the Asopus called the River Oeroe, aka the 'Daughter of Asopus', which they felt would give them a secure base and viable water supply. The plan was to move half the army there during the night, and send the other half to Mt Cithaeron to reopen the supply lines.[103]

The Greeks repulsed the Persian cavalry assaults throughout the day, but the night manoeuvres dissolved into undisciplined

chaos. The 18,600 hoplites in the centre of the Greek line had probably experienced the worst of the day's Persian onslaught, and they were so relieved to get away from Barbarian cavalry that in an act of 'disobedience, desertion, and treachery'[104] they blatantly disobeyed orders. Rather than heading to the Island they moved twice as far as they should have done to a position about 4.5 km from Gargaphia, pitching their tents in random fashion at the Temple of Hera outside Plataea.[105] Pausanias, however, was under the misapprehension that they were heading to the Island, and he ordered the Spartans to follow them, only to encounter another form of insubordination. The Spartan Amompharetus son of Poliades, who commanded the *lokhos* from Pitana,[106] had not been at the planning meeting, and in an act of Homeric-style intransigence he refused to flee from 'the strangers' and bring shame on Sparta. This put Pausanias and Euryanax in an awkward situation: they could not allow him to disobey orders, but neither could they leave him behind. This delayed the Spartan departure, which in turn prompted the Athenians to send a rider to find out what was going on. He arrived in the middle of an epic-scale argument. To make his point Amompharetus picked up a huge stone in both hands, threw it in front of Pausanias, and yelled that this was his 'pebble' (*psephos* in Greek) with which he 'voted' (*psephizomai* = I vote) against fleeing from 'the strangers'. Pausanias thought Amompharetus was crazy. He told the rider to tell the Athenians about his difficulties and ask them to join up with his forces and follow what they did.[107]

With the row still raging at daybreak, Pausanias decided to call Amompharetus's bluff: the Spartans moved off across the spurs and foothills of Cithaeron to avoid the Persian cavalry;

the Tegeans covered their rear; the Athenians marched down into the plain; and Amompharetus finally caved in and led his *lokhos* at a steady walking pace behind the rest of the column. Pausanias only moved about 2 km before stopping by the River Molois and a place called Argiopium, near a shrine of Eleusinian Demeter. There are some clues as to the whereabouts of this shrine.[108] Plutarch says that there was 'a very ancient temple of Eleusinian Demeter and Kore near Hysiae, at the foot of mount Cithaeron',[109] and various architectural fragments, plus a couple of tantalisingly fragmentary inscriptions[110] referencing the worship of Demeter, suggest that there was a shrine to the goddess at the western base of what is now called the Pantanassa Ridge, roughly 2 km north-east of the modern village of Erythres. One of the inscriptions, written in early fifth-century-style Boeotian letter forms, references Demeter, and a statue possibly dedicated by the seer Tisamenus and Aeimnestus, the Spartan who later killed Mardonius.[111] The ridge could accord with ancient Hisiae, and the shrine might be the one significant geographical point on the battlefield that we can locate with any confidence. If this was Pausanias's location, it gave him protection to his rear, and access once again to the Gyphtokastro Pass. But then, just as Amompharetus caught up with him, so did the Persian cavalry.[112]

The Battle of Plataea

The Spartan night moves confirmed Mardonius's opinion that his enemy was grossly overrated. In a speech dripping with arrogant sarcasm, he called over Thorax of Larissa and vented his disdain to the Aleudae:

You always told me the Spartans would never flee from the battlefield. You said they were the best warriors in the world. But first they wanted to change positions, and now they have run away in the night! As soon as they come up against truly brave warriors they show how worthless they really are. I am astonished at Artabazus being frightened of them and advising us to go to Thebes in such a cowardly way.

And with that, he said it was time to pursue the Greeks and make them pay for all the wrongs they had done to the Persians. In the mistaken belief that the Greeks were fleeing, he led his Persian troops over the Asopus, advancing against the Spartans and Tegeans rather than the Athenians, who were not in his field of vision. The rest of Mardonius's army raised their battle standards and joined the attack in a shouting, screaming mass, but one which lacked the essential planning (*kosmos*) and ordered formations (*taxis*) to maximise its impact.[113]

The moment the Persian cavalry descended upon Pausanias, he sent a message to the Athenians: 'Men of Athens! The greatest contest lies before us, whether Greece is to remain free or be enslaved!'[114] He lamented how the Spartan and the Athenians had been 'betrayed' by their allies during the night and urged them to come to his aid. The Athenians responded positively but were intercepted by the Thebans and other Boeotians. Aristides heroically stepped forward and appealed to be allowed to get through to Pausanias, but the Boeotians were ardent Medisers, and his rescue mission had to be abandoned in favour of Greek versus Greek hand-to-hand fighting.[115]

Mardonius now had the 'straight Spartans v. Persians showdown' that he craved. His foot soldiers used their traditional

sparabara tactics, but Pausanias could still not secure favourable omens and he would not engage without them. The longer he waited, the more casualties his men incurred. The warrior Callicrates, who was the best-looking of all the Greeks, was fatally wounded by an arrow, and as he breathed his last he lamented not that he was dying – he was happy to die for Hellas – but that he had not managed to strike a single blow or do anything worthy of *kleos*.[116] Finally, Pausanias turned towards the Temple of Hera at Plataea and appealed to the goddess, and while he was doing that the Tegeans attacked on their own initiative. The sacrifices immediately turned positive, and Pausanias led his men into action.[117]

The Spartan spearmen assumed the character of a ferocious beast, stiffening its bristles to defend itself, and battled their way through the Persian missiles until they reached the wall of wicker shields. Once they had smashed that down there was a violent struggle outside the Temple of Demeter, which was decided by a textbook *othismos*. One Spartan to receive special mention was Aristodemus the Trembler, who redeemed his reputation in Herodotus's eyes by rushing forward in a frenzy as he gave his life for the cause. The Spartans, though, were less impressed. They regarded his heroics as motivated by peer pressure, and gave honours to Posidonius, because he sacrificed his life despite wanting to live, as did Philocyon ('Dog Lover') and the stubborn Amompharetus.[118] For their part, the Persians stood their ground, grabbing the Spartan spears and snapping them in half, and wielding their *akinakes* to murderous effect. But they lacked the Spartans' guile, skill and discipline in this type of combat, and their attacks were random and badly coordinated. Herodotus says, wrongly, that they had no body armour, and that it was practically a fight between armoured

fighters and naked men. Mardonius himself was magnificently conspicuous on his shining white charger, surrounded by 1,000 of Persia's finest fighters. But his men could not protect him from the Spartan Acimnestus (or possibly Arimnestus), who crushed his head with a stone, and so took full 'retribution on behalf of the Spartans for the slaying of Leonidas, as the oracle had predicted'.[119] A prominent Aeginetan called Lampon wanted Pausanias to sever and impale Mardonius's head like Xerxes had done to Leonidas's, so that in the future 'no Barbarian will dare to perpetrate wickedly hubristic acts against the Greeks',[120] but the Spartan sarcastically thanked Lampon for his 'thoughtfulness' and refused to do a deed that was 'more suited to Barbarians than Greeks'.[121] Mardonius's body disappeared mysteriously the day after the battle,[122] but with his death the Persians' *kosmos* now evaporated. They broke and ran for 'the wooden wall that they had erected in the land of Thebes'.[123]

One man who did not flee to the wooden wall was Artabazus. He had been opposed to giving battle in the first place, and was commanding a contingent of 40,000 men who were yet to engage. When he saw the Persians being routed he turned and fled to Phocis, with the object of getting away from there to the Hellespont. The Mantineans, who arrived inexplicably late for the battle, offered to make amends by harassing him as far as Thessaly, but the Spartans would not allow them to pursue fleeing men.[124] The Thessalians had not yet heard about the events at Plataea, and as long-standing Medisers they welcomed Artabazus, but he knew that they would probably turn against him if he told the truth about what had happened, so lied about being on a mission into Thrace, and said that Mardonius was following closely behind. He then took the shortest inland

route to Byzantium, and despite hunger, fatigue and Thracian aggression, he was eventually able to make it back to Asia. Strangely he does not seem to have been held accountable for the disaster at Plataea, and emerged with his already high reputation further enhanced, becoming satrap of Dascylium the following year.[125]

If Artabazus fought badly, so, we are told, did all the Greeks on the Persian side apart from the Boeotians. They and the Athenians remained locked in combat for a considerable time. The finest Athenian hoplite was said to be Sophanes of Decelea, who was famous for carrying an iron anchor that he tied to the belt of his breastplate with a bronze chain. When he arrived in the combat zone he would 'drop anchor' so that no enemy could dislodge him, but 'weigh anchor' to give chase.[126] His offbeat heroics helped his countrymen to wipe out an elite force of 300 Thebans as the Boeotians were finally routed. They fled to Thebes, by a different route from that used by the Persians and the rest of the 'undisciplined rabble' who Herodotus says had not had a meaningful military engagement with anyone.[127]

Only the Persian cavalry was not caught in the rout, and it provided some cover to those fleeing the rampant Greeks. Once the news of the victory reached the Corinthians, Megarians and Phliasians, who were still at the Temple of Hera, they started to move towards the combat zone. A Theban cavalry force led by Asopodorus ('Gift of the Asopus') intercepted the Megarians and Phliasians, killed 600 of them, and drove the survivors on to Cithaeron.[128] The Megarians later erected a cenotaph with verses supposedly written by Simonides, which memorialised the men who 'received the fate of death to nourish the day of liberty for Hellas and the Megarians', including

some who died 'on the Boeotian plain, who dared to lay hands on horse-back warriors'.[129]

Just as the Athenians had entrusted their safety to their wooden wall at Salamis, so now the fleeing Persians and their allies did so at theirs at Plataea. They just managed to get inside their palisade, man the towers and improve the fencing before the Lacedaemonians arrived, followed shortly afterwards by the Athenians. The fighting was later envisioned as an epic battle for the wall (Herodotus possibly invented the word *teikhomakhie*, 'wall-battle', to describe it) that resembled that between the Greeks and Trojans at Troy.[130] The defenders were able to hold out until the brave and persistent Athenians managed to scale and breach the wall. The Hellenes poured into the camp, led by the Tegeans, who plundered Mardonius's tent, which tradition had it contained a remarkable bronze manger for his luxuriously pampered horses. They dedicated this in the Temple of Athena Alea, where Herodotus may have seen it.[131] Crazed and confused, the defenders dissolved into a panic-stricken mass and completely lost the ability and will to defend themselves. Amid the carnage a woman from Kos, who had been violently and impiously abducted from her home and was now the concubine of Darius's nephew Pharandates, made her way to Pausanias, grabbed his knees and asked for mercy. Fortunately her father Hegetorides happened to be Pausanias's guest-friend, so he entrusted her safety to the ephors, who sent her to Aegina, which is what she wanted.[132] However, no such restraint was directed towards the tens of thousands of the invading soldiers who were now trapped in a tightly packed killing field, where the Hellenes hunted them down at will. Nemesis had finally come to avenge all Persia's acts of hubris, and Herodotus described it as 'the most beautiful of all the victories we know of'.[133]

To the Victors the Spoils

Establishing credible casualty figures for the Battle of Plataea is practically impossible: Diodorus says that 100,000 Barbarians were slaughtered; Herodotus gives us 257,000 dead and 3,000 POWs; Ctesias calculates 120,000 deaths after Salamis; and Aeschylus just speaks vaguely of 'piles of dead bodies'.[134] On the Greek side Herodotus catalogues 52 Athenians, 16 Tegeans and 91 Spartans, but ignores the Perioikoi and Helots; Diodorus numbers them at over 10,000; and Plutarch makes it 1,360, but repeats Herodotus's figures, adding that all 52 Athenians came from the tribe of Aiantis.[135] It was acknowledged that the best Barbarian fighters had been Mardonius as an individual, the Persian infantry and the Sacae cavalry. For the Greeks, Diodorus says that Aristides made sure that Pausanias got the award for men, and Sparta got the prize for cities.[136] The *aristeia* (= official award for excellence in battle) was highly coveted and conferred quasi-mythological heroic esteem, and Plutarch offers an alternative version in which some hardline Athenians would not agree to the Spartans being honoured in this way, and that a civil war was only averted by giving the prize to the Plataeans.[137]

Once the killing had stopped it was time to gather the plunder. Pausanias delegated the collection of the valuables to the Helots. It was normal for the Persians to go to war in luxurious style, and the booty was astonishing: tents decked out with gold and silver; couches that were gilded and overlaid with silver; mixing bowls for wine, shallow drinking bowls and other drinking vessels in the shapes of animal heads, all made of gold; carts laden with sacks full of gold and silver cauldrons; armlets, torques and the golden *akinakes* of the warriors; and fabulous

embroidered clothing, which, rather surprisingly, no one valued very highly (although it would become the height of fashion by the middle of the fifth century BCE). The Helots allegedly stole a considerable amount of this and sold it on to the Aeginetans at knockdown prices, and the Plataeans continued to find chests of treasure for some time afterwards.[138] Ten per cent of what the Helots did not pilfer was set aside for Apollo at Delphi, and financed the erection of the Serpent Column; another 10 per cent went towards the Bronze Zeus at Olympia, and a final 10 per cent paid for a 3.25-metre high image of Poseidon at the Isthmus.[139] The remaining concubines, camels, horses, beasts of burden and precious metals were divided up and distributed according to everyone's just deserts, with extra presents for the best fighters and a tenfold share for Pausanias. However, when the Spartan regent discovered the lavish contents of Mardonius's tent, he ordered the Persian caterers to prepare a typical Mardonius-style meal, and when he saw the blingy opulence of it all he told his own servants to make a Laconian meal, just for a laugh.[140] He thought the contrast between the two was hilarious, but called in the Greek generals to make a serious moral point: 'Men of Greece, I have brought you together because I wanted to show you the mindless stupidity of the [leader of] the Medes, who, as you can see, had such an amazing lifestyle, and yet came here to snatch away our poverty-stricken one'.[141]

The Greeks now buried their dead. The Spartans constructed three tombs: one for their priests or their youngest fighters (Herodotus's Greek text is obscure at this point, and the two words are very similar), one for the rest of the Spartiates and another for the Helots. The Tegeans buried theirs in a separate location, as did the Athenians, Megarians and Phliasians. When the travel writer Pausanias visited the site some 600 years later,

he was shown just the graves of the Athenians and Spartans, plus a communal Hellenic grave, an altar to Zeus, god of Freedom, and the trophy that the Greeks put up. Herodotus also mentions a number of cenotaphs erected by various states who had not taken part in the battle but wanted other Greeks to believe that they had, including (a scurrilous piece of anti-Aeginetan propaganda) the Tomb of the Aeginetans, erected a decade or so later.[142]

Although Plataea could never have been won without the success at Salamis, the resistance at Artemisium, the Spartan heroics at Thermopylae, and the Athenian victory at Marathon, it had still preserved a Greek way of life that might have been 'poverty-stricken', divided and fractious, but which had also created ideals and processes of freedom and democracy that would influence the world for centuries into the future. The Greeks themselves measured it against their mythological past, and the resistance to Persia acquired a status approaching that of the Trojan War. This is made clear by a Homeric-flavoured elegy written by Simonides that has fairly recently been published, which survives on a Roman-era papyrus found at Oxyrhynchus in Egypt. Probably written to order for the Spartans, it opens by invoking the death of Achilles at the 'much-sung-of city' of Troy, before switching seamlessly to the Battle of Plataea and 'Pausanias, the son of brilliant Cleombrotus', the 'best man', who led the Spartans to 'immortal glory [kleos]'. Simonides' Spartans become epic heroes, marching out to war in the company of Menelaus, the husband of Helen of Troy/Sparta to drive out the Persians.[143] Had Mardonius emerged triumphant at Plataea the previous Greek victories would have counted for nothing and, as Plato acknowledged, both the Athenians and the Persians knew it:

CLINIAS OF CRETE: We Cretans say it was the sea-battle at Salamis, fought by the Greeks against the Barbarians, which saved Greece.

ATHENIAN: Agreed, that's what most Greeks and Barbarians say. But, my friend, we, by which I mean me and Megillus the Spartan here, assert that it was the land-battle of Marathon that began the salvation of the Greeks, and Plataea that finished it.[144]

CHAPTER 13

Democracy on the Offensive

> The dominant exact what they can and the weak have to comply.
>
> The Athenian envoys to Melos, 416 BCE[1]

The Siege of Thebes

The victorious Hellenes looked to exact vengeance, and Thebes was first on their list. Under the Oath of Plataea they had sworn to 'totally destroy the city' but, for the moment, they just demanded the surrender of the ringleaders, including the arch-Medisers Timagenides and Attaginus.[2] The Thebans refused, so, ten days after the battle, the allies laid siege to the city and ravaged the surrounding land. When the devastation had gone on for twenty days Timagenides spoke to his people, stressing that Thebes' collaboration was a communal choice, and suggesting that the Hellenic demands might just be a pretext to extort money. However, he also offered that the ringleaders should be given up for trial to save the city. Attaginus escaped during the handover, but Timagenides and the other unnamed Medisers were confident that some well-directed bribery would secure

their acquittal. They were badly mistaken. Pausanias sent them to Corinth and executed them there.[3]

The Battle of Mycale, a Second Ionian Revolt

The Greek and Persian world was turning full circle. Since the spring of 479 BCE the Hellene and Persian fleets had been divided by the waters between Delos and Samos,[4] but now three Samian messengers approached King Leutychides of Sparta. Their spokesman Hegesistratus son of Aristagoras made a much more persuasive speech for intervention in Ionia than Aristagoras of Miletus (no relation) had made to King Cleomenes twenty years previously.[5] When he invoked their common gods to help them to liberate the Hellenes from slavery and beat the Barbarians back,[6] Leutychides asked what his name was. Hegesistratus means 'Army Leader', which was good enough for the Spartan king. His fleet would sail to Samos.

The Hellenes duly crossed over and anchored at 'The Reeds', an area of wetlands close to the Temple of Hera on Samos, which still bore the traces of Persian fire damage 600 years later,[7] and prepared for combat. The Persian navy took up a position on the mainland coast, but because of their post-Salamis loss of confidence they dismissed the Phoenician vessels, possibly for their own safety, and decided not to fight at sea.[8] Their preference was to take up a position on the Mt Mycale promontory, which juts out towards Samos, where they could rely on the support of the 60,000 land forces under the command of Xerxes' outstandingly big and beautiful cousin Tritantaechmes/Tigranes.[9] They sailed past the resonant landmarks of the Temple of Demeter and Kore on Mt Mycale, the River Gaeson, and the town later called Palisades (Skolopoeis),

which was the site of another temple of Eleusinian Demeter, before beaching their ships and building a defensive stockade using trees sacrilegiously chopped down in the sanctuaries. These places seem to be on the south side of Mt Mycale in the immediate vicinity of the later township of Priene, in the large bay at the mouth of the River Maeander delta. The modern villages of Atburgazı, about 5 km west of Priene, and Doğanbey/ Güllübahçe, 1.5 km to the east of Priene, are the two most favoured possible sites,[10] and it was there that the Persians prepared for siege or victory.[11] These tactics confused and annoyed the Greeks, who were unsure how to respond. Of the three options that they considered – sailing home, going north to the Hellespont and destroying the bridges, or sailing for the mainland – they chose the third. Stowing everything they needed for an old-school grappling-and-boarding sea fight, they set their course for Mycale.

Leutychides came into visual contact with his enemy, but no one came out to confront him. So, with the same intent as Themistocles at Artemisium, he sailed as near to the shore as he could, and got his herald to broadcast a message to the Greeks fighting on the Persian side:

Men of Ionia! [. . .] Take notice of what I say! In any case, the Persians will not understand a word of what I am telling you to do. When we join battle, remember freedom first and foremost, and after that the watchword 'Hebe'.[12] And if you hear this message, pass it on to someone who hasn't![13]

Choosing a site far enough away from the Persian camp to get ashore unopposed and then form up in full battle array, Leutychides landed with an ad hoc infantry force of perhaps

3,300 fighters taken from the marines on board his 110 triremes. Tritantaechmes was unsettled both by these preparations and by Leutychides' communications to the Ionians. He responded by disarming the Samians, whose commitment to the Persian cause was clearly suspect, and ordering the Milesians to guard the passes leading to 'the lofty peaks of Mycale'.[14] Having taken these steps to safeguard themselves from potential Ionian treachery, the Persians prepared to do battle *sparabara*-style, and constructed their customary barricade of wicker shields outside their stockade.[15]

The Hellenes formed their phalanx and advanced. As they approached the Persian positions a herald's staff was found at the water's edge, and a rumour began to fly that the Greeks had been victorious at Plataea.[16] Something uncanny seemed to be happening: Rumour (Pheme) was a goddess; there were precincts of Eleusinian Demeter on both battlefields; and the two battles were reputedly both fought on the same day, with Plataea happening in the morning, and Mycale in the afternoon.[17] Plutarch was circumspect about this, noting that the Athenians dated Plataea to the fourth day of Boedromion while the Boeotians had it four days before the end of the month of Panemus;[18] some suggest that the earlier death of Masistius triggered the rumour; others that the message came from a chain of beacon fires; others again that the battles were on separate days; and in Diodorus's account the rumour is rationalised into a deliberate morale-boosting fabrication by Leutychides.[19] Whether it was divine intervention, a genuine report or fake news which happened to be true, it bolstered the Greek courage. For their part, the Persian commanders tried to inspire their men by telling them that Xerxes himself was on his way with a huge army.[20]

Herodotus's narrative of the Battle of Mycale looks like a small-scale cut-and-paste version of Plataea, but with the Athenians achieving an *aristeia* on Ionian soil to match that of the Spartans in Greece. As they had done at Plataea, the Athenians, one of whose commanders was Xanthippus, advanced over the lower ground, this time along the beach and the level coastal plain, accompanied by initially unnamed others 'who were deployed next to them'; likewise the Spartans and unnamed others 'who were deployed next to them' moved over the higher ground, this time through a ravine and among the hills; while the Spartans were making their way around, the Athenians closed to action, hoping to score a victory before their allies-but-rivals arrived; and like at Plataea the Persians had a wooden palisade, a wicker shield wall and a combative attitude. The Athenians smashed through the shield wall and pursued the Persians into their palisade, at which point we learn that the Corinthians, Sicyonians and Troezenians were fighting alongside them. They breached the Persian fortifications, and as they stormed into the camp the Medising Greeks fled, leaving the Persians fighting for their lives until the Spartans arrived to help finish the job. The Hellenes collected the booty, torched the Persian ships, destroyed the palisade and sailed off. Xerxes' admirals Artaÿntes and Ithamitres got away, presumably by sea, but Mardontes was killed, alongside general Tritantaechmes. The rates of attrition on the Hellenic side were high, with the Sicyonians suffering especially badly, but earning themselves the fifth place on the Serpent Column.[21] The *aristeia* went to the Athenians, with their star man being Hermolycus son of Euthoenus, an exponent of the combat sport of *pankration*, a kind of hyper violent mixed martial art.[22]

Tritantaechmes had also been right to mistrust the Samians

and the Milesians. The former, despite having been disarmed, helped the Hellenes as best they could from inside the Persian camp, and brought various other Ionians over with them, while the Milesians detailed to guard the passes on Mt Mycale used their local knowledge to lead the fleeing Persians back into the clutches of the Greeks.[23] However, the role of the Samians and Milesians is very different in Diodorus's version, in which they carry out a pre-planned defection, pushing forward at the double as the two battle-lines engage, and causing complete confusion among the Greeks, who think Xerxes is coming. The Persians catch the Greeks while they are dithering in their response, and the battle remains finely poised until the Samians and Milesians intervene to turn it in favour of the Hellenes. The late-arrivers in this account are the Aeolians and numerous peoples of Asia, who have developed an overwhelming desire for their freedom. The Persians are driven back into their camp, where a frenzied bloodbath results in 40,000 Persian deaths, which in turn prompts Xerxes to flee from Sardis to Ecbatana.[24] Both accounts are problematical, but what mattered overall was the result: the Greeks were victorious.

The Future of Ionia and the Future of Greece

As the straggling Persian survivors were making their way to Sardis, Herodotus summarised the situation: 'so, for a second time, Ionia revolted from the Persians'.[25] For him the Battle of Mycale really ended the Persian Wars, or at least the Persian invasions. Yet there was still a great deal of unfinished business: the victory at Mycale raised the very serious question of what, if anything, should be done about Ionia, now that a process of liberation had started.[26] In a debate on Samos, the Spartans

floated the idea of resettling the entire population of Ionia to new homelands in Greece, which would be seized from Medising states. This was not acceptable to the Athenians, however. They resented the Spartans making decisions about places they regarded as their colonies, and they had oaths of alliance with the people of Samos, Chios and Lesbos that they were unwilling to violate. And in any case, the Ionians refused to move.[27]

The allied fleet now sailed towards the Hellespont to destroy Xerxes' bridges, only to find that they were already broken.[28] This generated a second inter-Hellenic disagreement: Leutychides and the Peloponnesian forces decided to sail home, while Xanthippus's Athenians opted to stay and attack the Chersonese. The area had long been subject to Athenian intervention and was a crucial fixture in their shipping lanes to the corn-producing areas of the Black Sea, and they immediately laid siege to the Persian stronghold of Sestos. A Persian named Oeobazus had taken the cables of the bridges there, and it was defended by both the Persians and local Aeolians under the overall control of the satrap/tyrant Artaÿctes, whose story brings Herodotus's *Researches* to their conclusion.

By playing on the double meaning of a Greek word that can mean 'house' or 'temple',[29] Artaÿctes had deceived Xerxes into granting him the treasures of the shrine and tomb of Protesilaus at Elaeus (near the modern Çanakkale Martyrs' Memorial in Turkey).[30] In myth, 'great-hearted, warlike' Protesilaus had been one of the suitors of Helen, leading forty 'black ships' to Troy. An oracle had predicted that the first Greek to step ashore in Asia would be the first to die, and, to the suicidal anguish of his wife, Protesilaus was that man:

The partner of his bed, both her cheeks torn in grief, was
 left in Phylace,
where his house [or family] was only half-built. A Trojan
 warrior
slew him as he jumped down from his ship, the first of the
 Achaeans by a long way.[31]

The Trojan War not only came to symbolise the conflict
between the East and the West but was also the reason why the
Persians regarded the Greeks as their enemy,[32] and Protesilaus
himself stands for all the aggression, transgression and counter-
aggression of the entire conflict from its mythical beginnings to
its historical end. As part of that process, Artaÿctes had taken
the fruits of his grave robbery to Sestos, and had then doubled
down on his desecration of Protesilaus's sanctuary by cultivat-
ing the sacred ground and having sex with local women in the
inner shrine. The latter was particularly appalling given that
Protesilaus and his wife had been denied their conjugal pleas-
ures by his untimely death.

 Artaÿctes had never imagined that he would have to pay for
his crimes, but as the Athenian siege dragged on into the winter,
the people in the city were reduced to boiling the leather straps
of their beds for food. Artaÿctes, Oeobazus and the Persians
eventually managed to sneak away during the night, at which
point the remaining defenders opened the gates of the city to
the Athenians. Oeobazus made it to Thrace, only for the local
Apsinthians to make him the scapegoat for every Persian who
had violated a Greek sanctuary by sacrificing him to their god
Plistorus; Artaÿctes was hounded down at Aegospotami ('Goat
Rivers') to the north-east of Sestos, where he and his son were
taken alive. In a further act of impiousness, cunning and hubris,

Artaÿctes offered an enormous ransom payment of 100 talents to the god for the treasure and 200 talents to the Athenians to buy pardons for himself and his son.[33] The amounts were eyewatering – it would later cost roughly 470 talents to construct the Parthenon at Athens – but Xanthippus was implacable, and the people of the Chersonese were outraged at the desecration by Asians of the tomb of a hero whose death marked the boundary between the two continents:[34] there had to be justice for Protesilaus.

The satrap was taken to a place overlooking the dividing line between Europe and Asia – either the headland where Xerxes had hubristically bridged the Hellespont or a hill above the town of Madytus (between Elaeus and Sestos in the vicinity of modern Eceabat)[35] – and there he was crucified in the Athenian style of *apotympanismos* by being fastened to a wooden plank with iron bonds around his neck, wrists and ankles.[36] As he died a slow, lingering death, his son was stoned to death in front of his eyes.

In one sense, the Athenians had inverted the beginning of the Trojan War: the Asian Artaÿctes dying in Europe mirrored the European Protesilaus dying in Asia. But this atrocity also inverted all the norms of Hellenism and Barbarism,[37] and by defeating the Barbarians, the Athenians had started a process in which they themselves became barbarised. They sailed home, taking the bridge cables with them back to Athens, where they were dedicated in their temples.

The capture of Sestos, which Thucydides places in early 478 BCE,[38] effectively marked the end of any meaningful Persian occupation in Europe.[39] Freedom had triumphed. Democracy had triumphed. Herodotus finished his magnificent work by paraphrasing the thoughts of Cyrus the Great, who back in the

day had told his Persians that it was better to live and rule in a rough poverty-stricken land than to cultivate flat fertile plains and be the slaves of others.[40]

Freedom v. Slavery; Ruling v. Being Ruled

Cyrus's idea that it was better to rule than be ruled was very much taken to heart by the Athenians in the post-invasion era, although with a new focus. The Great King of Persia had been warning against gratuitous expansionism, but as history moved on the Athenians took up the baton of imperialism. As they exacted retribution and reparations from the Persians, their struggle made a nuanced shift away from that between freedom and slavery to focus on ruling and/or being ruled. Freedom from external menace effectively gave the Greeks the freedom to fight one another.

There was initial cooperation as Peloponnesian, Athenian and sundry allied ships conducted successful mopping-up operations against Cyprus and Byzantium,[41] but Pausanias went rogue. He abandoned his Spartan lifestyle, and started dressing like a Mede and dining in the Persian fashion that he had experienced at Plataea. As luxury and hubris overwhelmed him, the allies turned to Athens for leadership, and the Spartan authorities lost patience with him. He was walled up in the Temple of the Goddess of the Bronze House at Sparta and left to die. Themistocles found himself implicated in the affair, and his post-war career saw him ostracised in 472, and ultimately ending his days at the court of Xerxes' son and successor Artaxerxes (Old Persian: *Artaxšaça*, 'Whose Rule is Through Truth'), shortly after he became the Great King, King of Kings, King of Countries, King of the Great Earth Far and Wide[42]

following the assassination of Xerxes by his chief bodyguard Artabanus the Hyrcanian and a eunuch in August 465.[43]

Sparta reverted to inward-looking policies focused on the Peloponnesian League, leaving the anti-Persian actions of the 470s and 460s to be orchestrated by Cimon, son of 'Marathon Miltiades': 'No one humbled and abased the arrogant spirit of Great King himself more than Cimon. He did not let him go freely when he had been driven out of Greece, but followed hard on his heels before the Barbarian could stop and get his breath back.'[44] The Hellenes scored victories at Eion, Scyros, Carystus and, in 468, on both land and sea at the Pamphylian River Eurymedon (modern Köprüçay, Turkey), which effectively destroyed both the Persian fleet and with it any immediate threat to the Aegean. The signing of a treaty known as the Peace of Callias between Athens and Persia (assuming it was a genuine agreement – there is great debate about its existence) brought hostilities to a formal close in 449, and effectively acknowledged the Aegean Sea as belonging to Athens and her allies, with Egypt and Cyprus under Persian control, and the Asia Minor seaboard acting as a kind of 'demilitarised zone'.

This left the Athenians free to concentrate on her own cultural and imperial ambitions, and their astonishing post-Persian-invasion accomplishments – tragedy, comedy, oratory, history, philosophy, architecture, democracy – left an enduring legacy which their great statesman Pericles referred to rather prophetically: 'We have provided incontestable proof of our power, and there are many witnesses to it. We will be the wonder of the people of today, and of those in the future.'[45] Athens's culture shaped much of that of the West, and the city became a byword for resistance to alien invasion, but Pericles also led his city on a journey of ultimately unsuccessful and

unpopular maritime imperialism. The growth of Athenian power and Sparta's fear of it[46] would come to dominate the history of the Greek world, ending ultimately in Athens's shattering defeat to Sparta in the Peloponnesian War (431–404 BCE).

Looking back on these events, Plato saw the transition from hoplites to sailors during the Persian Wars as a moral watershed: 'We assert that the battles [of Marathon and Plataea] made the Greeks better people, but the sea-battles made them worse – if we can talk like that about the battles that saved us back then (I'll let you count Artemisium as a sea-battle as well as Salamis).'[47] Athens might have saved Greece and saved democracy, but her wholesale cultural appropriation of Persian hubris ultimately brought her own demise.

CHAPTER 14

Modern Afterlife

If I hate the manners of the Spartans, I am not blind to the greatness of a free people.

François-René, vicomte de Chateaubriand[1]

Anniversaries and Culture Wars

On 16 October 2019, an event took place in Athens to herald the forthcoming 'Thermopylae – Salamis 2020' anniversary, marking 2,500 years since the battles.[2] The Greek government said that these commemorations were 'for humanity as a whole'; 'these two decisive battles are seen by many to mark the very beginnings of Western civilisation itself,' said Prime Minister Kyriakos Mitsotakis, 'highlighting the importance of Greek unity throughout the centuries [. . .] a unique moment of unity, as the Greek city-states put aside their differences and united to defend their freedom'. President Prokopios Pavlopoulos asserted that 'the unconventional and creative ancient Greek spirit managed to demonstrate its overwhelming excellence and consequent categorical contrast to every illiberal form of a state organisation', and expressed his belief that

Greece still remains the bulwark of the West against the East, representing the values of genuine and unselfish peace, freedom and democracy. Pavlopoulos's successor, Katerina Sakellaropoulou, who presided over most of the celebrations in 2020, followed a similar line:

> At Thermopylae and Salamis, ancient Greece, at the dawn of its glory, came together, stood strong, fought for and saved its freedom, its independence and the humanist core of a civilisation that would later become the most precious historical legacy of Greek antiquity: democracy and the notion of the citizen, self-esteem and liberty.[3]

There is much in these rose-tinted, nationalistic statements that is overstated, controversial and wrong, but at the same time they perfectly capture the inspiring aspects of how the events of the Persian Wars era have often been received: achievements unsurpassed in their immediate results or beneficial in their permanent influence on the fate of mankind; the ultimate contest of freedom versus oppression; the quintessential noble defeat in a noble cause; the triumph of civilisation over barbarism against all the odds; the beginnings of the defining traditions of Western and Eastern styles of warfare; the archetypal struggle against the menacing alien invader; the epitome of patriotism harnessed in the name of Liberty; the encounters that saved Greece – and Western civilisation; the birth-cry of Europe; the First World War of West v. East; the 'Battles that Saved Democracy'.[4]

Prior to the Persian Wars, the Greeks had thought of 'Barbarians' purely in a linguistic sense, using the onomatopoeic word *barbaros* to describe anyone whose (to them)

unintelligible speech sounded like they were saying 'bar-bar-bar' all the time. Homer did not use the term *barbaros* at all: to him the Trojans are not Barbarians, although their Carian allies are *barbarophonos* ('of unintelligible speech'), either because they did not speak Greek or spoke it badly. Indeed, the Greeks called each another 'barbarian' if their dialects were difficult to understand.[5] Barbarity was about speech, not race, culture or behaviour.[6] But the Persian Wars changed all that. Henceforth the idea became embedded that everyone who was not Greek – Persians, Phoenicians, Phrygians, Egyptians, Scythians, Thracians, whatever – was a Barbarian. But the new divide between the two sides was as much behavioural as racial, and the fact that these 'Barbarians' readily accepted monarchy and were described by their Great Kings as slaves simply confirmed a fundamental equation in the Athenian mind: democracy = freedom; monarchy = slavery. Non-democratic Greek states would substitute 'Hellas' for 'democracy' in that formula, and Aristotle put it in a nutshell: 'the barbarian and the slave are identical by nature'.[7] For the Greeks, freedom gave people the reason, humanity, self-control, courage, generosity and high-mindedness that the childlike, bestial, effeminate, irrational, undisciplined, cruel, cowardly, selfish, greedy, luxurious, over-sexed, pusillanimous slave-Barbarians lacked. The core binary oppositions East/West, Greek/Barbarian, and freedom/slavery became permanently embedded in the tradition and have persisted for centuries.

Byzantine, Renaissance and Enlightenment Echoes

The classical Greek states were, in due course, taken over by the Macedonian and Roman empires, and after the Eastern Roman

Empire transformed into the Byzantine Empire, an adventur-
ous Italian man of letters known to us as Cyriac of Ancona, and
to himself as Kyriacus Anconitanus de Picenicollibus (or
K.A.P.) became acknowledged as 'the founding father of
modern classical archaeology'.[8] He travelled in the Peloponnese
in 1447 and 1448 and recorded a visit to Mistra, which was the
capital of the Byzantine despotate of the Morea. Mistra over-
looks the site of ancient Sparta, and although the ruins of the
noble cities of the past saddened him, so did the 'ruin of the
human race':

> That noble-minded, illustrious race of the Spartans, who
> were once the famous upholders of every kind of military
> virtue, not just in Greece, but in Europe, and indeed
> throughout the whole world, are nowadays a cowardly and
> shameful people who seem to have totally fallen from the
> renowned moral integrity of the ancient Laconian and
> Lacedaemonian lifestyle.[9]

A song came to him, in which he asked, 'great Laconian city of
Sparta, the glory of Greece, once upon a time the example to
the world of warfare and of chastity [. . .] where is your Leonidas
now?'[10] And there was no latter-day Leonidas to lead the resist-
ance when, in 1453, Constantinople fell to Mehmed II the
Conqueror and Greece ultimately entered around four centur-
ies of rule by the Ottoman Turks. Inevitably these 'alien Eastern
aggressors' became equated with the fifth-century BCE Persians
in a way that reinforced the East/West dichotomy.

Many of the big names of political science in the sixteenth
century were admirers of Sparta, however, including Niccolò
Machiavelli, who in his posthumously published *Discourses on*

Livy (1531), shared Cyriac's frustration at the way ancient history was not used as a role model in his day.[11] For him, the lessons of history were essential, and the freedom that the Hellenes fought for was the key to their triumph against Persian expansionism: 'It is easy to understand whence this love of liberty arises among nations, for we know by experience that States have never signally increased, either as to dominion or wealth, except where they have lived under a free government.'[12]

The notion of the superiority of the ancients is also apparent in the *Essays* of the philosopher Michel de Montaigne (1533–92), whose 'Of Coaches', written just less than a century after Christopher Columbus 'discovered' the New World in 1492, speculated that if its inhabitants had been conquered by Greeks, rather than by the Conquistadors, they would be far more 'civilised':

> Why did not so glorious a conquest happen [. . .] during the time of the ancient Greekes [. . .] under such hands as would gently have polished, reformed and incivilized what in them they deemed to be barbarous and rude [. . .] there-withall joyning unto the originall vertues of the country those of the ancient Grecians?[13]

Yet in his essay 'Of the Caniballes', Montaigne argued that these people's cannibalism was no worse than the 'barbarisme' of the sixteenth-century Europeans: 'We may then well call them barbarous, in regarde to reasons rules, but not in respect of us that exceede them in all kinde of barbarisme.'[14]

The Persian Wars were not always the source of serious moral and political contemplation. They could also provide some

glorious comedy for the music-loving public of the time, as was the case with *Xerse,* a *drama per musica* by Pier Francesco Cavalli (1602–76).[15] Loosely based on Herodotus – the librettist's *Argomento* says 'on this history together with these feigned veri-similitudes is the drama invented' – it opens with Xerxes wait-ing at the Hellespont for the bridge to be finished, but also having fallen in love with a plane tree.[16] His song to the tree triggers a convoluted love tangle, albeit with a happy ending, and *Xerse* was a great success, as were versions by Johann Philipp Förtsch, premiered in Hamburg in 1689 and featuring some extra '*honnêtes plaisanteries* . . . for the delight of those who love opera', Giovanni Bononcini by a reduced all-male cast in 1694[17] and, most famously, George Frideric Handel. His *Serse* was staged at the Theatre Royal in London on 15 April 1738, with the famous castrato Caffarelli playing Xerxes, and his audience could be expected to see the Persian Empire as a byword for absolute power exercised arbitrarily. Handel did not feel the need to labour the point:

> The contexture of this Drama is so very easy, that it wou'd be troubling the reader to give him a long argument to explain it. Some imbecilities and the temerity of Xerxes (such as his being deeply enamour'd with a plane tree, and the building a bridge over the Hellespont to unite ASIA to Europe) are the basis of the story; the rest is fiction.

The opera was not to everyone's Enlightenment taste. Charles Burney damned it as 'one of the worst librettos Handel ever set to Music',[18] although Xerxes' song to the plane tree, 'Ombra mai fu', aka 'Handel's Largo', is widely regarded as a work of melodic genius.[19]

The Enlightenment response to Xerxes' opponents was divided. In his poem *Le Siècle de Louis le Grand* (The Century of Louis the Great), published in 1687, the French writer Charles Perrault (1628–1703) put one side of the argument:

> Learned Antiquity, in all its duration,
> Was not the equal of our times in its enlightenment.[20]

On the other side, the German art historian and 'high priest of romantic Hellenism' Johann Joachim Winckelmann (1717–68) argued in his essay *Reflections on the Painting and Sculpture of the Greeks* that 'the only way for us to become great, or even inimitable if possible, is to imitate the Greeks'.[21] But this raised the question, which Greeks? For some, like Jean-Jacques Rousseau (1712–78) in *Du Contrat Social; ou, Principes du Droit Politique*[22] it was the virtuous, politically and morally disciplined Spartans, whose ideals were put into verse by the English poet and politician Richard Glover in *Leonidas, a poem* (1737). Leonidas's wife Gorgo is the opposite of the conventional hard-nosed Spartan women with their 'with it or on it' mentality, and she argues that he should put his family before his state. But true Spartiate that he is, Leonidas tells her that dying for Sparta *is* putting his family first, because freedom is everything:

> Leonidas must fall.
> Alas! far heavier misery impends
> O'er thee and these, if soften'd by thy tears
> I shamefully refuse to yield that breath,
> Which justice, glory, liberty, and heav'n
> Claim for my country, for my sons, and thee.

[. . .] When thy husband dies.
For Lacedaemon's safety, thou wilt share,
Thou and thy children, the diffusive good.
Should I, thus singled from the rest of men,
Alone intrusted by th' immortal Gods
With pow'r to save a people, should my soul
Desert that sacred cause, thee too I yield
To sorrow, and to shame; for thou must weep
With Lacedaemon, must with her sustain
Thy painful portion of oppression's weight.[23]

Others preferred the Athenian model. In a thoughtful moment on the Scottish island of Inch Kenneth in 1773, Samuel Johnson reflected on the heroism of Marathon: 'That man is little to be envied, whose patriotism would not gain force upon the plain of *Marathon*.'[24]

There was often a strong drive to appropriate Athens's cultural excellence for patriotic ends, and although Johnson was a Tory, the historical associations of the Greek success at Marathon were acceptable to all political views. A striking case is the brilliant, but decidedly weird, architect John Wood (the Elder), who wrote *The Origin of Building, or the Plagiarism of the Heathens Detected* (1741). In it he writes about the legendary King Bladud, who is described in Geoffrey of Monmouth's twelfth-century *Historia Regum Britanniae* as a descendant of Brutus (or Brute of Troy), the first king of Britain. Brutus, and hence the British nation which is named after him, was said to be descended from Aeneas of Troy, and according to Wood, Bladud founded a city (ultimately Bath), which became known as *Troy Novant* and was the refuge of the leading Athenians when Xerxes sacked their homes. Bladud reigned happily until

he was killed trying to fly with artificial wings on Solsbury Hill, but Britain absorbed the finest elements of Greek culture.

Nineteenth-century Philhellenism

As Greece embarked on its struggle for independence from the Ottoman Turks in the early part of the nineteenth century, the great French romantic François-René, vicomte de Chateaubriand (1768–1848) became a champion of the liberation of Leonidas's fatherland,[25] and it was easy to contrast the horrors of the Greek present with the glories of its past, and identify the Turks with the Persians. No one felt those connections more intensely than the 'mad, bad and dangerous to know'[26] Lord Byron (1788–1824):

> Fair Greece! sad relic of departed worth!
> Immortal, though no more; though fallen, great!
> Who now shall lead thy scatter'd children forth,
> And long accustom'd bondage uncreate?
> Not such thy sons who whilome did await,
> The hopeless warriors of a willing doom,
> In bleak Thermopylae's sepulchral strait –
> Oh! who that gallant spirit shall resume,
> Leap from Eurotas' banks, and call thee from the tomb?
> [. . .]
> The sun, the soil, but not the slave, the same;
> Unchanged in all except its foreign lord –
> Preserves alike its bounds and boundless fame
> The Battle-field, where Persia's victim horde
> First bow'd beneath the brunt of Hellas' sword,
> As on the morn to distant Glory dear,
> When Marathon became a magic word;

Which utter'd, to the hearer's eye appear
The camp, the host, the fight, the conqueror's career,

The flying Mede, his shaftless broken bow;
The fiery Greek, his red pursuing spear;
Mountains above, Earth's, Ocean's plain below;
Death in the front, Destruction in the rear!
Such was the scene – what now remaineth here?
What sacred trophy marks the hollow'd ground,
Recording Freedom's smile and Asia's tear?
The rifled urn, the violated mound,
The dust thy courser's hoof, rude stranger! spurns around.[27]

Cantos I and II of *Childe Harold's Pilgrimage* appeared in 1812, sold out quickly, and Byron 'awoke one morning and found [him]self famous'. As he was working on Cantos III and IV,[28] Jacques-Louis David finished his extraordinary history painting *Leonidas at Thermopylae*, which is now in the Louvre. David himself described it:

Leonidas, king of Sparta, seated on a rock in the midst of his three hundred heroes, reflects, rather moved, on the near and inevitable death of his friends. At Leonidas's feet, in the shade, there is his wife's brother, Agis, who, after putting down the crown of flowers he had worn during the sacrifice, is about to place his helmet on his head; with his eyes on the general, he awaits his orders. Next to him, at the sound of the trumpet two young men run to take their weapons that are hanging from the branches of trees. Further away, one of his officers, a devotee of the cult of Hercules, whose arms and outfit he wears, rallies his troops into battle formation.

He is followed by the high priest, who calls on Hercules to grant them victory. He points his finger at the sky. Further back the army parades.

He omits to mention the figure at the top left, who is already carving, 'Stranger, tell the Spartans that here we lie, obeying their words' into the rock.[29] David's patron Napoleon Bonaparte, ever the winner, could not understand why he would choose to paint the losing side, but the artist himself asserted that he was trying to characterise the profoundly religious sentiment that is inspired by the love for one's country.

Byron followed up *Childe Harold's Pilgrimage* with *Don Juan* (1819–24). Canto III, which features a digression entitled 'The Isles of Greece', was written just before the start of the Greek War of Independence. Here he used his rock-star level of celebrity to voice his opinions about the Ottoman Empire's dominance over Greece, and to hark back to the battles of the Persian Wars:

The mountains look on Marathon –
 And Marathon looks on the sea;
And musing there an hour alone,
 I dream'd that Greece might still be free;
For standing on the Persians' grave,
I could not deem myself a slave.
A king sate on the rocky brow
 Which looks o'er sea-born Salamis;
And ships, by thousands, lay below,
 And men in nations; – all were his!
He counted them at break of day –
And when the sun set, where were they?

And if Greeks were ruled by tyrants in the fifth century BCE, at least they were *Greek* tyrants:

> The tyrant of the Chersonese
> Was freedom's best and bravest friend;
> That tyrant was Miltiades!
> O that the present hour would lend
> Another despot of the kind!
> Such chains as his were sure to bind.[30]

Byron fought in the Greek War of Independence but died of an illness at Missolonghi in April 1824. During the conflict, in his poem 'Leonidas' (1822), the Irish writer and Anglican clergyman George Croly urged his readers to 'Shout for the mighty men':

> But there are none to hear –
> Greece is a hopeless slave.
> Leonidas! no hand is near
> To lift thy fiery falchion now;
> No warrior makes the warrior's vow
> Upon thy sea-washed grave.
> The voice that should be raised by men,
> Must now be given by wave and glen.

It is the Greek land, not her nineteenth-century inhabitants, who answers the call:

> And is thy grandeur done?
> Mother of men like these!
> Has not thy outcry gone

Where justice has an ear to hear? –
Be holy! God shall guide thy spear,
Till in thy crimsoned seas
Are plunged the chain and scimitar.
Greece shall be a new-born star!

When Greece's newborn star arose after the success of the War of Independence, one of the first great acts was the founding of a new, modern city of Sparta in 1834, close to the ancient site, as a concrete symbol of the rebirth of Greece and the values she stood for. But Athens too had its place in the picture, and Marathon, the battle that saved democracy, was seen as having resonance far beyond Greece.[31] In 1837 Edward Bulwer-Lytton dilated on the dominant themes of East v. West, democracy v. tyranny, and civilisation v. barbarity:

And still, throughout the civilised world (civilised how much by the arts and lore of Athens!), men of every clime, of every political persuasion, feel as Greeks at the name of Marathon [. . .] Never, in the annals of earth, were united so closely in our applause, admiration for the heroism of the victors, and sympathy for the holiness of their cause. It was the first great victory of OPINION! [. . .] The same blow which struck down the foreign invader smote also the hopes of domestic tyrants.[32]

When John Stuart Mill reviewed the first volumes of George Grote's monumental *History of Greece* in 1846, he famously went a stage further: 'The Battle of Marathon even as an event in English history, is more important that the Battle of Hastings.'[33] The Scotsman Mill is often misquoted ('British' for

his 'English'), but his point about its impact on Western society was powerfully and influentially made. Five years later Sir Edward Shepherd Creasy's publishers released his stupendously successful *Fifteen Decisive Battles of the World from Marathon to Waterloo*, which also inspired Gilbert and Sullivan's 'I Am the Very Model of a Modern Major-General' in *The Pirates of Penzance* (1879):

> I know the kings of England, and I quote the fights
> historical
> From Marathon to Waterloo, in order categorical.

Creasy opened his book at Marathon, where the Athenian *strategoi* were debating whether to engage: 'On the result of their deliberations depended not merely the fate of two armies, but the whole future progress of human civilization [. . .] On that vote, in all human probability, the destiny of all the nations of the world depended.'[34]

Not everyone was comfortable with these ideas,[35] but they were swimming against the tide. The majority opinion, however inaccurate, was that, had the Athenians been defeated, the political, cultural and religious freedom of Greece would have been crushed: oriental tyranny, irrationality and cruelty would have replaced Europe's democracy, philosophy and freedom.

The end of the nineteenth century saw the first staging of the modern Olympic Games in Athens in 1896, which generated what is probably the best-known modern cultural legacy of the Persian Wars, in the shape of the marathon race. There was no parallel event in any ancient Greek athletic contests, but the concept was suggested to Baron Pierre de Coubertin, the founder of the modern Olympic movement, by a Frenchman

named Michel Bréal: 'Since you are going to Athens, see if we can organize a race from Marathon to the Pnyx. It will have an antique flavour. If we knew the time the Greek warrior took, we could establish the record. For my part, I would claim the honour of offering the "Marathon Cup".'[36] Coubertin loved the idea.

The first marathon took place on 10 April, starting in the village of Marathon, and ending after about 40 kilometres (it is now standardised at 42,195 metres, or 26 miles 385 yards) in the newly built Panathenaic Stadium in Athens. As the race unfolded they heard that Spiros Louis, a Greek farmer who was running in a traditional fustanella, was winning. 'Hellene, Hellene!' they shouted, and as he entered the stadium he was greeted with paroxysms of delight and cannon fire. He did it in a time of 2 hours, 58 minutes and 50 seconds (the current men's Olympic record is 2:06:32), and his victory gave the Greek spectators immeasurable nationalistic pride.[37]

Twentieth Century: World Wars and the Cold War

As the Persian Wars tradition entered the twentieth century the responses became increasingly ambivalent. In his poem 'Thermopylae' (1903), the Alexandrian Greek poet Constantine P. Cavafy honoured the Spartans' qualities, while at the same time hinting that their undying *kleos* is inseparably linked to betrayal and treachery. The 'Nightmare' Ephialtes facilitates the sacrifice that brings the glory. It is no wonder that they do not hate those who lie:

Honour to those who in their lives
define and guard their Thermopylae.

Never departing from their duty;
just and fair in all their actions,
but showing pity and compassion too;
magnanimous when they are rich, and when
they are poor, magnanimous in little ways,
still helping to the best of their ability;
always speaking the truth,
but without hatred for those who lie.

And even more honour is due to them
when they anticipate (as many anticipate)
that Ephialtes will appear in the end,
and that the Medes will break through at the end of the
 day.[38]

Amidst the devastations of the First World War many of the combatants, who had been brought up on the Greek and Latin classics, felt the relevance of Greek history.[39] Marcel Proust's Baron Palamède de Charlus reflected on the heroic qualities of the British Tommies:

> My dear fellow, take all those English soldiers whom I thought of somewhat lightly at the beginning of the war as mere football-players presumptuous enough to measure themselves against professionals – and what professionals! Well, merely aesthetically they are athletes of Greece, yes, of Greece, my dear fellow, these are the youths of [. . .] the Spartans.[40]

At the outset the war was frequently envisioned in terms of the Greek struggle for freedom, with the Germans cast as the professional Persian invader and the British amateurs as a

curious mash-up between the freedom-fighting victorious Athenian democrats at Marathon and the heroic self-sacrificing Spartans at Thermopylae. W. Macneile Dixon's 'To Fellow Travellers in Greece, March–September 1914' opens with a time when 'there was peace', 'freedom was firmly based', and the only conflict the British had known was 'battl[ing] with ledger and with pen'. But then . . .

> Lest freedom's price decline, from far
> Zeus hurl'd the thunderbolt of war.
> And so once more the Persian steel
> The armies of the Greeks must feel,
> And once again a Xerxes know.

As the ghastly realities of the fighting hit home, the courage and sacrifice were still acknowledged, but so was the sheer industrial-scale horror, which could always be articulated by allusions to the Greek past. Simonides' epigram for the Spartans at Thermopylae was a perfect vehicle to express this, and was used with brutal brevity by H. W. Garrod after the British attempted to break through the German trenches at Neuve Chapelle in March 1915:

Epitaph: Neuve Chapelle

> Tell them at home, there's nothing here to hide.
> We took our orders, asked no questions, died.[41]

Rudyard Kipling also used Simonides in his 'altogether imaginary' *Epitaphs*.[42] In 'Common Form' the dead pass judgement on the living:

If any question why we died,
Tell them, because our fathers lied.

Those 'fathers' may be the Establishment, and Godfrey Elton's 'Simonides/Cicero' similarly deployed Simonides to criticise the Powers That Be who sent thousands of young men to their deaths for a meaningless ideology:

Tell the professors, you that pass us by
They taught political economy
And here obedient to its law we lie.[43]

In the eminent scholar-poet A. E. Housman's *Last Poems*, published in 1922, is a similarly desolate piece entitled 'The Oracles', which emphasises the purposeless loss of life in a world where even divinity does not care. The Delphic priestess prophesies in italics, before the narrator concludes with the famous picture of Spartan homoerotic heroism:

The King with half the East at heel is marched from lands of
 morning;
 Their fighters drink the rivers up, their shafts benight the
 air,
And he that stands will die for naught, and home there's no
 returning.
 The Spartans on the sea-wet rock sat down and combed
 their hair.

Beautiful-haired Spartan warriors were not to every man's taste, however. During the German invasion of Greece in the Second World War, ANZAC troops were stationed in the pass

at Thermopylae.[44] Writing in the Salonika POW camp at the time, the soldier-poet J. E. Brookes (1920–2004) wrote 'Thermopylae 1941', in which he dramatised a conversation between himself, who had a good classical knowledge, and a homophobic member of the Australian 6th Infantry Division, who did not, and was not impressed by it:

We had been deposited into the warlike lap
of ancient deities. I said to Blue,
my Aussie mate, 'There was this famous chap
Leonidas, he was the Spartan
who defended it with just 300 men
against an army.' Bluey took a draw
upon his cigarette. 'Well stuff'im then!'
a pungent comment on the art of war.
[. . .] I said 'They wore
long hair, the Spartans, a visible proof
that they were free, not Helots, and before
the battle they would gravely sit aloof
and garland it with flowers.' Bluey spat.
Continuing to watch the empty road
across the plain he took off his tin-hat
(a proof that he was bald) and said 'A load
of bloody poufdahs!' Thus he laid the ghost
of brave Leonidas. Herodotus
informs us Xerxes, leader of the host,
when told was equally incredulous,
though whether from a soldier's point of view
of army discipline or on the grounds
of social prejudice like my mate Blue,
was not elaborated.

The Germans took the pass, and their propaganda revelled in the victory, chillingly inverting the facts to cast Greece's allies as the Persian invaders, and the German invaders as Spartan heroes:

> Some 2,500 years ago, the Greek people under Leonidas held out against a numerically superior foe. They were later forced to surrender to the English. Today, with our powerful blows, we have chased the English out of Greece and out of Europe.[45]

Even when the invasion of Russia foundered at Stalingrad, Hermann Göring attempted to use the defence of Thermopylae as an inspirational example in a speech on 30 January 1943, which reworked Simonides: 'When you come to Germany, tell them you have seen us lying at Stalingrad, as the law has commanded, the law of the security of our people.'[46] Like Thermopylae, Stalingrad was supposed to be the heroic defeat before the glorious victory, but the Muse of History had other plans for the outcome of that war, and for the reputation of the defenders.

If, in the saying frequently misattributed to Aeschylus, truth is the first casualty of war,[47] and history is written by the victors, Robert Graves's 'The Persian Version', composed between 1938 and 1945, looks at the Battle of Marathon from the perspective of a Persian propagandist desperately attempting to snatch victory from the jaws of defeat with some alternative facts:

> Truth-loving Persians do not dwell upon
> The trivial skirmish fought near Marathon.
> As for the Greek theatrical tradition

Which represents that summer's expedition
Not as a mere reconnaissance in force
By three brigades of foot and one of horse
(Their left flank covered by some obsolete
Light craft detached from the main Persian fleet)
But as a grandiose, ill-starred attempt
To conquer Greece – they treat it with contempt;
And only incidentally refute
Major Greek claims, by stressing what repute
The Persian monarch and the Persian nation
Won by this salutary demonstration:
Despite a strong defence and adverse weather
All arms combined magnificently together.

This is very much the way in which the battle has been viewed by Iranian secularists and traditionalists since the 1920s, relegating Marathon to a 'trivial skirmish' in the midst of the glorious trajectory of Achaemenid history.[48]

The perceived East/West culture war inevitably infiltrated the world of cinema in the twentieth century. In 1959 the title sequence of Jacques Tourneur and Bruno Vailati's sword-and-sandal *The Giant of Marathon* presented Greece as

a land divided – Athens against Sparta – while Athens itself was torn by internal conflict and treachery. Enemy of all Greece and poised for conquest was the great Darius, king of the Persians. In that fateful moment the Greeks found a hero to Unite them – Philippides, the greatest athlete of his time, victor in the Olympic Games, who ran from Marathon to Athens [. . .] to save them from destruction.

Philippides (Steve Reeves) is a hybrid of both of the historico-mythical Marathon runners. Amid political intrigue, amorous entanglements and dastardly Persians, Philippides wins the Battle of Marathon, fights in a sea-battle, and saves his love interest Andromeda, who, in a neat mythological reference, is tied to the prow of a monstrous ship with mechanical jaws that eats other vessels. The Persians are repulsed; Athens and Sparta unite; Athens's internal tensions are solved; and love transcends politics as Philippides and Andromeda walk away into the sunset. A perfect ending to classic peplum.

More historically accurate, but more political in its references to the prevailing Cold War situation is Rudolf Maté's *The 300 Spartans* (1962).[49] The film is bookended with Simonides' epitaph, and its opening moments make it clear that it is about 'their [the Greeks'] freedom and ours [the spectators']'. The protagonists personify the power of the unity of free men with a 'freedom above life' attitude in the face of aggression from the Soviet-style Persian 'slave empire' whose king envisions 'one world one master'. 'It was more than a victory for Greece,' say the titles, 'it was a stirring example to free people throughout the world of what a few brave men can accomplish once they refuse to submit to tyranny.' At the end, the Persian arrows blot out the sun, and in a little over thirty seconds of screen time the 300 Spartans are shot down to a man, after which we are again shown Simonides' epitaph, and are informed that the events we have just watched are a prelude to a victory for freedom over tyranny. The film plays out with a shot of the Spartans marching across the screen superimposed on a Soviet-style monument to a dead hoplite. It was a message intended to inspire an audience chilled by the Cold War, and one that was nicely

articulated by William Golding in his essay 'The Hot Gates' after he had walked the Anopaea path:

> It is not just that the human spirit reacts directly and beyond all arguments to a story of sacrifice and courage, as a wine glass must vibrate to the sound of a violin. It is also because, way back and at the hundredth remove, that company stood in the right line of history. A little of Leonidas lies in the fact that I can go where I like and write what I like. He contributed to set us free.[50]

The Third Millennium

The popular perception of the Persian invasions of Greece is particularly powerful in Zack Snyder's 2007 movie *300*. The film is based on Frank Miller's graphic novel, also called *300*, which retells the Battle of Thermopylae in the style of a campfire story by a Spartan called Dilios. The text on the back cover replays the familiar tropes:

> The army of Persia – a force so vast it shakes the earth with its march – is poised to crush Greece, an island of reason and freedom in a sea of mysticism and tyranny. Standing between Greece and this tidal wave of destruction is a tiny detachment of but three hundred warriors. But these warriors are more than men . . . they are SPARTANS.[51]

The Spartans in Miller's work are drawn with the stereotypical red cloaks and lambda shields, but no body armour, although the author/artist was unconcerned by the inevitable criticisms:

The inaccuracies [. . .] are intentional. I took those chest plates and leather skirts off of them for a reason. I wanted these guys to move and I wanted 'em to look good [. . .] I was looking for more an evocation than a history lesson. The best result I can hope for is that if the movie excites someone, they'll go explore the histories themselves. Because the histories are endlessly fascinating.[52]

The film *300* is renowned for its shock value. Dilios is modelled on Aristodemus the Trembler and is described by Snyder as 'a guy who knows how not to wreck a good story with truth',[53] as he tells the life story of Leonidas (Gerard Butler). *300* combines memorable soundbites ('This is Sparta!'; 'Tonight we dine in Hell!'), original quotations ('Only Spartan women give birth to real men'; the 'with it or on it' instruction; the Spartans refusing to surrender their weapons in time-honoured *molon labe* style), artistic references (Leonidas wields his spear in a visual reference to Jacques-Louis David's *The Intervention of the Sabine Women*), historical accuracy, complete travesty and hyper-violence. Ephialtes (Andrew Tiernan) is not the able-bodied Malian of the historical sources, but a Spartan 'monster' whose parents took him away to avoid having him sent to the Places of Rejection because of his severe physical disabilities. Xerxes (Rodrigo Santoro) is presented as a monstrous, effeminate, 3-m-tall tyrant with an eclectic choice in jewellery, eye make-up and body piercings, and his bizarre army fighting under the lash is a weird Eastern horde full of giants, monsters with lobster claws, oversized war elephants and the occasional armoured rhinoceros. Amid comic-book style firebombs, gore and traumatic amputations created with greenscreen technology, the muscled-up Spartans repel them

all, until they are annihilated under an onslaught of swords, spears and arrows, laughing in the shade on the way.

Criticised for being over-sexualised, homophobic, ableist, misogynist and racist, *300* was also denounced by the Mission of the Islamic Republic of Iran to the United Nations, who protested about its 'excesses of [. . .] hate ideology over form' to the United Nations:

In The Name Of GOD [. . .] The Iranian people are outraged by the movie [*300*] which is full of deliberate distortions and derogatory depictions of ancient Persia. With its crude demonization of Persians, as the embodiment of evil, moral corruption, the nefarious and the destructive, the movie is a serious affront to both history and the proud Iranian people [. . .] The movie is so overly racist, so overflowing with vicious stereotype of Persians, as a dangerous, bestial force fatally threatening the civilized 'free' world, that conveys an implicit acquiescence to the contemporary discourses of hatred espousing a 'clash of civilizations'.[54]

'All the film's producers needed to do was to consult Herodotus,' the document said.[55] Critics in the West also saw *300* as based on a crude binary East/West divide, although as Chris Carey rightly pointed out, the reality is more specific: 'this is West versus Middle East [. . .] a vague Middle Eastern amalgam, Iran–Iraq with the subtext of Islam'.[56]

The music for *300* was written by Tyler Bates, also known for his collaborations with the American rock band Marilyn Manson, and after the release of the film, and the prior publication of Frank Miller's *300* and Steven Pressfield's acclaimed historical novel *Gates of Fire*,[57] heavy metal music latched on to

Thermopylae as a major creative influence.[58] The bands tend to use the classic statements – 'tonight we dine in Hell', '*molon labe*', and the 'Stranger, tell the Spartans . . .' epitaph – to build their sonic edifices: Greek power metal band Sacred Blood's album *Battle of Thermopylae: The Chronicles* tracks the combat from the opening 'The Defenders of Thermopylae' to 'The Gates of Fire'; *Gates of Fire* is also the title of the album by Manilla Road that dropped in 2005 on Battle Cry Records, which ends with 'Stand of the Spartans', 'Betrayal' and 'Epitaph to the King'; another Greek progressive/black/heavy/thrash metal band Zemial's song 'Η Ταν ή Επί Τας' ('Either With It or On It') includes the war cry for freedom from Aeschylus's *Persians*;[59] and in 'Moment of Truth' by the American thrash metal/crossover/hardcore punk band S.O.D. (Stormtroopers of Death), the 300 Spartans stand as one – they're not so impressed by 3,000,000 adversaries dressed in their best, and 'they'd rather die on their feet than live on their knees'.[60] These escapist narratives of heroic, masculine, underdog resistance to controlling authority suit heavy metal's ethos very well: the pagan Greek heroes can be cast as fighting to preserve their culture against a foreign monster, and Xerxes' invasion can represent 'alien' religions such as Christianity coming to destroy their Hellenic heritage, however far this might be from historical reality.

Thermopylae has never been far away from narratives such as these, whatever the context. In 2011, when former President Bill Clinton spoke in commemoration of the victims of the 9/11 attack on United Airlines Flight 93, he used Leonidas's 300 to emphasise the ideals of citizenship and democratic freedom:

There has always been a special place in the common memory for people who deliberately, knowingly, certainly laid down their lives for other people to live [. . .] The first such great story I have been able to find that reminds me of all your loved ones [. . .] occurred almost 2,500 years ago, when the Greek king of Sparta facing a massive, massive Persian army took 300 of his finest soldiers to a narrow pass called Thermopylae [. . .] They all knew they were going to die. He told them that when they went [. . .] But the casualties they took and the time they bought saved the people they loved. [However] this is something different [. . .] your loved ones just happened to be on a plane [. . .] With almost no time to decide, they gave the entire country an incalculable gift [. . .] They allowed us to survive as a country that could fight terrorists and still maintain liberty and still welcome people from all over the world from every religion and race and culture as long as they shared our values.[61]

For Clinton, the passengers on Flight 93 had saved democracy. And as the Greek government prepared to commemorate the 2,500th anniversary of Thermopylae and Salamis, they issued a declaration that encapsulated how those battles were felt to resonate in the third millennium:

DECLARATION
FOR DEMOCRACY AND A
GLOBAL CULTURE OF VALUES

On the occasion of the 2,500 year
Anniversary of the Battle of Thermopylae
and the Naval Battle of Salamis

We, the modern Greeks and all of civilized humanity,
Recalling the achievements of our forebears,
who stood up and fought for their Liberty,
Culture and Values
even when the Struggle seemed hopeless,

Profoundly aware of their Sacrifice at Thermopylae
and their stand at the straits of Salamis,

Proud that, on the foundations of those Victories,
we established and
developed what is today the Global civilization,
[. . .]
Determined to always serve these
Ideals to promote humanity
and the world it created,

As brothers and sisters from many cultures,
Declare,
From the sacred soil of Attica and Greece,
That the Liberty, Culture, Values and Ideals
established through struggle and
springing from the blood of Heroes
throughout time on this earth
shall forever constitute the core of our Existence
and our Legacy for the generations to come.

Athens, 29 September 2020[62]

Marathon, Artemisium, Thermopylae, Salamis and Plataea
have embedded themselves in the tradition as the battles that

saved democracy, sometimes in very overt ways, but also quite subliminally. Just a few weeks after the start of the First World War, Laurence Binyon, a Classics graduate of Trinity College, Oxford, sat on a cliff between Pentire Point and the Rumps in north Cornwall, and wrote 'For the Fallen'. The poem was published in *The Times* on 21 September 1914, and its fourth stanza is now read on every Remembrance Day. It owes a great debt to the classical tradition, and specifically to the lines 'This shroud is such that neither dank decay / Nor all-subduing Time shall fade' in Simonides' *Of Those Who Died at Thermopylae*.[63] It could easily have been written for the Greek citizens who fought for, and saved, the democracy that they had created:

They shall not grow old, as we that are left grow old:
Age shall not weary them, nor the years condemn.
At the going down of the sun and in the morning
We will remember them.[64]

Notes

Chapter 1

1 Cicero, *Pro Flacco* 62.
2 Homer, *Iliad* 2.200–6.
3 Homer, *Iliad* 2.225–38.
4 See p. 90 f.
5 Pausanias 1.3.6.
6 *Die Fragmente der griechischen Historiker* (*FGrH*) 239; *Inscriptiones Graecae* (*IG*) XII.5.444. Part of it is now lost; a major fragment is in the Ashmolean Museum of Art and Archaeology in Oxford; another fragment is in the Archaeological Museum of Paros. See the Digital Marmor Parium project directed by Monica Berti at the University of Leipzig, http://digital-marmorparium.org/ [accessed 7 September 2020]; Harsch, U., *Bibliotheca Augustana*, http://www.hs-augsburg.de/~harsch/graeca/Chronologia/S_anteo3/MarmorParium/mar_paro.html [accessed 21 September 2020]; Rotstein, A., *Literary History in the Parian Marble*, Hellenic Studies Series 68 (Washington, DC: Center for Hellenic Studies, 2016).
7 I.e. 1318 + 264/263 = 1582/1581, but, because the author counts the dates inclusively, we have to deduct 1, giving 1581/1580 BCE. Not all the calculations on the marble are consistent and/or accurate; they sometimes conflict with more orthodox chronologies; the author uses different methods of reckoning, counting inclusively prior to the Battle of Salamis, but exclusively after it; and the stonemasons occasionally get the items out of sequence. All dates tend to have a one-year margin of error in modern publications.
8 *FGrH* 239.1.
9 Scholiast on Aristophanes, *Wealth* 773; Tacitus, *Annales* 11.14.2; Cicero, *De Legibus* 2.63; Apollodorus 3.14.1.
10 The mark of Poseidon's trident on the acropolis at Athens was a tourist attraction in antiquity. It and the seawater well, 'the Sea of Erekhtheus', were incorporated in the design of the Erechtheion on the acropolis; Pausanias 1.26.5 says that when the south wind blew the well gave forth a sound of waves.
11 It stood in the Pandroseion, an enclosure to the west of the Erechtheion. The olive tree was (and still is!) another tourist attraction and seems to have survived down to the second century CE; some guides will still show it to you.
12 *FGrH* 239.4. For the tale of Deucalion's flood, and those of Noah, Gilgamesh, Atrahasis and Hathor, see Kershaw, S., *A Brief History of Atlantis: Plato's Ideal State* (London: Robinson, 2017), pp. 334–8.

13 *FGrH* 239.12, 13, 15. Other sources ascribed these events to the reign of Pandion I.

14 Plutarch, *Theseus* 6.6.

15 *FGrH* 239.20.

16 Plutarch, *Theseus* 24.2.

17 Plutarch, *Theseus* 27.

18 Homer, *Iliad* 2.546–80.

19 Homer, *Iliad* 2.546, noted by Plutarch, *Theseus* 25.2.

20 Euripides, *Suppliant Women* 399–466.

21 Plutarch, *Theseus* 25.1.

22 Plutarch, *Theseus* 25.3.

23 Plutarch, *Theseus* 21.2. See e.g. Armstrong, E., 'The Crane Dance in East and West', *Antiquity* 17:66 (1943), pp. 71–6; Lawler, L. B., 'The Geranos Dance – A New Interpretation', *Transactions and Proceedings of the American Philological Association* 77 (1946), pp. 112–30.

24 See pp. 120–2.

25 Plutarch, *Theseus* 31.1.

26 Plutarch, *Theseus* 32–3.

27 Plutarch, *Theseus* 32.1. 'Multitude' is a translation of *okhlos* – the same word used by the herald in the argument with Theseus, there rendered 'mob'.

28 Plutarch, *Theseus* 32.1.

29 Homer, *Iliad* 4.327–8.

30 *FGrH* 239.23–4. For discussions of the date of the fall of Troy, see p. 45 f.

31 By Cambridge postdoctoral researcher Anna Judson: https://itsallgreektoanna.wordpress.com/2017/04/01/sensational-new-linear-b-tablet-discovery-in-athens/ [accessed 21 September 2020].

32 Homer, *Iliad* 4.338–48.

33 See https://linearbknossosmycenae.com/2016/07/19/eponyms-or-personal-names-in-mycenaean-linear-b-minoan-linear-a-followed-by-the-ideogram-for-man/ [accessed 21 September 2020].

34 A man called Echelawon possibly had high enough status to have been king, but the idea is much disputed.

35 E.g. Linear B tablets PY Ae 303, PY En 609, PY Eo 224.

36 See Cline, E. H., *1177 B.C.: The Year Civilisation Collapsed* (Princeton: Princeton University Press, 2014).

37 The people who lived in north-western Greece, across the Ionian Sea from Italy, were called the Graeci, and the Romans used this name to describe all Hellenic people. In myth, Graecus was the son of Pandora and Zeus, and had a brother called Latinus, who gave his name to the Latins, who in the Roman tradition mingled with the Trojan survivors of the Trojan War to create the Roman race. See Hesiod, *Theogony* 1011–13; Aristotle, *Meteorology* 352b.

38 Plato, *Laws* 877d.

39 Aristotle, *Politics* 1326a–b.

40 It was first used by the poet Archilochus, fr. 19.3 (West, M. L., *Iambi et Elegi Graeci ante Alexandrum cantati (editio altera aucta atque emendata), Vol. I* [Oxford: University Press, 1989]). For individual tyrants see e.g. Aristotle, *Politics* 1284a, 1305a, 1310b, 1311a; Herodotus 5.92 ff.; Thucydides 1.126; Hammond, N. G. L., 'The Family of Orthagoras', *Classical Quarterly* 6:1/2 (1956), pp. 45–53; Andrewes, A., *The Greek Tyrants* (London: Hutchinson, 1956).

41 Herodotus 5.92 η 1–5.

42 See Herodotus 5.71; Thucydides 1.126; Aristotle, *Constitution of the Athenians* fr. 8.

43 See Ingvarsson, A., Bäckström, Y., Chryssoulaki, S., Linderholm, A., Kjellström, A., Kempe Lagerholm, V. and Krzewińska, M., 'Bioarchaeological field analysis of human remains from the mass graves at Phaleron, Greece', *Opuscula: Annual of the Swedish Institutes at Athens and Rome* (2019), pp. 7–158.

44 Plutarch, *Solon* 17.1–2.

45 *IG* I³ 104; Demosthenes, *Against Leptines* 158. See Phillips, D. D., *Avengers of Blood: Homicide*

in Athenian Law and Custom from Draco to Demosthenes. Historia Einzelschriften; Bd. 202 (Stuttgart: Franz Steiner Verlag, 2008).

46 Aristotle, *Constitution of the Athenians* 5.2.

47 Plutarch, *Solon* 14.1.

48 Plutarch, *Solon* 12.

49 Solon fr. 36, quoted in Aristotle, *Constitution of the Athenians* 12.4; cf. Plutarch, *Solon* 15.

50 Aristotle, *Politics* 1274a17–9.

51 'Tribes' is the normal, albeit slightly inaccurate, translation of *phylai* (sing. *phyle*), which usually just means the main divisions/components of the citizen body. At this period the *phylai* can function as both political 'constituencies' for selecting magistrates and military units.

52 Aristotle, *Constitution of the Athenians* 8.1.

53 See Aristotle, *Politics* 1274a1–3, 1274a15–18, 1281b25–34; Isocrates 7.22–23, 12.145; Demosthenes, *Against Neaera* 75; Plutarch, *Perikles* 9.4; Pausanias 4.5.50. See De Ste. Croix, G. E. M., Harvey, D., Parker, R. and Thonemann, P., *Athenian Democratic Origins: and other essays* (Oxford: Oxford University Press, 2004); Blok, J., *Citizenship in Classical Athens* (Cambridge: Cambridge University Press, 2017); White, M., 'Hippias and the Athenian Archon List', in Evans, J. A. S. (ed.), *Polis and Imperium: Studies in Honour of Edward Togo Salmon* (Toronto: Kakkert, 1974).

54 Aristotle, *Constitution of the Athenians* 8.4.

55 Plutarch, *Solon* 25.

56 Aristotle, *Politics* 1273b36–1274a1.

57 Plutarch, *Solon* 15.2.

58 Herodotus 1.59.3; Aristotle, *Constitution of the Athenians* 13.4; Plutarch, *Solon* 29.1.

59 Plutarch, *Solon* 30.1. Date: Aristotle, *Constitution of the Athenians* 14.1; *Parian Chronicle*, *FGrH* 239.40.

60 Herodotus 1.59.3–6; Aristotle, *Constitution of the Athenians* 14.1–3; Plutarch, *Solon* 30.1–3.

61 Aristotle, *Constitution of the Athenians* 14–15.2 has a different chronology: 561/560: first takeover; 556/555: first expulsion; 552/551: second takeover; 546/545: second expulsion; 536/535: final takeover.

62 Herodotus 1.60.3.

63 Herodotus 1.60; Aristotle, *Constitution of the Athenians* 14.4.

64 Herodotus 1.61.1. Aristotle, *Constitution of the Athenians* 15.1 just says they didn't have sex at all, which was just as bad.

65 Herodotus 1.61.1–2. Aristotle, *Constitution of the Athenians* 15.1.

66 Herodotus 1.61.3–63.2; Aristotle, *Constitution of the Athenians* 15.2–3.

67 Attic black figure *Amphora* signed by Exekias: Vatican 334, https://www.beazley.ox.ac.uk/tools/pottery/painters/keypieces/blackfigure/exekias.htm [accessed 26 September 2020], http://www.museivaticani.va/content/museivaticani/en/collezioni/musei/museo-gregoriano-etrusco/sala-xix--emiciclo-inferiore--collezione-dei-vasi--ceramica-atti/anfora-attica-a-figure-nere-firmata-da-exekias.html [accessed 26 September 2020]. See also e.g. Aberdeen 744, *ARV* 73, no. 28, Epiktetos; Berlin 3199, *ARV* 1114, no. 9, Hephaistos Painter; London E10, *ARV* 90, no. 33, Euergides Painter; Oxford, Ashmolean Museum 1885.653 (V. 224), *ABV* 435.2.

68 Boardman, J., 'Exekias', *American Journal of Archaeology* 82:1 (1978), pp. 11–25; Cook, R. M., 'Pots and Pisistratan Propaganda', *Journal of Hellenic Studies*, vol. 107, (1987), pp. 167–9.

69 Thucydides 6.53.3.

70 Aristotle, *Constitution of the Athenians* 22.1.

71 Aristotle, *Constitution of the Athenians* 16.

72 Aristotle, *Constitution of the Athenians* 16.7.

73 Thucydides 6.54.2.

74 Herodotus (5.55–65) and Thucydides (6.53–9) both recount the events, although Herodotus makes no reference to the homosexual aspects of it.

75 See Davidson, J. N., *The Greeks and Greek Love: A Radical Appraisal of Homosexuality in Ancient Greece* (London: Weidenfeld & Nicolson, 2007); Dover, K. J., *Greek Homosexuality* (London: Duckworth, 1979).

76 Herodotus 1.135.

77 Xenophon, *Cyropaedia* 2.2.28.

78 Page, D. L. (ed.), *Poetae Melici Graeci* (Oxford: Clarendon Press, 1962), nos 893–6.

79 Thucydides 6.59.1.

80 Herodotus 6.123.2.

81 Thucydides 6.59.1.

82 Thucydides 6.59.4.

83 Permission was granted by the Amphictyony (literally, 'Group of Neighbours'), the organisation that administered the sanctuary of Apollo at Delphi.

84 Thucydides 6.53.3.

85 Aristophanes, *Lysistrata* 1150–6.

86 Herodotus 5.66.1.

87 Maybe of the Philiadai family.

88 Aristotle, *Constitution of the Athenians* 20.1; Herodotus 5.66.2.

89 Our two sources diverge on the timing: Herodotus locates Cleisthenes prior to Sparta's intervention (5.66 ff.); Aristotle, *Constitution of the Athenians* (20–1) says that the Spartans intervened *and then* the laws were passed.

90 See p. 13.

91 Aristophanes, *Lysistrata* 273–80.

92 Aristotle, *Constitution of the Athenians* 22.1.

93 Aristotle, *Constitution of the Athenians* 21.5; Forrest, W. G., *The Emergence of Greek Democracy: The Character of Greek Politics, 800–400 BC* (London: Weidenfeld & Nicolson, 1966), pp. 194–6; Osborne, R., *Demos: The Discovery of Classical Attika* (Cambridge: Cambridge University Press, 1985), pp. 41–2, 64, 80; Stockton, D. L., *The Classical Athenian Democracy* (Oxford: Clarendon Press, 1990); Whitehead, D., *The Demes of Attica 508/7–ca 250 BC: A Political and Social Study* (Princeton: Princeton University Press, 1986), pp. 103–9, 291.

94 Aristotle, *Constitution of the Athenians* 21.4.

95 Thucydides 2.14.1–2, 16.1–2; Osborne, *Demos*, pp. 15–35; Stockton, *The Classical Athenian Democracy*, p. 58.

96 Lysias, *For Mantitheus* 14, *For Polystratus* 13, *Against Pancleon* 2–3, 31.15; Thucydides 2.16.1–2; Crowley, J., *The Psychology of the Athenian Hoplite: The Culture of Combat in Classical Athens* (Cambridge: Cambridge University Press, 2012), pp. 43–6; Jones, N. F., *The Associations of Classical Athens: The Response to Democracy* (Oxford: Oxford University Press, 1999), pp. 63, 91–115, 122, 126, 297, 300; Osborne, *Demos*, pp. 1–6, 41–5, 74, 88–104, 144–6, 179, 182, 198; Stockton, *The Classical Athenian Democracy*, pp. 57, 60–6; Whitehead, *The Demes of Attica*, pp. 23, 26, 67–9, 85, 178, 222–34, 335–8.

97 Aristophanes, *Wasps* 578; Aristotle, *Constitution of the Athenians* 42.1–2, 53.4–7; Lysias, *Against Alcibiades* 1, 6. See Osborne, *Demos*, pp. 72–3, 151; Stockton, *The Classical Athenian Democracy*, pp. 62–3; Whitehead, *The Demes of Attica*, pp. 97–109.

98 See Ogden, D., 'Homosexuality and Warfare in Ancient Greece', in Lloyd, A. B. (ed.), *Battle in Antiquity* (London: Duckworth and Classical Press of Wales, 1996), pp. 107–68.

99 Lysias, *For Mantitheus* 14, *For Polystratus* 23; Demosthenes, *Against Polycles* 6.

100 Figures calculated on the basis of the number of representatives they sent to the Council of 500, adjusted pro rata: Prasiai had 3 councillors out of 500, so 56 hoplites out of the 9,000 at Marathon; Kydathenaion had 12 councillors, Konthyle had 1. For the numbers of hoplites at Marathon, see p. 166 f.

101 Crowley, *The Psychology of the Athenian Hoplite*, pp. 9, 43; Cooley, C. H., *Social Organization: A Study of the Larger Mind* (New York: C. Scribner's Sons, 1909), p. 23.

102 Crowley, *The Psychology of the Athenian Hoplite*, p. 9.

103 See Homer, *Iliad* 22.105–10. For the impact of gossip on the fighters, see Crowley, *The Psychology of the Athenian Hoplite*, pp. 118–9; Gluckman, M., 'Gossip and Scandal', *Current Archaeology* 44 (1969), pp. 307–16; Hunter, V. J., 'Gossip and the Politics of Reputation in Classical Athens', *Phoenix* 44 (1990), pp. 299–325.

104 As did Pericles in his Funeral Oration, Thucydides 2.39.1. See Crowley, *The Psychology of the Athenian Hoplite*, p. 70.

105 Crowley, *The Psychology of the Athenian Hoplite*, p. 69.

106 Aristotle, *Constitution of the Athenians* 21.4.

107 When Athens's navy became important, the *trittyes* played a part in the way it was organised. See Demosthenes, *On the Navy* 22–3.

108 For the various heroes, see p. 3 f., and Kershaw, S., *A Brief Guide to the Greek Myths* (London: Robinson, 2007), pp. 258–74.

109 For mobilisation and combat, see pp. 165–71.

110 Aristophanes, *Lysistrata* 452–4; Aristotle, *Constitution of the Athenians* 61.3; Plutarch, *Aristides* 14.2–3; Thucydides 5.66.2–4; Xenophon, *Memorabilia* 3.1.5, 4.1; Xenophon, *Constitution of the Lacedaemonians* 11.4.

111 See Plato, *Republic* 5.475a; Crowley, *The Psychology of the Athenian Hoplite*, pp. 36–9; Whitehead, *The Demes of Attica*, p. 225; Sekunda, N., 'Athenian demography and military strength 338–322 BC', *BSA* 87 (1992), pp. 311–55; Siewert, P., *Die Trittyen Attikas und die Heeresreform des Kleisthenes*, Vestigia 33 (Munich: C. H. Beck, 1982), pp. 142–5.

112 See Aristotle, *Constitution of the Athenians* 4.2–3, 17.2, 22.2; Herodotus 1.59.4; Plutarch, *Solon* 11.2; Rhodes, P. J., *The Athenian Constitution Written in the School of Aristotle* (Liverpool: Liverpool University Press, 2017), p. 250.

113 Aristotle, *Constitution of the Athenians* 22.2. Precisely how the command structure was organised between the *strategoi* and the polemarch is disputed. See Herodotus 6.109–10 and p. 173.

114 Crowley, *The Psychology of the Athenian Hoplite*, p. 79.

115 The Outer Cerameicus, just outside the Dipylon gate.

116 Thucydides 2.34.2–6. The valour of the Marathon Men was felt to be such that they were buried on the field of battle, and the fallen at Plataea were also accorded special status: Herodotus 9.85; Pausanias 1.29.4, 9.2.5–6; Diodorus Siculus 11.33.3; Aristotle, *Constitution of the Athenians* 58.1. See pp. 175 f., 184 f.

117 Plutarch, *Aristides* 19.4–5.

118 *IG* I³ 1162, ll. 2–48. The Acamantis tribe suffered no fatalities on this occasion. Cf. *IG* I³ 1147, 1149, etc.

119 Aristotle, *Constitution of the Athenians* 22.1, 22.5; Aristotle, *Politics* 1284a; Diodorus Siculus 11.55.1; Harpocration s.v. 'Hipparchos' = Androtion, *FGrH* 324 F 6; *Vaticanus Graecus* 1144, fol. 222rv. Thomsen, R., *The Origin of Ostracism* (Copenhagen: Glyndenal, 1972), pp. 11–60. See p. 189.

120 Also, Elamite: *Irdaparna* or *Irdupirna*, and Akkadian: *Ar-ta-pir-na*. Artaphernes is attested in Aeschylus and some manuscripts of Herodotus.

121 Herodotus 5.73.2.

122 See Hornblower, S., *Herodotus Histories Book V* (Cambridge: Cambridge University Press, 2013), p. 110.

123 Herodotus 5.73.3.

124 See Hornblower, *Herodotus Histories Book V*, p. 218 f.

125 The chronology of these events is unclear and much disputed.

126 See p. 114 for the Peloponnesian League.

127 Herodotus 6.75.3.

128 They may have got as far as Eleusis. See *Supplementum Epigraphicum Graecum* (*SEG*) 56.521; Aravantinos, V. L., 'A *Kioniskos* from Thebes', *Annual of the British School at Athens* 101 (2006), pp. 369–77. For a translation, see p. 33.

129 Herodotus 5.75.1. See Hornblower, *Herodotus Histories Book V*, pp. 220–1.

130 For the Spartan kingship, see pp. 96–8.

131 Prior to this they were obliged unquestioningly to follow the Spartans wherever they might lead them. See p. 114.

132 Herodotus 5.77.1.

133 Herodotus 5.77.2–4; Pausanias 1.28.2; *IG* I³ 501.

134 Herodotus 5.78; cf. Plato, *Laws* 6.698a.

135 *SEG* 56.521; Aravantinos, 'A New Inscribed *Kioniskos* from Thebes', pp. 369–77; Hornblower, *Herodotus Histories Book V*, pp. 224–5.

136 Herodotus 5.80.1; Pindar, *Isthmian* 8.16–18; Bacchylides 9.53–5.
137 Herodotus 4.152.3, 5.82–89.1; Strabo 8.6.16.
138 Herodotus 5.80.2.
139 Herodotus 5.90.1–91.2.
140 Herodotus 5.92–94.1. See Hornblower, *Herodotus Histories Book V*, p. 268.
141 Herodotus 5.94.1.
142 Herodotus 5.96.2.

Chapter 2

1 DNa 4. (Darius Naqsh-i Rustam Inscription a).
2 Elamite: *Da-ri-(y)a-ma-u-iš, Da-ri-ya-(h)u-(ú-)iš*; Babylonian: *Da-(a-)ri-ia-(a-)muš, Da-(a-)ri-muš*; Aramaic: *dryhwš, drwš, drywš*; Egyptian: *tr(w)š, trjwš, intr(w)š, intrjwš*; Lycian: *Ñtarijeus-*.
3 Herodotus 6.98.3.
4 Šulmānu-ašarēdu = 'The God Shulmanu is Pre-eminent'.
5 Herodotus 1.96–106.
6 Herodotus 1.96.2–97.3.
7 Herodotus 1.98.2–99.1; cf. the Late Babylonian Nabonidus Chronicle in the British Museum: British Museum 35382. See http://www.britishmuseum.org/research/collection_online/collection_object_details.aspx?objectId=327273&partId=1 [accessed 28 December 2016]. For a translation see http://www.livius.org/cg-cm/chronicles/abc7/abc7_nabonidus1.html [accessed 28 December 2016].
8 Herodotus 1.100.2.
9 Herodotus 1.98.1, 102.1.
10 Herodotus 1.101–2.
11 Herodotus 1.73. There is scholarly doubt about the father–son relationship.
12 See e.g. Jeremiah 25:25–6 and 51:27–8.
13 Trans. Waters, M., *Ancient Persia: A Concise History of the Achaemenid Empire, 550–330 BCE* (Cambridge: Cambridge University Press, 2014), p. 35. For the Akkadian text, see Borger, R., *Beiträge zum Inscriftenwerk Assurbanipals* (Wiesbaden: Harrassowitz Verlag, 1996), pp. 191–2.
14 Josephus, *Contra Apionem* I, 19; cf. *Jewish Antiquities* X: 11.
15 Antipater of Sidon or Antipater of Thessalonica, 'On the Temple of Artemis at Ephesus', *Greek Anthology* 9.58, trans. Paton, W. R., *The Greek Anthology* (London: Heinemann, 1915). Cf. Herodotus 1.178.3–79.3; the *Topography of Babylon* tablets in the British Museum, ME 35385, ME 54634.
16 Herodotus 1.8–14; cf. Plato, *Republic* 359d.
17 Herodotus 1.14–15.
18 Herodotus 1.94.1.
19 His name could be derived from the Lydian word *walwi* = 'lion'.
20 Herodotus 1.17–22.
21 Herodotus 1.73–4.
22 Herodotus 1.103.2.
23 Herodotus 1.93.2–4.
24 Herodotus 1.26, 28.
25 Herodotus 1.30–3.
26 Herodotus 1.32.1.
27 Cyrus, Latin form of Greek *Kûros*, later also *Kóros*; Old Persian *Kuruš* [spelled *kᵘ-u-rᵘ-u-š*], reflected in Elamite *Ku-raš*, Babylonian *Ku(r)-raš/-ra-áš*, Aramaic *kwrš*, Hebrew *Kôreš* and Egyptian *kwrš*.
28 Nabonidus Cylinder from Sippar, Nbn. 1, col. 1, ll. 26–33.

29 British Museum 35382. See http://www.britishmuseum.org/research/collection_online/collection_object_details.aspx?objectId=327273&partId=1 [accessed 28 December 2016]. For a translation see http://www.livius.org/cg-cm/chronicles/abc7/abc7_nabonidus1.html [accessed 28 December 2016].

30 British Museum, no. 90920 + NBC 2504. A second fragment, containing lines 36–45, was identified in the Babylonian collection at Yale University (Nies and Keiser, no. 32) by P.-R. Berger. See Kuhrt, A., *The Persian Empire: A Corpus of Sources from the Achaemenid Period* (London and New York: Routledge, 2007), pp. 70–4.

31 Cyrus Cylinder ll. 20—22 (Berger, P.-R., 'Der Kyros-Zylinder mit dem Zusatzfragment BIN II Nr.32 und die akkadischen Personnamen im Danielbuch', *Zeitschrift für Assyriologie und verwandte Gebeit* 64, [1975], pp. 197–8).

32 Gadd, C. J., Legrain, L. and Smith, S., *Royal Inscriptions (Ur Excavation Texts 1)* (London: Joint Expedition of the British Museum and of the Museum of the University of Pennsylvania to Mesopotamia, 1928), no. 194.

33 Herodotus 1.95, 107–8. Xenophon, *Cyropaedia* 1.2.1, cf. 1.4.25.

34 Herodotus 1.123–28, 2.1, 3.2, 3.88.2. Cf. Justin 6.16; Strabo 15.3.8; Xenophon, *Cyropaedia* 8.5.17–19, *Anabasis* 3.4.11. Ctesias's assertion (*Persica* = *FGrH* 688 F 9[2]) that Cambyses' mother was Amytis, daughter of the Median king Astyages, is not reliable.

35 Xenophon, *Cyropaedia* 1.1.4.

36 Herodotus 1.74–5.

37 See Waters, *Ancient Persia*, p. 39; Grayson, A. K., *Assyrian and Babylonian Chronicles* (Locust Valley: J. J. Augustin, 1975), p. 107, col. 2, ll. 15–17.

38 Herodotus 1.46.2–49, 1.53–4.

39 Herodotus 1.53.2.

40 Herodotus 1.53.3.

41 Herodotus 1.75–77, cf. 1.83; cf. Polyaenus 7.8 and Justin l.7.3.

42 Herodotus 1.79–85.

43 Herodotus 1.86–90, 1.207; cf. Ctesias (7, epit. 30); Pompeius Trogus (in Justin 1.7.7); Xenophon, *Cyropaedia* 7.2.5ff; Bacchylides, *Ode* 3.23–62; Nabonidus *Chronicle* (col. II, ll. 15–18); the Myson amphora in the Louvre, *c.* 500 BCE.

44 Herodotus 1.153.3–4.

45 Herodotus 1.155.4.

46 Herodotus 1.157.2.

47 Herodotus 1.161–77.

48 See e.g. Kershaw, S., *A Brief Guide to Classical Civilization* (London: Robinson, 2010), pp. 42–55.

49 See Burkert, W., 'Lydia Between East and West or How to Date the Trojan War: A Study in Herodotus', in Carter, J. B. and Morris, S. P. (eds), *The Ages of Homer: A Tribute to Emily Townsend Vermeule* (Austin: University of Texas Press, 1995), pp. 139–48.

50 *FGrH* 76 F 41. Douris lived *c.* 350 to after 281 BCE.

51 *FGrH* 242 F 1. Eretes' dates are uncertain.

52 Herodotus 2.145.4.

53 *FGrH* 239.23–4.

54 *FGrH* 566 F 125. Timaeus lived *c.* 345 to *c.* 250 BCE.

55 *FGrH* 241 F 1a. Eratosthenes lived *c.* 276/273–194/191 BCE. See Möller, A., 'Epoch-making Eratosthenes', *Greek, Roman, and Byzantine Studies* 45 (2005), pp. 245–60.

56 *FGrH* 70 F 223. Ephorus lived *c.* 400–330 BCE.

57 Assuming three generations = 100 years. *FGrH* 3 F 2. Pherecydes *floruit c.* 465. See Fowler, R. L., 'The Authors Named Pherecydes', *Mnemosyne* 52:1 (1999), pp. 1–15.

58 The archaeological dating can be as varied and imprecise as the ancient Greek dating: Korfmann, M. O., *Troia/Wilusa* (Çanakkale and Tübingen: Çanakkale–Tübingen Troia Vakfı Foundation: enlarged and revised edn, 2005), dates Troy I at 2920–2350.

59 Korfmann's dates: 1740/30–1300.

60 The Luwians were a people of western and southern Anatolia in the Late Bronze Age (1500–1200), known principally from contemporary Hittite texts. See e.g. Melchet, C. (ed.), *The*

Luwians: Handbook of Oriental Studies, Section One. The Near East and Middle East, vol. 68 (Leiden and Boston: Brill, 2003); Yakubovich, I., *Sociolinguistics of the Luvian Language*, Brill's Studies in Indo-European Languages & Linguistics (Leiden: Brill, 2010); https://luwianstudies.org/who-are-the-luwians/ [accessed 8 July 2020].

61 Korfmann's dates: 1300–950.

62 These are collected in Laroche, E., *Catalogue des Textes Hittites* (Paris: Klincksieck, 1971).

63 Laroche, *Catalogue des Textes Hittites*, 183 = Beckman, G. M., Bryce, T. R. and Cline, E. H., *The Ahhiyawa Texts* (Atlanta: Society of Biblical Literature, 2011), AhT 6; 6571.2, obv. 38–9 = AhT 22, obv. 38–9. See Bryce, T., *The Kingdom of the Hittites* (Oxford: Oxford University Press, 2nd edn, 2005), pp. 57–60; Bryce, T., *The Trojans and their Neighbours* (London: Routledge, 2006), pp. 100–6; Beckman, Bryce and Cline, *The Ahhiyawa Texts*, p. 138 f.; Hoffner Jr, H. A., *Letter from the Hittite Kingdom*, WAW 15 (Atlanta: Society of Biblical Literature, 2009), p. 290 f.

64 See Bryce, *The Trojans and their Neighbours*, pp. 83–86, 107–12.

65 Laroche, *Catalogue des Textes Hittites*, 181 = Beckman, Bryce and Cline, *The Ahhiyawa Texts*, AhT 4; obv. 3–8 = AhT 7, obv. 3–8.

66 Laroche, *Catalogue des Textes Hittites*, 722, rev. 46. Cf. 147, obv. 1–5; 60–5 = Beckman, Bryce and Cline, *The Ahhiyawa Texts*, AhT 3, obv. 1–5; 60–5. See Ünal, A, 'Ein hethitisches Schwert mit akkadischer Inschrift aus Bogazkoy', *Antike Welt* 23.4 (1992), pp. 256–7 and figs 2–3; Ertekin, A. and Ediz, I., 'The unique sword from Bogazkoy/Hattuia', in Mellink, M. J., Porada, E. and Özgüç, T. (eds), *Aspects of Art and Iconography: Anatolia and its Neighbors. Studies in Honor of Nimet Özgüç* (Ankara, 1993), pp. 719–25, with illustrations; Cline, E. H., 'Aššuwa and the Achaeans: The "Mycenaean" Sword at Hattušas and Its Possible Implications', *The Annual of the British School at Athens*, vol. 91, 1996, pp. 137–51.

67 See Edmunds, L. *Stealing Helen: The Myth of the Abducted Wife in Comparative Perspective* (Princeton and Oxford: Princeton University Press, 2016).

68 *FGrH* 239.27. In fact, we learn from Hittite expeditions under Mursili II against a city called Milawata, which had joined with the king of Ahhiyawa and was destroyed by fire *c.* 1320. This is probably Miletus, predating its foundation date in the *Parian Chronicle*.

69 Aristotle, *Politics* 1327b24–35.

70 Herodotus 1.142, 149.

71 Homer, *Iliad* 2.867–75.

72 Herodotus 1.146.

73 Herodotus 2.150–2, 159, 178–82.

74 Herodotus 5.92.

75 Aristophanes, *Lysistrata* 106.

76 Diogenes Laertius, *Lives of the Eminent Philosophers* 1.1–4.

77 See Graham, D. W., *The Texts of Early Greek Philosophy: The Complete Fragments and Selected Testimonies of the Major Presocratics, Part 1* (Cambridge: Cambridge University Press, 2010).

78 Plato, *Protagoras* 343a. The list of the names of the sages varied dramatically over the years: see e.g. Diogenes Laertius, *Lives of the Eminent Philosophers* 1.22–122; Lendering, J., 'Seven Sages', https://www.livius.org/articles/people/seven-sages/ [accessed 31 August 2020]; Martin, R. P., 'Seven Sages', in Bagnall, R. S., Brodersen, K., Champion, C. B., Erskine, A. and Huebner, S. R. (eds). *The Encyclopedia of Ancient History* (Oxford: Wiley-Blackwell, 2017).

79 DK 11A22; DK 11A23. 'DK' stands for Diels–Kranz: Diels, H., *Die Fragmente der Vorsokratiker*, ed. Kranz, W. (Berlin: Weidmann, 6th edn, 1951).

80 Plato, *Theaetetus* 174a.

81 Herodotus 1.74.2. For the battle fought on that day, see pp. 39–41.

82 Archilochus fr. 122 (West, *Iambi et Elegi Graeci: Vol. I*). The eclipse probably occurred in 648, or possibly in 689 or 711.

83 DK 12A9, 12B1.

84 DK 12A9, 12B1.

85 DK 12A11; cf. Aristotle, *On the Heavens* 295b. This idea later becomes the paradox of 'Buridan's ass'.

86 DK 12A30.
87 DK 22B42; DK 22B57.
88 DK 22B15.
89 DK 22B67.
90 DK 22B10.
91 DK 22B10.
92 DK 22B30.
93 DK 22B125.
94 Plato, *Cratylus* 402a8–10.
95 DK 22A6, B91.
96 Herodotus 1.178.1; Pliny, *Naturalis Historia* 6.92; Arrian, *Anabasis* 6.24.3, 3.27.4; cf. Diodorus Siculus 17.81.1; Darius's Bisitun monument (referred to below and in scholarly publications as DB).
97 Herodotus 1.178.2–3; cf. Herodotus 1.179.3–193.4.
98 This works out as slightly less than ten times the volume of the Great Pyramid at Giza (conventionally calculated at 2,583,283 m³), and slightly less than twice the height of Nelson's Column (51.6 m).
99 Herodotus 1.190.2; Cyrus Cylinder ll.30–2 (Berger, 'Der Kyros-Zylinder').
100 Herodotus 1.189–90.1.
101 Cyrus Cylinder l.13 (Berger, 'Der Kyros-Zylinder').
102 Cyrus Cylinder l.17 (Berger, 'Der Kyros-Zylinder'); cf. Nabonidus Chronicle iii.16 (Kuhrt, *The Persian Empire*, p. 51). The Greek tradition says that the fighting was intense: Herodotus 1.188–91; Xenophon, *Cyropaedia* 7.5.7–32.58; Berossus, *Babyloniaca* = FGrH 680 F10a. Nabonidus was exiled: Dynastic Prophecy ii.18 (Kuhrt, *The Persian Empire*, p. 80, n. 7). Cf. Berossus, *Babyloniaca* = FGrH 680 F10a (Kuhrt, *The Persian Empire*, pp. 80–1).
103 Nabonidus Chronicle iii.18.
104 Cyrus Cylinder l.18 (Berger, 'Der Kyros-Zylinder').
105 Ezra 1.2–4, 6.3–4; Daniel 5:30–31, 6:28. The chronology of this became confused, since Daniel has Babylon ruled first by the 'Mede' Darius (he was Persian) son of Xerxes (he was Xerxes' father), and then (out of chronological sequence) by Cyrus.
106 Isaiah 44.24–45.1; cf. Isaiah 41.1–5, 41.25, 42.1–7.
107 Plato, *Laws* 694a–d; Xenophon, *Cyropaedia, passim*.
108 Plato, *Laws* 694b.
109 Cyrus Cylinder ll.28–30 (Berger, 'Der Kyros-Zylinder').
110 Cyrus Cylinder l.20 (Berger, 'Der Kyros-Zylinder').
111 Herodotus 1.205, 214–5.
112 Herodotus 1.214.1.
113 Herodotus 1.212.5; cf. Ctesias, *Persica* = FGrH 688 F 9(7–8); Berossus, FGrH 680 F10; Diodorus Siculus 2.44.2; Xenophon, *Cyropaedia* 8.7.
114 Arrian, *Anabasis* 6.29.4–11; Strabo 15.3.7.
115 Arrian, *Anabasis* 6.29.8.
116 Herodotus 3.160.1.
117 Old Persian: *Kambūjiya-*; Elamite: *Kanbuziya*; Akkadian: *Kambuziya*; Aramaic: *Knbwzy*; Greek: *Kambyses*.
118 Herodotus 3.31, 32, 68. Otanes in Greek is *Utāna* in Old Persian, rendered in Elamite as *Hu-ud-da-na* and Babylonian as *Ú-mi-it-ta-na-na-*', and possibly means 'Having Good Descendants'.
119 Plato, *Laws* 694c–95a.
120 Herodotus 3.1.3. The Greek word *megale* used to describe her is frequently translated as 'tall' (e.g. Waterfield, R., *Herodotus, the Histories* [Oxford and New York: Oxford University Press, 1998]), but Holland's 'statuesque' (Holland, T., *Herodotus: The Histories*, trans. Holland, T., introduction and notes by Cartledge, P. [London: Penguin, 2013]) is preferable: it is her ampleness, not her height, that is noteworthy. See p. 72.
121 Uehabre, aka Apries, Hophra, or Oafri[s].
122 Herodotus 3.1–3.

123 Herodotus 3.44.1.

124 Herodotus 2.1.2; cf. 3.1.1.

125 Herodotus 3.10–11.

126 Floppy hooded caps, or turbans, that could be tied across the face to cover the mouth and nose or worn open.

127 Herodotus 3.12.1–4.

128 Egyptian hieroglyphic inscription on a granite sarcophagus, Serapeum, Saqqara (Posener, G., *La première domination Perse en Égypte* [Paris: Le Caire, 1936], no. 4).

129 Herodotus 3.13.3–4.

130 Herodotus 3.16, 19.2, 25–29, 37. See also the Egyptian hieroglyphic stele, Serapeum, Saqqara (Posener, *La première domination Perse en Égypte*, no. 3 and pl. 11), which suggests a different, less anti-Cambyses narrative.

131 Herodotus 3.30–2. Darius's inscription at Bisitun confirms that Cambyses had Bardya murdered: DB i.10.

132 Herodotus 3.34–6.

133 See Kuhrt, *The Persian Empire*, p. 151, n. 1.

134 DB i.10.

135 DB i.11. This may have been natural or accidental, but was not suicide. See e.g. Waters, *Ancient Persia*, p. 69.

136 DB i.13.

137 DB iii.68. Cf. Herodotus, 3.70.2-3, who also names the first five of these as Darius's accomplices in his takeover from Bardiya/Gautama/Smerdis.

138 The location of Sagartia is unclear, but must be reasonably close to Arbela.

139 DB ii.33.

140 Darius introduces a Cishpish (Greek: *Teispes*) son of Hakhaimanish (*Achaemenes*) in his genealogy (DB i.2), which links him to Cyrus's ancestor Cishpish, who appears on the Cyrus Cylinder l.21 (Berger, 'Der Kyros-Zylinder').

141 Herodotus 3.61–6.

142 Herodotus 3.74–5. Ctesias, *Persica* = *FGrH* 688 F13(11–15), and Justin 1.9.4–13 tell the tale with different degrees of divergence.

143 Herodotus 3.69.

144 J. Paul Getty Museum, Malibu, 85, AN. 370.26; Boardman, J., *Greek Gems and Finger Rings: Early Bronze Age to Late Classical* (London: Thames & Hudson, 2nd edn, 2001), pl. 1065, cf. pl. 906 and fig. 298.

145 Herodotus 3.70, cf. DB iii.68. Ctesias, *Persica* = *FGrH* 688 F13(16) gives the names differently: Onophas, Idernes (= Vidarna), Norondabates, Mardonius, Barrisses, Ataphernes (= Vindafarna) and Darius.

146 Herodotus 3.77–8.

Chapter 3

1 DNb §2a (DN refers to Darius inscriptions from the tomb at Naqsh-i Rustam).

2 Herodotus 3.80–3; cf. Euripides' dramatisation of Theseus versus the Herald, see p. 5 f.

3 Herodotus 3.84.

4 Herodotus 3.85–7, 88.3.

5 The word, with singular *dahyu*, can mean peoples or countries.

6 DB i.1–4. See Kuhrt, *The Persian Empire*, p. 152, n. 4.

7 CMa; CMc (CM refers to inscriptions at Pasargadae).

8 DNa; DSe (DS refers to a Darius inscription at Susa).

9 DNb §1; cf. DNa; XPl (XP refers to a Xerxes inscription at Persepolis).

10 DNb §2a.

11 DNb §2a–f; cf. Xenophon, *Anabasis* 1.9.1–2, 5–8, 11, 13–20, 22–8.

12 DNb §2g–h (Kuhrt, *The Persian Empire*, pp. 504–5).
13 British Museum, London, Inv. Nr. 89132a. See Curtis, J. E. and Tallis, N. (eds), *Forgotten Empire: The World of Ancient Persia* (London: British Museum Press, 2005), cat. 398; Merrillees, P. H., *Catalogue of the Western Asiatic Seals in the British Museum: Pre-Achaemenid and Achaemenid Periods* (London: British Museum Press, 2005), cat. 16.
14 Cf. DNb §2h.
15 Quintus Curtius Rufus 3.3.17–9.
16 The terminology for the headdress is rather vague: Arrian 4.7.4 calls it *kitaris*; Ammianus Marcellinus calls it both *apex* (18.5.6) and *tiara* (18.8.5).
17 Arrian 4.29.3; Ammianus Marcellinus 18.5.6, 18.8.5.
18 Aristophanes, *Birds* 486 f.
19 See Kuhrt, *The Persian Empire*, figs 11.26, 11.27, 11.28.
20 Persepolis Fortification Tablet (PF) 1795; Persepolis Fortification Tablet Seal (PFS) 9*.
21 PF 654, 665, 669.
22 PFa 14; PFS N-110.
23 PF 1028; PFS 36*.
24 Plutarch, *Moralia* 140b.
25 Plutarch, *Artaxerxes* 27.2, Quintus Curtius Rufus 6.6.8.
26 Esther 2.12–14, King James version.
27 Athenaeus 12, 514b = Heraclides of Cumae, *History of Persia*, FGrH 689 F 1. The word translated 'frequently' here could also be rendered 'as concubines': the manuscripts vary in their readings.
28 Plutarch, *Artaxerxes* 27.1.
29 Athenaeus 13, 556b = Deinon, *History of Persia*, FGrH 690 F 27.
30 See Llewellyn-Jones, L., 'The Big and Beautiful Women of Asia: Picturing Female Sexuality in Greco-Persian Seals', in Curtis, J. and Simpson, St-J. (eds), *The World of Achaemenid Persia: History, Art and Society in Iran and the Ancient Near East* (London and New York: I. B. Tauris, 2010), pp. 165–78; Boardman, *Greek Gems and Finger Rings*, pp. 303–57.
31 Boston 03.1013; Boardman, *Greek Gems and Finger Rings*, pl. 964; cf. pl. 874 = Paris, BN M5448, showing a fine Maltese dog.
32 Oxford 1921.2; Boardman, *Greek Gems and Finger Rings*, pl. 880.
33 London 436; Boardman, *Greek Gems and Finger Rings*, pl. 891 and p. 307.4.
34 Baltimore 42.517; Boardman, *Greek Gems and Finger Rings*, pl. 892. See Lewis, S., *The Athenian Woman: An Iconographic Handbook* (London: Psychology Press, 2002), pp. 163–6.
35 See Goldman, B., 'Women's Robes: The Achaemenid Era', *Bulletin of the Asia Institute* NS 5 (1991), pp. 83–103.
36 See e.g. London 434, London 433; Boardman, *Greek Gems and Finger Rings*, pl. 879 and p. 307.2.
37 Berlin F 181; Boardman, *Greek Gems and Finger Rings*, pl. 854. London 434; Boardman, *Greek Gems and Finger Rings*, pl. 879 and p. 307.2. London 436; Boardman, *Greek Gems and Finger Rings*, pl. 891 and p. 307.4.
38 See p. 58 f.
39 Xenophon, *Anabasis* 3.2.25. The Lotus Eaters reference is to Homer, *Odyssey* 9.94 ff. See Kershaw, *A Brief Guide to the Greek Myths*, p. 402.
40 Boston Lewis House Gems (LHG) 63; Boardman, *Greek Gems and Finger Rings*, pl. 862.
41 Aristophanes, *Lysistrata* 229 f.; cf. Aristophanes, *Women in the Assembly* 265; Theophrastus, *Characters* 28.3.
42 Quintus Curtius Rufus 6.6.8.
43 Quintus Curtius Rufus 6.5.22–3; Ctesias, *Persica* = FGrH 688 F9a, FGrH 688 F15 (54).
44 Xenophon, *Cyropaedia* 7.5.59–65.
45 Plato, *Alcibiades* 121d; Herodotus 3.77–8, 3.130, 8.105; Plutarch, *Alexander* 30; Quintus Curtius Rufus 4.10.25–34.
46 Herodotus 6.31–3. See p. 140.
47 Herodotus 7.105.1; cf. Herodotus 5.102.1; Juvenal 8.176; Strabo 14.1.23.
48 Herodotus 7.105.2.

49 Herodotus 3.118–9.
50 Oroetes is the Greek form of an Old Iranian name, possibly a diminutive of *Arv-ita-* (= 'Little Swift/Brave').
51 Herodotus 3.120–8.
52 Herodotus 3.89.1. In fact, the satrapy system seems to go back to Cyrus and Cambyses.
53 DB §25, §26, §29, §33, §41, §50.
54 DB §6; DPe §2 (DP refers to a Darius inscription at Persepolis); DSe §3; DNa §3; XPh §3. Herodotus 3.89–97. The number of *dahyāva* varies from list to list but is always more than twenty.
55 Herodotus 3.90.1–2; [Aristotle], *Oeconomica* 2.1.1–4. See Kuhrt, *The Persian Empire*, pp. 672–729 and 763–825 for copious examples.
56 Herodotus 3.89.3.
57 [Aristotle], *On the Cosmos* 398a.
58 E.g. Aristophanes, *Acharnians* 91 ff.; Herodotus 1.114.2; Plutarch, *Artaxerxes* 12.1; Xenophon, *Cyropaedia* 8.2.10–12. See Balcer, J., 'The Athenian *episkopos* and the Achaemenid King's Eye', *American Journal of Philology* 98 (1977), pp. 252–63.
59 [Aristotle], *On the Cosmos* 398a.
60 See Mousavi, A., 'The Discovery of an Achaemenid Way-station at DehBozan in the Asabad Valley', *Archäoligisches Mitteilungen aus Iran* 22 (1989), pp. 135–8; Kuhrt, *The Persian Empire*, p. 738.
61 For the location of Cilicia, see Hornblower, *Herodotus Histories Book V*, p. 169.
62 Herodotus 5.52.
63 Herodotus 5.53.
64 Herodotus 8.98.
65 PF 1550; cf. PF 1318, 1351, 1361, 1477, 1501, 1544, 1555; Ctesias, *Persica = FGrH* 688 F33.
66 DPh §2; DH §2 (DH refers to a Darius inscription at Hamadan). See Herodotus 3.94, 3.98, 4.44.
67 Herodotus 2.158.
68 DZc §3 (DZ refers to a Darius inscription at Suez). It is one of four such inscriptions.
69 The exact date of the expedition is not entirely clear. See Herodotus 3.139, 4.1, 5.94.1; Thucydides 6.59.
70 Herodotus 3.134, 4.83. See p. 152 f.
71 Herodotus 4.1, 4.118.1, 7.20.2.
72 See e.g. DSe §3, DNa §3.
73 Herodotus 4.1, 7.5.2–3; 4.118.1, 7.8.a2, 7.54.2; 4.83, 7.10; 4.83.1, 4.96.2, 7.185; 3.134.4, 4.118.1, 7.33.1; 4.137, 7.85.1; 4.135, 7.115; 4.137.1, 8.108.2, 8.97.1.
74 Herodotus 4.83.1, 4.87–8; Polybius 4.43.2.
75 Athenaeus 13, 557b = Dicaearchus fr. 64 (Wehrli, F., *Die Schule des Aristoteles I2* [Basel: Scwabe, 1967]); fr. 77 (Mirhady, D. C., 'Dicaearchus of Messana: The Sources, Text and Translation', in Fortenbaugh, W. W. and Schü-trumpf, E. [eds], *Dicaearchus of Messana: Text, Translation, and Discussion* [New Brunswick: Rutgers University, 2001]).
76 Herodotus 4.89–96.
77 On Scythians, see Cernenko, E. V., *The Scythians 700–300 BC* (London: Osprey,1983); Basilevsky, A., *Early Ukraine: A Military and Social History to the Mid-19th Century* (Jefferson: McFarland, 2016).
78 Homer, *Iliad* 13.5; Hesiod, Oxyrhynchus Papyri (P. Oxy) 1358, fr. 2.15; see Kershaw, *A Brief Guide to the Greek Myths*, pp. 92–115.
79 Herodotus 4.1–82; cf. Strabo 7.3.2, 7.4.6.
80 E.g. on the males and female from the Pazyryk *kurgans* 2 and 5, and the female from Ak-Alakha.
81 Pseudo-Hippocrates, *On Airs, Waters and Places* 20.
82 Pseudo-Hippocrates, *On Airs, Waters and Places* 18.10–22.
83 Herodotus 46.2–3. See, e.g. a cart with spoked wheels from the Pazyryk *kurgan* 5 in Siberia, now in the State Hermitage Museum in St Petersburg, https://web.archive.org/web/20000106182748/http://www.hermitagemuseum.org/html_En/03/hm3_2_7e.html [accessed 8 November 2021].

84 E.g. the horse headdress made of felt, leather and wood from the Pazyryk 2 burial mound (late fourth–early third century BCE) in the State Hermitage Museum, St Petersburg.

85 Moretti, L., *Inscrizioni Agonistiche Greche* (Rome: A. Signorelli, 1953), pp. 82–4, no. 32.

86 Aristotle, *On Marvellous Things Heard* 141.

87 Pseudo-Hippocrates, *On Airs, Waters and Places* 17.4–19.

88 See Kershaw, *A Brief Guide to the Greek Myths*, p. 163.

89 Herodotus 4.110.1.

90 Herodotus 4.110–17.

91 Herodotus 4.116.2.

92 Pseudo-Hippocrates, *On Airs, Waters and Places* 22.34–7, 65–9; Herodotus 1.105.2, 4.67.2.

93 Pseudo-Hippocrates, *On Airs, Waters and Places* 20.1–8.

94 For wine and barbarism, see Kershaw, S., *Barbarians: Rebellion and Resistance to the Roman Empire* (London: Robinson, 2019), p. 26 f.

95 Anacreon fr. 356(b) 1–5 (Campbell, D. A., *Anacreon: Greek Lyric, Volume II: Anacreon, Anacreontea, Choral Lyric from Olympus to Alcman* [Cambridge, MA: Harvard University Press, 1988]) = Athenaeus 10.427.

96 Aristophanes, *Lysistrata* 426–7. See Pritchard, D., 'The Archers of Classical Athens', *Greece and Rome* 65:1, (2018), pp. 86–102.

97 Such a ceremony is beautifully illustrated on a gold plaque from the *kurgan* of Kul'-Oba in the State Hermitage Museum in St Petersburg. See https://www.hermitagemuseum.org/wps/portal/hermitage/digital-collection/25.+archaeological+artifacts/879764 [accessed 8 November 2021].

98 Herodotus 73.2.

99 E.g. in *kurgan* 2 at Pazyryk.

100 Herodotus 4.75.1–2

101 Now in the State Hermitage Museum in St Petersburg. See https://www.hermitagemuseum.org/wps/portal/hermitage/digital-collection/25.+archaeological+artifacts/788291 [accessed 8 November 2021].

102 Herodotus 4.97–8.

103 Herodotus 4.99–117.

104 Cunliffe, B. W., *The Scythians: Nomad Warriors of the Steppe* (Oxford: Oxford University Press, 2019), pp. 132–5.

105 Herodotus 4.119.

106 Herodotus 4.120–4.

107 Herodotus 4.126.

108 Herodotus 4.127.

109 Herodotus 4.128–9.

110 Herodotus 4.134.

111 Herodotus 4.133, 4.135–6.

112 See p. 2.

113 Herodotus 4.137.2.

114 Herodotus 4.142.

Chapter 4

1 Thucydides 1.18.1.

2 Thucydides 1.10.2.

3 See e.g. Kershaw, *A Brief Guide to Classical Civilization*, pp. 102–10.

4 Thucydides 5.68.1.

5 Plutarch, *Lycurgus* 19.1.

6 Aristotle, *Rhetoric* 1394b35.

7 See Reger, G. et al., 'Skiritis: a Pleiades place resource', *Pleiades: A Gazetteer of Past Places* (2013), https://pleiades.stoa.org/places/570675 [accessed 25 September 2020].

8 See e.g. TH Fq 229.4; Fq 253.3; Fq 254[+]255.13; Fq 258.3; Fq 275.3; Fq 284.3; Fq 325.1; Fq 339.3; Fq 382.3; and TH Gp 227.2.

9 Homer, *Iliad* 2.581; *Odyssey* 4.1. See Hope Simpson, R. and Lazenby, J. F., *The Catalogue of the Ships in Homer's Iliad* (Oxford: Clarendon Press, 1970), p. 76; Cartledge, P., *Sparta and Lakonia: A Regional History 1300–362 BC* (London, Boston and Henley: Routledge and Kegan Paul, 1979), p. 337 f.; Morris, S. P., 'Hollow Lakedaimon', *Harvard Studies in Classical Philology* 88 (1984), pp. 1–11.

10 See Catling, H. W., 'The work of the British School at Athens at Sparta and in Laconia', in Cavanagh, W. G. and Walker, S. E. C. (eds), *Sparta in Laconia: The Archaeology of a City and its Countryside* (London: BSA Studies 4, 1998), pp. 19–27, https://warwick.ac.uk/fac/arts/classics/intranets/students/modules/greekreligion/database/clunbf [accessed 24 July 2020]; Catling, H. W., *Sparta: Menelaion I. The Bronze Age* (London: BSA Suppl. vol. 45, 2009), https://www.orea.oeaw.ac.at/en/research/mediterranean-economies/studies-on-the-new-mycenaean-palace-of-ayios-vasileios-in-laconia/ [accessed 24 July 2020].

11 Thucydides 1.12.3, i.e. around 1120 BC by his reckoning (5.112). Hellanicus and his school (fifth century) date the Dorians' arrival to 1149 BC; Isocrates and Ephorus (fourth century) to c. 1070; Sosibius, Eratosthenes (third century) and later writers give dates from 1125 to 1100. Cf. Diodorus Siculus 7.8.1; Diodorus calls Eurysthenes 'Eurystheus'. For the difficulties in dating the Trojan War, see p. 45 f.

12 Thucydides 1.10, quoted p. 88 f.

13 Born in Syracuse, c. 300, died after 260.

14 Ironically, he uses the same broad vowels that so irritate him. He may be mimicking the ladies to make his point.

15 She is typically succinct for a Doric speaker all the way through her speech: here she actually says, 'Having got, order!', which is very close to Leonidas's famous *molon labe* (= 'having come, take!') at Thermopylae. See p. 264.

16 Syracuse was originally a colony of Corinth, which was a source of great pride to the Syracusans. When the Athenians invaded Sicily during the Peloponnesian War, the Syracusan general Hermocrates inspired his fighters by telling them that they were 'Dorians, free men from the independent Peloponnese' (Thucydides 6.77.1).

17 In myth, Bellerophon was the son of King Glaucus of Corinth. See Kershaw, *A Brief Guide to the Greek Myths*, pp. 138–40.

18 Theocritus, *Idyll* 15.87 ff.

19 Greek *speiro* = 'I sow'.

20 *IG* V.1.27. There is considerable discussion of precisely how many *obai* there were – five is the mainstream view – and what their relationship to the three Dorian tribes might have been. See e.g. Cartledge, *Sparta and Lakonia*, p. 107; Forrest, W. G., *A History of Sparta 950–192 BC* (London: Duckworth, 2nd edn, 1980), pp. 42–6.

21 Servius, commentary on Virgil, *Aeneid* 10.564; Lucilius, *Satires* 3, fr. 696–7 (Warmington, E. M., *Remains of Old Latin, Vol. III: Lucillius* [London: Heinemann, 1938]).

22 See p. 98 f.

23 Tyrtaeus fr. 5.2–3 (Diehl, E., *Anthologia Lyrica Graeca*, 2 vols [Leipzig: Teubner, 1925]) = fr. 5 (West, M. L., *Iambi et Elegi Graeci ante Alexandrum cantati (editio altera aucta atque emendata): Vol. II* [Oxford: Clarendon Press, 1992]).

24 Tyrtaeus fr. 5.4 (Diehl, *Anthologia Lyrica Graeca*) = fr. 5 (West, *Iambi et Elegi Graeci: Vol. II*); Strabo 6.3.3.

25 Tyrtaeus fr. 10.15–32 (Gerber, D. E., *Greek Elegiac Poetry* (Cambridge, MA: Loeb Classical Library, 1999]) = Lycurgus, *Against Leocrates* 107.

26 'There is a Chinese curse which says "May he live in interesting times." Like it or not, we live in interesting times. They are times of danger and uncertainty; but they are also the most creative of any time in the history of mankind.' Robert F. Kennedy, The Day of Affirmation speech, 6 June 1966.

27 Herodotus 1.65.2.

28 See e.g. Thucydides 1.18.1.
29 See Forrest, *A History of Sparta*, pp. 55–8
30 Plutarch, *Lycurgus* 1.1.
31 The Greek word here is *rhetrai*, plural of *rhetra* = verbal agreement, bargain, covenant, treaty, a compact between a lawgiver and the people, decree, ordinance.
32 Tyrtaeus fr. 4.2–9 (West, *Iambi et Elegi Graeci: Vol. II*).
33 Plutarch, *Lycurgus* 20.1.
34 See pp. 96–100.
35 Herodotus 1.66.1.
36 Plutarch, *Lycurgus* 9.3.
37 Herodotus 6.52.
38 See p. 154 f.
39 Aristotle, *Politics* 1285b.29.
40 For a discussion of the Spartan king-lists, see Cartledge, *Sparta and Lakonia*, appendix 3.
41 Plutarch, *Lycurgus* 5.6. The Plato reference is to *Laws* 691e. Cf. Isocrates 12.154; Demosthenes, *Against Leptines* 107; Polybius 6.45; Dionysius of Halicarnassus 2.14.
42 Aristotle, *Politics* 1270b29, 1271a11, 1285b29.
43 Described in Plutarch, *Lycurgus* 26.3.
44 Aristotle, *Politics* 1272a, 1273a; cf. Tyrtaeus fr. 4.2–9 (West, *Iambi et Elegi Graeci: Vol. II*); Plutarch, *Lycurgus* 5.6–6.
45 Aristotle fr. 539 (= Plutarch, *Lives of Agis and Cleomenes*, 9.3; *On the Delays of Divine Vengeance* 4; Proclus commentary of Hesiod, *Works and Days*, opposite verso 722). See Amendola, S., 'Reading Plutarch through Plutarch (?): De sera numinis vindicta and the Commentary on Hesiod's Erga', in Schmidt, T. S., Vamvouri, M. and Hirsch-Luipold, R. (eds), *The Dynamics of Intertextuality in Plutarch: Brill's Plutarch Studies, Volume 5* (Leiden: Brill, 2020), pp. 252–66.
46 Plutarch, *Lycurgus* 28.2–3
47 Xenophon, *Constitution of the Lacedaemonians* 14.7.
48 Plutarch, *Agesilaus* 2.3.
49 Literally 'even a sum of 10 *minai*' – not a great amount.
50 Xenophon, *Constitution of the Lacedaemonians* 7.3–6; cf. Plutarch, *Agesilaus* 9.6.
51 Lycurgus's alleged ban on gold and silver coins is grossly anachronistic: he predates the Greek use of this type of currency by hundreds of years.
52 For hoplites, see pp. 168–71.
53 Plutarch, *Lycurgus* 16.1–2.
54 Plutarch, *Lycurgus* 16.4, *IG* V.1.273–334.
55 Plutarch, *Lycurgus* 16.6.
56 Plutarch, *Lycurgus* 17.4–5; cf. Xenophon, *Constitution of the Lacedaemonians* 2.6–8.
57 See Henderson, J., *The Maculate Muse: Obscene Language in Attic Comedy* (New York and Oxford: Oxford University Press, 2nd edn, 1991), pp. 211, 220.
58 Plutarch, *Lycurgus* 17.1.
59 Xenophon, *Constitution of the Lacedaemonians* 2.13.
60 Xenophon, *Constitution of the Lacedaemonians* 2.14; Xenophon, *Symposium* 8.5.
61 Aelian, *Varia Historia* 3.12.
62 Theocritus, *Idyll* 12.13.
63 Maximus of Tyre, *Oration* 20.8.
64 Cicero, *De Re Publica* 4.4.
65 Boston Museum of Fine Arts, 13.94. Beazley, J. D., *Attic Red-figure Vase-painters* (Oxford: Oxford University Press, 2nd edn, 1963), 1570.30; Carpenter, T. H. with Mannack, T. and Mendonca, M., *Beazley Addenda* (Oxford: Oxford University Press, 2nd edn, 1989), p. 389. See Lear, A. and Cantarella, E., *Images of Ancient Greek Pederasty: Boys Were Their Gods* (London and New York: Routledge, 2008), fig. 4.18.
66 Apollodorus 3.116; Pausanias 3.1.3; Ovid, *Metamorphoses* 10.162. Variant traditions give him different parents, and the Thessalians their own special Hyacinthus, although the Spartans acknowledged this making his mother, Diomede, a Thessalian.

67 E.g. Beazly, *Attic Red-figure Vase-painters*, 1570.30, and Davidson, *The Greeks and Greek Love*, pp. 234–51, argue for Zephyrus and Hyacinthus; Shapiro, H. A., 'Courtship Scenes in Attic Vase Painting', *AJA* 85 (1981), pp. 133–43 argues for Eros and *eromenos*; Lear and Cantarella, *Images of Ancient Greek Pederasty*, pp. 152–7, lean towards the latter. Cf. Herodotus 9.6.1–7.1; Pausanias 3.19.3–5, 4.19.4; Colluthus, *Rape of Helen* 240 ff.

68 Metropolitan Museum, New York, 28.167. Beazley, *Attic Red-figure Vase-painters*, 890.175, 1673; Carpenter with Mannack and Mendonca, *Beazley Addenda*, p. 302. See Lear and Cantarella, *Images of Ancient Greek Pederasty*, fig. 4.16. Again, alternative identifications are suggested: Thanatos (Death) or Eros for the winged figure, and Ganymede for the boy. Images at https://www.metmuseum.org/art/collection/search/252976 [accessed 13 August 2020].

69 Hesychius λ 224 (fifth or sixth century CE).

70 Hesychius λ 226.

71 Hesychius μ 4735.

72 Photius s.v. '*kysolakon*'.

73 Aristophanes, *Lysistrata* 1103–5. Lysistratos is the masculine form of Lysistrata.

74 See Anaxandrides fr. 33.17; Aristophanes, *Knights* 54 f. See Henderson, *The Maculate Muse*, p. 202.

75 Aristophanes, *Lysistrata* 1173 f.

76 See p. 171.

77 See Jeffery, L. H., *The Local Scripts of Archaic Greece* (Oxford: Clarendon Press, rev. edn, 1990), p. 318 f.

78 *IG* 12.3.541; *IG* 12.3.537a; *IG* 12.3.538b; *IG* 12.3.536.

79 See e.g. Dover, *Greek Homosexuality*, p. 122 f.; Davidson, *The Greeks and Greek Love*, p. 334 f.; Lear and Cantarella, *Images of Ancient Greek Pederasty*, p. 8.

80 *IG* 12.3.536, 730.

81 Plutarch, *Lycurgus* 18.9.

82 Xenophon, *Constitution of the Lacedaemonians* 3.1–2.

83 Plutarch, *Lycurgus* 15.5.

84 Plutarch, *Lycurgus* 22.1.

85 Herodotus 7.209. See p. 263, and for the origins of Spartan long hair, see p. 113 f.

86 Aristotle, *Rhetoric* 1367a.

87 Athenaeus 12.554c mentions a rather bizarre beauty contest between two Dorian sisters from Syracuse, based on their buttocks, who became known as the Kallipygoi ('Women with Beautiful Arses'). Aphrodite was also worshipped in her aspect of *Kallipygos* = 'of the beautiful buttocks'. The word *bibasis* is associated with animals mounting one another; cf. Aristophanes, *Lysistrata* 78 ff.

88 I.e. perfumed oil from Cyprus; Cinyras was a mythical king of the island.

89 Alcman fr. 3.61–81. = P. Oxy 2387

90 Alcman fr. 1.77–9, in Page, *Poetae Melici Graeci*.

91 Plutarch, *Lycurgus* 14.4.

92 Plutarch, *Lycurgus* 18.9.

93 Dover, *Greek Homosexuality*, p. 122 f.; Davidson, *The Greeks and Greek Love*, p. 181.

94 Müller, K., *FGrH ii*, p. 211.8 (where the passage is wrongly attributed to the fourth-century philosopher Heraclides Ponticus). Digital text at http://www.dfhg-project.org/DFHG/index.php?volume=Volumen%20secundum#urn:lofts:fhg.2.heraclides_ponticus [accessed 9 August 2020].

95 Plutarch, *Lycurgus* 14.4.

96 Plato, *Republic* 458d. Plato is referenced by Plutarch, *Lycurgus* 15.1.

97 Plutarch, *Lycurgus* 14.4.

98 Plutarch, *Lycurgus* 14.4.

99 Plutarch, *Moralia* 241F. It is just five words in Greek also and means 'come back victorious, or die in the attempt and be carried home on your shield'.

100 Plutarch, *Moralia* 240F (Damatria); 241A (anonymous woman).

101 Aristotle, *Politics* 1269b22.

102 Euripides, *Andromache* 595–600.

103 Tyrtaeus fr. 5 (Diehl, *Anthologia Lyrica Graeca*) = fr. 6 (West, *Iambi et Elegi Graeci: Vol. II*).
104 Plato, *Laws* 777c.
105 · For Peisistratus, see Herodotus 1.59–64 and p. 18 f; for Cyrus, see Herodotus 1.72–92 and pp. 41–5.
106 Herodotus 1.82; cf. Panites, the surviving member of Leonidas's 300 at Thermopylae: Herodotus 7.232, and p. 275. For long hair, see p. 263.
107 This changed in *c.* 504. See p. 32 f.
108 Herodotus 1.69–83.
109 Herodotus 3.47.1–2.
110 Herodotus 1.152–53.3.
111 Herodotus 3.45.
112 Herodotus 1.70, 3.47.
113 Herodotus 3.48–53.
114 Herodotus 3.54–6.
115 In some respects, this a classic parallel to the biblical tales of Sarah and Hagar, Rachel and Leah, and Hannah and Peninnah, where a previously childless wife gives birth after a second one has done so: Genesis 16, 21, 29; Samuel 1–2. See Hornblower, *Herodotus Histories Book V*, pp. 149–53.
116 Herodotus 4.40.2.
117 Herodotus 5.43–48, 7.205.
118 Herodotus 5.42.1; cf. 6.76.1, 6.84.1. See p. 155 f.
119 Dated on the basis of Thucydides 3.68.5.
120 Herodotus 6.108.2–3.
121 Herodotus 3.120–5; Diodorus Siculus 10.16.4.
122 See e.g. Cartledge, P., *The Spartans: An Epic History* (London: Pan, revised edn, 2013), p. 88.
123 Plutarch, *Lycurgus* 28.8–10.
124 Herodotus 6.84.
125 Herodotus 5.49. Herodotus is counting inclusively – the 'third day' is our 'day after tomorrow'.
126 Herodotus 3.51.2.
127 Herodotus 5.97.2.
128 Homer, *Iliad* 5.62–3.
129 Herodotus 5.97.3; cf. 5.28, 5.30.1.

Chapter 5

1 Herodotus 5.105.2.
2 See Thucydides 1.5.1–2.
3 Cicero, *Laws* 1.5
4 For the Greek version, see Kershaw, *A Brief Guide to the Greek Myths*, pp. 134–6.
5 Herodotus 1.1–2.
6 Herodotus 1.3.
7 Herodotus 1.4.1
8 Herodotus 1.4.2–4.
9 See p. 45 f.
10 Herodotus 1.5.3.
11 Herodotus 5.24.4.
12 See e.g. Heraclides, *FGrH* 689 F 2.
13 See p. 76 f.
14 PF 1404 (Hallock, R. T., *Persepolis Fortification Tablets* [Chicago: Chicago University Press, 1969]), available online at https://oi.uchicago.edu/sites/oi.uchicago.edu/files/uploads/shared/docs/oip92.pdf [accessed 21 August 2020].

15 PF 1455, (Hallock, *Persepolis Fortification Tablets*). 1 QA = approximately 930 ml of dry measure; 10 QA = 1 BAR. Hidali was an important Elamite centre roughly halfway between Persepolis and Susa, identified with the modern town of Behbehan: see Hinz, W., 'zu den Persepolis-Täfelchen', *Zeitschrift der Deutschen Morgenländischen Gesellschaft* NF 35 (1961), p. 250 f.

16 This is not the same Otanes who proposed democratic government for Persia at Herodotus 3.80. See p. 65 f.

17 Herodotus 5.26–7 and cf. 4.145.2; Aeschylus, *Libation Bearers* 635–6; Thucydides 4.109.4, 7.57.2; Strabo 13.1.58.

18 Herodotus 5.30.1.

19 Herodotus 5.30.1; 'fat cats' is what Herodotus means here: the word he uses can mean 'fat' but also 'thick' in the physical and intellectual sense.

20 Herodotus 5.30.4–5.

21 Euboea is 3657 km²; Cyprus is 9251 km².

22 Herodotus 5.31.3.

23 Herodotus 5.32. See Hornblower, *Herodotus Histories Book V*, p. 132; Chiasson, C. C., 'An ominous word in Herodotus', *Hermes* 111 (1983), pp. 115–18.

24 Myndus is in Caria, at the western tip of the Halicarnassus peninsula. Its population was probably mixed Greek and Carian.

25 Herodotus 5.33.4.

26 Herodotus 5.35.1.

27 Herodotus 5.35–6.

28 Herodotus 5.35–6.

29 Herodotus 5.97.3. See p. 118 f and Herodotus 5.39–97.

30 Modern Küçük Menderes, 'Small Maeander'.

31 Homer, *Iliad* 2.459–68.

32 See e.g. Hanfmann, G. M. A. (assisted by Mierse, W. E.), *Sardis from Prehistoric to Roman Times: Results of the Archaeological Exploration of Sardis 1958–1975* (Cambridge, MA: Harvard University Press, 1983), pp. 68–9; Cahill, N. D., (ed.), *Love for Lydia: A Sardis Anniversary Volume Presented to Crawford H. Greenewalt, Jr* (Cambridge, MA: Harvard University Press, 2008), pp. 118–9.

33 See Herodotus 5.97, 5.102, 5.105, 6.94, 7.8.β, 7.11; Rookhuijzen, J. Z. van., *Herodotus and the Topography of Xerxes' Invasion: Place and Memory in Greece and Anatolia* (Berlin and Boston: Walter de Gruyter, 2020), pp. 56–60.

34 Herodotus 5.102.1.

35 See p. 114.

36 Herodotus 5.105.2.

37 Herodotus 5.108.1.

38 Herodotus 5.106.1–2.

39 Dardanus (modern Şehitlik Batarya), Abydus (Çanakkale), Percote (near Umurbey), Lampsacus (Lapseki), Paesus (near Çardak), Parium (Biga), Cyzicus (Erdek), Cardia (near Bolayır); Chalcedon (Kadıköy district of Istanbul), Artace (near Erdek), Cius in Mysia (modern Gemlik), the Aeolians living in the territory of Ilium, and 'Teucrian' (i.e. Trojan) Gergis (modern Karincali). See Herodotus 5.5.117, 122, 6.33.

40 Including, somewhat unexpectedly, the prosperous port city of Caunus (Dalyan).

41 Herodotus 5.104.3.

42 See Petit, T., 'Herodotus and Amathus', in Karageorghis, V. and Taifacos, I. (eds), *Herodotus and His World: Proceedings of an International Conference held at the Foundation Anastasios G. Leventis, Nicosia, September 2003 and organized by the Foundation Anastasios G. Leventis and the Faculty of Letters, University of Cyprus* (Nicosia: Foundation Anastasios G. Leventis, 2004), pp. 9–25.

43 DB, Col II. §29 (Kuhrt, *The Persian Empire*, p. 145).

44 Greek: *Artybios*; Old Persian: *Ardifiya* or *Ardufiya*, rendered in Elamite as *Ir-tap/tup-pi-ya*.

45 See pp. 168–70.

46 Or possibly not in fact: Herodotus's story has many generic features of the 'clever groom' archetype, which goes back to the mythical charioteer Myrtilus. See Kershaw, *A Brief Guide to the Greek Myths*, p. 300 f; cf. Herodotus 3.85.5–7 (see p. 66).

47 Herodotus describes the weapon as a *drepanon*, which can be an agricultural scythe, but here it looks like a proper piece of military hardware, a curved sword or long-handled scythe which was a typically Carian/Lycian weapon.

48 Herodotus 5.115.1.

49 Collitz, H. and Bechtel, F. (eds), *Sammlung der griechischen Dialekt-Inschriften* (Göttingen, 1905), I, no. 60.

50 See the Gypsum wall panel relief, British Museum 124906, https://www.britishmuseum.org/collection/object/W_1856-0909-14_2 [accessed 25 August 2020]. Croesus's troops used ramps at Smyrna; Harpagos's did likewise in Ionia, Teos and Phocaea; the Lydian army dug mines at Ephesus; Persian forces did the same at Miletus, Soli and Barce.

51 Burn, A. R., *Persia and the Greeks: The Defence of the West, c. 546–478 BC* (London: Edward Arnold, 1962), p. 203, thinks that these arrows were shot from the battlements against the working parties, and that those shot at the men on the wall by archers giving covering fire were naturally less in evidence.

52 A fine gypsum wall panel relief from the Palace of Ashurbanipal II (r. 883–859 BCE) shows two sappers in action during the siege of a city by some Assyrians: British Museum 124554, https://www.britishmuseum.org/collection/object/W_1849-1222-23 [accessed 26 August 2020]. See also Kuhrt, *The Persian Empire*, p. 221, fig. 6.3.

53 See Wartburg, M.-L. von and Maier, F. G., 'Reconstruction of a siege: the Persians at Paphos', in Kiely, T., *Ancient Cyprus in the British Museum: Essays in honour of Veronica Tatton-Brown* (London: British Museum Press, 2009), pp. 7–20.

54 Herodotus 5.115.2.

55 Herodotus 5.116. The year was probably 478 BCE.

56 Different attempts have been made to recover the Old Persian forms of these names: Daurises might reflect the Elamite *Da-a-ú/hu-ri salša*, a name linked to 'Land'/'Country'; Hymaees is elusive; for Otanes see p. 58 and n. 18.

57 The location of the White Pillars has not been identified with certainty; for the Marsyas (not the more famous River Marsyas known to Herodotus 7.26.3 as the Katarrhektes and today as the Düden Su), see https://pleiades.stoa.org/places/599789 [accessed 25 August 2020].

58 Herodotus 5.119.1. The figures are doubtless a massive exaggeration.

59 Herodotus 5.120. The location of the battle is not known.

60 See Hornblower, *Herodotus Histories Book V*, p. 304 f.

61 Herodotus 5.121. Amorges could have had connections to the royal family, possibly through descent from a Saca king who Ctesias says initially fought against Cyrus, but later became his friend and ally (*FGrH* 688 F9, 3 and 7); Sisimaces is the Zissamakka who appears on the Persepolis Fortification Tablets, PF 1493 (500/499), and possibly the same as the Zissawis who appears issuing sealed documents to travellers, and rations of sheep, beer, wine, flour and grain, and generally discharging his official obligations in the years before the revolt.

62 See p. 122 f.

63 Herodotus 5.126.2; cf. Thucydides 4.102.2.

64 See p. 130 f.

65 Herodotus 6.1.2.

66 Herodotus's language is ambiguous here. The Greek could read that he sent the letters *because* they had had discussions, or *as if/intimating that* they had. See Hornblower, S. and Pelling, C., *Herodotus Histories Book VI* (Cambridge: Cambridge University Press, 2017), p. 88 f.

67 PF-NN 1809. See Lewis, D. M., 'Datis the Mede', *Journal of Hellenic Studies* 100 (1980), pp. 194–5.

68 Old Iranian: *Dātiya-*; Elamite: *Da-ti-ya*.

69 Herodotus 7.90. See p. 132.

70 A *drepanon*; see p. 133 and n. 47.

71 Herodotus 7.89, 91.

72 It makes good geographical and historical sense for the episode to have taken place in 494 BCE, although it is sometimes associated with the Marathon campaign of 490, and sometimes seen as spurious. See Burn, *Persia and the Greeks*, p. 218; Hornblower and Pelling, *Herodotus Histories Book VI*, p. 214 f.

73 *FGrH* 532. See Higbie, C., *The Lindian Chronicle and the Greek Creation of their Past* (Oxford: Oxford University Press, 2003).

74 *FGrH* 532, col. D, 1, 1–47.

75 *FGrH* 532, col. B, 32, 66–7.

76 Due to the silting of the Maeander plain Lade is now a small inland hillock several kilometres from the Aegean coast.

77 For triremes and their crews, see pp. 204–10.

78 Herodotus 6.9.1.

79 Herodotus 4.87.1, 6.95.2. See pp. 78, 158.

80 Herodotus 6.9.4. Bactria is at the opposite end of the Persian Empire, about as far away from Ionia as a Greek can imagine.

81 Herodotus 6.10.

82 Homer, *Iliad* 10.173–4.

83 Herodotus 6.11.2–3.

84 See Herodotus 3.39.2, 4.138.2, 5.37–8.

85 See pp. 210, 286 f., 301.

86 Herodotus 6.16.

87 Herodotus 6.19.2. For the rest of the oracle, see p. 156.

88 Other ancient writers attribute the burning of Didyma to Xerxes in 479, on his way back to Susa after his defeat at nearby Mycale, but this cannot be correct: he had gone straight back to Susa via Sardis after the defeat at Salamis in 480 (see p. 319). See Fontenrose, J., *Didyma: Apollo's Oracle, Cult and Companions* (Berkeley, Los Angeles and London: University of California Press, 1988), pp. 11–15.

89 See p. 159.

90 Herodotus 6.27.

91 Herodotus 6.29.1–2.

Chapter 6

1 Herodotus 3.134.5.

2 Herodotus 6.31.2.

3 Herodotus 6.9.4, 6.32. See p. 140.

4 Hammond, N. G. L., 'II. The Philaids and the Chersonese', *Classical Quarterly* 6:3/4 (1956), p. 113.

5 The genealogies and chronologies here are complex and disputed. It has been argued that the figure of Miltiades son of Cypselus is a conflation of two different people called Miltiades. See Hammond, N. G. L., 'Miltiades', *The Oxford Classical Dictionary* (Oxford: Oxford University Press, 1st edn, 1947), pp. 687–8; Hornblower and Pelling, *Herodotus Histories Book VI*, p. 133 f.

6 The chronology is tricky to unravel, but he probably went to the Chersonese a short while before Darius's Scythian expedition of *c.* 513.

7 Herodotus 6.38–9.

8 See p. 86.

9 Herodotus 6.40.1.

10 *IG* I³ 522 bis. See Petrakos, V., 'Ἀνασκαφὴ Ραμνοῦντος', *PAAH* 140 (1984 [1988]), pp. 146–211.

11 *IG* I³ 518; cf. *IG* I² 453 Athens and *IG* I³ 1466 from Olympia; Sekunda, N., *Marathon 490 BC: The First Persian Invasion of Greece* (Oxford: Osprey, 2002), pp. 15–16; Rausch, M., 'Miltiades, Athen und die "Rhamnusier auf Lemnos" (*IG* I³ 522 bis)', *Klio: Beiträge zur Alten Geschichte* 81:1 (1999), pp. 7–17.

12 *IG* XII Suppl. 337. See Picard, C. and Reinach, A.-J., 'Voyage dans la Chersonèse et aux îles de la mer de Thrace', *Bulletin de Correspondance Hellénique* 36 (1912), pp. 275–352;

Arrington, N. T., 'Topographic Semantics: The Location of the Athenian Public Cemetery and its Significance for the Nascent Democracy', *Hesperia* 79:4 (2010), p. 504; Arrington, N. T., 'Inscribing Defeat: The Commemorative Dynamics of the Athenian Casualty Lists', *Classical Antiquity* 30:2 (2011), pp. 179–212. Herodotus 6.136, 140; Diodorus Siculus 10.19.6.

13 Numismatica Genevensis 14 December 2015, 32; Münzkabinett, Staatliche Museen zu Berlin 18242608; Numismatica Ars Classica NAC AG 54 (24 March 2010) 92; Ashmolean Museum, Oxford, 3584; British Museum, London 1919, 0911.11; Bibliothèque nationale de France, Paris 1966.453.812; Bibliothèque nationale de France, Paris, Fonds general 1540; Münzen & Medaillen 31 (23 October 2009) 15; Bibliothèque Royale de Belgique, Brussels, Hirsch 897; Alpha Bank Numismatic Collection, Athens 7277 & 7278; Münzen & Medaillen AG Basel 18–19 June 1970, 45.

14 Seltman, C., *Athens, its history and coinage before the Persian invasion* (Cambridge: Cambridge University Press, 1924), p. 141; Loukopoulou, L., 'Thracian Chersonesos', in Hansen, M. and Nielsen, H. (eds), *An Inventory of Archaic and Classical Poleis* (Oxford: Oxford University Press, 2004), pp. 900–11. Davis, G. and Sheedy, K., 'Miltiades II and his alleged mint in the Chersonesos', *Historia: Zeitschrift Für Alte Geschichte* 68:1 (2019), pp. 11–25, propose, alternatively, that the coins were minted at Cardia on the Persian standard after c. 480 BCE.

15 Herodotus 6.41.1, 7.135.1.

16 Herodotus 6.41.2.

17 Herodotus 6.104.2; cf. Marcellinus, *Life of Thucydides* 13.

18 Herodotus 6.104.2. See Carawan, E. M., '"Eisangelia" and "Euthyna": the Trials of Miltiades, Themistocles, and Cimon', *Greek, Roman and Byzantine Studies* 28:2 (Summer 1987), pp. 167–208; Evans, J. A. S., 'Note on Miltiades' Capture of Lemnos', *Classical Philology* 58:3 (1963), pp. 168–170; Ostwald, M., *From Popular Sovereignty to the Sovereignty of Law: Law, Society, and Politics in Fifth-century Athens* (Berkeley, Los Angeles and London: University of California Press, 1986), pp. 28–31.

19 There is scholarly dissent as to whether Themistocles did in fact hold the Archonship of 493/492: see Fornara, C. W., 'Themistocles' Archonship', *Historia: Zeitschrift Für Alte Geschichte* 20:5/6 (1971), pp. 534–40; Mosshammer, A. A., 'Themistocles' Archonship in the Chronographic Tradition', *Hermes* 103:2 (1975), pp. 222–34.

20 Plutarch, *Themistocles* 1.2. Cornelius Nepos, *Themistocles* 1 says his mother was a western Greek from Acarnania.

21 Plutarch, *Themistocles* 2.5.

22 Plutarch, *Themistocles* 3.1.

23 See Burn, *Persia and the Greeks*, p. 263.

24 Plutarch, *Themistocles* 5.4.

25 Thucydides 1.138.3.

26 See p. 34.

27 Plutarch, *Themistocles* 19.2.

28 Herodotus 6.42; cf. Herodotus 1.170 and Diodorus Siculus 10.25.

29 Old Persian: *Mṛduniya-*; Elamite: *Mar-du-nu-ia* (DB El. 3.91 and on the Persepolis tablets); Babylonian: *Mar-du-ni-ia* (DB Bab. 111); Aramaic: *mrd[wn]y* (DB Aram. 76).

30 Artozostre. Old Persian: *Artozō strē*. See Herodotus 6.43.1, PFa 5:1 f. She is the only one of Darius's daughters to be named by Herodotus.

31 Herodotus 6.43.3; cf. 3.80–2, where Otanes had suggested something similar. See p. 65 f. Diodorus Siculus 10.25 says that Artaphernes did this, and also reassessed the tribute.

32 Herodotus 6.44.1.

33 Herodotus 3.134.

34 DNa ll. 15–29. *Yauna/Yaunâ* is the generic Old Persian word for 'Greeks', derived from *Iones* ('Ionians').

35 Herodotus 7.22.2.

36 Herodotus 6.44.3. The numbers are impossible to verify; the sea-monsters are hard to identify. For the Persians' lack of swimming ability, see p. 307.

37 Herodotus 6.45.1–2, 6.94.2.

38 See p. 31 f.
39 Plutarch, *Themistocles* 6.2.
40 Herodotus 7.133.1.
41 Herodotus 6.50.2–3, 6.62–3, 6.70.2, 6.69.5; Xenophon, *Hellenica* 3.1.6.
42 Herodotus 6.72.
43 See Herodotus 5.42 and p. 117.
44 Herodotus 6.75.3.
45 Herodotus 6.84.3.
46 See p. 142 f.
47 Herodotus 6.77.2.
48 See Nicander, *Theriaca* 157–67, 258, 333–7 for vipers.
49 Herodotus 7.148.2.
50 See Herodotus 6.62, 6.93.2, 9.73, 9.75; Lysias, *Defence against a Charge of Taking Bribes* 5; *IG* II² 2311, l. 78.
51 Herodotus 6.94.1.
52 Herodotus 6.94.2. See pp. 151–4.
53 See p. 137.
54 Herodotus 6.94.2.
55 Herodotus 6.95.2.
56 See pp. 125–7.
57 Herodotus 6.133.1; Pausanias 1.33.1–3.
58 See e.g. Homeric *Hymn 3 to Apollo*; *9 to Artemis*; *27 to Artemis*; Pindar, *Hymn* 5; Callimachus, *Hymn 4 to Delos*.
59 Herodotus 6.97.2.
60 Herodotus 6.99.1.
61 Herodotus 6.101.1; cf. Diogenes Laertius 2.144. Plato, *Menexenus* 240b, says it took half a week.
62 Herodotus 6.101.1; Plutarch, *Moralia* 510b; Pausanias 7.10.2.
63 Herodotus 6.101.3, 6.107.2; Plato, *Menexenus* 240b–c, *Laws* 698c–d; Strabo 10.1.10.
64 Philostratus, *Life of Apollonius* 1.23–4; Herodotus 6.119.1–3.
65 *Greek Anthology* 7.256; cf. *Greek Anthology* 7.259.

Chapter 7

1 Mill, J. S., 'Review of G. Grote, *History of Greece I–II*', *Edinburgh Review* 84 (1846), p. 343.
2 Naples Museo Archeologico Nazionale 81947 (H3253), *c.* 340–320 BCE. Trendall, A. D. and Cambitoglou, A., *The Red-Figured Vases of Apulia, vol. I. Early and Middle Apulian*, Oxford Monographs on Classical Archaeology (Oxford: Clarendon Press, 1978), pp. 482–508.
3 Shapiro, H. A., 'The invention of Persia in Classical Athens', in Eliav-Feldon, M., Isaac, B. H. and Ziegler, J. (eds), *The Origins of Racism in the West* (Cambridge: Cambridge University Press, 2009), p. 76; cf. the frieze on the tomb of Lycian ruler Arbinas (aka 'the Nereid Monument') now in the British Museum, and see Llewellyn-Jones, L., 'The Great Kings of the Fourth Century and the Greek Memory of the Persian Past', in Marincola, J., Llewellyn-Jones, L. and MacIver, C. (eds), *Greek Notions of the Past in the Archaic and Classical Greece* (Edinburgh: Edinburgh University Press, 2012), p. 340.
4 There are suggestions that the vase takes its inspiration from Phrynichus's lost play *Persians*. See Anti, C., 'Il vaso di Dario e i Persiani di Frinico', *Archaeologica Classica* iv (1952), pp. 23–45; Schmidt, M., *Der Dareiosmaler und sein Umkreis: Untersuchung zur Spätapulischen Vasenmalerei* (Munich: Aschendorff, 1960); Taplin, O., *Pots and Plays: Interactions between Tragedy and Greek Vase Painting of the Fourth Century BC* (Los Angeles: J. Paul Getty Museum, 2007), pp. 235–7; Shapiro, 'The invention of Persia in Classical Athens', pp. 57–87.
5 Plato, *Laws* 689d.

6 Diodorus Siculus 10.27.1–3.

7 Herodotus 6.107.1.

8 Herodotus 1.60.3. See p. 18 f.

9 Strabo 3.4.9; Pindar, *Olympian* 134.110; Nonnus, *Dionysiaca* 13.184, 18.18; Aristophanes, *Birds* 245–6; Pausanias 1.15.3; Plutarch, *Theseus* 32.4; Suda s.v. 'Marathon'; Philostratus, *Life of Apollonius* 2.2.7.

10 Pausanias 1.32.4; Lucian, *Theon Ekklesia* 7; Herodotus 6.108.1, 6.116; *IG* I³ 1015 bis; Pindar, *Olympian* 9.88–90; Pindar, *Pythian* 8.78–80. See Dionysopoulos, C. D., *The Battle of Marathon: An Historical and Topographical Approach* (Athens: Kapon Editions, 2016), pp. 160–8.

11 Pausanias 1.27.10; Strabo 9.1.2; Plutarch, *Theseus* 14.1; Diodorus Siculus 4.59; Scholiast on Plato, *Menexenus* 240c; Scholiast on Aristophanes, *Lysistrata* 1032; Suda s.v. '*empis*'.

12 Pausanias 1.32.5.

13 Pausanias 1.32.6.

14 See Dionysopoulos, *The Battle of Marathon*, pp. 132–69.

15 Quoted by Pausanias 1.14.4.

16 Other locations have been suggested, including by the Sanctuary of Heracles, and in the lake in the great marsh: see Dionysopoulos, *The Battle of Marathon*, pp. 171–4.

17 Plato, *Laws* 698boc.

18 Pausanias 1.32.7. See Dionysopoulos, *The Battle of Marathon*, pp. 174–6.

19 Freud, S., *The Interpretation of Dreams*, authorised translation of 3rd edition with introduction by A. A. Brill (New York: Macmillan, 1913), p. 234 f. Hornblower and Pelling, *Herodotus Histories Book VI*, p. 237, read it as 'penetration of the motherland as well as ejaculation'.

20 Herodotus 6.107.4.

21 Quoted by Aristotle, *Rhetoric* 1411a9–11. Typically they would take three days' rations: see Diodorus Siculus 11.81.4–5; Aristophanes, *Acharnians* 197, 1073–142, *Peace* 311–12, 1181–2, *Wasps* 242–3; Thucydides 1.48.1.

22 Diodorus Siculus 11.84.4–5; Plutarch, *Pericles* 18.2; cf. Aristophanes, *Birds* 1364–9.

23 Aristotle, *Constitution of the Athenians* 21.2–6; Herodotus 5.66.1–69.2; Lysias, *For Mantitheus* 14, *For Polystratus* 13, *Against Pancleon* 2–3, *Against Philon* 15; Thucydides 2.16.1–2. Osborne, *Demos*, pp. 88–104; Whitehead, *The Demes of Attica*, p. 224; Crowley, *The Psychology of the Athenian Hoplite*, p. 29.

24 *IG* I³ 138.

25 Christ, M. R., 'Conscription of Hoplites in Classical Athens', *Classical Quarterly* 51:2 (2001), p. 401. Crowley, *The Psychology of the Athenian Hoplite*, p. 29.

26 Herodotus 6.109.1, 6.112.2.

27 See Harding, P., *The Story of Athens: The Fragments of the Local Chronicles of Attika* (London: Routledge, 2007); Harding, P., 'Local History and Atthidography', in Marincola, J. (ed.), *A Companion to Greek and Roman Historiography* (Malden: Blackwell, 2007), pp. 165–72.

28 Nepos, *Miltiades* 5.1, 5.5; Plutarch, *Moralia* 305b; Pausanias 10.20.2, 4.25.5 ('under 10,000, say the Messenians'); Suda s.v. *Hippias (II)*; Justin, 2.9.9; cf. Aristophanes, *Knights* 781.

29 Pausanias 10.20.2.

30 Pausanias 1.32.3.

31 Pausanias 7.15.4; Polybius 38.15.

32 Herodotus 6.112.2.

33 Aeschylus, *Persians* 236–44; cf. Aristophanes, *Knights* 781.

34 This could carry a sexual double entendre: see Sommerstein, A. H., *Aristophanes: Wasps* (Warminster: Aris & Phillips, 1983).

35 Cf. Tyrtaeus fr. 10 (Gerber, *Greek Elegiac Poetry*), quoted on p. 94.

36 Aristophanes, *Wasps* 1081–5.

37 Crowley, *The Psychology of the Athenian Hoplite*, pp. 101–4.

38 Thucydides 4.40.2.

39 See Sophocles, *Antigone* 668–71l; cf. Plato, *Apology* 28b–9a.

40 See e.g. Cartledge, P., 'Hoplites and Heroes: Sparta's Contribution to the Technique of Ancient Warfare', *Journal of Hellenic Studies* 97 (1977), pp. 11–27.

41 Nymphodorus, *FGrH* 592 F 15.

42 Tyrtaeus fr. 11.4, 24, 28, 31, 35; 12.25; 19.7.15 (West, *Iambi et Elegi Graeci: Vol. II*); Plutarch, *Moralia* 220A (2), 239B (34). For alphabetic nationalist insignia, see p. 257 f.

43 See Hanson, V. D., *Hoplite: The Classical Greek Battle Experience* (London: Routledge, 1993), pp. 63–84.

44 Thucydides 5.71.1.

45 See Lazenby, J. and Whitehead, D., 'The myth of the hoplite's hoplon', *Classical Quarterly* 46:1 (1996), pp. 27–33.

46 Diodorus Siculus 15.44.3.

47 Aeschylus, *Seven Against Thebes* 466, 717; cf. Pindar, *Isthmian* 1.23 (458).

48 See Hanson, *Hoplite*, pp. 63–84.

49 See Krentz, P., 'Marathon and the Development of the Exclusive Hoplite Phalanx', *Bulletin of the Institute of Classical Studies Supplement* 124 (2013), pp. 35–44.

50 Aristotle, *Politics* 1297b19–20.

51 Asclepiodotus, *Tactics* 2.2.

52 Anderson, J. K., *Military Theory and Practice in the Age of Xenophon* (Berkeley and Los Angeles: University of California Press, 1970), pp. 174–6; van Wees, H., *Greek Warfare: Myths and Realities* (London: Duckworth, reprinted, 2005), p. 189; Crowley, *The Psychology of the Athenian Hoplite*, p. 54.

53 Asclepiodotus, *Tactics* 2.1. See Crowley, *The Psychology of the Athenian Hoplite*, pp. 53–66.

54 See p. 259 f.

55 Aristotle, *Rhetoric* 1411a10; Scholiast on Demosthenes, *On the False Embassy* 303; Pausanias 7.15.4; Nepos, *Miltiades* 4.4–5.2. See Hamel, D., *Athenian Generals: Military Authority in the Classical Period* (Leiden, Boston and Cologne: Brill, 1998), pp. 164–7.

56 Herodotus 6.105.1; Plutarch *Moralia* 862a; Nepos, *Miltiades* 4.

57 Herodotus 6.105.1. This is impressive, but not unbelievable: on the modern road network it is a journey of around 215 km and takes about 2 hours 30 minutes to drive, and in 1982 a fifty-six-year-old RAF wing-commander ran in it 35 hours 30 minutes. See Lazenby, J. F., *The Defence of Greece 490–479 BC* (Warminster: Aris & Phillips, 1993), p. 52.

58 Herodotus 6.107.2.

59 Herodotus 6.103.1.

60 Herodotus 6.103.1.

61 Nepos, *Miltiades* 5; Herodotus 6.108.1; *IG* I³ 1015 bis. See Krentz, P., *The Battle of Marathon* (New Haven and London: Yale University Press, 2010), pp. 118–21.

62 Nepos, *Miltiades* 5.3; Frontinus 2.2.9.

63 Herodotus 6.108.1.

64 E.g. Nepos, *Miltiades* 5.1; Scholiast on Aristophanes, *Knights* 781; Suda s.v. '*Hippias (II)*'; Justin 2.9.9. For a survey of the scholarly discussion of the total numbers of Greek troops deployed, see Dionysopoulos, *The Battle of Marathon*, pp. 39–78.

65 Herodotus 6.109.2; Aristotle, *Constitution of the Athenians* 22.2. See Bicknell, P., 'The Command Structure and Generals of the Marathon Campaign', *L'Antiquité Classique* 39:2 (1970), pp. 427–42; Marincola, J., 'Plutarch, "Parallelism", and the Persian-War *Lives*', in Humble, N. (ed.), *Plutarch's Lives: Parallelism and Purpose* (Swansea: Classical Press of Wales, 2010), pp. 121–44; Hornblower and Pelling, *Herodotus Histories Book VI*, p. 246 f.

66 Herodotus 6.109.3–6.

67 Herodotus 6.110; cf. Plutarch, *Aristides* 5.1–2.

68 Because the ancient sources hardly give any precise dates for the events of the Marathon campaign, and the ones which they do give are subject to a variety of interpretations, there are many conflicting scholarly calculations: most place the battle and its associated events to within a margin of a couple of days in September; others prefer August. See the discussions in Dionysopoulos, *The Battle of Marathon*, pp. 79–98.

69 Herodotus 6.111.1; Plutarch *Moralia* 628d–e. Aiantis would usually be number 9, so some kind of adjustment of the sequence would be needed. See p. 27; and Krentz, *The Battle of Marathon*, p. 221.

70 See the survey by Dionysopoulos, *The Battle of Marathon*, pp. 178–84.

71 Aristophanes, *Wasps* 1086.

72 Aeschines 3.186; Scholiast on Aristides 3.566, ed. Dindorf, W. (1829); Herodotus 6.112.1.

73 *Dromoi* in Greek: Herodotus 6.112.1. See Krentz, *The Battle of Marathon*, pp. 143–52.

74 Eight *stadia*, says Herodotus 6.112.1; 1 *stadion* = 600 Greek feet; 1 Athenian foot = 29.7 cm.

75 Herodotus 6.112.2.

76 Suda s.v. '*Khoris hippeis*'. There are numerous options of meaning in the Greek text, indicated by italics here.

77 E.g. Hignett, C., *Xerxes' Invasion of Greece* (Oxford: Clarendon Press, 1963), pp. 65–6; Krentz, *The Battle of Marathon*, pp. 139–42.

78 Hammond, N. G. L., 'The Expedition of Datis and Artaphernes', in Boardman, J., Hammond, N. G. L., Lewis, D. M. and Ostwald, M. (eds), *The Cambridge Ancient History, Volume IV, Persia, Greece and the Western Mediterranean c. 525 to 479 BC* (Cambridge: Cambridge University Press, 2nd edn, 1988), p. 511; Krentz, *The Battle of Marathon*, pp. 143.

79 E.g. Rhodes, P. J. 'The Battle of Marathon and Modern Scholarship', *Bulletin of the Institute of Classical Studies. Supplement* 124 (2013), pp. 3–21; cf. Nepos, *Miltiades* 5.3.

80 Herodotus 6.112.3–113.2.

81 Herodotus 6.115; Pausanias 1.32.3 says 'some' ships.

82 Herodotus 6.114.

83 Justin, *Epitome of Pompeius Trogus' Philippic Histories*, 2.6.18–20.

84 Pliny, *Naturalis Historia* 35.57.

85 Pausanias 1.15.3.

86 See Dütschke, H., *Antike Bildwerke in Oberitalien IV. Antike Bildwerke in Turin, Brescia, Verona und Mantua* (Leipzig: Engelmann, 1880), 143 f., cat. no. 366; Harrison, E. B., 'The South Frieze of the Nike Temple and the Marathon Painting in the Painted Stoa', *American Journal of Archaeology* 76:4 (1972), pp. 353–78; Evans, J. A. S., 'Herodotus and the Battle of Marathon', *Historia: Zeitschrift Für Alte Geschichte* 42:3 (1993), pp. 279–307; Vanderpool, E., 'A Monument to the Battle of Marathon', *Hesperia* 35 (1966), pp. 94–106 and plates 31–5; Steinhauer, G., *Marathon and the Archaeological Museum* (Athens: John S. Latsis Public Benefit Foundation and EFG Eurobank Ergasias S.A., 2009), https://www.latsis-foundation. org/content/elib/book_16/marathon_en.pdf [accessed 29 November 2020].

87 IG I³ 784. See Keesling, C., 'The Callimachus monument on the Athenian Acropolis (CEG 256) and Athenian Commemoration of the Persian Wars', in Baumbach, M., Petrovic, A. and Petrovic, I. (eds), *Archaic and Classical Greek Epigram* (Cambridge: Cambridge University Press, 2010). p. 109. For other restorations see Fornara, C. W., *Archaic Times to the End of the Peloponnesian War* (Cambridge: Cambridge University Press, 2nd edn, 1983), p. 49.

88 Herodotus 6.114; Plutarch, *Moralia* 305c; cf. Lucan 4.787; Ammianus Marcellinus 18.8.12.

89 Pausanias 1.32.3.

90 See Krentz, *The Battle of Marathon*, pp. 122–9; Dionysopoulos, *The Battle of Marathon*, pp. 185–94.

91 *SEG* 56.430, ll. 2–28. See Steinhauer, G., 'Oi steles ton Marathonomachon apo ten epaule tou Herode Attikou sti Loukou Kynourias', in Bourazelis, K. and Meidani, K. (eds), Μαραθών: η μάχη και ο αρχαίος Δήμος / *Marathon: the Battle and the Ancient Deme* (Athens: Institut du livre – A. Kardamitsa, 2010), pp. 99–108.

92 See Marinatos, S., 'From the Silent Earth', *Arkhaiologika Analekta ex Athenon* (1970), pp. 63–8; 'Further News from Marathon', *Arkhaiologika Analekta ex Athenon* (1970), pp. 164–6; 'Further Discoveries at Marathon', *Arkhaiologika Analekta ex Athenon* (1970), pp. 357–62; Krentz, *The Battle of Marathon*, p. 129 f.; Dionysopoulos, *The Battle of Marathon*, pp. 52–64.

93 Pausanias 1.32.4.

94 Pausanias 1.32.5.

95 See e.g. Aristophanes, *Lysistrata* 285.

96 Plutarch, *Theseus* 35.8.

97 Pausanias 1.15.4.

98 Pausanias 1.32.4–5.

99 Plutarch, *Moralia* 305c; cf. Plutarch, *Moralia* 347d.

100 Herodotus 6.117.2.

101 Worcester, D. A., 'Shell-Shock in the Battle of Marathon', *Science* 50: 1288 (1919), p. 230.

102 Rees, O., 'We Need to Talk about Epizelus: "PTSD" and the Ancient World', *Medical Humanities* 46 (2020) pp. 46–54.

103 See https://www.nhs.uk/conditions/post-traumatic-stress-disorder-ptsd/symptoms/ [accessed 30 November 2020].

104 See Buxton, R. G. A., *Myths and Tragedies in Their Ancient Greek Contexts* (Oxford: Oxford University Press, 2013), p. 188; Crowley, J., 'Beyond the universal soldier: combat trauma in classical antiquity', in Meineck, P. and Konstan, D. (eds), *Combat Trauma and the Ancient Greeks: The New Antiquity* (New York: Palgrave Macmillan, 2014), pp. 105–30; Rees, O., 'We Need to Talk about Epizelus', pp. 46–54; Shay, J., *Achilles in Vietnam: Combat Trauma and the Undoing of Character* (New York: Atheneum Publishers/Macmillan Publishing Co., 1994).

105 Pausanias 1.32.6; Herodotus 6.117.1.

106 Xenophon, *Anabasis* 3.2.11–12; Plutarch, *On the Malice of Herodotus* 862B–C.

107 E.g. Hammond, 'The Expedition of Datis and Artaphernes', p. 511 ('in the light of dawn'); Dionysopoulos, *The Battle of Marathon*, p. 221 ('at 5 o'clock in the afternoon').

108 Herodotus 6.113.1; Aristophanes, *Wasps* 1085.

109 Herodotus 6.115, 6.120–32.

110 Plutarch, *Moralia* 347c. Lucian, *Pro Lapsu Inter Salutandum* 3, calls him by the name of the first runner, Phidippides; Heraclides Ponticus calls him Thersippus of Eroeadae.

111 Herodotus 6.120; Plato, *Menexenus* 240c, *Laws* 698e.

112 The Archaeological Museum of Olympia, 142 B2600. It could also come from another campaign, such as Lemnos.

113 *IG* I³ 1463.

114 Pausanias 1.28.2.

115 Boardman, J., 'The Parthenon Frieze: Another View', in Höckmann, U. and Krug, A. (eds), *Festschrift für Frank Brommer* (Mainz: Von Zabern, 1977), pp. 39–49; 'The Parthenon Frieze, a Closer Look', *Revue Archéologique*, Nouvelle Série, Fasc. 2 (1999), pp. 305–30.

116 Aristophanes, *Knights* 781, 1334, *Wasps* 711, *Holkades* fr. 429 K–A, *Acharnians* 181, *Clouds* 986.

117 *Vita* 11, Pausanias 1.14.5; Athenaeus 14.627d; Plutarch, *On Exile* 13–15 (604–6). For the dispute over who wrote the epitaph, see Radt, S., *Tragicorum Graecorum Fragmenta, Vol. 3, Aeschylus* (Göttingen: Vanden-hoeck & Ruprecht, 1985), pp. 106–7.

118 Lysias, *Epitaphios* 22–5; cf. Andocides, *On the Mysteries* 107; Lycurgus, *Against Leocrates* 104; Demosthenes, *On the Crown* 208.

Chapter 8

1 Plato, *Laws* 698e.

2 Herodotus 6.132. The Greek word *troma* used here by Herodotus implies physical but not psychological hurt. He uses the same word to describe the battles at Thermopylae (7.233.1, 7.236.3, 8.27.1), Plataea (9.90.1) and Mycale (9.100.2).

3 They had sent just twenty to join the Ionian Revolt, and only had fifty during the recent conflict with Aegina: see pp. 118 f, 157 f; Herodotus 5.97.3, 6.89.

4 Herodotus 6.132.

5 Herodotus 6.132 ff.; Ephorus, *FGrH* 70 F 163; Nepos, *Miltiades* 7 f. See Develin, R., 'Miltiades and the Parian Expedition', *L'Antiquité Classique* 46 (1977), pp. 571–7.

6 Herodotus 6.133.1. See p. 159.

7 Herodotus 6.133.1, 7.83.1, 7.135.1.

8 Ephorus, *FGrH* 70 F 63.

9 Herodotus 6.136.1. Cornelius Nepos, *Miltiades* 7.5, 8.1–3, makes it a charge of treason, and says that his tyranny in the Chersonese played a significant part in the jurors' assessment.

NOTES

10 See e.g. Euripides, *Hippolytus* 176, 1342, 1358 f.

11 See p. 148.

12 Plato, *Gorgias* 516e.

13 Herodotus 6.136.3; cf. 3.66.2. Cornelius Nepos, *Miltiades* 7.6, sets the fine at 500 talents, and has him die in prison. Miltiades' son Cimon paid the fine.

14 Nepos, *Miltiades* 8.4.

15 Aristotle, *Constitution of the Athenians* 22.4–6. For a slightly differently nuanced view, see Lavelle, B. M., 'A Note on the First Three Victims of Ostracism (Ἀθηναίων Πολιτεία 22. 4)', *Classical Philology* 83:2 (1988), pp. 131–5.

16 *GHI* (Meiggs, R. and Lewis, D. M., *A Selection of Greek Historical Inscriptions to the End of the Fifth Century* BC [Oxford: Oxford University Press, 1969]), no. 21, p. 42; Fornara, *Archaic Times to the End of the Peloponnesian War*, pp. 41–4.

17 See Holladay, J., 'Medism in Athens 508–480 BC', *Greece & Rome* 25:2 (1978), pp. 174–91.

18 Aristotle, *Constitution of the Athenians* 23.3. The author contradicts himself at 28.3, where he says Aristides was the champion of the upper classes.

19 Plutarch, *Aristides* 22.1.

20 Herodotus 7.1–2.

21 Herodotus 6.98.3.

22 See p. 155.

23 Herodotus 7.3; cf. Justin 2.10.1–10.

24 XPf §1, 4.

25 Herodotus 7.4. Ctesias's *Persica* gives him a thirty-one-year reign (*FGrH* 688 F 13 [23]), but contemporary Babylonian documents support Herodotus.

26 XPf §2. The formula occurs, with minor variations, on numerous monuments and inscriptions: XV §2, XE §2, XPh §2, etc.

27 Plato, *Laws* 695d–e. For Cambyses, see pp. 58–60.

28 Herodotus 7.187.2.

29 XPl §1–2i; cf. DNb, and see p. 67 f.

30 Ctesias, *Persica* = *FGrH* 668 F 13 (24).

31 Herodotus 7.7.

32 See Waerzeggars, C., 'The Babylonian Revolts Against Xerxes and the "End of Archives"', *Archiv für Orientforschung* 50 (2003/4), pp. 150–73; Lendering, J., 'Bêl-šimânni and Šamaš-eriba', https://www.livius.org/articles/person/bel-simanni-and-samas-eriba/ [accessed 21 January 2021].

33 Ctesias, *Persica* = *FGrH* 688 F13 (26): worth roughly £7.5 million on 12 May 2021; cf. Herodotus 1.183.3.

34 Ctesias, *Persica* = *FGrH* 688 F13 (26); Herodotus 7.5 ff. See p. 153 f.

35 Herodotus 7.5–6.1.

36 Herodotus 7.6.1.

37 Herodotus 7.6.

38 The Greek uses Zeus, the sky god.

39 Herodotus 7.8.γ.1–3.

40 Herodotus 7.9.

41 See p. 86 f.

42 Herodotus 7.11.3–4.

43 See Kershaw, *A Brief Guide to the Greek Myths*, pp. 296–305.

44 Herodotus 7.18.3.

45 Herodotus 7.20.

46 Herodotus 7.23.1–3.

47 See Isserlin, B. S. J., 'The Canal of Xerxes: Facts and Problems', *The Annual of the British School at Athens* 86 (1991), pp. 83–91; Isserlin, B. S. J., Jonges, R. E., Karastathis, V., Paramarinopoulos, S. P., Syrides, G. E. and Uren, J., 'The Canal of Xerxes: Summary of Investigations 1991–2001', *The Annual of the British School at Athens* 98 (2003), pp. 369–85; Rookhuijzen, *Herodotus and the Topography of Xerxes' Invasion*, pp. 101–5.

48 See http:/www.world-archaeology.com/features/xerxes-canal.htm [accessed 21 January 2021].

49 Herodotus 7.114.1.

50 Herodotus 4.85.4, 7.34, gives it as 7 *stadia* (*c.* 1400 m); Xenophon, *Hellenica* 4.8.5, makes it 8 *stadia* (*c.* 1600 m). Today it is slightly over 2 km, but the ancient sea level was not the same, and the coastline has been eroded by the fast-flowing waters. See Hammond, N. G. L. and Roseman, L. J., 'The Construction of Xerxes' Bridge over the Hellespont', *Journal of Hellenic Studies*, 116 (1996), pp. 88–107.

51 Herodotus 7.33; Strabo 7, fr. 55. See Rookhuijzen, *Herodotus and the Topography of Xerxes' Invasion*, pp. 78–86.

52 See e.g. Aeschylus, *Persians* 68–73, 104.

53 Herodotus 7.34; cf. Aeschylus, *Persians* 68, 104. See Hammond and Roseman, 'The Construction of Xerxes' Bridge over the Hellespont', p. 93; Shepherd, W., *The Persian War in Herodotus and Other Ancient Voices* (Oxford: Osprey, 2019), p. 181, is sceptical about the figures.

54 Herodotus 7.34.

55 Aeschylus, *Persians* 722.

56 Timotheus, *Persians* 791.73f.

57 See Harrison, T., *Writing Ancient Persia: Classical Essays* (London and New York: Bristol Classical Press, 2011), p. 61.

58 Herodotus 7.35.1–2.

59 Aeschylus, *Persians* 745–51.

60 *Laterculi Alexandrini* 8; Diels, H. (ed.), *Laterculi Alexandrini* (Berlin: Verlag der Königlichen Akademie der Wissenschaften, 1904).

61 For a detailed hypothesis, see Hammond and Roseman, 'The Construction of Xerxes' Bridge over the Hellespont', pp. 95, 101–2.

62 Herodotus 7.36.

63 Herodotus 7.25.

64 Herodotus 7.26–31. See Rookhuijzen, *Herodotus and the Topography of Xerxes' Invasion*, pp. 39–60.

65 The location is disputed: see French, D., 'Pre- and Early-Roman Roads of Asia Minor: The Persian Royal Road', *Iran* 36 (1998), pp. 15–43.

66 Rookhuijzen, *Herodotus and the Topography of Xerxes' Invasion*, pp. 40–2; Baragwanath, E., *Motivation and Narrative in Herodotus* (Oxford: Oxford University Press, 2007), p. 271.

67 Herodotus 7.26. See Kershaw, *A Brief Guide to the Greek Myths*, p. 57.

68 See Rookhuijzen, *Herodotus and the Topography of Xerxes' Invasion*, pp. 46–8; Bowie, A. M., 'Mythology and the Expedition of Xerxes', in Baragwanath, E. and de Bakker, M., *Myth, Truth, and Narrative in Herodotus* (Oxford: Oxford University Press, 2012), p. 274 f.; Kershaw, *A Brief Guide to the Greek Myths*, pp. 57–8.

69 Herodotus 7.27–29; cf. Plutarch, *On the Virtues of Women* 27.

70 Cylinder seal SXe. See Kuhrt, *The Persian Empire*, p. 247, fig. 7.1; Rookhuijzen, *Herodotus and the Topography of Xerxes' Invasion*, pp. 51–6.

71 Herodotus 7.132.1; cf. 7.138.

72 See Cartledge, P., *Thebes: The Forgotten City of Ancient Greece* (London: Picador, 2020), p. 95.

73 Herodotus 7.32, 7.133.1. See p. 154.

74 See Herodotus 7.144.1–2; Thucydides 1.14.3. See pp. 34, 157 f.

75 Aeschylus, *Persians* 23; cf. Herodotus 7.144.1; Aristotle, *Constitution of the Athenians* 22.7; Plutarch, *Themistocles* 4.1–3; Cornelius Nepos, *Themistocles* 2.2, 2.8; Polyaenus 1.30.6; Justin 2.12.12.

76 See p. 150 f.

77 Plutarch, *Themistocles* 4.1.

78 Herodotus 7.144.2.

79 Plutarch, *Themistocles* 4.2.

80 Plutarch, *Themistocles* 3.2; cf. Plutarch, *Aristides* 3.1.

81 See Brenne, S., *Ostrakismos und Prominenz in Athen: Attische Bürger des 5. Jhs. v. Chr. auf den Ostraka*, Tyche Suppl. 3 (Vienna: Holzhausen, 2001); Sickinger, J. P., 'New Ostraka from the

Athenian Agora', *Hesperia: The Journal of the American School of Classical Studies at Athens* 86:3 (2017), pp. 443–508; Lang, M. L., 'Ostraka', *Athenian Agora* 25 (1990), pp. iii–188.

82 Aristotle, *Constitution of the Athenians* 22.7; cf. Plutarch, *Aristides* 25.10.

83 Plutarch, *Aristides* 7.5–6.

84 Herodotus 8.79.1; Plutarch, *Aristides* 8.2.

85 *IG* II² 1604–32.

86 Bockius, R. et al. *Trireme Olympias: The Final Report, Conference Papers 1998* (Oxford and Oakville: Oxbow, 2012); Coates, J. F., *The Athenian Trireme* (Cambridge: Cambridge University Press, 2nd edn, 2000); Casson, L., *The Ancient Mariners* (Princeton: Princeton University Press, 2nd edn, 1991); Casson, L., *Ships and Seamanship in the Ancient World* (Baltimore: Johns Hopkins University Press, 1995); Morrison, J. S., Coates, J. F. and Rankov N. B., *The Athenian Trireme: The History and Construction of an Ancient Greek Warship* (Cambridge: Cambridge University Press, 2nd edn, 2000); Welsh, F., *Building the Trireme* (London: Constable, 1988).

87 See p. 141 f.

88 Aristophanes, *Frogs* 236–9.

89 This was what the sailors shouted as they prepare for rowing.

90 Aristophanes, *Frogs* 1072–5

91 Thucydides 1.14.3.

92 *IG* I, 2(1), 44

93 See Casson, *Ships and Seamanship in the Ancient World*, pp. 350–5.

94 Aristophanes, *Peace* 142, *Women in the Assembly* 964; Epicrates (10); Xenarchus 1.8; Plato Comicus 3.4 = Athenaeus 456a.

95 Aristophanes, *Women in the Assembly* 1091.

96 Aristophanes fr. 544.2.

97 Aristophanes, *Birds* 1256.

98 E.g. Aristophanes, *Peace* 341, *Lysistrata* 411, 675, 1170, *Women in the Assembly* 37–9, 964, 1091, 1105–7.

99 Plato Comicus 3.3–4 = Athenaeus 456a.

100 Aristophanes, *Women in the Assembly* 37–9.

101 Herodotus 8.94; Thucydides 4.9.8; cf. Aristophanes, *Knights* 77. See Henderson, *The Maculate Muse*, p. 164 f.

102 Aristophanes, *Lysistrata* 59 f; cf. Aristophanes, *Birds* 1204f ff.

103 Aristophanes, *Frogs* 48 f., 428–30, *The Women at the Thesmophoria* 804; cf. Herodotus 7.96; Thucydides 3.95, 8.42.

104 Aristophanes, *Knights* 1300 ff.

105 *Anthologia Palatina* (AP) 9.416.

106 See Herodotus 8.1.1–2, 8.44.1.

107 Herodotus 7.139.1–2, 5.

108 See p. 156 f.

109 See p. 154.

110 Herodotus 7.135.3.

111 See Kershaw, *A Brief Guide to Classical Civilization*, pp. 151–5; Foster, J. and Lehoux, D., 'The Delphic Oracle and the Ethylene-intoxication Hypothesis', *Clinical Toxicology* 45:1 (2007), pp. 85–9; Aune, D. E., 'Oracles', in Eliade, M. (ed.), *The Encyclopedia of Religion* (New York: Macmillan, 1987), p. 81; Fontenrose, J., *The Delphic Oracle, Its Responses and Operations, with a Catalogue of Responses* (Berkeley, Los Angeles and London: University of California Press, 1978); Parke, H., *Greek Oracles* (London: Hutchinson, 1967); Parke, H. W. and Wormell, D. E. W., *The Delphic Oracle. Vol. I: The History; Vol. II: The Oracular Responses* (Oxford: Blackwell, 1956). Scott, M., *Delphi: A History of the Center of the Ancient World* (Princeton and Oxford: Princeton University Press, 2014).

112 Herodotus 7.220.4.

113 Herodotus 7.148.3.

114 Herodotus 7.148.4–152.3.

115 Herodotus 7.140.2–3.

116 Herodotus 7.141.3–4.
117 Herodotus 8.51.2.
118 Herodotus 7.153–171; Diodorus Siculus 11.15.1.
119 Herodotus 7.147.1.
120 Herodotus 7.145.1; Pausanias 3.12.6.

Chapter 9

1 Philostratus, *Life of Apollonius* 1.25.2.
2 See p. 201.
3 Herodotus 7.38–9.
4 Herodotus 7.40–1.
5 Herodotus says that Xerxes entered the territory of Ilium with Mt Ida 'on his left' (7.42). This is unlikely, and hard to explain: see Rookhuijzen, *Herodotus and the Topography of Xerxes' Invasion*, pp. 61–5.
6 See Bowie, 'Mythology and the Expedition of Xerxes', pp. 275–6; Rookhuijzen, *Herodotus and the Topography of Xerxes' Invasion*, pp. 65–7.
7 Herodotus 7.43.2. See Rookhuijzen, *Herodotus and the Topography of Xerxes' Invasion*, pp. 67–78.
8 Herodotus 7.44.
9 See pp. 194–6.
10 Herodotus 7.45–50.
11 Herodotus 7.51–53.1
12 Herodotus 7.54.3.
13 Aeschylus, *Persians* 68–131.
14 Herodotus 7.55.
15 Herodotus 7.56.1.
16 In reality it would have taken considerably longer.
17 Ancient scientific writers were sceptical about whether this could really happen: see Aristotle, *Historia Animalium*, 6.24; Varro, *De Re Rustica*, 2.1.28. See Mitchell, F. S., 'Monstrous Omens in Herodotus' Histories', *Proceedings of the Annual Meeting of Postgraduates in Ancient Literature 2013*, http://ojs.st-andrews.ac.uk/index.php/ampal/article/view/690/579 [accessed 5 February 2021].
18 Apollodorus 2.5.9. He was a son of Poseidon, not the more famous Sarpedon, son of Zeus, who was slain at Troy; cf. Strabo, 7, fr. 52. See Bowie, 'Mythology and the Expedition of Xerxes', p. 276. Cape Sarpedon is the modern Gremea or Paxi headland, 12 km from Ergene in Turkey.
19 Herodotus 7.115; Livy 39.27. See Hammond, N. G. L., 'The Expedition of Xerxes', in Boardman, J., Hammond, N. G. L., Lewis, D. M. and Ostwald, M. (eds), *The Cambridge Ancient History, Volume IV, Persia, Greece and the Western Mediterranean c. 525 to 479 BC* (Cambridge: Cambridge University Press, 2nd edn, 1988), p. 538; Rookhuijzen, *Herodotus and the Topography of Xerxes' Invasion*, p. 91 f.
20 Herodotus 7.60.1.
21 Herodotus 7.60.
22 Herodotus 7.87, 7.184.4.
23 Herodotus 7.89.1, 7.184.1–2.
24 Herodotus 7.184.5.
25 Herodotus 7.185–6.
26 Herodotus 7.187.
27 XPh §3. See *Achaemenid Royal Inscriptions: XPh ('Daiva inscription')* – Livius, https://www.livius.org/sources/content/chaemenid-royal-inscriptions/xph/ [accessed 7 February 2021]; Kent, R. G. 'The Daiva-Inscription of Xerxes', *Language* 13:4 (1937), pp. 292–305.

28 See Gainsford, P., 'Herodotus' Homer: Troy, Thermopylae, and the Dorians', in Matthew, C. A. and Trundel, M. (eds), *Beyond the Gates of Fire: New Perspectives on the Battle of Thermopylae* (Barnsley: Pen & Sword Military, 2013), pp. 117–37.
29 Herodotus 7.61–2.1, 7.83.
30 Herodotus 7.65.
31 Herodotus 7.62.2–67.
32 Herodotus 69–71.
33 Or 'spears made in Lycia'.
34 Herodotus 7.72–9.
35 Herodotus 7.80; PF 1352.8–9.
36 Herodotus 7.81–2.
37 Herodotus 7.85, cf. 1.125.4; DB §33.
38 Herodotus 7.84–6.
39 Herodotus 7.89–90. See p. 138.
40 Herodotus 7.91–2.
41 Herodotus 7.93–5.
42 Herodotus 7.99. See pp. 290 f., 305 f., 319 f. For Artemisia as a sexy 'sea-fighter', see Aristophanes, *Lysistrata* 675, *Women at the Thesmophoria* 1200.
43 Cf. Tyrtaeus fr. 10.15–32 (Gerber, *Greek Elegiac Poetry*) = Lycurgus, *Against Leocrates* 107 (quoted on p. 94), fr. 12, 10–20 (Gerber, *Greek Elegiac Poetry*) = Stobaeus 4.10.6; Homer, *Odyssey* 17.210–34; Aristotle, *Nicomachean Ethics* 1169a–b.
44 Herodotus 7.101–5.
45 *Parian Chronicle*, FGrH 239.51; cf. Herodotus 8.51.
46 Herodotus 7.121.2–3.
47 Herodotus 7.110–111.1. See Tuplin, C. J., 'Xerxes' March from Doriscus to Therme', *Historia: Zeitschrift Für Alte Geschichte* 52:4 (2003), pp. 385–409.
48 Herodotus 7.114.1 and p. 198. See Catling, H. W. 'Archaeology in Greece, 1976–77', *Archaeological Reports* 24 (1977), pp. 3–69.
49 Herodotus 7.114.2. See Rookhuijzen, *Herodotus and the Topography of Xerxes' Invasion*, pp. 95–101.
50 Herodotus 7.116. For Persian gift-giving, see Kuhrt, *The Persian Empire*, pp. 633–43, 658–66.
51 Herodotus 7.118–20.
52 Herodotus 7.122–7.
53 Herodotus's vagueness has generated considerable scholarly discussion about the geography here. See Rookhuijzen, *Herodotus and the Topography of Xerxes' Invasion*, pp. 110–13.
54 Herodotus 7.131.
55 Herodotus 7.172.
56 Herodotus 7.173.1; Thucydides 1.132.2; Plutarch, *Aristides* 21.1, *Themistocles* 23.
57 Herodotus 9.81. See Stephenson, P., *The Serpent Column: A Cultural Biography* (New York: Oxford University Press, 2016).
58 Thucydides 1.132.2; cf. Diodorus Siculus 11.33.2.
59 GHI, no. 27, pp. 57–60. See Stephenson, *The Serpent Column*, pp. 8–15.
60 Pausanias 5.23.1–2; cf. Herodotus 9.28–31.
61 See Meritt, B. J., Wade-Gery, H. T. and McGregor, M. F., *The Athenian Tribute Lists, Vol. III* (Princeton: The American School of Classical Studies at Athens, 1950), pp. 95–105.
62 Herodotus 8.46.3, 5.30–4, 9.97; Simonides, *AP* 6.2. See pp. 286, 310.
63 Herodotus 8.82.1.
64 Herodotus 8.129, 9.28.3.
65 Herodotus 9.77.
66 Herodotus 8.2.2.
67 Herodotus 8.3.1.
68 Herodotus 8.3.1.
69 Herodotus 7.132.2.
70 Aristotle, *Constitution of the Athenians* 22.8; Plutarch, *Themistocles* 11.1.

71 *GHI*, no. 23, pp. 48–52, ll. 44 ff.; Jameson, M., 'A Decree of Themistocles from Troizen', *Hesperia* 29 (1960), pp. 198–223; Epigraphical Museum, Athens, EM 13330.

72 Cf. Herodotus 8.51.2, where those who remained at Athens are 'treasurers of the shrine and poor men'.

73 *GHI*, no. 23, pp. 48–52, ll. 4–18.

74 Herodotus 8.41.1; Diodorus Siculus 11.13.3; Plutarch, *Themistocles* 10.1–3.

75 The opening wording 'Themistocles son of Neocles from the deme of Phrearrhioi proposed the motion', using the proposer's patronymic and deme, is not normal prior to about 350 BCE.

76 See Burn, *Persia and the Greeks*, pp. 364–77; Robertson, N., 'The Decree of Themistocles in its Contemporary Setting', *Phoenix* 36 (1982), pp. 144; Hammond, 'The Expedition of Xerxes', pp. 558–63; Lazenby, *The Defence of Greece 490–479 BC*, pp. 102–4; Cawkwell, G., *The Greek Wars: The Failure of Persia* (Oxford: Oxford University Press, 2005), pp. 277–80; Bowie, A. M., *Herodotus: Book VIII* (Cambridge: Cambridge University Press, 2007), p. 131 f.

77 Plutarch, *Themistocles* 10.5–6.

78 *GHI*, no. 23, pp. 48–52, ll. 18–44.

79 Herodotus 8.51.2.

80 See pp. 194–6.

81 Herodotus 7.172.1. See p. 193.

82 Plutarch, *Themistocles* 7.1–2.

83 Herodotus 7.176.2. See Rookhuijzen, *Herodotus and the Topography of Xerxes' Invasion*, p. 154 f.; Kraft, J. C., Rapp Jr, G., Szemler, G., Tzavios, C. and Kase, E. W., 'The Pass at Thermopylae, Greece', *Journal of Field Archaeology* 14:2 (1987), p. 183, n. 2.

84 Herodotus 7.176.1, 8.2.1; Plutarch, *Themistocles* 8.2–3; *IG* XII.9, 1189.

85 Herodotus 7.178; Clement of Alexandria, *Stromata* 753.

86 Aristotle, *On the Cosmos* 395a.

87 Herodotus 7.179–82.

88 Homer, *Iliad* 19.1–2.

89 Herodotus 7.188–91.

90 There is considerable scholarly dispute concerning the whereabouts of Aphetae. See Rookhuijzen, *Herodotus and the Topography of Xerxes' Invasion*, pp. 140–3.

91 Herodotus 7.194–5.

92 Herodotus 7.198–201; Strabo 9.3.7, 9.4.17; cf. Herodotus 7.176.2, quoted on p. 240.

Chapter 10

1 Herodotus 8.26.3.

2 Herodotus 7.204; Plutarch, *Themistocles* 7.3, 11.2; cf. Herodotus 7.145.2–52, 153–62, 9.26–28.1. For Leonidas becoming king of Sparta, see p. 116.

3 Not all modern authorities accept the bribery story, probably rightly. The Greeks could just have easily stayed because it made sound strategic sense. See Hammond, 'The Expedition of Xerxes', p. 552; Shepherd, *The Persian War in Herodotus and Other Ancient Voices*, pp. 229–31.

4 Cf. Herodotus 8.57–8, 8.75, 8.79–80, 8.110.

5 Herodotus 8.4–5; Plutarch, *Themistocles* 7.4–5.

6 Herodotus 8.6.2. For the nuances of the expression, see Bowie, *Herodotus: Book VIII*, p. 97.

7 See e.g. Shepherd, *The Persian War in Herodotus and Other Ancient Voices*, p. 231.

8 Herodotus 8.7. Losses: Herodotus 7.183.2, 7.190, 7.194; gains: Herodotus 7.185.1.

9 Herodotus 8.8; Pausanias 10.19.1–2; Apollonides, *AP* 9.296. See Frost, F., 'Scyllias: Diving in Antiquity', *Greece and Rome* 15:2 (1968), pp. 180–5.

10 See p. 131 f.

11 Herodotus 8.10–11.2.

12 Herodotus 8.11.3; Diodorus Siculus 11.12.6.

13 Herodotus 8.13; cf. Diodorus Siculus 11.13.1.

14 The location is hard to pinpoint. See Strabo 10.1.2; Livy 31.47; Bowie, *Herodotus: Book VIII*, p. 106; Rookhuijzen, *Herodotus and the Topography of Xerxes' Invasion*, pp. 143–8.

15 Herodotus 8.124.

16 See pp. 268–70.

17 XPl §2b; cf. DNb §2b.

18 Plutarch, *Themistocles* 8.1.

19 Suda s.v. 'Simonides'.

20 Plutarch, *Themistocles* 8.3 = Bergk, T., *Poetae Lyrici Graeci* (London: Heinemann, 1914), vol. iii (4), p. 480. Cf. Plutarch, *On the Malignity of Herodotus* 867f. It has been suggested that the temple itself was a victory monument. See Rookhuijzen, *Herodotus and the Topography of Xerxes' Invasion*, p. 139.

21 Pindar fr. 77 (Bergk, *Poetae Lyrici Graeci*); cf. Plutarch, *On the Glory of the Athenians* 7.350.

22 Herodotus 8.20.2.

23 Herodotus 7.207.

24 Herodotus 7.176.3.

25 See Rapp, G., 'The Topography of the Pass at Thermopylae Circa 480 BC', in Matthew, C. A and Trundel, M. (eds), *Beyond the Gates of Fire: New Perspectives on the Battle of Thermopylae* (Barnsley: Pen & Sword Military, 2013), pp. 39–59; Carey, C., *Great Battles: Thermopylae* (Oxford: Oxford University Press, 2019), pp. 23–34.

26 Herodotus 7.176.3.

27 Herodotus 7.176.4; Diodorus Siculus 11.6.4.

28 Herodotus 7.177.

29 Herodotus 7.176.5.

30 Marinatos, S., 'Forschungen in Thermopylai', in Wenger, M. (ed.), *Bericht über den VI internationalen Kongress für Archäologie, Berlin 21–26 August 1939* (Berlin: De Gruyter, 1940), p. 336 f.; Marinatos, S., *Thermopylae: An Historical and Archaeological Guide* (Athens: Greek Archaeological Service, 1951), pp. 56–9; Rapp, G., 'The Topography of the Pass at Thermopylae Circa 480 BC', pp. 39–59; Carey, *Great Battles*, pp. 31 f.

31 This has led some scholars to wonder whether the pass at Thermopylae was accessible at all, and to suggest that Herodotus is simply presenting us with a traditional, quasi-mythologised tale. See e.g. Kase, E. W. and Szemler, G. J., 'Xerxes' March through Phokis (Her. 8, 31–35)', *Klio* 64 (1982), pp. 353–66; Szemler, G. J., 'The Great Isthmus Corridor, Delphi, Thermopylae: Centers of Resistance against Great Powers in North-Central Greece', in Yuge, T. and Doi, M. (eds), *Forms of Control and Subordination in Antiquity* (Leiden: Brill, 1986), pp. 553–66. In opposition see Pritchett, W. K., *Studies in Ancient Greek Topography: Part IV (Passes)*, Classical Studies 28 (Berkeley: University of California Press, 1982), pp. 211–33; Pritchett, W. K., *Studies in Ancient Greek Topography: Part V*, Classical Studies 32 (Berkeley: University of California Press, 1985); Pritchett, W. K., *The Liar School of Herodotus* (Amsterdam: Gieben, 1993), pp. 317–28. For an overview of the debate see Albertz, A., *Exemplarisches Heldentum. Die Rezeptionsgeschichte der Schlacht an den Thermopylen von Antike bis zur Gegenwart* (Munich: R. Oldenbourg Verlag, 2006), pp. 37–39; Rookhuijzen, *Herodotus and the Topography of Xerxes' Invasion*, pp. 54–6.

32 For discussions see e.g. Carey, *Great Battles*, pp. 57–62; Matthew, C. A., 'Was the Greek Defence of Thermopylae in 480 BC a Suicide Mission?', in Matthew, C. A. and Trundel, M. (eds), *Beyond the Gates of Fire: New Perspectives on the Battle of Thermopylae* (Barnsley: Pen & Sword Military, 2013), pp. 65–71.

33 Herodotus 7.204. For the outcome, see Herodotus 7.233. For the presentation of Thebes in the story, see Cartledge, *Thebes*, pp. 95–9.

34 Herodotus 7.202–203.1

35 Pausanias 10.20.2.

36 Diodorus Siculus 11.9.2; cf. Herodotus 7.222.

37 Diodorus Siculus 11.4.6.

38 Herodotus 7.228.1.

39 Isocrates, *Panegyricus* 90.

40 Isocrates, *Archidamus* 99–100.

41 See pp. 89 f., 112 f.

42 Herodotus 7.229.1, 8.25.1. See Flower, M. A., 'Simonides, Ephorus, and Herodotus on the Battle of Thermopylae', *Classical Quarterly* 48:2 (1998), p. 368; Burn, *Persia and the Greeks*, p. 378 f.

43 Herodotus 7.224.1; Pausanias 3.14.1.

44 Cornelius Nepos, *Themistocles* 3.1.

45 Hignett, *Xerxes' Invasion of Greece*, p. 125; Burn, *Persia and the Greeks*, p. 363; How, W. W. and Wells, J., *A Commentary on Herodotus: With Introduction and Appendices, Vol. II* (Oxford: Oxford University Press, reprint with corrections, 1923), p. 85.

46 Herodotus 6.56.

47 Herodotus 7.205.2.

48 See e.g. Herodotus 1.82, 8.124, 9.64, and p. 113; Thucydides 4.125, 4.128.

49 See e.g. Cartledge, 'Hoplites and Heroes', pp. 11–27; Holladay, A. J., 'Hoplites and heresies', *Journal of Hellenic Studies* 102 (1982), pp. 94–103.

50 Plutarch, *Moralia* 234c–d.

51 Photius, *Lexicon* s.v. 'Lambda'.

52 Pausanias 4.28.5–6.

53 Photius, *Lexicon* s.v. 'Lambda' = Eupolis fr. 394.

54 See Storey, I. C., *Eupolis: Poet of Old Comedy* (Oxford: Oxford University Press, 2003).

55 See e.g. Jocelyn, H., 'A Greek Indecency and Its Students: ΛΑΙΚΑΖΕΙΝ', *Proceedings of the Cambridge Philological Society* 26 (1980), pp. 12–66; Bain, D., 'Six Greek Verbs of Sexual Congress (βινῶ, κινῶ, πυγίζω, ληκῶ, οἴφω, λαικάζω)', *Classical Quarterly* 41:1 (1991), pp. 51–77.

56 Theopompus fr. 35.

57 See Jocelyn, 'A Greek Indecency and Its Students', p. 32.

58 Aristophanes, *Women in the Assembly* 920.

59 Thucydides 5.66.3–4; cf. Thucydides 5.68.1–3; Xenophon, *Hellenica* 6.4.12, *Constitution of the Lacedaemonians* 11.4–7; van Wees, *Greek Warfare*, pp. 243–9.

60 Xenophon, *Constitution of the Lacedaemonians* 11.8–10; Arrian, *Tactica* 23.1.3, 24.2; Vegetius, *Epitome* 3.17.

61 See p. 175.

62 Thucydides 5.70.

63 National Etruscan Museum of Villa Giulia, Rome, inv. no. 22679.

64 Herodotus 6.60; Xenophon, *Constitution of the Lacedaemonians* 13.7; Tyrtaeus fr. 15 (West, *Iambi et Elegi Graeci: Vol. II*); Athenaeus 630F. See Campbell, D. A., 'Flutes and Elegiac Couplets', *Journal of Hellenic Studies* 84 (1964), pp. 63–8.

65 Herodotus 7.225.1, 9.62.2. See p. 170 for *othismos*.

66 Tyrtaeus fr. 19.2–10 (West, *Iambi et Elegi Graeci: Vol. II*) = P. Berol. 11675 fr. A col. ii. See p. 94.

67 Diodorus Siculus 11.4.3.

68 Plutarch, *Moralia* 225b–c.

69 Diodorus Siculus 11.11.4.

70 Diodorus Siculus 11.4.4.

71 Plutarch, *Moralia* 225b.

72 Pluratch, *Moralia* 225a.

73 Herodotus 7.205.2. See p. 256.

74 See e.g. Carey, *Great Battles*, pp. 66–72; Matthew, 'Was the Greek Defence of Thermopylae in 480 BC a Suicide Mission?', pp. 60–99; Cartledge, P., *Thermopylae: The Battle that Changed the World* (London: Pan Books, 2006), p. 130; Hignett, *Xerxes' Invasion of Greece*, p. 115; Grant, J. R., 'Leonidas' Last Stand', *Phoenix* 15:1 (1961), p. 25; Burn, *Persia and the Greeks*, p. 378.

75 Herodotus 7.206.

76 Herodotus 7.176.5.

77 Herodotus 7.203.1–2.
78 Herodotus 7.206, 8.12.1, 8.26, 8.40.2, 8.71–2; Scholiast on Pindar, *Olympian* 3.33a (= *FGrH* 410 T 1); Scholiast on Pindar, *Olympian* 3.35a; 3: Scholiast on Pindar, *Olympian* 3.35g; Porphyrius on *Iliad* 10.252; Hesiod, *Works and Days* 663 f.; Polyaenus, *Stratagems* 1.32.2. See Hignett, *Xerxes' Invasion of Greece*, p 448 f.; Sacks, K. S., 'Herodotus and the Dating of the Battle of Thermopylae', *Classical Quarterly* 26:2 (1976), pp. 232–48; Hammond, 'The Expedition of Xerxes', p. 548 f.; Strauss, B., *The Battle of Salamis: The Naval Encounter That Saved Greece – and Western Civilization* (New York: Simon & Schuster, 2004), p. 12.
79 Herodotus 7.206.
80 Herodotus 7.208.3.
81 Herodotus 7.209.2–3; cf. Plutarch, *Lycurgus* 22.1; Tyrtaeus fr. 10.15–32 (Gerber, *Greek Elegiac Poetry*).
82 Herodotus 7.209.4–5.
83 Diodorus Siculus 11.6.1–2.
84 Plutarch, *Moralia* 225c.
85 Diodorus Siculus 11.5.4–5.
86 Plutarch, *Moralia* 225d. The phrase has had widespread usage since antiquity, ranging from the motto of the Greek First Army Corps to a slogan used by pro-gun activists in the USA. See https://blog.gunassociation.org/molon-labe-history-true-meaning/ [accessed 4 May 2021].
87 Herodotus 7.226.2.
88 Herodotus 7.210.1; Diodorus Siculus 11.6.3–4.
89 See p. 175.
90 Herodotus 7.210.2, 7.212.1; Diodorus Siculus 11.7.1–2.
91 Herodotus 7.211.3; cf. Diodorus Siculus 11.7.4.
92 See pp. 246–9.
93 Herodotus 7.212; Diodorus Siculus 11.8.1–4.
94 See Matthew, 'Was the Greek Defence of Thermopylae in 480 BC a Suicide Mission?', pp. 76–83; Peddie, J., *The Roman War Machine* (Stroud: Sutton, 1994), p. 50; Engels, D. W., *Alexander the Great and the Logistics of the Macedonian Army* (Berkeley: University of California Press, 1978), pp. 123–30, 144–5; Roth, J. P., *The Logistics of the Roman Army at War: 246 BC–AD 235* (Boston: Brill, 1999), p. 128; Brothwell, D. and Anderson, A. T., *Diseases in Antiquity* (Springfield: Charles Thomas, 1967), p. 352; Gabriel, R., *Man and Wound in the Ancient World: The History of Military Medicine from Sumer (4000 BCE) to the Fall of Constantinople (1453 AD)* (Washington, DC: Potomac, 2011), pp. 28–35.
95 Herodotus 7.176.5.
96 See Homer, *Odyssey* 17.295–300; Aristotle, *Constitution of the Athenians* 50. Van Wees, *Greek Warfare*, p. 108.
97 Aeschylus, *Persians* 790–2.
98 Herodotus 7.213.1. Diodorus Siculus says he was a native of the region from Trachis. Herodotus (7.214) mentions a story that a Carystian called Onetes son of Phanagoras and Corydallus of Anticyra were the traitors, but he does not believe it.
99 Herodotus 7.175.2, 7.212.2, 7.219.1.
100 Herodotus 7.216; Pausanias 10.22.5. 'Black Buttock Rock' is associated with two mythical twins, called the Cercopes, who were greatly amused by Heracles' hairy buttocks. See Kershaw, *A Brief Guide to the Greek Myths*, p. 173.
101 See e.g. Carey, *Great Battles*, pp. 92–6; Shepherd, *The Persian War in Herodotus and Other Ancient Voices*, p. 253 f.; Cartledge, P., in Holland, T., *Herodotus: The Histories*, p. 695, n. 110; Hammond, 'The Expedition of Xerxes', pp. 555–7; Sánchez-Moreno, E., 'Communication Route in and Around Epicnemidian Locris', in Pasqual, J. and Papakonstantinou, M.-F. (eds), *Topography and History of Ancient Epicnemidian Locris* (Leiden: Brill, 2013), pp. 279–335; Waters, *Ancient Persia*, p. 127; Rookhuijzen, *Herodotus and the Topography of Xerxes' Invasion*, pp. 158–62.
102 Herodotus 7.219.1–2; Diodorus Siculus 11.8.5.

103 Herodotus 7.220.2; cf. Diodorus Siculus 11.9.1.
104 Homer, *Iliad* 9.413.
105 Herodotus 7.222.
106 Diodorus Siculus 11.9.4.
107 Diodorus Siculus 11.10.4; Plutarch, *On the Malice of Herodotus* 866A–B.
108 See Carey, *Great Battles*, pp. 92–6; Shepherd, *The Persian War in Herodotus and Other Ancient Voices*, p. 107 f.
109 Herodotus 7.223.1.
110 Herodotus 7.223.1–224.1.
111 Herodotus 7.233. For Theban Medism, see Cartledge, *Thebes*, pp. 94–103; Bradford, E., *Thermopylae: The Battle for the West* (New York: Da Capo Press, 1980), p. 143.
112 Herodotus 7.225.3.
113 See Marinatos, 'Forschungen in Thermopylai', pp. 333–41; Marinatos, *Thermopylae*, p. 64. Others are more sceptical. See e.g. Rookhuijzen, *Herodotus and the Topography of Xerxes' Invasion*, pp. 162–8.
114 Herodotus 7.238.1.
115 Diodorus Siculus 11.12.1; cf. Herodotus 1.166.1–2; Plato, *Laws* 641c. See also Liddell, H. G. (compiler), Scott, R. (compiler), Jones, H. S. (ed.) and McKenzie, R. (ed.), *A Greek–English Lexicon* (9th edn, New York: Oxford University Press, 1995); Kershaw, *Barbarians*, p. 70.
116 Herodotus 8.24–5.
117 Herodotus 7.228.1, quoted on p. 255; cf. Diodorus Siculus 11.33.2.
118 Herodotus 7.228.2 = *Greek Anthology* 7.249; cf. Diodorus Siculus 11.33.2.
119 Simonides fr. 4 (Bergk, *Poetae Lyrici Graeci*), quoted by Diodorus Siculus 11.11.6.
120 Herodotus 7.213.2–3.
121 Herodotus 7.229–232.
122 Diodorus Siculus 11.11.5.

Chapter 11

1 Aeschylus, *Persians* 433–4.
2 Herodotus 8.21.2.
3 Herodotus 7.22.1, which implies that there was just one inscription at Artemisium; Plutarch, *Themistocles* 9.1–2 has them in multiple locations.
4 Herodotus 8.22.1–2.
5 Herodotus 8.26.3.
6 Herodotus 7.235.
7 Herodotus 7.236–7.
8 E.g. Hignett, *Xerxes' Invasion of Greece*, p.134–41; Shepherd, *The Persian War in Herodotus and Other Ancient Voices*, p. 291 f.
9 Herodotus 8.27–31.
10 Sherman, W. T., *Memoirs of General William T. Sherman*, 2 vols (New York: Da Capo Press, 1984), cited in Crane, G., *Thucydides and the Ancient Simplicity: The Limits of Political Realism* (Berkeley: University of California Press, 1998).
11 For the route, see Kase, E. W., Szemler, G. J., Wilkie, N. C. and Wallace, P. W. (eds), *The Great Isthmus Corridor Route: Explorations of the Phokis-Doris Expedition, Vol. I* (Dubuque: University of Minnesota Publications Studies, 1991); Tuplin, 'Xerxes' March from Doriscus to Therme', pp. 385–409; Rookhuijzen, *Herodotus and the Topography of Xerxes' Invasion*, pp. 169–77.
12 Herodotus 8.32; Diodorus Siculus 11.14.1; Pausanias 10.32.8
13 Herodotus 8.33. For the possible locations, see McInerney, J., *The Folds of Parnassus: Land and Ethnicity in Ancient Phokis* (Austin: University of Texas Press, 1999), pp. 256–306;

Rookhuijzen, *Herodotus and the Topography of Xerxes' Invasion*, p. 171, n. 474, with references.

14 Herodotus 8.27.5, 8.134; Pausanias 10.35.1–3.
15 Herodotus 8.33.
16 Herodotus 8.34.1, 8.50.2; Diodorus Siculus 11.14.5.
17 Herodotus 8.35.2; Diodorus Siculus 11.14.2; Ctesias in Photius, *Bibliotheca* 72.39b.
18 See Kershaw, *A Brief Guide to Classical Civilization*, pp. 151–5; Scott, *Delphi*.
19 Herodotus 7.140, 7.141–2, 7.148.2–4, 7.169, 7.220.3–4. See pp. 215–7.
20 Herodotus 7.36.2; Aeschylus, *Eumenides* 21; Euripides, *Bacchae* 559; Pausanias 10.32.2–7; Strabo 9.3.1.
21 Herodotus 8.37–9; Diodorus Siculus 11.14.3–4.
22 Diodorus Siculus 11.14.4 = *SEG* 28.495.2.
23 See pp. 278–81.
24 Herodotus 8.71–3; Plutarch, *Themistocles* 9.3.
25 Plutarch, *Themistocles* 9.4.
26 See Kershaw, *A Brief Guide to the Greek Myths*, pp. 258–67.
27 Herodotus 8.51–3; Aeschylus, *Persians* 347–9 (where the city is not sacked); Diodorus Siculus 11.14.5.
28 See Hurwit, J. M., *The Athenian Acropolis: History, Mythology, and Archaeology from the Neolithic Era to the Present* (Cambridge: Cambridge University Press, 1999), p. 135 f.; Bowie, *Herodotus: Book VIII*, p. 141; Rookhuijzen, *Herodotus and the Topography of Xerxes' Invasion*, pp. 189–207.
29 Sophocles, *Oedipus at Colonus* 694–702; cf. Dionysius of Halicarnassus 14.4.
30 Two hundred and seventy-one triremes at Artemisium, reinforced by 53 Athenian triremes – 324 (not including the 9 pentecontcrs): Herodotus 8.2, 8.14.1; 378 triremes at Salamis (not including 4 pentecontcrs). The additional states were Hermione, Ambracia, Leucas, Naxos, Cynthus, Seriphos, Siphnos, Melos and Croton.
31 Hyperides, *Against Diondas* 145v, 12–16, numbers the Athenian contingent at 220, possibly including the 20 ships they provided for the Chalcidians.
32 See Simonides, *AP* 6.2 = XIXa Page.
33 Herodotus 8.42–8; *IG* I² 655.
34 Herodotus 8.49; Diodorus Siculus 11.15.2–3.
35 Herodotus 8.56–8, 8.60; Diodorus Siculus 11.15.4.
36 Herodotus 8.64.1.
37 Plutarch, *Themistocles* 11.3.
38 Plutarch, *Themistocles* 11.5.
39 Herodotus 8.59. Plutarch, *Themistocles* 11.2–3, makes the exchange between Themistocles and Eurybiades.
40 Plutarch, *Themistocles* 14.3, says the Greek vessels were lighter and lower.
41 Herodotus 8.60β; Diodorus Siculus 11.15.4; cf. Plutarch, *Themistocles* 12.3; Aeschylus, *Persians* 413.
42 Herodotus 8.60–1; Plutarch, *Themistocles* 11.3–5.
43 Herodotus 8.62.
44 Herodotus 8.64–5. Plutarch, *Themistocles* 15.1, makes the omen happen in the middle of the battle.
45 Plutarch, *Themistocles* 12.1.
46 See e.g. Shepherd, *The Persian War in Herodotus and Other Ancient Voices*, pp. 229–31; Rookhuijzen, *Herodotus and the Topography of Xerxes' Invasion*, pp. 234–7.
47 Herodotus 8.71.1.
48 Herodotus 8.97.1; Ctesias, *Persica*, *FGrH* 688 F 13 (30); Plutarch, *Themistocles* 16.1; Strabo 9.1.13.
49 For his dress, see p. 68 f.
50 Herodotus calls them 'kings', although their names do not match with any known monarchs of the cities: Tabnit or Eshumanazar ruled Sidon at this time, and it is not known who ruled Tyre.

51 Herodotus 7.99.1. See p. 305 f.

52 Herodotus 8.68α1, 8.88.3, 8.93.2.

53 Herodotus 8.68γ.

54 Herodotus 9.10.4. See Broneer, O., *Temple of Poseidon. Isthmia: Volume I (Excavations by the University of Chicago under the Auspices of The American School of Classical Studies at Athens)* (Princeton: American School of Classical Studies at Athens, 1971), pp. 3 ff.

55 Herodotus 8.70.2; Diodorus Siculus 11.16; cf. Plutarch, *Themistocles* 12.

56 Plutarch, *Themistocles* 12.3.

57 Aeschylus, *Persians* 353–60.

58 Herodotus 8.75; Plutarch, *Themistocles* 12.4. Diodorus Siculus, 11.17.1, does not name him or provide details about him. For the *paidagogos* see Kershaw, *A Brief Guide to Classical Civilization*, pp. 127–30.

59 Most likely Salamis, although some scholars favour the smaller island now known as Agios Giorgios in the strait just off Salamis.

60 Aeschylus, *Persians* 361–73; cf. Plutarch, *Themistocles* 12.5.

61 See p. 247.

62 Diodorus Siculus 11.17.3.

63 See Wallinga, H. T., *Xerxes' Greek Adventure: The Naval Perspective* (Leiden: Brill, 2005), pp. 78–81.

64 Cawkwell, *The Greek Wars*, p. 99; cf. Hignett, *Xerxes' Invasion of Greece*, p. 231; Hammond, 'The Expedition of Xerxes', p. 579; Bowie, *Herodotus: Book VIII*, pp. 164–6; Rookhuijzen, *Herodotus and the Topography of Xerxes' Invasion*, p. 215.

65 Scholiast on Aeschylus, *Persians* 429.

66 Plutarch, *Themistocles* 12.5; Diodorus Siculus 11.17.2; Herodotus 8.76.1.

67 Pausanias 1.36.2.

68 Aeschylus, *Persians* 441–3.

69 Aeschylus, *Persians* 447–471; Plutarch, *Aristides* 9.2; Pausanias 4.36.6.

70 E.g. Hammond, 'The Expedition of Xerxes', pp. 574, favours Agios Georgios; Bowie, Herodotus: Book VIII, pp. 164–6, favours Psyttaleia/Leipsokoutali (the majority viewpoint). See also Burn, *Persia and the Greeks*, p. 454; Hignett, *Xerxes' Invasion of Greece*, p. 402; Wallace, P. W., 'Psyttaleia and the Trophies of the Battle of Salamis', *American Journal of Archaeology* 73:3 (1969), pp. 293–303; Shepherd, *The Persian War in Herodotus and Other Ancient Voices*, p. 326 f.; Rookhuijzen, *Herodotus and the Topography of Xerxes' Invasion*, pp. 216–21.

71 Herodotus could be referring to the island (most likely) or its main town: 8.76.2; cf. 8.86.

72 Herodotus 8.76.1.

73 Herodotus 8.76.3.

74 Aeschylus, *Persians* 357; Plutarch, *On the Glory of the Athenians* 7.

75 Herodotus 8.78.

76 Herodotus 8.78–82; Plutarch, *Themistocles* 12.6.

77 See pp. 233–5.

78 Aeschylus, *Persian* 386 f.

79 Plutarch, *Themistocles* 13.1; Herodotus 8.90.4.

80 Plutarch, *Themistocles* 13.2–3.

81 Herodotus 83.1.

82 Plutarch, *Themistocles* 15.1.

83 Aeschylus, *Persians* 392–5.

84 Aeschylus, *Persians* 396–8.

85 Herodotus 8.85.1; Diodorus Siculus 11.17.2.

86 Diodorus Siculus 11.18.1, 11.19.1.

87 Lolosa, Y. G. and Simossib, A., 'Salamis Harbour Project, 2016–2017: Summary of Results', in *'Under the Mediterranean': The Honor Frost Foundation Conference on Mediterranean Maritime Archaeology 20th–23rd October 2017 Short Report Series*, https://doi.org/10.33583/utm2020.12 [accessed 21 March 2021].

88 Hammond, 'The Expedition of Xerxes', p. 570 f.

89 Diodorus Siculus 11.18.2.
90 Plutarch, *Themistocles* 13.1.
91 Bowie, *Herodotus: Book VIII*, p. 172, n. 85.1; Shepherd, *The Persian War in Herodotus and Other Ancient Voices*, p. 333 f.; Wallinga, *Xerxes' Greek Adventure*, pp. 55–66.
92 Aeschylus, *Persians* 358; Herodotus 8.76.1. See p. 295 f.
93 Herodotus 8.42–8; Aeschylus, *Persians* 341 f., 368 f. Cf. Plutarch, *Themistocles* 14.1.
94 Morrison, Coates and Rankov, *The Athenian Trireme*, p. 59.
95 Morrison, Coates and Rankov, *The Athenian Trireme*, p. 258.
96 Pritchett, W. K., *Studies in Ancient Greek Topography: Part 1*, Classical Studies 22 (Berkeley: University of California Press, 1965), pp. 94–102 (esp. pp. 99ff.); Wallace, 'Psyttaleia and the Trophies of the Battle of Salamis', pp. 293–303.
97 Herodotus 8.87.1.
98 See Rookhuijzen, *Herodotus and the Topography of Xerxes' Invasion*, pp. 231–3.
99 Herodotus 8.94.
100 See e.g. Hignett, *Xerxes' Invasion of Greece*, pp. 411–4; Cartledge, in Holland, *Herodotus*, p. 698, n. 55; Wallinga, *Xerxes' Greek Adventure*, pp. 126–8.
101 Simonides in Plutarch, *On the Malignity of Herodotus* 39 871b; cf Athenaeus 13.573c–e; Pausanias 2.5.1; Theopompus, *FGrH*, 115, F 285; Timaeus, *FGrH* 566, F 10.
102 Plutarch, *On the Malignity of Herodotus* 39.871a.
103 Plutarch, *On the Malignity of Herodotus* 28 863e, 39.870b–71c; *GHI*, no. 27, coil 2 (see p. 256); *AP* 7.347.
104 Aeschylus, *Persians* 402–5.
105 Plutarch, *Themistocles* 14.2.
106 Zerefos, C., Solomos, S., Melas, D., Kapsomenakis, J. and Repapis, C., 'The Role of Weather during the Greek–Persian "Naval Battle of Salamis" in 480 BC', *Atmosphere* 11:8 (2020), p. 838.
107 Timotheus, *Persians* 132 f.
108 Aeschylus, *Persians* 409–11. Herodotus places the Phoenicians opposite the Athenians, so we can infer that the Greek ship was Athenian.
109 Herodotus 8.84.1; Plutarch, *Themistocles* 14.3; Diodorus Siculus 11.27.2; Aelian, *Varia Historia* 5.19; *Life of Aeschylus* 4.
110 Plutarch, *Themistocles* 14.3.
111 Plutarch, *Themistocles* 15.2.
112 Herodotus 8.84.2.
113 Diodorus Siculus 11.18.3–6.
114 Old Persian: *varu-sanhu-* - 'widely famed'.
115 Herodotus 8.85.2–3.
116 Aeschylus, *Persians* 412–8; cf. Plutarch, *Themistocles* 15.2.
117 Herodotus 8.88.3.
118 Herodotus 9.107.1.
119 Herodotus 8.90; cf. Diodorus Siculus 11.19.4, where a number of Phoenicians are executed after the battle for being the first to turn tail.
120 Aeschylus, *Persians* 441–4.
121 Herodotus 6.44.3, 8.89.1–2, 8.129; Thucydides 7.30.2. See Hall, E., 'Drowning by Nomes: the Greeks, Swimming, and Timotheus' *Persians*', in Khan, H. (ed.), *The Birth of European Identity: The Europe–Asia Contrast in Greek Thought* (Nottingham: Nottingham University Press, 2004), pp. 44–80.
122 See Rosenbloom, D., *Aeschylus: Persians* (London: Duckworth, 2006), p. 71.
123 Aeschylus, *Persians* 424–6.
124 Aeschylus, *Persians* 426 f.
125 Timotheus, *Persians* 791.31–4.
126 Diodorus Siculus 11.19.1–2.
127 Aeschylus, *Persians* 431 f.
128 Herodotus 8.95. Aeschylus does not name either the island or Aristides.
129 Aeschylus, *Persians* 456–64; Herodotus 8.95; cf. Plutarch, *Aristides* 9.1–2.

130 Aeschylus, *Persians* 436 f.
131 Aeschylus, *Persians* 470.
132 See p. 241.
133 Herodotus 8.92.
134 Aeschylus, *Persians* 428.
135 Diodorus Siculus 11.19.3.
136 Timotheus, *Persians* 791.94–7; Aeschylus, *Persians* 273–7.
137 Herodotus 8.96.2. The location of Colias is uncertain, although it was the site of a shrine to
 Aphrodite: Pausanias 1.1.5; Strabo 9.1.21; *IG* II² 5119; Aristophanes, *Clouds* 52; Aristophanes,
 Lysistrata 1–3.
138 Herodotus 8.121–3; Pausanias 2.1.7, 5.11.5, 10.14.5.
139 Plutarch, *On the Malignity of Herodotus* 39 870e.
140 Plutarch, *On the Malignity of Herodotus* 39 870e.
141 Plutarch, *Aristides* 9.2; Timotheus, *Persians* 791.196; Plato, *Menexenus* 245a; Xenophon,
 Anabasis 3.2.13; *Athenaeus* 1.37; Lycurgus, *Against Leocrates* 73; Pausanias 1.36.1; *IG* I³ 255;
 IG II² 1035.
142 Herodotus 8.93.1; Diodorus Siculus 11.27.2.
143 Plutarch, *On the Malignity of Herodotus* 39 869d.
144 Herodotus 8.125.2. In Plato's *Republic* 329e–30a the man who provokes Themistocles is an
 unnamed native of the insignificant island of Seriphos.
145 Herodotus 8.123–4; Plutarch, *Themistocles* 17.
146 Plutarch, *Themistocles* 15.2.

Chapter 12

 1 Quoted by Herodotus 9.121.3.
 2 Aeschylus, *Persians* 515–6, 532–44.
 3 Aeschylus, *Persians* 550–4.
 4 Aeschylus, *Persians* 560–3.
 5 Diodorus Siculus, 11.19.6, gives the number as not less than 400,000.
 6 Herodotus 8.101–3.
 7 Plutarch, *Themistocles* 16.1–3, makes Aristides speak against Themistocles' plans, using simi-
 lar arguments.
 8 Herodotus 8.110; Plutarch, *Themistocles* 16.4; Diodorus Siculus 11.19.5.
 9 See Marr, J., 'Themistocles and the Supposed Second Message to Xerxes: the Anatomy of a
 Legend', *Acta Classica* 38 (1995), pp. 57–69; Hammond, 'The Expedition of Xerxes', p. 583 f.
10 Herodotus 8.111–12; Aelian, *De Natura Animalium* 10.17; Plutarch, *Themistocles* 21.
11 Herodotus 8.113.1–2; Aeschylus, *Persians* 480–91.
12 Herodotus 8.113.2–3, 9.31–2.
13 Aeschylus, *Persians* 492–5; Herodotus 8.115.
14 Aeschylus, *Persians* 495–514.
15 Herodotus 8.117.
16 Herodotus 118–20.
17 Herodotus 9.108. 'Making' translates *katergasthenai*, which can also mean 'conquer', in the
 same sense as it is used in the Rolling Stones' song, '(I Can't Get No) Satisfaction' (London
 Records, 1965), where Mick Jagger is 'trying to make some girl'.
18 Rosenbloom, *Aeschylus*, p. 122.
19 Aeschylus, *Persians* 917–52.
20 Aeschylus, *Persians* 957–1002.
21 Aeschylus, *Persians* 1017.
22 Aeschylus, *Persians* 1038–62.
23 Aeschylus, *Persians* 1046. See Rosenbloom, *Aeschylus*, p. 136 f.

24 Aeschylus, *Persians* 1075 f.

25 Herodotus 7.114.2.

26 See the punishment of Cicantakhama by Darius, DB ii.33, p. 62.

27 Herodotus 9.108–13; cf. Ctesias, *Persica* = *FGrH* 688 F 14.

28 See p. 70.

29 Reichterter, K. et al., 'Holocene tsunamigenic sediments and tsunami modeling in the Thermaikos Gulf area (northern Greece)', *Zeitschrift für Geomorphologie* 54 (Suppl. 3) (2010), pp. 99–126; Reichterter, K., et al., 'The first description of a tsunami in 479 BC by Herodotus: sedimentary evidence in the Thermaikos Gulf (Greece)', paper presented at the annual meeting of the Seismological Society of America in San Diego, 19 April 2012. Cf. Šmid, T. C., 'Tsunamis in Greek Literature', *Greece & Rome*, Second Series, 17:1 (1970), pp. 100–4. Guidoboni, E., Comastri, A. and Traina, G., *Catalogue of Ancient Earthquakes in the Mediterranean Area up to the 10th Century* (Bologna: SGA Storia Geofisica Ambiente, 1994); Papadopoulos, G. A., 'Tsunamis in the East Mediterranean: A catalogue for the area of Greece and adjacent seas', *Proc. IOC-IUGG International Workshop Tsunami Risk Assessment Beyond 2000: Theory, Practice and Plans, June 14–16, Moscow, 2000* (2001), pp. 34–43.

30 Four hundred, according to Diodorus Siculus 11.27.1.

31 If an emendation of Herodotus's text is correct.

32 Diodorus Siculus 11.34.2 puts the figure at 250.

33 Herodotus 3.132.3.

34 Herodotus 8.130–1; Diodorus Siculus 11.27.3.

35 Herodotus 8.136.1.

36 See Kottardi, A. and Walker, S. (eds), *Heracles to Alexander the Great: Treasures from the Royal Capital of Macedon, A Hellenic Kingdom in the Age of Democracy* (Oxford: Ashmolean Museum of Art and Archaeology University of Oxford, 2011).

37 Pindar fr. 120–1; Bacchylides fr. 20B; Thrasymachus 85 B 2 DK; Herodotus 5.22; Hesiod fr. 7; Thrasymachus, *FGrH* 4; Hellanicus F 74. See Kershaw, *Barbarians*, pp. 116–8.

38 Herodotus 8.140–1; Plutarch, *Aristides* 10.1–6.

39 Herodotus 8.143.2; cf. Plutarch, *Aristides* 10.6.

40 Herodotus 8.144.

41 Herodotus 8.144; Diodorus Siculus 11.28.1–2.

42 'From the time the battle in Plataea took place, the Athenians versus Xerxes' commander Mardonius, which the Athenians won, and Mardonius died in the battle, and the fire erupted [in] Sicily at [Mount] Etna, 216 years [= 480/479], when Xantippus [*sic*] was archon in Athens', *Parian Chronicle*, *FGrH* 239.52.

43 Herodotus 8.144; Diodorus Siculus 11.28.3.

44 Herodotus 9.3.1; Aeschylus, *Agamemnon* 281–316.

45 Herodotus 9.3; Diodorus Siculus 11.28.5–6; Thucydides 1.89.3; Pausanias 1.18.1, 1.20.2.

46 Later tradition calls him Cyrsilus and places the incident before the Battle of Salamis: Demosthenes, *On the Crown* 204.

47 Herodotus 9.4–5.

48 Herodotus 9.6–11; Diodorus Siculus 11.28.5; Plutarch, *Aristides* 10.7–8, 20.1. The precise make-up of the delegation, or possibly delegations, is unclear: see Flower, M. A. and Marincola, J. (eds), *Herodotus: Histories Book IX* (Cambridge: Cambridge University Press, 2002), p. 109. Only four of the ten generals for 479/478 are known – Xanthippus and Aristides, plus possibly Myronides and Leocrates.

49 Herodotus 9.7.1; Pausanias 3.19.3; Athenaeus 4.139d–f.

50 Plutarch, *Aristides* 11.3–5.

51 Herodotus 9.9.

52 Simonides fr. 11.29–34 (West, *Iambi et Elegi Graeci: Vol. II*). Menelaus and the 'sons of Zeus' Castor and Polydeuces accompanied the army either as carved images or in divine epiphany.

53 Herodotus 9.11.1–2; Plutarch, *Aristides* 10.7–8.

54 Herodotus 9.12.

55 Herodotus 9.14; Pausanias 1.40.2, 1.44.6.

56 Herodotus 9.15.1–2.

57 Herodotus 9.15.3.
58 Based on comparisons with later Roman legionary encampments. See Burn, *Persia and the Greeks*, p. 511.
59 Herodotus 9.16.
60 See pp. 254 f., 263, 268–70, 280 f.
61 Herodotus 9.17.4.
62 Herodotus 9.19.1; Simonides fr. 11.35–41 (West, *Iambi et Elegi Graeci: Vol. II*).
63 See e.g. Stylianou, P. J., *A Historical Commentary on Diodorus Siculus Book 15* (Oxford: Oxford University Press, 1998), pp. 49–139.
64 Diodorus Siculus 11.29.2; Lycurgus, *Against Leocrates* 81; Tod, M. N., *A Selection of Greek Historical Inscriptions, Vol. II* (Oxford: Clarendon Press, 1948), no. 204, pp. 303–7. See Flower and Marincola, *Herodotus: Histories Book IX*, pp. 323–5; Cartledge, P., *After Thermopylae: The Oath of Plataea and the End of the Greco-Persian Wars* (Oxford: Oxford University Press, 2013), pp. 2–30.
65 The *enomotarckhos* is a 'Leader of a Band of Sworn Soldiers'.
66 The word translated 'tithe' here really means 'completely destroy the city and dedicate 10 per cent of the spoils to the god'.
67 Based on the translations in Flower and Marincola, *Herodotus: Histories Book IX*, p. 323 f.
68 Diodorus Siculus 11.29.1; Tod, *A Selection of Greek Historical Inscriptions, Vol. II*, no. 204, ll. 39–45. Plutarch, *Aristides* 21.1, says the festival was initiated after the battle.
69 Theopompus of Chios, *FGrH* 115 F 153.
70 Flower and Marincola, *Herodotus: Histories Book IX*, p. 325; Cartledge, *After Thermopylae*, p. 29 f.
71 Herodotus 9.20.
72 Herodotus 9.21–25.1; Diodorus Siculus 11.30.2–3; Plutarch, *Aristides* 14.
73 See p. 326.
74 Plutarch, *Aristides* 11.3.
75 Plutarch, *Aristides* 11.3–9. For the shrine, see p. 342.
76 Herodotus 9.25.2–3; cf. Thucydides 3.24.1–2; Plutarch, *Aristides* 11.3, 11.8.
77 Herodotus 9.9.26.1.
78 Herodotus 9.27.5.
79 Herodotus 9.26–8.1.
80 Herodotus 9.28.2–30.
81 Ctesias, *FGrH* 688 F 13.28, puts Mardonius's force at 120,000. Diodorus Siculus, 11.30.1, puts the total number of the Greeks at around 100,000 and the Barbarians at 500,000. Modern estimates range from 120,000 to as low as 30,000.
82 Herodotus 9.31–2.
83 Herodotus 9.32.2.
84 Plato, *Laches* 199a.
85 Herodotus 9.33–36. Tisamenus's other four victories were at Tegea (*c.* 473–470), Dipaea (*c.* 470–465), probably Mt Ithome (465) and Tanagra (458 or 457).
86 Herodotus 9.37–9; cf. Plutarch, *Aristides* 15.1.
87 Plutarch, *Aristides* 13.
88 Herodotus 9.39.
89 Herodotus 9.40.
90 At this time Thebes only contained around 25 hectares within its wall, which would only accommodate a fraction of the entire Persian army.
91 Herodotus 9.40.
92 Herodotus 9.42.3–4.
93 See pp. 281–3.
94 Herodotus 9.42.4; Euripides, *Bacchae* 1336–8.
95 A local river that flows to the north-west of Thebes.
96 Herodotus 9.43.2.
97 See p. 321.
98 Herodotus 9.44–5; Plutarch, *Aristides* 15.2–5.

99 Herodotus 9.46–7; Plutarch, *Aristides* 16.

100 See p. 113 f.

101 Herodotus 9.48–9.1. See Flower and Marincola, *Herodotus: Histories Book IX*, p. 196 f.

102 Herodotus 9.49.2–50; Plutarch, *Aristides* 16.6.

103 Herodotus 9.51.

104 Plutarch, *On the Malignity of Herodotus* 872b–c. Plutarch thinks Herodotus is being unfair to the Greeks at this point.

105 Herodotus 9.52; Plutarch, *Aristides* 17.1. See Rookhuijzen, *Herodotus and the Topography of Xerxes' Invasion*, pp. 259–62.

106 For the Spartan *lokhoi* see p. 259. Thucydides 1.20.3 states unequivocally that there was no such thing as the *lokhos* of Pitana. See Cartledge, *Sparta and Lakonia*, pp. 255–7.

107 Herodotus 9.54; Plutarch, *Aristides* 17.2–3.

108 See Rookhuijzen, *Herodotus and the Topography of Xerxes' Invasion*, pp. 262–8.

109 Plutarch, *Aristides* 11.6.

110 *IG* VII.1670, *IG* VII.1671. Pritchett, *Studies in Ancient Greek Topography: Part 1*, pp. 104–5, 109–10, pl. 96–7.

111 *IG* VII.1670. See Flower and Marincola, *Herodotus: Histories Book IX*, pp. 207, 320–2. The inscription is now in the Thebes Museum, inv. no. 202.

112 Herodotus 9.55–6.

113 Herodotus 9.58–9; Plutarch, *Aristides* 17.4.

114 Herodotus 9.60.

115 Herodotus 9.61.1; Plutarch, *Aristides* 17.4–5.

116 Plutarch, *Aristides* 17.7; Herodotus 9.72.

117 Herodotus 9.61.2–2.1; Plutarch, *Aristides* 17.8–18.2.

118 Herodotus 9.71.2–4.

119 Herodotus 9.84.1, 9.71.1, cf. Plutarch, *Aristides* 19.1.

120 Herodotus 9.78.2.

121 Herodotus 9.79.1.

122 Pausanias 9.2.2, 1.27.1; Herodotus 9.84.1; cf. Demosthenes, *Against Timocrates* 129.

123 Herodotus 9.65.1. For differently nuanced narratives of the whole engagement, see Herodotus 9.62.2–65; Diodorus Siculus 11.31.1–2; Plutarch, *Aristides* 18.2–3.

124 Herodotus 9.77.

125 Herodotus 9.66, 8.126.1; Thucydides 1.129.1; Diodorus Siculus 11.31.1 (who gives Artabazus ten times as many troops as Herodotus does); Demosthenes, *On Organisation* 24, *Against Aristocrates* 200 (who anachronistically says that King Perdiccas of Macedon killed a lot of Barbarians).

126 Herodotus 9.73–5. Herodotus notes that there was also a more mundane version in which the anchor was just the blazon on his shield.

127 Herodotus 9.67; Diodorus Siculus 11.31.3; Plutarch, *Aristides* 19.3.

128 Herodotus 9.68–9.

129 *IG* VII.53, ll. 4–5, 9–10; cf. Herodotus 9.70.1.

130 Herodotus 9.70.1.

131 Herodotus 9.70.3; cf. Herodotus 1.66.4. Pausanias 8.45.4.

132 Herodotus 9.76; Pausanias 3.4.9.

133 Herodotus 9.64.1.

134 Diodorus Siculus 11.32.5; Herodotus 9.70.5; Ctesias, *Persica* = *FGrH* 688 F 13.30; Aeschylus, *Persians* 808.

135 Herodotus 9.70.5; Diodorus Siculus 11.33.1; Plutarch, *Aristides* 19.4–6; Cleidemus, *FGrH* 323 F 22. See Cartledge, *After Thermopylae*, p. 117.

136 Herodotus 9.71; Diodorus Siculus 11.33.1.

137 Plutarch, *Aristides* 20.1–3.

138 Herodotus 9.80, 9.83.1.

139 Herodotus 9.81.1; Diodorus Siculus 11.33.2. See pp. 233–5 for the Serpent Column and the Zeus. Nothing else is known about the Poseidon.

140 For the extreme frugality of Laconian meals, see Plutarch, *Lycurgus* 10.

141 Herodotus 9.82.3. The correct reading of the Greek manuscripts is disputed here – it is not clear whether 'leader of' should be included, and whether 'Medes' should be singular or plural.

142 Herodotus 9.85; Pausanias 9.2.4; Thucydides 2.34.5 (who says that the Athenians always buried their dead in the Kerameikos in Athens, apart from the Marathon Men. See Flower and Marincola, *Herodotus: Histories Book IX*, pp. 254–6; Rookhuijzen, *Herodotus and the Topography of Xerxes' Invasion*, pp. 269–72.

143 Simonides fr. 11.28, 33–4 (West, *Iambi et Elegi Graeci: Vol. II*). See p. 327.

144 Plato, *Laws* 707b–c.

Chapter 13

1 Thucydides 5.89; cf. Hesiod, *Works and Days* 233–11; Demosthenes, *On the Liberty of the Rhodians* 29.

2 See pp. 329, 337.

3 Herodotus 9.86–8; Diodorus Siculus 11.33.4. See Burn, *Persia and the Greeks*, pp. 545–6; Cartledge, *After Thermopylae*, pp. 101–3.

4 See p. 322.

5 See p. 117 f.

6 Herodotus 9.90.2–3; Diodorus Siculus 11.34.

7 Herodotus 9.93–6.1; Pausanias 7.5.4.

8 Herodotus 9.96.1. Diodorus Siculus, 11.19.4, says the Phoenician ships sailed directly home after Salamis.

9 Herodotus 9.96.2. Tritantaechmes had previously commanded the Medes in Greece: see pp. 224, 227, 230, 278 f. Sixty thousand seems an implausibly high number.

10 See Müller, D., *Topographischer Bildkommentar zu den Historien Herodots: Kleinasien und Angrenzende Gebiete mit Südostthrakien und Zypern* (Tübingen: Ernst Wasmuth Verlag, 1997), pp. 627–34, 674–80; Rookhuijzen, *Herodotus and the Topography of Xerxes' Invasion*, pp. 275–81; Shepherd, *The Persian War in Herodotus and Other Ancient Voices*, p. 465 f.

11 Herodotus 9.97; Diodorus Siculus 11.34.3.

12 Hebe was the goddess of Youth. Some scholars prefer to read the Greek text as 'Hera'.

13 Herodotus 9.98.3; cf. Diodorus Siculus 11.34.4–5.

14 Homer, *Iliad* 2.869.

15 Herodotus 9.99.

16 Herodotus 9.100.2; Diodorus Siculus 11.35.1.

17 Herodotus 9.90.1, 9.101–2; Diodorus Siculus 11.34.1, 11.35.2.

18 Reconciling the lunar calendars of varying Greek states with the modern Gregorian one is fraught with difficulty and dispute.

19 Herodotus 9.100–1; Diodorus Siculus 11.35.2–3; Plutarch, *Aristides* 19.4–7. See also Flower and Marincola, *Herodotus: Histories Book IX*, p. 276 f.; Grundy, G. B., *The Great Persian War and Its Preliminaries: A Study of the Evidence, Literary and Topographical* (London: John Murray, 1901), p. 526; Hignett, *Xerxes' Invasion of Greece*, p. 259; How and Wells, *A Commentary on Herodotus, Vol. II*, p. 331.

20 Diodorus Siculus 11.35.4. He already numbers their forces at 100,000 (11.34.3).

21 Herodotus 9.102–3.1.

22 Herodotus 9.105–6.

23 Herodotus 9.103.2–104.

24 Diodorus Siculus 11.36.1–7. See Flower and Marincola, *Herodotus: Histories Book IX*, p. 33.

25 Herodotus 9.104. For the first Ionian Revolt, see pp.120–45.

26 See Thucydides 1.90.

27 Diodorus Siculus 11.37.1–3.

28 Herodotus 9.114.1; cf. Herodotus 8.117.1, Thucydides 1.89 and see p. 317.

29 *Oikos*. Herodotus rather bizarrely makes the Persians speak Greek to each other – the same deception cannot be practised in their language. *Oikos* can also mean 'family'. The Old Persian word *vith-* can also mean 'house, palace, family, and clan', but not 'temple'.

30 Pausanias 3.4.6, 3.34.2; Thucydides 8.102.4. See Rookhuijzen, *Herodotus and the Topography of Xerxes' Invasion*, pp. 282–6.

31 Homer, *Iliad* 2.700–2; cf. Homer, *Iliad* 2.695–9, 15.704–6; *Cypria* fr.17, quoted by Pausanias 4.2.7; Hyginus, *Fabulae* 97, 103, 104; Apollodorus, *Epitome* 3.14, 3.30. Both his killer and his wife are variously named in the tradition, see Kershaw, *A Brief Guide to the Greek Myths*, pp. 314, 498, n. 21.

32 Herodotus 1.5.1, and see pp. 120–2.

33 Herodotus 9.120.

34 See Boedekker, D., 'Protesilaos and the End of Herodotus' "Histories"', *Classical Antiquity* 7:1 (1988), pp. 30–48; Vandiver, E., *Heroes in Herodotus: The Interaction of Myth and History* (Frankfurt am Main: Peter Lang, 1991), pp. 223–9.

35 Herodotus 9.120.1; cf. Herodotus 7.33.

36 See Gernet, L., *The Anthropology of Ancient Greece*, trans. Hamilton, J. and Nagy, B. (Baltimore and London: Johns Hopkins University Press, 1981), pp. 252–78.

37 Cf. Euripides, *Trojan Women* 764 f.

38 Thucydides 1.89.2.

39 Diodorus Siculus 11.37.6.

40 Herodotus 9.121.4.

41 Thucydides 1.94.

42 Trilingual inscription A¹Pa from Palace H at Persepolis. An inscribed silver shallow drinking bowl in the Freer Gallery of Art, Washington, DC, Smithsonian Institution, 74.30, calls him 'The Great King, King of Kings, King of Lands, son of Xerxes the King . . . the Achaemenid'.

43 Ctesias, *Persica* = FGrH 688 F 13 (33), F 14 (34); Aristotle, *Politics* 1311b; Diodorus Siculus 9.69; Justin 3.1; Babylonian tablet, BM 32234 (which says that Xerxes' son killed him). Plutarch 27.1 follows Thucydides in placing Artaxerxes on the throne, although he notes other sources who say that Xerxes was still ruling when Themistocles arrived.

44 Plutarch, *Cimon* 12.1; cf. Thucydides 1.96.1.

45 Thucydides 2.41.4.

46 Thucydides 1.23.6.

47 Plato, *Laws* 707c.

Chapter 14

1 Chateaubriand, F.-R., vicomte de, *Travels in Greece, Palestine, Egypt, and Barbary, during the years 1806 and 1807* (New York: Van Winkle and Wiley, 1814), p. 106.

2 Commemorative events took place throughout 2020, seemingly unaware that the 2500-year anniversary of 480 BCE was in 2021 (there is no year '0').

3 https://www.thermopylaesalamis2020.gr/en/#home [accessed 20 April 2021].

4 See e.g. Fuller, J. F. C., *A Military History of the Western World: From the Earliest Times to the Battle of Lepanto* (New York: Funk and Wagnalls, 1954), p. 25; Hanson, V. D., *Why the West Has Won: Carnage and Culture from Salamis to Vietnam* (London: Faber & Faber, 2001); Strauss, *The Battle of Salamis*; Holland, T., *Persian Fire: The First World Empire and the Battle for the West* (London: Little, Brown, 2005); Billows, R. A., *Marathon: How One Battle Changed Western Civilization* (New York: Overlook Duckworth, 2010); Trundel, M., 'Glorious Defeat', in Matthew, C. A. and Trundel, M. (eds), *Beyond the Gates of Fire: New Perspectives on the Battle of Thermopylae* (Barnsley: Pen & Sword Military, 2013), pp. 150–63; Cartledge, *After Thermopylae*, p. 163; Carey, *Great Battles*, pp. 163–201.

5 Aristophanes, *Birds* 1700f; Theocritus, *Idyll* 15; Plato, *Protagoras* 341c.

6 See Hall, E., *Inventing the Barbarian: Greek Self-Definition through Tragedy* (Oxford: Oxford University Press, 1989), p. 5.

7 Aristotle, *Politics* 1252b.8 ff.

8 Bodnar, E. W., *Cyriac of Ancona: Later Travels*, edited and trans. Bodnar, E. W. with Foss, C. (Cambridge, MA, and London: Harvard University Press, 2003), p. ix; Evans, J. A. S., 'Father of History or Father of Lies; The Reputation of Herodotus', *Classical Journal* 64:1 (1968), pp. 11–17.

9 Cyriac of Ancona, *Diary* V.55.

10 Cyriac of Ancona, *Diary* V.58.

11 Machiavelli, *Discourses on Livy*, Book 1, Preface, trans. The Federalist Papers Project, https://thefederalistpapers.org/wp-content/uploads/2013/08/Discourses-on-Livy.pdf [accessed 22 April 2021].

12 Machiavelli, *Discourses on Livy*, Book 2, Chapter 2, trans. The Federalist Papers Project, https://thefederalistpapers.org/wp-content/uploads/2013/08/Discourses-on-Livy.pdf [accessed 22 April 2021].

13 Montaigne, M., *Essays*, Book 3, Chapter VI, §47, trans. John Florio, *Florio's Translation of Montaigne's Essays* (London: Edward Blount, 1603).

14 Montaigne, M., *Essays*, Book 1, Chapter XXXI, §16, trans. Florio, *Florio's Translation of Montaigne's Essays*; cf. Book 1, Chapter XXXI, §19.

15 Set to a libretto by Count Nicolò Minato, first performed in the Teatro SS. Giovanni e Paolo in Venice on 12 January 1655.

16 See p. 201 f.

17 See Kimball, D., 'Operatic Variations on an Episode at the Hellespont', in Bridges, E., Hall, E. and Rhodes, P. J. (eds), *Cultural Responses to the Persian Wars: Antiquity to the Third Millennium* (Oxford: Oxford University Press, 2007), pp. 203–23.

18 Burney, C., *Charles Burney: A General History of Music* [1776–1789], ed. Mercer, F. (London, 1935), vol. ii., p. 822.

19 See Kimball, 'Operatic Variations on an Episode at the Hellespont', pp. 201–3, 223–30.

20 Perrault, C., *Le Siècle de Louis le Grand* (1687), ll. 69–70.

21 1765, first published as *Gedanken über die Nachahmung der griechischen Werke in der Malerei und Bildhauerkunst* (1755). See Evangelista, S., *British Aestheticism and Ancient Greece: Hellenism, Reception, Gods in Exile* (Basingstoke and New York: Palgrave Macmillan, 2009).

22 Rousseau, J.-J., *Du contrat social; ou, Principes du droit politique* (Amsterdam: Marc Michel Rey, 1762).

23 Glover, R., *Leonidas, a poem* (1736), Book 1, ll. 291–301, 327–46.

24 Johnson, S., *A Journey to the Western Islands of Scotland* (London: W. Strahan and T. Kadell, 1775), p. 346 f.

25 Chateaubriand, *Travels in Greece*, p. 106.

26 Attributed to Lady Caroline Lamb, after their first meeting in 1812.

27 Byron, Lord, *Childe Harold's Pilgrimage*, Canto II, ll. 693–701, 837–54.

28 Canto III came out in 1816 and Canto IV in 1818.

29 See p. 272.

30 Byron, 'The Isles of Greece', ll. 13–24, 67–72.

31 Macgregor Morris, I, 'To Make a New Thermopylae: Hellenism, Greek Liberation, and the Battle of Thermopylae', *Greece and Rome* 47 (2000), pp. 211–30; Rood, T., 'From Marathon to Waterloo: Byron, Battle Monuments, and the Persian Wards', in Bridges, E., Hall, E. and Rhodes, P. J. (eds), *Cultural Responses to the Persian Wars: Antiquity to the Third Millennium* (Oxford: Oxford University Press, 2007), pp. 267–97.

32 Bulwer-Lytton, E., *Athens: Its Rise and Fall* (London: Saunders and Otley, 1837), p. 331 f.

33 Mill, 'Review of G. Grote, *History of Greece I–II*', p. 343.

34 Creasy, E. S., *Fifteen Decisive Battles of the World from Marathon to Waterloo* (New York: Harper & Brothers, 1851), p. 13.

35 See e.g. Mahaffey, J. P., *Rambles and Studies in Greece* (London: Macmillan and co., 1876), pp. 191, 194.

36 Letter from Michel Bréal to Baron Pierre de Coubertin, 15 September 1894. See Müller, N., 'Michel Bréal (1832–1915) – The Man Behind the Idea of the Marathon', *Sport Journal* 22 (2015),https://thesportjournal.org/article/michel-breal-1832-1915-the-man-behind-the-idea-of-the-marathon/ [accessed 8 November 2021].

37 See Spathari, E. (ed.), *Mind and Body: The Revival of the Olympic Idea, 19th–20th Century* (Athens: Ministry of Culture, 1989).

38 Cavafy, C. P., 'Thermoplyae' (1903). See https://cavafy.onassis.org/object/u-71/ [accessed 30 April 2021].

39 See Vandiver, E., *Stand in the Trench, Achilles: Classical Receptions in British Poetry of the Great War* (Oxford: Oxford University Press, 2013), p. 38.

40 Proust, M., *Remembrance of Things Past, Vol. VII Time Regained*, Chapter 2: 'M. de Charlus During the War, His Opinions, His Pleasures', trans. Schiff, S. (Online: Centaur Editions, 2016), https://archive.org/details/InSearchOfLostTimeCompleteVolumes/page/n1/mode/2up [accessed 8 November 2021].

41 Garrod, H. W., *Worms and Epitaphs* (Oxford: Blackwell, 1919).

42 Kipling, R., *The Years Between* (London: Methuen, 1919); cf. letter from Rudyard Kipling to Col. C. H. Milburn, quoted in Milburn, C. H., 'Kipling's Epitaphs', *Kipling Journal* 39 (September 1936), pp. 84–95.

43 Elton, G., *Years of Peace: Poems by Godfrey Elton* (London: Allen & Unwin, 1925).

44 See e.g. Carey, *Great Battles*, pp. 111–29.

45 *Völkischer Beobachter*, quoted and translated in Carey, *Great Battles*, p. 129. See Stocking, C. and Hancock, E., *Swastika Over the Acropolis: Re-interpreting the Nazi Invasion of Greece in WWII* (Leiden: E. J. Brill, 2013).

46 'Kommst du nach Deutschland, so berichte, du habest uns in Sta!'ngrad liegen sehen, wie das Gesetz, das heißt, das Gesetz der Sicherheit unseres Volkes, es befohlen hat.' Trans. Carey, *Great Battles*, p. 184.

47 'God does not stand aloof from a just deceit' are his words: Aeschylus, *Fragm. Incert* 9. Cf. Samuel Johnson's 'Among the calamities of War may be justly numbered the diminution of the love of truth, by the falsehoods which interest dictates and credulity encourages', *Idler* 1:30 (11 November 1758), p. 169.

48 See Venetis, E., 'The Battle of Marathon and Contemporary Iran', in Buraselis, K. and Koulakiotis, E., *Marathon the Day After: Symposium Proceedings, Delphi 2–4 July 2010* (Athens: European Cultural Center of Delphi, 2013), pp. 269–74; Cuylor Young, T., 'BC – A Persian Perspective', *Iranica Antiqua* 15 (1980), pp. 213–39.

49 See Levene, D. S., 'Xerxes Goes to Hollywood', in Bridges, E., Hall, E. and Rhodes, P. J., *Cultural Responses to the Persian Wars: Antiquity to the Third Millennium* (Oxford: Oxford University Press, 2007), pp. 383–401.

50 Golding, W., *The Hot Gates: and Other Occasional Pieces* (London: Faber & Faber, 1965), p. 20.

51 Miller, F., *300* (Milwaukie: Dark Horse Books, 1998).

52 Daly, S., 'Miller's Tales', *Entertainment Weekly* (13 March 2007), https://ew.com/article/2007/03/13/how-300-went-page-screen/ [accessed 3 May 2021].

53 Nelson, R., '300 Mixes History, Fantasy', *Sci Fi Wire* (1 February 2006).

54 'Press Release Regarding the Movie 300', UN, New York, 22 March 2007, IRNA, quoted in 'Iran's UN mission: Movie *300* is full of deliberate distortions', *Islamic Republic News Agency* (22 March 2007),

55 Cf. 'واکنش مشاور رییس جمهور به فیلم *300*' [Presidential Adviser Responds to Movie *300*], *Sharif News* (16 March 2007), https://web.archive.org/web/20070316101445/http://www.sharifnews.com/?22728 [accessed 3 May 2021]; Hanson, V. D., "300' – Fact or Fiction?', *RealClear Politics* (22 March 2007), https://www.realclearpolitics.com/articles/2007/03/300_fact_or_fiction.html [accessed 3 May 2021].

56 Carey, *Great Battles*, p. 194.

57 Pressfield, S., *Gates of Fire: An Epic Novel on the Battle of Thermopylae* (London: Doubleday, 1999).

58 See e.g. Polydeykis, guitarist with Sacred Blood, interview with Dr Metal, 19 March 2014, quoted by Fletcher, K. B. F., 'Virgil's Aeneid and Nationalism in Italian Metal', in Fletcher,

K. B. F. and Umurhan, O., *Classical Antiquity in Heavy Metal Music* (London: Bloomsbury, 2020), p. 51, n. 83.

59 Aeschylus, *Persians* 402–5, quoted on p. 302.

60 See Swist, J. J., 'Why is Heavy Metal Music Obsessed with Ancient Sparta?', *Society for Classical Studies* (27 December 2019), https://classicalstudies.org/scs-blog/jeremy-j-swist/ blog-why-heavy-metal-music-obsessed-ancient-sparta [accessed 4 May 2021]. For a playlist compiled by Jeremy J. Swist of epic metal songs based on the warriors of ancient Sparta, especially their famous last stand against the Persians at Thermopylae, see https://open.spotify.com/playlist/4ohV5kdSEkhXYIA9EKnYoz?si=PGw3pKHEQPOkWmzPGjVtUQ &nd=1.

61 William Clinton, 'Speech in commemoration of UAF 93', 10 September 2011, available at https://www.youtube.com/watch?v=LolGCTdBVuc [accessed 4 May 2021]. See Langerwerf, L., '"And they did it as citizens": President Clinton on Thermopylae and United Airlines Flight 93', in Ambühl, A., (ed.), *Krieg der Sinne – Die Sinne im Krieg. Kriegsdarstellungen im Spannungsfeld zwischen antiker und moderner Kultur / War of the Senses – The Senses in War. Interactions and tensions between representations of war in classical and modern culture = Thersites* 4 (2016), pp. 243–73.

62 https://www.thermopylaesalamis2020.gr/wp-content/uploads/2020/10/%CE%94%CE%99 %CE%91%CE%9A%CE%97%CE%A1%CE%A5%CE%9E%CE%97-EN-PRINT- %CE%914.pdf [accessed 4 May 2021].

63 Simonides fr. 4 (Bergk, *Poetae Lyrici Graeci*), quoted by Diodorus Siculus 11.11.6.

64 Binyon, L., 'For the Fallen', *The Times* (21 September 1914). The italics are mine, used to emphasise the connection with Simonides.

Bibliography

Andrewes, A., *The Greek Tyrants* (London: Hutchinson, 1956).

Austin, M. M. and Vidal-Naquet, P., *Economic and Social History of Ancient Greece: An Introduction*, trans. and revised by Austin, M. M. (London: Batsford, 1977).

Balcer, J., 'The Athenian episkopos and the Achaemenid King's Eye', *American Journal of Philology* 98 (1977), pp. 252–63.

Barnes, J., *The Presocratic Philosophers* (London and New York: Routledge, revised edn, 1982).

Barron, J. P., *The Silver Coins of Samos* (London: Athlone Press, 1966).

Basilevsky, A., *Early Ukraine: A Military and Social History to the Mid-19th Century* (Jefferson: McFarland, 2016).

Bayliss, A. J., *The Spartans* (Oxford: Oxford University Press, 2020).

Beazley, J. D., *Attic Red-figure Vase-painters* (Oxford: Oxford University Press, 2nd edn, 1963).

Beckman, G. M., Bryce, T. R. and Cline, E. H., *The Ahhiyawa Texts* (Atlanta: Society of Biblical Literature, 2011).

Bicknell, P., 'The Command Structure and Generals of the Marathon Campaign', *L'Antiquité Classique* 39:2 (1970), pp. 427–42.

Bigwood, J. M., 'Ctesias as historian of the Persian Wars', *Phoenix* 32 (1978), pp. 19–41.

Billows, R. A., *Marathon: How One Battle Changed Western Civilization* (New York: Overlook Duckworth, 2010).

Blok, J., *Citizenship in Classical Athens* (Cambridge: Cambridge University Press, 2017).

Boardman, J., *Greek Gems and Finger Rings: Early Bronze Age to Late Classical* (London: Thames & Hudson, 2nd edn, 2001).

——, *Persia and the West: An Archaeological Investigation of the Genesis of Achaemenid Art* (London: Thames & Hudson, 2000).

Boardman, J., Hammond, N. G. L., Lewis, D. M. and Ostwald, M. (eds), *The Cambridge Ancient History, Volume IV, Persia, Greece and the Western Mediterranean c. 525 to 479 BC* (Cambridge: Cambridge University Press, 2nd edn, 1988).

Bockius, R. et al. (ed.), *Trireme Olympias: The Final Report: Sea Trials 1992–4, Conference Papers 1998* (Oxford and Oakville: Oxbow, 2012).

Boedeker, D. and Sider, D. (eds), *The New Simonides: Contexts of Praise and Desire* (Oxford: Oxford University Press, 2001).

Bourazelis, K. and Meidani, K. (eds), *Μαραθών: η μάχη και ο αρχαίος Δήμος / Marathon: The Battle and the Ancient Deme* (Athens: Institut du livre – A. Kardamitsa, 2010).

Bowen, A. J. (ed.), *Plutarch: The Malice of Herodotus* (Warminster: Aris & Phillips, 1992).

Bowie, A. M., *Herodotus: Book VIII* (Cambridge: Cambridge University Press, 2007).

——, 'Mythology and the Expedition of Xerxes', in Baragwanath, E. and de Bakker, M., *Myth, Truth, and Narrative in Herodotus* (Oxford: Oxford University Press, 2012), pp. 269–87.

Bradford, E., *Thermopylae: The Battle for the West* (New York: Da Capo Press, 1980).

Bridges, E., Hall, E. and Rhodes, P. J. (eds), *Cultural Responses to the Persian Wars: Antiquity to the Third Millennium* (Oxford: Oxford University Press, 2007).

Bryce, T., *The Kingdom of the Hittites* (Oxford: Oxford University Press, 2nd edn, 2005).

——, *The Trojans and their Neighbours* (London: Routledge, 2006).

Buraselis, K. and Koulakiotis, E. (eds), *Marathon the Day After: Symposium Proceedings, Delphi 2–4 July 2010* (Athens: European Cultural Center of Delphi, 2013).

Burgess, J. S., *The Tradition of the Trojan War in Homer and the Epic Cycle* (Baltimore: Johns Hopkins University Press, 2001).

Burkert, W., *Babylon, Memphis, Persepolis: Eastern Contexts of Greek Culture* (Cambridge, MA: Harvard University Press, 2004).

——, *The Orientalizing Revolution: Near Eastern Influence on Greek Culture in the Early Archaic Age*, trans. Pinder, M. E. and Burkert, W., Revealing Antiquity 5 (Cambridge, MA: Harvard University Press, 1992).

Burn, A. R., *The Lyric Age of Greece* (London: Edward Arnold, 1960).

——, *Persia and the Greeks: The Defence of the West, c. 546–478 BC* (London: Edward Arnold, 1962).

Cameron, G. G., *Persepolis Treasury Tablets* (Chicago: Oriental Institute, 1948).

Carey, C., *Great Battles: Thermopylae* (Oxford: Oxford University Press, 2019).

Carpenter, T. H. with Mannack, T. and Mendonca, M., *Beazley Addenda* (Oxford: Oxford University Press, 2nd edn, 1989).

Cartledge, P., *After Thermopylae: The Oath of Plataea and the End of the Graeco-Persian Wars* (Oxford: Oxford University Press, 2013).

——, 'City and Chora in Sparta: Archaic to Hellenistic', *British School at Athens Studies* 4 (1998), pp. 39–47.

——, 'Hoplites and Heroes: Sparta's Contribution to the Technique of Ancient Warfare', *Journal of Hellenic Studies* 97 (1977), pp. 11–27.

——, *Sparta and Lakonia: A Regional History 1300–362 BC* (London, Boston and Henley: Routledge and Kegan Paul, 2nd edn, 2001).

——, *Spartan Reflections* (London: Duckworth, 2001).

——, *The Spartans: An Epic History* (London: Pan, revised edn, 2013).

——, *Thebes: The Forgotten City of Ancient Greece* (London: Picador, 2020).

——, *Thermopylae: The Battle that Changed the World* (London: Pan Books, 2006).

Casson, L., *The Ancient Mariners* (Princeton: Princeton University Press, 2nd edn, 1991).

——, *Ships and Seamanship in the Ancient World* (Baltimore: Johns Hopkins University Press, 1995).

Cawkwell, G., *The Greek Wars: The Failure of Persia* (Oxford: Oxford University Press, 2005).

——, 'Orthodoxy and Hoplites', *Classical Quarterly* NS 39 (1989), pp. 375–89.

Cernenko, E. V., *The Scythians 700–300 BC* (London: Osprey, 1983).

Chateaubriand, F. R., vicomte de, *Travels in Greece, Palestine, Egypt, and Barbary, during the years 1806 and 1807* (New York: Van Winkle and Wiley, 1814).

Christ, M. R., 'Conscription of Hoplites in Classical Athens', *Classical Quarterly* 51:2 (2001), pp. 398–422.

Christesen, P., *Olympic Victor Lists and Ancient Greek History* (Cambridge and New York: Cambridge University Press, 2007).

Clark, J. H. and Turner, B. (eds), *Brill's Companion to Military Defeat in Ancient Mediterranean Society* (Leiden; Boston: Brill, 2017).

Coates, J. F., *The Athenian Trireme* (Cambridge: Cambridge University Press, 2nd edn, 2000).

Coleman, J. E. and Walz, C. A. (eds), *Greeks and Barbarians: Essays on the Interactions between Greeks and Non-Greeks in Antiquity and the Consequences for Eurocentrism* (Bethesda: Occasional Publications of the Department of Near Eastern Studies and the Program of Jewish Studies, Cornell University, 1997).

Cook, J. M., *The Greeks in Ionia and the East* (London: Thames & Hudson, 1962).

BIBLIOGRAPHY

Crowley, J., *The Psychology of the Athenian Hoplite: The Culture of Combat in Classical Athens* (Cambridge: Cambridge University Press, 2012).

Curtis, J., *Ancient Persia* (London: British Museum Press, 2nd edn, 2000).

Curtis, J., Sarikhani Sandmann, I. and Stanley, T., *Epic Iran: 5,000 Years of Culture* (London: V&A Publishing, 2021).

Curtis, J. and Simpson, St-J. (eds), *The World of Achaemenid Persia: History, Art and Society in Iran and the Ancient Near East* (London and New York: I. B. Tauris, 2010).

Curtis, J. E. and Tallis, N. (eds), *Forgotten Empire: The World of Ancient Persia* (London: British Museum, 2005).

Cuyler Young Jr, T., '480/79 BC – a Persian perspective', *Iranica Antiqua* 15 (1980), pp. 213–39.

Davidson, J. N., *The Greeks and Greek Love: A Radical Appraisal of Homosexuality in Ancient Greece* (London: Weidenfeld & Nicolson, 2007).

De Souza, P., *The Greek and Persian Wars 499–386 BC* (Oxford: Osprey, 2003).

Dionysopoulos, C. D., *The Battle of Marathon: An Historical and Topographical Approach* (Athens: Kapon Editions, 2016).

Dover, K. J., *Greek Homosexuality* (London: Duckworth, 1979).

Drews, R., *The Greek Accounts of Eastern History* (Cambridge, MA: Harvard University Press, Center for Hellenic Studies, 1973).

Echeverría, F., 'Hoplite and Phalanx in Archaic and Classical Greece: a Reassessment', *Classical Philology* 107:4 (2012), pp. 291–318.

Emlyn-Jones, C. J., *The Ionians and Hellenism: A Study of the Cultural Achievements of the Early Greek Inhabitants of Asia Minor* (London, Boston and Henley: Routledge & Kegan Paul, 1980).

Figueira, T. J. (ed.), *Spartan Society* (Swansea: Classical Press of Wales, 2004).

Fisher, N. R. E., *Hybris: A Study in the Values of Honour and Shame* (Warminster: Aris & Phillips, 1992).

Fleming, D. E., *Democracy's Ancient Ancestors: Mari and Early Collective Governance* (Cambridge: Cambridge University Press, 2004).

Fletcher, K. B. F. and Umurhan, O., *Classical Antiquity in Heavy Metal Music* (London: Bloomsbury, 2020).

Flower, M. A. and Marincola, J. (eds), *Histories: Histories Book IX* (Cambridge: Cambridge University Press, 2002).

Fontenrose, J., *The Delphic Oracle, Its Responses and Operations, with a Catalogue of Responses* (Berkeley, Los Angeles and London: University of California Press, 1978).

——, *Didyma: Apollo's Oracle, Cult and Companions* (Berkeley, Los Angeles and London: University of California Press, 1988).

Fornara, C. W., *Archaic Times to the End of the Peloponnesian War* (Cambridge: Cambridge University Press, 2nd edn, 1983).

Forrest, W. G., *The Emergence of Greek Democracy: The Character of Greek Politics, 800–400 BC* (London: Weidenfeld & Nicolson, 1966).

——, *A History of Sparta 950–192 BC* (London: Duckworth, 2nd edn, 1980).

Fowler, R. L., *The Cambridge Companion to Homer* (Cambridge: Cambridge University Press, 2004).

Fraser, A. D., 'The Myth of the Phalanx-Scrimmage', *Classical Weekly* 36 (1942), pp. 15–6.

Gainsford, P., '"Odyssey" 20.356–57 and the Eclipse of 1178 BCE: A Response to Baikouzis and Magnasco', *Transactions of the American Philological Association (1974–)* 142:1 (2012), pp. 1–22.

Gershevitch, I. (ed.), *The Cambridge History of Iran: The Median and Achaemenian Periods* (Cambridge: Cambridge University Press, 1985).

Goldman, B., 'Women's Robes: The Achaemenid Era', *Bulletin of the Asia Institute* NS 5 (1991), pp. 83–103.

Gould, J., *Herodotus* (London: Weidenfeld & Nicolson, 1989).

Graham, D. W., *The Texts of Early Greek Philosophy: The Complete Fragments and Selected Testimonies of the Major Presocratics, Part 1* (Cambridge: Cambridge University Press, 2010).

Graziosi, B., *Inventing Homer: The Early Reception of Epic* (Cambridge: Cambridge University Press, 2002).

Green, P., *The Greco-Persian Wars* (Berkeley and London: University of California Press, new edn, 1996).

Grundy, G. B., *The Great Persian War and Its Preliminaries: A Study of the Evidence, Literary and Topographical* (London: John Murray, 1901).

Hall, J. M., *Hellenicity: Between Ethnicity and Culture* (Chicago: University of Chicago Press, 2002).

Hallock, R. T., *Persepolis Fortification Tablets* (Chicago: Chicago University Press, 1969).

Hamel, D., *Athenian Generals: Military Authority in the Classical Period* (Leiden, Boston and Cologne: Brill, 1998).

Hammond, N. G. L., 'The Campaign and Battle of Marathon', *Journal of Hellenic Studies* 88 (1968), pp. 13–57.

——, 'The Expedition of Datis and Artaphernes', in Boardman, J., Hammond, N. G. L., Lewis, D. M. and Ostwald, M. (eds), *The Cambridge Ancient History, Volume IV, Persia, Greece and the Western Mediterranean c. 525 to 479 BC* (Cambridge: Cambridge University Press, 2nd edn, 1988), pp. 491–517.

——, 'The Expedition of Xerxes', in Boardman, J., Hammond, N. G. L., Lewis, D. M. and Ostwald, M. (eds), *The Cambridge Ancient History, Volume IV, Persia, Greece and the Western Mediterranean c. 525 to 479 BC* (Cambridge: Cambridge University Press, 2nd edn, 1988), pp. 518–591.

Hammond, N. G. L. and Roseman, L. J., 'The Construction of Xerxes' Bridge over the Hellespont', *Journal of Hellenic Studies* 116 (1996), pp. 88–107.

Hanfmann, G. M. A. (assisted by Mierse, W. E.), *Sardis from Prehistoric to Roman Times; Results of the Archaeological Exploration of Sardis 1958–1975* (Cambridge, MA: Harvard University Press, 1983).

Hanson, V. D., *The Western Way of War: Infantry Battle in Classical Greece, With a New Preface* (Berkeley and London: University of California Press, 2nd edn, 2009).

——, *Why the West Has Won: Carnage and Culture from Salamis to Vietnam* (London: Faber & Faber, 2001).

—— (ed.), *Hoplites: The Classical Greek Battle Experience* (London and New York: Routledge, 1991).

Harrison, T. (ed.), *Greeks and Barbarians* (Edinburgh: Edinburgh University Press, 2002).

Hartmann, A. V. and Heuser, B. (eds), *War, Peace and World Orders in European History* (London and New York: Routledge, 2001).

Henderson, J., *The Maculate Muse: Obscene Language in Attic Comedy* (New York and Oxford: Oxford University Press, 2nd edn, 1991).

Higbie, C., *The Lindian Chronicle and the Greek Creation of Their Past* (Oxford: Oxford University Press, 2003).

Hignett, C., *Xerxes' Invasion of Greece* (Oxford: Clarendon Press, 1963).

Hodkinson, S., *Property and Wealth in Classical Sparta* (London: Duckworth, 2000).

Holladay, A. J., 'Hoplites and heresies', *Journal of Hellenic Studies* 102 (1982), pp. 94–103.

Holland, T., *Herodotus: The Histories*, trans. Holland, T., introduction and notes by Cartledge, P. (London: Penguin, 2013).

——, *Persian Fire: The First World Empire and the Battle for the West* (London: Little, Brown, 2005).

Hornblower, S., *Herodotus Histories Book V* (Cambridge: Cambridge University Press, 2013).

Hornblower, S. and Pelling, C., *Herodotus Histories Book VI* (Cambridge: Cambridge University Press, 2017).

How, W. W. and Wells, J., *A Commentary on Herodotus: With Introduction and Appendices*, 2 vols (Oxford: Oxford University Press, reprint with corrections, 1923).

Hurwit, J. M., *The Athenian Acropolis: History, Mythology, and Archaeology from the Neolithic Era to the Present* (Cambridge: Cambridge University Press, 1999).

Huxley, G. L., *The Early Ionians* (London: Faber & Faber, 1966).

Jones, A. H. M., *Sparta* (New York: Barnes & Noble, 1993).

Jones, N. F., *The Associations of Classical Athens: The Response to Democracy* (Oxford: Oxford University Press, 1999).

Kagan, D. and Viggiano, G. V., *Men of Bronze: Hoplite Warfare in Ancient Greece* (Princeton and Oxford: Princeton University Press, 2013).

Kahn, C. H., *The Art and Thought of Heraclitus* (Cambridge: Cambridge University Press, 1979).

Kershaw, S. P., *Barbarians: Rebellion and Resistance to the Roman Empire* (London: Robinson, 2019).

——, *A Brief Guide to Classical Civilization* (London: Robinson, 2010).

——, *A Brief Guide to the Greek Myths* (London: Robinson, 2007).

Khan, H. (ed.), *The Birth of European Identity: The Europe–Asia Contrast in Greek Thought* (Nottingham: Nottingham University Press, 2004).

Kirk, G. S., Raven, J. E. and Schofield, M., *The Presocratic Philosophers, A Critical History with a Selection of Texts* (Cambridge: Cambridge University Press, 2nd edn, 1983).

Kottardi, A. and Walker, S. (eds), *Heracles to Alexander the Great: Treasures from the Royal Capital of Macedon, A Hellenic Kingdom in the Age of Democracy* (Oxford: Ashmolean Museum of Art and Archaeology University of Oxford, 2011).

Kraft, J. C., Rapp Jr, G., Szemler, G., Tzavios, C. and Kase, E. W., 'The Pass at Thermopylae, Greece', *Journal of Field Archaeology* 14:2 (1987), pp. 181–98.

Krentz, P., *The Battle of Marathon* (New Haven and London: Yale University Press, 2010).

——, 'Marathon and the Development of the Exclusive Hoplite Phalanx', *Bulletin of the Institute of Classical Studies Supplement* 124 (2013), pp. 35–44.

Kroenig, M., *The Return of Great Power Rivalry: Democracy versus Autocracy from the Ancient World to the US and China* (Oxford: Oxford University Press, 2020).

Kuhrt, A., *The Persian Empire: A Corpus of Sources from the Achaemenid Period* (London and New York: Routledge, 2007).

Kulesza, R., 'Leonidas Myth and Reality', in Kulesza, R. and Sekunda, N. (eds), *Studies on Ancient Sparta* (Gdansk: Gdansk University Press, 2020), pp. 165–82.

Lagos, C. and Karyanos F., *Who Really Won the Battle of Marathon? A Bold Re-appraisal of One of History's Most Famous Battles* (Barnsley: Pen & Sword Military, 2020).

Laroche, E., *Catalogue des Textes Hittites* (Paris: Klincksieck, 1971).

Lazenby, J. F., *The Defence of Greece 490–479 BC* (Warminster: Aris & Phillips, 1993).

——, *The Spartan Army* (Warminster: Aris and Phillips, 1985).

Lazenby, J. F. and Whitehead, D., 'The myth of the hoplite's *hoplon*', *Classical Quarterly* 46:1 (1996), pp. 27–33.

Lear, A. and Cantarella, E., *Images of Ancient Greek Pederasty: Boys Were Their Gods* (London and New York: Routledge, 2008).

Lewis, D. M., 'Datis the Mede', *Journal of Hellenic Studies* 100 (1980), pp. 194–5.

Lewis, S., *The Athenian Woman: An Iconographic Handbook* (London: Psychology Press, 2002).

Llewellyn-Jones, L., 'The Big and Beautiful Women of Asia: Picturing Female Sexuality in Greco-Persian Seals', in Curtis, J. and Simpson, St-J. (eds), *The World of Achaemenid Persia: History, Art and Society in Iran and the Ancient Near East* (London and New York: I. B. Tauris, 2010).

Lloyd, A. B. (ed.), *Battle in Antiquity* (London: Duckworth and Classical Press of Wales, 1996).

Lolosa, Y. G. and Simossib, A., 'Salamis Harbour Project, 2016–2017: Summary of Results', in *'Under the Mediterranean': The Honor Frost Foundation Conference on Mediterranean Maritime Archaeology 20th–23rd October 2017 Short Report Series*, https://doi.org/10.33583/utm2020.12.

Luginbill, R. D., 'Othismos: The Importance of the Mass-Shove in Hoplite Warfare', *Phoenix* 48:1 (1994), pp. 51–61.

Luraghi, N. and Alcock, S. E. (eds), *Helots and their Masters in Laconia and Messenia: Histories, Ideologies, Structures*, Hellenic Studies 4 (Cambridge, MA: Center for Hellenic Studies, Trustees for Harvard University, 2003).

Malkin, I., *Myth and Territory in the Spartan Mediterranean* (Cambridge: Cambridge University Press, 1994).

Marinatos, S., 'Forschungen in Thermopylai', in Wenger, M. (ed.), *Bericht über den VI internationalen Kongress für Archäologie, Berlin 21–26 August 1939* (Berlin: De Gruyter, 1940), pp. 333–41.

——, *Thermopylae: An Historical and Archaeological Guide* (Athens: Greek Archaeological Service, 1951).

Marincola, J., 'Plutarch, "Parallelism", and the Persian-War *Lives*', in Humble, N. (ed.), *Plutarch's Lives: Parallelism and Purpose* (Swansea: Classical Press of Wales, 2010), pp. 121–44.

—— (ed.), *A Companion to Greek and Roman Historiography* (Malden: Blackwell, 2007).

Matthew, C. A. and Trundel, M. (eds), *Beyond the Gates of Fire: New Perspectives on the Battle of Thermopylae* (Barnsley: Pen & Sword Military, 2013).

Meier, C., *A Culture of Freedom: Ancient Greece and the Origins of Europe* (Oxford: Oxford University Press, 2011).

——, *The Greek Invention of Politics* (Cambridge, MA: Harvard University Press, 1990).

Meritt, B. J., Wade-Gery, H. T. and McGregor, M. F., *The Athenian Tribute Lists, Vol. III* (Princeton: The American School of Classical Studies at Athens, 1950).

Merrillees, P. H., *Catalogue of the Western Asiatic Seals in the British Museum: Pre-Achaemenid and Achaemenid Periods* (London: British Museum Press, 2005).

Middleton, G. D., *Understanding Collapse: Ancient History and Modern Myth* (Cambridge: Cambridge University Press, 2017).

Miller, F., *300* (Milwaukie: Dark Horse Books, 1998).

Mitchell, H., *Sparta* (Cambridge: Cambridge University Press, 1964).

Morris, I. and Raaflaub K. A. (eds), *Democracy 2500? Questions and Challenges* (Dubuque: Kendall/ Hunt, 1998).

Morrison, J. S., Coates, J. F. and Rankov, N. B., *The Athenian Trireme: The History and Construction of an Ancient Greek Warship* (Cambridge: Cambridge University Press, 2nd edn, 2000).

Mousavi, A., 'The Discovery of an Achaemenid Way-station at DehBozan in the Asabad Valley', *Archäoligisches Mitteilungen aus Iran* 22 (1989), pp. 135–8.

Müller, D., *Topographischer Bildkommentar zu den Historien Herodots: Kleinasien und Angrenzende Gebiete mit Südostthrakien und Zypern* (Tübingen: Ernst Wasmuth Verlag, 1997).

Müller, K. O., *Die Dorier* (Bredlau: Max, 1824).

Murray, O., 'The Ionian Revolt', in Boardman, J., Hammond, N. G. L., Lewis, D. M. and Ostwald, M. (eds), *The Cambridge Ancient History, Volume IV, Persia, Greece and the Western Mediterranean c. 525 to 479 BC* (Cambridge: Cambridge University Press, 2nd edn, 1988), pp. 461–90.

Ober, J., *Political Dissent in Democratic Athens: Intellectual Critics of Popular Rule* (Princeton: Princeton University Press, 1998).

Osborne, R., *Demos: The Discovery of Classical Attika* (Cambridge: Cambridge University Press, 1985).

Pankova, S. V. and Simpson, St-J.(eds), *Masters of the Steppe: The Impact of the Scythians and Later Nomad Societies of Eurasia: Proceedings of a conference held at the British Museum, 27–29 October 2017* (Oxford: Archaeopress Archaeology, 2020).

Papalas, A. J., 'Development of the Trireme', *Mariner's Mirror* 83:3 (1997), pp. 259–71.

——, 'Polycrates of Samos and the First Greek Trireme Fleet', *Mariner's Mirror* 85:1 (1999), pp. 3–19.

Parke, H. W. and Wormell, D. E. W., *The Delphic Oracle. Vol. I: The History; Vol. II: The Oracular Responses* (Oxford: Blackwell, 1956).

Parker, R., 'Myths of Early Athens', in Bremmer, J. (ed.), *Interpretations of Greek Mythology* (London and Sydney: Croom Helm, 1987).

Pearson, L., *Early Ionian Historians* (Oxford: Clarendon Press, 1939).

Pritchett, W. K., *Studies in Ancient Greek Topography: Part I*, Classical Studies 22 (Berkeley: University of California Press, 1965).

——, *Studies in Ancient Greek Topography: Part IV (Passes)*, Classical Studies 28 (Berkeley: University of California Press, 1980).

——, *Studies in Ancient Greek Topography: Part V*, Classical Studies 32 (Berkeley: University of California Press, 1985).

Raaflaub, K. A., *The Discovery of Freedom in Ancient Greece* (Chicago: University of Chicago Press, 2004).

Raaflaub, K. A., Ober, J. and Wallace, R. W., *Origins of Democracy in Ancient Greece* (Berkeley, Los Angeles and London: University of California Press, 2007).

Raaflaub, K. A. and van Wees, H. (eds), *A Companion to Archaic Greece* (Malden and Oxford: Wiley-Blackwell, 2009).

Rahe, P. A., *The Grand Strategy of Classical Sparta: The Persian Challenge* (New Haven: Yale University Press, 2015).

Rapp, G., 'The Topography of the Pass at Thermopylae Circa 480 BC', in Matthew, C. A. and Trundel, M. (eds), *Beyond the Gates of Fire: New Perspectives on the Battle of Thermopylae* (Barnsley: Pen & Sword Military, 2013), pp. 39–59.

Rawson, E., *The Spartan Tradition in European Thought* (Oxford: Clarendon Press, 1969).

Rees, O., *Great Naval Battles of the Ancient Greek World* (Barnsley: Pen & Sword Maritime, 2018).

Rhodes, P. J., *Aristotle, The Athenian Constitution*, trans. with introduction and notes by Rhodes, P. J. (Harmondsworth: Penguin, 1984).

——, *The Athenian Constitution Written in the School of Aristotle* (Liverpool: Liverpool University Press, 2017).

——, 'The Battle of Marathon and Modern Scholarship', *Bulletin of the Institute of Classical Studies, Supplement* 124 (2013), pp. 3–21.

Roberts, J. T., *Athens on Trial: The Anti-Democratic Tradition in Western Thought* (Princeton: Princeton University Press, 1994).

Robinson, E. W., *The First Democracies: Early Popular Government outside Athens*, Historia Einzelschriften 107 (Stuttgart: F. Steiner, 1997).

Rookhuijzen, J. Z. van., *Herodotus and the Topography of Xerxes' Invasion: Place and Memory in Greece and Anatolia* (Berlin and Boston: Walter de Gruyter, 2020).

Rosenbloom, D., *Aeschylus: Persians* (London: Duckworth, 2006).

Sacks, K. S., 'Herodotus and the Dating of the Battle of Thermopylae', *Classical Quarterly* 26:2 (1976), pp. 232–48.

Saïd, S., *Homer and the Odyssey* (Oxford: Oxford University Press, 2011).

Scott, M., *Delphi: A History of the Center of the Ancient World* (Princeton and Oxford: Princeton University Press, 2014).

Sekunda, N., *Marathon 490 BC: The First Persian Invasion of Greece* (Oxford: Osprey, 2002).

Sekunda, N. and Chew, S., *The Persian Army 560–330 BC* (Wellingborough: Osprey, 1992).

Shepherd, W., *The Persian War in Herodotus and Other Ancient Voices* (Oxford: Osprey, 2019).

Shipley, G., *A History of Samos 800–188 BC* (Oxford: Oxford University Press, 1987).

Solomon, J., *The Ancient World in the Cinema* (New Haven and London: Yale University Press, revised and expanded edn, 2001)

Stephenson, P., *The Serpent Column: A Cultural Biography* (New York: Oxford University Press, 2016).

Stockton, D. L., *The Classical Athenian Democracy* (Oxford: Clarendon Press, 1990).

Strauss, B., *The Battle of Salamis: The Naval Encounter that Saved Greece – and Western Civilization* (New York: Simon & Schuster, 2004).

Szemler, G., Cherf, W. and Kraft, J., *Thermopylai: Myth and Reality in 480 BC* (Chicago: Ares, 1996).

Thonemann, P., *The Maeander Valley: A Historical Geography from Antiquity to Byzantium* (Cambridge: Cambridge University Press, 2011).

Tod, M. N., *A Selection of Greek Historical Inscriptions, Vol. II* (Oxford: Clarendon Press, 1948).

Trundle, M., 'Reinstating the Hoplite: Arms, Armour and Phalanx Fighting in Archaic and Classical Greece', *Mouseion: Journal of the Classical Association of Canada* 10:2 (2020), pp. 287–93.

Tuplin, C. J., 'Xerxes' March from Doriscus to Therme', *Historia: Zeitschrift Für Alte Geschichte* 52:4 (2003), pp. 385–409.

Vandiver, E., *Stand in the Trench, Achilles: Classical Receptions in British Poetry of the Great War* (Oxford: Oxford University Press, 2013).

van Wees, H., *Greek Warfare: Myths and Realities* (London: Duckworth, reprint, 2005).

—— (ed.), *War and Violence in Ancient Greece* (London: Duckworth and Classical Press of Wales, 2000).

Wallace, P. W., 'The Anopaia path at Thermopylae', *American Journal of Archaeology* 84 (1980), pp. 115–23.

——, 'Psyttaleia and the Trophies of the Battle of Salamis', *American Journal of Archaeology* 73:3 (1969) pp. 293–303.

Wallinga, H. T., *Xerxes' Greek Adventure: The Naval Perspective* (Leiden: Brill, 2005):

Waterfield, R., *Herodotus, the Histories* (Oxford and New York: Oxford University Press, 1998).

Waters, M., *Ancient Persia: A Concise History of the Achaemenid Empire, 550–330 BCE* (Cambridge: Cambridge University Press, 2014).

Welsh, F., *Building the Trireme* (London: Constable, 1988).

West, M. L., *Early Greek Philosophy and the Orient* (Oxford: Oxford University Press, 1971).

——, *The East Face of Helicon: West Asiatic Elements in Greek Poetry and Myth* (Oxford: Clarendon Press, 1997).

——, 'The Homeric Question Today', *Proceedings of the American Philosophical Society* 155:4 (2011), pp. 383–93.

Whatley, N. 'On the possibility of reconstructing Marathon and other ancient battles', *Journal of Hellenic Studies* 84 (1964), pp. 119–39.

Whitehead, D., *The Demes of Attica 508/7–ca 250 BC: A Political and Social Study* (Princeton: Princeton University Press, 1986).

Zerefos, C., Solomos, S., Melas, D., Kapsomenakis, J. and Repapis, C., 'The Role of Weather during the Greek–Persian "Naval Battle of Salamis" in 480 BC', *Atmosphere* 11:8 (2020), 838, https://doi.org/10.3390/atmos11080838.

Index

Abrocomes, 272
Abronichus son of Lysicles, 252
Abrotonon, 150
Aceratus ('Pure'), 282
Achaemenes, 191, 279
Achaemenid dynasty, 66–7, 285
Acharnae, inscription, 330
Achilles, 19, 221, 350
Acragas, 11
Acrocorinth, 301–2
Acropolis, 4, 13, 18, 21, 31, 33, 130, 148, 184
 memorial to Callimachus, 178, 284
 meals, seeParthenon construction, 360
 meals, seesurrender and destruction, 284–6,
 289, 302, 325
 'Wooden Wall' oracle, 217, 238, 282
Actaeus, king of Attica, 3–4
Adeimantus, 246, 287–8, 301–2
Aeacus, 289, 298
Aeaces son of Syloson, tyrant of Samos, 142
Aegina, enmity with Athens, 33–4, 154–5,
 157–8, 202–3, 218
Aeimnestus, 342, 345
Aelian, 104
Aeneas, 371
aer ('Cosmis air'), 53
Aeschylus, 164, 177, 184–5, 208, 383
 The Persians, 167, 199, 203, 268, 292–6,
 298, 300, 303, 306–9, 313, 316, 318–19,
 321, 348, 389
Agamemnon, 3, 9, 45, 47
Agathyrsian women, 84–5
Agenor, king of Sidon, 120–1
Agesilaus, king of Sparta, 89
Agis, 373
Aglaurus, shrine of, 284
Ahmose (Amasis) II, pharaoh, 58–9, 114–15

Ahura Mazda (god), 61–2, 67–8, 130, 145,
 153, 191, 193, 271
 Sacred Chariot of, 220, 317
Aietes, king of Colchis, 121
Ajax, 19, 288, 309
akinakes (king's dagger), 68–9, 318, 348
Alcmaeon, 23
Alcmaeonid dynasty, 13, 18, 21–3, 34, 183,
 189
Alcman, 109
Alexander I, king of Macedon, 240, 281,
 322–5, 339
Alpheus son of Orsiphantus, 274
Alyattes, king of Lydia, 40–1, 115
Amazons, 5, 81–2
Ameinias of Pallene, 303–5, 310
Amekhania (Lack of Resources), 315
Amestris, 192, 318–20
Amompharetus son of Poliades, 341–2, 344
'Amyclaean silence', 93
Amyclas, king of Sparta, 105
Amyntas, king of Macedon, 35
Amyntis, 38
Amytas, king of Macedonia, 153
Anacreon, 82
Anankaia (Necessity), 315
Anaxagoras of Aegina, 234
Anaxagoras son of Dimagoras, 80
Anaxandridas II, king of Sparta, 115–16
Anaximander of Miletus, 51–4
Anaximenes, 53
Anchimolius, son of Aster, 21
andreia (manly reputation), 26
Androcrates, 333
Andromeda, 385
Antipatrus son of Orgeus, 232
Apate (Deception), 161

449

Aphrodite, 161, 301–2
Apothetae ('Places of Rejection'), 101, 387
apotympanismos (crucifixion), 360
Arabian Nights, 201
Araxes, river, 57
Archidamus II, king of Sparta, 100
Archilochus, 51
archons, 16–17, 23, 150–1, 189
Ardys, king of Lydia, 40
Argeia, queen, 96–7
Ariabignes, 229, 306
Ariamenes, 303–4
Arimnestus, 174, 333
Aristagoras of Miletus, 353
Aristagoras son of Milpagoras, 117–19, 122,
 125–8, 131, 136–7, 140, 142, 145
Aristides the Just, 174, 189, 203–4, 236, 297,
 307, 325–7, 332–4, 336, 339, 343, 348
Aristodemus, king of Sparta, 96
Aristodemus the Trembler, 275, 344, 387
Aristogeiton, 20–1, 173, 284
aristoi, ('best' men), 12
Aristophanes, 163
 The Birds, 69
 The Frogs, 208, 212
 The Knights, 212
 Lysistrata, 21–2, 24, 73, 83, 106, 212
 The Wasps, 167–8, 183
 The Women in the Assembly, 211, 258–9
Aristotle, 13, 89, 97–8, 111, 173, 366
Arnaces (eunuch), 315
Arta (truth/justice), 291
Artabanus son of Hystaspes, 78, 194–5, 222,
 226, 239, 248, 285, 248, 285
Artabanus the Hyrcanian, 362
Artabazus, 321–2, 337, 345–6
Artaphernes son of Artaphernes, 158, 160,
 165, 177, 187, 219, 227
Artaphernes son of Hystaspes, 31, 35, 123–7,
 129, 136, 144, 152
Artaxerxes, 361–2
Artaÿctes, 358–60
Artaÿnte, 318–20
Artaÿntes, 322, 356
Artemis, 39, 41, 159, 161, 241, 250–1, 296,
 328
Artemisia, queen of Halicarnassus, 229,
 290–1, 305–6, 314
Artemisium, Battle of, 245–52, 255, 262, 266,
 284, 291, 294–5, 350, 354, 363, 391
Artobazanes, 190–1
Artybius, 132–3, 138
Ashurbanipal, king of Assyria, 38, 40
Ashuruballit II, king of Assyria, 39
Asopodorus ('Gift of the Asopus'), 346
Asopus, river, 243, 268–9, 328, 332, 338, 340,
 343
aspis (shield), 169

Assembly of the People (*Ekklesia*), 17–18
Assyrians, 37–40, 50, 134, 226, 273
Astyages, king of Media, 42–3
Athena, and foundation of Athens, 4–5
Athenades, 275
'Athenian Owls', 19
Athens and Athenians
 Age of Cronus, 19
 alliances, 31–5
 army, 25–30
 demes, 24–7
 democracy, 22–30, 189–90
 enmity with Aegina, 33–4, 154–5, 157–8,
 202–3, 218
 ethnicity, 7
 historical, 10–22
 imperial ambitions, 361–3
 mobilisation, 165–71
 mythical history, 2–8
 naval power, 203–13
 proto-historic, 8–10
 sexual habits, 19–20, 211–12
 Solon's reforms, 14–17
 surrender of the city, 283–5
 synoecism, 5
 Spartan involvement in, 21–4, 31–4
 violation of Persian ambassadors, 154, 188
 women's dress, 34
Atossa, queen, 43, 58, 69–72, 77, 146, 152–3,
 167, 190, 227, 277, 292, 307
Attaginus, 329, 352
Atthides and Atthidographers, 166
Attic pottery, 19
Autonous ('Freedom of Thought'), 283
Axius, river, 232, 316
Ayois Vasilios, excavations, 90

Babylon, conquest of, 42–3, 55–7
Babylonia, revolts in, 192
Babylonian Chronicles, 38, 43
Bacis (seer), 251, 338
'Barbarians' (the word), 365–6
Bardiya/Smerdis, king of Persia, 60–2
Bates, Tyler, 388
Battle of the Champions, 113–14, 440
Battle of the Solar Eclipse, 39–40
Bel-shimanni, king of Babylonia, 192
bibasis (workout), 108
Binyon, Laurence, 392
Bisitun, reliefs and inscriptions, 61, 63, 78,
 132
'Black Cloaks', 85
Black River, 224, 243
Bladud, King, 371–2
Boeotians, 32–3
Bononcini, Giovanni, 369
Book of Esther, 71
Boreas (North Wind), 242

Borysthenes (Dneiper), river, 79, 84
Boubares, 323
Bréal, Michel, 378
Brookes, J. E., 382
Brutus (Brute of Troy), 371
Bulwer-Lytton, Edward, 376
Bundinians, lice-eating, 84
burial alive, 231
Burner, Charles, 369
Butler, Gerard, 387
Byron, Lord, 372–5
Byzantine Empire, 367

'Cadmean victories', 273
Caffarelli (castrato), 369
Caicus, river, 221
Calliades, archon, 230
Callicrates, 344
Callimachus, polemarch, 2, 158, 172–4,
 177–9, 284
Cambyses, king of Persia, 42
Cambyses II, king of Persia, 43, 58–61, 63,
 114, 124, 192, 228
Candaules, king of Lydia, 40
cannabis, 83
Carey, Chris, 388
Carneian Apollo, 107, 171, 261–2
Carystus, surrender of, 159
Cassandane, 43
Cavafy, Constantine P., 378–9
Cavalli, Pier Francesco, 369
Caÿster, river, 129
Cecrops I, king of Athens, 3–4
Cephisus, river, 280
Chalcidian Hippobotia ('Horse-feeders'), 33
Chalouf Stela, 77
Charadra, river, 163, 165, 174–5
Charilaus, 96
Charopinus, 128
Chateaubriand, François-René, vicomte de,
 364, 372
Chertomlÿk warrior graves, 82
Chigi vase, 260
Chileus of Tegea, 326
Choasper, river, 76
Cicantakhama of Sagartia, 62
Cicero, 1, 104, 381
Cimon son of Miltiades, 325, 362
Cleisthenes, 22–4, 26, 29–31, 86, 189, 212
Cleombrotus, regent of Sparta, 116, 283
Cleomenes I, king of Sparta, 21, 23–4, 31–2,
 115–18, 128, 155–7, 353
 self-mutilation and death, 155–6
Clinias of Crete, 351
Clinias son of Alcibiades, 250
Clinton, Bill, 389–90
Colophon, capture of, 40
Columbus, Christopher, 368

Constitution of the Athenians, The, 16, 236
Cornelius Nepos, 188, 256
Coubertin, Baron Pierre de, 377–7
Council of 400 (Boule), 17, 23, 29–30
Cranaus, king, 4
'Crane Dance', 7
Crasey, Sir Edward Shepherd, 377
Croesus, king of Lydia, 41, 43–4, 53, 114–15,
 122
Croly, George, 375–6
Ctesias, 192, 289, 348
Cyaxares, 38–40
Cybele, 130
Cynegirus (brother of Aeschylus), 177–8
Cyprus, revolt of, 131–5
Cyriac of Ancona, 367–8
Cyrus I, king, 38
Cyrus II 'the Great', king, 20, 41–4, 53, 55–8,
 62–3, 66–7, 73, 113–14, 122, 130, 192,
 228, 312, 360–1
Cyrus Cylinder, 42, 56–7

Damasithymus, king of Calydnus, 305–6
Darics (coins), 68
Darius, Crown Prince, 318–19
Darius I, king, 1–2, 31, 35–6, 60–72, 74–5
 his bowshot, 130
 his cousin, 321
 death and succession, 190–2
 and defeat at Marathon, 185–6, 190
 his ghost, 199, 268
 and invasion of Greece, 146, 152–5, 157–8,
 161–2
 and Ionian Revolt, 123–4, 126–8, 130–2,
 135–6, 138–9, 144–5
 and Miltiades, 147–9
 and Scythian expedition, 77–87, 117–18,
 147–8, 194, 222
 his sons, 191–2, 227, 229
 his wives and concubines, 69–72
 and Xerxes, 199, 202, 228
Darius Painter, 'name vase', 161
Darius Seal (British Museum), 68
Datis, 137, 139, 159–60, 162–3, 165, 176–7,
 187, 219
Daurises, 135–6
David, Jacques-Louis, 373–4, 387
death penalty, 14, 188
Deh-Bozan, excavations, 76
Deinon, 71
Deioces, king of the Medes, 37–8
Delphi
 oracle, 34, 41, 43, 95, 97, 142, 155, 157,
 187, 215, 217, 240, 281–2, 326, 333,
 381
 Persian raid, 281–3
 Serpent Column, 233–4, 297, 302, 349,
 356

Demades, 14
Demaratus, king of Sparta, 32, 155, 191,
 229–30, 263, 267, 279, 289
Demeter, 4, 157, 187, 333, 342, 344, 353–5
Democritus of Naxos, 234, 310
demokratia (rule of the people), 24
Demophilus son of Diadromes, 270
Deucalion, 4
diamerion (non-penetrative) intercourse, 104
Dicaeus, 289
Dicearchus, 78
Didyma, burning of oracle of Apollo, 143
diekplous and *periplous* tactics, 141–2, 206,
 248, 300, 304
Dieneces, 264, 274
Diodorus Siculus, 169, 237, 315, 325, 330–2,
 348, 355, 357
 and Battle of Salamis, 294, 299–300, 303,
 308
 and Battle of Thermopylae, 255–6, 260,
 270, 273
Diogenes Laertius, 50
Dionysus, 208, 211–12, 298
Dionysius (Phocaean commander), 141–2
Dithyrambus son of Harmatides, 274
Dixon, W. Macneile, 380
Doreius, 116
Doric dialect, 91–2, 112
Douris of Samos, 45
Drako, 14
Druids, 50
Dyras, river, 243

Ecbatana, inscriptions, 77
Echetlaus ('Ploughshare-handle Man'), 181
Egypt, revolt of, 190–2
Egyptian canal, 77
Elam, kingdom of, 39
Eleusinian Mysteries, 4, 289
Eleusis, capture of, 32–3
eleutheria (freedom), 275
Eleutheria ('Festival of Freedom'), 331
Elton, Godfrey, 381
Enlightenment, 369–70
Ephesus, capture of, 41
Ephialtes son of Eurydemus ('Nightmare'),
 268–71, 275, 378–9, 387
ephors, election and powers, 96, 98–100
Ephorus, 46, 330
Epidanus, river, 243
epilepsy, 60, 102
Epizelus son of Cuphagoras, 181–2
Eratosthenes, 46
Erekhtheus, king, 4, 242, 285
Eretes, 45
Eretria, subjugation of, 159–60, 162, 219
Erikhthonius, 4
Eros, 104, 161

Etesian winds, 241
Euaenetus son of Carenus, 240
Euboean sheep, 251
Eucles, 183
Eumenes of Anagyrus, 310
eunomia (good government), 95–6, 210
eunuchs, 73–4, 225, 362
Eupatridai, 12, 14, 18, 22
Euphorbus son of Alcimachus, 159
Euphrantides (seer), 298
Euphrates, river, 76
Eupolis, 258–9
Euripides
 Andromache, 111
 Suppliant Women, 5–6
Europa, 120
Eurotas, river, 92
Euryanax son of Dorieus, 327, 341
Eurybiades son of Eurycleides, 246–7, 286–8,
 292, 297, 314
Eurymedon, river, 362
Eurysthenes, 97
Eurytus, 275
eutaxia ('good order'), 170
Euterpe, 150
Exekias, 19

Förtsch, Johann Philipp, 369
funeral games, 261

Gaeson, river, 353
Gargaphia spring, 340–1
Garrod, H. W., 380
Gaumata the Magus, 61
Gaymanoca Mogila, silver bowl, 84
Gelon, tyrant of Syracuse, 217
gene (clans), 14
Geoffrey of Monmouth, 371
Gergis son of Ariazus, 227, 230
Gilbert and Sullivan, 377
Glover, Richard, 370–1
Gobryas, 61, 63, 69, 190
Golding, William, 386
Gorgo (daughter of Cleomenes), 118–19
Gorgo (wife of Leonidas), 111, 261, 370–1
Gorgus, king of Cyprus, 248
Gorgus, king of Salamis, 131–3
Göring, Hermann, 383
Graves, Robert, 383–4
Great Flood, 4
Greek War of Independence, 375–6
Grote, George, 376
Gygaea, 323
Gyges, king of Lydia, 40
Gyndes, river, 56

Haliacmon, river, 232
halmis (sealed documents), 124

Halys, river, 40, 44, 76, 201
Handel, George Frideric, 369
Hanging Gardens of Babylon, 38–9
Harmocydes, 329
Harmodius, 19, 21, 173, 284
Harpagus, 43–4, 144
Hastings, Battle of, 161, 376
Hattusa, Hittite archives, 46
heavy metal music, 388–9
Hebrus, river, 224
Hegesipyle, 147
Hegesistratus ('Leader of the Army') of Elis,
 336, 338
Hegesistratus son of Aristagoras, 253
Hegetorides, 347
Helen of Troy (Helen of Sparta), 7, 47, 90,
 106, 111, 119, 121, 350, 358
Hellas (personification), 161
Hellespont bridges, 193, 198–9, 219, 251,
 289, 313–15, 317, 358, 360, 369
Helots, 93–4, 99–101, 112–13, 117, 155, 157,
 256, 273, 275, 326, 334, 348–9, 382
Hephaestus, 4, 50
Hera, 333, 341, 344, 346, 353
Heracles, 4–5, 91, 164, 172, 181, 183–4, 212,
 224, 246, 300
 his club, 257
 cult of Hercules, 373–4
Heraclides Lembus, 110
Heraclides of Cumae, 71
Heraclitus of Ephesus, 53–5
Hermippus (messenger), 136
Hermolycus son of Euthoenus, 356
Hermophantus, 129
Herodotus, 18, 20, 22, 31–2, 36–7, 39–40,
 42, 46, 49, 55, 57–60, 62, 66, 74, 76
 afterlife, 369, 382, 388
 and Athenian navy, 203, 213
 and Battle of Artemisium, 245, 247–8
 and Battle of Marathon, 166, 172–3,
 175–7, 179, 181–3
 and Battle of Mycale, 356–8
 and Battle of Plataea, 334–5, 344, 346–50
 and Battle of Salamis, 286–7, 289–91,
 293–6, 299–301, 309–11
 and Battle of Thermopylae, 254–6, 262,
 268–9, 271, 273, 275
 catalogue of Persian army, 224–7
 end of his work, 360–1
 and Ionian Revolt, 120–2, 125, 138, 140,
 144
 and Persian invasion, 152–4, 157, 164
 and Scythian expedition, 77–83, 85–7
 and Spartans, 89, 94, 96, 116, 118, 213–14
 and Xerxes' invasion, 192, 195, 197–202,
 213–14, 216, 219, 223–7, 229, 231, 233,
 235, 237, 242–3, 277–8, 280–2
 and Xerxes' retreat, 317, 321, 325, 329

Hesiod, 54, 79
Hesychius of Alexandria, 105
Hipparchus son of Charmus, 30, 189, 236
Hipparchus son of Peisistratus, 19–21
Hippias, 19, 21–3, 31, 34–5, 116, 152, 158,
 163–5, 173, 189
Hippobotai ('Horse-feeders'), 33
Hippomachus of Leucas, 336
Hisarlik, 45
Histiaeus of Miletus, 86–7, 123, 125, 127,
 130–1, 136–7, 143–5, 194
Hittites, 46–7
Homer (Iliad), 3, 5, 9, 45, 47, 49, 79, 90,
 119, 129, 141, 169, 177, 245, 366
homosexuality, 19–20, 106–7, 211–12, 381–2
hoplites (the name), 169
Housman, A. E., 381
Hyacinthia festival, 326–7
Hyacinthus, 105
Hybrillides, archon, 1
Hydarnes (conspirator), 61, 63, 225, 265,
 268–70, 275, 316
Hydarnes (Phoenician admiral), 149
Hydarnes son of Hydarnes, 187
Hymaees, 135
Hyperanthes, 272
Hypomeiones ('Inferiors'), 111
Hypsechides, archon, 236
Hystaspes, 190, 192, 316

Iatragoras, 128
Idanthyrsus, king of Scythia, 85
Immortals, 220, 223, 225, 265–6, 268–71,
 316
Indian hunting dogs, 225
infinity, 51, 54
Intaphrenes (conspirator), 61, 63, 74
Io, abduction of, 120
Isagoras, 22–3, 31
isegoria (equality of speech), 24
Isocrates, 255–6
isokratia (equality of power), 24
isonomia (equality under the law), 24, 28
Ister (Danube), river, 79, 84–6, 147, 194
Ithamitres, 322

Jews, return of, 56
Johnson, Samuel, 371
Justin, 166, 177

Kennedy, Robert F., 94
kidaris (king's head-dress), 68–9
'King's Eyes' and 'King's Ears', 75
King's Road, 224
Kipling, Rudyard, 380–1
kleos (glory), 266, 270, 272, 274, 309, 344
Koes, king of Lesbos, 128
Kore, 333, 342, 353

Krypteia (secret police), 99
Kul'-Oba, gold beaker, 84
kurgans (burial mounds), 79–81
Kylon, 13

Lachish, siege of, 134
'Laconian *exeligmos*' (manoeuvres), 259
Laconic statements, 89, 154
Lade, Battle of, 138–42, 206
Lady of Aegae, 323
Lampon, 345
Lemnos, Miltiades' conquest of, 148–9, 188
Leon ('Lion'), 241
Leonidas, king of Sparta, 111, 116, 252, 254,
 256–7, 259–61, 263–4, 266, 270–3, 345
 afterlife, 370–3, 382–3, 386–7, 389
Leonidas son of Anaxandridas, 246
Leontiades, 254
Lesbians, and fellatio, 258–9
Leutychides, king of Sparta, 155, 322, 353–5,
 358
Lighthouse at Alexandria, 39
Lindian Chronicle, 138–9
Linear B, 8, 10, 90
Lisus, river, 231
lokhoi (armed bands), 27
Lotus Eaters, 72
Louis, Spiros, 378
Lycides, stoned to death, 325
Lycomedes, king of Scyros, 8
Lycomedes son of Aeschraeus, 248, 304
Lycurgus, 18, 95–6, 103, 105–8, 110; *Against
 Leocrates*, 330
Lycus, river, 201
Lydians, and Persian empire, 39–45
Lygdamis, tyrant of Halicarnassus, 229

Macaria spring, 164
Machiavelli, Niccolò, 367–8
Maeander, river, 48, 135, 201, 354
Maeandrius, 117
'Man with the Tattooed Head', 127–8
Mandane, 42
'Man-eaters', 85
map of the inhabited world, first, 51
Marathon, Battle of, 26, 28, 30, 86, 137, 157,
 159, 161, 174–85, 203, 213, 248, 259,
 264, 284, 296, 334, 339, 350–1, 363
 afterlife, 371–2, 374, 376–8, 380, 383–5,
 391
 Athenian mobilisation, 165–71
 casualties, 182
 consequences, 185–6, 190, 193
 late arrival of Spartans, 171, 173–4, 184,
 261
 Marathonomakhoi ('Marathon-fighters'),
 184
 Persian landing, 163–5, 171–3

runners, 171, 183, 384–5
Soros mound, 179–80
supernatural manifestations, 181
'Marathon Cup', 378
Marathos (hero), 164
Mardonius ('The Soft Man'), 152–4, 158
Mardonius son of Gobryas, 193–4, 196, 227,
 230, 278, 290, 312–14, 316, 321–9, 332,
 335–40, 343–5, 347–50
Mardontes, 322, 356
Mardontes (Mardunda), 227
Marduk (god), 42
Marinatos, Spyridon, 253, 273
Maron son of Orsiphantus, 274
Maronea silver mines, 203
Marsyas, flaying of, 201
Masistes, 190, 227, 230, 318, 320–1
Masistius, 332–3, 355
Maté, Rudolf, 385
Matten, tyrant of Tyre, 290
Mausolus, tomb of, 39
Maximus of Tyre, 104
Medea, 121
Medes, and Persian empire, 37–9
medimnoi (measures), 15–16
Medism, 32, 35, 202, 213, 216–18, 230, 239,
 255, 272, 280–2, 308, 316, 323, 325,
 329, 333–6, 343, 345, 352, 356, 358, 361
Medon, king of Athens, 48
Megabates, 126–7, 159
Megabazus, 87, 123, 125
Megabyzus (conspirator), 61, 63, 65
Megabyzus (son-in-law of Xerxes), 192
Megabyzus son of Zopyrus, 227, 231
Megacles, 13, 18, 23
Megacles son of Hippocrates, 189, 236
Megacreon of Abdera, 232
Megillus the Spartan, 351
Megistias (seer), 270, 274
Mehmed II the Conqueror, sultan, 367
Menelaus, 47, 90, 327
Menestheus, 7–9
Metiochus son of Miltiades, 149
Midas, king of Phrygia, 40, 201
Milesian wool, 50
Miletus
 intellectual flowering, 49–53
 revolt of, 136–43, 148–9
Mill, John Stuart, 161, 376–7
Miller, Frank, 386, 388
Miltiades of Callimachus, 2
Miltiades son of Cimon, 2, 25, 86, 147–51,
 158, 171–7, 180, 184, 187–9, 375
 'Decree of Miltiades', 165, 171
Miltiades son of Cypselus, tyrant of the
 Chersonese, 147
Minotaur, 4, 7
Mitsotakis, Kyriakos, 364

Mnesiphilus, 287
Molois, river, 342
Montaigne, Michel de, 368
moustaches, 99
Mt Aegaleus, 295, 297
Mt Agrieliki, 163–4, 172, 175
Mt Athos, 1, 153, 159, 193
 canal, 196–7, 202, 219, 231
Mt Cithaeron, 331, 333, 340–2
Mt Ida, 221
Mt Kallidromon, 252, 254, 268
Mt Kotroni, 163, 174–5
Mt Mycale, 353–5, 357
Mt Oeta, 254, 269
Mt Olympus, 232–3
Mt Ossa, 232
Mt Othrys, 240
Mt Pangaeum, 231, 316
Mt Parnassus, 280, 282
Mt Pelion, 242, 249
Mt Sipylus, 195
Mt Stavrokoraki, 163, 174
Murychides, 325
Muwattalli II, king of the Hittites, 47
Mycale, Battle of, 227, 353–7
Mycenean Period, 8–10
Myronides, 325

Nabonidus, king of Babylon, 41–2, 55–6
Nabopolassar, 38–9
Napoleon Bonaparte, 374
Naqsh-i Rustam, tomb of Darius, 67, 153,
 192
Naxos, revolt of, 125–8, 159, 219
Nedbuchadnezzar, king of Babylon, 38, 56
Neileus, 49
Nemesis, 148, 159
Nepos, 166
Nesaean horses, 220
Nestor, 141
Nestus, river, 231
'netting', 146, 160, 162
Neurian werewolves, 85
Nicodemus, archon, 203
Nike, 105, 178, 180, 284
Nile, river, 77
'Nine Ways', 231
Nineveh, sack of, 39
Nitetis, 58–9, 72
Nonnus, 163
Nymphs of Sphagis, 333

Odysseus, 3, 9
Oeobazus, 358–9
Oeroe, river, 340
Olorus, king of Thrace, 147
Olympia, 184, 234, 261–2
 Bronze Zeus at, 297, 349

Olympias (trireme), 205, 210
Olympic Games, 278, 311, 336, 377–8, 384
Olynthus, siege of, 321
Onesilus, king of Salamis, 132–3, 138
Onochonus, river, 243
Onomacritus, 193
oracles, importance of consulting, 214–17
oral sex, 258–9
orgeones (members of guilds), 14–15, 18
Oroetes, 74, 117
ostracism, 30, 189, 204
Otanes, 61, 63, 65, 69, 124–5, 135, 225
othismos ('shoving') tactics, 170, 260, 265, 344
 othismos of words, 297, 334
Othyrades, 113–14
Ottoman Turks, 367, 372, 374
Ovens of Mt Pelion, 242
Oxus Treasure, 69
Oxyrhynchus, papyrus, 350

Pactolus, river, 40
Painted Stoa (Athens), 177, 181
Pammon of Scyros, 242
Pan, 171
Panaetius son of Sosimenes, 234, 297
Panagia Mesoporitissa, church of, 180
Panathenaia Festival, 5, 20
Panathenaic Stadium (Athens), 378
Panionius, 74
Panites, 97, 275
pankration, 356
panoploi ('totally equipped men'), 169–70
Paphos, siege of, 133–5
Parian Chronicle, 3–4, 8, 46, 48
Parian marble, 159, 178, 184, 187
Paris, 47, 121
Parnaka son of Arshum, 70
Paros, siege of, 187–8
Partheniai (Songs for Choruses of Virgins),
 109
'Parthian shot', 81
Pasargadae, tomb and inscriptions, 58
Pausanias (geographer), 3, 89, 166, 177–80,
 182, 254, 258, 268, 349
Pausanias son of Cleombrotus, 233, 326–7,
 333–4, 336, 339–45, 347–50, 353, 361
Pavlopoulos, Prokopios, 364–5
Peace of Callias, 362
Peisistratids, 21–2, 34, 158, 163, 188, 284
Peisistratus, 18–19, 113, 163, 193, 211
Peitho (Persuasion), 315
Peloponnesian League, 33–4, 114, 154, 213,
 235, 362
Peloponnesian War, 363
Pelops the Phrygian, 7, 193, 195
Pelusium, battle of, 59
Peneus, river, 232, 241
Penia (Poverty), 315

Pentakosiomedimnoi, 16
Penthesilea Painter, 105
Periander, tyrant of Corinth, 13, 115
Pericles, 362
Perioikoi, 93–4, 100, 113, 256, 327, 348
Perrault, Charles, 370
Persepolis, reliefs and inscriptions, 68–9, 77, 192, 225, 290
Persepolis Fortification Tablets, 70, 76, 123, 137, 227
Perseus, 216
Persians
 administration and communication, 74–7
 army under Xerxes, 224–9
 ending of Ionian Revolt, 145–7
 engineering projects, 196–200
 and Lydians, 39–45
 and Medes, 37–9
 punishments, 125, 231, 320
 Scythian expedition, 77–87, 117–18, 122–3, 147–8, 194, 222
 sexual habits, 63, 72–3
 and Trojan War, 121
 women, 71–4
Phaedymia, 63
Phaenippus, archon, 187
Phalaris of Acragas, 13
Pharandates, 347
Phaullus, 286
Pheme (Rumour), 355
Pherecydes the Athenian 46
Phidias, 184
Philagrus son of Cineas, 159
Philip of Thessalonica, 212
Philippides, 171, 384–5
Philocyon ('Dog Lover'), 344
Philostratus, 160, 219
Phocis, devastation of, 280–1
Phoenicians, and abduction of Io, 120
Phoenix, river, 240, 243
Photius, 258
Phraortes, 38
Phrynichus, *The Fall of Miletus*, 143
Phylacus ('Guardian'), 283
Phylacus of Samos, 304
Pindar, 163, 251
piracy, 120, 137
Piraeus, fortification of, 151
Piyamaradu, 47
'Places of Rejection', *see Apothetae*
Plataea, Battle of, 29, 233, 235, 275, 330–51, 355–6, 361, 363, 391
 casualties, 348
 Oath of Plataea, 330–1, 352
 tombs, 349–50
Plato, 11, 13, 51, 55, 57–8, 110, 112, 160, 336, 350, 363
 and the Athenian Stranger, 186, 191–2

Plato (comedian), 211
Pleistarchus, 283, 327
Pliny the Elder, 177
Plistorus (god), 359–60
Plutarch, 4–6, 70, 89, 95, 103, 110, 150–1, 154, 166, 174, 179, 181, 203, 236–7, 261, 315, 342, 348
 and Battle of Salamis, 289, 293–5, 302, 304, 310
polis, 10–13
Polycrates, tyrant of Samos, 59, 114–15, 117
Polycritus of Aegina, 310
Polycritus son of Crius, 308
Polyzelus, 181
porphyrogeniture, 97
Poseidon, 4, 292, 309–10, 349
Posidonius, 344
post-traumatic stress disorder, 181–2
Potidaea, siege of, 321–2
Pressfield, Steven, 388
Prexaspes, 60, 62–4
Priam, 45, 47, 121
Procles, 97
prostitutes, 41, 212, 302
Protesilaus, 358–60
Proust, Marcel, 379
Prytaneis (and 'acting in prytany'), 30
Psammetichus III, pharaoh, 59–60
Pseudo-Aristotle, 75
Pseudo-Hippocrates, 79, 82
psiloi (light-armed troops), 167–8
Psyttaleia, location of, 295
Pyrrhus of Epirus, 273
Pythagoras (citizen of Miletus), 136
Pytheas son of Ischenous, 241, 308
Pythian Games, 144, 286
Pythius the Lydian, 201, 219–20

Reconciliation (personified), 106
'Reeds, The', 353
Reeves, Steve, 385
Rhamnus, sanctuary of Nemesis, 159
Rhoecus, king of Amathus, 132
Rocks of Trachis, 243
Roman Empire, 366–7
Rousseau, Jean-Jacques, 370
Royal Road, 76, 124, 201–2

Sadyattes, king of Lydia, 40
Saka Haumawarga, 78
Saka Tigrakhauda, 78
Sakellaropoulou, Katerina, 365
Salamis, Battle of, 237, 262, 285–311, 315–17, 321–2, 348, 350–1, 353, 363
 afterlife, 364–5, 390–1
 casualties, 308
 oracles and omens, 214–17, 289, 298
 'Sicinnus Affair', 292–3

Salamis, sexual habits, 211–12
Santoro, Rodrigo, 387
Sardis, burning of, 129–31, 158–9, 190, 193
Sarpedon, 49, 224
Satrae, never subject to any man, 231
satrapies, 74–5
Sauromatian women, 81–2, 84
sauroter ('lizard-slayer'), 169–70
Scamander, river, 221
Scironian Road, 283
Scyllies of Scione, 247, 294
Scythian horses, 80
Scythians, and Persian expedition, 77–87,
 117–18, 122–3, 194, 222
'Going Scythian', 156
seisakhtheia ('shaking off of burdens'), 15
Sennacherib, king of Assyria, 134
Sestos, siege of, 358–60
Seven Sages of Greece, 50–1
Seven Wonders of the World, 39
sex toys, Milesian, 50
Shalameser III, king of Assyria, 37
Shamash-eriba, king of Babylonia, 192
Siberian Collection of Peter the Great, 79
Sicinnus, 292–3, 315
siege tactics, 133–4
Simonides of Ceos, 233, 250, 274, 310–11,
 327, 346, 350, 380–1, 383, 385, 392
Sirius the Dog Star, 262
Skhunda, king of the Scythians, 78
Skylax, 126–7
slaves and slavery, 15, 44, 160, 167, 171, 193,
 196, 291
 Persian army 'under the lash', 223, 229–30,
 387
Smerdomenes, 227, 230
Snyder, Zack, 300, 386–8
Socles of Paeania, 304
solar eclipses, 40, 51, 219, 292
Solon, 14–17, 19, 41
Sophanes of Decelea, 346
sparabara tactics, 175, 265, 344, 355
Sparta and Spartans
 ancient, 88–91
 expansion and alliances, 92–4, 113–18
 currency, 100
 enmity with Argos, 156–7, 213, 215–17
 and freedom under law, 230
 government and constitution, 94–100
 and growth of Athenian power, 362–3
 hairstyles, 108, 110
 and Helotage, 112
 intervention in Aegina, 154–5
 and lambda device, 257–9, 386
 late arrival at Marathon, 171, 173–4, 184,
 261
 leadership against Xerxes, 213–18, 235
 and secrecy, 326–7

sexual habits, 103–10
'Sown land', 93
training and education, 100–11
violation of Persian ambassadors, 154, 214
women, 108–11
Spercheius, river, 243, 316
Stalingrad, Battle of, 383
Stasicyprus, king of Idalion, 133
Stesagoras son of Cimon, 147
Strabo, 289
strategoi (generals), 28
Strymon, river, 123, 198, 231, 317
Strymonian Wind, 317
submarine warfare, 247
Suda lexicon, 166, 175–6
Susa, inscriptions, 67
Syloson, tyrant of Samos, 117

tacht (banquet), 320
Takht-I Sangin, ivory, 69
Tanais (Don), river, 85
taxeis (military unit), 27–8
Taygetus mountains, 93, 101
teikhomakhie ('wall-battle'), 347
Telamon, 288
Temple of the Goddess of the Bronze House
 (Sparta), 361
Tetramnestus, tyrant of Sidon, 290
Thales of Miletus, 40, 50–1
Thebes, fragmentary inscription, 33
Themistocles son of Neocles, 25, 150–1, 154,
 174, 203–4, 211, 217, 236–7, 240,
 277–8, 314, 322
 and Battle of Artemisium, 246, 251, 354
 and Battle of Salamis, 287–9, 292–4,
 297–9, 302–3, 308, 311
 Decree of Themistocles, 236–7
 post-war career, 361–2
Theocritus, 92, 104
Theomestor of Samos, 304
Theopompus, 258
Thera/Santorini, inscriptions, 106–7
Thermodon, river, 338
Thermopylae, Battle of, 108, 116, 134, 219,
 235, 237, 240, 243–4, 252–76, 279–80,
 290, 335, 350
 afterlife, 364–5, 372–3, 378–80, 382–3,
 386, 389–92
 and Battle of Artemisium, 246, 249–50,
 252, 255, 262, 266
 casualties, 273–4
 Phocian Wall, 253, 263
Thersander of Orchomenus, 329
Theseus, 4–8, 10, 106, 181, 184
Thesmophoria festival, 142
Thetes (labourers), 16–18, 308
Thirty Years Truce, 215
'Thirty-One, The', 234–5

Thorax of Larissa, 325, 342
Thrasybulus, tyrant of Miletus, 40, 49
Thucydides, 88–9, 91–2, 150, 209, 233, 360
Tiernan, Andrew, 387
Timaeus, 46
Timagenides son of Herpys, 337, 352
Timo, 187
Timodemus of Aphidnae, 311
Timon son of Androbulus, 216
Timotheus, 308
Tisamenus ('the Avenger') of Elea, 336, 342
Tmolus mountains, 129
to apeiron ('The Boundless'), 52–3
Tomyris, queen of the Massagetae, 57
Tourneur, Jacques, 384
Tresantes ('Tremblers'), 111
Tricorythian gnats, 164
Triptolemus, 4
triremes
 Athenian, 204–13
 names, 210–11
 Phoenician, 228–9
 and sexual innuendo, 211–12
Tritantaechmes/Tigranes son of Artabanus, 226–7, 230, 245, 278–9, 353, 355–6
trittyes (thirds), 27, 30
Trojan War, 8, 10, 19, 45–9, 90–1, 121, 129, 221, 325, 347, 350, 358–60
tropaion ('trophy'), 180
Troy Novant, 371
tsunami, at Potidaea, 322
tyrannos ('tyrant'/'dictator'), 12–13
Tyrtaeus, 94–5, 112, 169

'Unheralded War', 34
United Nations, 388
Ur, inscriptions, 42

Vailati, Bruno, 384
Vale of Tempe, 232, 239–40

Wilusa, 46–7
Winckelmann, Johann Joachim, 370
Wood, John, 371

Xanthippus son of Ariphon, 188–9, 236–7, 322, 325, 356, 358, 360
Xenophon, 42, 72–3, 89, 100, 103, 107, 259
Xerxes, king, 33, 60, 71, 78, 130, 162, 191–202
 afterlife, 369, 371, 382, 387, 389
 assassination, 321, 362
 and Battle of Artemisium, 246–51
 and Battle of Mycale, 355, 357
 and Battle of Salamis, 287, 289–95, 297–300, 304–6, 308
 and Battle of Thermopylae, 254, 259, 262–8, 271–3, 275
 diplomatic strategy, 218
 and Hellespont bridges, 193, 198–9, 219, 289, 313–15, 317, 358, 360, 369
 hubris, 198, 201, 220–1, 224, 232, 279, 318, 345, 360
 invasion of Greece, 200–2, 213–16, 218–44, 277–82, 284–5
 and Masistes' wife, 318–21
 and portents, 223–4
 retreat from Greece, 312–21, 323–6
 size of his army, 224–9
 succession to Darius, 191–2
 temperament, 249–50
 his throne, 290
 treatment of Leonidas, 273, 345

Zagros mountains, 37, 61
Zephyrus, 104–5
Zeugitai, 16, 25, 170, 308
Zeus, 39, 135, 139, 161, 184, 216, 221, 234, 283, 313, 323, 327, 333, 350
 festival at Olympia, 261–2
Zopyrus, governor of Babylon, 192
Zoroastrianism, 78, 201